THE TRIUMPH OF ART
FOR THE PUBLIC
1785-1848

THE TRIUMPH OF ART
FOR THE PUBLIC
1785-1848

The Emerging Role
of Exhibitions and Critics

SELECTED AND EDITED BY
ELIZABETH GILMORE HOLT

Princeton University Press
Princeton, New Jersey

This book is dedicated to understanding
and helpful librarians.

Anchor Books edition, 1979
First Princeton Paperback printing, 1983

Grateful acknowledgment is made for use of material in
Art in Paris 1845–1862, by Baudelaire, translated
and edited by Jonathan Mayne. Published by Phaidon Press Ltd.,
England, and Phaidon Publishers, Inc., New York.

Published by Princeton University Press,
41 William Street, Princeton, New Jersey 08540
In the United Kingdom:
Princeton University Press, Guildford, Surrey
Published by arrangement with Doubleday & Company, Inc.

Library of Congress Cataloging in Publication Data
Holt, Elizabeth Basye Gilmore.
The triumph of art for the public.
Includes index.
1. Art, Modern—19th century. 2. Art—Exhibitions.
3. Art exhibition audiences. 4. Art criticism. I. Title.
N6450.H62 709'.034
ISBN 0-691-00349-1 pbk.
Library of Congress Catalog Card Number: 83-60461

CONTENTS

V. *Corinne at Misenum*
by Gérard; VI. Gérard,
Thetis; IX. Genre
Pictures; X. Genre, con-
tinued; XXII. Landscape;
XII. Sculpture; first pub-
lished as a series of articles
in *Le Constitutionnel*,
Paris, 1822.

PARIS The Exhibition in an Artist's
 Studio 235

 Adolphe Thiers 235
 "Remarks on a private
 exhibition by Horace
 Vernet," first published
 as one of the above series.

1824 PARIS The Official Exhibition of the
 State 238

 Auguste Jal 245
 *The Artist and the
 Philosopher: Critical
 Conversations on the Salon
 of 1824:* Letter from "the
 philosopher" to the
 author; First Visit to the
 Salon; Second Visit:
 Delacroix, *The Massacre
 at Chios*; Fifth Visit:
 Bouton, *Interior of a
 Gothic Ruin,* and
 Daguerre, *Ruins of
 Holyrood Chapel*; Sixth
 Visit: Constable; Eighth
 Visit: Influence of
 English Landscapes on
 French Artists; *L'Artiste*

LIST OF ILLUSTRATIONS

PREFACE

The Period of Revolution and Transition
1785–1848

The French Revolution and the Napoleonic era, which disrupted eighteenth-century conventions, coupled with the liberalization of the Enlightenment, brought three significant changes to the European art world of the nineteenth century: (a) nationalization of art objects and establishment of public museums (four in Paris and twenty-two in the provinces were founded between 1795 and 1805, followed by the British Museum in 1824 and the Prussian Museum in Berlin, 1824–28); (b) displacement of Rome as the foremost international art center of Europe following the looting by the French revolutionary army in 1796 and the levies exacted by the victorious Napoleon; (c) recognition of the artist who, though now independent of the guild or the academy, was nevertheless dependent on exhibitions and, as in France, on the state and its exhibitions, for commissions and patrons.

With the opening of the Musée Napoléon in the Louvre in 1802, the most comprehensive exhibition of European art was to be found in Paris rather than in Rome. The massive transferral of works of art by the French had far-reaching consequences. A new art entity was formed in Paris, albeit reduced in splendor after the art restitutions in 1816. With a regularly held Salon open to all nationalities after 1793, Paris remained the permanent international art exhibition center of Europe throughout the nineteenth century. With the mounting nationalism in

Europe, a spirit of international competition spread into cultural activity. The Salon in Paris and the international exposition wherever it was held became a type of Olympic games for the fine arts at which a nation's artistic vitality could be tested against other countries, especially France.

Prior to the French Revolution, only members of the Académie de peinture et sculpture had been permitted to exhibit in the biennial Salon. After the Revolution, any artist could submit work to the jury and the Salon became essential to the French artist's existence. If he was admitted, it enabled him to show his work to a wide public, receive notice in the press, and thus attract purchasers. Only artists whose work was accepted for the Salon received lucrative state commissions. Since admittance to the Salon was controlled by a jury, the composition of the jury was of direct concern to every French artist. Although the Salons were organized by a commission of artists between 1793 and 1803, a jury of Academicians was established under Napoleon. Henceforth the state, through the academy, a division within the Ministry of the Interior, assumed the right to name the Salon jury. That jury, the arbiter of "acceptable" art, was a constant source of contention.

Famous, well-established artists had always been independent of any academy and its exhibitions. Certain artists at the end of the eighteenth century had held exhibitions of their own work partly to improve their finances and partly because of innovations in their work. The independence of the successful artists encouraged some whose style and philosophy of art were at variance with the academy to hold exhibitions and present their work directly to the public in an appeal for recognition and approbation, confident of the public's sensitivity to "true art." The German Asmus Carstens hoped by his one-man show in Rome in 1795 "to announce a new epoch in art" and to challenge concepts promulgated by the Prussian Academy. William Blake offered his art to the public accompanied by a catalogue "manifesto" in 1809. Casper David Friedrich displayed his revolutionary Tetschner altarpiece in his

studio in Dresden in the same year. A group of non-conforming German artists utilized the first exhibition of German artists in Rome in 1819 to present examples of an unacademic style to the international art world. In each instance the artist asserted his position or it was defined by a critic. Art reviews, descriptive, laudatory or critical, became an accompanying feature of art exhibitions in this period.

The first critical essay, *Reflexions sur quelques causes de l'état présent de la peinture en France* (1746) by Lafont de St. Yenne, discussed the works of art exhibited in the Salon of 1746. Denis Diderot had established the popularity of art reviews among art patrons by reporting his reaction to and judgment of what was on view at the Salon. An uncritical descriptive, explanatory account of an exhibition accompanied by engraved illustrations was initiated by Charles Landon's *Annales du musée et de l'école moderne des beaux-arts* (1801–8). His innovation, which contributed to the pleasure of viewing and studying a display of works of art, proved popular and was imitated throughout the nineteenth century.

An ever increasing number of entries to the Salon and academy called for considerable literary skill to provide visitors with an interesting, critical guide to the exhibition. This type of writing could provide its author an entrance to the world of letters and win public attention as well as income for him. It was utilized in this manner by Guizot and Thiers, who aspired to a public career, and by writers: Schlegel, Stendhal, Heine, Planche, Baudelaire, Ruskin, Thackeray, Thoré and Delécluze. Notes on art events became regular features in newspapers and magazines. London vied with Paris in the number and size of its news publications. Paris led with the number of small publications devoted to *belles-lettres* and *beaux-arts*. Dresden, Berlin and Augsburg were publishing centers. Art events in Rome, Paris, London or Munich reported by resident foreign correspondents or visitors on tour were featured in publications throughout Europe.

Beginning with the period of revolution and transition,

1785–1848, art exhibitions throughout the nineteenth century seem to have been a method, unique to Europe, whereby its visual language, its visual symbols, and its art styles were subject to constant review, criticism and revision.

ACKNOWLEDGMENTS

In no century before the nineteenth were so many works of art, both painting and sculpture, offered to the public through exhibition or created with an awareness that the work would be viewed in an exhibition to which the public would be admitted. The official exhibitions contained the art accepted by tradition and some experimental work. The single artist or group whose style was at variance with the accepted conventions of representation were usually obliged to seek facilities independent of the established institutions.

The exhibitions documented here were chosen to illustrate both the official, socially acceptable, art and the innovative art. The reviews were chosen from various publications and illustrate a variety of responses: straight reporting, explanatory commentary and the art criticism essay. As the first half of the century was dependent on literary descriptions of the works of art, the report of an exhibition was usually long. Therefore portions have been selected that document the contemporary taste, the innovative tendencies and the writing of an author of influence or of literary note.

The reviewers of the exhibitions kept a wide public abreast of events and the stylistic tendencies in the art world. They influenced the public's judgment, shaped its taste and could excite its curiosity. Commentary accounts of exhibitions were—like those of the theater—regular features to be found in the daily press. They were included in *belles-lettres* journals and many were published in pamphlets or books. The reviews established a connection between the art and the general intellectual interests of the epoch. The period 1850–1900 will be documented in subsequent volumes.

For assistance in obtaining the texts, available in no one library, I am grateful to many librarians. In as many instances as possible the illustrations are taken from the

publications where the text first appeared. They were secured with the generous assistance of the Print Department of the British Museum, the Boston Museum of Fine Arts, the Victoria and Albert Museum, the Bowdoin College Library, the Fogg Art Museum, the Library of Congress and the Cabinet des Estampes of the Bibliothéque Nationale, Paris.

The compilation has benefited from the counsel of many scholars. Among these I mention especially Professors Jean Adhémar, Robert Alexander, Paola Barocchi, Helmut Borsch-Supan, Anita Brookner, the late Frederick Deknatel, Herbert von Einem, Ernst Gombrich, Klaus Lankheit, Ulrich Middeldorf, Agnes Mongan, Fritz Novotny, Nicolas Pevsner, Joseph Sloane, Joshua Taylor. I am grateful to Professor Wolfgang Lotz for his timely assistance and to Professors Horst W. Janson and Ruth Butler for their unfailing encouragement.

I have appreciated the privileges extended to me by Bowdoin College, the Boston Athenaeum, the Fine Arts Library, Harvard University, the Hertziana Library, the Kunsthistorisches Institut, Florence, Bibliothèque de l'Art et l'Archéologie, Geneva, the Library of Congress, the University of Iowa and the University of Michigan.

The translations are offered with the hope that the reader will be stimulated to read the original texts in their entirety. The translations from the French are by Elizabeth Holt Muench and Caroline Riding. I am grateful to David Armborst and to my husband, John Holt, for their collaboration on those from the German.

The volume owes much to Susan Waller, who has assisted in its research, in translations from French texts and in readying the manuscript for publication. Sally Brown prepared the Artists' Index.

The anthology has been completed thanks to the encouraging support received from the trustees of the Chapelbrook Foundation and the American Council of Learned Societies.

<div style="text-align: right">Elizabeth Gilmore Holt</div>

Georgetown, Maine
1978

INTRODUCTION

The emergence in the eighteenth and nineteenth centuries of the art exhibition and of art criticism as principal intermediaries between the European artist and his public resulted from a change in the public's relationship to painting and sculpture and in the role of the artist himself. Greek and Roman artists had exhibited their works of art before they were installed in public buildings; the Acropolis was what could be called today an open-air museum. But at that time the works were seen as offerings to a deity. The carved or painted image, the fruit of man's special gift of creation, was considered a worthy offering, as were the selected fruits of the earth. An image fashioned by man could be endowed with power by the deity it represented, or images were sometimes made by the deity itself. Thus the image possessed "magic," and in every culture it was provided with a setting to enhance its supernatural power. On specific occasions the image was publicly displayed in the setting or paraded around the temple or shrine in order to encourage belief in its supernatural power. When a culture vanished, the supernatural power that had sustained the image faded; the image became an object of curiosity or admiration, but not of veneration, and could be removed from its setting. The Romans pillaged the temples of Greece, the Christians pillaged those of both the Greeks and the Romans, but every new dominant culture cut off the hand or the head of any who pillaged its own sacred shrines.

In the sixteenth century, artists began to turn away from the religious image and to paint pictures without any reference to the supernatural except where it was manifest in nature. A painting by Giorgione completed in 1505 was referred to by his contemporaries as *la tempesta*, because

the artist paid significant attention to a thunderstorm. In 1532, Albrecht Altdorfer painted the first landscape. In the seventeenth century, exhibitions of works of art were held in Rome, Venice and Florence to enhance religious celebrations, and artists quickly realized that such exhibitions could be used to promote their own reputations as well as those of the saints whose festivals were being celebrated. Guilds and art dealers established galleries to display their wares in the Netherlands, where pictures were freed from the cult connotation and used for the embellishment of residences. At the same time that religious attitudes in European culture were changing, academies were being established which held exhibitions within royal precincts, and the artists were transferred from the service of the church to that of the palace.

The oldest academy in Europe was the Accademia delle Arti del Disegno in Florence, founded in 1563 by Cosimo de' Medici at the suggestion of Vasari. It was followed by Sixtus V's Accademia Romana di San Luca in 1593, as well as by private academies such as those sponsored by Leonardo da Vinci in Milan and the Carracci brothers in Bologna.

The ascendancy of Italian culture was so strong at this time that Italian institutions as well as art forms were copied in France. L'Académie Royale de Peinture et de Sculpture was established in Paris under the leadership of LeBrun in 1648 to raise the status of the independent artist above that of the artist in the bourgeois guild and to provide the French nation with pictures and statues representative of the enhanced power of the monarchy. The Academy was responsible for the direction of the state's educational program in the fine arts and in 1655 was given the exclusive right to instruction in life drawing, the basis of all art during the period. Its members served as professors, thereby ensuring certain standards for the style of execution and type of representation.

By 1664, under Louis XIV's minister Colbert, who suppressed all particularism in favor of centralized control in France's institutions, the Academy was reorganized as

part of the reorganization, all artists who received royal commissions were required to join the Academy and all members were required to display their work within the Academy annually at the time of the general assembly. The first exhibition was held in 1665, and court society was admitted for the first time to the galleries of the Palais Royal and the court of the Hôtel Brion, the seat of the Academy, in 1667.

Throughout the eighteenth century only academicians, unlimited in number but rarely more than a hundred, and *agréés* or associates were permitted to exhibit. Initially the exhibitions, in which all works by academicians were accepted before 1748, consisted almost exclusively of works by French artists. After Louis XIV's death in 1715, when admission to the Academy was liberalized to admit any competent non-French artist, an increasing number of foreign artists were accepted into the Academy and gradually the exhibitions acquired a more international character.

After 1725, the paintings, sculpture, engravings and architectural drawings were displayed to the public in the Salon Carré and the Galerie d'Apollon of the Louvre, and the exhibition became known as the Salon. Accompanied by formalities which emphasized its official character and its role in enhancing the image of national sovereignty as embodied in the monarch, the exhibition opened, with few exceptions, on St. Louis's Day, August 25, and remained open for about three weeks.

The hanging arrangement was determined by *le tapissier* or *décorateur* chosen by the Academy. The groupings of small and large canvases on each wall resulted in an ornamental quality corresponding to the fashionable interior decoration of the period. Eventually the increasing number of entries caused the rooms to be converted into exhibition halls with blocked windows, resulting in a decline in any organic unity in the arrangement of the exhibition.

As the size of the exhibitions increased, so did complaints about the declining quality of the work exhibited. In 1748 a jury was instituted, consisting of the Academy's

directors, its four rectors and twelve others selected by the academicians from the Academy's professors and counselors.

As long as the exhibition was an annual event between the pupils and professors of the Academy, it was used to demonstrate and enforce the principles derived from the neoclassic doctrines of Boileau, Roger de Piles and Bellori, speaking for Poussin. This style was endorsed through purchases made for the royal household from the exhibited works and through the selection of the painters, sculptors and architects to receive the state commissions. By exposing the art approved by the Academy to the public at regular intervals, the Academy determined the public taste and was in turn influenced by the public's interest and criticism.

Supported by the French king and royal pomp and joined to the political importance of France, the Academy and its exhibitions were widely reported and set a pattern throughout Europe. Academies and exhibitions were gradually instituted in other countries. By 1720 there were nineteen academies of painting and sculpture in Europe. Seventy years later there were over a hundred academies assuming instruction for the fine arts and determining the art style for the societies by exhibitions of the members' work. These were usually the first formal exhibitions held in the European capitals, but nowhere did they assume the overwhelming importance they had in France.

Most of the small Italian principalities boasted academies with diversified memberships functioning independently of state direction or financing, like the Accademia delle Arti del Disegno in Florence or the Accademia Romana di San Luca in Rome. Lacking financial means and a reservoir of artistic talent, except in the larger cities, the Italian academies and their exhibitions could not sustain or influence the direction of the fine arts to any great extent.

The city of Rome, however, was the capital of the world for artists: with its churches, palaces and museums (the first to be established in Europe), it constituted in itself a

most significant exhibition of European art. On permanent display were objects that formed the canon of art for Europe, and a young artist's training was not considered complete until he had studied in Rome. The astute French first established an adjunct of their Academy there in 1666 and many other states were to follow the French example. Promising students were sent on state stipends to study—a period in Paris was often included—and then returned to staff the local academy. A European style based on the study of classical art was formed by the international society of Rome and was disseminated in turn throughout Europe by the academies and their exhibitions.

Rome teemed with connoisseurs from all Europe; these collectors, amateurs, dilettanti and artists sponsored numerous private exhibitions throughout the city. By the seventeenth century renowned artists and sculptors in Rome had adopted the practice of displaying their work in their own large studios. It had long been a tradition for a noble or ecclesiastical patron of an artist to show his work to an invited public. Young foreigners who were not pupils at an official academy were given an opportunity to display their works at exhibitions held in conjunction with two competitions, the Corso Clementino and the Corso Balestro.

In England, the Royal Academy of Arts in London was formed when a group of artists split off from the Incorporated Society of Artists in Great Britain, which had been granted a charter in 1765. The Royal Academy secured its own charter in 1768, with Sir Joshua Reynolds as president and a membership of forty. It at once assumed a major role, for no other group in England could give such socially glamorous exhibitions or enjoyed equal fame both at home and abroad. The Royal Academy's first annual exhibition was opened to the public on April 26, 1769, to remain open for one month. The one hundred and thirty-six works exhibited were chosen by the president and the council of the Academy. By 1780, when the exhibitions were moved to Somerset House, the returns from the sales

of catalogues (whose purchase was required for entrance) were sufficient not only to finance the exhibition but also to secure the Royal Academy a financial independence from the government. It has maintained this independence ever since, distinguishing it from the French Academy.

The Royal Academy's second president, the Philadelphian Benjamin West, was one of the first European artists to charge admission to view a painting, *The Death of General Wolfe*, in 1770. His example was followed by other English artists, like John Henry Fuseli, who in 1799 completed a series of forty pictures to illustrate Milton's poems and charged admission to see them in his Milton Gallery. West's venture was mentioned by the Abbé Barthélemy in *Voyage du jeune Anacharis en Grèce* (*Travels of Anacharis the Younger in Greece*; 1788) as a modern example of the use of a practice of the ancient Greeks. It did not become a common practice for one-artist exhibitions, however, and when Jacques Louis David charged admission to view *The Battle of the Romans and the Sabines* between 1799 and 1804, he cited the abbé's statement to justify the practice to the public.

In German-speaking regions the political fragmentation and economic distress resulting from the Thirty Years' War delayed the establishment of art academies until the eighteenth century. Not until 1750 was an academy on the French model functioning in Belgium at Antwerp. The same situation prevailed in Holland; exhibitions were left in the hands of the guilds and the art dealers. When art academies were established or reorganized in the German courts—Dresden (1762), Vienna (1770), Berlin (1786), Copenhagen (1754)—regularly scheduled exhibition programs were instituted with awards in imitation of the French. The first academy exhibitions were held in Dresden in 1764 and in Cassel in 1778; Berlin followed in 1786 with an exhibition that mounted contemporary work along with that of artists active between 1696 and 1713 in an earlier, short-lived academy.

One result of regularly scheduled exhibitions attended

by an increasing number of diverse visitors was the prolif-
eration of written commentary in the form of reports, ex-
planations and criticism. The French Academy began in
1738 to publish regularly a catalogue or *livret* to help the
spectator identify the works of art, which were not la-
beled. Similar in form to the catalogues for art auctions,
which also came into use in the eighteenth century, they
listed the title of the work, a brief résumé of the subject
depicted, and the artist's name. The Salon catalogue could
be purchased only at the entrance, but since admission
was free, its purchase was not required, as it was at the
British Royal Academy exhibitions. Such catalogues be-
came a general feature of exhibitions but were not explan-
atory and did not help the visitors beyond identifying the
works exhibited.

Visitors initially based their aesthetic judgments on the
same principles that had guided the artists in making the
works. A treatise such as Roger de Piles's had a useful
table of values for determining whether or not a work ap-
proximated academic standards. The significance of the
Academy exhibitions was acknowledged in a small pam-
phlet published privately by Lafont de St. Yenne in 1746:
addressing himself directly to the works exhibited, Lafont
de St. Yenne relied heavily on traditional academic aes-
thetics. His appraisals were not appreciated by the artists,
but they were read by the wider exhibition audience, and
so such reports increased.

Because of the ritual of the opening on the name day or
fête of the king and of the ceremony of the awarding of
prizes, the annual or biennial exhibition became an event
in the court calendar, particularly in France. French was
the *lingua franca* of the European courts, as French fash-
ions and customs were paramount. What transpired in
Paris was "news."

An enterprising German resident in Paris, Baron Frie-
drich von Grimm, wrote and edited a confidential news-
letter, the *Correspondance littéraire*. Its subscribers were
Grimm's friends: princes, kings and the Empress Cather-
ine. Grimm enlisted his friend, the editor of the *Encyclo-*

pédie, Denis Diderot, to write the news of the Salon of
1759. What Diderot wrote for Grimm's periodical was not
aesthetic theory such as he had published in the *Encyclo-
pédie* or judgments based on theory, but his personal opin-
ions of the Salon works, drawn from his own taste and
written in a conversational style. He made available the
current views on painting in Paris so that Grimm's
subscribers' taste would correspond to the current views of
Parisians. Grimm's *Correspondance* was not a newspaper:
it was written for and sent to a small select circle of per-
sons of the same social class spread across Europe.

Newspapers reporting on events taking place in London,
St. Petersburg, Rome, Paris and Berlin followed in the
eighteenth century in the wake of the *Gazette de France,*
which had appeared in 1631. Many periodicals devoted to
literature, book reviews and aesthetic questions, such as
the Parisian *Mercure de France, Der teutsche Merkur,*
and London's *Monthly Review,* also appeared in different
European centers at the end of the eighteenth century.
They were read by individual subscribers eager to keep
abreast of trends in art and letters or in clubs and reading
rooms by people from a wide range of social classes. With
the general liberalization of thought and the desire for the
expression of individual views or principles, at the end of
the eighteenth century, magazines appeared that were ve-
hicles of expression for editors opposed to current prac-
tices or tastes and desirous of effecting a change in social,
literary or artistic tendencies. They included such journals
as the Schlegels' *Athenaeum,* Schiller's *Horen,* Goethe's
Propyläen and Taylor's *Artists' Repository.* As in politics
and civic life, such journals played an ever increasing role
throughout the nineteenth century in the world of the cre-
ative arts, by contributing to the formation of styles, win-
ning support for innovations, or defending older tradi-
tions.

The development of a paper-manufacturing machine
and an iron printing press put books, journals and news-
papers in the hands of a larger and larger circle of people.
The technical advances permitted circulation to soar and

new publications to be founded. Political factors, however, determined the particular direction of the development of the press in various countries. In France and England, politically unified, the capital was the center of the cultural activity and supported large daily newspapers and periodicals. In Germany, divided into many small states, each capital desired its own newspaper, and small journals sprouted in large numbers. The censorship of the Papal States in Italy discouraged publications of any sort.

All types of publications drew their copy from the annual exhibitions of the academies, the exhibitions held in conjunction with competitions, and the one-artist exhibitions that began at the end of the eighteenth century. The form these reports took was determined by the type of publication and its subscribers. It could be an informative, descriptive or even critical account of what was to be seen, written for the twenty thousand middle-class subscribers who were as eager to keep up with the news as were the two thousand persons in the literary and artistic world more intimately involved with the works exhibited. Literary and artistic circles wished the report of what was on view to be a criticism or analysis based on their conception of contemporary artistic principles or tendencies. Newspaper and general literary periodicals throughout Europe often contained criticism equal to that in the art periodicals, for distinguished literary figures and budding authors were on the staff.

It was to be expected that the reports of the exhibitions published in the press would reflect different points of view; conservative or "establishment," radical or anti-establishment, and middle-of-the-road or, to use the term that came into use in the 1820s in France, *juste milieu*. Where censorship prevailed, criticism based on officially acceptable aesthetic principles continued. In England and Germany, more varied and personal art reviews were possible.

The liberalization produced by the Enlightenment and the disruption of many eighteenth-century social patterns caused by the French Revolution and the Napoleonic era

brought about significant changes in the European art world of the nineteenth century. Some were the indirect results of political changes and shifts in wealth. Others were more direct: the nationalization of art objects formerly owned by the French nobility and the establishment of public museums, the displacement of Rome as the foremost international artistic center in Europe following its looting in 1796, the levies imposed by the French armies, and the opening of the Salon to any artist, French or not, academician or not.

Throughout Europe critics reported a growing number of entries in the annual exhibitions after 1815. There was a similar increase in the number of exhibitions, and artists became aware of the value of the exhibition to themselves and its role in determining taste. As Ferdinand Hartmann noted in the last issue of *Phöbus* in 1808:

> From earliest times, artists have used public exhibitions to make their work known to the public. The artist presented to the public the beauty and glory which he perceived through his genius and which he carefully and diligently cultivated by arousing the best forces of the soul into action with his imaginative power. The diverse views and remarks of various observers concerning the work stimulate discussion and refinement of judgment and lead the reader from the work of art to the idea of art itself. The horizon of the artist and the public is generally expanded and as this occurs, the artist becomes aware of the shortcomings of the exhibited work, and if he has been by training or inclination one-sided, he is most surely led to the perfection of which he is capable.

Such awareness on the part of artists led not only to a growing number of one-artist exhibitions but to the increasing use of exhibitions as the artist's means of stating a political or aesthetic position.

Hartmann's statement indicates that artists were as aware of the importance of criticism as of the exhibition.

Reports on the exhibition could influence the public's reaction and this would directly affect the financial support the artist received. Criticism affected equally the livelihood of the art dealer who appeared when marketing practices changed after the commission system broke down.

The advent of art exhibitions as such and of widely published popular interpretive criticism brought major changes in both the artist's manner of working and the viewer's manner of evaluating art. By the end of the eighteenth century the artist no longer addressed himself, as he had for centuries, to the preferences of a particular patron or to the requirements of a particular occasion or installation site. He conceived and executed his work according to aesthetic, philosophical and personal principles which belonged to him individually or to a group of artists. Finished works were sent out to compete for public recognition with those of other artistic persuasions. Here they were judged by the public, whose opinion might be disparaged or lauded but could never be disregarded. Because the public, unlike the earlier highly cultured aristocratic patron, frequently felt itself in need of an introduction to and an interpretation of, the myriad of works and schools set before it, the critic became a persuasive and thus powerful arbiter of taste and value in the visual arts.

The translations of titles of paintings are those in common usage. The names of institutions and organizations have not been translated in order to facilitate identification. The titles of books have not been translated except when a translation has been published; the publication date given is for the original work. "M" is an abbreviation of "Monsieur." Footnotes in brackets are the editor's. All others are from the original texts.

1785

ROME: The Exhibition
in an Artist's Studio

In 1785, Rome provided the common bond between the English, the Germans and the French. It was the city of the world, for every country was attached to it by history. The sound of its name evoked specific images: the pyramid of Cestius, the Colosseum, Castel Sant' Angelo and St. Peter's cupola, the curving Tiber, villas and pines on the Seven Hills. These images, formed with the help of engravings and paintings, were populated with heroes described by poets and dramatists.

At the end of the eighteenth century profound changes had occurred. A general presentiment that an epoch had ended was documented by Edward Gibbon's *Decline and Fall of the Roman Empire* (1776). The philosophers of the Enlightenment had declared that every man possessed inalienable rights, an idea that would lead to revolution. Artists still linked to Rome turned from the frivolities of the French rococo to classical heroes who had started Rome on its road to greatness and had participated in episodes exemplifying civic virtues and patriotism. Sculptured portraits of the heroes stood in Rome. The Forum where they had spoken was there. A pilgrimage to the Eternal City was a necessity for those who aspired to culture and especially for artists born "beyond the Alps." The king of France had established an academy there in the seventeenth century so painters and sculptors could gain an impression of the majesty of empire. Now artists looked to the sacrifices of citizens in the Roman Republic for their inspiration. The new direction was encouraged by

the state and by patrons with stipends for their artists to
study in Rome. Artists with no money trusted in their gen-
ius and walked there.

In 1785 the city of Rome lived in large measure by
means of wealth that was attracted to it by its art treas-
ures. The Museo Pio-Clementino and the Museo Capito-
lino, where the finest pieces were exhibited, had been es-
tablished by Pope Pius VI in 1765. Roman cardinals and
princes "mined" their properties for ancient marbles.
Copyists flourished to produce statues and paintings for
English, German, Russian and French visitors. Sets of
plaster casts of the most renowned sculptures were availa-
ble for art academies and museums. In the fashionable
Caffè del Veneziano, the Caffè Inglese and the Caffè
Greco, the papers *Cracas* (named for its printer), the
Diario Romano, the *Giornale delle Belle Arti* (edited by
the Abate Bacattini), and the *Memorie per le belle Arti*
were read for the latest art news. Correspondents for for-
eign journals—the *Mercure de France, Der teutsche Mer-
kur* and the London *Times*—sent in reports of the art
events. Success "north of the Alps" could be secured by
receiving notice in Rome. "Where else does the German
artist have an arena?" Swiss-born John Henry Fuseli asked.

Every cicerone and beggar who crowded Rome's un-
paved streets was eager to show the way to ancient monu-
ments or to the studios of successful artists where their
work could be viewed and orders given. Pompeo Battoni
ranked as the greatest Italian painter; the ability and
charm of the Swiss Angelica Kauffman, a pupil of both
Mengs and Battoni, were acclaimed. Joseph Marie Vien
directed the French school and Anton von Maron, an
Austrian and a friend of Winckelmann, had been elected
director of the ancient Roman Accademia di San Luca.

In the autumn of 1784, art circles in Rome were aware
that a former *pensionnaire* at the French school, now
an *agréé* of the Academy, Jacques Louis David, had
returned with his wife and a pupil, Jean Germain Drouais,
and had taken a studio on Trinità dei Monti to begin

work on a painting commissioned for the French king. David's inspiration for the picture had come while he witnessed a performance of Corneille's *Horace*. His sketch of the action in the last act secured him the commission from the Minister of Fine Arts. Curiosity soon mounted, for David allowed no one to view his work in progress. Just prior to shipping the finished canvas to Paris for the opening in August of the 1785 Salon, David opened his studio, and all Rome hurried to view *The Oath of the Horatii*.

A young German artist from Cassel, Wilhelm Tischbein, had been admitted earlier in the company of an older cousin, Friedrich, who had come to Rome and visited David, a friend from his student years in Paris. In a studio in the Palazzo Zuccaro, near David's, Tischbein was engaged in painting an episode taken from the history of the Holy Roman Empire, *Conrad of Swabia and Friedrich of Austria Receive Word of Their Condemnation to Death While Playing Chess*, commissioned by his patron. Eager to have David's criticism, he prevailed on David to come to his nearby studio. This David did and then took Tischbein to see the *Horatii* just completed. Thus Tischbein, who supplemented his income with reports of art events for *Der teutsche Merkur* in Weimar (a connection Goethe had arranged), was able to send off an early account of the painting and the Roman reaction to it. In his report, Tischbein granted David the excellence of Raphael in draftsmanship and the exalted spirit of antiquity, thus awarding David the highest praise possible for a young artist. Equally laudatory reports by other correspondents appeared in the press in the various art centers of Europe. The painting established David as a leader of the neoclassical movement in Europe and the head of the new school in Paris.

Tischbein himself later made an indirect but important contribution to neoclassicism. After serving as host and guide to Goethe in 1786–87, Tischbein was appointed in 1789 director of the academy in Naples. At the Neapoli-

tan court, Tischbein met the British ambassador, Sir William Hamilton, an active participant in the excavations at Pompeii and Herculaneum. The meeting resulted in the appearance of Tischbein's *Collection of Engravings from Antique Vases in the Possession of Sir William Hamilton* (Naples, 1791–95), in four volumes. Throughout the nineteenth century its folio-sized engravings, used as study material by artists, fostered contour line drawing and strengthened classicism in both England and Germany. The heroic themes illustrated on the vases fired imaginations already in rebellion against the themes and style of the rococo period. The publication survives as an invaluable record of a portion of the Hamilton collection, which was lost at sea.

The French revolutionary army's conquest of Rome and Naples in January 1799 forced Tischbein to return to Germany after an absence of twenty years. He established himself with his art collection as a painter of importance in Hamburg. The Duke of Oldenburg purchased Tischbein's collection and installed him as court painter at Eutin in 1808. An appreciative description in prose and verse of Tischbein's *Idyllencycle*, a series of small decorative paintings executed for the ducal palace, was written by Goethe, and published anonymously by him in the journal *Kunst und Altertum*, II (1822), 3. Tischbein's autobiography, *Aus meinem Leben* (1822), provides an account of the taste and interests of an artist whose activity spanned the transition from rococo to romanticism in the nineteenth century.

The event Tischbein had witnessed as a young man in Rome marked a turning point in the history of art and culture: David's *Oath of the Horatii* and other paintings were later said to have "inflamed more souls for liberty than the best books." The *Horatii*, painted and first shown in the capital of art and classicism, would prove to be a representation of the concept of patriotism so clear and so forceful that it was immediately comprehensible to the French public. Its powerful stylistic fusion of austere

classicism and convincing naturalism would exert an equal
impact on artists and critics throughout Europe.

J. H. Wilhelm Tischbein, "Letters from Rome about new works of art by contemporary artists," Jacques Louis David's The Oath of the Horatii[1]

I. Recently a painting was put on exhibition which at-
tracted the attention of all Rome. In the history of art we
read of no painting that might have awakened more up-
roar on its appearance than this one. Not only artists, art
lovers, and connoisseurs, but even the people troop by
from morning until evening to see it. The enthusiasm is
general. We must, willingly or unwillingly, join one side
or the other. No one is allowed, in this case, to have his
own opinion; that modest judgment of finding the good
good and the mediocre mediocre no longer counts here.
With the present public, a matter is either raised up to
heaven or, with a peremptory order, cast down among the
most wretched stuff. At parties, at coffeehouses, and on
the streets, we hear one judgment or the other, for noth-
ing else is spoken of but David and *The Oath of the
Horatii*. No affair of state of ancient Rome, no papal elec-
tion of recent Rome ever stirred feelings more strongly.
For who in Rome today does not want to be a *bel esprit*
and achieve prominence as a connoisseur of the fine arts?
The most ordinary Roman claims this privilege; his judg-
ment in the field of aesthetics is decisive; and he believes
that people north of the Alps can have a taste for the
beautiful only if they have sojourned in the capital of
Italy. The nature of the Romans is to see other nations as
their inferiors. Since the shackles of power and prejudice
by which they bound the ancient and more recent worlds
to Rome are now broken, their pride and superiority

[1] [Translated from *Der teutsche Merkur*, February 1786, pp.
169–85.]

depend upon the possession of the greatest works of art. Therefore a new work of art produces in Rome the same stir that is caused in Paris by a new fashion; in London, by the affairs of the East and West Indies; in Berlin, by a revolutionary new type of military science; in Vienna, by the Reformation; in Petersburg, by civilization. The fine arts daily produce something new in Rome: the talking, praising and criticizing never cease, but the appearance of *The Oath of the Horatii* produced a kind of ferment in which everyone desired to participate.

First, I want to acquaint you more closely with the artist. His name is David; he is a Frenchman, born in Paris and now a man of about thirty-six. In his youth he concentrated upon the painting of battles. However, when he came to Rome as a pensioner of the French Academy,[2] and with closer contemplation of the ancients[3] and the greatest works of the more recent masters, his sensitivity became more developed. He left his specialty and shifted to the heroic in historical painting. He studied several years in Rome without becoming better known. He himself acknowledged it cost him no little effort to break away from the false style to which he had been led in his own country and attain the only proper path that led to the ancients and the works of Raphael. Thereupon he returned to France three years ago to be admitted to membership in the L'Académie Royale de Peinture et de Sculpture. In Paris he prepared two paintings; the sketches for them were to be seen here at the exhibition of *The Oath of the Horatii*. The first shows Hector's corpse on the deathbed mourned by Andromache; the other, the blind Belisarius, who sits at the foot of a triumphal arch and begs for alms. The first was the piece executed for admission into the

[2] [David won the Prix de Rome in 1774. In 1775 his teacher, Joseph Marie Vien, was named director of the French School in Rome. David accompanied him there.]

[3] [The most admired pieces of Greco-Roman sculpture were in collections guarded by avaricious *portieri*, and art students could not afford frequent access to them. White plaster casts of many were available in the collections of Trippel, Gavin Hamilton (an art patron and painter), and Anton Raphael Mengs.]

Academy. Although both paintings, to judge only from
the sketches, must have had unusually great merit, Herr
David won scant applause. The stylishness and frivolity
cherished by the masters in Paris is not compatible with
such serious subjects;[4] nor does the coloring of this painter
have the pleasing and flattering colors from which the
fashionable painters know how to extract such advantage.
Still, Herr D. received the commission for an important
work for the king. Convinced that Rome is the true source
of inspiration and the only place for the true artist, he
came back to Rome with his young wife at the end of the
fall to execute the sketch for *The Oath of the Horatii,*
which he is said to have already drafted seven years ago.

After three quarters of a year the work now stands there
completed. It represents the three Horatii at the moment
they swear either to conquer or to die. The figures are life
size.[5] . . . The whole arrangement of the picture is mas-
terly; nothing is in excess; nothing is farfetched either in
principal or secondary matters. All that is there belongs
there and contributes to the effect of the whole. Therefore
the expression, which without doubt forms the most essen-
tial part of this picture, is naturally very much heightened.
The stance of the men, the motion of their arms and legs,
their countenances full of martial courage and undaunted
determination, cause the viewer to feel that these are
Romans. We find ourselves suddenly transported back to
Rome's first youth, and realize that the descendants of
such warriors must become the rulers of the world. The fa-
ther, one hand holding the swords, the other in the air,
with eyes raised to heaven, expresses completely the
awesome noble character of Corneille's *qu'il mourut!*[6] The

[4] [Tischbein is referring to the taste prevalent in Rome and
lesser centers—Cassel, Copenhagen, Dresden, Vienna—where art
patrons and connoisseurs, as disciples of the neoclassical aes-
thetics of Johann Joachim Winckelmann and Gotthold Ephraim
Lessing, endorsed the art of Mengs and his pupils.]

[5] [The description of the composition is omitted.]

[6] [After seeing a performance of Corneille's *Horace,* David
began sketches to find a visual image to correspond to the play's
exalted concept of devotion to family and *patria.* The outcome

eldest son, his face without emotion, is cold-blooded, a man to whom the matter is not new and the outcome certain. At the moment of the oath-taking the second son clasps the elder about the waist with one arm and the third son clasps the second, as if the younger were placing the hope of conquering in the older, or as if, so united, they would fight and conquer or die. Their faces express more enthusiasm than does their older brother's. The eye wanders from the group of men to the women, and the spectator feels in himself conflicting emotions: the heroically agreeable element of painful virtue, a most terrible contrast with inevitable desolation. It would be necessarily quite unpleasant and painful, if the spectator did not remember in time that he has only a picture before him. He now begins to marvel at the master hand able to bring him this mixture of conflicting emotions. Determination, courage, strength, reverence for the gods, love of freedom and of the fatherland show themselves in the men; in the women inconsolable dejection, weak and numb collapse, tenderness for the spouse, the bridegroom, the children, the brothers; in the children playful innocence and naïveté.

What could be lacking in this scene to storm the heart of the sensitive? Could a secondary matter, a matter without final purpose, interrupt the power and the force of the effect? Does the viewer feel less in this case than when viewing *The Expulsion of Heliodorus* in the Vatican Stanze, which is considered to be Raphael's masterpiece and, indeed, the masterpiece of expression in general? If, after Leonardo da Vinci and Raphael, the Carracci, Guido and Domenichino are among those who more recently have most understood noble expression, where are the works of still later masters that have a more forceful and correct expression than *The Oath of the Horatii* by David?

Many find the drawing in this picture so good that they

of the combat between the brothers Horatii and Curiatii would determine, according to the legend, which city-state, Rome or Alba Longa, was to rule Latium.]

maintain Michelangelo and Raphael never drew bettter and wish to compare it with the perfection of the ancients. Others place David's drawing in the class of the Carracci school. Even the least well disposed must admit that the parts of the nude, the arms, legs, hands, heads, are excellently drawn. Without considering this, others reproach the artist for drawing the forms of the legs and arms of the brothers who swear the oath more vigorously than the occasion demanded merely to make his knowledge of anatomy and drawing more striking. They therefore call the drawing "French-affected" and the artist a draftsman like Boucher and Van Loo, who often introduced muscles and parts not found in nature and exaggerated and distorted forms in a comical fashion. In spite of these critics, beauty of form, veracity and relative correctness cannot be denied David, even if it were equally true that, however enthusiastic the sinewy warriors and however excited their imaginations, when taking the oath their nerves and muscles would not tense as strongly taut as when they were already actually fighting their foes. We leave the decision of this matter to those who have had an opportunity to study more closely the strength of fantasy.

The faithfulness in reproducing the scene of the event, of which we have already spoken, as also the clothing, completely agrees with what history and other monuments have left us from the first Roman era. Not only is the clothing appropriate to the time, but the selection and drapery are very beautiful. Even if Raphael has far outdistanced all modern artists in this field, the garments, particularly of the two young women, in David's painting still seem not inferior to Raphael. The taste of antique simplicity, the proper delineation of the body under the garments, the beginning and end of each fold are plainly evident and give proof of the great knowledge of the artist in this field. On the other hand, the criticism of the nature of the materials is well founded. In this matter the eye is so little able to distinguish what material this or that is

supposed to be that in general one must view it as fine leather or a very fine English cloth quite similar to leather.[7]

I am acquainted with living artists who know how to paint the nature of materials excellently, but I know of none who might have this taste in drapery.

In coloring David has sought from youth on, like other fellow countrymen, to imitate the style of Caravaggio, Valentin, and Guercino. These artists painted for the effect; they noted that strong shadows employed directly next to light produce relief and cause objects to stand out. Such a style has something striking and creates a sudden effect; although judged by nature it is entirely wrong, for this sudden contrast of light and shadow is never so evident on a body, except in a dark room where a slanting light comes from only one side and illuminates the body without the power of reflection. One indeed sees that such a light can be selected in a painter's studio, yet one cannot help but notice that this style is inappropriate and unreal when an event has to be presented in natural illumination. David, who took on this strong style, sought indeed in this picture to make the shadows translucent, but they nevertheless remain hard, unpleasant, and without soft reflection; the flesh is brown and monotonous, and the women have no advantage over the men [as they lack] the dazzling coloring which gives the round and slim forms of the sex their true charm. But even though the eye perceives so little that flatters in the play of colors, we cannot deny that the whole does make a penetrating effect; we do not know, in consequence, whether one should wish a different type of coloring for a painting which seems to have been made entirely for the soul's expression and the lofty effect of the whole.

Besides, all parts of the picture have been diligently worked over and completed. Secondary objects, such as breastplates, helmets, weapons, iron, steel, bricks, marble, have been painted with astonishing reality. Taken to-

[7] Apparently the great artist did it on purpose and for obvious reasons.

gether, the whole has a wonderful harmony, and through
well-understood perspective the architecture has been held
to a good tone. . . .

The French artists and their faction are never tired of
elevating *The Oath of the Horatii* above anything that has
been produced in modern times. In the judgment of these
people in whose mouths the smallest thing grows to a gi-
gantic greatness, Michelangelo and Raphael never drew
better, indeed even at times without this correctness and
selection. According to them, only among the ancients is
to be found the perfection and correct characterization of
such arms and legs (for other parts of the nude are not in
the picture). According to them, the Italian painters have
indeed represented the pictures of Mary and other sacred
stories very well, but David alone has rendered the heroic
element of historical painting, the true ancient style, and
the soul of the sublime disposition of the ancients. Ac-
cording to them, the drapery is as fine as the most beauti-
ful statues of the ancients. Even in the way the painting is
colored, their enthusiasm finds it, as far as technique and
chiaroscuro are concerned, to be compared only with Cor-
reggio. In short, the French want to convince the world
that *The Oath of the Horatii* is at present the foremost
work of art in the world.

The Italians, on the other hand, find it laughable that
anyone should wish to elevate above the works of the
Bolognese school, and even above Raphael, to the an-
cients, a painting in which, according to them, first, the
composition transgresses the prime rules by having the
three brothers stand in a line and leaving the middle space
between the two groups where the figure of the father
stands alone too empty; second, the drawing is that of a
caricature; third, the expression of the whole is not harmo-
nious because the women seem to sleep instead of express-
ing their grief while the men take the oath; fourth, the
features of the father and the women are too harsh and
common; fifth, the drapery is of tin and colored leather in-
stead of wool and linen; sixth, the artist is said to have no
feeling at all for the coloring, since the flesh is in a mono-

tone, the shadows black, the women as well as the men a brownish yellow—the painter, in short, has sacrificed reality and the pleasant in an effort to produce an effect; seventh, the sabers, the other pieces of clothing and the architecture as well as the manner and way of taking the oath in the father's house are said to be contrary to history.

These two nations seem to have been made to contradict each other. It is all too clear that the Italians' exaggerated criticisms stem mainly from the desire to humble the pride of French enthusiasm. This sort of criticism and praise will not, however, add or subtract the slightest bit from the merit of the painting and the artist.

Listen in the meantime to the judgment of other critics and cooler observers. I count among these the Germans, the English, and other neutral nations. Far from believing the painting to be flawless and far from viewing it with the French as the highest that the human spirit can produce in art, they grant the artist the modest praise due a great draftsman, although one would necessarily have to see entirely naked figures by him and not just arms and legs in order to compare David with Michelangelo, Raphael and the Carracci school. In their opinion the arrangement of the whole and the composition are grandly and nobly conceived; all breathes of remote antiquity. Corneille is no grander in his tragedies than the artist in his painting. One sees in it the nobly disposed, sensitive man. He is not merely a mechanical artist who charms only through color, effect and a certain pleasing element of chiaroscuro. He paints the soul. He represents with dignity and spirit men in their most solemn actions and passions. All is clear to the intellect; illusion takes its start and forcefully snatches from the heart its emotion. Here David is not only painter but also poet, judge of human nature and philosopher. His knowledge of costumes and his taste in garments and other ornaments is too evident for one not to grant him his due. If in style of painting and coloring he is not to be compared with the foremost artists, in these areas he is, nevertheless, far from being poor, and they would redound

to his credit even if in other areas he did not so far exceed himself. But to take him as an entity and then to wish to raise him to Raphael or indeed to the ancients is not to recognize their worth or David's. David himself surely feels best how inimitable the great painter of Urbino is and by how far the perfection of this man exceeds his own powers. Nevertheless, one believes that, for so great an artist as David already is, it is no exaggerated praise to put him in the class of Domenichino and the Carracci and preferably to call *The Oath of the Horatii* the masterpiece of French art and the picture of our century.

The painting goes now to Paris where it will also be displayed for public viewing in the hall of the Academy from the twenty-fifth of August. In addition the artist later will travel with his painting to London to have it engraved there. I wish I could be in Paris at this time to make known to you the opinions of the Paris public of such a perfect work of contemporary art with the same candor that I have given those here in Rome. The future works of this man and posterity will determine more accurately his true worth.

Anonymous, "Painting," Jacques Louis David, The Oath of the Horatii[1]

Few examples will be found in the history of this century's painting that have been awaited with such expectation and have excited such universal curiosity as the large painting representing *The Oath of the Horatii*, which was exhibited to public view last month by Sig. Giacomo Luigi David, the famous painter from Paris. . . .

It is possible to say that this painting, which combines great beauty and a tragic scene, moves us in the same in-

[1] [Translated from *Memorie per le belle Arti,* September, 1785, Vol. I, pp. 135–44. This periodical, published in Rome from 1785 to 1788, was devoted to the contemporary arts; its articles and reviews were never signed.]

stant to compassion and terror and seems to be composed with the highest measure of perfection. The group of weeping women, besides being well arranged, has a great sense of expression. The mother is less dejected than the others, perhaps because this is not the first time she has been present at such an event and because she is Roman. In showing the wife to be so terribly sorrowful it seems that the painter had in mind the work of Corneille, who imagined her as the tragic sister of the Curiatii. The young sister-in-law seems to be attempting to hide her grief. The attitude of the old father is animated and one could not give a more energetic expression than that of the sons, who extend their arms with maximum impetus and force, showing their eagerness to fight and win. It demonstrates great shrewdness on the part of the painter to represent the warriors as neither mixing with the women nor heeding their weeping, for that is most appropriate for the proud, bellicose nature of the three brothers, one of whom would rather stain his hands in the blood of his sister than suffer those tears, which seem to him an outrage against their land.

This painting has been designed with unusual exactness, and nature's beauty is often coupled with the *ideal*; the appearance of the heads of the three brothers is beautiful, their extremities are handled with precision, and every part of the nude shows an understanding of anatomy and of the decisiveness the spontaneous movements of our body have. The draperies are conceived and disposed with a fine sense of symmetry and a grandiose manner of folding, but they lack any sense of exaggeration, those of the females being graceful without affectation. We see here imitation of the antique, but not in the false manner of some who believe that they have perfectly acquired the character of the antique by leaving all the hardness of marble in their figures, which, as a result, seem mere coldly colored statues. Although in this picture there are neither great masses of shade nor strong contrasts of light, the effect of the chiaroscuro is both true and pleasing: it combines suitably with the quietly handled colors, harmo-

nizing without that affected vagueness of hue which is the delight of the Mannerists. We must confess, however, that perhaps in a few areas he might have shown off the brushwork a little more, giving more attention to the reflected light, and although the tones of the two young women are beautiful, they perhaps could have been nobler and bolder. Even though we do not wish to join in criticism of this work, we must nonetheless do just that.

The critics begin by finding fault with the choice of subject because the painter has shown an event the historians have not recorded. One could almost say that this imperfection is extrinsic to painting itself; nevertheless, in our opinion, that could reasonably be excused. Since the poet is permitted to introduce some episode into the history that he is ornamenting with his verse, the painter ought to have the same liberty, for this is the license which the two orders of nature's imitators have in common, as was already accorded them by the poet Horace. Further, we are dealing with a historical fact of such obscurity that we are not sure whether the defenders of our liberty were indeed called Horatii or Curiatii. A more relevant objection against tradition is certainly that of Signor David's having two brothers extend not their right, but their left hands in the oath. Because the painter wanted to group the three figures by having the second press against the shoulder of the first, he has fallen into this equivocal situation—one we do not know how to defend in that he has depicted three Romans, whose natures were no less superstitious and incapable of altering a sacred ceremony than warlike. Not of equal gravity is the difficulty seen by some that the attitude of the three brothers extending their arms is too uniform. For three valiant young men equally fond of their country, equally warmed by their father's words, it is all too natural that they show in the same way the sentiments of their ardent spirits. Nature persistently pushes toward certain movements in particular circumstances. Expressions of similar passions generally resemble one another, and rules of symmetry and contrapposto must be silent when nature speaks. Was it perhaps because of this difficulty that Raphael, although so

rich and fecund in invention, put so many figures all with their arms extended in similar manner in adoration of the Magi? No. Because he knew that in such circumstances the greatest part of the people must move with that attitude. In antique reliefs we also find frequent examples of this.

Some have called the composition of this work poor and would wish other figures added, just as many spectators would like to have unnecessary characters introduced into plays simply for the pleasure of seeing a great number of new actors added to the scene. But to the particular taste of such persons the poets have never paid much attention. Also, some would like to find fault with that division of composition that we noted as a clever artifice. In our view, however, what we have said above is enough to convince one to the contrary. Some have also felt that it offends tradition to represent the act of an oath without an altar and without an image. The artist, however, thinking that the oath had been but an accessory request of the father, who began to speak to his sons while handing them their arms and in order to exhort them to the fight, did not believe it necessary to introduce either one. In regard to tradition a greater deficiency is to have depicted the three swords as being different one from another, and here desire for variety has made Signor David fall into this slight error.

In such a multitude of objections almost all are directed against the composition and not the observance of tradition. It is to the glory of a painter when one of his works is attacked only from these standpoints, because it is a sign that the eye has not been offended by the execution of the imitation, which is undeniably the principal part of the painting. To know how to create well and to compose a painting, ingenuity and fancy are enough; but then to express it and to execute the imagined concept *hoc opus hic labor est*. One will never stop admiring *The Expulsion of Heliodorus* in the Vatican, although one sees a Pope with his cortege in the Hebrew temple, nor will *The Death of Dido* [by Guercino] in the Galleria Spada [Rome] lose its power to astonish us, although [Dido's] courtiers are dressed as Spaniards.

A more reasonable criticism is that the artist has por-
trayed the father of the Horatii as too young. The painter
should have refrained for two reasons: first, because he
had depicted the wife as being much older and, second,
because had he represented this man as older, it would
then have been possible to give him another type of
musculature and thus avoid the uniformity, perhaps too
strong, in the four male figures. The head of the father
imitates that of the Marcus Aurelius and is in part after
Raphael; however, it could have been nobler, as it is some-
what coarse, and perhaps also small in proportion to the
body, which one would see if the beard, which makes it
seem larger than it is, were taken away. Now we have
stated the major part of the criticism of this work, it being
useless to mention any which is more frivolous and inade-
quate. How many times should be repeated to some the
advice of Apelles, who, seeing Alexander speak in his stu-
dio with little understanding of painting, counseled him
to be silent and pointed to the craftsmen who could
scarcely contain their laughter.

Signor David had already finished his studies in Rome
and now, having to do this canvas of the greatest impor-
tance, he wished to return in order to execute it here.
Thus the immortal Poussin also once thought; therefore he
wrote to the Cavalier del Pozzo that far from Rome he
recognized his merit was weakened with each passing day
and that he desired to return here quickly in order to see
the antiquities and the works of the modern masters: to
return to rekindle his imagination and to impress upon his
intellect the noble and beautiful idea that he had lost
while away. One can say that Rome has the right to be
called the Mother of the Arts and that all who have
learned them here are her children. Considering, on one
hand, the fine style that Signor David has adopted in his
work and remembering, on the other hand, that it is in
Rome that he has acquired it, we can echo what was said
so gracefully of Poussin by others and call him *Homo
Parigino, e pittore Romano* [A Parisian man, and a Roman
painter].

PARIS: The Official Exhibition of the State

Anonymous, "Salon of 1785: No. 103, The Oath of the Horatii"[1]

This year David is exhibiting only three pictures,[2] but any one of them alone would be sufficient to establish his reputation. I dare not undertake the praises of the one showing *The Oath of the Horatii*; I cannot rise to the level of the substance; it is absolutely necessary to see it to know how much it deserves admiration. In it, I note drawing that is correct and of the highest character; its style is noble but not showy; the colors are true and harmonious, vigorous without being exaggerated, giving a clear and light effect that is attractive; a composition full of energy, reinforced by the strong and fearsome expressions of the men that form an effective contrast with the grief that reigns in the group of women. Finally, if I judge the feelings of others by my own, seeing this picture one experiences a feeling that lifts one's soul—to use J. J. Rousseau's expression, it has something *poignant*, which attracts one: all the conventions are so well observed that one feels oneself transported to the early days of the Roman Republic. David's earlier works had been criticized as being too exaggerated; like a truly great man, instead of complaining about the criticism, he has profited by it. . . .

1 [Translated from the *Journal de Paris*, September 17, 1785, pp. 1071–73. The *Journal de Paris* (1777–1840) was merged into the *Gazette de France* in 1872.]
2 [The other two were the portrait of M.P.*** and *Belisarius*.]

1787
ROME: The Unveiling
of a Monument

In the spring of 1787, eighteen months after David's exhibition of *The Oath of the Horatii*, connoisseurs, patrons, social gossips and the curious filled the two narrow streets that lead from the Corso to Santi Apostoli. The church, said to have been built originally by the Emperor Constantine, stands at the base of the Quirinal Hill in a small piazza overshadowed by the towering Palazzo Colonna. The object of the people's curiosity was the mausoleum of Pope Clement XIV, being exhibited for the first time at the end of the right aisle of the church.

During the consecration of the monument, attention had been fixed as much on the tall, strikingly handsome Carlo Giorgi and the slim young sculptor, Antonio Canova, as on the officiating ecclesiastical dignitaries. Giorgi was known to all because of his great wealth and his proficiency as a horse breeder. None but a small circle knew of his liberal social and political views, which were only now finding public expression.

Clement XIV, the son of a physician and a member of the Franciscan Order, was a hero to liberals and the Rationalists. Deeply religious, he had spent many years as a scholar in the convent attached to Santi Apostoli before he was elevated to the papacy as a compromise candidate in the struggle between, on the one hand, France, Spain and Portugal and, on the other, the Roman Curia. The former were demanding the suppression of the Jesuit Order within their boundaries; the order had long outlived its original function of spreading the Counter Reforma-

tion and had intruded into secular affairs, thereby increasing the anti-ecclesiastical temper of the time. Clement XIV, however, had delayed taking action against the Jesuits and had devoted himself to the reform of the financial administration of the Church, securing a reduction of the oppressive taxes in the Papal States. In the field of art he had entrusted to Johann Winckelmann the museum he founded in the Vatican in 1773, which was to be continued by his successor and named Museo Pio-Clementino.

Pope Ganganelli, as Clement XIV was often called, had finally signed the brief dissolving the Jesuit Order in July 1773. The viciousness of the order's attacks damaged papal prestige and shortened Clement XIV's life. Not having increased either his own or his family's wealth (though that was a customary use of papal power), he left no means to erect a mausoleum. His successor, Pius VI, whose temporizing policies disappointed liberals like Giorgi, was only concerned with the aggrandizement of his own family.

Giorgi, determined to provide a mausoleum worthy of Clement XIV, secured the assistance of the eminent engraver, Giovanni Volpato, to act as his agent. They chose for the commission the thirty-year-old Venetian sculptor, Antonio Canova, protégé of the former Venetian ambassador Zuliani and a suitor of Volpato's daughter. Canova had been born into a family of stone carvers and builders and his grandfather had instructed him before the young sculptor went to nearby Venice for further training. Senator Giovanni Falieri had brought him to the attention of Cavaliere Girolamo Zuliani, the young Venetian ambassador to the Holy See. When Zuliani exhibited Canova's *Theseus and the Minotaur* in the Palazzo Venezia in 1781–82, the sculptor became known to art connoisseurs in Rome. Volpato's choice for the mausoleum commission was supported by an influential member of Rome's art colony, the Scottish painter and antiquarian, Gavin Ham-

ilton. Giorgi provided Canova with 2,000 scudi, allowed him an extra 1,000, and requested him to prepare models.

Canova's finished mausoleum pleased liberals and the international circle of innovating theorists, artists and connoisseurs, who had hoped that the artist would incorporate into his sculpture the theories of the classicists. They saw with satisfaction that Canova had broken with the past and discarded the elaborate, excessive ornamentation characteristic of the eighteenth-century ecclesiastic manner: he had observed the principles established by Winckelmann and Mengs. As Hamilton had urged him, he united "in so exact and beautiful an imitation of nature, the fine taste and beau ideal of the ancients of which Rome contains so many models."[1]

The young sculptor had elevated a group of three figures on a plain cylindrical base pierced by the door to the sacristy. The figure of the Pope, seated on the *pala* above and behind the sarcophagus, directed his gaze down to the spectator, his right hand raised in a decisive, noble gesture of benediction. Lower down, flanking and contrasting with the dynamic, authoritative figure of the Pope, were the passive figures of Temperance and Clemency. The Pope's gesture was reminiscent of that of the equestrian statue of the stoic Marcus Aurelius, "a Roman in self-effacement for the service of the State" and author of *Meditations*, in which the goal of life was described as the cultivation of wisdom, justice, fortitude and temperance.

The Stoic philosophy had been adopted by young French liberals; prominent among them was the encyclopedist and archaeologist, Antoine Quatremère de Quincy, who had been a *pensionnaire* in sculpture at the École Français at Rome from 1776 to 1780, contemporaneously with Jacques Louis David. Quatremère de Quincy, sojourning for a second time in Rome in 1783, visited Canova's studio and afterward held him up as an exemplar to the young French sculptors. Only Antoine Denis Chaudet was

[1] L. Cigonara, *Works of A. Canova*, trans. Henry Moses (Rome, 1876), p. vi.

attracted to Canova as a teacher and brought his neoclassic manner to Paris.

Quatremère de Quincy recalled his early association with Canova in *Canova et ses ouvrages* (Paris, 1834) and evaluated the monument to Clement XIV in Chapter 2:

> The general composition of Ganganelli's mausoleum marks a change in plan, in the style of the architectural details, in the conception of the figures and in their arrangement. The artist has at last banished from his work the banal allegories, the tormented masses and the false magic of "picturesqueness" which are very inappropriate to the character of such monuments. In general, it must be agreed that the arrangement of Christian mausoleums, absolutely foreign to those of antiquity, could find no guide or example among the ancients either for the ideas or the arrangements, or for the principal motifs or sculptural accessories. As regards the type presented in the Ganganelli mausoleum, the artist could scarcely find any precedents or inspirations to follow other than those of the Medici tombs by Michelangelo in Florence or those of the sovereign pontiffs in the basilica of St. Peter's.
>
> Earlier funeral monuments, that is to say those of the fourteenth and fifteenth centuries, had found a general model in the usual practice of a more or less public representation of the person seen in death upon his bier with the robes or the attributes of his status and certain religious symbols. It was above all in the precious detailing of ornaments and in similar fashions by which the art of the chisel exhibited itself. But this taste had long been forgotten.
>
> We do not want to speak here of the mania for those so-called dramatic compositions which reigned later in some countries and which gave rise to the most revolting abuses.
>
> Generally, therefore, we can agree that in the ab-

sence of a model established by customs and institu-
tions, especially in Rome and where a funeral monu-
ment of a Pope was concerned, Canova would have
arranged the model of his composition on that of the
mausoleums in St. Peter's. However, he was able to
apply to the volumes and architectonic details of his
ensemble a grand and pure style that would form a
contrast with that of the broken and bizarrely twisted
shapes with which the Borromini school had infected
architecture in large as well as in the smallest works.

The public exhibition of Canova's work encouraged two
German sculptors, Johann H. Dannecker and J. Gottfried
Schadow, who had come to Rome in 1785. They lived in
the Via Babuino, near Canova's studio, and worked at the
studio school of the Swiss sculptor Alexander Trippel.
Like Canova, they sought to contain naturalism in a sim-
ple neoclassic contour. Both carried Canova's neoclassic
style to Germany: Dannecker to Stuttgart and Schadow to
Berlin.

Goethe was also in Rome and lived near Canova's stu-
dio as a painter under the alias Phillip Moeller. His inter-
est in classicism had contributed to his humanistic drama,
Iphigenie auf Taurus (*Iphigenia in Taurus*), which he
finished and read, in February 1787, to Angelica
Kauffman, a leading painter of the Germanic school living
near the studio of her compatriot Trippel. Goethe, on his
return from Sicily and Naples, may have been brought to
Santi Apostoli by his host and guide, Wilhelm Tischbein.
John Flaxman would have gone to view Canova's work
soon after he and his wife joined the colony of English
artists in the fall of 1787, for the mausoleum's style was in
keeping with his own inclinations.

Written notices appeared at once in the Roman papers;
the *Giornale delle Belle Arti* carried an item on April 14,
1787:

On the whole, without there being anything man-
nered, there reigns in the monument—by means of

the greatest simplicity, by imitating and employing the ancient taste of the most beautiful period in Greece and Italy—such a majesty and a unity so grand that the spectator is arrested and surprised. The choice and the arrangement of the figure are marvelous.[2]

On April 21, a week after the notice in the *Giornale delle Belle Arti* appeared, Francesco Milizia, the author of the widely read *Le Vite degli Architetti più celebri (The Lives of Celebrated Architects*; 1768), wrote of his impression of Canova's work to the art connoisseur, Francisco San Giovanni, the Count of Vicenza. Milizia did not relate details of its first exhibition, but provided the count with an appraisal of the monument. Milizia, a Neapolitan, had settled in Rome in 1761 and begun his study of architecture. In 1781 he had restated, at a time when their influence was beginning to wane, the theories for the figurative arts of two influential classicists in his *Dell'arte de vedere nelle belle arti del disegno secondo i principi di Sulzer ed di Mengs* (Venice, 1781). He denied to Bernini almost every value except that of execution, a disparagement that influenced taste well into the nineteenth century. By 1787 he had completed his second book on architecture, *Principi de Architettura Civile* (1785). In it he set forth the theory that the purpose of a building should be clear in its architectural forms, a theory he based on the function of material and its bearing upon the style of a building. Canova's monument satisfied Milizia's desire to see a complete thing with no imperfect part. Milizia's opinion carried weight; known as "that severest of critics in the fine arts, a man of profound judgment and independent mind," his letter to the count was cited to affirm the importance of Canova's early work in the first history of Italian sculpture.[3]

[2] *Giornale delle Belle Arti*, April 14, 1787, p. 114.
[3] L. Cigonara, *Storia della Scultura* (Venice, 1813).

Francesco Milizia, "Letter to Count Francisco di
San Giovanni of Vicenza"[1]

Rome, 21 April 1787
In the Church of the Holy Apostles, near the sacristy en-
trance and facing one of the side aisles, a mausoleum to
Pope Ganganelli has been erected by the sculptor Antonio
Canova, a Venetian. The smooth base is divided into two
levels: on the first sits a beautiful female figure of
Gentleness, as gentle as the lamb which lies beside her,
and on the second level is the urn, over which on the op-
posite side another beautiful figure, Temperance, reclines.
From behind rises a pedestal supporting an antique seat
on which His Holiness sits at ease, dressed in papal robes,
with his right arm and hand extended horizontally in a
gesture of commanding, of pacifying, of protecting.

Such is the monument. It is entirely of white marble ex-
cept the lower base, the pedestal and the chair, which are
of a grayish *lumachello*[2] marble. The harmony is delight-
ful. The light which comes from above is moderated and
gently brings out each element.

The composition is of that simplicity which seems so
easy and yet is so difficult to achieve—what repose, what
elegance, what harmony! The sculpture and the base, both
as a whole and in the details, are in the classical style.
Canova is an ancient, I am not sure whether from Athens
or Corinth; I am sure, however, that if it had been neces-
sary to depict a pope during the height of Greek art, the

1 [Translation adapted from J. S. Memes, *Memoirs of Antonio
Canova* (Edinburgh, 1825), pp. 325–27. Letter orginally pub-
lished in L. Cigonara, *Biografia de A. Canova* (Venice, 1823).]

2 [*Lumachello*, literally "little snail," is a grayish-brown lime-
stone containing fossil shells.]

subject would not have been treated any differently than it has in this work.[3]

During the twenty-six years which I have spent here, I have never seen any work so generally admired by the people of Romulus. The most liberal and intelligent artists call it the nearest to the antique of all the works of modern sculpture. Even ex-Jesuits cannot refrain from praising and admiring this marble Ganganelli: certainly it has worked a miracle and the model will in the future derive as much glory from this monument as from having suppressed the order.

It is indeed a perfect work, as has been attested by the censures of the Michelangelists, the Berninists and the Borrominists who regard the greatest of the monument's beauties as its defects; they criticize the drapery, the forms, the expressions as being antique. Heaven pity them!

Our friend Pietro Vitali is making an engraving of the monument. I congratulate myself, then, and all Venetians. I wish that young artists would follow the noble direction laid down by Canova and that the fine arts would be restored. I wish for much, but I have little hope. I do hope, however, that Canova will do wonders with the mausoleum for Pope Rezzonico[4] at St. Peter's. And I also hope that His Highness, the count, will graciously remember me, etc.

[3] [David's statement of 1799 in the notes for the exhibition of *The Battle of the Romans and the Sabines* will reverse the order: "My desire was to represent the customs of antiquity with such exactitude that, had the Greeks and Romans seen my work, they would not have found me a stranger to their customs."]

[4] [Clement XIII.]

Anonymous, "Sculpture: Mausoleum of Pope Clement XIV, Antonio Canova"[1]

. . . It is impossible for anyone having the capacity to appreciate beauty not to be carried away with warm enthusiasm when admiring this mausoleum. The unity of the invention and the simplicity of the composition that radiates equally from the architecture and from the sculpture give it an imposing and majestic feeling not to be found in many other works in which the richness of the rarest marbles and also metals have been prodigiously used. Beauty and majesty have their source not in opulence but in elegant simplicity. The works of the Greeks give an example of this. . . . The representation of a Virtue demands a supernatural beauty, a beauty, moreover, adapted to the character of the Virtue itself; thus our sculptor has selected not only beautiful forms but those very forms that disclose a gentleness of spirit, something nature does not present as a complete model in a single object. The expression of sorrow which had to be given to this figure—this also had to be sought in the ideal. A Virtue who grieves and laments cannot be lowered to the vulgar expression of an ordinary sorrow. Oh, how well Signor Canova has succeeded in this! Meekness is grieving; her face says it, but it also says that her affliction is accompanied by a humble resignation. Although her face conveys an unequivocal sense of grief, no part of it has been unusually altered, nor is there any caricature. This is also one of the ingenious artifices for which we rightly praise the Greeks.

[1] [Translated from *Memorie per le belle Arti,* Rome, March 1787, pp. xlix–liv.]

1793—96
PARIS: The Official Exhibition of the State[1]

The Salon of 1793 opened in the Palais National des Arts (as the Louvre was then designated) on the tenth of August—the anniversary of the 1792 attack on the Tuileries that ended in the imprisonment of the royal family —rather than on the twenty-fifth, the king's name day, St. Louis's Day, as had been traditional since Louis XIV's minister Colbert admitted court society to see the Academy's exhibition in 1667. Louis XVI had been beheaded on January 21, 1793, and Marie Antoinette would follow him to the guillotine on October 16. The *ancien régime* and its calendar had been replaced by the Age of Reason, and 1793 appeared on the republican calendar as the Year II and August as the month Fructidor. The Salon, however, retained its name and its function as the most important French art exhibition. Nor were the dramatic changes caused by the Revolution, which had begun four years earlier, reflected in the works of art exhibited.

In May 1789 the third estate, which represented ninety-six per cent of the French population, had been called by Louis XVI to the Estates-General. It then seized power and declared itself a National Assembly in order to end privilege and secure civil liberty and equality. The Bastille, a symbol of the *ancien régime*, was razed on July 14, 1789, and on October 2, 1789, a Declaration of the Rights of Man and Citizens was formulated. The principles of the declaration were extended to all aspects of civil life by

[1] [Much of the information for this section was provided by Susan Waller, who examined the changes in the organization of the French Salon during the years 1789–1800.]

the Constitution of 1791, which made France a constitu-
tional monarchy despite the attempted flight of the king.
It was not until France was faced with the threat of a
foreign invasion that the forces of the Revolution erased
the symbols of monarchical power, toppled the statues of
the kings of France from their bases, and discarded orna-
mentation from their clothing. In September 1792 the
National Assembly was replaced by the revolutionary Com-
mune of Paris and a National Convention, with power
centered in the Commune's Committee for Public Safety.

Early in 1790, Jacques Louis David, hailed as a "pre-
cursor of liberty" when his painting, *Lictors Bringing Back
to Brutus the Bodies of His Sons,* was exhibited in the
Salon of 1789, had prepared a *Mémoire* which delineated
the political and social usefulness of the arts and called on
the Assembly to reform the Academy and the Salon. The
Assembly began the reform of the Salon the following year
with the decree of August 21, 1791, which stated: "All
artists, French or Foreign, members or not of the Aca-
démie de peinture et de sculpture, will be admitted equally
to exhibit their work in that part of the Louvre assigned
for that purpose." The decree came too late to have any
affect on the organization of the 1791 Salon, but it was to
affect the Salon of 1793: for the first time since it had
begun mounting the Salon exhibitions in 1667, the
Academy lost control over the biennial exhibition which
had had such far-reaching consequences in maintaining
the fine arts as an "emanation of the throne" and in
determining the art styles of Europe.

The sensations of the exhibition that had opened on
September 8, 1791, two weeks after the decree, were the
three paintings by David ordered by the king and com-
pleted and exhibited prior to the Revolution—*The Oath
of the Horatii, The Death of Socrates,* and *Lictors Bring-
ing Back to Brutus the Bodies of His Sons*—and his
sketch for *The Oath of the Tennis Court* commemorating
the National Assembly's formal act of disobedience to the
king. David was unable to finish *The Oath of the Tennis*

Court before 1792, when the National Assembly fell from power.

On September 17, 1791 the National Assembly stipulated that a jury, consisting of two members appointed from the Academy of Science, two members appointed from the Academy of Literature, and twenty members elected from the Academy of Painting and Sculpture by the exhibiting artists, would select the recipients of the awards to be distributed at the close of the Salon. When artists objected that this arrangement permitted the members of the Academy of Painting and Sculpture too much power, the jury was enlarged to include twenty non-academic artists elected by the exhibitors. This compromise between the Academy's authority and the demands of artists who were not members could not be maintained for long.

In November 1792, David—now a member of the Convention's Committee of Public Instruction, a leader with Danton and Robespierre of the Revolution, and director of the organization of public festivals intended to symbolize the goals of the Revolution and to inculcate the masses with republican ideology—presented to the Convention a petition from the free artists that called for the suppression of the Royal Academy. On August 8 of the following year, 1793—Year II of the Republic—the Convention dissolved, by decree, the Royal Academies. The Commune Générale des Arts, open to all artists, which David had formed in 1790, was finally instituted officially by the Convention in July 1793. The artists who composed it immediately organized the Salon of 1793, which opened on August 10 and to which "all artists, French or foreign, members or not of the Academy," were admitted equally. It was the largest Salon in the eighteenth century, with 1,462 entries submitted by 367 artists, as compared to the exhibition of 1789, when 88 artists were represented with 423 works.

The late summer of 1793 also marked the beginning of the Terror, instituted by the Convention and the Committee of Public Safety. A Committee of General Security

was created and the guillotine set up in what is now the Place de la Concorde, not far from the Louvre, where the Salon was located. Visitors to the Salon would have worn the short jacket, blue linen pantaloons and red cap of the galley slave considered proper revolutionary attire; any other dress made the wearer suspect.

In keeping with the former practice, a catalogue was printed which listed the works as they were numbered and followed the progression of their hanging. New, however, was an introduction, written by Gazat, the Minister of the Interior. Using words similar to David's when he had presented his painting of the "martyr of liberty" Le Peletier to the Convention on March 29, 1793, Gazat exhorted artists to remember their responsibility to the new order and to seek subjects encouraging patriotism.

David did not participate in the August Salon, being fully engaged in painting *The Death of Marat*—who had been stabbed July 13, 1793. The sensational propaganda picture, a masterpiece of painting, was ready October 14 to be exhibited with the earlier painting of *Le Peletier de St. Fargeau*. Dedicated to the Revolution's martyrs, the two works were publicly displayed in a courtyard of the Louvre before being hung on either side of the president's chair in the hall of the Convention.

In spite of the admonitions and appeals voiced as manifestoes of the new order and used as introductions to the catalogues of the Salons of 1793 and 1795, an examination of titles of exhibited works shows no marked increase in themes of "heroic morality" taken from antiquity. There is, however, an increase in genre and portraiture and a decline in Christian subjects.

To encourage artists to depict revolutionary subjects, several competitions were created. One, open to students, was initiated in August 1793 by the Convention as a replacement for the abolished competition for the Prix de Rome. The fifty members of the jury, chosen from various occupations by David, were devoted to republicanism. After numerous meetings they awarded the prize for painting to *The Death of Brutus* by seventeen-year-old Fulcean

Jean Harriet, a pupil of David, but they decided that none
of the sculpture entries was worthy of a first prize. The
Committee of General Security, of which David was now
a member, opened a second competition for designs for
public monuments, including a monument to the French
people and a memorial to those who had died in the upris-
ing of August 10, 1792. David presented a plan for select-
ing the jury for this competition, but before a decision on
the plan could be reached, David and the other members
of the Committee of General Security had fallen from
power when Frenchmen reacted against the Terror.

The Terror came to an end in 1794. After victories won
by the French revolutionary army in the spring, the
dictatorial rule of the Committee of Public Safety and
Robespierre seemed less imperative. On 9 Thermidor (July
27, 1794) those in the Convention antagonized by Robes-
pierre's policies outlawed him and he was beheaded the
next day. Several artists were among those who followed
him to the guillotine; David escaped with several months
in jail. The reaction that followed restored power to the
Convention, which was determined to make another at-
tempt at constitutional government. In October 1795 the
Convention dissolved itself and the Constitution of the
Year III (1794) went into effect. The new Constitution,
which restricted the franchise to propertied citizens, called
for a national legislature made up of two houses, the
Council of Five Hundred and the Council of Ancients,
and for an executive body, the Directory, made up of five
members chosen by the legislature.

The Convention also reorganized the Academy. In Oc-
tober 1795 the four former organizations of the *ancien
régime*, each known as an academy, were brought to-
gether to form L'Institut de France with three depart-
ments: one for physical and mathematical science, a sec-
ond for moral and political science, and a third for
literature and the fine arts. The third department was
composed of eight divisions, three of which—painting,
sculpture and architecture—formed the Section of Fine
Arts (Section des beaux-arts). The Directory initially ap-

pointed forty-eight of the one hundred and forty-four
members of the entire Institute and the forty-eight then
elected the remaining members, associates and corre-
spondents. In December 1795, David and Gerard von
Spaedonck were appointed by the Directory to member-
ship in the painting division of the Section of Fine Arts;
Joseph Marie Vien, former director of the Academy, Fran-
çois Vincent, Jean Baptiste Regnault, and Nicolas An-
toine Taunay were elected to fill the four remaining seats
in the divisions. When seats became empty, they were to
be filled by election by Institute members.

Though the Section of Fine Arts elected teachers for
the School of Fine Arts (École des beaux-arts), it had no
control over admissions to the Salon. Salons continued to
be open to all in keeping with the Directory's republican
ideals. The Directory nominated a jury of twenty-seven to
select the winners in the competitions for public monu-
ments initiated by the Committee of General Security.

Many continued to hope that artists would use their art
to further patriotism. Discussions of the social usefulness
of the fine arts appeared in the press. The advice given art-
ists by Bénézech, Minister of the Interior, for the 1796
Salon is an official appeal to artists to celebrate republican
virtues and French history in a public competition.

The public competitions which Bénézech and others
saw as valuable did not necessarily encourage artists, how-
ever, to deal with republican subjects: the buying public
was made up of the bourgeoisie, who were far more inter-
ested in portraits and easel paintings. Furthermore, history
paintings with political overtones carried a risk in uncer-
tain times, as the fate of David and other artists after the
death of Robespierre had demonstrated. Salons without
juries encouraged the exhibition of many mediocre paint-
ings. In 1798, to improve the quality of the works at the
Salon, an admission jury appointed by the Minister of
the Interior was instituted, but it produced so many com-
plaints, it was abolished in 1799.

The art exhibited and the changing regulations govern-

ing the Salons and the Academy demonstrated the problem of reconciling artistic freedom and a demand for government support and regulation of the arts.

Official Catalogue: Salon of Year II (1793)[1]

Introduction:

The forms of the arts, like the political system, must change: art should return to its first principle—to the imitation of nature, that unique model for which unfaithful copies have so long been substituted. Genius, once more, should no longer drag itself along the beaten track, but, flying with its own wings, should offer us its productions with an originality of character suitable to it. If this is accomplished we shall no longer see a long succession of artists who copy each other in servile fashion, but a varied imitation of nature, according to the diversity of the genius of nature's imitators. There will no longer be style or academic manner, but in their place the true and the natural in a thousand forms, in a thousand different characters, multiplied to the infinite from an inexhaustible source.

The arts should never limit themselves to the single aim of pleasing by faithful imitation. The artist must remember that the goal which he has set before him is, like that of all work of genius, to instruct men, inspire in them the love of goodness and to encourage them to honorable living. The artist should not abuse his gift of charming the eye in order to let slip into his heart the poison of vice and the fires of passion: he will rather set himself to extinguish these and to light instead the enthusiasm of generous and social virtues.

This is the moment when we must bring back the arts

[1] [Translated from texts in *Recueil* by J. Mariette, C. N. Cochin and M. Deloynes; George Duplessis, *Catalogue de la collection de pièces sur les beaux-arts* (Paris, 1881).]

to the memory of their noble beginnings, when the nation should once more turn her gaze upon them, when she should use them as powerful instruments to bring about the moral regeneration essential to her happiness and her new Constitution. Let her raise statues to the great men who have deserved well of their country: following the example of the Greeks and the Romans, let her gardens and her public walks be filled with these, so that in the place of the unreal, sometimes insignificant and often immoral monuments we have seen, we shall behold those of greater worth, that shall continually place before our eyes the events of our national history and those of ancient peoples worthy to serve us as examples. May the arts speak to us always of the love of country, of humanity and of virtue; may these cold marbles warm in every heart the seeds of good that we have received from nature. May our warriors, following the example of the Athenians, come to the tombs of our heroes who have died for their country, and there sharpen the iron destined to avenge them. Mothers shall bring their children, so that their hearts may early be formed by the sentiments of magnanimity and of courage, and like new Hannibals swear, from earliest infancy, an eternal hatred for the devastators of the world. . . .[2]

It may seem strange to austere republicans that we occupy ourselves with the arts, while Europe in coalition assails the territory of Liberty. Artists do not fear at all the reproach of heedlessness of the interests of their country. They are free by their very nature. Independence is the property of Genius. Surely we have seen them, in this memorable Revolution, as the most zealous partisans of a regime which gives to man the dignity long refused by the class that was the protectress of the ignorance which flattered it.

We do not accept the well-known adage: "At the rattle of arms the arts fall silent."

[2] In our own days we have seen our soldiers sharpening their sabers on the tomb of Marshal Saxe. [The tomb executed 1753–70 by Jean Baptiste Pigalle in the Thomas Church, Strasbourg.]

More willingly we would remember Protogenes, tracing a masterpiece during the siege of Rhodes, or Archimedes meditating upon a problem during the sack of Syracuse. Such deeds have the sublimity of character which belongs to Genius; and Genius must always soar over France and raise herself to the level of liberty. Wise laws shall prepare her for new flights; the National Convention has just enlarged her field, she is now free at last. With enlightenment, Liberty is no longer bound. The Usurper alone fears this light. He commands us to forget science, but a free government encourages and honors it. A Decree of September 1, 1791, sufficiently proves that the legislators understood this eternal truth. But they desired that mediocrity, often reckless, not lay claim to national rewards where merit alone has place and that the artists, following the public judgment of their peers, be charged to produce works which are a part of the exhibition and for which the artists have been paid by the nation: these are the ones that are referred to under the title of Works Belonging to the Nation. The public will judge.

Official Catalogue: Salon of Year IV (1795)[1]

Preliminary Statement:

Of all means to excite rivalry among artists, none is more powerful than contests open to all comers in which all test their strength against each other. Such jousts were held by the Greeks, whom we ourselves resemble. Even cities contested among themselves for the ownership of the most beautiful works of art and the most famous monuments. If the question arose in Athens, in Rhodes, in Corinth, in Sicyon,[2] of erecting a statue to their gods,

[1] [Translated from texts in *Recueil* by J. Mariette, C. N. Cochin and M. Deloynes: George Duplessis, *Catalogue de la collection de pièces sur les beaux-arts* (Paris, 1881).]

[2] [Peloponnesian art center, flourished sixth to third century B.C.]

men and women of all classes hurried to show themselves
unveiled to the sculptors and were glorified if they were
chosen as models for masterpieces which should surpass
those owned by rival cities.

But without entering into discussions of such ambitions
between city and city, which among these gifted people
was the result of their passion for the fine arts, competi-
tion between artists is an absolute necessity to awake them
from their sleep and to develop their creative genius. But
there are different types of competitions, more or less use-
ful.

Among students, rivalry cannot be too much en-
couraged. These are young coursers who need exercise
daily. They have as yet no laurels to fade. Today they are
vanquished: tomorrow they will be victors. Their fall is al-
ways light and without dangerous consequences.

For artists who already enjoy a reputation it is not the
same. For example, competitions opened for this or that
public work, although good in themselves, have their
drawbacks. Their inherent disadvantage is that they offer
only one prize to be won by athletes who are already re-
nowned. Those who enjoy the greatest reputation, uncer-
tain of the success of which no one can be sure and in fear
of exposing their glory to an attack and their self-esteem to
humiliation, may perhaps not enter the competition—this
is unfortunate for the good of things, yet it may happen.
The artist of merit does not put himself forward: he waits
to be called. He has no wish to engage in hand-to-hand
combat with a warrior of equal rank whose talent he es-
teems. If he has a noble heart, which every true artist
should have, he never wishes to humiliate his rival nor to
be humiliated by him. So because of a certain self-esteem
—a certain pride, if you wish—which accompanies great
merit, competitions of this type will attract only second-
rate competitors.

Among gifted people, then, the only competitions that
may produce wonders are those in which the artists, free
to follow their own muse, free to choose the subject to be
treated and without fearing an afflicting defeat, without

anxiety, work with freedom of spirit, hoping to display their work to an enlightened public which they accept as judge. This public, which is fair-minded when it is not disturbed by an alien influence, does not award only one set of laurels: it will choose one for grace, another for strength, another for precision, and one for felicity of ideas, so that each may bear away with him the palm he deserves. All are then content and encouraged, while the other type of competition of which we have spoken breeds cabals, hatreds, discouragement and jealousy.

The really useful competitions, then, are without exception public exhibitions. If they have the drawback of sometimes hearing feeble and discordant voices among excellent singers, this is a light matter compared with the good that may result. It is the leader of this sort of exposition who knows how to blend the mediocre voices with the chorus and to give the solos to the great virtuosi. It is in these general meetings that the government may distinguish those whose consistent success sets them apart from the crowd, and note in them those who should be employed for major undertakings and be encouraged and developed by smaller commissions. It is to be wished—and everything makes it seem hopeful—that at stated intervals artists will be invited to such meetings as this, without giving pain to those who do not wish to take part. If talent is proud, it also has its capriciousness and extravagance: witness the immortal Rousseau. One may find more than one Diogenes who will not wish to leave his tub: it will be necessary then, following the example of Alexander, that the eye of the nation should go to visit him there.

If, in these exhibitions, so salutary and so honorable to the arts, the artists, after having lived through the persecutions and the furies of vandalism, after having been forced by the Terror to abandon their work, still suffer from the wounds of an unjust and poisonous criticism, let them bear in mind that their nation opens to them her palace, protects them by her shield, watches over and consoles them.

Official Catalogue: Salon of Year V (1796)[1]

Introduction:

Innovations, even the most valuable, have always been obliged to overcome the resistance of traditional opinion: it would be wonderful if this effect led to the truth. Many persons have seemed to fear that opening a Salon to the fine arts every year would become harmful to the arts, for this interval is too short. The majority should be thankful to the government for not having shared their doubts and for having facilitated the means of exhibiting works that, for the most part, would have been sent out of Paris in a space of two years.

In London, exhibitions are held each year. Foreign artists and nationalized citizens who live in that city are invited to submit their work to public judgment. It is said that a jury rejects works that are too mediocre. It is added that many are so rejected. Have the arts gained in England since this custom has existed?

However this may be, special interests, above all those of the moment, will disappear here as circumstances improve. But since as of today the number of artists inscribed in the exhibition is larger than last year, it is proved that the invitation of the Minister of the Interior to the exhibition which is to take place has satisfied the majority of the artists.

It seems useful and suitable to repeat here the text of his invitation. Here it is:

The Minister of the Interior to the Artists of the French School

9 Floréal An IV[2]

[1] [Translated from texts in *Recueil* by J. Mariette, C. N. Cochin and M. Deloynes; George Duplessis, *Catalogue de la collection de pièces sur les beaux-arts* (Paris, 1881).]

[2] [I.e., 1796, ca. April 28. Floréal, Prairial and Ventôse were months of the *Calendrier républicain* reckoned from September 22, 1792, and abolished by Napoleon in 1805. Floréal was the approximate equivalent of April 20–May 19. Prairial of May 20–June 18, Ventôse of February 19–March 20.]

You have proved, Citizens, by the last public exhibition, that the spirit of the arts has remained the faithful companion of the spirit of Liberty. You have had too little time and leisure, too little quiet, above all, to produce all that could have been expected from the rivalry of your talents; yet you have aroused excitement and admiration by the great number and the great merit of your works. I invite you, this year, to reap a new harvest of glory. It would not be enough for French activity, for the progress and encouragement of the arts, to limit them, as was the case before the Revolution, to one public exhibition every two years. The arena has widened. A greater volume of talent has appeared; emulation will be born again with competition, and with the organization of public instruction, and with commissions for encouragement. Offer, Citizens, every year, joys to the nation, food to the arts and commerce; impose upon the Universe the obligation of admiring the French School, become fertile, like the nature she studies, and to which she draws near.

Liberty invites you to retrace her triumphs. Pass on to posterity the deeds which do honor to your country. What French artist does not feel the need of celebrating the grandeur and the strength which the nation has shown, the power with which she has governed events and created her destinies? The subjects which you take from the history of ancient peoples have multiplied about you. Have a pride, a national character; depict our heroism, so that the generations to follow may not reproach you by asserting that you did not seem French in the most remarkable epoch of our history. . . .

<div align="right">Signed
Bénézech[3]</div>

[3] [A young politician, Pierre Bénézech, was twenty in 1795 when he was the Directory's Minister of the Interior. At twenty-seven he was sent by the First Consul to be colonial prefect at St. Domingue (Haiti), where he died.]

1795

ROME: The Exhibition
by an Artist of His Own Work

Early in April 1795 the usual number of German-speaking artists were crowded around the marble-topped tables in the smoky rooms of the Caffè Greco on the Via Condotti just off the Piazza di Spagna. By the entrance, a board of small bulletins announced departure times for tours of galleries and villas and related events. Similar notices were posted on the board in the nearby Caffè Inglese, where they attracted the attention of artists and visitors on the Grand Tour. By such notices word of events reached the colony of foreign residents and visitors.

One of the notices in April announced an exhibition of drawings by Asmus Jakob Carstens to be held at the nearby Via Bocca di Leone 25. The address was familiar to everyone in any way concerned with painting or art in Rome. All knew it as the former studio of the technical virtuoso Pompeo Battoni, the last exponent of Mengs's doctrines and a portraitist for whom nobility, the great and the wealthy aspired to sit when in Rome. Struggling, indigent artists knew the studio because Battoni, generous in his prosperity, had provided a live model for them and had occasionally given criticism. Carstens' rental of Battoni's studio served to dramatize the difference between Battoni's classicism and Carstens' own work and theories, developed from a variety of sources during the long years before he was able to come to Rome.

Born in Denmark, Carstens was determined to be an artist even though he had been apprenticed to a cooper. He had learned what he could from a sign painter and by following instructions given in Kroker's *Wohlführenden*

Steffirmaler (1736). He had found theories to pursue in a German translation of Roger de Piles's *Abrégé de la vie des peintres, L'Idée du peintre parfait* (*The Art of Painting and the Lives of the Painters;* 1699), G. de Laresse's *Het Groot Schilderboek* (1707) and especially Daniel Webb's *Investigation of Beauty in Painting* (1771). Webb maintained that a universal idea lay beneath the appearance of all things, a concept he had derived from the writings of the engineer and theologian Emanuel Swedenborg.

In 1776, after Carstens had received an inheritance sufficient to purchase his freedom from apprenticeship, he entered the Copenhagen Art Acadmy (Det Konge-lige Akademi for de Skønne Kunster). But he found drawing single elements of a figure from plaster casts "dis-integrating" and drawing from a live model repellent, in that nature could not be a model. He did enter Nicolai Abilgaard's drawing class when he learned that the winner of the Academy's gold medal in drawing received a stipend for study in Rome. His drawing received the silver medal, but he refused to accept anything less than the gold (although the silver was prerequisite to receiving the gold) and left in 1778 for Lübeck to earn the money himself by "taking likenesses." Early in 1783, Carstens and his brother set out on foot for Rome. Warned in Mantua of the precariousness of an unsupported artist's existence in the Italian center, the Carstenses turned back. At the end of 1783, Carstens was again in Lübeck "taking likenesses" and studying Michelangelo's work from engravings.

Financially assisted by Charles Overbeck, father of Johann Friedrich Overbeck, who founded the Brother-hood of St. Luke, the "Nazarenes," Carstens sent a draw-ing of *The Four Elements* to the Prussian Akademie der Künste exhibition and then followed it to Berlin. He secured employment decorating apartments in the royal castle. His entries in the Academy exhibitions, which were open to any artist, demonstrated his competence, and he was named a professor of drawing from plaster casts at the Academy in 1790. Two years later he received from

the Academy a two-year scholarship to study in Rome under the general supervision of Friedrich Rehberg, a former professor of the Prussian Academy.

From the moment he entered the Caffe Greco in Rome in September 1792, Carstens maintained he was a drafts-man with no interest in color. He argued that only volumes indicated in monochrome and contained in contour lines were necessary to give visual form to an abstract concept such as "tragedy" or "gaiety" and that color was an ele-ment that should be considered separately. He himself had never had an opportunity to learn the technique of oil painting, which was not taught at the Academy but in a master's studio. Confident he was giving a new direction to art, as soon as he had completed sufficient work in water color, tempera and crayon to demonstrate his principles, Carstens gave up his small studio in the Via Babuino and defiantly rented Pompeo Battoni's studio.

He had been encouraged in this venture by the arrival in September 1794 of Karl Fernow, a friend from Lübeck. A onetime apothecary turned artist, Fernow had decided, after two years' study of Kant with Karl L. Reinhold and conversations with Schiller in Jena, to devote himself to the theory of art rather than its practice. From Rome he sent four articles *"Über den Stil in den bildender Kunst"* to *Der neue teutsche Merkur*—a connection he had se-cured through Reinhold, the son-in-law of the owner-edi-tor Wieland. In these articles he followed and developed Reinhold's interpretation of Kant. Reinhold argued that the idea "is related both to an object and a subject," which led to his assumption of a "thing-in-itself" which is experienced as fact. Fernow later supplied other articles to the *Deutschen gemeinützige Magazine* in Copenhagen, published by the liberal Danish statesman Christian Egger, and to the *Miscellanea*, published in Erlangen by J. G. Meusel. Through the interest of Prince August Friedrich of Hanover, Fernow was able in 1795–96 to be-gin lectures in the Villa Malta—previously a gathering place of the German-speaking colony during the visit of the Duchess Anna Amalie of Weimar in 1787—to a reading

circle of twenty-five members. These lectures on aesthetics derived from Kantian principles were among the first of the "art appreciation" courses. In connection with this circle Fernow set up a bookshop and library that became a center in the German-speaking community of Swiss, Danes, Austrians and Germans.

Carstens' exhibition was well attended. The Earl of Bristol, Bishop of Derry, Frederick A. Hervey, who was known previously to be interested in the artist's work, now purchased several paintings. Fernow's review, *"Über einige neue Kunstwerke des Herrn Professor Carstens,"* the second of his series on style for *Der neue teutsche Merkur,* presented Carstens as the "creator of a new art ideal *(Kunstideale)"* whose work was the reflection of the experience of the artist. This new emphasis on the artist's personality—even if it found expression in classical forms— was viewed with suspicion and seen as possibly related to the romanticism that emerged from Wackenroder's writing. The exhibition and the review brought into the open a debate that had been waged around the tables of the Caffè Greco.

When the news reached Berlin and inquiries were made, Rehberg, a traditional academician unsympathetic to Carstens' independence and novel technique, disparaged both Carstens' work and Fernow's review. When Von Heintz, the Prussian Minister of Education, then called Carstens to task for his failure to fulfill his obligation to the Academy—the artist had neglected to send back the required reports—Carstens replied: "I do not belong to the Academy, but to humanity, which has the right to require of me the greatest development of my ability. God has entrusted me with my ability. . . ." Joined with this was a penetrating criticism, the first by an artist, of the Academy and its system of instruction. Von Heintz understandably stopped Carstens' stipend. For the remaining three years of his life the artist was supported by a commission from the Danish poet Friedricke Brun for an Ossianic theme, "Fingal's Battle with the Spirit Lodas,"

and by the money received from Lord Bristol's purchase of several works from the exhibition.

An objective appraisal of Carstens' art by the connoisseurs in Germany was hindered by a clever, stinging review of the exhibition written—probably at Rehberg's instigation—by the painter-poet Friedrich Müller and published in 1797 in *Die Horen,* a journal founded in 1795 by Schiller and Goethe to compete with *Der neue teutsche Merkur.* Müller's criticism was directed primarily against Fernow's qualifications as a critic.

Artists who shared Carstens' dissatisfaction with the academic mode rallied to him. They were the historical painters, Ferdinand Hartmann and Eberhardt Wachter, and the German landscapists, Johann Reinhart and Joseph Koch, who also sought a new means of expression, albeit through light and color. In Koch's words: "Even when art appears natural it should transform nature by formulating it stylistically." Koch, the most gifted, engraved Carstens' compositions and used them in his own work. Through these men Carstens' influence was carried to Vienna and Dresden. Carstens' concept of form also influenced his countryman and friend, the sculptor Bertel Thorvaldsen.

The advance of the French troops and the capture of the Papal States scattered the majority of the international set in Rome. The French army established a republic in 1797 and began the shipment of the famous works of art to Paris. Carstens remained in Rome until his death from tuberculosis in 1798. Although Fernow was sympathetic to the Revolution and continued as a reporter for *Der neue teutsche Merkur,* when in 1802 its new editor, Karl Bottiger, secured him an appointment as professor of history at the Jena University, Fernow accepted it. From Jena, Fernow went to Weimar as librarian to the grand duchess in 1804, taking with him Carstens' unsold works. Goethe, when he saw them, arranged for their exhibition and purchase for the library of the grand duchy.

Fernow's importance derives from his review of the Carstens exhibition and his *Leben des Künstlers A. I. Carstens* (Leipzig, 1806). Interspersed with Carstens' verba-

tim recollections, it is a moving account of an artist's determined struggle to obtain the freedom and the technical proficiency needed to express in a new visual idiom the conceptual images that possessed him.

Karl L. Fernow, "Concerning some new works of art of Professor Carstens"[1]

Rome, 2 May 1795

Most Worthy Friend![2] To recompense you for my last, scarcely encouraging, letter about the present condition of the fine arts in Rome, I now take pleasure in surprising you with a more promising prospect for a new upward endeavor in the fine arts. Like many another true friend of art, I have been astonished by this phenomenon so unexpected here and little hoped for now in a period so unfavorable to the cultivation of art.

Herr Carstens, professor at the Berlin Academy of Art, who has been living in Rome for several years, gave us in the past month a public exhibition which is noteworthy in several respects, but particularly because it seems to announce a new epoch of art. This artist, when he came to Rome, had already given his talent and study a most fortunate direction and acquired a simple, masculine style—one, we conjecture, that could come to fruition only on this side of the Alps. The degree of perfection he has developed here in a short time in the sight of Raphael, Michelangelo and the ancients justifies this conjecture. He had the advantage of not needing first to unlearn what he had brought with him in order to follow in the footsteps

[1] [Translated from *Der neue teutsche Merkur*, II, Weimar, June 1795.]

[2] [Karl A. Bottiger, the philologist and archaeologist, who was to succeed Wieland as editor of *Der neue teutsche Merkur* in 1798 and to continue its publication until 1880. The reference is to the first of Fernow's four letters, "*Über den Stil in den bildender Kunst.*" The *neue* first appeared on the paper's masthead in 1790.]

of these great predecessors; on them, even from a distance, he had always kept his eye. As much is shown by his Berlin ventures[3] wherein he already demonstrated his calling to art and aroused well-founded expectations of his ability.

A courageous, self-confident spirit and a noble selflessness are necessary to resist the current of generally prevailing opinions and to work against it. Usually it may count on little applause from its contemporaries, and leaves posterity to judge its merit. Still, taste for the pure and noble in the fine arts—which has its permanent domicile in Rome and will have so long as the art treasures of the Vatican endure—has not fallen so deeply asleep amid the degeneracy of recent art and its total withdrawal from old goals that an artist who shows some affinity of spirit with the art of his fathers is not granted his due. That the simple, plain and masculine style of the ancients is no longer suitable for our times is a prejudice nourished even by would-be art connoisseurs. It seems to be based upon the fact that no one in recent times has offered works in this style to the public, rather than work in the spoiled taste and the enervated spirit of our artists, and not in the changed spirit of our era. This was strikingly confirmed at the Carstens exhibition. In spite of the great difference of his style from the one currently prevalent, it received the undivided applause of artists and art lovers. The simplicity and accuracy of his works and their richness of ideas were marveled at, and they were compared to the works of the old masters. Indeed, if one wishes to judge them through comparison, they can be compared to no others, since they have similarity with no others.

One should never write descriptions of works of art if they do not contain simultaneously a sound judgment instructive for the formation of taste. But I am not presumptuous enough to undertake this in regard to Carstens' works of art. My report is meant only to make you acquainted to some extent with the spirit of the artist.

[3] [Two had been composed in Berlin: *Socrates in the Basket* and *Night with Her Children, Sleep and Death*.]

Therefore, first of all, I impart to you in German his own announcement inviting the public to his work.[4]

The following works of art are on display for public review in the house of the deceased Pompeo Battoni.

(1) *The Crossing*, a painting in tempera. Megapenthes, a rich young libertine (as Lucian narrates in an essay of the same title), struggled against dying in the flower of his years and yielding to common fate; but along with other mortals he had to follow Mercury, leader of the dead, into Orcus. . . .

(2) *Parcae* [*The Fates*], a painting in tempera. The dreadful goddesses who rule over all are represented here as sitting at the boundaries of creation and singing the fate of the mortals. Atropos tears asunder the thread.[5] Behind them is nothing for the naked understanding but impenetrable darkness.

(3) *Time and Space*, a painting in tempera. A graphic representation of these abstract forms of material existence, all phenomena are located in them. Space embraces the cosmos; Time is eternally young, only the things in it change.[6]

(4) *Plato's Symposium*, a painting in water color. . . .

(5) *Parnassus*, a painting in water color. The nine muses dance around the graces to the music of Apollo's lyre.

(6) *The Heroes of Troy*, a painting in water color. The subject is taken from the ninth canticle of the *Iliad* and represents the delegation sent to Achilles by the Greeks, hard pressed by the Trojans. . . .

[4] [Carstens wrote the text describing, as was customary, the subject and literary source of each painting. Fernow did the Italian translation. The stories depicted are for the most part omitted here.]

[5] [A statue of *Atropos* (1794) is Carstens' only surviving sculpture.]

[6] [When Schiller heard that this painting was an allegorical representation of a Kantian concept, he wrote this distich: "The latest from Rome: Time and Space are really painted! Now with equal luck we may expect the Virtues to dance for us."]

(7) *The Argonauts,* a sketch from the poem of the same name which is ascribed to Orseus. . . .

(8) *Achilles and Priam,* a sketch. The subject is taken from the last book of the *Iliad* and well enough known. . . .

(9) *The Birth of Light,* a sketch from Sanchon-iath, an ancient Phoenician author. Ftas (the original power of things) begat with Neitha (Night) Fanes (Light). After Light was born, from Ftas's breath went forth the cosmos in which reposed the germ of all creation. It was hatched by the warmth of Fire; Heaven and Earth arose, and all things developed. Ftas here shows the course taken by the cosmos into the infinite.

(10) *Ganymede,* a sketch.[7] An allegory of a youth in the prime of life snatched away by death.

(11) *Socrates in the Basket*[8] from Aristophanes' comedy *The Clouds.* He is arguing with the farmer Strepsiades, who had come to Socrates' school to learn dialectic from him.

Merely from this list of contents you see that the artist has for his representations almost exclusively new subjects, little or not at all used previously for pictorial art, and that his inclination is to noble and lofty subjects more suited to his emotional character than the purely gracious and charming. In works of the pictorial arts, the poetic material or the poetic imagination rarely belongs to the artist. He can and should borrow his subjects from fable and history. But, apart from this limitation, there remains for him opportunity enough to show the peculiar inventiveness and representational ability of his fantasy, and his own merit consists in what he has made out of the subject offered him: in the choice of the most interesting factor, the one most favorable for the representation; in the arrangement and lively expression of the characters involved.

[7] [The only picture partially completed in oil. It, the *Socrates, Plato's Symposium, Time and Space* and *Parcae* were purchased by Frederick A. Hervey (1730–1803).]

[8] [This red chalk drawing had been executed in Berlin.]

He represents visually what the author expresses only imperfectly in words. I cannot help but impart to you some special observations about the manner in which the artist has treated his above-mentioned subjects—observations which admittedly would be dispensable had you the opportunity to see his works yourself. They have what is characteristic of all genuine products of genius and mature judgment as well as being a constant companion of the beautiful and true: one can see and find new interest in them repeatedly without lessening the pleasure of one's first impression. . . .

During the exhibition the artist composed a cartoon for a new picture which had as its subject *Night with Her Children*, from the story by Hesiod. This drawing confirms once again the artist's talent for the depiction of lofty inventions of fantasy. It is in a grand and simple ideal style which agrees with that in *The Birth of Light*, and, in regard to composition, it is a masterpiece. Night, as the mother of the other beings, is the picture's main figure, one of a splendid group, with the Genii of Sleep and Death reposing in her lap under her veil. The artist has employed with great success the description by Pausanias of a similar picture on the so-called *Box of Cypeselus* and his fine, poetically beautiful characterization of the two Genii: "Death seemed only to sleep; Sleep, on the other hand, actually slept. . . ."

What, in my opinion, characterizes these works of art to their profit and especially the genius of their creator are the adroitness of his fantasy visible everywhere and the ability to adapt the representation to the subject in every instance. His style, which in general is one of a simple grandeur and beauty, is always in accord with the content of the work of art, yet is so happily modified that he consistently is able to keep himself free from any reproach of mannerism. This has become possible for the artist perhaps only through long and varied exercise of fantasy and power of judgment and through strict adherence to the principle to render strict account of everything and to execute nothing without mature, thorough judgment. But this

discipline demands much perseverance and an ardent, vital fantasy that forfeits none of its freedom under the necessary restraint of rules. The spirit of the artist must know how to move freely in these chains and to rise above the rules without violating any of them, if the representation is to appear not merely correct, but free and beautiful. Thus, for example, the style in *The Crossing* is just as different from that in *Plato's Symposium* and the style in *Parnassus* from that in *The Birth of Light,* and *The Heroes of Troy* from that in *The Fates* as all these subjects are different from each other. So, if only one of these pictures had been seen one would scarcely recognize the artist in the others if he did not reveal himself to the true connoisseur through the constant agreement of the subject, manner of representation and the selective means whereby all the parts augment the total impression; through the simplicity and modesty of the execution; and through the spirit and determination of expression—qualities which are repeatedly found in each of his works. For this reason these works of art, so unassuming from the point of view of technique, are not only pleasing at first sight, but can also stand repeated viewing and colder examination, and offer new beauties with every viewing—a property which is a certain sign of inner, lasting worth. Next, this artist deserves the applause of the true connoisseur for his rare modesty in not displaying his technique beyond the essential to represent the work of art and always subordinating secondary effects to the main goal, as well as his disdain for everything that only delights the senses and creates no interest either for the understanding or the heart. I may say in praise of the Romans that they are not indifferent to these merits. We scarcely notice in the case of his works that they are *composed.* We see the representation and nothing else. Actually—as I, for my part, am completely convinced and venture to prove—art will never again be elevated to a height worthy of it until the currently dominant mechanical technique[9] and materialism—hitherto

9 [From Rome, Carstens wrote to the Genelli brothers, Friedrich, Hans Christian and Janus: "Here a crowd of brush

and still cultivated in excess and at the cost of the more essential components—are cast down from their position of respect and strictly subordinated to art's higher purposes: to engage fantasy and emotion and elevate the spirit through beauty, grandeur and interesting expression. Art will not again be elevated unless it be led back to its previous simplicity, truthfulness and dignity. . . .

wielders who place the worth of art not in color but in mechanical technique and who would not allow me the right to advance because only this and nothing else in my work would have been judged. In order not to be thwarted by these people, I have therefore worked only in tempera and water color."]

WEIMAR: The Exhibition
by a Society

The first exhibitions intended to stimulate artists to treat themes more serious than those in vogue, to educate the taste of collectors and the public, and to raise the level of art criticism were held in Weimar between 1799 and 1805.

Weimar was the capital of the grand duchy of Saxe-Weimar-Eisenach, one of the many small principalities that later would form the national state of Germany. That Weimar, a town with a population of 7,000 off the main highway between Frankfurt-am-Main and Leipzig, became known as the "Court of the Muses" was due to the intelligence and ability of the Duchess Anna Amalie, regent for nineteen years. A genuine liking for the arts and literature, developed by an excellent education, prompted her to invite writers, musicians and actors to her court to provide an intellectual atmosphere in which she could actively participate, rather than passively patronize. In 1772 the duchess appointed one of Germany's leading authors, Christoph Martin Wieland, to be tutor to her son Karl August. Wieland launched his successful *Der teutsche Merkur* the following year; the art, theater and literary news with the masthead "Weimar" led the 2,500 subscribers and others to identify the town with the arts. Wieland's pupil, Duke Karl August, met Goethe, already a literary celebrity as author of *The Sorrows of Werther*, in Frankfurt in 1774 and urged him to visit the court in Weimar. Goethe did so the following year, and, the duke having named him one of the three members of the Privy Council in 1776, he remained in Weimar the rest of his life.

In 1800 the Duchy of Weimar was still untouched by the French army engaged in war with Austria but was fully involved with European humanistic thought. In spite of war and revolution, the cultural and intellectual life of Europe continued on a course begun in the middle of the eighteenth century which was marked by reaction against the frivolity of the rococo style of which the French had been the leading exponents. The reaction had two streams —classicism and romanticism—which were simultaneously entwined with and opposed to each other. Classicism, fed by archaeological discoveries, sought to discipline the creative spirit within limits set by an ideal form found in the art and culture of the ancient world. Romanticism, encouraged by political liberalism, fostered individuality, emotional expression and a sense of identity through the continuity of history. In response to it, northern Europeans rediscovered the sagas, minnesingers, Gothic art and architecture and, in seeking to revive these forms, were brought to a national awareness.

Goethe's youthful essay, *Von Deutscher Baukunst* (1773), his popular *Die Leiden des jungen Werthers* (*The Sorrows of Young Werther*, 1774), and *Wilhelm Meisters Lehrjahre*; (*Wilhelm Meister's Apprenticeship*, 1795) were early expressions of romanticism, also referred to by the phrase *Sturm und Drang*, and contributed to it. However, a year and a half in Italy in 1786 and 1787 among the monuments of the classical world led Goethe to consider the means by which the *Sturm und Drang* movement might be channeled into more disciplined art forms, thereby stimulating man's intellectual and rational side. Unable to return to Italy as he had hoped to investigate the sociopolitical elements that had produced Roman culture, Goethe brought to Weimar in 1791 Heinrich Meyer, a Swiss artist and former companion and guide in Rome. Meyer was well grounded in the aesthetics of classicism, more an art historian than an artist. He taught at the Weimar School of Drawing, established in 1766, where a drawing master and the court sculptor were also instructors, and served as Goethe's collaborator in the field of

fine arts. Together they were to explore means by which
the current standards of taste could be raised.

Goethe's inclination to instruct was sharpened, after his
return from Italy, by the changes in the cultural life
caused by the French Revolution and conquests. He was
concerned with fostering humanism (*Bildung*) in society
as a whole, which he believed was dependent on the culti-
vation of man's inner life. His concern led him to found a
review, *Propyläen* (1798–1800). The marble gateway to
the Acropolis in Athens, the Propylaeum, symbolized for
him a "space between the inner and the outer, between the
sanctuary and the commonplace world" where discussions
on nature and art, on ancient and modern art, could take
place between "us and our friends." Schiller was to collab-
orate as a poet, Goethe as a dramatist, Meyer as an artist
and art theoretician, and Wilhelm von Humboldt as the
reporter on events in Paris. Goethe hoped to bring to-
gether in the journal different opinions in drama, music
and the visual arts.

In the preface to *Propyläen*,[1] Goethe set forth his
theory of art, which called for an artist to have knowledge
of anatomy, the properties of light, the nature of stones
and organic growth, for "a man only sees what he knows."
In the first number he also published his translation of
Diderot's "Essay on Painting" with a commentary which
criticized genre painting for being merely an imitation of
nature:

> To the works of nature the beholder must supply
> significance, feeling, thought, effect, emotional in-
> fluence; in the work of art he expects to find all that,
> and it must be there. A perfect imitation of nature
> is in no sense possible; the artist is only called upon
> to represent the surface of an object. The outside of
> the vessel, the living whole that speaks to all our
> mental powers and sense, arouses our desires, elevates
> our mind, makes us happy when we possess it, that

[1] *Jubiläums-Ausgabe*, Vol. XXXVI, p. 109.

is the artist's concern, to produce the effect of life, strength, perfect growth and beauty.[2]

Around the journal were grouped the Weimar Friends of Art—actually Schiller, Goethe and Meyer—who in May 1799 published an invitation to German painters and sculptors to send in by August 25 their interpretation in an outline drawing, with shading and color if they wished, of "Aphrodite bringing Helen back to Paris," an episode from the *Iliad* (II.380–440) selected by Goethe. The drawings would be exhibited in September at the same time as the work of the Weimar School of Drawing. The drawing that was judged to be the best interpretation would be reproduced, the judgment would be explained and each entry criticized in *Propyläen*. In a period when literary art forms were more familiar and more prestigious than visual art forms, the announcement that each entry would be criticized by Goethe, a major figure, and thereby awarded a status equal to that of a literary work, made the competition unique. Only nine entries were received the first year. The second year, 1800, the episodes were again selected from the *Iliad*—"Hector's farewell to Andromache" (VI.395) and "The Death of King Rhesus" (X.377)—and the number of entries increased to thirty. Schiller, who had moved to Weimar in 1799, was prevailed upon to write an unsigned commentary on the different entries for the September 23, 1800, issue of *Propyläen*. Goethe wrote some short introductory remarks to the criticism of the individual entries and a brief survey of the German art centers; Goethe's name also appeared over the judgment of each entry, but it was soon known that the writer was Heinrich Meyer, and a lampoon of his neoclassical theories appeared in the *Zeitung für die elegante Welt*. The *Propyläen* ceased publication in 1800, because it had not aroused sufficient interest to make its way financially. The Weimar Friends of Art exhibitions continued until 1805 with the subjects supplied by Goethe.

Goethe's device to stimulate creative talent to treat

[2] Ibid., Vol. XXXIII, p. 22.

more consequential subject matter, to educate the taste of the public and to raise the level of art criticism by means of the exhibition was an innovation that came to be increasingly used—notably in England—as the century advanced. The Weimar Friends of Art exhibitions had created a precedent for the use of the exhibition as a means to, in Goethe's words, "rouse a general and higher interest in what is purely human" and to stimulate creative talent.

Johann Wolfgang von Goethe, "The Weimar Kunstfreunde Open Art Competition: Awarding of the Prize for 1800"[1]

When the editors of the *Propyläen* decided to publish a few things about plastic art, a subject with which they had been occupied more or less all their lives, they were quite conscious of their qualifications. They hoped to pass on many items interesting to the amateur and helpful to the expert and the artist. Far from insisting on theory in its strictest sense they intended to provide statements by artists and art patrons that would serve the immediate interest and the later needs of the philosopher, who, after determining the value of these items in the light of conclusions he had arrived at by deductions based on higher sources, could use them when he came to formulate clearly his theory of aesthetics.

So far we have done what time and circumstances have allowed us. We intend to continue along these lines and request the interest of art lovers in the future.

Initially, one fact caused us concern for our undertaking: in our experience insoluble misunderstandings exist between artists, between connoisseurs, and between friends of art as well as among each of these three groups.

[1] [First published in *Propyläen*, III, Bd. 2. Translated from *Goethes Werke*, ed. A. Meyer and G. Witkowski, *Deutsche Nationalliteratur* (Stuttgart, 1882–97), Vol. XXX, pp. 160–67.]

One need only have gone through the art collections of
Rome in a large group, or visited the Caffè Greco, the
Roman "stock exchange" for artists, or compared the
opinions of artists, *ciceroni* and strangers to give up hope
of reconciling the attitudes of such different people, who
cannot easily agree on either the goals to be achieved or
the merits of what has been accomplished. How would it
be possible for them to agree, since everyone takes art for
granted without having informed himself closely about its
requirements, just as everyone takes for granted that man
is alive without knowing much about him? As an individ-
ual, one praises and rejects, loves and hates. Only rarely
does one arrive at a kind of total view of the matter.

There have been times, however, when there appeared
to be a closer agreement, especially about something
created on the spot. There was a time when German artists
met frequently in the evening, agreed at once on an ar-
tistic contest and engaged in it immediately. What was
created in the moment enlightened the moment. During
this stimulating game all demands were silent: the merito-
rious was recognized and praised; the conversation was less
partisan and pleasanter than otherwise.

Certainly this is the course that art follows during its
fortunate days. The artist expresses his conception with
the stylus; genius places a new creation in our midst; con-
noisseur and amateur discuss what has just been finished,
which—if one is lucky—is commensurate with the level of
contemporary culture. Another contemporary artist looks
at the work of his rival, takes what is effective for his own
work, and so one work is created from another.

Thus art is on its proper course toward its goal when, in
the process of working to perfect a work of art, a prospect
suddenly opens that makes greater perfection possible.

These and related observations persuaded us to pose
problems annually and to invite artists to solve them. . . .

Before we turn to the discussion of the works them-
selves, we still have a few things to mention.

As to the sequence in which we shall present the works
that have been submitted: we have decided from *The*

Death of King Rhesus, which Herr Joseph Hoffmann of Cologne sent and which was awarded one third of the prize money (ten ducats), to ascend then by stages from the least work, *Hector's Farewell,* to the best work in the collection, a drawing by Professor Nahl of Cassel to whom two thirds of the prize money (twenty ducats) was given, so that the beginning and end of our critique of this year's exhibition may be arranged as poles, side by side. . . .[2]

A more general survey of all the entries sent from the various regions of Germany grants a concomitant view of the spirit, culture and talent of the nation as they prevail and exist in the field of the fine arts today. This survey is, indeed, very satisfying; it is even gratifying. We say gratifying, for no one will perceive without happiness that something at once courageous, right, good and, moreover, of noble and sensitive feeling exists even in those artists who have not advanced very far in art. This is a good basis from which beauty and taste can surely blossom, if they are cultivated. The honored artists and some of the others who approached them are shown to be well informed in what we term the scientific in art and consequently may be compared with the best of those artists who now boast of the greatest fame in the nation.

In respect to purity, beauty, worthiness of thought; to natural concise, vivid representation; to perception of the realm of art and its boundaries—in short, in respect to that which constitutes the essence and the essential usefulness of art (in so far as art helps to develop and refine the infinite intellectual powers of man), these artists have done more—as we can easily maintain for the reasons mentioned above—than even the most loudly acclaimed of other artists can show in their work.

Therefore, let no one complain unjustly, as happens so often, about the slowness, clumsiness and inferior quality of German genius, so that our young artists, blinded by

[2] [The discussion of the individual entries written by Meyer, Section 2, is omitted. See Walter Scheidig, *Goethes Preisaufgaben für bildende Künstler,* I:1799–1805, *Schriften der Goethe Gesellschaft* (Weimar, 1958), Vol. 57.]

the fame of foreigners, will not try to imitate it. For the modest, not very arrogant German, it has always been difficult to have faith in himself, and yet without it nothing perfect can be achieved.

If only one were to take stock in general and to put aside those prejudices about the purpose of art which still cling to us from previous times and which now hold us back, even though they cannot stop us completely! If only the best of those who have a voice in the matter would join us to combat the harmful errors and distortions of public taste! If only patrons would not favor the fine arts with new expenditures, but rather utilize purposefully the existing funds already designated for the improvement of the arts!

The fruits thereof would soon have to show themselves in great, meaningful, universal results. Our efforts and our small institution have proved that they would not fail to appear. Unquestionably general taste would soon improve, as we have with pleasure already noticed in the judgment of the Weimar public at our present exhibition in comparison to last year's. Love for true art, which has become so rare, would again gradually increase, and soon talents which now wither unused and hidden would develop brilliantly. A new day would awaken for art and give us joy with its beautiful gifts. . . .[3]

Johann Wolfgang von Goethe, "A Brief Survey of Art in Germany"[1]

We believe it useful to present a general survey of art in the various regions of Germany which we have compiled from information we obtained partly through the competition entries and partly from other fragmentary data. May some liberal, perceptive residents in each area, or qualified

[3] [The section containing the Schiller critique is omitted.]
[1] [First published in *Propyläen*, III, Bd. 2.]

travelers, give us soon particular, detailed accounts! If sent to the editor of the *Propyläen*, he would know how to make suitable use of them.

In Stuttgart[2] and Cassel[3] the fortunate effect of what some princes have done to benefit the fine arts may be seen. Here, at the very beginning, one finds the study of antiquity and the best moderns: style, form, symbolic presentation, with perfected execution. Herren Nahl and Hartmann have given us splendid proof of this by their entries.

In Cologne, through Herr Joseph Hoffmann, the continuation of an old school has been recognized. We hope to be able to say more about conditions there in the future.

In Düsseldorf the influence of an understanding, talented and active teacher, who has taught his students to use a gallery, a collection of drawings and antique models, may be seen.[4] One might say that this school should beware of too much practice and the influence of the *mechanographical* institute.

Herr Kolbe, an excellent member of the same, will be going to Paris this year. Our best wishes accompany him there, and we hope that he will continue his association with us from there.

In Lower Saxony one finds fine talent, except that it is on the sentimental-theatrical path. How can it be avoided, if one wants to present sentiment instead of observation and takes a foreign art for the model from which one works?

Would it not be possible for a commercial enterprise to bring to Hamburg or Bremen a collection of plaster casts?

[2] [As the Kunst Akademie and the Karlschule in Stuttgart were dissolved in 1794, art activity was centered around the sculptor Johann Dannecker (1758–1841).]

[3] [At Cassel, the Tischbein family of artists was active: Johann H. (1722–89) as director of the Academy founded in 1776; his nephews Friedrich August (1750–1812) and Heinrich Wilhelm (1751–1829), known as "Goethe" Tischbein.]

[4] [The Düsseldorf Academy of Art was founded in 1767; its director in 1800 was Johann Peter von Langer, who followed David's classical precepts.]

They are available in better quality than ever before and can be bought quite reasonably. One must display them appropriately and let them be viewed for a modest fee. The investment capital would find it quite profitable and an artistic genius in northern exile would not be deprived of all light.[5]

In Berlin, naturalism with its demand for reality and utility seems to be at home, except for the individual merit of well-known masters. The prosaic spirit of the time seems to be most evident here. Poetry is being suppressed by history; character and ideal by portrait;[6] symbolic treatment by allegory; landscape by prospects; the universally human by the patriotic.

Perhaps one will soon be convinced that there is neither patriotic art nor patriotic science. Both belong, as does everything good, to the whole world and can advance only through the general, free interchange of action among all contemporaries with constant consideration for what remains and is known to us from the past.

One blames libraries and galleries, which through their imposing presence, through a certain incoherent intrusion upon the human spirit, are more detrimental than beneficial to the pure development of talent. Something like this seems to be the case at Dresden. The models that have been established in the large portrait gallery there usually fall between the perfect and the imperfect; copying them repeatedly causes the mind to stop and hesitate at a time when capabilities and insights are being increased.

Perhaps the editors of the *Pirnäischen deutschen Kunstblätter*,[7] who have already given examples of the insight, impartiality and courage, will bring us sometime

[5] [Mengs's collection of plaster casts, one of the finest of the time, was installed in the Japanese Palace, Dresden, in 1782.]

[6] [A vigorous retort in defense of the portrait, written by Johann Gottfried Schadow, the Prussian court sculptor, came immediately from Berlin and was published in Ignaz Fessler's magazine, *Eunomia*.]

[7] [This magazine, *Das deutschen Kunstblätter*, was published at Dresden and nearby Pirna in 1800–1.]

an exact description of that situation. That way, in our opinion, the older artist, as a cultivated, developed individual, would be treated with respect and his works would be compared with his previous accomplishments, and the younger artist, without being indulged, would be directed toward the higher, more universal demands of art.

While in Dresden the presence and plenitude of great works of art bind the artists' minds; in Leipzig the opposite situation seems to do the same thing. Since the artists and friends of art no longer have access to the Winckler collection,[8] Oeser's works[9] are almost the only ones by which their taste is formed. This influence is apparent in the works that have come to us from Leipzig. This is not necessarily advantageous for art.

In Vienna also the historical appears to reign instead of the poetic, the allegorical instead of the symbolic, and, in general, a certain easy manner prevails. Even in works of the better, more famous artists we often noticed too many caprices, too little strict observation of the rules, too much neglect of the scientific; more the intent to please the eye than to satisfy the intellect.

It would be desirable for the younger artists to practice with old, serious, carefully finished models; with these they have the lesser danger of falling into hardness or dryness than into the loose or characterless.

We will gladly accept and use corrective and informative data concerning the present condition of German art as well as news about its progress.

[8] [The famous collection of the Leipzig merchant, Gottfried Winckler, was dispersed after his death in 1795.]

[9] [Adam F. Oeser, landscapist and Goethe's teacher, came often to Weimar to paint scenery for the theater.]

1803

PARIS: The Museum Exhibition

On his thirty-fourth birthday, the First Consul's carriage stopped before the Louvre. As he approached, Napoleon read the inscription above the portal: Musée Napoléon. With the director general, Baron Vivant Denon, lean, dark and twenty-two years his senior, Napoleon entered the museum. The palace of the Louvre had been designated the Musée central des arts by a decree of the legislative assembly on September 16, 1793. The paintings, statues and furniture of the French kings, the collections of the Académie royale de peinture et de sculpture, and the paintings left by the aristocracy were gathered in its Grande Galerie.

To this artistic inheritance that had come as a result of the Revolution had been added the trophies of conquest won by the prowess of the French soldiers. On November 17, 1800 (16 Brumaire, An IX, according to the revolutionary calendar), Napoleon had inaugurated the galleries of Greek and Roman art installed on the ground floor by Ennius Quirinus Visconti, once director of the Museo Capitolino in Rome. Visconti had accompanied to Paris the statues taken from this museum and the Museo Pio-Clementino in the Vatican.

In March 1802, Napoleon ascended a commodious staircase to enter the large Salon Carré and opened the greatest exhibition of art ever assembled in Europe. In the Salon Carré hung the finest paintings of the Italian school, works ceded to France by the Duke of Parma, by the Republic of Venice, and by Pope Pius VI, after Napoleon's victorious Italian campaign. The Grande Galerie, which adjoins the Salon Carré and extends the entire length of the south side of the Louvre, was hung with the

paintings of the great masters of countries the French army had defeated. The Flemish, Dutch and Italian schools had been added to those of the French school. Denon had arranged the paintings in chronological order and according to schools (an innovative departure from the usual method of the period, according to which paintings were hung in a haphazard jumble of artists and styles) and observed contemporary practice only in hanging the pictures close together. As the catalogue stated: "This method has the advantage of facilitating a comparison of school to school, master to master, and of master with himself."

The opening of the museum coincided with the Peace of Amiens, March 25, 1802, and with the frontiers open, art lovers, literati and the curious from Germany and England came to Paris, eager to see the exhibition of art treasures from all Europe and what changes the Revolution had caused. At the Musée Napoléon, visitors saw for the first time pictures and statues removed from the locations for which they had, in most instances, been executed. Even those already familiar with the paintings in former locations mentioned the concentration required to assimilate the wealth of visual material gathered in one place. Goethe voiced his concern in his introduction to the *Propyläen* in 1798:

> For the education of the artist, for the pleasure of the art patron, where works of art are to be found has never been of great importance. There was a time when, with few exceptions, works of art remained generally in the same location and place. However, now a great change has occurred that, in general as well as specifically, will have important consequences for art. Perhaps there is more cause than ever before to realize that Italy as it existed until recently was a great art entity. Were it possible to give a general survey, it could then be demonstrated what the world has now lost when so many parts have been torn from this immense and ancient totality. What has been destroyed by the removal of these parts will

remain forever a secret. Only after some years will
it be possible to have a conception of that new art
entity which is being formed in Paris. The way in
which an artist and an art devotee will use France
and Italy will become clearer. . . .

Martin Archer Schee was only one of the many English
artists and writers who journeyed to Paris; some of these
left their impressions, among them Benjamin West, John
Henry Fuseli, John Flaxman, and Opie. Among the nu-
merous visitors from the German states were Johann
Friedrich Reichardt, the writer and aesthetician Frie-
drich von Schlegel and his wife Dorothy Mendelsohn, the
Cologne merchants and collectors Melchior and Sulpiz
Boisserée, and the popular playwright August von Kotze-
bue. Born in Weimar and trained in law, Kotzebue
entered the Russian civil service. He had begun to write
plays as a boy—one had received Goethe's favorable com-
ment—and many of the two hundred plays he wrote
enjoyed prolonged popularity both in their original Ger-
man and in translation. His two most popular plays,
Menschenhass und Reue (*Misanthropy and Repentance*
or *The Stranger;* 1788) and *Das Kinde der Liebe* (*The
Child of Love, The Natural Son,* or *Lovers' Vows;* 1788),
piqued audiences with their treatments of adultery and
illegitimacy, prevalent in society but ignored in literature.
Kotzebue's autobiographical, confessional travel books,
written in the style of Jean Jacques Rousseau, laughed at
the pretensions of art connoisseurs and were also popular.
After his return from Russia, Kotzebue spent a brief period
in Weimar and then moved to Berlin, where he lived
from 1802 to 1806. His residence there was broken by
travel to France and Italy which resulted in two books:
Erinnerungen aus Paris im Jahr 1804 (*Travels from Berlin
through Switzerland, to Paris in the year 1804;* 1804) and
*Erinnerungen von einer Reise aus Leifland nach Rom und
Neapel 1805* (*Travels through Italy in 1804 and 1805;*
1805).

Kotzebue's lively account of Paris in 1803 included a de-

scription of the art in the Musée Napoléon. As he was nei-
ther a classicist nor an adherent of the newly emergent
romanticism, formal aesthetic theories or values did not
enter into his judgments, except in his demand that the
subject matter be appropriate to representation in the fine
arts. He was not unsophisticated; he had spent a month in
Paris in 1790, had served as director of the German theater
in St. Petersburg, wrote for the Burgtheater in Vienna,
and was possibly Europe's most successful playwright. His
attention was aroused by a natural interest in the character
and personalities depicted and the episodes illustrated in
the art exhibited. His non-partisan and journalistic re-
sponse to the works reflected accurately the wider public
taste of his time.

The frank naturalism and flippancy of his plays and the
lack of philosophic or aesthetic principles in his writing
earned Kotzebue the criticism of the romantic writers,
Ludwig Tieck, Friedrich von Hardenberg (Novalis), and
the Schlegel brothers, who were grouped at the time in
Jena, as well as that of Goethe and his classical circle at
Weimar. While in Weimar, Kotzebue warred with both
literary camps—each committed in its different way to
regard art as a vehicle for the elevation of mankind.

His gift for satire and mockery eventually cost Kotzebue
his life. In 1815 he provided the Russians with secret re-
ports on political trends in Germany. His activity became
known, and he was accused of espionage. The established
literary circles seized the opportunity to vent their pent-up
irritation and aroused a general, widespread antagonism
toward him, especially among the students organized in
the Burschenschaft to press for political reforms denied by
the Confederation of German States after Napoleon's de-
feat. Kotzebue's mocking slurs in his successful journal *Li-
terarisches Wochenblatt* against students' abuse of aca-
demic liberty to further political rather than scholarly
ends enraged Karl Sand, a University of Jena theology stu-
dent, and Sand's companions in the Burschenschaft. Sand
went to Kotzebue's home in Mannheim, stabbed the
writer and then himself in an attempted suicide. Kot-

zebue's assassination resulted in the repression of academic
and civil liberties in the German states and Austria where
the fear of a resurgence of revolutionary nationalism was
still strong among the heads of state.

The exhibition in the Musée Napoléon which Kotzebue
reviewed with such verve in 1803 was the most compre-
hensive ever assembled, and it was augmented further
after each conquest of a European state. Its apogee was
reached in 1810 when, after the bridal procession had
passed through the Grande Galerie, the religious marriage
of Napoleon and Marie Louise of Austria was celebrated
in the Salon Carré. On view for over ten years and seen by
hundreds of people, the exhibition marked a change in the
relationship of the art object to society and in the role art
would play in society. In spite of the eventual restitution
of the works to their countries of origin, the former associ-
ation of an art object with a specific location had been
broken, and the art work came increasingly to be consid-
ered as an object *per se*. The possession of art had been
identified with national prowess and superiority. The need
to assert national superiority in the arts affected the Salon
exhibitions which, after Napoleon's trophies were returned
to the victors of the Battle of Waterloo, became the
greatest art exhibitions in Europe, a position they held
until they were relegated to second place by the inaugura-
tion in 1851 of the International Fine Arts Exhibitions
held in connection with the world expositions.

August von Kotzebue, Musée Napoléon[1]

I. Painting Gallery.[2]
Before I write one word about this, the richest treasury

[1] [Translated from *Erinnerungen aus Paris im Jahr 1804, Kot-
zebue Schriften* (Wien, 1843), Vol. XI, pp. 169–93.]
[2] [The Grande Galerie reopened in 1801, though sections
closed between 1804 and 1810 when skylights were installed.]

of art in the entire world, I must come to an under-
standing with the readers about what they should expect
from my description. I must, that is to say, make the sad
confession that I am so unfortunate as to bring to all
works of art my emotions, indeed first of all, always my
emotions. I know quite well and have often heard from
our mighty new school that a work of art may not and
does not have to play upon the emotions; that it is a
wretched clumsy piece of work as soon as it does so; that
it should not imitate or indeed rival nature, because it is
then unbearably vulgar; that it does not matter at all what
theme is depicted, and so forth. I am so unfortunate as to
hear all these beautiful and manifest truths with one ear
and to let them pass out the other. I do not ask ahead of
time: Whom is the picture by? Is it also old enough that
one dares praise it enthusiastically? Is there no defect at
all in the drawing? Also, I never ask: What impression
should the picture *not* make? Rather I ask: What impres-
sion does it make? because I am so obstinate as to imagine
that the painter has painted it to produce this or that im-
pression upon the spectator. Since all these defects cling
to my inelegant nature, the reader should expect no judg-
ments of art from me. I want to, and will, do nothing else
but recount what I saw and what emotions were aroused
in me by what I saw. Therefore, I will often dwell upon
subjects which may seem secondary to many, and will slip
past other subjects over which many raise a great hue and
cry. Quite deliberately I take along with me none of those
cursed connoisseurs with two lorgnettes in front of their
eyes, who know of nothing better to do than to spoil every
pleasure for the ingenuous visitor, or, on the other hand,
to force him to enjoy that which only sublime revelations
make them receptive to. The only thing that consoles me
a bit in my sinful simplicity is Lessing's phrase in *Emilia
Galotti*: "Away with him who waits to learn from the
painter what is beautiful." Indeed, the good Lessing these
days would also have no great luck with his works of art,

for he would have to learn from *Lacrymas* how he should have written his *Nathan.*[3]

Enough by way of introduction. The apostles of art and the snobs might just as well skip the whole chapter.

We step into the first hall: it contains the fruits of conquest reaped from Venice, Florence, Naples, Turin and Bologna. A scene showing the expiation of a transgression committed unintentionally by St. Julian [by Cristofano Allori, from the Pitti Palace] captivates the imagination. The poor man had the misfortune to murder his mother and father, because he found them in his bed and believed them to be his wife and her lover. As a penance for the sin, he went with his wife to a mighty river that was extremely dangerous to cross, and on its bank established a hospital for the poor and needy. . . .

A *Holy Family* by Andrea del Sarto is ineffably charming; but one sinks into sadness with a kneeling figure (by the Roman [Domenico] Feti) [of *Melancholy*]. Its gaze, which rests upon a skull, says very clearly: "I have lost all!"

The *Abduction of Helen*, by Guido Reni, is a beautiful but comical picture. Is it imaginable that in the case of a hasty abduction the sweetheart would think of all her valuables and even her pet dog? Also, while in ordinary life it might perhaps happen that the chambermaid is prettier by far than her mistress, Guido Reni still should have been wary of this in his picture. Those who consider the subject of a work of art irrelevant may marvel at Murillo's *Beggar*, who is delousing himself. I turn my back on him and smile as I pass a *Holy Family* by the same painter [both from the royal collections], in which the child Jesus is playing with a rosary. My smile gives way to deep seriousness, however, when my eye fixes upon that beautiful picture of Charles I, the beheaded king of England. A

[3] ["*La commedia lacrimosa*," a type of drama initiated by Nivelle de la Chaussée, enjoyed success in the eighteenth century. Lessing considered it in *Abhandlungen von dem weinerlichen der rührenden Lustspiel*, Theatralische Bibliothek I, 1754.]

Dutchman, Mytens,[4] painted him at the age of twenty-
seven. This picture does indeed make an even stranger im-
pression in Paris than it may have in Turin, where it was
acquired by conquest. The *Marriage at Cana* by Paolo
Veronese is in many respects noteworthy. First, because it
is probably one of the largest paintings in the world;
secondly, because the painter incorporated many portraits
of renowned and unrenowned persons of his time into the
work. The bridegroom, for example, is a certain Marquis
of Guasto; the bride is the wife of Francis I; next to her
sits Francis himself, and next to him, Queen Mary of Eng-
land. Then follows the Turkish Emperor Suleiman II,
even, and then a woman with a toothpick, the wife of the
Marquis of Pescara. The Emperor Charles V has a some-
what uncomfortable seat at the corner of the table and is
therefore seen only in profile. Several cardinals and monks,
friends of the painter, sit or stand. Finally, the choir of
musicians is very interesting; among them Veronese de-
picted the most famous Venetian painters of his time: he
himself is playing a violoncello. The violations of chro-
nology are very droll. The musicians are playing from
notes, Charles V boasts the Order of the Golden Fleece,
and so on. The painting previously decorated the refectory
of Giorgio [Maggiore] in Venice, and the artist received
for it less than a single good portrait often costs these
days—namely, not more than ninety ducats.

A picture by Rubens, in which he depicted himself and
his best and most famous friends, accords great delight.
Here is Hugo Grotius, the trusty philosopher, with the
dog he loved. Next to him is Justus Lipsius, the famous
professor at Louvain; the bust of Seneca behind him refers
perhaps to his writings about Stoicism, just as the tulips
are supposed to indicate that during his leisure hours he
zealously cultivated these flowers, which were new at the
time. The great painter himself and his brother [Philip]
round out this interesting group. Not far away, however,
hangs a repulsive painting by Sebastiano del Piombo,

[4] [Daniel Mytens was named painter to Charles I in 1625.
The portrait was in the royal collections of Savoy at Turin.]

namely the *St. Agatha* [taken from the Pitti Palace]. She, who may have been very pretty, has rejected the love of a governor of Sicily, and as punishment, her nipples are being pinched loose from her fair bosom with pliers. How can the sublimest art afford pleasure with such subjects? I step into the actual gallery. It is no less than four hundred paces long, and is supposed to be lengthened very soon by a few hundred more, for the wooden partition at the end of the gallery conceals yet another long extension jammed with paintings which lean against each other on the walls. They have not yet been arranged or restored. . . .

There is a large collection of Van Dyck's lively pictures here, and there is not a one among them which does not confirm his fame. I particularly like an *ex voto* in which those making the vow, a man and wife, kneel before the Holy Virgin, and the child Jesus receives them in a divine friendly manner. Divine, did I say? No, in a manner a bit earthly, for the little Christ deigns to stroke the man's beard.

There hangs a portrait painted by a German by the name of Faes, a good likeness, it is said. Who would, however, chance to seek the Protector Cromwell in this physiognomy? Either Holbein or nature has delivered much more legibly the countenance of the chancellor Thomas More. I could believe of this man that he calmly bent his neck under the ax. Everyone will enjoy, as I did, another pair of pictures by Holbein, a young woman with a veil, her hands folded across her knees, and Erasmus, author of *Praise of Folly*. To turn that enjoyment into hearty laughter, let one step in front of the *Bean Festival* (*Fête des Rois*) by Jordaens. All the guests gaze laughingly at the drinking bean king, and one cannot look at it for a minute without laughing with them. I found Lairesse's *Hercules between Voluptuousness and Virtue* very unsatisfactory; and a fat Venus in Flemish costume with beautiful large earrings by Rembrandt very comical. Indeed, if a pair of wings had not been glued to the youth standing in front of her, not a soul would guess that he

was supposed to represent a Cupid. Thank heaven for the magnificent family picture [of the artist's relations] by the less famous [Adriaen] Ostade. I would give up three such Rembrandt Venuses for it.

[Gerhard] Terborch has treated a somewhat frivolous scene very dramatically. A fat soldier, a jovial drinking companion, offers money to a girl who, although her eyes are indeed lowered in shame, does not refuse the money. The portrait of an old house steward from the Painters' Academy at Antwerp by Cornelis de Vos has an overpowering reality; and the *Micheline* [*St. Micheline of Pesaro Kneeling on Mount Calvary*] by Barocci, of ineffable charm. If this beautiful pilgrim really looked like this her saintliness probably had great difficulty in protecting her from profane love. Again the *Martyrdom of Sts. Placida and Flavia* by Correggio is all the more shocking. God! What a base wench this St. Flavia is here. It is quite natural that the Saracens, who were otherwise not exactly cruel to the fair sex, treated this example of the same so impolitely. *God's Curse on Our First Parents* by Domenichino arouses laughter instead of awe. A large crowd of angels carry the dear Lord among the clouds. He would surely fall if the angels were not using their hands to support Him everywhere, especially under the *posteriora*. Again, *The Slaughter of the Innocents* is one of those subjects before which not even Guido Reni's name can detain me. Furthermore, this otherwise great painter has betrayed very scanty knowledge of a mother's heart and failed to take full advantage of his subject. The mothers do nothing but implore and scream; not one entreats, not one offers resistance. The last fact especially should not be overlooked since even the weakest hen protects her brood against an eagle. I remember seeing—in Vienna, I believe, in the princely gallery of Lichtenstein—a painting of the same atrocity, by what master I no longer know. It was far more correctly conceived than this one. The hand of a despairing mother whose child had just been pierced tore to pieces the cheek of the murderer. It was horribly beautiful and real. Whoever has seen David's famous painting,

The Battle of the Romans and the Sabines, should also take a look at Guercino's treatment of the same story. One sees at first glance that the latter was no poet at all. Who, indeed, can ever become a great painter without being a poet? If one mentally compares the two pictures, it seems as if our "opera smith" V———s⁵ had wanted also to write a *Wallenstein. The Return of the Prodigal Son* by Spada has a great attraction for me; especially the figure of the son, this living picture of fault and contrition. Two feminine portraits by Leonardo da Vinci grip me irresistibly. One represents the unfortunate Anne Boleyn and is interesting more because of the fate of the original than because of the art. The other is Lisa, wife of a Florentine nobleman [Zenobi del Giocando]. If Heaven should ever again need a Holy Virgin, it could choose no other figure for the purpose than this one. Two youths by Raphael,⁶ both pensive, are excellent and gave me a far more exalted impression of this great master than his St. Michael conquering the devil. I end with Guercino's *Mars, Venus and Cupid,* in which the latter, mischievously threatening, is about to loose his arrow, while the beguiled spectator waits for the arrow to strike his heart at any second but cannot make up his mind to dodge the shaft.

That is approximately all that gave me particular delight. "What?" I hear asked. "Not one word about Rubens, who is represented here by more than fifty pictures? Not a word about [Claude Joseph] Vernet's landscapes stolen from nature? Nothing about the twenty-five [Francesco] Albanis and the just as many Annibale Carraccis? Not even a syllable about Domenichino's famous *Communion of St. Jerome,* and so forth?" Nothing about all that. I have already confessed my weakness. Whatever I view with purely artistic sensitivity, and, if one will, also marvel at, does not settle into my memory. I can recount nothing of it. *The Descent from the Cross,*⁷

⁵ [Unknown.]

⁶ [Today one is attributed to Franciabigio.]

⁷ [A fresco from S. Trinità de' Monti by Daniele da Volterra removed by Denon.]

for example, is highly praised; indeed, I also find it extraordinarily beautiful, but I can never forget that a descent from the gallows is not at all a subject for the fine arts. I feel the same about odious martyrs, with whom this gallery likewise swarms. Such a roasted, basted or flayed saint, even if the Dear Lord Himself had painted him, is to me an unbearable work of art which I pass quickly by.

As far as landscapes are concerned, there again I cherish my own heresy. Indeed, painted landscapes are much dearer to me than ones described, and [Claude Joseph] Vernet and [Jakob] Hackert, by whom there is nothing [exhibited] there, often transport me to astonished admiration, but no picture remains in my soul unless the landscape is enlivened by a historical event, for I find historical painting to be at once the loftiest and the unequaled in this art! . . .

III. Gallery of Ancient Art, Statues, Busts, Bas-reliefs.

I will end as I began: that is, I will communicate my feelings as well as I can to the reader and in doing so forbid no one to have other feelings or indeed none at all. On entering this gallery of antique art, my emotions, though faint, resembled those I am accustomed to when I stand under a clear, starry sky. Suddenly, with a feeling of awe and its compelling emotional response, one stands among two hundred and fifty of the most splendid monuments of Greek and Roman antiquity. One hall is dedicated to the emperors, another to famous men, this one to Laocoön, that one to Apollo, and a third to the Muses, because the splendid representatives of the beings named are its most distinguished ornaments.

I intend to comment as I stroll about. There stands a magnificent *Diana* of Parian marble, which has been in France since the time of Henry IV and was once the only great work of art that France possessed. She seems angry and reaches for an arrow to guard a deer which takes refuge under her bow. It is claimed that a certain family likeness exists between her and her brother, *Apollo Belvedere*. I proceed to a statue of *Julian the Apostate* and tarry

longer in front of it than before the *Diana*, in spite of the danger of being laughed at by the connoisseurs. The *Diana* appeals only to my imagination, this appeals to my spirit. Hail to you, grand hero, oft misunderstood and branded with a spiteful name by fanatical Christians! Your virtues, your philosophy, your misfortune have raised you for eternity to be an object of honor for every unbiased man. . . .

I found a *Faun Resting* especially noteworthy, since it was excavated from a villa of the good Marcus Aurelius, who probably often delighted in it. It has also very high artistic value, since it is believed with good reason that it is a marble copy of the bronze *Faun* of Praxiteles, which was so famous throughout Greece that it was known simply as *periboëtos*, the famous one. . . .

I gladly confess that the contents of the Hall of Famous Men interested me much more than all the statues of gods and goddesses. Here one finds *Zeno*, the leader of the Stoics, and *Demosthenes*, the prince of orators. Seated, the latter unrolls a scroll upon his knees and seems to be lost in deep thought. One can recognize the very inward arched upper lip which was probably the natural defect that hindered him from speaking clearly. . . .

. . . The so-called *Dying Gladiator* (more exactly a non-Roman warrior or barbarian, perhaps a German or a Gaul, expiring upon the field of battle) is well known through thousands of copies and imitations. It is one of those works which make no impression on me. I would also like to admit as much about the famous *Belvedere Torso* and therewith unburden my conscience of a heavy guilt.

Most charming of all is the *Faun with the Metal Spot*. His joyous laughter is contagious and his youthful ingenuousness most expressive. One cheek and shoulder have a metallic shine, which gives him his name. . . .

It is indeed strange that, even if one does not immediately feel inclined to admiration and blind adherence, one still retains a certain shyness about voicing an opinion against that of the crowd. This is exactly how I feel in regard to the *Venus de' Medici* and the *Laocoön and His*

Two Sons. How can I help it if this Venus strikes me as a rather pretty chambermaid who has been surprised by the young master of the house in a state of extreme *deshabille* and seeks, if not very seriously, to evade his lascivious gaze? She has pierced ears and probably once sported magnificent earrings, just as the mark on her left arm clearly indicates she once wore a bracelet called a *spinthor*. It is said that they wish to restore these ornaments to her in order to imitate the taste of the ancients, who liked to mix gold and marble. That would not be my taste. The artist who created this Venus is said to have been named Cleomenes and to have been very fortunate in the representation of beautiful women: so much so that Pliny even related that a Roman knight fell mortally in love with one of his statues. How can I help it if the Laocoön has an effect upon me similar to that of the man-eater of the Berka (a village near Weimar), when in my youth I saw him stretched on the rack?

"Art, sublime art!" All due respect to art, since I did not come here to study anatomy, I pass on without disturbing anyone in his belief. Only permit me to have my own view, which unswervingly consists of the belief that the fine arts must also treat fine subjects and that, just as a presentation of Gerstenberg's excellent *Ugolino*[8] would afford little pleasure on the stage, neither would the *Laocoön* with its horrid serpents. In order to turn my imagination away from it, I linger in front of the statue of this beautiful youth who is named *Paris* because a restorer placed an apple in his hand. . . .

But stop! I am standing in front of *Apollo Belvedere* and this time I kneel down willingly and join my astonishment and my admiration to that of the experts and non-experts. Yes, his hastening foot has reached the serpent Python, the death-dealing arrow has already flown from the bow, every limb still shows the effort; indignation is enthroned upon his lip, but the confidence of victory and the satisfaction of having freed Delphi from that monster

[8] [Heinrich von Gerstenberg (1737–1823), poet and writer published *Ugolino* in 1768.]

are in his eye. The light locks curl around his neck or struggle out from under his divine headband. The quiver hangs from a strap over his right shoulder, and rich sandals decorate his feet. The *chlamys*, thrown back, reveals every part of his godlike figure. Eternal youth, nobility, suppleness, strength and grace; those are the elements which compose it. Yes, I willingly bend my knee; I only regret, along with many others, that the installation of this marvelous work of art does not permit it to be observed from all sides. In compensation, however, one reads a nice new inscription which says: "This Apollo was found at the end of the fifteenth century at Antium, installed by Julius II in the Vatican at the beginning of the sixteenth century, acquired through conquest by Bonaparte in the year V of the Republic, and in the year VIII, in the first of his consulate, brought here." The names of the three consuls[9] and that of the Minister of the Interior, Lucien Bonaparte, are inscribed on the reverse side.

I would almost like to say nothing more, for once the sun is present, one no longer sees the stars. . . .

[9] [Bonaparte, Premier Consul; Carnbaceres, Second Consul; Lebrun, Third Consul.]

1806—10

PARIS: The Official Exhibition of the State

The crowd going to the opening of the Salon stepped gingerly, for the area along the north side of the Tuileries—where the Convention had met from May 10, 1793, to November 4, 1796, and which had become in 1800 the residence of Napoleon, the First Consul—was under construction for the Rue de Rivoli. The people on their way to the Louvre, now designated as the Musée Napoléon, glanced up at the Arc de Triomphe du Carrousel, completed in 1808 to commemorate the victories of 1805. A smaller imitation of the Arch of Septimius Severus in Rome, it was crowned with the ancient bronze Quadriga brought as a trophy of war from the portal of St. Mark's in Venice. The great bronze lion of St. Mark's had been placed on a column before Les Invalides. The masonry shaft of the Colonne Vendôme (1806–10) commemorating victories over the Austrians and Russians in 1805 awaited its sheathing of bronze secured from melting down the cannons of the vanquished. The column filled the site of an equestrian statue of Louis XIV.

In the warmth of August, the women wore light muslin dresses with low-cut bodices, high waists and short gathered sleeves and plain, flat-soled shoes. The style, originally derived from the English chemise, was named "Grecian" and, with the drawstring tied tight beneath the breast, the light material showed off to advantage the form it covered. The most fashionable wore dresses with skirts so narrow that walking was difficult. Of the men walking with them, some wore the new pantaloons, long enough to cover the tops of their English boots, while others retained

the traditional knee breeches. But all wore double-breasted coats with high collars and long tails. They carried round hats and many wore their hair *au coup de vent*, or *à la Titus*, as the style was also called: short at the back and brushed to the eyes in front, a fashion that became popular in 1806.

Parisians who went to the Salons in the years 1806, 1808 and 1810 enjoyed a sense of security and prosperity. The Peace of Amiens of 1802 had been advantageous to the French. In December 1804, Napoleon had crowned himself Emperor of the French in the presence of Pope Pius VII in Notre Dame de Paris. Successive campaigns made Paris the capital of a Grand Empire envisioned as a European federation. Napoleon believed the continental blockade he imposed in 1806, after Prussia had been quickly defeated, would force England to acknowledge French suzerainty. The 1807 Treaty of Tilsit established a truce with Russia. In the countries where French troops were quartered, there was resistance to the French language and to French administrators in office. French fashions were censured as indecent by the Pope and were banned in conservative courts, but they were very popular with liberals.

The Emperor had also brought order within France. The Napoleonic Code of 1804, granting all men equality before the law, and the regulation and codification of taxes had realized some of the hopes of the Revolution. Encouragement had been given to industry and the French economy recovered from the ravages of a decade of instability.

In 1803, Napoleon had also reorganized L'Institut National de France, renaming it L'Institut Impérial de France. The membership of the Section of Fine Arts was increased: four more members were added to the six in the painting division and Visconti and Denon were among the four named to the office. The reforms changed also the election procedures of the Institute: ratification by Napoleon was required for membership in addition to the vote of the members. The Section of Fine Arts was, however, given complete control over the selection and jurying

of the Salon, now held biennially. David, named first
painter to the First Consul in 1800, was occupied with
huge canvases glorifying the festivals of Napoleon's reign,
and Antoine Jean Gros was commissioned to paint scenes
from the Emperor's battles and campaigns. In these and
the many portraits of the Emperor painted by a number
of artists, Napoleon's courage and heroism were recorded
on canvas, and all these paintings were placed before the
public at the Salons.

Jean Baptiste Publicola Chaussard's (1766–1823) criti-
cism of the Salon of 1806 reflected the continuance of
revolutionary thought and neoclassic principles. Like David,
Chaussard had participated actively in the Revolution. In
1787, as an aspiring writer, he had competed for admis-
sion to the French Academy with an ode to the Duke of
Brunswick, a benevolent despot admired by the liberals. In
1789 he had praised the National Assembly in *Théorie des
lois criminelles* and argued, in an *Essai philosophique sur
la dignité des arts*, that through encouragement, which
would not abrogate artists' freedom, it was possible to use
the arts to control public values. When the Belgians
revolted in 1792 and an independent Belgium seemed
likely, Chaussard, as a Jacobin, was sent to Belgium as
commissioner for the Executive Council. Returning to
Paris in 1794, after the French were driven from Belgium
by the Austrians, he was named secretary general of the
Committee of Public Instruction, which supported Da-
vid's campaign against the Academy in the Convention
and played an important part in planning festivals and
competitions for monuments which would encourage pub-
lic patriotism.

Chaussard's review of the Salon of 1806, which in-
cluded a *"Notice historique et inédite sur Louis David,"*
reflects the sensitivity and taste of a member of the intel-
lectual revolutionary class. His judgments are based on the
philosophical concepts of the Revolution and the neoclas-
sical demand for naturalism, subjective presentation of
sublime themes combined with the disciplined restraint of
the ancient Stoics—all qualities which were embodied in

David's *The Battle of the Romans and the Sabines* of 1799. Chaussard's reaction to Girodet's *Scene from the Deluge*—a painting which reflected a strong interest in Michelangelo unusual in France at this time and, perhaps, the influence of the English artist, Fuseli—was the reaction of a classicist to a proto-romantic lack of restraint. The critic's values were to be overturned: in the category of history painting in the contest for the Academy's Prix Décenneaux, *The Battle of the Romans and the Sabines* was placed beneath *Scene from the Deluge*.

Chaussard's criticism of Ingres as "Gothic" and his comparison of the artist's work with that of Jean de Bruges—with which the critic was familiar because of his stay in Flanders—expressed the critic's doubts about another proto-romantic tendency to be seen at the Salon during these years: a resurgence of medieval and Christian subjects that had been possible after the Concordat of 1801 and was encouraged further by the Empress Josephine's preference for the *style troubadour*. Chaussard's criticism caused the artist much consternation. When Ingres heard of it, he wrote from Rome—where he had gone in 1806 as a *pensionnaire* of the L'Institut Impérial, having won the Prix de Rome in 1801—expressing his dismay:

> Senseless men, it is you who cannot walk straight. I don't know where they got their idea of citing Jean de Bruges, as if my works were meant to follow those of that painter. I esteem Jean de Bruges very much, I should be glad to resemble him in many ways; but still he is not my painter, and I imagine that he was cited at random.

Two months later he added:

> The only advice I want is the kind I can give myself. With their talk about Gothic, senseless creatures that they are, they are referring to what possesses true character; it is not possible that in one day I have become Gothic; I say, rather, it is comparison with their feeble and cowardly painting on the walls round

about that has caused error about my work in the
minds of men who have some title to judgment; it is
the contrast which makes them regard as Gothic what
is severe and noble. . . . Something Gothic in Mad-
ame Rivière's portrait, or that of her daughter! I lose
the connection when I hear such talk—I don't know
what they mean.

Chaussard's criticism did not meet the needs of all who
were going to the Salons during these years. In Paris a
greatly increased number of civil servants and the newly
formed middle class desirous to be as familiar with the na-
tional trends in painting and sculpture as with those in
the music halls, theaters or fashions, frequented the Salon.
To meet the needs of this group who, as a result of the
political upheavals, could now aspire to an understanding
and appreciation of art that would lead to connoisseur-
ship, Charles Paul Landon (1760–1826) began in 1800
a prodigious career as art editor and publisher.

Landon had sufficient talent as a *peintre de genre* to
have won a Prix de Rome in 1792. During his five years of
residence in Rome he had acquired a wide knowledge of
classical art and considerable skill as an engraver, for he
studied with two of Europe's foremost engravers, Gio-
vanni Volpato and Tommaso Piroli. Landon commenced
an ambitious series of volumes called the *Annales du
musée et de l'école moderne des beaux-arts* in 1801. He
personally supervised the first series, which covered
selected paintings and sculpture in the Musée Napoléon,
Versailles and other museums, until 1812, after which the
series was continued under the supervision of Fabien
Pillet. Engravings illustrating the selected works were exe-
cuted by Landon, or under his supervision, and he wrote
the explanations. A second series of the *Annales* published
contemporaneously with the first dealt in a similar manner
with the Salons (*Salon de 1808: Recueil de pièces choisies
parmi les ouvrages de peinture et de sculpture exposés au
Louvre le 14 Octobre et autres productions nouvelles et*

*inédites de l'école française, gravés au trait, avec explica-
tion des sujets, un Examen général du Salon et des
Notices biographiques sur quelques artistes mort depuis la
dernière exposition,* Paris). The reader was provided with
an informative description of the selected work of art free
from aesthetic theories and moralizing or subjective reac-
tions. Engravings were included. Landon's volumes on the
individual Salons were the first of what might be called il-
lustrated catalogues rather than critical reviews: certain
auction catalogues were illustrated and the noted engraver
Gabriel de St. Aubin had provided sketches in the margin
of official catalogues of the Salons, but these remained un-
published in quantity. The engraved reproduction with
the accompanying descriptive text in Landon's *Salons* and
Annales removed the work of art from the ensemble of
the exhibition, and for the first time placed, as it were, an
illustrated art book on the coffee table—and in doing so
contributed to the autonomy of the single art object and
placed the spectator and the work in a new relationship.

Landon exercised influence in the literary and art world,
for he was also part owner and art critic for France's
oldest paper, the *Gazette de France* (1631–1913). The
paper was a royalist organ with a circulation in Landon's
day of eight to ten thousand. His other publishing ven-
tures included the multi-volume illustrated books, *Vies et
oeuvres des peintres les plus célèbres* (*A Collection of
Etchings from the most celebrated ancient and modern
productions in painting, sculpture, and architecture of the
French and Italian schools;* 1805–11) and *Grandes vues
pittoresques des principaux cités et monuments de la
Grèce et de la Sicile et des sept collines de Rome*
(1813). He also launched the short-lived *Journal des arts
et de la politique.* He continued to exhibit at the Salon
from 1791 to 1812, was a correspondent of the Section of
Fine Arts, served as painter to Charles, Duc de Berry, and
became curator of the gallery of the Duc de Berry's widow
and, later, of the paintings in the Louvre.

Pierre Jean Baptiste Publicola Chaussard, The French Pausanias, the State of the Pictorial Arts in France at the Beginning of the Nineteenth Century[1]

Salon of 1806: The present exhibition will become a milestone in the annals of art. New strides have been made. In the midst of several historical paintings, two, each according to its kind, show to what level the power of draftsmanship and color can be raised. The power of Michelangelo's draftsmanship seems to breathe in M. Girodet's scene, despite some faults, and the magic transparency of Rubens' color, mixed with the vivacity of Tintoretto's, animates and almost brings to life M. Gros's composition. Both have ventured beyond the well-traveled paths with both boldness and success.

Those who have not left the established routes continue their deliberate rate of progress.

Most remarkable is the absence of any system; no sort of school appears: each artist obeys his inner promptings and gives way to the particular genius which inspires him.

This variety is no less remarkable than the abundance and superiority of these new productions of the French school despite the fact that the Salon is bereft of many talents long recognized by the public. The Messieurs David, Vincent,[2] Regnault, Gérard, Guérin, Meynier, et cetera, have not exhibited. The quotation from Tacitus can be applied to them: *Eo magis apparebant quod desiderabantur.*

Even women dispute the honors here; the ranks of fe-

[1] [Translated from Pierre Jean Baptiste Publicola Chaussard, *Le Pausanias français, état des arts du dessin en France à l'ouverture du XIX^e siècle: Salon de 1806*, (Paris: F. Buisson, 1806), pp. 69–84, 114–21, 177–82.]

[2] There is a quick sketch of *The Battle of the Pyramids* by M. Vincent which is itself a handsome picture.

male artists seem to press forward and increase. Our interest is divided among them but focuses particularly on easel and genre paintings. If the French school shows itself today the worthy rival of the schools of Florence, Rome and Venice in the major concerns of painting, it does not seem to be inferior to the school of Holland in matters of finish and laborious perfection. To be convinced of this, it is sufficient to glance at the paintings of Richard and particularly those of Grobon.

But battles are the main concern of the brushes and are what we notice first. Truly, have we not found in the abundance of our military glory material to enrich all the arts? History, poetry, painting, sculpture, drama, architecture, all seem to be overflowing with Homeric themes.

The sight of these great themes elevates our spirits, and the foremost value of these representations is to create illustrious followers for the intrepid defenders of our country. The portrait of him who leads men into battle—or rather to victory—and from whose breast beams the flame of heroism has been multiplied by the brushes of the artists. He seems to be the deity of this temple of the arts and fills the surrounding area.

The first picture which seizes our attention—by its vast dimensions, by the interest of its subject, by the unusual skill of its execution—is exhibited under the number 241.

A *Cavalry Charge, led by General Murat, at the Battle of Aboukir in Egypt.* A painting 32 by 22 feet by M. Gros, a student of David. Explanation of the subject, given by the artist[3]: "This battle decided the memorable victory which the French army, led by Commander-in-Chief Bonaparte on the 7 *Thermidor*, year VII, won over the Turkish army, commanded by Kincei Mustapha, pasha of Romelie. . . ."

This picture is a beautiful page of history, or perhaps of an epic poem. Like the Greeks, the French have triumphed over the ancient Orient; it was thus that Homer gathered both Europe and Asia beneath the walls

[3] We always prefer in the interest of historical accuracy to use explanations given by the artists themselves.

of Ilium and showed us, in the words of Bossuet, the
calmness of superiority and enlightened values, on the one
side, and, on the other, brute rage, dumb ferocity, and
blind courage, as if he had wished to show us the triumph
of light and civilization over darkness and barbarity.

The artist, and this is his strongest quality, has pene-
trated deeply into this profound aspect of his subject. . . .

The foremost merit of this painting lies therefore in its
veracity, without which there can be no beauty. We recog-
nize this truthfulness in the difference in the characters'
plights and, above all, in the difference in their moral
characters. To seize these nuances is the mark of a think-
ing artist. . . .

We have heard artists exclaim at the sight of this paint-
ing: "What brush power!" In fact, one said to me, "This
picture sends us all back to school with its understanding
of color, or rather not to school: this is the coloring of na-
ture. Objects are not separated from each other by the op-
position of light and shadow. Shading and intermediate
tones are not even used: the brightest colors burst forth
next to each other from a vigorous background in which
the tones repel and work with one another simulta-
neously."

The artist has thus opened his own individual path in
this area of art. Doubtless this excess of strength is itself
an abuse, because great quality always verges on weakness;
but he must be praised for having taken on this task even
if he has pushed it too far, because he encounters no rivals
there.

In proceeding to examine the draftsmanship, despite
some unevenness, the forms are grand, characteristic and
firm. If in his color the artist often rivals Rubens, in his
drawing he seems to reproduce something of Julio Ro-
mano. . . .

The faults that we feel in this beautiful composition are
a matter of various parts, either of the action, or the color-
ing, or the perspective. Firstly, concerning the general ac-
tion: although the execution of the whole is really admira-
ble and done with the boldest brush strokes, although

groups are posed with the rapidity of thought, confusion is also found there. It is the weakness of a fiery imagination in which smoke mixes with the flame.

An extended cavalry corps naturally forms a large mass; here the mass seems to have melted: neither the eye nor the mind can locate the bodies of the horses and men whose heads alone can be seen.

In similar subjects the great masters usually drew first in their entirety on the canvas those figures that would later be covered by others. Let us not say that the confusion found here belongs to a melee: one can, one must paint a melee, disorder itself, in an orderly fashion. A little thought would convince this estimable artist of that. If he doubts it we invite him to consider thoughtfully the compositions of *The Passage of the Granique* and *The Battle of Arbelles* by LeBrun. He will discover that secret, that beautiful art of drawing a melee coherently. . . .

To conclude: all that is admirable in this painting is the fruit of genius, and even the faults come from an excess of this beautiful facility. Let us add that the merit is found in the most important aspects and the faults only in the accessories. This painting shows beauty of the first rank and things so perfect that despite the noticeable unevenness we are convinced that the artist has already come far and that he cannot help but go further still, for while time and thought can give him what he lacks, he already possesses genius, strength and warmth, which cannot be learned; in sum he is a born painter. . . .

No. 223: *Scene from the Deluge,* by M. Girodet, a student of David. A painting 14 feet, 4 inches in height by 11 feet, 6 inches in width, figures larger than life size. . . .

It will be with this work as with all works that are marked by extraordinary genius: neither enthusiasts nor detractors will be lukewarm in their opinions. But let us hasten to say and thus fix the limits of the controversy: all criticism will fall on the genre that the painter has chosen, and once the foregoing is agreed upon, all the praise will

be rightfully concentrated on the extraordinary merit of an execution which seems beyond the capabilities of the majority of painters of the present school.

Anyone who has never felt the frightening beauties, the horrible charm, of some of the scenes by Aeschylus, Dante, Shakespeare, Milton, Crébillon, Klopstock or Schiller will never appreciate either the compositions of Michelangelo or this one in which M. Girodet seems to have sought out and accumulated dramatic effects which are exaggerated beyond even the limits of terror.

Perhaps it is his responsibility, more than others', to watch carefully and see that principles are preserved—that is to say, that genres are not pushed beyond their limits—and to show, as the ancients did, a beauty without effort and an energy with calmness. Terror should never be exaggerated. The *Medusa*, the *Niobe*, *Laocoön* are the true models, and in departing from them we meet *Moses* or *The Last Judgment* by Michelangelo, but between the latter and the former, there is the same distance as between the poems of Lucian and Stace and those of Virgil and Homer.

We emphasize these judgments, because at a time when all the arts are tending to exaggeration and consequently to corruption, the masters of art should not be reinforcing this tendency. Drama and then melodrama have invaded the theaters; a poetic style has sprung up in prose, and prose has taken vengeance by flooding into poetry in its turn; a melancholy and shadowy literature has penetrated into novels. It seems that paralyzed brains can only be moved by violent and electrical shocks. Are the gentle tears of feeling dried up in the depths of withered hearts? Are we condemned to weep tears of blood? Montesquieu said: "You must skin a Muscovite to make him feel anything." Can the same be true of an Athenian or a Frenchman? This disastrous development resembles a Gothic invasion: all the boundaries between the arts seem to be broken down, and the temple itself sways on its foundations.

Whether one blames this effect on the march of time or

on the influence of the terrible scenes presented by a great revolution, painting itself, at least in a certain school, has multiplied tragic and even horrible subjects. Without doubt it is a means of acting powerfully on vulgar people, on that inert mass that a violent situation inflames like a strong drink; but this is a merit that would have to be shared with the writers of dramas, with the author of *Juge écorché par les ordres de Cambyse*, because the crowd is not capable of judging excellence of execution. It sees on the canvas, as elsewhere, only a spectacle. This, however, is whence the abuse of dramatic effects in painting leads.

I will repeat again, the great strength of the painter in question is entirely separate from this criticism, which falls only on the genre. Only the interests of art provide the motive for these judgments. The motto of an impartial observer is that of one of the ancients: *"Amicus Plato, magis amica Veritas."* . . .

The first time I went to the Salon, my eyes were drawn naturally to M. Girodet's handsome picture because everyone else was looking at it. I did not need the catalogue to recognize the sublime talent of this artist. He is the only one who could have developed that virile energy in composition, that purity of drawing, that admirable precision, that firmness of contour, that amplitude of the forms, that anatomical skill with which he has forcefully rendered the details according to the characteristics of the different ages. Finally it was impossible for me not to recognize Girodet's brush in that perfect execution of which he alone seems to have the secret. . . .

No. 272: *His Majesty the Emperor on His Throne*; painting 9 feet 3 inches by 13 feet 2 inches. This picture belongs to the legislature.

No. 273: Grouped under this same number are several portraits by M. Ingres, *pensionnaire* at the School of France in Rome, a student of David.

The artist has not given any explanation of these paintings.

Let us first consider the *Portrait of the Emperor.*

How—with so much talent, with such correct drafts-
manship, with such perfect precision—has M. Ingres man-
aged to paint a bad picture? It is because he wished to be
extraordinary, to be different. Doubtless it is bad always to
follow foot by foot the established paths, but one should
not be concerned only with the heights: there are keen
spirits who, like the goat, are only happy on cliffs. Wis-
dom consists in choosing a sure and easy path to arrive by,
and this is the path the great masters, aided by experience,
have marked. By leaving it one risks being lost and it was
thus, by a fervid passion for the extraordinary in archi-
tecture, that Borromini and Openore have wholly per-
verted the arts of design, despite the fact those inventors
of depraved taste had the masterpieces of antiquity and
Italy before their eyes. Here, in another way no less detes-
table because it is Gothic, M. Ingres strains to push art
back at least four centuries, to bring it back to its infancy,
to revive the manner of Jean de Bruges. But in that in-
fancy of art, there was at least naïveté and truth: the art-
ists did not paint that way on purpose; they could do no
better. If chance showed them nature in a happy manner
or advantageous form, they were quick to render it with
infinite patience as they had seen it. We often encounter
very realistic details in their works, but we consider them
coldly and without interest because they lack life, har-
mony and movement; because they are not inspiring, hav-
ing been painted without inspiration. Those painters did
not know what constituted the art of painting, did not
know the expression and the illusion or the effect, the
sublimity of composition, the magic of color, of shading,
of aerial perspective which deepens, which gives depth to
objects, submerges them, makes them stand out, advance,
withdraw, gives them solidity, and finally transforms a
planar surface into a realistic scene fertile with illusions.

Deprived of these means, painting is nothing more than
coloring a cold, flat silhouette.

We listened to what was being said around us at the
Salon and we observed that the feelings of art connois-
seurs agreed with those of the crowd. To begin with, first

impressions are unfavorable to this picture: people ex-
claimed over it, scoffing at its composition and organi-
zation. But later, when they went closer, the meticulous
finish, the exact detailing of the fabrics, and the cor-
rectness of the drawing were admired. Nevertheless, peo-
ple turned away discontented, regretting that the artist
had pursued such bizarre effects. In the first place, why
paint the Emperor full face: it is a most difficult thing to
do. The character of a great man—that heroic physiog-
nomy, his mobility of expression, that profundity of gen-
ius, those lightning gleams of inspiration—did this not
offer sufficient difficulty to surmount? Many artists have
found this to be true. This is not all; others would have
felt that the Emperor's clothing, which is very handsome
and very rich, needed to be developed as much as possible
because of the difficulty of rendering the foreshortening
under fabrics so heavy and stiff that they mask the forms.

M. Ingres believed he conquered these difficulties, but
his foreshortenings do not make themselves felt; the figure
finds itself packaged in fabric like those Italian Virgins
which, for all their being bundled up in gold brocades, vel-
vet and satins, are no better made than and do not equal
the marble ones which are embellished only by their sim-
plicity and the elegance of their chiseling. The throne is
heavy and massive; the hand that holds the scepter is not
well executed. The artist seems to have borrowed the pose,
like the other elements, from some Gothic medallion. As
for the Emperor's head, it is too big, a poor resemblance,
and inaccurately, overly pale in color. In spite of the me-
ticulous brushwork, fine finish and delicate fusing of the
tones, the head is dry in its execution, does not produce
an effect and remains flat on the canvas.

Even though M. Ingres has emphasized the color white
in his picture, it has not made it more harmonious; the
rapid changes between opposing hues, those hard or bro-
ken tones, tire the eye and spoil the effect.

In his *Portrait of Himself* the painter has not depicted
himself any more advantageously and he would have been
pardoned for flattering himself. When one has the advan-

tage of being an artist and being talented, why paint one-self in such an unfavorable way? Again, M. Ingres wished to do something extraordinary. You see a tanned head with black hair that stands out against a white canvas; a coat thrown over one shoulder, hiding its shape; a white handkerchief in his hand; to sum up, he uses a systematic opposition of black and white which produces an infinitely disagreeable discordance.

M. Ingres is at an age where the success of an entire lifetime often depends upon the course one follows. He is talented; he draws well; he has been the student of a great master. Let him follow his master's teachings without succumbing to the fires of a disorganized imagination, mistaking them for the fires of genius—which at his age one is tempted to do. Let him remember above all that in art one must either please or instruct and that conquering difficulties—virtuosity—brings only a sterile admiration which is soon forgotten and is of no use because it inspires nothing and often displeases. The principal aim of the arts is to move, to excite the passions through feeling and illusion, or to enchant and please, by the unity of the whole, by the harmony of the details, by the simple and accurate imitation of nature. Vanquishing difficulties—or virtuosity —rarely produces these effects. Those tormented, Baroque forms of the bad architecture and sculpture of Louis XV's era were also virtuosity; it was hard work to imagine and execute those bizarre designs and contorted forms: they resemble poets' acrostics and musicians' hemidemisemiquavers too closely.

The *Portrait of Mme. Rivière* seems to be better organized, better posed than the others. But the pose and organization do not suit a lady whom we know to be a model of grace and decency. She leans on a cushion; its brightness spoils the harmony, attracting the eye and overpowering the rest. The head and hands, although painted with care and with colors well fused, are pale, and the execution is still dry and flat. The right arm is too long, the hand badly drawn; the fine line of the nose has disappeared; the hair is heavy. The accessories are highly

finished: above all the shawl—too wrinkled and with skimpy folds—is rendered with an illusionary veracity.

Another *Portrait* included under No. 273 seems to be the best of M. Ingres's work. The subject must have inspired him. It shows a young and beautiful girl, Mme. Rivière's daughter, as fresh as a rosebud, who should have been painted by the brush of Correggio. The charming head stands out vigorously against a light background showing a misty landscape. The tonality is truer and more vigorous, but this figure is again clothed in white, and the green gloves, too bright, wound the eye. Yet this portrait is not so dry and the figure stands out better from the canvas and is better executed than those in M. Ingres's other works. Here we see that, instead of the extraordinary and different, the artist has studied nature and the great masters. The beauty of the head makes us sorry that the arms and hands are hidden by gloves.

Charles Paul Landon, Observations on the Salon of 1808[1]

The Salon has never been so rich or so well organized; today's vital school has never before shown itself with such splendor, even more glorious because it throws light upon a greater number of artists. Talent is no longer concentrated, as in some of the past exhibitions, in one or two painters who exclusively monopolize the tribute of esteem and admiration that the public likes to pay the most skillful, those who seem to hold with an unshakable hand the scepter of painting. But since a numerous group of artists has been visible carrying the graphic arts toward a state of splendor worthy of a golden age, we have seen the elite among them each in his turn obtain the foremost place. Do we not see, at each public exhibition, the rise of some

[1] [Translated from Charles P. Landon, *Salon de 1808, Annales de musée et de l'école moderne des beaux-arts,* 2nd coll. (Paris, 1808), pp. 28–31, 33–34, 37, 38, 52.]

painters whose success is greater than the hopes one might
have formed from their early work? Suddenly captivating
the attention of all, do they not seem to force into obliv-
ion those who have preceded them in this career, and
whom they expected to equal?

But this variation in success contributes basically to the
progress of art and the happiness of painters. It inspires
the more timid with a happy confidence in their own
strength; it warns others not to pride themselves too much
on their advantages; to still others it gives the hope of seiz-
ing again the palm that they have allowed to escape. It
consoles the self-esteem of those who in their luckier days
enjoyed too brief a glory; finally, it is for all a necessary
reason for modesty and emulation.

The catalogue of the exhibit of 1808 contains 864
items, some of which indicate a group of several objects. It
appears, then, that the Salon contains more than a thou-
sand objects of every type. At least three quarters belong
to the domain of painting. The rest are divided among
sculpture, engraving and architecture. The productions of
the latter are the least numerous.

The portrait class is the largest. Then come landscapes
and genre pictures. The class of historical painting,
though the least numerous of the three, is, however, the
most conspicuous because of the dimensions of the objects
of which it is composed.

In the catalogue there is a list of 410 exhibiting artists:
50 women are among them, some of whom have produced
works which would do honor to the proudest men.

In announcing a choice among the works in the Salon,
we have felt the impossibility of gathering into one vol-
ume all those who were worthy of publicity. . . .

Plates 1, 2, 3, 4: *The Coronation of Napoleon and
Josephine,* painting by David, First Painter to the Em-
peror.

The Coronation of Napoleon and Josephine: such is the
title given by the artist to this picture. In producing it
under this indeterminate title, David marks his intention

of depicting in one scene the two principal circumstances of this memorable ceremony. He has chosen the moment in which His Majesty the Emperor and King, having just placed on his own head the two crowns, removes one and prepares to place it on the head of his august spouse. The brilliant gathering of princes and of the powers of the Church around the head of the Empire—a silent scene, in which the pomp of religious ceremony and the majesty of the throne are displayed in all their splendor: what a magnificent picture rises in the mind's eye! For art, what an honorable and difficult task! No one could have missed feeling how a work of this importance would tax the care and effort of even the most skillful talent; let us say more: there is no artist who, in similar circumstances, having two painters of inimitable reputation as rivals, say, Paolo Veronese and Rubens, would not have expected to find severe or perhaps prejudiced judges. . . .

Plate 5: *Equestrian Portrait of His Majesty the King of Westphalia*, by M. Gros.[2]

It was a mistake to try to make a separate class out of portrait painters: those who have most distinguished themselves in the genre are the great historical painters. It is sufficient to cite some, such as Raphael, Titian, Rubens and Van Dyck. Are the majority of the historical subjects to be seen in the present exposition therefore only portraits placed in action? Yet they have all been entrusted to artists who are habitually occupied with compositions of the highest style.

If modern history does not offer to painters skilled in the study of nudes the occasion to show their skill as advantageously as do poetic or heroic subjects, it yet presents them with difficulties of another kind, which they should be proud to overcome: such as the likeness; the simplicity of the attitudes, from which they cannot wander without exaggeration; the accurate rendering of the costume; and

[2] [The king of Westphalia from 1807 to 1813 was Jérôme Bonaparte; Gros, a pupil of David, received a state commission to paint him.]

finally, the depiction of that superb animal, man's friend
and faithful companion in his warlike pursuits. The pic-
ture whose outlines are engraved is the proof. . . .

Plate 20: *Justice and Divine Vengeance Pursuing Crime,*
painting by M. Prud'hon.

This painting, intended to decorate the criminal court
of the Département of the Seine, has an originality of
style, of coloring and of effect which places it in the ranks
of the most striking pictures of our school. It is the fruit
of a graphic genius whose inspiration was maintained from
the initial idea to the last brush stroke.

A murder has just been committed in the shadows of
the night; but the murderer cannot escape from Divine
Vengeance, remorse seizes him and casts the light of its
fearful torch upon him; Justice, pursuing him, raises her
sword above the guilty one's head; she is ready to strike.

This painting, as noble as it is ingenious and expressive,
is not an experimental attempt of the artist in the use of
allegory, so difficult to do well, and which is so often ac-
cused of coldness. Prud'hon has known how to animate
his subjects through action and through intensity of emo-
tion.

The picture must be seen to obtain an accurate idea of
the beauty of the figures, the quality and the vigor of the
coloring, and, above all, the magical effect of the graceful
brushwork that reminds one of the chiaroscuro and soft
touch of Correggio. . . .

Plate 41: *Cupid and Psyche,* a group in marble by M.
Canova.

This charming group, whose figures are approximately
four feet high, is the work of a Roman artist who enjoys
in France, as in his native land, a high degree of fame. His
productions can be justly placed next to those of our
foremost sculptors.

The group *Cupid and Psyche,* exhibited here in the
Salon of 1808 and possessed by France for the past several

years,[3] is remarkable for the grace and simplicity of the attitudes, the lightness of the contours, the gentleness of the expressions, the softness and the delicacy of the chiseling.

It has often been remarked that an artist, zealously desiring to give his work the greatest perfection of which he is capable, does not always know when to stop and leave it alone. Thus in the general execution, and above all in that of the most expressive parts, such as the facial features or the articulation of the extremities, a too finished chiseling almost always tends to round off and weaken the forms; and it tends to attenuate their character, to make their fine points disappear, and to destroy the solidity of the planes. Canova has perhaps not sufficiently guarded himself against a similar weakness. He allows a bit of languor in his works of a middle style, but those to which the artist wishes to give a stronger character distinguish themselves by a generous and vigorous touch. . . .

Charles Paul Landon, Salon of 1810[1]

Plate 6. Aurora and Cephalus, painting by Guérin.

"Aurora, accompanied by Cupid, lifts the starry veil of Night and scatters flowers over the earth. In her rapid flight she saw Cephalus sleeping, fell in love with him, and stole the young hunter from his loving wife." The sleeping Cephalus, gently stretched upon a cloud, seems to rise softly toward the skies. A star shining over Aurora's head lights this voluptuous scene with a soft and peaceful

[3] General Murat acquired it to decorate his house at Villiers-la-Garenne, near Paris. [Footnote from text. See 1787: ROME. Four replicas were made of the group by Canova, who employed a new technique. He created his work first in clay, took a gesso cast of it, and by points transferred the model into marble. He retained the gesso cast from which replicas could be made.]

[1] [Translated from Charles P. Landon, Salon de 1810, Annales du musée et de l'école moderne des beaux-arts (2nd coll.; Paris, 1810), Vol. II, pp. 19–20, 35–38.]

light. The goddess' figure is slender and graceful; her arms are bare; no drapery hides her breast or shoulders. A light and flimsy robe, fastened below her breast, descends to her feet, only one of which is visible through the clouds.

This charming subject worthy of Correggio's brushes lends itself perhaps less readily to Guérin's talent than would a purely historical scene in which everything should be clearly enunciated. Accustomed to giving his productions an energetic character, he appears to have tried on this occasion to imitate the forms and the color presented him by judiciously chosen models rather than to create, as his subject permitted him—perhaps demanded of him—a celestial and airy nature. The composition of the picture is in excellent taste; the drawing is correct; the flesh tones are brilliant; the general effect is bold and clear; but more fluent forms, a more delicate, lighter coloring, a vaguer and more mysterious effect, in a word, the ideal charm, the mythological accent that should characterize pictures of this type might have been desired.

In addition the public's attention has fixed itself on two minor points: it is felt that the figure of Cupid, the least successful in the group, has a little stiffness in his pose and too much roundness in the drawing; that the cloud carrying Cephalus lacks lightness; that it is too evenly divided into small masses; and that a purplish cast reigns over the picture that is unfavorable to the harmony.

Plates 19, 20, 21, 22: *The Army Giving Its Oath to the Emperor after the Distribution of the Eagles at the Champ-de-Mars*, picture by David.

The Emperor, surrounded by princes, princesses, great dignitaries, ministers, staff officers, and the earliest formed military corps, has just distributed the eagles to La Grande Armée and addresses it with these remarkable words, which formed the end of his speech: "Soldiers, here are your flags! These eagles will always serve you as a rallying point; they will be wherever your Emperor judges it necessary for the defense of his throne and his people; do you swear to sacrifice your life to defend them, and to main-

tain them constantly through your courage on the path of victory; do you so swear?" The whole army answers him with an unanimous acclamation and the words "We swear it, *vive l'empereur!*" are repeated amid the liveliest applause. The eagles dip before the Emperor; the imperial marshals lift their batons of command; officers, soldiers, all swear with the most noble enthusiasm, obedience, devotion, and faithfulness to their sovereign. . . .

Such is the subject of this painting, which would need a much more detailed explanation, if the engraving joined with this article did not provide a substitute.

So far as the examination of the picture is concerned, it can confine itself to a few general observations, even to some points of comparison with *The Coronation of Napoleon and Josephine* by the same artist. We discussed the latter at the time of the Salon of 1808.

These two pictures, of equal dimensions (39 feet long by 19 feet high), were doubtless intended to form a pair: their large masses balance each other. In each of them, the principal figure, the Emperor in imperial costume, is standing, and seen in profile. They are a counterverification for each other.

The Coronation of Napoleon and Josephine was felt to lack movement and variety. In *The Distribution of the Eagles* there is noise and restlessness. A diagonal dividing line dominates the general arrangement of the subject, separating the composition into two distinct masses; the effect is even more disagreeable, especially at first glance, because the left part is very complicated, and the right has considerable empty space.

In the group of colonels and standard-bearers, there are some figures whose attitude is exaggerated, even forced. The scene appears overly tumultuous, the warriors rush and crowd so much, by rights they should push each other over as they come to the foot of the throne. The group of marshals, whose enthusiasm should still be dignified, strike theatrical and exaggerated poses, among which one vainly seeks the sentiment of a noble simplicity; their action

brings too clearly to mind certain inferior dramatic productions.

The Coronation gave us several details executed in a free and skillful manner, in which one saw the talent of a great artist. But the number of neglected parts was considerable and formed an unfortunate contrast. The picture of *The Distribution of the Eagles* is free from this criticism. Everything is carefully executed, though it does not present equally striking beauties. Still, the group of princesses is tasteful and to good effect. The two pages are the most correctly drawn and skillfully executed—they might be compared with the children in the choir at *The Coronation of Napoleon and Josephine*; there was nothing prettier than this group in the whole picture.

So far as the general effect is concerned, *The Coronation of Napoleon and Josephine*, with the exception of the area around the altar, appeared dull. The other painting has the opposite fault: the bright and raw colors are spread too uniformly to give the eye any rest and bring confusion into all the objects. They do not stand out enough from one another. The spectator is dazzled; long examination is necessary to distinguish clearly the intention and the movement of each figure.

What is the result of the comparison of these two works, both carrying the mark of a superior talent? In our opinion, all allowances made, they may be placed in the same rank. Each offers beautiful parts which, in the relationship of the design, of the coloring and the firmness of the brush, are worthy of serving as models to young artists.

Since each of these paintings leaves less to be desired in the details than in the whole, one may conclude that if David confined his subjects to a few figures depicted with character he would obtain, at every public exhibition, more brilliant and less controversial successes.

LONDON: The Exhibition
by a Private Collector

By the summer of 1808, London had recovered from the invasion alarm of 1803, when the defeat of the French at the Battle of Trafalgar had established the supremacy of the British navy. With the failure of direct invasion, Napoleon had attempted to use his political control of the Continent to shut British shipping out of European ports, but British mercantile power was strong enough to withstand French attempts to subvert it. The British Empire, consolidated in the late eighteenth century, and the Industrial Revolution, more advanced in England than on the Continent, continued to maintain the British monopoly over goods and markets. While the continental blockade was a nuisance to English merchants and shippers, it did not seriously affect the lives of the literary and art circles, beyond forcing the closing of some galleries that depended on the European market for prints. But the continuing war was a major preoccupation of the government, which had sent troops to Spain, where they met with French troops in the Peninsular War.

This was one reason Thomas Bruce, Earl of Elgin and Kincardine, could attract no attention to his petition for reimbursement of his personal expenditure in bringing to England the marbles from the Parthenon. Elgin had been appointed envoy to Brussels in 1792, then to Berlin in 1795, and to Constantinople in 1799. As ambassador to the Ottoman Empire, he had acted in England's best interests when he secured from the Porte "the most extensive permission" for himself and his staff "to view, draw and model the ancient temples of the idols and the sculp-

tures upon them and to make excavations and to take away any stones that might appear interesting to them."

The stones that interested Elgin were the Phidian sculptures from the Parthenon, already familiar from the reproductions in Stuart and Revett's *Antiquities of Athens* (1762). Removed with great difficulty between 1801 and 1803, the sculptures were crated and shipped off to London. Surviving one shipwreck—250 feet of the 524-foot frieze were lost, but recovered by Elgin at a cost of £76,000—and eluding French men-of-war under orders to intercept them, they eventually arrived safely. Elgin, less fortunate, was a prisoner of the French from 1803 to 1806. Upon his release, he found the still packed crates, bought Burlington House on the corner of Park Lane and Piccadilly at Hyde Park Corner, and built a shed twenty-five feet square in the garden to house the collection, where he exhibited it from 1807 to 1812.

An art collector as well as a diplomat, Lord Elgin moved in circles where there was avid interest in acquiring Greek and Roman sculpture, and he was aware that the rivalry between Britain and France extended to the acquisition of ancient art objects. The French had confiscated art treasures from Belgium and Rome. The British navy under Nelson had enriched the country in 1802, when it captured French navy vessels carrying treasures—including the famous Rosetta stone—found by the French expeditionary force in Egypt.

A parliamentary grant in 1772 had made possible the collection of ancient works assembled by Sir William Hamilton, ambassador to the king of Naples, and Elgin had assumed that a grateful country would reimburse him.

Objections to the purchase were raised, however, by the influential Dilettanti Society. Moral misgivings were voiced: was the nation to so countenance vandalism? More significant was the argument that the marbles were not works of art: they were so perfect that they must be casts of human figures. To defend their authenticity Elgin published in 1810 a pamphlet on his *Pursuits in Greece* and the argument grew. Among the many connoisseurs, lit-

erati and artists opposed to the opinion of the Dilettanti
Society were the anatomist Dr. Bell, Benjamin Haydon,
Henry Fuseli and the painter-engraver George Cumber-
land.
Cumberland's lifelong interest was the study of engrav-
ings and engravers, begun in 1785 on a visit to Rome. He
had formed a collection of Julio Bonasoni's engravings,
purchased later by the British Museum, and published
*Some Anecdotes of the Life of Julio Bonasoni, A Bolo-
gnese Artist* in 1793. He could stand as an authoritative
judge of sculpture, for he had published *Thoughts on
Outline, Sculpture and the System That Guided the An-
cient Artists . . . Accompanied with Free Remarks on the
Practice of the Moderns* (1796). To illustrate the work he
had evolved a new, but costly, engraving process later
simplified by his lifelong friend, William Blake, who
helped him prepare the plates and executed four himself;
the result was, in Blake's words, a "beautiful book." Ac-
tive as he was in art circles, Cumberland was recruited by
the liberal Whig *Morning Chronicle* to write notes on art
and art events, which were published under the name
"Candid." His later works included *An Essay on the Util-
ity of Collecting the Best Works of the Ancient Engravers
of the Italian School and Accompanied by a Critical Cata-
logue* (1826) and another work on sculpture, *Outlines
from the Ancients Exhibiting Their Principles of Compo-
sitions in Figures and Basso-Relievos* (1829).
A strong believer in public support for the arts and an
advocate of the National Gallery, Cumberland was among
the first invited to see Lord Elgin's marbles. While his let-
ter to the editor of the *Monthly Magazine* gave support to
Elgin's cause, the controversy continued. It was not until
1816, when Canova, in London to secure British support
for the return of the Italian art treasures taken from the
Papal States by the French (see 1803: PARIS), examined
the marbles and pronounced them authentic, that Parlia-
ment voted £35,000 for their purchase. Even after they
were installed in the British Museum, however, the debate
persisted in the widely read *Lettres écrites de Londres à*

Rome et addresées à M. Canova sur les marbres d'Elgin ou sculptures du Temple de Minerve à Athènes (1818, Rome) of the French archaeologist Quatremère de Quincy.

Because of the controversy over their authenticity, Lord Elgin's exhibition of the fifth century B.C. sculpture—and the 1821 exhibition in Paris of the Venus de Milo—did much to shatter the prevalent conceptions of, and theories about, ancient art born of naïve literary accounts and Roman copies of ancient sculpture. These works "so perfect they must be casts of human figures" did much to encourage and justify an increasing interest in naturalistic representation.

George Cumberland, "Lord Elgin's Collection of Antiquities from Athens"[1]

To the Editor of the *Monthly Magazine*.

Sir,

Ever since the year 1762, when the first volume of *Stuart's Athens*[2] made its appearance, has the public curiosity been raised to the highest pitch, to view even small fragments of the sculpture still abounding in that celebrated city and its vicinity. I well remember the pride with which the architect Reveley [sic], who was there with Dr. Richard Worsley,[3] once shewed me a piece of mould-

[1] [Verbatim from the *Monthly Magazine*, July 1, 1808, pp. 519–20.]

[2] [James Stuart, an artist, and Nicholas Revett, an architect, made drawings and took measurements of ancient monuments in Athens from 1750 to 1755. The result of their studies, *The Antiquities of Athens*, published by the Society of Dilettanti, revived an interest in classical architecture.]

[3] [Worsley was one of the first Englishmen to return from a sojourn in Greece (1785–87) with pieces of ancient sculpture. He published splendid engravings of the collection in *Museum Worsleianum*, 1798.]

ing that for many years he had carefully carried about with him, and which was equally remarkable for the delicacy of its finish, and the justness of its proportions. Since that period, another traveller, a Mr. Walker, brought over a few fragments, one of which, a small figure in bas-relief, now in my possession, he had carried on a mule above eight hundred miles. But I know of nothing else of any size, or likely to convey to us an idea of the grandeur of art, at the period of the building of the temple in the *Acropolis*, until Lord Elgin, availing himself of his advantageous situation at Constantinople, found means to acquire that noble collection, now happily deposited near Hyde-Park Corner, in a building erected purposely for their security; and, on Saturdays and Sundays, most liberally opened to the inspection of the public, as such things ought to be, without fee or reward, or even the necessity of previous application.

These now consist first of a considerable part of the frieze that surrounded the porticos under the soffit of Peripterous. They are three feet four inches in height, and were continued all round the outside of the wall of the temple; so that the whole, consisting of a procession, measured above five-hundred feet. This procession was the *Panathenaic*, consisting of horsemen and charioteers, some clothed in the chlamys and tunic, others in the tunic only, and many, as from the bath, quite naked.

Among those of Lord Elgin's marbles are the three scaphephori, or men carrying trays, the sacrificers of the ox, the noble sitting figures of *Neptune* and *Ceres*, the *Hydriaphorae*, or women carrying pitchers of water, the *Canephorae*, or basket carriers, and others that I cannot now recollect; for, at the first view of such stupendous works of art, the mind is too much elated for the memory to exert its activity with precision. Next we find the greater part of the *Metopes* of the frieze of the south side; many in fine preservation, and nearly statues; for they are in very protuberant alto-relievo, consisting of part of the groupes [sic] of figures on the south side also, which were

ninety-two in number, each representing a centaur com-
bating one of the *Lapithae*; all infinitely varied, and some
not much injured by the hand of time.

Thus we are become possessed of two species of speci-
mens of Greek sculpture in their utmost perfection; but
what renders this noble museum complete, is, we find
these entire figures from the pediment, and statues of the
Caryatides from the temple of *Erechtheus*, in the most
perfect preservation.

Of the statues from the pediment, that of Theseus
reposing on a skin of the feline kind is the first that com-
mands our attention. It was, I apprehend, to the right of
the western pediment of the portico, that, in the time of
Stuart and Revely [sic], was a mere fragment of a vast
pediment filled with excellent sculpture.

This figure is reposing, nearly naked, with the head,
trunk, and limbs, almost entire; every part is simple, com-
posed, and dignified; it is a genuine fine specimen of what
the Italians would call the Pastoso, in marble, soft, plump,
and fleshy, looking truly like a figure covered with skin; a
gentle relaxation pervades the whole recumbent image;
while it represents that species of strength, which belongs
to blood rather than bone. Nothing can be more er-
roneous than the idea of its having any thing to do with
the family of the Hercules's; which some people have ad-
vanced, probably from seeing him seated on a skin; forget-
ting that the skin of the lion was the couch of every hero,
and not perceiving, that even in one of the metopes, the
centaurs use it as a shield.

There are also, on this magnificent pediment, four or
five other statues, particularly two dressed figures sitting,
that look as if the sculptor had worked in clay instead of
marble, so profound are the folds, and so flowing the lines,
of their draperies;—to speak of the beauties of which, as
they deserve, would, in this place, take up too much room.
We may, however, venture from these to prognosticate,
that the art of sculpture will now take good footing in this
country; our artists having before them in the British Mu-

seum, the high Egyptian antiques,[4] the Greek and Roman specimens selected by the late Mr. Townley;[5] and, not to mention the numerous fine casts we possess, Mr. Knight's[6] inestimable collection of bronzes in Soho-square; Tassie's vast collection of gems;[7] and, lastly, these treasures of Lord Elgin's snatched from the Turks; consequently we may boast, that scarce any helps are wanting towards the revival of the noblest art that the faculties of man have hitherto produced.

The temple of Minerva called *Parthenon* and *Hecatompedon*, was erected in the time of Pericles, who employed Callicrates and Ictinus, as architects; while Phidias directed and executed all the fine sculpture and ornaments, as well as the statue of the goddess, composed of ivory and gold, and which was, according to Pliny, twenty-six cubits high. There is no doubt, therefore, that the models in clay from which they were worked, were chiefly by this excellent and renowned artist, perhaps all the finish of the work; and we have reason, I think, to believe, that, in imitating these examples, we follow his exquisite chisel. Such a treasure as we here have before us, would have gratified the ambition of any of the Roman Emperors; and will at this day excite the envy of every collector in Italy. Even the French, after all their depredations,

[4] [The "high Egyptian antiques" were chosen by Baron Denon during Napoleon's Egyptian campaign but never reached Paris: they were captured at sea by Admiral Nelson.]

[5] [The "Greek and Roman specimens" of Charles Townley were collected during a residence in Italy (1765–72). He contributed funds to archaeological excavations in return for a share of the findings. A trustee of the British Museum, he bequeathed his collection to it.]

[6] [Payne Knight and Townley determined the attitude toward the art of antiquity taken by the influential Society of Dilettanti. Knight's *Specimens of Ancient Sculpture, selected from several collections in Great Britain*, published by the society in 1809, was said to form "a brilliant conclusion to the century of antique dilettantism in England." See W. T. Whitley, *Art in England, 1800–1937*, (Cambridge, 1928–30), Vol. I.]

[7] [James Tassie was the Scottish engraver famous throughout Europe for his medallions and duplication of gems.]

must, at a peace, submit to cross the channel, if they wish to see such specimens of art, as Paris, with all its boasted splendour, cannot exhibit.

In *A plan for promoting the arts in England*, annexed to the life of Julio Bonasoni, it will be found, that I considered it as a proof of the rapid advances, which, in the year 1793, the French government were making towards a good taste, that they had procured only casts in plaster of these fine models; and I almost flatter myself, that my invective against our indolence excited this effort to possess the originals. Permit me to quote a passage from that Essay.

"Refinement in the arts could be productive to the Greeks of glory only; to *us* a good taste in them, superadded to this reward, will secure the means of our longer continuance as a great people." And as this sentiment is now more than ever necessary to inspire our industry, I trust that this opportunity of completing our studies, so as to rival our neighbours on the Continent, will not be neglected; and that the parliament of England will, among other subsidies, consent to subsidize the arts; by purchasing, if possible, this entire collection, and building a well-lighted museum to contain it, so situated that the whole public may benefit by the magnificent exhibition.

Your's, &c.
G. Cumberland

LONDON: The Exhibition
by an Artist of His Own Work

The end of the eighteenth century saw many one-artist exhibitions in London. There were few possibilities for artists to exhibit other than the Royal Academy exhibitions begun in 1780, and there was increasing dissatisfaction with its installations at Somerset House. As patronage and commission practices of the eighteenth century changed, the private exhibition was becoming a way of reaching the public. Single-artist shows were held by Thomas Gainsborough, John S. Copley and Nathaniel Hone, among others; James Barry, Benjamin West and Henry Fuseli established semi-permanent galleries in their studios. Fuseli's Milton Gallery was an attempt to compete with the engraver John Boydell's Shakespeare Gallery (1786–1802), for which Boydell had commissioned 162 paintings from different contemporary artists. Thomas Macklin had done likewise for the one hundred paintings he exhibited in his Poet's Gallery. Bowyr opened an English History Gallery representing the same artists. These three galleries hoped to be financed by admissions and by the sale in England and Europe of engravings and of the exhibited paintings; all were forced to close as a consequence of the Napoleonic continental blockade. While most of the one-artist exhibits and galleries were prompted by the commercial interests of the artists or owners, they created precedents for independent exhibits in general. In this ambience, Joseph M. W. Turner opened his gallery for aesthetic rather than commercial reasons.

Turner (1775–1851), whose father kept a barbershop near the Covent Garden Market, had begun his career as an artist at thirteen years of age. He learned water-color drawing, studied perspective with an architect, and colored

prints for an engraver. At fourteen he was a student at the Royal Academy; at fifteen he sent his first contribution, a drawing, to the Academy's exhibition. At seventeen, he and Thomas Girtin were sketching together to supply topographical drawings to be engraved for magazine illustrations. At twenty-four, recognition of his artistic perception and technical skill in water-color and oil painting led to his election to associateship in the Royal Academy. In 1802 he became an academician.

Turner's concern with heightening the overall tone of his painting developed shortly after studying the Italian and Flemish masters in the Musée Napoléon in 1802. He had begun to turn away from the dark palette required for "Picturesque and Sublime Colouring" as set forth in *Letter on Landscape Colouring*, written about 1768 by his friend, the animal painter, William Sawry Gilpin. By 1808 he had begun to set down his color analysis of the old masters in which he wrote, "Light is a body in painting of the first magnitude and Reflection is the medium, or in other words, the half light, while shade is the deprivation of light only, but with the deprivation of Reflection likewise, becomes Darkness."

In 1804 his concern with controlling the light in the space where his paintings were hung led Turner to establish his own gallery in Queen Anne's Street, the center of artistic activity in London. It was probably designed with skylights so he and others might see his work in the illumination best for it. The importance of light as a complement to his art is confirmed by the fact that, after Turner built his gallery, he sent few paintings to be exhibited at the Royal Academy or the British Institution (which, after it was established in 1806, held exhibitions in the Shakespeare Gallery purchased from Boydell, who had been driven to bankruptcy when the print market was destroyed). Instead of this, Turner invited "the classes of Dilettanti, Connoisseurs and Artists" to view his work in his private gallery. This was an overture very different from that of Blake, whose 1809 exhibit in his brother's hosiery shop—which opened a week before a Turner exhibit of eighteen pictures in oil and water color—was an

appeal to the public for their patronage. Turner's interest was in creating an environment for his work, an interest similar in intent, if opposite in procedure, to executing a commissioned painting for a specific location with known lighting.

In 1819, when he was again lightening his palette, Turner remodeled his gallery prior to a trip to Rome. Although he missed the exhibition of German art held in April in the Palazzo Caffarelli, Charles Eastlake, studying then in Rome and a resident there for fourteen years, brought Turner together with the German landscapists. Goethe's *Zur Farbenlehre* (1810), which included Philip Otto Runge's color sphere, stimulated the study of color and light by artists; Eastlake published the only English translation of Goethe's *Theory of Colours* in 1840. Turner's own interest in the theory and science of color was constant, and he formulated it in lectures given between 1811 and 1828 after he was elected Professor of Perspective to the Royal Academy in 1808.

Turner's most effective means of demonstrating his color theories were not his lectures, however, but his exhibitions. Throughout his long career, his interest in the science of color was accompanied by a romanticism that dictated his choice of subjects. At his exhibitions he provided the spectator with a clue to the meaning of his paintings in the form of verses, either from one of his favorite authors, Milton or Thomson, or from his own fragmentary poem, "Fallacies of Hope." Turner's innovations in the field of painting—marked by *Ulysses Deriding Polyphemus* (1829), *The Fighting Téméraire* (1839), *The Slave Ship* (1840) and *Rain, Steam and Speed* (1844)— culminated in the two pictures, *Shade and Darkness: The Evening of the Deluge* and *Light and Color (Goethe's Theory): The Morning after the Deluge, Moses Writing the Book of Genesis* (1843), which made his interest in color theory explicit in the titles.

Whether exhibited at Somerset House, the British Institute or in his own gallery, Turner's paintings aroused interest and excited comment. The exhibition of a number of landscapes held in his own gallery in 1808 was reviewed

by his friend and associate, John Landseer (1761–1852), for Landseer's own short-lived publication, *Review of Publications of Art*. Landseer was an associate engraver in the Royal Academy and advocated granting engraving the same equality in the Royal Academy that it enjoyed in other academies. Of his three sons, Thomas became an eminent engraver and Charles and Edwin painters: Edwin became noted for his paintings of animals and was appointed Painter to the Queen (see 1836–39: LONDON). Landseer had in his "Lectures on the Art of Engraving" (1807) been critical of color printing because there was no agreed-upon scale of color values in terms of monochrome to aid the engraver in reproducing or "translating" color landscapes. When the series of lectures delivered in 1806 at the Royal Institution were cut short, Landseer had published them himself.

Landseer's reliance on poetry in his review of Turner's work reflects the persistence of the principle *Ut pictura poesis*, derived from Horace's dictum, "As in poetry, so in painting." Since there were no classical writings on the theory of the visual arts for humanist aestheticians to turn to, they had derived principles for painting from classical poetic theory on the strength of this dictum. On a less abstract level, the correspondence between poetry and painting was generally accepted: painters were often referred to as "poets" or "authors" throughout Europe, and in England comparisons of art works and poetry were common in criticism.

John Landseer, "Mr. Turner's Gallery"[1]

As the Gallery of J. M. W. Turner, R.A., in Queen Ann-Street West, is now open to the public, (gratis), we shall

[1] [Verbatim from *Review of Publications of Art*, 1808, pp. 151–96. Helene Roberts generously supplied this text. See Helene Roberts, " 'Trains of Fascinating and of Endless Imagery': Associationist Art Criticism Before 1850," *Victorian Periodicals Newsletter*, Vol. X, No. 3, September 1977, pp. 91–105.]

naturally be expected to communicate our remarks on the
principal works which he this year exposes to view.

In the Exhibition which Mr. Turner thus liberally
throws open to the eye of the public, the genuine lover of
Art, and the faithful observer of Nature in her broader
purposes, will find himself very highly gratified. The shew
of landscape is rich and various, and appears to flow from
a mind clear and copious as that noble river on whose
banks the artist resides, and whose various beauties he has
so frequently been delighted to display.

To exalt Mr. Turner, it is not at all necessary to
depreciate others: such an idea must be ever remote from
impartial reviewers of art; and Turner is a diamond that
needs no foil. Yet the good and evil of fine art, are com-
parative terms, and we need not fear nor forbear to
remark, how much less Mr. Turner appears to depend
than most other exhibitors, on those dazzling and extrinsic
qualities which address themselves to the external sense,
and how much more on the manifestation of mind. He
seems to feel with Akenside,[2] that—

———— Mind!—mind alone!
The living fountain in itself contains
Of beauteous and sublime: ——

and from this source the science which regulates his vari-
ous art, appears to flow with spontaneous freedom and in
an ample stream.

His effects are always well studied, and in most in-
stances striking. Where they are otherwise, they are still
well studied; and he who thinks most, and who knows and
feels most of art, will be best satisfied that they are what,
in those cases and under those circumstances which the
painter has prescribed to himself, they ought to be.
Where other artists have thought it necessary to exagger-
ate in order to obtain credit for superior truth, Turner
begets a temperance and steadily relies on the taste and
knowledge of his observers to credit the veracity of his
pencil.

[2] [Mark Akenside (1721–70), poet, author of *Pleasures of
Imagination* (1744).]

The brightness of his lights is less effected by the contrast of darkness than that of any other painter whatever, and even in his darkest and broadest breadths of shade, there is—either produced by some few darker touches, or by some occult magic of his peculiar art—a sufficiency of natural clearness. Like those few musicians of transcendant [sic] skill, who while they expose much less than others, the extremes of the compass of their instruments, produce superior melody.

His colouring is chaste and unobtrusive, yet always sufficiently brilliant; and in the pictures of the present season, he has been peculiarly successful in seeming to mingle light itself with his colours. Perhaps no landscape-painter has ever before so successfully caught the living lustre of Nature herself, under all her varying aspects and phenomena, of seasons, storms, calms, and time of day. The verdant and chearful [sic] hues of spring, the rich mellowness of autumn, and the gleams and gloom of equinoxial storms, are to him alike familiar; and he dips his pencil with equal certainty and with equal success in the grey tints of early dawn, the fervid glow of the sun's meridian ray, and the dun twilight of evening.

Yet colouring however brilliant, and chiaroscuro however forceful, appear in him to disclaim all other than intellectual value, and always to be subservient to some grand presiding mental purpose.

The greater number of the pictures at present exhibited are views on the Thames, whose course Mr. Turner has now studiously followed, with the eye and hand at once of a painter and a poet, almost from its source,[3] to where it mingles its waters with those of the German ocean.

In the order of our Review we shall descend with the current of the river.

In the *Union of the Thames and Isis*, the sun gilds with his mildest radiance, a scene of Claude-like serenity, which is much to be admired for its exquisite colouring, pictur-

[3] Including the pictures of Thames scenery which Mr. Turner has formerly exhibited.

esque groups of cattle, and the delicate management of
the air tint which intervenes between the several distances.
The negative grey by means of which this beautiful
sweetness of gradation is accomplished, is with great art
insensibly blended with, and in parts contrasted to, the
positive and even rich colouring of the cows, and with
which the painter has touched the plumage of the ducks
and other objects of the foreground; where grow some
well-painted dock-leaves, and where also some old fishing
baskets, lying in the water, are introduced with that pecul-
iar charm which can only proceed from fine feeling in the
artist.

That continuity of line which so often contributes to
the *grandeur* of Mr. Turner's pictures, is here, in the
wooden bridge, and in the ridge of distant hill, made sub-
servient to a milder sentiment, and more gently contrasts
the other forms which prevail in the composition; and the
tasteful observer will here see an instance of the great art
with which (as we have noticed in our prefatory remarks
on this Exhibition) Mr. Turner gives perspicuity to his
shadows, the cows in the river (which at this distance
from the metropolis has no visible current) is [sic] literally
as true to nature as a mirror.

His *Eton College* is also a placid *River* scene, on a
smaller canvas, but of more stately dignity than the for-
mer. The College itself,

> Where grateful Science still adores
> Her Henry's holy shade—

forms an elegant distant object; some stately and well-
painted elms grow on the right hand bank of the Thames,
between which, and over some park paling, which serves
to keep up an artful play of light in this part of the pic-
ture, the village of Eton is partially seen; and this prevail-
ing character of calm stateliness is kept up by a group of
swans, which the painter has introduced with much art,
and which contributed at once to the effect of his chiaro-
scuro and the sentiment of his picture.

You cannot here fail to call to mind Gray's inimitable Ode on the same subject,[4] (from which we have quoted above,) for you here behold Eton College under the tranquil circumstances which the poet contemplated from a station somewhat more remote, and you here

> The grove, the lawn, the mead, survey,
> Whose turf, whose shade, whose flowers among
> Wanders the hoary Thames along
> His silver-winding way.

We conceive that Mr. Turner will not find it easy to assign to some of the pictures which he this year exhibits, decided places under the new classification of landscape scenery, which he has recently ushered forth in the Prospectus to his "*Liber Studiorum.*" His Union of the Thames and Isis, may without impropriety be called "pastoral," but in his Eton College, the building is too far off for him to call it an "architectural" landscape, neither is it "mountainous," "pastoral," nor "marine," (at least we cannot suppose that two figures angling from a boat, will bring it with propriety under this class,) neither is it, what Mr. Turner would call "historical" landscape.

We shall doubtless be glad to see what an artist of Mr. Turner's mind, may have to say on the subject of classifying "the various styles of landscape;" but if he has specified all those styles[5] in his Prospectus, we conceive that he will find it expedient (if not necessary) to encrease [sic] or diminish, the number.

He has doubtless remarked that a just classification of landscape scenery, if it met with general concurrence, would be a great help to memory. It certainly would; and moreover (beside other facilities) a great step towards ren-

[4] [*Ode on a Distant Prospect of Eton College.*]

[5] See "Proposals for publishing one hundred Landscapes, to be designed and etched by J. M. W. Turner, R.A. and engraved in Mezzotinto," in which Mr. Turner says, "It is intended in this publication to attempt a classification of the various styles of landscape, viz. the historic, mountainous, pastoral, marine, and architectural."

dering the mysteries of refined art more conducive, than at
present they are, to the pleasure of colloquial intercourse,
and colloquial intercourse in its turn, by being rendered
more critical, more conducive than at present to the ad-
vancement of art; but should such a classification be at-
tempted, without being arranged on such perennial princi-
ples as can only be found in the lasting features of Nature,
it will rather tend to embarrass and confound, than to
elucidate.

We are next presented with a view of *Pope's Villa at
Twickenham*, during its dilapidation, and as seen from the
Middlesex bank of the river, or perhaps, (as we conjec-
ture,) from one of the Twickenham ayts:[6] probably that
which lies off the grounds of Strawberry Hill. We think
the channel in this part, on the right hand side of the pic-
ture, is else too narrow for the whole breadth of the bed
of the Thames.

The artist has here painted not merely a portrait of this
very interesting reach of the Thames, but all that a poet
would think and feel on beholding the favourite retreat of
so great a poet as Pope, sinking under the hand of modern
improvement.

Mr. Turner will perhaps call it a pastoral landscape, in
reference to the occasional Muse of Pope, to the calm
character of the scene, and to the group of figures and
sheep which he has introduced, but we are tempted to
think that as Sterne brought up the rear of *his* classifica-
tion of travellers, with "the sentimental," so Mr. Turner
should allow this to be called a *sentimental* land-
scape. . . .

Much of the prevailing sentiment of the picture must
be ascribed to the perfect accordance and assimilation of
its parts. The whole is serenely pensive: "far from all
resort of mirth," yet still farther from gloom. On the
banks of a tranquil stream, the mansion of a favourite

6 [An "ayt"—more often spelled ait, ayte, or eyot—is an islet
or small island, especially one in a river.]

poet which has fallen into decay, is under the final stroke
which shall obliterate it for ever, a ruined tree lies athwart
the foreground: the time represented is the decline of day,
and the season of the year is also declining.

In fact, we scarcely remember any picture that more
powerfully imparts its prevailing tone of tranquillity—that
tone, which gives birth to pensive thought—to the mind
of the beholder, than this; or which more plainly shews
that its author has developed the mysteries of the arcana
of affinities between art and moral sentiment. The tran-
quil state of the human intellect, like that of a river, is the
time when it is most susceptible of reflection. At such a
time the mind, willingly enthralled by a certain feeling of
melancholy pleasure, is instinctively led to compare the
permanency of Nature herself with the fluctuations of
fashion and the vicissitudes of taste; and in the scene be-
fore us, the Thames flows on as it has ever flowed, with its
silent majesty, while the mutable and multifarious works
which human hands have erected on its banks, have
mournfully succeeded each other; and not even the taste,
and the genius, and the reputation of Pope, could retard
the operations of Time, the irksomeness of satiety, and
the consequent desire of change.

At the sight of this picture who but will be induced to
pause, and reflect on the celebrity and the superlative
merits of *Pope*? Who but will recollect that the landscape
which has caught the eye and called forth the talents of
Turner, has resounded to *his* lyre? The claims of so great a
poet on posterity, and the respect due to the favourite
haunts of one so highly favoured by the Muses, will like-
wise occur to the reflective mind; and the beholder of this
endeared scene, will conceive in the thoughts, if he do not
exclaim in the words of Goldsmith,

———— could not all,
Reprieve the tott'ring mansion from its fall?

He will rejoice, however, that he cannot with equal truth
add the succeeding couplet—

Obscure it sinks, nor shall it more impart
An hour's importance to the feeling heart.[7]

At least it should mitigate our regret, that the pencil of
Turner has rescued the Villa of Pope from the oblivion in
which other mansions which have from time to time
adorned the borders of the Thames, have been suffered to
sink. . . .

His view of *Richmond Hill and Bridge* is taken from
the Surrey bank, looking up the Thames, and is that beau-
tiful river scene, ornamented with the villas of the noble
and the opulent embowered in wood, which is celebrated
throughout Europe, and called by the Italians the Frescati
of England. . . .
The most conspicuous feature in the picture is Rich-
mond Bridge, of which, the sun being low in the horizon,
the Surrey end is faintly overshadowed. By obscuring the
detail of Richmond itself in the mistiness of the morning;
by introducing some sheep, and the simple incident of
women bathing a child near the fore-ground—an incident
which we deem worthy of the pastoral Muse of painting,
and which, had it been met with in the morning pastorals
of Theocritus, would have called forth general admiration
—Mr. Turner has given a pastoral character to a scene of
polished and princely retirement. . . .
Obedient to this impulse, we feel delighted with the
effects which we here behold "of incense-breathing morn."
The indistinct distance of mingled groves and edifices
with which Mr. Turner here presents us, leaves the imag-
ination to wander over Richmond, and finish the picture
from the suggestions of the painter, where another artist
would have exhausted his subject, and perhaps the pa-
tience of his observers, by the attention which he would
have required to the minute accuracy of his distant
detail. . . .
When we compare British art with British literature,
and consider the former as, not less than the latter, in-

[7] [From Goldsmith's *The Deserted Village*.]

timately connected with the progress of civilization and
patriotic virtue, we cannot but feel much disposed to
regret that the same means of diffusing taste and classical
information among the public, which has assisted the
growth of our national taste for poetry, has been withheld
from the arts of imitation.

Dr. Beattie, Dr. Blair, Dr. Drake, and fifty other univer-
sity professors and well-informed critics in poetry, will tell
us how much Virgil excels Ovid in the delicate taste
which he discovers in the arts of poetical indication, or
suggestion, but who has yet stepped forward to say how
much Mr. Turner, (or any other artist,) by eloquently
addressing the fancy and the passions, excels those
painters who are exhausting their subjects, and their
means of art, and annihilating the pleasures of the specta-
tor's imagination? or how much Mr. Turner, in his pic-
tures from Ovid, excels Ovid himself in this respect? Yet
what is admired in poetry, if it be really admirable on
principle, should be admirable also in painting.

The great object of our endeavours, in a world of trou-
ble and inquietude of which many complain, is, by
awakening those perceptions and those tastes upon which
the enjoyment of every kind of merit in art depends, to
open new avenues of pleasure; firmly persuaded that if
every man possessed that fine feeling for the charms of
landscape, which we trace in the writings of Mr. Uvedale
Price, the sum of human happiness would be greatly in-
creased.

The remaining *Thames* subjects, are views below Lon-
don bridge, where the river assumes a distinct character,
and are such as Mr. Turner may very properly term *ma-
rine* landscapes. . . .

In treating such objects as agitated seas, the motion and
conduct of Mr. Turner's pencil, eludes observation: your
eye cannot travel along the scooped edges of his waves, as
it can in the works of other marine painters. You do not
know that it is a pencil which he uses: as in the works of
Nature herself, you cannot tell nor trace the instrument

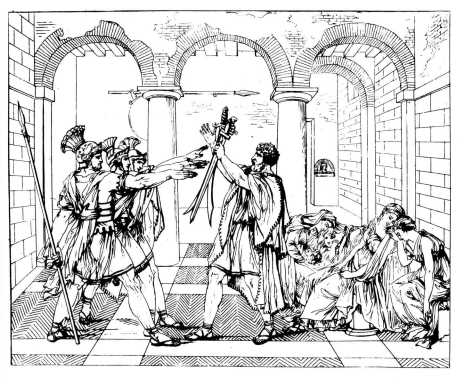

1. David, *Oath of the Horatii*

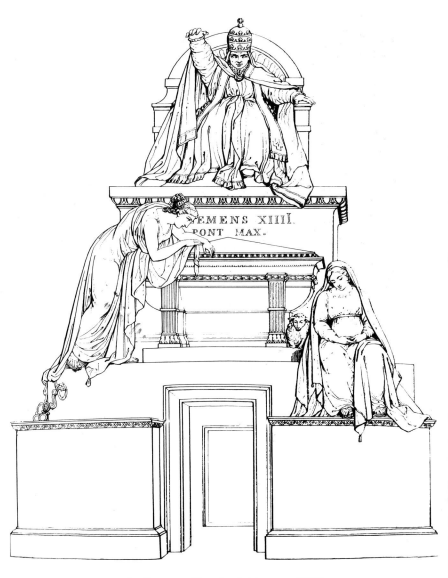

2. Canova, *Tomb of Clement XIV*

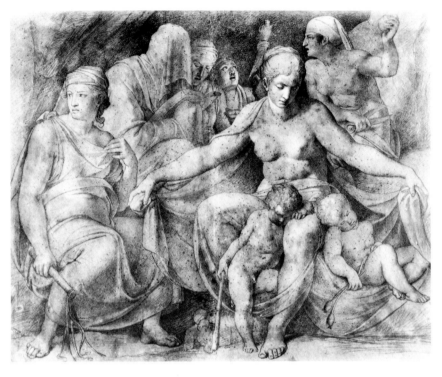

3. Carstens, *Night with her Children*

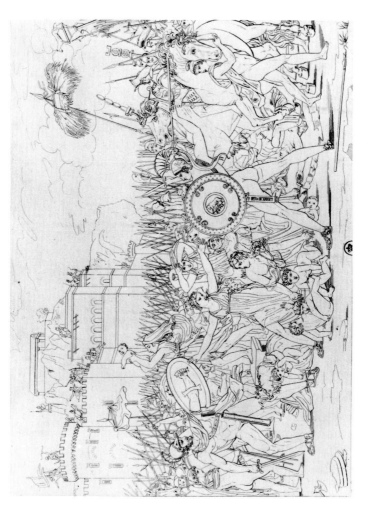

4. David, *The Sabines*

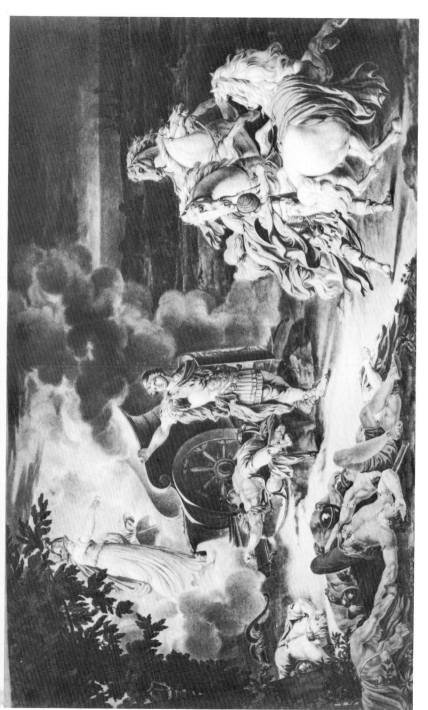

5. Hoffman, *The Death of King Rhesus*

6. M. Cosway, *Triumph of Art Works*

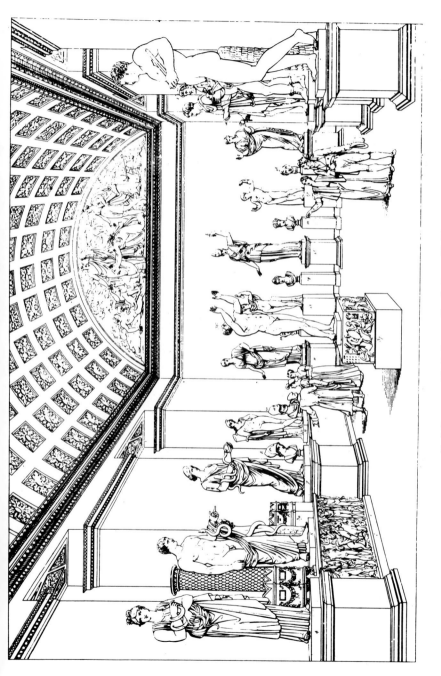

7. *Museum Napoleon, Sculpture Hall*

8. Prud'hon, *Justice and Divine Vengeance Pursuing Crime*

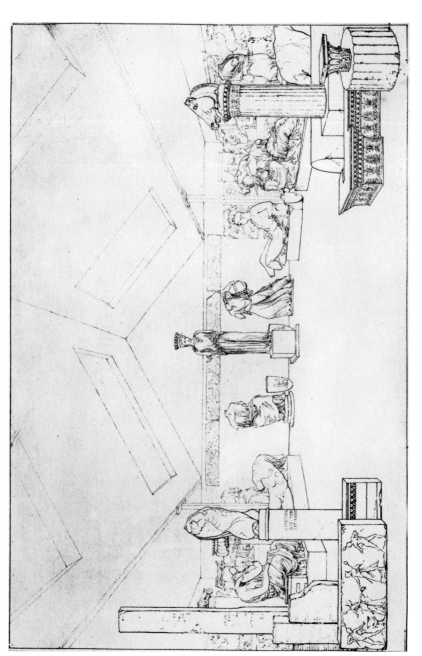

9. *Elgin Marbles*

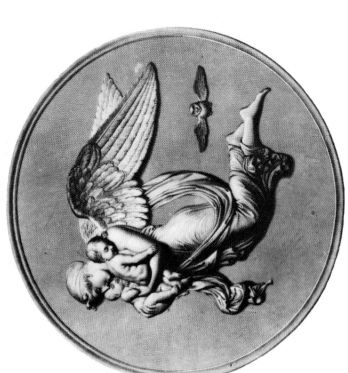

10. B. Thorvaldsen, *Night Morning*

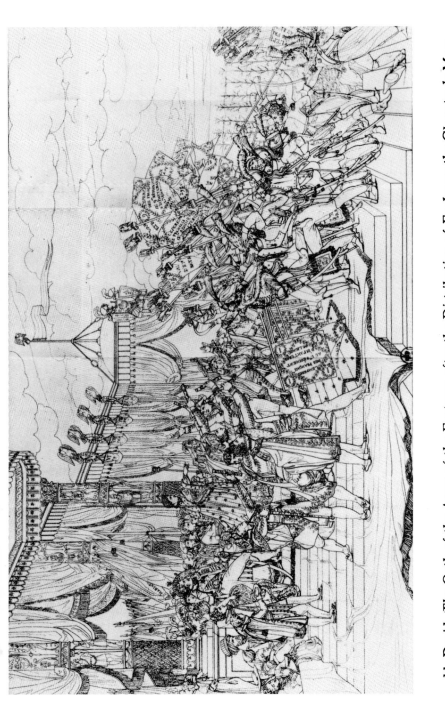

11. David, *The Oath of the Army of the Emperor after the Distribution of Eagles on the Champs de Mars*

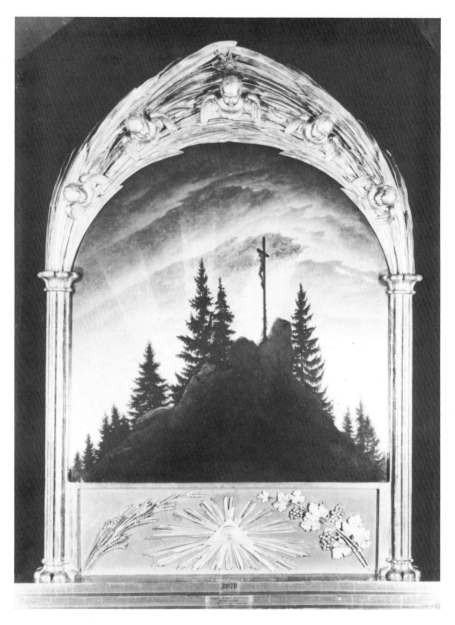

12. Friedrich, *Tetschen Altar, The Crucifixion in the Mountains*

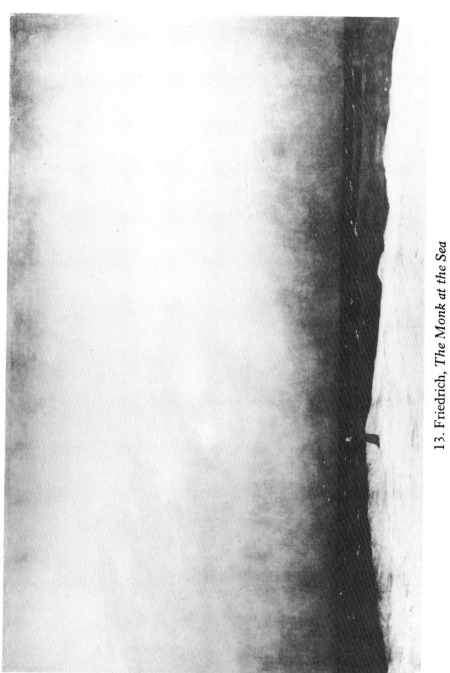

13. Friedrich, *The Monk at the Sea*

14. Overbeck, *Flight into Egypt*

15. Cornelius, *Dante Cartoon*

ceau, les souffrances de cette année désastreuse. Les artistes admirent les dessins faits d'après nature où il a représenté nos braves soldats rentrant à Paris blessés, sanglants, ap- puyés les uns sur les autres : il y a dans ces figures une am- pleur de style, une noblesse d'expression, dignes de l'art antique. Sous leurs capotes usées et noircies dans les com-

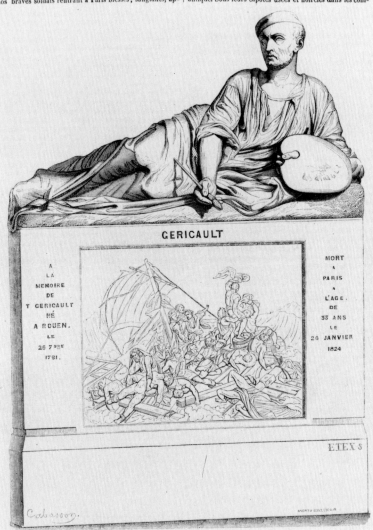

16. Etex, *Tomb of Géricault*

with which the work is produced. A tempestuous sea with all its characteristic features and ever-varying forms, of foam, spray, and pellucid wave, is presented to your eye, but no man shall positively say this is the work of a pencil, or any other known instrument. You see only the presiding mind. The hand is concealed.

We know that people of precise tastes abjure this indefinity, and love to trace in art the necessary connexion between means and end. We are not fastidious: let them enjoy this pleasure: but, let them reflect whether the well-defined forms of his ships, boats, and rigging (and figures, we would add, if Mr. Turner would define his figures a little more carefully) do not reciprocally acquire importance from, and confer value on, this indefinity, by their mutual contrast? and whether the *ever-varying* shapes of a tempestuous sea, ought to be penciled with the same sedulous and precise attention to the detail, as the forms of those other objects which are unvarying, or ever the same? We will then trust them to determine whether Mr. Turner falls short of what the rules of art require, or "rises to faults true critics dare not mend." . . .

1809

LONDON: The Exhibition
by an Artist of His Own Work

The republicanism that accompanied the Age of Enlightenment rediscovered the "civic use of the arts." It was felt that painting and sculpture should record the virtues and heroic actions of a nation's forebears and its contemporary citizens, and that the people should, by patronage, encourage the arts. The system of wide state support which had developed early in France was unique in Europe; in England a variety of societies and institutions sought to foster the country's artistic development. In 1753 men of republican persuasion formed the Society for the Encouragement of Arts, Commerce and Manufacture—a first attempt to extend the word "art" beyond the narrow connotation of fine art and to relate it once more to the mechanical arts. Holding that painting is a stimulant for useful commercial arts, the society offered prizes to young painters and gave exhibitions of contemporary art. Interest in public patronage finally prompted the founding of the Royal Academy in England in 1760. In 1777, English reformers, stimulated by the American rebellion and French revolutionary thought, proposed the establishment of a national gallery and a great free public library at the British Museum, which had been founded in 1753. In 1806 prominent art patrons eager to encourage contemporary art, including Sir George Beaumont and Payne Knight of the Society of Dilettanti, formed the British Institution and took over Boydell's Shakespeare Gallery. Loan exhibitions of older works were alternated with exhibitions of contemporary paintings and admission fees were used to form a fund for the purchase of contemporary art.

Outspoken advocates for the participation of the people in the arts included the Irish painter James Barry, who executed the murals for the Society for the Encouragement's building, the Adelphi; the painter John Opie, a carpenter's son; John Wilkes, the Whig M.P. expelled from Parliament but later returned as an alderman for the City of London who, in 1760, had been president of the committee responsible for the first exhibition of contemporary art in England; the liberal thinker and friend of the arts, George Cumberland; his cousin, the playwright Richard Cumberland; and the artist William Blake.

Despite the proliferation of institutions and societies, official public patronage was fraught with problems, largely financial. The "glorious death" of Admiral Nelson in 1805 was an event which demanded a public commemorative monument and brought to the fore the question of support for artists to be employed by the state to decorate Westminster Hall, St. Paul's and other public buildings. Although King George III commanded a committee of the Royal Academy to prepare plans for the Nelson monument, no funds were available and the column in Trafalgar Square was not completed until 1867.

In 1809, William Blake made a private appeal to the public at the opening of an exhibition of his own works. Blake was sensitive to the problem of patronage because of his own difficulties, which had come to a head at this time. The son of a hosier, Blake had been sent to the Paris drawing school and apprenticed to James Basire, engraver to the Royal Academy and the Society of Antiquaries. Blake studied for a year at the Royal Academy before resuming his association with Basire's firm, an association which continued until 1784. During these years Blake evolved a singular linear style from a study of sixteenth-century draftsmen—Raphael, Michelangelo, Giulio Romano, Dürer—and English Gothic sculpture. Like Carstens, he rejected color, except as a secondary element. He may not have been able to receive instruction in the medium of oil painting, and the pictures he sent to the Royal Academy were executed in tempera or water color.

He developed his own techniques: one that he called "fresco," and another that was a form of relief etching. The latter technique, devised by the artist for his illustrated books, which were the fullest expression of his genius, may have been first suggested to him in 1787 by his lifelong friend George Cumberland. Blake's first successful book, *Songs of Innocence* (1789), combined his poetic and artistic genius as well as his skills as an engraver. The next year his first prophetic illustrated book appeared, *The Book of Thel* (1790). *The Marriage of Heaven and Hell* (1790–93), a prose work, was followed in 1793 by *Visions of the Daughters of Albion* and *America, a Prophecy*, the last with magnificent designs. The next year he issued *Songs of Experience*, in which each lyric poem of a sorrow parallels one of innocent joy from the *Songs of Innocence*. His symbolic poem, *Jerusalem* (1820), and his illustrations for the *Book of Job* (1825) are the summation of his talent as an exalted poet and artist.

To supplement his meager income from engravings and illustrated books of poetry, Blake supplied engravings of his own and after the drawings of others to be used for illustrations. John Flaxman entrusted to Blake the reengraving of his *Iliad* drawings (1795) and those for *Hesiod's Theogony* (1816–17). Blake was disappointed when the publisher J. H. Cromek gave his illustrations for Robert Blair's *The Grave* to another engraver and the artist later refused Cromek his illustration for *Canterbury Pilgrims*. When Cromek asked Stothard for a design, Blake determined to appeal to the public by means of an exhibition of the fresco of the illustration after Chaucer and his other works.

Blake had early been involved with the radical Friends of Liberty grouped around the American Thomas Paine, author of *The Rights of Man*. His friends and associates were republicans among the middle class who supported the rebels in America and followed with sympathy events in France. They called for reforms in England—among them public patronage of the arts—and all, Blake espe-

cially, believed in Rousseau's philosophy of general availability of art for all levels of society.

Blake believed his exhibition would serve two ends: to attract possible customers for his engraved Chaucer series, and to offer examples of art suitable for public buildings. His advertisement for the exhibit made both these intentions clear to the prospective visitor:

> The execution of my Designs, being all in Watercolours, (that is in Fresco) are regularly refused to be exhibited by the Royal Academy, and the British Institution has, this year, followed its example, and effectually excluded me by this Resolution; I therefore invite those Noblemen and Gentlemen, who are its Subscribers, to inspect what they have excluded; and those who have been told that my Works are but an unscientific and irregular Eccentricity, a Madman's Scrawls, I demand of them to do me the justice to examine before they decide.
>
> There cannot be more than two or three great Painters or Poets in any Age or Country; and these, in a corrupt state of Society, are easily excluded, but not so easily obstructed. They have excluded Watercolours; it is therefore become necessary that I should exhibit to the Public, in an Exhibition of my own, my Designs, painted in Water-colours. If Italy is enriched and made great by Raphael, if Michael Angelo is its supreme glory, if Art is the glory of a Nation, if Genius and Inspiration are the great Origin and Bond of Society, the distinction my Works have obtained from those who best understand such things, calls for my Exhibition as the greatest of Duties to my Country.

The exhibition opened May 1809 and was held in his brother's hosiery shop at 28 Broad Street, in the West End of London, far from the Strand frequented by the wealthy and the powerful.

Among the few visitors to the exhibition was Henry Crabb Robinson (1777–1867). Robinson had studied in

Germany and then was assigned there as a correspondent for the *Times*. He became its foreign editor and was sent to Spain to report on the Peninsular War of 1808. On his return to London he wrote a review of Blake's exhibition for Dr. Perthes, Philip Otto Runge's associate and editor of the Hamburg *Vaterlandisches Museum*. Sensitive to Blake's genius and appreciative of his artistic greatness, Robinson accepted Blake's allegories even if he could not decipher them. He was aware that the poem *Europe* "probably contains the artist's political visions for the future, but is wholly inexplicable" and tolerantly overlooked their obscurity, as well as that of the *Songs*, respecting without question Blake's artistic personality. Robinson did not, however, recognize Blake's plea for public patronage of the arts, one of the purposes of the exhibition explained in the catalogue. Blake's political ideology and convictions regarding the artist's place in society remained determining factors in his choice of subject and the form of his creative expression.

Henry Crabb Robinson, "William Blake; Artist, Poet, and Religious Mystic"[1]

The lunatic, the lover, and the poet
Are of imagination all compact.
 Shakespeare

Of all the conditions which arouse the interest of the psychologist, none assuredly is more attractive than the union of genius and madness in single remarkable minds, which, while on the one hand they compel our admiration by their great mental powers, yet on the other move our pity by their claims to supernatural gifts. Of such is the whole

[1] [Originally published in German in *Vaterlandisches Museum*, February 1810. Excerpts taken from K. A. Esdaile, "An Early Appreciation of William Blake," *The Library Quarterly Review*, Third Series, No. 19, Vol. V, July 1914, pp. 229–56.]

race of ecstatics, mystics, seers of visions and dreamers of dreams, and to their list we have now to add another name, that of William Blake.

This extraordinary man, who is at this moment living in London, although more than fifty years of age, is only now beginning to emerge from the obscurity in which the singular bent of his talents confined him. We know too little of his history to claim to give a complete account of his life, and can do no more than claim to have our information on very recent authority. It must suffice to know by way of introduction that he was born in London of parents of moderate means, and early gave himself up to his own guidance, or rather, misguidance. In his tenth year he went to a drawing school, in his fourteenth (as apprentice) to an engraver of the name of Basire, well known by his plates to Stuart's *Athens* and his engraving of West's *Orestes and Pylades*. Even as a boy, Blake was distinguished by the singularity of his taste. Possessed with a veritable passion for Gothic architecture, he passed whole days in drawing the monuments in Westminster Abbey. In addition he collected engravings, especially after Raphael and Michael Angelo, and idolised Albert Dürer and Heemskerk.

Although he afterwards worked as a student at the Royal Academy, he had already shown his bent to an art so original that, isolated from his fellow-students, he was far removed from all regular or ordinary occupation. His name is nevertheless to be found under some very commonplace plates to children's books; but while he cherished artistic visions utterly opposed to the taste of connoisseurs, and regarded more recent methods in drawing and engraving as sins against art, he preferred, in his phrase, to be a martyr for his religion—i.e., his art—to debasing his talents by a weak submission to the prevailing fashion of art in an age of artistic degradation. Moreover, as his religious convictions had brought on him the credit of being an absolute lunatic, it is hardly to be wondered at that, while professional connoisseurs know nothing of him, his very well-wishers cannot forbear betraying their

compassion, even while they show their admiration. One attempt at introducing him to the great British public has indeed succeeded, his illustrations to Blair's *Grave*, a religious poem very popular among the serious, which connoisseurs find remarkable alike for its beauties and defects, blaming its want of taste and delicacy, while admiring the imaginative powers of the poet. Blake, although properly speaking an engraver, was not commissioned to engrave his own drawings, the execution being entrusted, for reasons which we shall soon hear, to Schiavonetti, who executed his task with great neatness, but with such an admixture of dots and lines as must have aroused the indignation of the artist. This work, which besides the twelve drawings contains an excellent portrait of Blake and the original text; costs two and a half guineas. It is preceded by some remarks of Fuseli's, which we insert as a proof of the merits of our artist, since we cannot give an actual reproduction of his work. After mentioning the utility of such a series of moral designs in an age so frivolous as ours, before which the allegories of antiquity faint and fail, Fuseli continues, "the author of the moral series before us has endeavoured to wake sensibility by touching our sympathies with nearer, less ambiguous, and less ludicrous imagery, than that which mythology, Gothic superstition, or symbols as far-fetched as inadequate, could supply." . . . One can see this is no "damning with feigned praise,"[2] for the faults indicated by Fuseli are only too apparent. In fact, of all the artists who ever lived, even of those perverted spirits described by Goethe in his entertaining "Sammler und die Seinigen" (*Propyläen*,' B. 2. St. 2) under the title of poetisers, phantom-hunters and the like, none so completely betrays himself as our artist. We shall return to these drawings later, and will now proceed to speak of the little book on which we have specially drawn, a book, besides, which is one of the most curious ever published.

The illustrations to the *Grave*, though only perhaps ad-

[2] [The deliberate misquotation of Pope's familiar phrase may reflect general amusement over Fuseli's strong German accent.]

mired by the few, were by these few, loudly and extravagantly praised. Blake, who had become known by their praises, now resolved to come forward. Only last year he opened an exhibition of his frescoes, proclaiming that he had rediscovered the lost art of fresco. He demanded of those who had considered his works the slovenly daubs of a madman, destitute alike of technical skill and harmony of proportion, to examine them now with greater attention. "They will find," he adds, "that if Italy is enriched and made great by Raphael, if Michael Angelo is its supreme glory, if art is the glory of the nation, if genius and inspiration are the great origin and bond of society, the distinction my works have obtained from those who best understand such things calls for my exhibition as the greatest of duties to my country." At the same time he published a *Descriptive Catalogue* of these fresco pictures, out of which we propose to give only a few unconnected passages.[8] The original consists of a veritable olio of fragmentary utterances on art and religion, without plan or arrangement, and the artist's idiosyncrasies will in this way be most clearly shown. The vehemence with which, throughout the book, he declaims against oil painting and the artists of the Venetian and Flemish schools is part of the fixed ideas of the author. His preface begins with the following words: "The eye which prefers the colouring of Rubens and Titian to that of Raphael and Michael Angelo should be modest and mistrust its own judgement," but as he proceeds with his descriptions his wrath against false schools of painting waxes, and in holy zeal he proclaims that the hated artists are evil spirits, and later art the offspring of hell. Chiaroscuro he plainly calls "an infernal machine in the hand of Venetian and Flemish demons." The following will make it appear that these expressions are not merely theoretical phrases. Correggio he calls "a soft, effeminate, and consequently most cruel demon." Rubens is "a most outrageous demon." . . . He

[8] [For complete text of Blake's *Descriptive Catalogue*, see David V. Erdman, *The Poetry and Prose of William Blake* (New York, 1965).]

does not conceal the ground of this preference [for Raphael and Michelangelo], and the following passage, while it reveals the artist's views on the technique of his art, contains a truth which cannot be denied, and which underlies his whole doctrine. "The great and golden rule of art, as well as of life, is this: That the more distinct, sharp, and wirey the bounding line, the more perfect the work of art; and the less keen and sharp, the greater is the evidence of weak imitation, plagiarism, and bungling. Great inventors, in all ages, knew this: Protogenes and Apelles knew each other by this line. Rafael and Michael Angelo and Albert Dürer, are known by this and this alone. The want of this determinate and bounding form evidences the want of idea in the artist's mind, and the pretence of the plagiary in all its branches. How do we distinguish the oak from the beech, the horse from the ox, but by the bounding outline? How do we distinguish one face or countenance from another, but by the bounding line and its infinite inflexions and movements? What is it that builds a house and plants a garden, but the definite and determinate? What is it that distinguishes honesty from knavery, but the hard and wirey line of rectitude and certainty in the actions and intentions? Leave out this line, and you leave out life itself; all is chaos again, and the line of the almighty must be drawn out upon it before man or beast can exist. Talk no more then of Correggio, or Rembrandt, or any other of those plagiaries of Venice or Flanders. They were but the lame imitators of lines drawn by their predecessors, and their works prove themselves contemptible dis-arranged imitations and blundering misapplied copies." This passage is sufficient to explain why our artist was not permitted to engrave his own designs. In the same spirit he proclaims the guilt of the recent distinction between a painting and a drawing. "If losing and obliterating the outline constitutes a picture, Mr. B. will never be so foolish as to do one. . . . There is no difference between Raphael's Cartoons and his Frescoes or Pictures, except that the Frescoes or Pictures are more highly finished." He denies Titian, Rubens and Correggio

all merit in colouring, and says, "their men are like leather and their women like chalk." In his own principal picture his naked forms are almost crimson. They are Ancient Britons, of whom he says, "the flush of health in flesh, exposed to the open air, nourished by the spirits of forests and floods, in that ancient happy period which history has recorded, cannot be like the sickly daubs of Titian or Rubens. As to modern man, stripped from his load of clothing, he is like a dead corpse."

We now pass from the technique of his art to the meaning and poetical portions in which the peculiarities of our artist are still more clearly seen. His greatest enjoyment consists in giving bodily form to spiritual beings. Thus in the *Grave* he has represented the re-union of soul and body, and to both he has given equal clearness of form and outline. In one of his best drawings, the *Death of the Strong Wicked Man*, the body lies in the death agony, and a broken vessel, whose contents are escaping, indicates the moment of death, while the soul, veiled in flame, rises from the pillow. The soul is a copy of the body, yet in altered guise, and flies from the window with a well-rendered expression of horror. In other engravings the soul appears hovering over the body, which it leaves unwillingly; in others we have the re-union of both at the Resurrection and so forth. These are about the most offensive of his inventions.

In his *Catalogue* we find still further vindication of the reproaches brought against his earlier work. "Shall painting be confined to the sordid drudgery of facsimile representations of merely mortal and perishing substances, and not be, as poetry and music are, elevated into its own proper sphere of invention and visionary conception?" He then alleges that the statues of the Greek gods are so many bodily representations of spiritual beings. "A Spirit and a Vision are not, as the modern philosophy asserts, a cloudy vapour or a nothing; they are organised and minutely articulated beyond all that the mortal and perishing nature can produce. Spirits are organised men."

In a certain sense every imaginative artist must maintain

the same, but it will always remain doubtful in what sense
our artist uses these expressions. For in his own descrip-
tion of his allegorical picture of *Pitt Guiding Behemoth,*
and *Nelson Leviathan* [*Descriptive Catalogue* Nos. I and
II] (pictures which the present writer, although he has
seen them, dares not describe) he says, "these pictures are
similar to those Apotheoses of Persian, Hindoo, and Egyp-
tian antiquity, which are still preserved on rude monu-
ments." . . . As this belief of our artist's in the intercourse
which, like Swedenborg, he enjoys with the spiritual world
has more than anything else injured his reputation, we
subjoin another remarkable passage from his *Catalogue.*
His greatest and most perfect work is entitled *The An-
cient Britons* [*Descriptive Catalogue* No. V]. It is founded
on that strange survival of Welsh bardic lore which Owen
gives thus under the name of Triads:

In the last battle that Arthur fought, the most beautiful
 was one
That returned, and the most strong another: with them
 also returned
The most ugly; and no other beside returned from the
 bloody field.
The most beautiful, the Roman warriors trembled before
 and worshipped;
The most strong they melted before and dissolved in his
 presence;
The most ugly they fled with outcries and contortions of
 their limbs.

The picture represents these three beings fighting with the
Romans; but we prefer to let the artist speak of his own
works.

The three general classes of men who are represented
by the most Beautiful, most Strong, and the most
Ugly, could not be represented by any historical facts
but those of our own country, the Ancient Britons;
without violating costume. The Britons (say histo-
rians) were naked civilized men, learned, studious, ab-

struse in thought and contemplation; naked, simple, plain, their acts and manners; wiser than after-ages. They were overwhelmed by brutal arms all but a small remnant; Strength, Beauty, and Ugliness escaped the wreck, and remain for ever unsubdued, age after age.

Elsewhere he says that Adam and Noah were Druids, and that he himself is an inhabitant of Eden. Blake's religious convictions appear to be those of an orthodox Christian; nevertheless, passages concerning earlier mythologies occur which might cast a doubt on it. These passages are to be found in his Public Address on the subject of this picture of *Chaucer's Pilgrims*, certainly the most detailed and accurate of his works since, kept within limits by his subject, he could not run riot in his imagination [*Descriptive Catalogue* No. III].

These passages could be explained as the diatribes of a fervid monotheist against polytheism; yet, as our author says elsewhere, "The antiquities of every nation under the Heaven are no less sacred than those of the Jews," his system remains more allied to the stoical endurance of Antiquity than to the essential austerity of Christianity.

These are the wildest and most extravagant passages of the book, which lead to the consideration with which we began this account. No one can deny that, as even amid these aberrations gleams of reason and intelligence shine out, so a host of expressions occur among them which one would expect from a German rather than an Englishman. The Protestant author of *Herzensergiessungen eines kunst-liebenden Klosterbruders* [*Effusions from the Heart of an Art-loving Monk*; W. H. Wackenroder, 1797] created the character of a Catholic in whom Religion and love of Art were perfectly united, and this identical person, singularly enough, has turned up in Protestant England. Yet Blake does not belong by birth to the established church, but to a dissenting sect; although we do not believe that he goes regularly to any Christian church. He was invited to join the Swedenborgians under Proud, but declined, notwithstanding his high opinion of Swedenborg, of whom he says: "The works of this visionary are well worth the at-

tention of Painters and Poets; they are foundations for grand things. The reason they have not been more attended to is because corporal demons have gained a predominance." Our author lives, like Swedenborg, in communion with the angels. He told a friend, from whose mouth we have the story, that once when he was carrying home a picture which he had done for a lady of rank, and was wanting to rest in an inn, the angel Gabriel touched him on the shoulder and said, "Blake, wherefore art thou here? Go to, thou shouldst not be tired." He arose and went on unwearied. This very conviction of supernatural suggestion makes him deaf to the voice of the connoisseur, since to any reproach directed against his works he makes answer, why it cannot in the nature of things be a failure. "I know that it is as it should be, since it adequately reproduces what I saw in a vision, and must therefore be beautiful."

It is needless to enumerate all Blake's performances. The most famous we have already mentioned, and the rest are either allegorical or works of the pen. We must, however, mention one other of his works before ceasing to discuss him as an artist. This is a most remarkable edition of the first four books of Young's *Night Thoughts*, which appeared in 1797, and is no longer to be bought, so excessively rare has it become. In this edition the text is in the middle of the page; above and below it are engravings by Blake after his own drawings. They are of very unequal merit; sometimes the inventions of the artist rival those of the poet, but often they are only preposterous translations of them, by reason of the unfortunate idea peculiar to Blake, that whatsoever the fancy of the spiritual eye may discern must also be as clearly penetrable to the bodily eye. So Young is literally translated, and his thought turned into a picture. Thus for example the artist represents in a drawing Death treading crowns under foot, the sun reaching down his hand, and the like. Yet these drawings are frequently exquisite. We hear that the publisher has not yet issued a quarter of the drawings delivered to

him by the artist, and has refused to sell the drawings, although a handsome sum was offered him for them. . . .

We have now given an account of all the works of this extraordinary man that have come under our notice. We have been lengthy, but our object is to draw the attention of Germany to a man in whom all the elements of greatness are unquestionably to be found, even though those elements are disproportionately mingled. Closer research than was permitted us would perhaps shew that as an artist Blake will never produce consummate and immortal work, as a poet flawless poems; but this assuredly cannot lessen the interest which all men, Germans in a higher degree even than Englishmen, must take in the contemplation of such a character. We will only recall the phrase of a thoughtful writer, that those faces are the most attractive in which nature has set something of greatness which she has yet left unfinished; the same may hold good of the soul.

DRESDEN: The Exhibition
in an Artist's Studio

Dresden, the capital of Saxony, was called "the German Florence" not only because of the river, the bridges and the handsome palaces, but also because of the splendid collection of paintings and sculpture, the Academy of Art, and the patronage the arts enjoyed at court. Writers, artists, musicians and connoisseurs were attracted to the city. Then, in December 1808, although performances of German plays and the Italian opera were well attended, pedestrians on the Brühl Terrace looked with apprehension down the Elbe River. They had seen the remnants of Frederick the Great's once invincible Prussian army straggle across the bridges and their own soldiers return after their defeat at Jena by Napoleon only two months before. Packing cases still stood ready in the art gallery to save from French confiscation the treasured Italian, Dutch and Flemish paintings and Anton Mengs's collections of casts of classical sculpture. When members of the Reading Club gathered at "Resource," a suite of rooms appropriate for keeping the communal subscriptions to the *Zeitung für die elegante Welt, Der neue teutsche Merkur* or the avant-garde *Phöbus*, they debated, as people did wherever they gathered, the possible consequences of the Congress of Erfurt that Napoleon had held September 27 with Tsar Alexander, four German kings and thirty-four princes. Everyone in Dresden was aware a lull prevailed only until forces could gather for the next storm.

Confronted by the rise of French nationalism and aggression, they and Germans everywhere found security in a deepening consciousness of nationality as defined in the

writer-philosopher Johann von Herder's concept of a unity of nature, culture and people. This consciousness led to an exploration of their Nordic roots in legends and sagas. The *Volkslieder* (folk songs) which had become increasingly popular were converted to *Freiheitslieder* (songs of freedom) as the French occupied principalities along the Rhine. Three volumes of folk poetry were collected and published as *Das Knaben Wunderhorn* (1806–8) by Achim von Arnim and his brother-in-law, Clemens Brentano.

Like the literary sagas of Edda and Ossian, works of northern artists had been established as worthy of imitation by Wilhelm Wackenroder's *Herzensergiessungen eines kunstliebenden Klosterbruders* (*Effusions from the Heart of an Art-loving Monk*; 1797), which told of the monk's pilgrimage to Nuremberg and of his revelation, received in a dream, that Albrecht Dürer was in "the same room" with Raphael. Wackenroder's writings strengthened the pietistic painter Caspar David Friedrich, a native of Greifswald, in his natural inclination to a pantheistic approach to the world. Although schooled in classical composition at the Copenhagen Academy of Art, Friedrich endeavored to find a style which would enable him "not just to paint what he sees before him but also what he sees within himself."[1]

When the young, devout Countess Maria Theresa of Thun-Hohenstein saw Friedrich's drawing *The Crucifixion in the Mountains* at the Academy exhibition, she commissioned the artist to execute it as an altar painting for a chapel in the Thun ancestral Castle at Tetschen in Bohemia. The painter entrusted the execution of the frame to a friend, the sculptor Gottlob Christian Kühn. Shortly before Christmas 1808, Friedrich placed the altarpiece on a table in his studio and opened the door of his studio to the public.

The exhibition of the Tetschner Altar aroused strong reactions. Instead of the usual iconographical elements,

[1] [Kermit S. and Kate H. Champa, *German Painting of the Nineteenth Century* (New Haven, 1970), p. 42.]

Friedrich had selected familiar natural forms and arranged them in a composition to convey a symbolic meaning and thereby achieved a startling effect of immediacy.

Those who favored Friedrich's altarpiece were his associates: the artist Philip Otto Runge, the poet-painter Friedrich von Klinkowström, and Ferdinand Hartmann and Gerhardt von Kügelgen, both of whom had been friends of Carstens and Fernow in Rome. These artists were opposed to the classicism which Goethe envisioned as the "correct" one for the "new" German school and had helped to foster by the Weimar exhibition competitions. Taking exception to his own theoretical position, Goethe intervened in the 1805 competition to award Friedrich half of a prize for two sepia drawings unrelated to the assigned classical subject because of his emotional response to the works.

Temporarily gathered in Dresden and associated with the artists was a group centered around the philosopher and political scientist Adam Müller and the writer Ludwig Tieck. Tieck, friend and posthumous publisher of Wackenroder and Friedrich von Hardenberg ("Novalis"), had come from the circle grouped around August and Friedrich von Schlegel in Jena. The Schlegels had employed the term "romantic" to expand the connotation of "Nordic" to include medieval Christian elements; Mme. de Staël used the word "romantic" in this sense in De l'Allemagne (Germany; 1810). The poet-dramatist Heinrich von Kleist came to Dresden in 1807, arriving from Königsberg, where the Prussian court took residence when Napoleon occupied Berlin in 1806. Von Kleist and Müller founded the avant-garde literary review Phöbus. Gotthilf Schubert, the popular writer and lecturer on dreams and animal magnetism, collaborated as an editor.

Some who visited the exhibition of Friedrich's altarpiece were as moved as Marie von Kügelgen, who wrote her husband, "It affected everyone who entered the room as if they stepped into a church. The most loud-mouthed spoke softly and seriously as if in a church." Another visitor was a lawyer from Hanover, Friedrich W. Basil von Ramdohr,

an academic classicist less open-minded than Goethe. He had come to Dresden with the empty title of court chamberlain, given him by the Prussians when Hanover was temporarily assigned to Prussia in 1805, only to be taken away in 1806. Ramdohr had busied himself in Dresden writing of his experiences as a jurist and serving as a spokesman for the academic classical connoisseurs. He was considered well qualified, for he had studied aesthetics as well as law at Göttingen University. After a half year in Rome (1784) with Johann Reiffenstein, a painter, archaeologist and dealer in casts of antiquities, as his tutor, guide and host, Ramdohr had published *Über Malerei und Bildhauerarbeit in Rom* (1787). This had been followed by a similar work, *Über die Kopenhagener Galerie* (1792), with a detailed account of the Academy's course of instruction. His two books on aesthetics, *Charis* (1793) and *Venus Urania* (1798), had aroused the antagonism of romanticists such as Wackenroder. In January 1808, Ramdohr indignantly questioned in the *Zeitung für die elegante Welt* Friedrich's use of a landscape painting as an altarpiece and the philosophy that justified it. In doing so, Ramdohr enumerated his conception of the features of the traditionally acceptable landscape and described Friedrich's startling innovations.

An immediate defense of Friedrich's painting written by Gerhardt von Kügelgen appeared in the *Zeitung für die elegante Welt*. Another by Ferdinand Hartmann was published in *Phöbus*. In another issue, owner-editor Adam Müller expostulated in "On Landscape Painting" on the validity of the personal response to a work of art and the pleasure thus derived. Read at Müller's popular evening circle that winter were Kleist's current dramas *Amphitryon* and *Penthesilea*, in which by a new use of language everyday people and their emotions were made mysterious, shocking and disturbing. In this way he changed familiar forms of literature much as Friedrich was changing the forms of painting. The *Journal des Luxus und den Mode* published in Weimar by C. A. Semler prolonged the discussion of Friedrich's works by subsequent commentary.

Friedrich, Ferdinand Hartmann and Kügelgen remained in Dresden, where Kügelgen later became a professor at the Academy and was eventually killed by a bandit, but events soon scattered other members of the group. Runge returned to Hamburg. Ramdohr served as the Prussian consul in Rome from 1811 until he was transferred to the kingdom of Naples as ambassador in 1816, where he died in 1822. Adam Müller and Heinrich von Kleist moved to Berlin: Müller was named a professor at the new university and Kleist went in 1810 full of hope for a new opportunity.

F. W. B. von Ramdohr, "Remarks concerning a landscape painting by Herr Friedrich in Dresden"[1]

A landscape painting intended as an altarpiece and concerning landscape painting, allegory and mysticism in general: I do not like to come out publicly with a criticism of a work from the hand of a contemporary artist. If the altarpiece which the landscape painter Herr Friedrich exhibited here in Dresden during the Christmas holidays just past were a work executed according to those principles that long experience and the example of great masters have sanctioned—whether it were excellent or poor—I would remain silent. Were it a work without effect, without bewitching charm for eye and fantasy, without the hint of an uncommon talent in the artist, I would again remain silent. The ordinary and the poor fall of themselves. It is a maxim of intelligence not to jeopardize unnecessarily their place in literary relationships. But Herr Friedrich's picture deviates from the common path. It opens a new, hitherto—at least to me—unknown view of landscape painting. It gives evidence of an imaginative,

[1] [Translated from *Zeitung für die elegante Welt*, Nos. 12, 13, 14 and 15, Dresden, January 19–21, 1809, pp. 91–94, 97–102, 105–10, 113–18.]

sensitive artist; it is in accord with the public's opinion; it produced an effect upon the great crowd. But now when I see that the tendency which talent takes here is becoming dangerous to good taste; that it robs the essence of painting, particularly landscape painting, of its most distinguishing characteristic; that it relates to a spirit that is the unfortunate spawn of the present age, and the dreadful omen of a rapidly onrushing barbarism—now it would be pusillanimity to remain silent: . . .

I repeat; I say it more clearly and definitely: my criticism is not directed simply against Herr F.'s picture, but the system that projects from it: against a group of concepts which seem false to me and which are now creeping into art and science: against mistakes that in part the picture does not show, though those it does show are closely connected. The public will therefore forgive me if I bring to its hands such a lengthy treatise about a single picture. . . .

Before I proceed to a description and judgment of the altarpiece by Herr F., I must anticipate an objection which, if it were well founded, would immediately silence my criticism. One can say, "The picture produces an effect; what more should one ask?" Indeed it does produce an effect and therefore proves that Herr F. possesses what Diderot called *le secret*. But precisely because Herr F. possesses this valuable talent he must be doubly watchful not to misuse it to the detriment of art. Otherwise the "secret" of evoking emotions among the great mass becomes dangerous charlatanry. Effect proves nothing about the goodness of a work. When Algardi and Bernini *painted* in their sculpture, when Cortona and his followers indulged their imagination in their painting, and Boucher and his school joked in a lewd fashion in the same manner, their contemporaries marveled at what now gives rise to disapproval and in part disgust. A beautiful work of art should lay claim to our admiration and that of all centuries after us. It receives this power from the genius of the artist, from his "secret," but that element of this power which always lasts, its permanence, is bound to the

observance of such principles as are derived from the most
characteristic essence of that form to which the work be-
longs. . . . There is no doubt that behind the natural
scene presented by the painter an allegorical meaning lies
hidden, intended to evoke in the viewer a pious mood
akin to partaking of the Lord's Supper.

What is this allegorical meaning? I intend to unravel it.
If I have seen less than I should see, so much the worse
for Herr F. Why did he not express himself more clearly?
Why did he, in a painting which is meant to edify so
many, count upon the acuteness of a select few?

I imagine Herr F. saw this natural scene himself: he ex-
pressed the emotions which it awakened in him. I will
allow him to comment upon his painting:

> Everything was still around us when I came into the
> area that gave me the material for the picture which
> here stands on display. Behind the mountain that lay
> before me, the sky was already brightening. Red strips
> traversed it to announce the approach of day. The
> reflection of several rays on the firmament already
> showed the sunrise; the view of it was hindered by the
> intervening mountain. Hidden deep behind the
> mountain was the sun. The separate parts of the earth
> mass were sensed in an uncertain brightness rather
> than discovered. But the outline of the mountain
> stood out sharply against the sky. At the very top
> stood a crucifix, its face turned toward the far side of
> the mountain. I concluded this from a few places
> which the sun's rays illuminated. How meaningful
> this sight! Christ the crucified one in a solitude. At
> the partition between darkness and light! But
> enthroned high above the highest in nature, visible to
> all who seek Him! But He, He views the light face to
> face, and to us, whom twilight surrounds in this vale
> of tears, we, whose dull eye may not yet bear the full
> splendor of clarity, to us He imparts only a reflection
> of the same! Thus, a proclaimer of the salvation that

awaits us, He becomes simultaneously the mediator between earth and heaven. And we, we take heart, we rejoice at His message, His service, just as we rejoice at the approach of the sun when after a dark night we perceive its faint illumination and its effects earlier than its appearance. Here I felt the need to celebrate that commemorative feast which, itself a secret, be comes the symbol of another: the Incarnation and the Passion of the Son of God!

If I might flatter myself with the hope of having wholly comprehended Herr F., I would cry out: Much, much fantasy! But when and where? If I had read this description in the confessions of a pious soul, in a novel in the taste of *Atala!*[2] Yes! If the owner of a chapel in the vicinity of this mountain with the crucifix were to have an opening set in the altar, and the gaze of the faithful who approach the altar were led by perspective toward the scene in nature, the idea would be fanciful enough, but I could imagine that, considered from certain viewpoints and at a certain hour of the day, the view could summon many a pious soul to a solemn mood similar to one Herr F. might have experienced.

But here we have a painted picture, a work of art before us, and here quite different questions come into consideration.

Can the indicated scene of nature be painted without sacrificing the most essential merits of painting and particularly of landscape painting? Is it a happy thought to use a landscape as an allegory of a specific religious idea or even to devotion? Finally, is it compatible with the dignity of art and the truly pious man to invite to worship by such means as Herr F. has employed?

I intend to answer these questions one after the other.

2 [René de Chateaubriand's *Atala ou les amours de deux sauvages dans le désert* (1801), published on his return from America, established his fame, which was heightened by his *Génie du christianisme* (1802). His writings opened the romantic movement in French literature.]

To the answer for the first, however, I will join an exami-
nation of the worth of the execution.

The intent here cannot be to expound a theory of land-
scape painting, least of all my own. I must, nevertheless,
determine a few basic principles which must be evident to
any, even the layman, and which have a direct bearing
upon Herr F.'s painting. . . .

Landscape painting [in contrast to figure painting] lays
down before me a surface upon which it has arranged a
group of objects—one cannot in painters' terms call them
all figures—layer by layer, like stage scenery, one behind
the other, shown to me always from some distance. In this
way, it counts upon my attention concentrating upon what
I want to recognize and examine in a view into open na-
ture. . . . The definite, graduated divisions, the unsepa-
rated flowing together of the outlines would destroy the
character of inanimate, open nature. Landscape painting
must, therefore, renounce the pleasing form of organic
nature. But inanimate, open nature has, on the other hand,
a different sort of pleasing form which flows forth from
the arrangement in layers of the objects that project from
behind each other at different distances: a pleasing form,
which grottoes in nature, the perspective of a stage, and
the excellent arrangement of landscapes of a Nicolas
Poussin make comprehensible. . . .

In regard to color, landscape painting cannot deliver the
local tones so faithfully, that is, expose them to so close an
examination, as can figure painting. Between my eye and
the objects which the landscape painter represents, colored
for me in the distance, so much air always presses in that
a sort of fog or haze is formed which not only modifies the
local color but transforms it. The more distant the objects
are from me, the more conspicuous these changes become.
The brown or green color of a mountain becomes violet,
blue, and so forth. . . . What immeasurable advantage
has Claude Lorrain drawn from the transformation of
colors through aerial perspective! Let us designate the

properties of coloring in landscape painting according to this aerial perspective.

Finally, landscape painting does not consider light merely as a means of modeling figures, of setting off pleasing form and the charm of color. No! It paints light itself and to this representation it joins the most piquant effects. One need only consider a sunrise by Claude Lorrain, a forest with beams of light shining through it by Ruisdael, and several similar works by Cuyp and other Dutchmen where the rays of the sun seem to gild the object upon which they fall! . . .

The pleasing form of linear perspective is especially characteristic of landscape: its distinction is the charm of the picture's general tone and aerial perspective in color and light; only linear perspective has completely at its command the most piquant effects of light in open air. . . .

Herr F. has wholly, and quite intentionally, violated in his altarpiece all these basic principles. He has, without noticeable indication of different layers, filled the entire base of his picture with the single crag of a cliff, like a cone. He has rejected all aerial perspective—yes! and worst of all, he has spread a darkness over the earth and thereby abandoned all the favorable effects that an influx of light can offer. . . .

The execution of the picture evinces all the results that invariably follow the neglect of the principles I set up.

The painter has taken no point of view at all; nor could he have taken one, to express what he wanted to express.

In order to see the mountain simultaneously with the sky in this relation, Herr F. would have had to stand several thousand paces away, on the same level with the mountain and in such a way that the line of the horizon parallels the mountain. From such a distance he would not have been able to see any detail within the outline of the mountain: no granite boulders, no moss, no trees which surrounded the front side of the mountain. . . .

What led Herr F. to stray—to make this mistake that

insults all the rules of optics—is either that he cast an artificial light against a clay or wax model of the mountain, or imagined that he stood at the side of the mountain and not behind it. In the latter case, the sunlight would indeed have fallen across the mountain, which lies much lower than the sun; but then not merely the crucifix would have been illuminated, and least of all, from below, but rather everything located upon the mountain would have been illuminated by parallel light. Standing behind the mountain, Herr F. could see nothing at all of the sun's rays, as little as if he had held his hand horizontally in front of his eyes.

Another error in the picture is that the time of day remains uncertain owing to the loss of all surfaces. The coldness of the air speaks for morning, the lack of fog against it. Apparently the silver star on the highest angel's head in the frame is to replace this loss. But Herr F. could just as well have written: "Here is morning! . . ." But the treatment of the mountain leads to a faulty method which regrettably finds at present too many adherents for me not to use this opportunity to state my case against it.

Some painters who have not devoted themselves exclusively to art until their later years and feel the lack of an earlier technical training try to make up for it by doubling their attentiveness to copying nature as carefully as possible. The example of Albrecht Dürer and several other old masters may be cited. They expressed every hair in a beard, every fiber in a plant with anxious concern for the model and for their works. Finally, some are also led astray by the idea, attractive in itself, of stamping the German school with a peculiar national character of honest faithfulness and unassuming truth.

But these men forget that a timid imitation of detail of form does not give any object in nature its true character: that Albrecht Dürer and his whole school would have provided Nuremberg with wretched knickknacks if from early youth they had not sharpened their feeling for the essential element in every form and trained their hands in that

freedom which contributes so much to creating a natural impression. . . .

Woe to the artist who has not from earliest childhood sharpened through long years of practice his inborn feeling for what is characteristic of forms and does not seek to retain and extend it daily through renewed observation and study. But woe also to him who, born without a memory for or an imagination of forms, needs to peer continually at the individual model while executing his painting in order to see how nature is represented in an individual example. Not even a good portrait can be made if the artist does not have his original in his head as well as before his eyes.

In the case of landscape painting, a careful copying of detail of forms is indeed entirely inappropriate. Everything in the landscape is offered to the eye *en masse* and allows no other detail than what is necessary to characterize the mass. Not to mention the impossible: to copy timidly on the spot large objects in nature.

Herr F., however, did not let this stop him from employing this censured method for the landscape. How did he do it? Since he could not take the mountain along, he substituted a model of clay or wax; for the trees, which likewise could not be easily transported, he pressed in tops of firs and Scotch pines, and instead of the boulders of granite, single granite pebbles and moss. Behind this mass he placed an artificial light and himself before it and diligently took the portrait. This is the only possible approach by which one can explain even to a limited extent the treatment of the picture. Every twig, every needle on the firs, every spot on the granite boulders is expressed: the exterior outline is perfectly exact. But neither the firs nor boulders have come from this. Silhouettes without modeling, and at most, specimens from a herbarium or from a mineralogical collection. One might here paraphrase Wieland's[3] famous line:

You cannot see the tree for all the twigs.

[3] [Christoph Martin Wieland. See 1800: WEIMAR.]

What would Ruisdael and Everdingen[4] say to such firs and boulders!

I think I have proved that Herr F. has not produced a good landscape painting. . . . But I feel too strongly about this type of art to stop here.

Thus, to continue: *Is it a good idea to employ a land-scape as the allegory of a certain religious idea, or even simply to arouse reverence?* . . .

It is doubtful whether the artist copying a subject should work toward an emotional sentiment, that is, toward the production of an emotionally charged condition in the spectator similar to the one he himself receives from the subjects in nature he depicts. I have shown in my earlier writings the dangers which threaten such an intentional tendency. An aesthetic sentiment is quite different from an emotional one. The latter plays only with our sensibilities, belongs to the character and to the expression of every work of art, and stands as all the others at the command of the imitative arts. I must inject the remark that in regard to the strength of the sentiment, even the aesthetic sentiment, the imitative arts cannot at all compete with music, dance and poetry. . . .

But the imitative arts do, indeed, in the case of the aesthetic impression which they want to produce, count *mainly* upon the association of ideas which the depicted objects awaken and by virtue of association of ideas they are in a position to awaken, unlike music, not merely an indefinite, dark impression, but rather a definite aesthetic impression dependent upon particular situations and relations. Only, let one not believe that the rhythm in drawing, color and light is indifferent in this respect. It can always support this association of ideas well and, at least, may never contradict it. . . .

Let us now see how far it is possible to allegorize with landscape. Allegorical paintings are such as depict percep-

4 [Seventeenth-century Dutchmen given to rocky landscapes, Ruisdael's gloomy, Everdingen's wild and rugged (after a four-year sojourn in Norway).]

tible objects under such conditions in the picture as we are not accustomed to see the perceptible objects in everyday life and in the story or fable that belong to the picture. This strange relation of the perceptible to its manifestation in a set of circumstances different from normal in the picture is what makes us aware of the secret meaning and is the basis of the allegory and helps to solve it.

How is it then possible in a landscape to change the visible, familiar condition of objects into one so strange that we say to ourselves: Here is allegory? Indeed, one could set the earth above, the sky below, put pastry on the trees as foliage, et cetera. But then nature itself is destroyed. Figure painting can retain its nature while allegorizing. It broadens this nature through the fable; it differs from the customary view of things principally in the depiction of customs and attributes. Nevertheless, where it cannot give the allegory at least a moral probability and offer in addition to the allegorical meaning a purely human or historical one, there it may not attempt allegory at all.

Let us not confuse the expression of landscape with allegory! In the gallery at Dresden there is a landscape with a cemetery by Ruisdael.[5] A replica in larger proportions, which is considered original, is in the possession of M. Tourton in Paris. It is a masterpiece of expression. It depicts a scene representing a common situation of human life and awakens not merely a generally solemn mood but the definite solemnly religious emotion that arises from the consideration of the nothingness and transitoriness of all things human. But where is the allegory? Nowhere but in the average prosaic brain of presumptuous declaimers who dare to wax poetical when they joke coldly with symbols and to awaken emotion when they reason about emotion. . . .

The allegorical meaning of a landscape must always be sought outside the painting; it is determined either by the place where the painting is to be set up or by the frame. This Herr Friedrich also did and had to do, since, hung

[5] [*The Jewish Graveyard*, c. 1655, State Picture Gallery, Dresden.]

up in a public gallery without this frame, his landscape
would have to count as simply the depiction of a poorly
selected nature scene and the crucifix as a mere accessory
figure or fabrication. But he did not consider that an inde-
pendent work of art is thereby degraded to a bare symbol,
which, like the scales in the hand of Justice, receives its
explanation only through one raising the question: How
did you come here into this frame, into this chapel, upon
this altar?

"But," one will protest to me, "since a landscape can
supply the expressive scene for a very general but definite
situation of human life, why should it not depict the re-
gion where every educated person gives himself up so
willingly to devotion? God's holy nature is His most beau-
tiful temple!"

Here the important difference between emotional and
aesthetic feeling comes into consideration.

Go into the true nature! The fresh air which you inhale,
the true splendor of the sun, the height of the mountains,
the broad expanse of surfaces, et cetera, affect directly all
your organs, awaken and strengthen through tension and
relaxation and piquant enticement of the nerves those
ideas of grandeur, well-being and life in general which
move every refined spirit to love, gratitude and admiration
for the Creator. It is absurd to expect such truly emotional
sentiments from a painting which completely lacks the
means for it. What it offers is an aesthetic sentiment
whereby we, always conscious of the distance from real
life, enjoy the game which art plays with our sentiments.
Were it possible for art to transport us into a true emo-
tional sentiment, the aesthetic one would fall away, the
work of art would pass over into nature, the enjoyment of
the beautiful into the pleasure of sympathy. Would that
be an advantage for the work? Not at all! Any relic of a
commonly venerated saint set up on the altar can awaken
an emotional sentiment stronger than the most beautiful
work of art, and the grossest caricatures have a more un-
disputed claim to this advantage than the most beautiful
painting.

If the painting is not to be the actual basis of our emotional sentiment, of our true devotion, should it lie in the pious action itself that we perform in front of the altar; should the work of art only *support* this mood through aesthetic sentiment? In how much closer relation, then, to this purpose historical painting stands! It, which paints devotion itself! It, which depicts for us events we have known about since youth, whose gentlest intimation excites a crowd of the most moving facts, traits and words! . . .

Indeed, it is true presumption when landscape painting wants to slink into the churches and creep onto the altars.

But! Let us leave all that aside and explore the most important.

Is it compatible with the dignity of art and the truly pious man to invite to devotion by such means as Herr F. has employed?

Here I must mention the fame which surrounds the picture. It stands in direct contact with the painting and it forms the most integrating factor in the altarpiece, for without it the allegory would not be understandable at all: and this frame itself forms the composition on the altar. In addition, the carved and silver-coated morning star at the top above the picture is evidently a designation of the time of day represented.

When I stepped into the room where the painting was displayed here in Dresden, I found it in its frame standing on a brown table and covered with a black cloth.

The frame, however, is without any relation to the picture.[6] Below is a large pedestal to which steps are

[6] [Friedrich's explanation of the frame, which was prepared after his design by the sculptor Gottlob Christian Kühn, is the following: "The side is formed of two Gothic columns. Palm branches rise from these and arch over the picture. In the palm branches are five angel heads looking down to the cross in adoration. Above the central angel is the silver evening star. In the space below, the all-seeing eye of God is enclosed in the holy Triangle. Rays of light go out from it. Ears of wheat, clusters and branches of grape incline toward the all-seeing eye and point to the Body and Blood of Him who is fastened to the cross." Translated from K. Eberlein, *C. D. Friedrich Bekenntnisse* (Leipzig, 1924), p. 205.]

affixed. In the middle of the frame, one sees an eye in a triangle surrounded by rays, and on either side a winding grapevine and an ear of wheat. Upon this pedestal rest two Gothic columns formed from several staffs. From the capitals project palm branches which meet above to form a sort of arbor. Children's heads with wings [on the heads] peer forth from among the branches. Above the uppermost child's head stands a silver-coated star. The rest is gilded.

If one joins these emblematic elements with the allegory of the painting and weighs the tendency of the whole— with the sacrifice of truth and taste, with an idea, indeed reverential in itself and consoling, of our religion, yet not at all aesthetic: of making corporal the belief in the mysterious effects of the Lord's Supper—how is it possible to mistake the influence that a currently dominant doctrine has had on Herr. F.'s composition? That mysticism which currently slinks in everywhere and wafts across us like a narcotic vapor from art as well as learning, from philosophy as well as religion. That mysticism which supplies symbols and visions for artistic and poetic pictures and would like to confuse classical antiquity with Gothic carvings, rigid *Kleinmeisterei*[7] with legends. That mysticism which sells word games instead of concepts; builds principles upon remote analogies and everywhere cares only to have a presentiment where it ought either to know and recognize or else modestly keep silent. That mysticism for whose followers ignorance of facts and literature serves as a shibboleth. That mysticism which prefers the times of the Middle Ages and its institutions to the age of the Medici, Ludwigs and Fredericks. That mysticism which would like to confuse the brave, vigorous enthusiasm which goes very well with the true religion of Christ with a languishing, hypocritical, exaggerated devotion for the Cross. That mysticism, finally, which makes me tremble in fear for the consequences of the present times and reminds me of those who toward the end of the Roman

7 [*Kleinmeisterei* refers to a sixteenth-century guild of fine copper engravers.]

monarchy brought the decline of true learning and taste! For then as now, neo-Platonic Sophists, Gnostic and Orphic shamans appeared on the scene. Then as now, one played with legends, with declamations, with amulets and symbols: then as now, art was crippled through the presumption of leading it back to its first simplicity. Brave Friedrich, and all you men of talent and genius whom fashion led away for a time from the true path, turn back to the style that experience has shown you to be tried and true. That vogue will not easily spread in places where history is taught with thoroughness and classical antiquity is preached with taste, anywhere that ability and knowledge are the chief purposes of the artist and the scholar. But in the principal cities, in the vicinity of the courts, in any place where diversion prevents men from studying thoroughly whatever lies outside the circle of business life; where art and learning are chiefly used only as material for light, social entertainment; where saturated sensuousness seeks out renewed enticement and increased pleasure in the imagination; there, I say, such teachings which pass off word games, pictures, facts comprehended in a one-sided fashion, clothed in rich-sounding phrases, will gain admission as knowledge and wisdom, and particularly, as far as art is concerned, babble constantly about godliness and good-naturedness without postulating the first requirement for both—truth and a skilled hand!

Gerhardt von Kügelgen, "Remarks of an artist concerning the criticism by the Court Chamberlain von Ramdohr on a picture exhibited by Herr Friedrich"[1]

However much this artist's delicate self-esteem is affronted and offended by this truly ungenerous essay, one must still

[1] [Translated from *Zeitung für die elegante Welt*, No. 50, March 11, 1809, Dresden, pp. 389–92.]

acknowledge Herr von R.'s desire to lead those artists who, in his opinion, are wandering about in a state of uncertainty back to the proper path. One can also agree with some of the theses that he has established for landscape painting. Allow me, as a practicing artist, only to argue with the manner and fashion Herr von R. uses to force Herr Friedrich's efforts into these theses and to set such narrow limits for the field of art. May Herr von R. forgive me if I call his procedure in this matter dictatorial and fail to recognize why he should feel called upon to follow it. Another artist, Herr Hartmann, has very thoroughly also made it evident to Herr von Ramdohr in an essay in *Phöbus*. In all classical works we find the idea or inner intellectual content and the form or outer arrangement of the work of art joined as a whole in the most beautiful union, like soul and body. As the body takes its shape according to the germ of life, so does the work of art receive its outer form according to the idea and the feeling which the artist wants to articulate; indeed, [the idea and feeling are articulated] only through this form, which is admittedly arranged in keeping with rules, but one not only finds these rules but also invents them, as the first artists, who did not inherit these rules from Adam, had to do.

Why then should Herr F. not also be able to shape the outer form in his own fashion, corresponding to his idea and according to his feeling, which is certainly recognizable? Why, because it belies the rules Herr von R. finds in the old classics. Yet had the ancients always been satisfied with. the ancient, would art then have progressed? . . .

Let me ask only the question: which presumption would indeed be greater—that of elevating the spirit to devotion with objects from a landscape, that is, causing us to feel within ourselves our better soul, which indeed every work of art should accomplish (Herr von R. says landscape painting wants to slink into churches and creep onto the altars)—or that of disparaging with such expressions the fine endeavor of a genius developing itself and of

designating with his own laws the boundaries of how far art can go?

Where Herr von R. declaims against mysticism, he may be entirely right. But I do find it wrong of him to want to push Herr F. into this senseless and shapeless crowd of mystics. Herr F.'s spirit, filled by true devotion, wants only to go entirely on its own, a course for which Herr von R. predicts great misfortune. If the hypocrisy from which our age suffers should receive too much nourishment from the piety one perceives in Herr F.'s pictures, and if his (i.e., F.'s) view of landscape painting should presume to pass as the only prevailing one—then would be the time to show the aberrant side in this endeavor.

It is indeed sad that almost all contemporary criticisms of art prove so little and that these gentlemen, the art critics who themselves know so little of what they should ask and think of art, act for propriety's sake as if they were initiated into the most intimate secrets of the goddess. Usually one reproaches the artist with the fact that one sees in his works too many reminiscences of old classics and too little originality. Then one censures this same originality when it appears, and wishes to be reminded more of the classical works. Would that these critics might once come to the quite simple idea of judging every work of art according to the vitally warm impression that it makes upon the senses and the spirit, and of censuring those that are cold, sluggish and untrue. There are rules in art, of course, just as there are laws in the citizen's life. But if they are difficult to find and uphold in the latter, how much more so are they in the spiritual life of art. Throughout its history we see art consent to varied forms, and who among us is able to determine whether it might not [in the future] agree to forms as yet unknown? Herr F.'s originality should be all the more welcome to us, since it offers us a previously little known form of landscape painting in which, along with its peculiarity, a spirited striving after truth is revealed.

May the public begin to think well of artists and to de-

velop the ability to recognize the good and the true, rather
than the opposite, as it has done until now. Then the art-
ist might receive encouragement and certainly not be
turned away from his inspiration.

Permit me to cite another remark of Herr von R.'s,
namely that our age, spoiled by the grand style of
Michelangelo and Raphael, cannot pay homage to the in-
significance of recent apostles of art. Would that he had
spoken truthfully, that it were not easier to show him
proof of the opposite, and that where he fancies grandeur,
only emptiness is to be seen which, derived from gay Eng-
lish copper engravings and a mania for forms aping the
style of antique statues, regrettably still prejudices too
much the taste of our age.

1808–10

BERLIN: The Official Exhibition
of the State

In the spring of 1809, King Frederick William III of
Prussia had returned to Berlin from East Prussia. Re-
sponding to the current movement toward national renais-
sance, he named the philologist and man of letters Karl
Wilhelm von Humboldt as his Minister of Education, es-
tablished the Frederick William University in the Prince
Heinrich Palace on Unter den Linden, and made plans for
the embellishment and reorganization of the capital with
David Gilly, which were finally executed five years later by
Gilly's pupil, Karl F. Schinkel. Scholars and writers al-
ready in Berlin were joined by those from other centers;
among them were Achim von Arnim and Clemens Bren-
tano, who had been leaders of the small Heidelberg group
of the younger generation of romanticists and were ardent
patriots.

Berlin was, as Mme. de Staël put it in *De l'Allemagne,*
"a large city, with very broad streets, perfectly straight, the
houses handsome and the general appearance regular. . . .
What can be better, either for buildings or for institu-
tions, than not to be encumbered with ruins?" The city
now became the center for a coalescence of national iden-
tity and the cultural consciousness necessary to form a na-
tion and to mobilize effective resistance to Napoleon.

Müller and Kleist again collaborated and published the
first daily paper in the Prussian capital, *Berliner Abend-
blätter.* Brentano, Arnim and the popular writer Friedrich
de la Motte Fouqué, who lived in Berlin, co-operated to
report politics, events, art and theater at home and

abroad. The paper's editorial policies, a continuation of those of *Phöbus*, made it the organ of the young, politically active writers. They opposed the court's conciliatory political policy and demanded war with Napoleon rather than a humiliating peace and they criticized the state-supported theater and Art Academy. These were courageous expressions in the face of oppressive censorship.

The Prussian Academy—Institut Königlichen Kunst Akademie—followed the French model and, since 1786, had held biennial exhibitions of paintings, sculpture and architectural drawings. Exhibitors included its own members and students, "dilettantis," members of academies in neighboring states, and its pensioners and members of the German colony in Rome. With a determined optimism, the Academy opened the 1810 exhibition on September 23 and the official catalogue was once more freed of the French translation required in 1808. From Dresden, Ferdinand Hartmann, already a professor at the Dresden Academy, Gerhard von Kügelgen and Caspar David Friedrich sent works to the exhibition. Also represented among the 422 works on view were paintings sent from Rome by Reinhart, Koch, Schick, Voogd, Feodor, sculpture by Thorvaldsen and Rauch, as well as works by the successful Italian painter Camuccini and the Greek sculptor Demetrios Pieri.

Friedrich, a member of the Berlin Academy by 1810, though not to be admitted to the Dresden Academy until 1816, sent two paintings. Completed after the Tetschner Altar, *Abbey in the Oak Forest* and *Monk at the Sea* were both profoundly symbolic expressions of the mood of these years. The provocative *Monk at the Sea* was singled out in No. 13 of the *Berliner Abendblätter* for discussion by Clemens Brentano. He and Arnim wrote a dialogue presenting different reactions because they could not agree on a conclusive judgment. Kleist edited the dialogue, published it as his own on October 13, 1810, and gave the explanation of his edited version in the October 22 issue. The Brentano-Arnim dialogue was not published until 1851, in Brentano's collected works.

After the exhibition closed on November 4, Arnim summarized reactions to it in three issues of *Berliner Abendblätter*. He noted on November 13:

> Among the landscapists, we must indeed place Friedrich first because of his power, on one hand, to seize upon the superior moments of atmospheric phenomena which can make even meager ordinary regions very remarkable for a few hours and, on the other hand, his awkwardness in handling colors. This brought out the most contradictory judgments. The effect of his winter landscape was most decisive. His much more extraordinary landscape in sepia was generally overlooked.

Beginning on October 6, Ludolp Beckendorff had already reviewed in eight issues the portraits in the exhibition. Baron Friedrich de la Motte Fouqué called attention to the exhibition in the innocuous *Berliner Hausfreund* (1810, No. 69). The exhibition received few serious reviews, for journalism in general was discouraged by the continuing severity of censorship.

The immediate hopes of the romanticists and patriots for the independence and regeneration of Prussia and, with it, of Germany was extinguished when Prussia offered France an alliance. By March 1811 the *Berliner Abendblätter*, which had enjoyed immediate success because of its independence, had been compelled by the political censor to restrict itself to the trivial, and ceased publication. Kleist's *"Brief eines Maler an seinen Sohn"* (October 22) and *"Brief eines jungen Dichters an einen jungen Maler"* (November 5) had been found offensive because they included his criticism of the Academy's director and its course of instruction. Performance of his drama *Prinz Friedrich von Homburg (The Prince of Hamburg)* was banned. Kleist, who at thirty-four saw no future for himself or Germany, entered into a death pact with a companion, Henriette Vogel, and after shooting her, shot himself. Adam Müller, Brentano, Arnim and others had already left Berlin.

Kleist's work was brushed aside and forgotten, even though Ludwig Tieck published his collected work in 1821. Not until the end of the nineteenth century was his genius realized. Friedrich's two paintings in the Prussian Academy exhibition of 1810, purchased by King Friedrich Wilhelm III, remained unnoticed in the royal collections until early in the present century. Friedrich's work did, however, provide the impetus for a redefinition of landscape painting. The task was assumed by Friedrich's friend, the physician and artist Dr. Carl Gustav Carus, in *Briefe über Landschaftsmalerei, geschrieben in den Jahren 1815–1835* (Leipzig, 1835), dedicated to Goethe. Carus explained Friedrich's work as an "earth-life portrait" (*Erdlebenbildnis*) painted to reflect the same spiritual well-being that is experienced when the being responds to the life of nature. The exhibition of Friedrich's Tetschner Altar in 1808 in Dresden and of his two works in the Prussian Akademie der Künste exhibition two years later offered an interpretation of nature which would not be generally shared until the end of the nineteenth century.

Heinrich von Kleist, "Emotions upon Viewing Friedrich's Seascape"[1]

It is marvelous, in an endless loneliness on the shore of the sea, under a dull sky, to gaze upon a limitless desolate expanse of water. Part of it is, however, that one has gone there, that one must return; that one would like to go across, that one is unable to; that one misses all elements of life and yet perceives the voice of life in the roar of the tide, in the breeze of the air, in the passing of the clouds, the lonely cry of the birds. Part of it is a demand that the

[1] [First published in the *Berliner Abendblätter*, No. 12, 13 October 1810, over the initials "c.b.," it was actually Kleist's abridgment of a dramatic dialogue written by the poet-novelist Clemens Brentano and his brother-in-law, Achim von Arnim. Translated from H. V. Kleist, *Werke*, Meyers Klassiker Ausgabe, Bibliographisches Institut, 4 Bd., Leipzig, no date.]

heart makes and a loss, if I may so express it, that nature inflicts on one. This, however, when gazing at the picture, is impossible, and what I should find in the picture itself, I found only between me and the picture, namely a demand that my heart made of the picture and a loss that the picture inflicted upon me so I myself became the Capuchin, the picture became the dune. However, that upon which I should gaze with longing, the sea, was entirely missing. Nothing can be more sad and more unpleasant than this position in the world; the single spark of life in the broad kingdom of death, the lonely center in a lonely circle. The picture lies, with its two or three mysterious objects, like the Apocalypse there, as if it were dreaming Young's *Night Thoughts*.[2] As the picture, in its monotony and boundlessness, has nothing but the frame for a foreground, when one studies it, it seems as if one's eyelids had been cut away. The painter has, however, undoubtedly opened an entirely new path in the field of his art. I am convinced that, with his genius, a square mile of sandy province could be depicted, with a barberry bush on which a lone crow ruffles its feathers, and that this picture would create a truly Ossian[3] or Kosegarten effect.[4] Yes, if one were to paint this landscape with its own chalk and its own water, then I believe one could cause the foxes and the wolves to howl, without doubt the strongest thing

2 [*The Complaint, or Night Thoughts of Life, Death and Immortality* (1742), a long poem in blank verse by Edward Young (1683–1765), enjoyed great popularity in England and on the Continent among those inclined to romanticism, and it contributed to the vogue for "melancholy and moonlight" in literature. An edition was illustrated by William Blake in 1797.]

3 [James Macpherson (1736–96), a Scottish poet, published *Fingal, an Ancient Epic Poem* . . . *composed by Ossian, the Son of Fingal, translated from the Gaelic Language* (1761) and *The Works of Ossian* (1765). These works, supposed to be those of a third-century Gaelic poet, did much to stimulate the romantic movement in literature. Later scholarship has determined that Macpherson combined fragments of ancient poems into his writings.]

4 [Ludwig G. Kosegarten (1758–1818), poet and author of *Melancholien* (1777). His poetry had wide appeal and had been published in Schiller's magazine *Horen*.]

that one can add to praise for this type of landscape painting. —But my own emotions with regard to this wonderful painting are too confused. Therefore, I have resolved, before I dare to express them, to be instructed through the comments of those who pass in pairs before it from morning until evening.

Clemens Brentano and Achim von Arnim, "Various Emotions on Viewing a Seascape with a Capuchin by Friedrich"[1]

A *lady and a gentleman, who is perhaps quite clever, come into view. The lady looks into her catalogue and says:* Number two: Landscape in Oil. How do you like it?

Gentleman: Endlessly deep and dignified.

Lady: You mean the sea; yes, it must be astonishingly deep, and the Capuchin is also very dignified.

Gentleman: No, Frau Kriegsrat, I mean the sensitivity of the one and only Friedrich in this picture.

Lady: Is it then so old that *he*[2] also has seen it?

Gentleman: Oh, you misunderstand me, I speak of the painter Friedrich. Ossian plucks his harp before this picture. (*They depart.*)

Two young ladies.

The first: Did you hear, Luise? That is Ossian.

The second: Oh no, you misunderstood him; it is the ocean.

The first: But he said, "He plucks his harp."

The second: But I see no harp. It appears indeed quite grayish. (*They depart.*)

[1] [This dialogue, written by Clemens Brentano and Achim von Arnim in 1810 for *Die Berliner Abendblätter,* was first published in 1851 in Brentano's *Collected Writings.* Translated from *Kunstanschauung der jüngeren Romantik,* ed. Dr. A Müller, *Deutsche Literatur* (Leipzig: Verlag Reclamer, 1934), Bd. 12.]

[2] [The reference is to Frederick II (1712–86), "the Great."]

Two art connoisseurs.

First: Yes, indeed, grayish. It is all quite gray as he likes only to paint such dry things.

Second: You mean rather, as he likes to paint so dryly such wet things.

First: He probably paints as well as he can. (*They depart.*)

A governess with two demoiselles.

Governess: That is the sea by Rügen.[3]

First demoiselle: Where Kosegarten lives.

Second demoiselle: Where the foodstuffs come from.

Governess: Why does he only paint such a dull sky? How nice if he had painted some amber fishermen in the foreground.

First demoiselle: Oh yes, I would like once for myself to fish together a beautiful string of amber. (*They depart.*)

A young lady with two blond children and two gentlemen.

First gentleman: Magnificent, magnificent; this man is, I tell you, the only one who expresses spirit in his land-scapes. There is a grand individuality in this picture. The sublime reality, the loneliness, the dull, melancholy sky; he knows what he is painting, I tell you.

Second gentleman: And he also paints what he knows, and feels it, thinks it, and paints it.

First child: What then is it?

First gentleman: That is the sea, my child, and a Capu-chin who is going for a walk along it and is sorry that he hasn't a boy as nice as you are.

Second child: Why doesn't the Capuchin dance around in front? Why doesn't he wag his head as in a shadow play? That would be nicer.

First child: I guess he's a Capuchin who indicates the weather, like the one in front of our window.

Second gentleman: He is not such a one, my child, but he also indicates the weather. He is the unity in the totality, the lonely center in the lonely circle.

3 [A Baltic island near Friedrich's birthplace.]

First gentleman: Yes, he is the spirit, the heart, the reflection of the entire picture in and above itself.

Second gentleman: How divinely chosen is this accessory; not, as in the case of ordinary painters, a simple standard for the height of the objects, the Capuchin is it himself. He *is* the picture, and while he seems to dream into this region as into a sad mirror of his own isolation, the encompassing, shipless ocean restrains him like his vow, and the barren sandy shore, joyless as his life, seems symbolically to drive him forth again like a lonely self-prophesying shore plant.

First gentleman: Magnificent; certainly, you are right; (*to the lady*) but, my dear, you are not saying anything.

Lady: Oh, I felt at home before the picture. It indeed moved me, is indeed quite natural. As you were talking it was just as unclear to me as when I walk along the sea with our philosophical friends. Only I wish that a fresh sea breeze blew and that a glimpse of the man shone through and the water roared. As it is, it seems to me a nightmare, yearning in a dream for the fatherland. Come along, it's making me sad. (*They depart.*)

A lady and a guide.

Lady (*stands quietly for a long time*): Grand, incomprehensibly grand! It is as if the sea were dreaming Young's *Night Thoughts*.

Gentleman: You mean, as if they had occurred to the Capuchin.

Lady: If only you were not always joking and disturbing one's mood. You secretly feel the same thing, but you want to mock in others what you revere in yourself. I say, it is as if the sea had Young's *Night Thoughts*.

Gentleman: I agree; and indeed, also the Karlsruhe reprint and the *Bonnet de Nuit* by Mercier[4] and Schubert's *Ansicht der Natur von der Nachtseite*.[5]

Lady: I can only answer you with a parallel anecdote.

[4] [Louis S. Mercier (1740–1814), whose *Mon Bonnet de Nuit* (1784) was a criticism of classicism.]
[5] [The title of G. H. von Schubert's (1780–1860) work was *Ansichten von der Nachtseite der Naturwissenschaften* (Dresden, 1808). In it, Schubert, a popular "natural philosopher" of

When the immortal Klopstock said for the first time in his poems, "The rosy Dawn smiles," Madame Gottsched, when she read it said, "What sort of a mouth does she make?"

Gentleman: Certainly not as nice a one as yours while you are saying this.

Lady: Now you are becoming disagreeable.

Gentleman: Gottsched gave his wife a buss for her *bon mot*.

Lady: I should then probably give you a nightcap for yours, but you are yourself one, a sleepy dullard.[6]

Gentleman: No, preferably a view of your nature from the side of night.

Lady: You are improper!

Gentleman: Oh, if only we were standing there together as the Capuchin stands.

Lady: I would leave you and go to the Capuchin.

Gentleman: And ask him to unite me with you.

Lady: No, to throw you into the water.

Gentleman: And you would remain alone with the father and seduce him and ruin the whole picture and its Night Thoughts. See, that's you women. You destroy in the end what you feel: out of pure lies, you speak the truth. Oh, I wish I were the Capuchin, who, so eternally lonely, gazes over the dark, foreboding sea, lying before him like the Apocalypse. Then would I wish only to yearn eternally after you, dear Julie, and to miss you forever, for this yearning is indeed the one single glorious emotion in love.

the day, attempted a description in science-fiction fashion of the night side of a planet where objects are without the sun's warmth and illumination. The book might have influenced Mrs. Catherine Crowe's popular *The Night Side of Nature, or Ghost and Ghost Seers* (London, 1848) so congenial to Baudelaire and his generation.]

6 [A play on the word *Mäulchen*, meaning "a little mouth" and "a buss, a smacking kiss"; likewise, *Nachtmütze*, meaning "nightcap" and "dullard." Luise Gottsched (1713–62) was a writer of popular comedies and the wife of the literary critic, Johann Gottsched (1700–66), a defender of the rules of French classicism in the field of drama.]

Lady: No, no, my love; if in this picture you also talk so, I will spring after you into the water and leave the Capuchin behind. (*They depart.*)

All this time a gentle, tall man had listened with several signs of impatience. I stepped lightly upon his foot and he answered me as if I had thereby asked him for his opinion. "It is good that pictures cannot hear. They would have veiled themselves long since. People treat them entirely too familiarly and are completely convinced that the pictures stand here in the pillory because of a secret crime, which the spectators must by all means uncover." "But tell me, what do you think of the picture?" *I asked.* "I am pleased," *he said,* "that there is indeed a landscape painter who pays attention to the wonderful cycles of the year and the sky that produces even in the poorest region the most moving effect. I would, however, I must say, prefer that the artist had, in addition to the feeling for it, also the talent and discipline to reproduce it faithfully in the representation. In this respect, he is just as far inferior to several Dutchmen who have painted similar subjects as he is superior to them in his conception of the total view. It would not be difficult to name a dozen pictures in which sea, shore and Capuchin are painted better. At a certain distance, the Capuchin appears as a brown speck. If I had wanted to paint a Capuchin above all, I would rather have him stretched out sleeping or praying or laid down gazing in all humility so that he would not ruin the view for the spectators, upon whom the broad sea evidently makes more of an impression than the minute Capuchin. Whoever later might look around for the coastal inhabitants would still find in the Capuchin every inducement to express what several of the spectators have generally with exuberant confidence loudly informed everyone."

This speech pleased me so well that I immediately went home with the same gentleman, where I still am and will be found in the future.

1819

ROME: The Exhibition
of a Group of Artists

The news that the Austrian Emperor Francis II and his
Empress, accompanied by Prince Metternich, would visit
Rome during Easter, 1819, brought the German-speaking
artists in Rome together to arrange what was to be the
first exhibition of the work of German-speaking artists
grouped on a "national" basis anywhere. Two large rooms
in the Palazzo Caffarelli, the embassy of Prussia, on the
Capitoline Hill were made available. Ambassador Barthold,
Georg Niebuhr, the Prussian Consul General Bartholdy
and Frau Caroline von Humboldt provided financial back-
ing.

Rome was again an international center. The allied
army's victory over Napoleon had been celebrated in the
Villa Borghese April 21, 1814. Pius VII had re-entered the
city in 1815. The art treasures confiscated by the French
began to return to Rome the following year and were in-
stalled once more in the Vatican Museo Pio-Clementino
and the Museo Capitolino. High-ranking English, Russian
and German visitors again frequented the Eternal City.

The sense of national identity of the German-speaking
community in Rome had been strengthened by several in-
cidents. Although the liberalizing reforms of the French
were countermanded and the Jesuit Order reinstated, in
1817 the German community had been permitted to ob-
serve the tercentennial of the Reformation in the Prussian
embassy secretary's residence and to celebrate for the first
time in Rome their Protestant communion service. Crown
Prince Ludwig of Bavaria had visited Rome in the spring
of 1818. He had mingled with the artists and, to their

delight, had worn the German cloak recently forbidden to students by the police in some of the reconstituted German states because of its association with the War of Liberation of 1813. This had been a national, popular movement against Napoleon, fostering the hope that a national unit would be formed from the diverse German states. The visit of the Austrian Emperor and Metternich seemed to offer an occasion to affirm a sense of a Nordic unity transcending the limitations of small principalities. Sixty-five painters, sculptors and engravers from Switzerland, the Netherlands, Denmark, Sweden and the German states assembled 181 examples of their work in the Palazzo Caffarelli and opened their exhibition on April 3, 1819. Although both classicists and romanticists were represented, the romanticists, grouped in the Brotherhood of St. Luke (or Lukasbund; also known as the Nazarenes), attracted the most attention.

Led by Johann Friedrich Overbeck and Franz Pforr, the Brotherhood had been formed in Vienna in 1809. The group hoped to revitalize painting by "transporting the spectator through Nature to a higher, idealized world," and for this purpose they chose to emulate the meticulous naturalism of the fifteenth-century northern painting, especially the art of Dürer. Their style also showed their admiration of the fifteenth-century Italian masters—Fra Angelico, Perugino and Raphael. They abandoned charcoal for fine pencil in order to achieve a precise contour line and revived the abandoned fifteenth-century techniques of fresco and tempera. Their images revealed a blend of medieval piety and pantheistic love with an awareness of national origin. This attitude showed a rejection of classicism in general. A declaration of Dürer, who had formalized his style after visiting Italy, rang in their ears: "I will paint neither antique nor Italian, but I will paint German."

The Brotherhood's aesthetic theories had beeen stimulated by the writings of Wackenroder, Tieck and Schlegel. Friedrich von Schlegel, his brother August, the poet Novalis (Friedrich von Hardenberg) and Ludwig Tieck

(the friend and publisher of Wackenroder) had turned from classicism when they became aware of "the romantic poets of the Middle Ages and the deep spiritual sense of love in their poetry" (Schlegel). The theories they formulated relating to the arts would be influential throughout the nineteenth century. Among their tenets were that art is a miracle inaccessible to reason alone and is to be attained through imagination and sensitivity; that the arts of "music, poetry and sculpture are synonymous" (thus anticipating the Synthesists at the end of the century and the Wagnerian ideal of a "total work of art"); that the creative spirit knows no national boundaries and the way is therefore open for the recognition of beauty in the images of other cultures.

Especially important for the German artists of the Brotherhood of St. Luke, intent on discovering a spiritual and national source for their art, were two of Schlegel's essays. One, "Gemäldebeschreibungen aus Paris und den Niederlanden [Description of Paintings in Paris and the Netherlands in the years 1802–4]," which appeared in Schlegel's periodical, Europa (Frankfurt, 1803–5), was the result of studies of the Italian, German, Flemish and Dutch art exhibited in the Musée Napoléon. Schlegel and his wife, Dorothy Mendelsohn, lived in Paris between 1802 and 1804. Writing the essays delayed Schlegel's studies of Sanskrit, which were to contribute an appreciation of mysticism and the concept of universality to European art. The second essay, "Brief auf einer Reise," published in Poetisches Taschenbuch für das Jahr 1806, appeared after he had accompanied Melchior and Sulpiz Boisserée to Cologne, where the brothers had begun a collection of German painting and sculpture to counter the dispersion and destruction which followed the French conquest of Westphalia and the Netherlands.

The Nazarenes had seceded from the Academy of Vienna—the first secession of artists in the nineteenth century—and moved to Rome. By 1819 they had received some recognition there. In 1813 the Prussian Consul General Jacob Salomon Bartholdy had commissioned frescoes

of scenes from the biblical story of Joseph for a room in his residence, the Palazzo Zuccaro. That success had been followed in 1817 by a commission to decorate the Casino Massino, a small house of a wealthy Roman family, with frescoes of scenes from Dante, Tasso, Petrarch and Ariosto. Canova had also arranged a commission for Philipp Veit to execute a fresco in the Museo Chiaramonti in the Vatican.

On April 19, 1819, the Emperor, Empress and Prince Metternich, accompanied by Schlegel, who was an adjutant of Metternich, came up the Capitoline to the Palazzo Caffarelli and visited the exhibition briefly. Officially, the Emperor and the Prince were opposed to the Nazarenes, for some wore the German cloak which was the garb of the militant students. Those who wore it were politically suspect, especially following the assassination of Kotzebue the month before, because it was associated with the demands for a unified Germany: Metternich feared that a unified Germany would jeopardize Austria's position in Europe. The German Confederation, established by the Congress of Vienna in 1814–15, had maintained a status quo of the numerous principalities and ignored both demands for the liberation of the political systems and the desire for a national union.

After the artists had been presented to the Emperor, he noted the absence of the *Graces*, a sculpture by the Dane, Bertel Thorvaldsen, who at the last moment had been unable to send it to the exhibition. The Emperor advised the artists to devote themselves more to nature and to pay less attention to the "old German" tradition of painting: because of these remarks the Nazarenes were ridiculed as "German tragedians" whose pictures, painted by a Chinese, had been found by a monk.

Among the reviews of the exhibition were an anonymous satirical criticism published in the *Allgemeine Zeitung*—actually written by an early sponsor, the Consul Bartholdy—and a critical article, *"Neu'deutsche religios-patriotische Kunst,"* written by an associate of Goethe and the Weimar Friends of Art, Heinrich Meyer.

Schlegel came to the defense of the exhibited work in the *Wiener Jahrbucher der Literatur* (VII, 1819), his last comprehensive consideration of the fine arts, with an essay directed less to Bartholdy than to Meyer. This defense was reiterated by Johann David Passavant (1788–1861), an earlier collaborator of Overbeck and Pforr who had become a practicing artist himself and joined the Nazarenes as an artist in 1817. In a pamphlet, *"Ansichten über die bildenden Künste und Darstellung des Ganges derselben in Toscana* [Views on the Fine Arts and an Exposition of Their Development in Tuscany]" of 1820, in which the exhibition catalogue was reprinted as an appendix, Passavant attempted to "establish the viewpoint from which the new German school of painting is to be regarded" by setting forth the aims of the artists.

In spite of the attention the exhibition brought the Nazarenes, they received no immediate large commissions equal to their earlier successes; however, their manner of representation would prove to be widely influential. Peter Cornelius, the group's strongest talent, and Julius Schnorr von Carolsfeld returned to Germany, where they executed vast frescoes in Munich and Berlin. The technique they used, as exemplified in the cartoons for the commissioned works and in their easel paintings, came to form a dominant element in religious art for most of the nineteenth century, when the mass of the people equated art with Christian worship and ascribed to it the moral implications that what is beautiful is good. The style opened the way to a new presentation of religious themes in Europe: its elements were present in the Italian *puristi* and in French artists Ary Scheffer, Victor Orsel and Hippolyte Flandrin. Its trace is to be found in Ingres's work, especially in his treatment of religious subjects. The *Marriage at Cana* (1819) of Julius Schnorr von Carolsfeld, commissioned by a Scottish collector and included in the exhibition, brought an example of the style to England. The elaborate allegories of the pictures exhibited by the Nazarenes contributed to the profane mysticism and allegories in the English Pre-Raphaelite work of twenty-five years later. The

Pre-Raphaelites' work was endorsed by Charles Eastlake,
who had been a student in Rome at the time of the Naza-
renes' exhibition. It was he who was to bring together
Turner and the German landscape painters Koch and
Reinhart in 1819. The technical excellence of the Naza-
renes' work attracted the attention of those interested in
reforming art education and separating instruction from
the academy.

The wide diffusion of the style was facilitated because
its precise contour line and pure flat color made it ideal
for reproduction by new graphic processes. Cheap color
prints, religious prints and the popular "ten-penny stations
of the Cross," were executed in the style of the Brother-
hood of St. Luke first exhibited in 1819 in Rome. It be-
came the art style of institutional religion.

Friedrich von Schlegel, "On the German Art Exhibition at Rome in 1819 and the Present State of German Art in Rome"[1]

Among the remarkable features that marked the presence
of the imperial court in the capital of the Old World—it
still remains a focal point for the arts and all its friends—
is the exhibition of the German artists in the Palazzo
Caffarelli, a place arranged for it with the Prussian em-
bassy's permission.

The *Österreichischen Beobachter* (May 7) gave a full
account of the visit with which His Imperial Highness
honored the exhibition, but as yet no detailed examination
has appeared—at least none fully deserving such a title or
accomplishing that purpose. The German exhibition does
seem well entitled to careful examination, both as a re-

[1] [Translated from Friedrich von Schlegel, *Kritische Aufgabe*,
8d, IV, ed. H. Eichner (Zurich: Thomas Verlag, 1959), pp.
233–36. The review appeared in the *Wiener Jahrbucher der Lit-
eratur*, October 1819, to answer a critical essay in the *All-
gemeine Zeitung* of July 23, 1819.]

markable feature of the times and in reference to the present condition and place of the arts. Besides, in the richness and variety of the compositions exhibited, far exceeding that produced by any other modern school for a long period of time, it possesses great intrinsic value. The common effort of such varied talent is both gratifying and delightful to witness.

It must be clear to us all that excellence, instead of springing up spontaneously like the grass of the field, cannot be attained without much careful study and cultivation. If among the numerous indifferent, or even bad, pictures which are usually preponderant in such an exhibition we find many good works and a few of distinguished merit, we may reasonably anticipate, from the united efforts of so much natural and varied talent, a successful and happy reaction in art generally.

With respect to what has been accomplished by some artists and the talents which for the first time have emerged here in larger works or in a more extended circle, the German exhibition was received with complete favor by the public. This was shown unmistakably in the profuse praise given many artists: to both the Schadows, Philipp Veit, Wach, and others. When left to form an unbiased opinion, the public judges generally appreciatively and in many respects approvingly. On another side, opinions were very divided and many censuring voices were even raised against the exhibition. In general, criticism was directed to the new school [of the Nazarenes]. The charge was made that it had regressed into an old German manner. Consequently, although great praise was awarded to individual merit, which was in no way misunderstood by the greater and better part of the public, it was generally asserted that on the whole the school was on an incorrect path.

I intend to examine closely and intensively this general criticism to ascertain how far it may be applicable either to the new school of art and the German exhibition in general or to particular works and artists. As numerous

points require attention, I shall recall to mind the essentials. . . .

Now with respect to the art of painting in our modern Christian Era, it has long been decided and universally acknowledged by those who know that it reached the summit of perfection during the end of the fifteenth and the first part of the sixteenth centuries with the great masters of that period—Raphael, Leonardo, Michelangelo, Titian and Correggio—and although in the subsequent epoch—in the school of the Carracci, under Guido, Domenichino and a few of the better Florentines—the art of painting still continued with renown, it never again attained the same degree of excellence it had reached under the first great masters. This, at least, is no longer disputed. As each school successively expired, their time being over, the necessity of a grand revival of an art in decline began to assert itself in the eighteenth century; it prompted an effort based upon a right assumption, but the right application was not made at once. Mengs, the one among us who undertook the work of restoration, believed that if a painter knew how to combine the living flesh tones of Titian, the magical illumination of Correggio, and the beautiful forms and rich compositions of Raphael, he would have reached his goal and that a true way would have to be directed toward this goal if it were to revitalize art. A new life can spring only from the depths of a new love. Excellence in art cannot be achieved, as can a health potion in medicine, by putting together many different ingredients. For this reason the compositions of Mengs appear frigid and his great, praiseworthy efforts never led to the formation of any school properly his own. Others afterward modified his recipe for the restoration of art, or even went to the extreme of demanding that the artist unite the antique style with that of Raphael and nature (that is, the model), but in this respect the same judgment is applicable to the tendency of recent art efforts. With respect to the antique, the immeasurable great and eternal distinction between the two related sister arts, sculpture and painting, is misunderstood; or at least, theories of art

could easily lead to such misunderstandings, though this was not actually true in the case of Mengs, since he remained for the most part within the boundaries of painting. Winckelmann's splendid enthusiasm for the antique, which called forth a new epoch in the field, was likewise the cause of many an erroneous application of it and led painters further and further from their goal. The French school withdrew most from the antique and took a particular and different turn from that described here. The models of the antique stood here and, although known to individual cultivated artists in Rome, they nevertheless did not stand in a like fullness and grandeur in the French people's mind. However, the mind of the French nation was directed with increasing admiration toward the republican tradition which we historically know and honor. The tragic heroes of Greece and Rome reigning in theatrical exaggeration on the stage were the idols of the day. Consequently art itself rushed into the arms of republican antiquity, with a special predilection for the tragic and complete theatrical exaggeration. In fact, it was a mightier and a more remarkable death-defying leap than that Egyptian trait present in sculpture under Hadrian, and was further removed from everything that can for us, according to our customs and our circumstances, be measured! It would require that all modern Europe should again become heathen, as was certainly hoped for and attempted during the Revolution. The French school is then a certain vigorous, remarkable but thoroughly false tendency. The entire character in all its peculiarities is best perceived in David, the greatest master of that school. The tendency is not at all limited to France. On the contrary, until now it has been basically the one reigning throughout Europe. This is not surprising because in many respects the tendency best corresponds to the feeling of our time, as the age still has not attained the calm from which the feeling for beauty emerges. . . .

Besides the French school, I find today only one other influence in art: that of the English copper engravings. We can hardly be surprised at the widespread taste for

them, since their style is so completely rooted in the spirit of the age and springs from the most intimate mood of the heart and sentimental feeling. It will not be necessary to describe more fully the spirit of the English engravings. It is self-evident that in general this *one dominant element* of contemporary taste is not limited to England or to copper engraving. We see the same element often enough in painting. We are apt to encounter it in marble, in churches, in grave monuments or wherever the subject lends itself to a sentimental treatment.

This, then, in general is the predominant contemporary taste in art—I should say "was" but, at least for the most part, is it not still so? Out of these circumstances then—between the domination of the French school and the English copper engravings; out of the many fruitless tendencies of Mengs or the misunderstood Winckelmann; and after many better, well-intended but not entirely realized or single isolated attempts—another serious effort has developed more and more in the last decade among the German artists.

This serious effort could once more widen the lonely path of higher beauty in painting to a general traveled road and could expand itself gradually into a truly German school of art and inaugurate a new epoch for it if the endeavor is lovingly cultivated and pursued with a sensitivity for the more noble and, for us, the more appropriate in art. If the lofty conception—through constant development in accordance with proven principles—will make great what is still incomplete, this conception also—by means of a comprehensible art criticism—would lead back any emerging digressions and exaggerations to true proportions and objectives.

Some time ago a decisive dislike of the prevailing taste of the French school and a serious return to the great painters of the past had become evident among German artists. While most of them strove to copy the inimitable Raphael, some were more inclined to choose Leonardo as a safe leader or were enraptured with the greatness of Michelangelo. . . .

Of the contemporary German artists now living in Rome, Overbeck and Cornelius were the first to become more widely known among us. Both are gifted with a rich imagination; the former is distinguished by an endearing gracefulness and intimate feeling for beauty in form, expression, position and arrangement; the latter by great forcefulness of expression and a wealth of creative invention. Several major works by Overbeck are in Germany and offer an opportunity to appreciate him, especially the large cartoon in Frankfurt depicting the sale of the boy Joseph. His artistic reputation is already sufficiently established and the magnificent cartoon of the liberated Jerusalem at the latest exhibition would alone be enough to reconfirm it. In addition to his existing works, he has been commissioned to paint the frescoes in the new art temple which the Crown Prince of Bavaria is having built in Munich, and this will give him ample opportunity to show what other, greater things he is capable of achieving, if we may judge by the masterly completed first cartoon. It depicts with rich meaning and an ingenious and characteristic interpretation the whole mythical cycle of Night with her numerous allegoric entourage as imagined by the ancients. If, in some earlier creations of this artist, the powerful strength of expression occasionally degenerates into exaggeration and threatens to become a mannerism, one notices with pleasure in this last excellent work that he has again remained more faithful to nature and noble simplicity.

Several younger talents have recently successfully followed these two well-known artists. Some have a very different artistic ability and disposition, but all of them are filled with the same seriousness in their attempt to lead art back to its former majesty. This common endeavor of the German artists in Rome gradually began to attract attention and was recognized even by the most distinguished men and artists of other nations. With great pleasure I may mention here in place of all others, Canova —the pride of Italy, the sculptor of our time, famous and celebrated all over Europe—as one of those who honor

and treasure German art. Canova on his journey through Germany fully appreciated the unique Boisserée collection. Although he is active in a totally different field of art, he not only showed an attentive interest and great respect for the artistic pursuit of the Germans in general, but even for individual, younger talents. Several German artists—Philipp Veit, Eggers and others—were, on his recommendation, commissioned to paint frescoes in the Vatican. The fact that fresco painting has again become so popular among the German artists in Rome—all credit for this is due to the Prussian Consul General Bartholdy, who initiated it—must be considered as great progress, for it compels the artist to employ large-scale composition and, at the same time, to be sure in the execution, excellent practice especially for younger talents.

After all that has been said thus far, it will not be difficult to find and determine the right point of view, in order to appreciate the present position of German art in Rome as it has presented itself at the last exhibition.

A few more words about the principles in general. . . . Where is the young artist to find an example for his greater achievements in form and expression, position and arrangement, or in interpretation and approach in general, so he may attach his own mind to a related, yet greater, or at least more widely experienced one, thereby strengthening and developing it? Where but from that period and from those works in which, indisputably, the art of painting reached the summit of perfection.

Should we perhaps refer him back to the French school or the English copper engravings or similar things? If he is wise, he will not allow himself to be confused by fashionable suggestions of this kind but will always keep his eye on Raphael and his contemporaries and, in general, on the great masters of the last half of the fifteenth and the first half of the sixteenth century, keeping them close to his heart as eternal models for his aspiration. In this connection it is quite certain that, next to the great masters who are recognized as supreme, no other artists deserve more attention than their immediate predecessors and older

teachers. They are far closer to the great artists than their pupils or later imitators. Should we honor Raphael and think less of the one through whom and from whom he learned so much in the beginning? There are some figures, even some groups and whole compositions, not only by Perugino, but also by Fiesole and even Giotto, which even after turning from Raphael one can view with great pleasure and with admiration, which, in spirit and interpretation, are truly Raphaelesque, if one may give this name to all that is of spiritual beauty and endearing harmony. . . .

As regards our German exhibition, it was really only the above-mentioned group of lesser talents, and therefore exaggerating imitators, who were criticized for "mannered archaism," and rightly so with respect to some of their products. This kind of artist will always be found, but the models he chooses can hardly be blamed. The works of people like this, no matter whether they look at and copy Leonardo and Dürer, or Guido and Guercino, or, if one likes, Mengs and Füger, will always be cold and stiff, exaggerated and distorted, or both together, and they will always be mannered. As said before, in every exhibition many mediocre achievements or even an occasional complete failure will be found together with the praiseworthy and excellent. The exhibition should be judged only by what is good. If it contains a reasonable amount of good, it can already be regarded as a positive indication of the course and progress of art as a whole. The German exhibition comprised the works and attempts of sixty-three artists, the majority of whom are still at the beginning of their careers. With regard to those young talents who distinguished themselves among this number, the public, as said before, did full justice to those who deserved it, and more, it praised them enthusiastically, irrespective of the differences. The two Schadows, Philipp Veit, Wach and others were not only acknowledged by the public in general but were praised by the most enlightened and distinguished visitors to the exhibition as emphatically as the artists and their friends could wish for, so that all that is

left for me to do is to acknowledge gratefully the sound judgment of the public and to add little or nothing to correct it. Neither do we need fear that these or other similarly worthy artists might, because of the appreciation of the good work they have achieved so far, forget the incomparably greater achievements which one might rightly expect from them. Should one artist really have received less attention or appreciation than he deserved, then this was due to accidental circumstances. Who would not, for instance, praise the wealth of inventive composition in Eberhard's excellent sketches? But drawings of this kind need to be looked at and studied in the peace and leisure of the cabinet and are less suited to attracting attention beside large-scale oil paintings in an exhibition where frequently not even a suitable place can be found for smaller pieces. The largest and most excellent works of some other artists were not shown at the exhibition, as for example the *Adoration of the Shepherds* by Johann Veit. The deep sincerity of feeling, the living truth and warmth of this painting would have won many friends. Nor was the above-mentioned excellent cartoon by Cornelius exhibited. Two single heads, as beautifully painted as those of the Madonna and the Angel Michael by Eggers and worthy of the best Italian period for their noble form and grace of treatment and color, are easily overlooked among numerous larger paintings.

Should one want to raise the question as to whether the criticism of archaism, as far as it is a mannerism and therefore a fault, should not also be extended to the works of the better German artists in Rome, I should have to reply that this would be justified in only a few cases and that even then, on closer inspection, the fault does not always lie in the supposed archaism, but somewhere else. Let me give an example: in a holy family by Wilhelm Schadow, the head of the Madonna is completely spiritual, of the utmost beauty, of the most happy and successful design; the holy Joseph, however, in the same picture is too small and really a failure. Still I was unable to find anything particularly "Old German" about this figure, no

more than the wonderful head of Mary is based on one by Raphael or on some other particular archetype.

As with every judgment, once a convenient fashionable formula has been found to express it, many repeat the formula without connecting a clear idea with it. It is often used incorrectly and for objects to which it does not apply. Thus the criticism of "Old German" mannerism in art has often been extended to things that lie hundreds of miles away. I could, were this the place for such details, quote examples of the strangest confusions in this respect. It is the same in art as it was in literature, where several years ago the party making the criticism believed he had entirely condemned a new poetic work and had dealt with it completely by uttering the terrible dictum "romantic" or "written by a romanticist," be it, incidentally, by Schiller, Tieck, Fouqué, or of a similar kind. In the same way, many people still call anything in science that is beyond their comprehension or causes them uneasiness "mystic," a word they are often as unable to explain or account for as the thing they are trying to designate as objectionable by the word's use. Words like this have a bad effect; they are formulae of deception which entirely confuse judgment.

A certain well-understood archaism will have to be granted to the visual arts, at least in some cases or for some objects. We cannot reject it absolutely and unreservedly. Only when archaism is incorrect and mannered does it deserve criticism. I find difficult to explain, however, how this criticism of the "Old German" mannerism as regards the typical German, has come about. With many, indeed with the majority of the excellent paintings of the new school, anyone who has seen many paintings will frequently notice that an artist may have studied with particular love this or that great Italian master of the older times without actually imitating an individual example. Far less frequently in the excellent paintings have we noticed anything reminiscent of the Old German school in general, let alone Dürer in particular. The artists' costume has probably contributed to the fact that the

criticism, contrary to all truth, has been given the term "archaic" which it has used and extended generally, transferring to the paintings the concept of Old German coats. At least, in an article published in the supplement of the *Allgemeine Zeitung*, No. 124, the criticism is directed almost more against the coats than the paintings, and the whole article seems to have been written by a fashionable couturier whose taste had been offended than by a true art critic.[2]

If, incidentally, "Old German" in art is considered synonymous with "stiff" or "severe," I am afraid I cannot quite agree with this meaning of the word, which, to me, seems new and arbitrary. But perhaps this definition was derived more from books or some early-conceived prejudice than from personal opinion. I have seen many Old German paintings in Boisserée's collection and on other occasions, which are indeed beautiful, alive, and do not lack grace either. On the other hand, it would be easy to name a large number of paintings from the period of the later mannerists or also from the older French school which appear quite cold and frosty, stiff and lifeless. To choose far more recent examples, we have only to remember some of the contemporary paintings, derived from a false imitation of antiquity which, as a rule, were mostly stillborn.

But why should we have such a low opinion of our own early art when this art deserves the criticism no more than it becomes us to criticize it? Raphael fully appreciated Dürer. There were other worthy German artists before Dürer who in some respects, especially where grace is concerned, stand above him. The Italians appreciate the Old German art. Even the French have become aware of it.

[2] For better understanding it must be said that some artists who had taken part in the last war continued for some time to wear their Old German soldiers' coats. However, during our sojourn in Rome, few were seen any more. Here is the proper place to mention that the young German artists in Rome have distinguished themselves in a most favorable way by an orderly, moral and decent behavior, so that one can only wish that the young people in our fatherland will behave equally well and earn as much respect.

Should we Germans alone fail to see that our old masters, after and beside the greatest and most successful masters of Italy, belong to the most excellent period in the art of painting? If German art did not reach the same peak of perfection as the Italian, the reason is easily found. We well know how it was hindered in the midst of its progress and was completely interrupted before it could reach its summit by the religious unrest and civil wars of the sixteenth century. On the other hand, it would not be easy to name an Italian master of the earlier pre-Raphael period who took such a giant step forward and in every respect advanced art as much as Van Eyck did.

This retrospective view is not unrelated to our subject, but let us return to contemporary German art and the new tendency and development it is showing currently in Rome. One more point—and it is a main point—needs to be discussed in order to clarify the concepts and to correct the judgment as we set out to do. It concerns the choice of subject matter. The attention of many of the young artists has been directed chiefly to the circle of most excellent contemporary painters; they followed these masters and those of the older school and chose to treat mainly Christian motifs. A large number of the public objects to, and shows considerable aversion to, Christian motifs, an aversion which has largely contributed to the opposition and to the conflict about art and its definition that have become so obvious on this occasion.

As far as I know, it has never been affirmed or claimed that Christian themes alone should be painted. It is true, of course, that the painters of the great period glorified mainly subjects of this kind in their greatest and most important works, as is only natural, since art in those days was still closely connected with religion, forming a unity with it and seeing as its noblest aim the decoration of churches and enriching the service. But quite often earlier painters also chose mythological subjects, especially for fresco paintings in secular palaces. Above all, Raphael did, also Giulio Romano (the latter in a particularly individual spirit), and, after them, the Carracci and their successors. Great poetic compositions, as offered by ancient mythol-

ogy or heroic poetry, are indeed especially suitable for
fresco painting, whereas they have to take second place in
oil painting, where the emphasis is on deep charac-
terization or where symbolic mysteries are to be brought
to life by perfect execution. It was, therefore, a happy
choice to select the most imaginative poets of Italy—
Dante, Ariosto and Tasso—as the material and source for
a number of cyclical portrayals for the fresco paintings in
the [Casino Massino at the] Villa Giustiniani, which the
German artists Overbeck, Philipp Veit and Julius Schnorr
have been commissioned to paint. I can imagine Trojan
and Homeric or any other epics depicted far more success-
fully in this splendid fresco technique than has so far been
achieved in oil. I do not dispute that even those pagan
motifs which are further removed from Christian art can
have a great attraction. Who would not look with pleasure
at a Danaë or Antiope by Titian, an Io by Correggio? But
I almost wish that the painting of such motifs were re-
served for masters of that rank alone; painted by less excel-
lent or even mediocre painters, they become unbearable
and vulgar at once. . . .

We are unable to agree with the hypothesis that Greek
painting—for which the Portici Collection supplies at
least some data—was more perfect and of a higher quality
than Raphael or that the most excellent Greek artists
achieved a degree of perfection which we can hardly hope
to attain, let alone surpass. The sculptor, however, must
first completely attach himself to antiquity, practically
continuing it. One of the first touchstones and proofs of
excellence in this art will always be the ability to supple-
ment antiquity. If accomplished as perfectly as Michelan-
gelo supplemented the famous Faun or, in our time, Thor-
valdsen the figures from Aegina, it is in itself sufficient to
arouse astonishment and is worthy of the greatest admira-
tion. Besides this, however, it remains the aim of the
sculptor to create a figure so classical that it could practi-
cally pass for an antique, as, for example, Thorvaldsen's
Mercury, who seems to have been girded with a sword for
the sole reason of heralding by its presence inevitable

death for many hundred modern marble statues. Only when our sculpture has reached this first and necessary stage of perfection may we raise the question as to whether it will now be able to treat with the same skill completely different and for us characteristic subjects, so as to carry out and in fact bring to an end the beginning and first attempts at a Christian sculpture which remained unfinished in the Middle Ages. In this regard the Christ designed by the excellent Dannecker commands our complete attention and keenest regard as a first great attempt of this kind in our time.

With regard to sculpture, the German exhibition was sufficiently provided with excellent works. A lot could be said about Rudolf Schadow's great talent or Schaller's praiseworthy works, and Eberhard's bas-relief, too, deserved closest attention. Since Thorvaldsen's *Graces* (because they were still unfinished) were not shown at the exhibition, giving rise to many a quip, I should remark that, if they had been exhibited, they would without any doubt have been called stiff and severe, if not even "Old German," for the great artist has indeed used this motif of the serious Greek style and they have no evidence of the popular modern softness. . . .

Nor do I wish to discuss in detail landscape painting, for I should first have to go into its theory (which is still little explored, or, I should say, little known) to determine the standard of comparison between my own opinion and the prevailing taste, which is widely divided in itself. . . . May it suffice here to mention that of the two types of landscape painting (and not only in the extremes but also in several stages of transition), the German exhibition included many praiseworthy works by Koch and Catel, Rebell, Rhoden, and others.[3] Further details on landscape painting must be reserved for a different place. . . .

[3] Among these the most successful works by Koch from his best period are the most characteristic of the whole period of contemporary German art, because of the boldness of choice of invention, the determined strength in the faithfulness of representation, and the abundant portrayal of nature and deeply felt meaning.

1819

LONDON: The Exhibition
of a Society

When peace was established after the banishment of Napoleon to St. Helena in 1815, the Industrial Revolution made England the first full-fledged manufacturing state in the world. The upper classes and the middle class of enterprising factory owners and merchants rapidly grew wealthy with the aid of the marvelous machines. At the same time the use of these machines caused the unemployment of men and the employment of cheaper workers: women and children. The distress of the working classes and accompanying agitation for social reforms mounted. Demonstrations of workers became frequent. In Manchester one resulted in the Peterloo Massacre of 1819 when a mass of people gathered to petition Parliament for reforms; Parliament reacted with the repressive Six Acts.

The growing wealth of the industrialists created a new market for art, but the disparity between the classes was extended to access to art. A Frenchman noted that in England the pleasures of the fine arts were enjoyed only by the well to do, while in France the poorest Frenchman could visit the Louvre. The National Gallery, long demanded by Cumberland and other liberal advocates of public patronage, was not to be founded until growing pressure for broad social reform became strong. It opened in 1832, the same year Parliament passed the Reform Bill reorganizing the House of Commons and paving the way for major social reforms in the late thirties and forties.

The deepening sociopolitical changes were accompa-

nied by a new taste for "Storm and Stress" (or *Sturm und Drang* as it was referred to in German-speaking countries), for the "Picturesque" as defined by Uvedale Price and Payne Knight, and for "Sublimity" as defined by Edmund Burke, who had discussed the aesthetic pleasure to be found in sensations aroused by the awesome, the terrifying and the repellent. Poets, playwrights, musicians, painters and sculptors selected subjects from history, poetry and real or imagined personal experience and attempted to reproduce with as much verisimilitude as possible through words, sounds or optical illusions that which was delightfully terrifying. The public appetite for such effects was whetted by the vast canvases of battle scenes and disasters painted by the academicians.

One form that resulted from the demands of this taste was the panorama. Devised by a Scottish architectural painter, Robert Barker, it was first exhibited in London in 1794 with a depiction of a peaceful scene. From 1806 until the Battle of Waterloo, Barker's son Henry used the panorama to permit a spectator to participate visually in Napoleonic battles and "feel" what it was like to be present.

It remained for John Martin (1789–1854) to translate the sensational effects of the circular panorama to the flat surface of immense canvases. Martin had come to London with his drawing master and was employed by him to decorate china until the foreign markets for English china were closed by the French blockade. Forced to support himself as best he could, Martin studied perspective and with his fertile inventive powers caught the taste of the time in the first picture he sent to the Royal Academy exhibitions: *Sadak in Search of the Waters of Oblivion* (1812) from the *Tales of the Genii*. He exaggerated perspective to achieve fantastic depths and accented them with strong color. The public reacted enthusiastically. Overnight Martin became a prominent figure in the social world. He received a prize of £100 from the British Institution for *Joshua Commanding the Sun to Stand Still*. He

had felt slighted by the exhibitions committee at the
Royal Academy and, although he continued to exhibit
there, was a lifelong opponent to it. *Belshazzar's Feast*,
which attracted crowds of viewers to the British Institu-
tion in 1821, was followed by the dramatic *Destruction of
Herculaneum* (1822) and an awesome *Creation* (1824).
His career closed with vast canvases depicting *The Judg-
ment*, *The Day of Wrath* and *The Plains of Heaven*. On
a smaller scale he rendered a notable set of illustrations of
Milton. A series of biblical illustrations, a continuation by
him of those begun by Richard Westhall, were very
influential: they were bound into Bibles in America as
well as in England. Martin's interests extended beyond
the fine arts: appalled by the contamination of the river
Thames, he devoted much time to a plan for a pure water
supply and a necessary sewage system for London.

In 1819, seven years after he had made his debut, Mar-
tin's *Fall of Babylon* was the central attraction of the an-
nual exhibition of modern paintings that opened at the
British Institution in February. The painting contributed
substantially to the revenues and sales of the institution
that year. An enthusiastic review of it appeared in the *Ex-
aminer*, which gave no notice to Constable's two paint-
ings, also included in the exhibit. The *Examiner* had been
founded by Leigh and John Hunt in 1808 to assist in pro-
ducing reforms in Parliament and the Church. It became
the literary magazine of the "romantic" radical poets after
1815 when the Hunts were released from prison, where
they had been sent for two years after libeling the Prince
Regent in their zeal to secure reforms. It was the first pub-
lisher of Keats and among its contributors were Byron,
William Hazlitt, Charles Lamb, and Shelley, Leigh
Hunt's close friend. The Fine Arts Notes were written by
Robert Hunt, an unsuccessful artist whose criticisms were
in keeping with the tone of the paper, though lacking the
brilliance of his brothers' writings.

Robert Hunt, "British Institution: Mr. John Martin's Fall of Babylon"[1]

Mr. Martin's *Fall of Baylon*. —Of Babylon, the renowned capital of the once mighty Chaldean Empire, whatever is related can be regarded as little else than fiction, as it was the earliest of the post-diluvian powers. Enough however is stated in the Old Testament, and by HERODOTUS the father of History, and subsequent ancient historians, to afford sufficient materials to a Painter of genius for a work of magnificent object and effect; a work, such as Mr. Martin here surprises us with, of mingled Poetry, Fiction, and Fact. Of all the cities of antiquity, Babylon is described as the most august—for size, population, and the grandeur and extent of its numerous edifices, some of which were several miles in circumference. To give us therefore a successful picture of such a city, and that under the most solemn circumstances, a destructive visitation from Heaven and from man, is evidence of a high order of inventive talent, and will, we think, now set at rest (if indeed it had not been already set at rest) the disputed question as to the capabilities of our countrymen in the superior walks of Art. This subject includes every kind of object of which historical and poetical landscape consists. It demands accumulated gifts of nature and study, a mind most industrious and strong, to grapple with and overcome the difficulties and laborious attention such multitudinous and important events and scenes present. From its many masses of building of antique character, an intimacy with Architecture and Perspective is required; for its groupes [sic] of trees, its river, and sky. a knowledge of the appearances of inanimate nature; from the time, place, and circumstances represented, an acquaintance with real and fabulous history, and of the costume of Asiatic antiq-

[1] [Verbatim from *The Examiner*, London, February 1, 1819, pp. 92–93.]

uity; from the multitude of human and other figures, under a great diversity of action and passion, an acquaintance with the human form and human feelings; from the unparalleled variety of object and circumstance, a rare power of attention to each particular part and to the whole, and a mind nobly daring and confident in its resources; and above all, a lively and poetical imagination, that can apprehend scenes far more impressive than are usually seen in Nature and in Art, can convey to the spectator a consciousness of something supernatural, at least of the sublime, and warm and expand his fancy, set his mind thinking and his heart feeling with a deep and delightful intensity. All these accomplishments and energies are displayed in this picture, around which it would indeed be surprising if we did not see the spectators crowding, some with silent, others with exclamatory admiration; sometimes very near, to look at the numerous small objects that cannot be distinguished at a distance, sometimes farther off, to feast upon the grandeur of the whole; leaving it, but, still thrilling with the strange and felicitous impression, coming back to it again after having looked at most of the other pictures with an absent mind, like a lover who is but half attentive to other women, in a delicious reverie on the superior charms of her who has the keeping of his heart. So exuberant is this noble work in matter for gazing and description, that a very extended criticism ought to be written upon it to do it justice. We shall endeavour to describe it as far as our brief limit will allow.

The Picture, like superior and finished works in literature, embraces all the requisites of its subject, having a beginning, a middle and an end, both in the composition or arrangement of the entire scene, and in the commencement and conclusion of the story told; for there is the attack on the Babylonians, their rout, the despair of the Royal Family and the Chaldean Priests, and the consummation of the *Fall of Babylon*, in its being fired by lightning. In the fore part of the piece is pourtrayed [sic] the attack by land and water, the retreat and the despair.

Ships are seen filled with armed men contending. Some of
the Babylonian vessels are on fire, some retreating up the
river from the combat. A huge host, that appear "like the
sand of the sea for number" are advancing in order of bat-
tle towards the palace. The foremost are engaged with and
routing the Babylonian army. Here the fervor of the
Painter's mind glows in the representation of the fierce
and dire struggle for existence, the existence not only of
the soldiers' life, but of empire over nations. Horsemen
and infantry are in a fierce commixture and confusion of
battle. We almost fancy we hear the clang of conflicting
arms, the shouts of war, and the groans of the wounded
and dying. It is the severest tug of horrid war; and in
reminding us of the following lines of our sublime Milton,
it is its own honourable eulogy:

> "Now storming fury rose and clamour
> Such as heard in Heav'n till now was never.
> Arms on armour clashing, bray'd horrible
> Discord, and the madding wheels
> Of brazen chariots rag'd. Dire was the noise
> Of conflict."

Some of the victors are destroying the images of *Bel and
the Dragon*, others are already advancing within the very
gates of the palace, led on by a commander who is cheer-
ing them as they advance, and whose noble and confident
port gives assurance of their now being about to reap the
harvest of their sanguinary toils and dangers. The Baby-
lonian monarch seeing this, is in an *attitude* of despair
amidst his priests and family. Here are some most touch-
ing instances of natural affliction and despair arising from
the successful advance of the Medes and Persians, among
which is a Princess, like another *Andromache*, vehemently
and in vain entreating her husband not to meet the com-
ing foe. These last scenes are described as passing in the
celebrated *Hanging Gardens*, beautifully enriching and
surmounting massive columniated architecture. A line of
objects, partly of an immense Palace, and partly of the
river *Euphrates*, whose waters have a beautiful touching of

the pencil, rises on the canvass [sic] immediately over the above mentioned agitated scenes in front, forming by its calmness of look a soothing contrast to those scenes. The mind reposes here, and also on the still sublimity of the numerous structures which border the river in its winding course, till they become lost to the eye from their remoteness. Among these are the *Temples of Venus* and *Belus,* and the *Tower of Babel,* consisting of twelve circular stories, and lifting its proud summit above the region of the clouds. We cannot sufficiently praise our Poetical Painter for this very difficult but grandly characterised passage. Nothing is so difficult in a picture as to convey even a tolerably adequate idea of extraordinary magnitude. We have never yet seen it so well done before on canvass. To assist him in doing it, our admirable Artist has not only passed a cloud midway across it, but has placed near it a tower which is not above half the height and breadth, and yet is of a grand and towering size. He has also judiciously planted it in a distant part of the city, so that it shews more loftily by its great altitude in that indistinct aerial distance. From the tranquil grandeur of these huge edifices, the mind is again roused by the awful burning of the city, and from the still more awful discharge of the vengeful artillery of the skies. Forked lightnings are darting in every direction; the clouds open with terrific beauty of mysterious, vivid light; and as "the Stars in their courses fought against Sisera," so Heaven in frowns and fiery glances fights against *Babylon.* We almost fancy (for it is one of the great peculiarities of superior Painting to excite trains of new ideas, as in Poetry, where

"More is meant than meets the ear,")

we almost fancy we hear from the august and angry face of Heaven a voice reiterating the denunciation of the Prophet: "Babel is fallen, Bel is confounded, Merodach is broken in pieces. Babylon, the glory of kingdoms, the beauty of the Chaldees' excellency, shall be as when God overthrew Sodom and Gomorrah."

These superlative beauties are not unalloyed with de-

fect. Mr. Martin's pencilling and outline, though improved, are still somewhat hard. There is richness of colour; it is varied and powerful; but he does not in colour yet reach the richness and power of Mr. Turner. But our objection as candid critics, who, while in love with genius, would wish not to be considered, like amorous lovers, blind to defect, is chiefly to a certain theatrical look in some of his figures, admirably expressive as they otherwise are. We confess, that from the vehement character of his subject, a Painter would be more likely than in any other to fall into this. There is a numerous class of different expressions by which calamity may be displayed, and none more so than by an abstracted and inward retiring of the thoughts, and a quiescent state of the bodily frame. With these exceptions, we congratulate our country on the possession of such a Painter; of one who paints to the judgment and the heart, the sound judgment and the feeling heart; who paints to the imagination; who assists in rescuing England from the charge of incapacity for high Art, and whose works do now, and will live to disprove it.

"His Art is Nature, and his Picture thought."

LONDON: The Exhibition
by an Artist of His Own Work

The differences between the exhibition facilities and cus-
toms in London and those in Paris which prevailed in the
early part of the nineteenth century persisted. In Paris, de-
spite successive reforms during the Revolution and under
Napoleon, the biennial Salon still dominated patronage
and artists. In London, the practice of private exhibitions
sponsored by artists and open to the public for a fee
remained common, as Jacques Louis David had noted in
1800 when he exhibited *The Battle of the Romans and
the Sabines*. These exhibitions competed with the private
galleries of artists, the Royal Academy and the British In-
stitution for the attention of the public. With the re-es-
tablishment of normal trade and travel between England
and the Continent, a new gallery, the Egyptian Hall, a
commercial venture similar to the Boydell and Macklin
galleries, which had been forced to close when the conti-
nental blockade curtailed the sale of the engravings of the
paintings exhibited in the galleries, was opened in 1812.
Mr. William Bullock, a naturalist and antiquarian, in-
stalled his collection of art, natural history specimens and
South Sea objects in the central hall of the elegantly de-
signed building he erected in Piccadilly and opened to the
public for an admission fee. Off the central hall, single
exhibition rooms were available to artists willing to share
admission receipts and have their work seen beside the
curios.

Théodore Géricault, the French painter, had been dis-
appointed with the reception his *Raft of the Medusa* had

been given in the Paris Salon of 1819. Earlier in his career
he had received recognition when he exhibited *The
Mounted Officer of the Imperial Guard*. During the tur-
bulent events of 1814 and 1815, Géricault had enlisted in
the Royal Musketeers and followed Louis XVIII in his
flight to Ghent. After his regiment was disbanded in 1816,
he went to Italy for a year. Soon after his return to Paris
the revelation that government corruption had been re-
sponsible for the high loss of life when the government
ship *Medusa* was wrecked so outraged Géricault that he
amassed information from the survivors and devoted two
years to painting, in a traditional academic manner, a po-
litical criticism of the event. Its subject matter, realistic
details and emotional appeal ensured the popular success
of *The Raft of the Medusa*, but because it was against the
government it was denied recognition. The political
shufflings of conservative Louis XVIII were to restrain the
liberal Independents after their success in the elections of
the fall of 1819 and, although he received an award,
Géricault was thwarted in his hope of securing a commis-
sion or effecting any reform. The painting was purchased
after his death by Charles X.

Forced to recover the cost of the painting, Géricault, ac-
companied by the painter and graphic artist Nicolas
Charlet and the economist Brimet, went to London in
January 1820 to take advantage of the exhibition facilities
there. He made an agreement with William Bullock to ex-
hibit *The Raft of the Medusa* at the Egyptian Hall for
one third of the admission receipts. Attention was called
to the opening June 12 by advertisements in the *Times* and
the *Morning Chronicle*. Géricault executed a lithograph
to aid the publicity. The painting was viewed by thirty
thousand persons before the exhibition closed on Decem-
ber 30. Attendance may have been aided by Benjamin
Haydon's successful exhibition in an adjoining room of his
Christ's Entry into Jerusalem. Favorable reviews appeared
in the *Examiner*, the *Times*, and the authoritative *Literary
Gazette*. The *Literary Gazette*, a weekly newspaper de-

voted to science, literature and the arts, had been founded in 1817. Its editor, William Jerdan, brought to it an accomplished group of writers, so by 1820 it was supreme in the literary world. William Paulet Carey, the fine arts editor, was one of three distinguished brothers: John, a classical scholar, and Mathew, a bookseller and publisher, whose successful career in Philadelphia was begun with a $400 loan from Lafayette, a fellow ship passenger en route to America in 1784. An eye injury turned William from his profession of painter and engraver to that of art dealer, writer and critic. He was notable for his sponsorship of living British artists and British works of art and patronage for them and for his opposition to art regarded as a "treasure" simply by reason of its having been purchased "on the Continent." Not a defender of any one style, in his own words, he judged a work of art "by the intrinsic qualities" he saw in it. And the qualities he saw in *The Raft of the Medusa* led him to suggest that this was one French painting worthy of study by British artists.

After leaving London, *The Raft of the Medusa* was exhibited for six weeks in Dublin. This exhibition was not as financially successful, for a diorama of the same disaster was being shown nearby to the accompaniment of band music. Nevertheless, receipts from the exhibition of the painting supported Géricault for two and a half years in England, a congenial place for an ardent horseman and romantic humanitarian. In London, Géricault took full advantage of English artists' studies in color to lighten his palette and while perfecting his lithographs he recorded his observations of social conditions.

On his return to France, Géricault continued to reflect his humanitarian social interests in his work: first in his portrayals of the insane—a group that had only recently begun to receive medical care and humane treatment— and later in preparatory studies for a painting, *The Slave Trade of Negroes,* and another, *Opening the Doors of the Inquisition.* When Géricault died at thirty-three, in conse-

quence of a fall from his horse, he had done much to free French painting from the themes and styles of classicism.

William Paulet Carey, "Raft of the Medusa; Mr. Jerricault's [sic] Picture, at the Egyptian Hall"[1]

We stated, on our first view of it, the impression made on us by this very clever performance; and have now the satisfaction of knowing that our most favourable opinions have been amply confirmed by the judgments both of artists and amateurs. Our further remarks, therefore, will add little to the fame or advantage of Mr. Jerricault [sic]. But, as more frequent views of the awful scene have increased our admiration of the power of art and the ability of the artist, we shall endeavour to point out some of the striking qualities by which the mind is thus strongly excited.

The details in the picture, however excellent their character, are lost if not exhibited under the judicious arrangement of composition, aided by the effect of light and colour; and that which the ardent imagination of the artist or the poet takes in at a glance, must by the painter, become the subject of great consideration, and be subjected to certain rules and principles, yet so concealed as to appear the spontaneous effort of some powerful impulse.

In this tremendous picture of human suffering, the bold hand of the artist has laid bare the details of the horrid facts, with the severity of M. Angelo and the gloom of Caravaggio: the flesh indeed might be more strongly reflected; but the whole of the colouring is so well suited to the subject, and is in most instances so just, that we scarcely know if its tone can be called a blemish so entirely as at first sight it appears.

[1] [Verbatim from *The London Literary Gazette and Journal of Belles Lettres*, No. 180, July 1, 1820, p. 427.]

But it is over the varied details of form, the most correct anatomical markings of the figure, and all the agitated emotions of hope and fear, that Mr. Jerricault has impressed the magic of an effect that was to give value to the whole. The light brought into the piece and thrown upon the upturned faces of a centre group, powerfully assists in arresting the attention. This seems to break on them from the reflection of a highly illuminated cloud above their heads, and is contrasted by much surrounding gloom, and this again by the bright rays of the morning. Perhaps it is not natural; that is, could not happen to be so distributed in the full light of day; but there are great authorities for such departure from truth, in this respect.

The powerful element of the mighty waters is very happily depicted by the hand of the artist; and, taken altogether, his work is, as we before observed, one of the finest specimens of the French school, ever brought into this country. It cannot therefore fail to stimulate the exertions of British talents, to a further display of those powers, which have already so happily and so honourably distinguished our artists and arts. To Mr. Bullock, we think, great praise is due for procuring us such opportunities for examination and comparison of the two national schools: if he continues to bring over *chefs d'oeuvre* of French painters, he will do as good a thing as could be done to advance British art. Emulation is a noble teacher.

PARIS: The Official Exhibition of the State

The five-year period during which the Salons of 1822, 1824 and 1827 were held was marked by the increasingly repressive politics of the Bourbon monarchs of the Restoration and the reaction of the liberals. Louis XVIII, who after Napoleon's defeat had been returned from his exile in England to the throne of France by the victorious allies, initially stabilized the government within the framework of an English type of constitutional monarchy. Throughout Europe, political power was in the hands of conservatives who were prepared to take up arms against revolutionary change of government in any country that might threaten the status quo in other states. Under the aegis of the protocol of Troppau, which embodied this policy, Louis XVIII in 1823 intervened in Spain, where revolutionaries and republicans had fled, to protect the "divine right" of the Spanish king and by this action bolstered French national pride. At the same time, Louis's sound fiscal policies resulted in the considerable material prosperity enjoyed by both the bourgeoisie and the well-to-do peasants.

With the Restoration, the Napoleonic l'institut impérial de France was renamed L'Institut de France and each of the four sections that composed it was now designated an academy. The Academy of Fine Arts of the Institute was in turn composed of five sections: painting, sculpture, architecture, engraving and music composition. The Academy's membership was increased to forty (fourteen painters comprised the painting section), and ten additional honorary academicians were elected from among

distinguished theorists and writers in various fields. The Academy retained control over admission to the biennial Salon, though the king appointed several government officials and amateurs to the jury, and supervised the competitions for the Prix de Rome and the school in Rome. Although the École des beaux-arts, where artists were prepared to execute official commissions, maintained its independence from the Academy and was subject only to the Minister of Public Instruction, it was the Academy that controlled the direction of French art. Its forty members were predominantly classicists, supported by the scholarly Quatremère de Quincy, who had been a friend of Jacques Louis David during the Revolution and now served as secretary to the Academy from 1816 to 1839. The classicists were opposed to the innovating art forms of young artists and thwarted their admission to the Salon, the gateway to state awards and a livelihood as an artist.

Physical changes accompanied the organizational changes. The Louvre was no longer the Grand musée Napoléon which had attracted visitors from all over Europe. During 1816 and 1817 the art trophies confiscated by the French armies had been returned to their countries of origin. Of the 347 paintings that remained on the walls of the Louvre, 207 were by French artists, and these were augmented in 1818 by paintings transferred from the Luxembourg Palace after it became the Gallery of Living French Artists. With the secularization of the Church in 1792, ecclesiastical sculpture had been placed in the Convent of the Petits Augustins to form the Museum of French Monuments. In 1816, Louis XVIII had directed the restitution of these works to the churches and, with this museum now empty, in 1822 he began its reconstruction to serve as the École des beaux-arts. It was completed in 1833.

After he returned to Paris from London in 1822, Géricault's studio on the Rue des Martyrs, near the Chaussée d'Antin in the *quartier* of the liberal bourgeoisie, was a gathering place for innovative artists and writers. Having been told of the glorious promise of the

Revolution by their parents and having themselves seen France's achievement during the leadership of Bonaparte, they now sought to develop their own relationship to history and society beneath the smothering censorship of the Restoration.

Jacques Louis David, the innovative painter of the Revolution, had been exiled when Napoleon was deposed, but his artistic principles were kept alive in the studios ot his pupils and followers: Gérard, Gros, Guérin and Girodet. Louis XVIII named Gérard painter to the king in 1817. Guérin was appointed rector of the French Academy in Rome between 1822 and 1828. Gros, to whom David had assigned his pupils, would complete in 1824 the decoration of the Dome of the Pantheon, reconsecrated to St. Genevieve, which he had begun in 1811. If Louis XVIII favored painters of David's classical school, in 1822 he awarded a pension to the young romantic writer Victor Hugo, whose collection of *Odes et Ballades*, written under the influence of Chateaubriand, established him as a poet of promise.

Among the visitors to the artist's studios and exhibitions was a group of ambitious young men seeking recognition and a livelihood as writers and reporters. A number of them had been forced to this by default: they were barred from state employment because of their previous association with Bonaparte or were artists of insufficient talent to become painters. Careers as writers and reporters were made possible by the technological advances in mechanical printing and papermaking techniques, which had resulted in an increase in the publication of newspapers and periodicals. Many secured work as art, drama, literary and music editors and reported on current taste and tendencies. Interest in the arts was such that some could finance the publication of their own lively reports of a Salon. Stylistically these young writers owed a debt to Diderot: five of the writers' reports on the eighteenth-century Salons, which had been circulated outside of France earlier, were published in France by 1820. Their increasing availability encouraged the young critics to record

their personal reactions to exhibits rather than forming theoretical aesthetic analyses. This approach was more palatable to the newspaper audiences than the earlier theoretical approach of critics writing for more restricted audiences had been.

Adolphe Thiers, an ambitious twenty-four-year-old lawyer from Marseille, frequented Gérard's studio. There he quickly assimilated the standards of the neoclassicists. In 1821 he joined the staff of the *Constitutionnel*, the journal of monarchical opposition, with a circulation of 17,000, one of the largest of the Parisian newspapers. Assigned to review the Salon of 1822, his report appeared two or three times a week during the months when the Salon was open. Thiers himself published the collected reviews as a brochure with five illustrations executed in the new graphic technique of lithography.

Writing for the general reader, Thiers preceded the actual discussion of the Salon with an informative historical résumé of French art. With self-assurance, he then considered what was to be seen in the different Salon categories of genre, landscape, et cetera. He demonstrated an astuteness and a sensitivity to genius by his admiration for Delacroix's *Bark of Dante and Virgil*. He was understandably uncertain, however, as to the precise definition of the term "romanticism," which had only recently come into use to designate the influence of Shakespeare on contemporary literature. Thiers thought that in the field of painting it had been applied to the school of David and questioned the appropriateness of that usage, but he assigned Delacroix's work, which was soon to typify romanticism, to the promising "new generation."

Thiers added to his Salon review a report on a private exhibition held by Horace Vernet which included two paintings refused by the jury, *The Defense of the Barrier of Clichy* and *The Battle of Jemmapes*. The reputed reason for the refusal of the latter was that Vernet, on grounds of historical accuracy, had refused to change the tricolored cockade worn by the victorious French revolutionary soldiers to the white cockade of the Bourbons.

The painting had been commissioned by Louis Philippe, Duc d'Orléans, whose father had taken the name Philippe Égalité and who was in command with General Dumouriez when the revolutionary Army of the North won its first important victory in 1792. Vernet and his father had both fought at Clichy, the last stand before Paris of Napoleon's army retreating from Waterloo.

Protesting the rejection of his paintings, the first artist to do so, Vernet opened his studio, which was located near Géricault's, to the public. For many who felt stifled by the Restoration, the grand battle scenes were reminders of the height of France's glory. In his review Thiers, who in eight years would head the delegation to request Louis Philippe to be king of France, minimized the political implications of the exhibition by discussing the artist's meticulous facility, which he found admirable, and his lack of discrimination, which could be potentially dangerous for the artist's subsequent development.

In 1823, Thiers was sent to the Spanish frontier. His astute political reports resulted in Tallyrand's launching him on a lifelong political career. At this time Thiers became a correspondent for the important Gazette d'Augsburg of Baron Cotta. With the publication of Thiers's Histoire de la Révolution Française (History of the French Revolution; 1823–27), which emphasized that side of the Revolution which confirmed liberal thought, his position with political liberals was strengthened.

In spite of an increasing involvement in political affairs, Thiers continued his art criticism. An appraisal of David's school and its position in the current art world was stimulated in the spring of 1824 by a private exhibition, held for one month in the rooms of a painter-art dealer, of the most recent work of the exiled seventy-six-year-old David, Mars Disarmed by Venus and the Graces. Thiers wrote "À propos de David," which appeared in Le Revue européen. In 1824 he also wrote two reviews of the current Salon; one was published over the signature "Y" in the newly founded liberal Globe, and another appeared with his own name in the Constitutionnel.

After 1826, Thiers served as the apparent proprietor of the *Constitutionnel* to conceal its purchase by Cotta, who was concerned with maintaining French support for the interests of the province of Württemberg-Baden in the face of Prussian expansion. Cotta did not, however, interfere with the newspaper's policy toward internal French politics and left Thiers free to conduct these. The newspaper's opposition to Charles X, successor to Louis XVIII, contributed to the overthrow of the Bourbon monarchy and to the invitation to Louis Philippe. In recognition of his role, Thiers was named Minister of the Interior, which gave him the responsibility for public construction. He directed the completion of the Arc de Triomphe de l'Étoile, the Pantheon, the Palais d'Orsay, and the decoration of the Madeleine. Thiers's political career was culminated when, after negotiating the peace treaty with Prussia in 1871, he was named first president of the Third Republic. The year before, the Paris Commune, established after the uprising of 1870, had confiscated Thiers's collection and Gustave Courbet, curator of fine arts, distributed it to state museums.

Adolphe Thiers: Salon of 1822[1]

INTRODUCTION

Section I. Taste is fickle, beauty is permanent; arguments about beauty are as lively as those which arise over the subject of goodness. We become too enamored of our impressions and wish to be sure that the pleasures that we have tasted are the only true ones. It is not sufficient to have enjoyed, we wish to have enjoyed justly. But if some

[1] [First published as a series of articles in *Le Constitutionnel*, Paris, 1822. Translated from Adolphe Thiers, *Salon de dix-huit cent vingt-deux* (Paris: Maradan Libraire, 1822), pp. 1–13, 19, 21, 37–38, 40, 43–44, 56–58, 70, 72–73, 81, 90, 82, 83–85, 90–92, 97, 121, 122, 136–39, 145–49.]

are obstinate and become angry, others to safeguard their taste take refuge in a sort of skepticism, and deny beauty. Thus, in art as in philosophy, politics, everywhere, the human spirit sometimes falls into despair, and then into doubt. *"Chacun à son goût,"* the tired or lazy dialecticians repeat, and they do not miss the opportunity, any more than do those who deny morals, justice or liberty, to enumerate the contradictions among peoples: they remind us of the odd monstrosities of savage races; they contrast Italy and France, the France of LeBrun and David with that of Boucher; they contrast even the judgments made at any one time on any one painting, and they pretend that there is no beauty, which I deny, for if taste is fickle, beauty is permanent. . . .

Everything can therefore be reduced to these terms: there are truths which are true enough to make us act, a beauty that is beautiful enough to charm us; but this beauty, like truth, is placed far from us, and we must laboriously rise to it. Even though La Harpe has cried out, "Woe unto the art that is only intended for connoisseurs,"[2] it is sure that Virgil, Racine and Raphael are not intended for the multitude. Beauty in the end is truth itself and truth is not made for everyone. Doubtless someday all will attain it, but they will not attain it at the same time; and while we wait it belongs to the most enlightened. Truth, beauty and goodness are goals toward which everyone strives, toward which some advance, and very few arrive; it is a long journey and this it should be: if man were placed here on earth with truth revealed, beauty known, goodness realized, he would have nothing more to do, nothing more to seek; there would be no more action, no more life, no more universe. It is this progress of man toward beauty, these different states through which he passes that result in the fickleness of his taste; but beauty is unchangeable and man stops when he has discovered a

[2] [Successful dramatist and critic Jean François de La Harpe's studies of French literature were collected and published with the title *Lycée* (1799–1805).]

part of it. Today we hold fast and we will always hold fast to the head of Apollo and the Virgin of Raphael.

Section II. Every art has its judges: beauty is the chosen imitation of nature. This imitation takes place through various means—sound, color, speech—and it divides itself into several arts, namely: music, painting and poetry. Therefore, even though there is but one nature to imitate, the means of imitation differ and highly trained senses are needed to judge if the means of imitation have been used well. Not only is it necessary to know the most beautiful nature, but it is necessary to possess the secrets of language to judge poetry, to know the relationship of sound to judge music, the proportions of shapes to judge drawing.

A singular conflict exists between painters, literary figures and the public. The painters and literary figures agree in declaring that the public is incapable of judging pictures. Painters in their turn contest the authority of writers and allow them only the privilege of praising them; because they may not deny the writers the indispensable organs of opinion. Also, painters judge each other with a singular diversity of opinion, and are rarely in agreement on their works. Thus the public is declared ignorant by all, writers by painters, and these latter find it difficult to agree among themselves: it seems impossible ever to come to any agreement in painting; yet truth establishes itself here, as elsewhere, bit by bit, through the encounter of opinions and the assimilation of the most contrasting impressions.

Painters should talk to the writers and ask them at the outset: Do you know the means of expression that belong to our art? Do you understand the relationship of line, form and color? If you do not know these things you cannot understand our language and you do not know whether we express ourselves well or poorly. . . .

Finally, painters are absolutely lacking in the impartiality necessary to judge accurately; if rivalries exist everywhere, nowhere are they as violent as among painters.

Numerous young painters rise up bearing the standards of various masters, only recognizing, only praising their own leaders, denying any qualities to anyone else. If a great artist's painting has just appeared, they group themselves around the new work, encouraging each other to attack it, and soon tear it to pieces with the blindness and anger of mediocrity. If a talented man rises among them, woe unto him if he cannot be ranged against an already established talent; he is broken if he is not a useful weapon. If you say to me that this is the case everywhere fame is sought, among men of letters, musicians, I would answer that, according to the art, more or less reasonableness or irritability is found among those who cultivate it. . . .

Section III. . . . The works of painting strike different classes of spectators differently and also I have often noticed that one painting does not always make the same impression on a person. . . .

A people, like a painter or an individual, can be passionately fond of one type or one particular style. This is what determines the direction of an epoch. Thus, Italy had as many different tastes as schools, France, as many different tastes as centuries. This diversity of taste in a people does not disprove the immutability of beauty any more than does that of individuals in the presence of the same painting. With the passage of time, proof emerges from these contrasting impressions; thus, all that has remained for us from Greece is the universal ideal of beauty, that is to say, the real ideal, the nations pass in front of the schools like individuals in front of a picture, and truth is the only thing that survives them all.

HISTORICAL RÉSUMÉ

. . . David had received the impulse of his epoch; the new masters received it from David and from a great man who thought, like all sovereigns, that the arts are very becoming to a crown and who insisted on proving that

human nature had not become less fertile under his command.[3]

At this time a singular taste showed itself in the arts. The sorrows produced by a cruel revolution were allowed to appear, and they borrowed an oriental and Ossianic dress.[4] Germanic mysticism replaced revolutionary skepticism; and the exclusive spirit of the old regime was replaced by an affected taste for foreign literature with which the French had become acquainted by mixing themselves with all of Europe. The new school, beneath David's vigilant eye, preserved the purity of design, but in every other respect it participated in the taste of the period. . . .

. . . At one time all one saw in Salons, as elsewhere throughout Europe, were battles. At one moment, one saw only knights and saints, but today all subjects are to be seen, Greeks and Romans, mythological and Christian divinities, knights and grenadiers, except those of one certain era. Doubtless the variety of subjects is an additional richness, but it proves the lack of a definite and dominant direction. Actually, with all subjects all styles are encountered, the diversity which exists today appears in the arts, the sciences and letters. Philosophical schools, political systems, literary doctrines are in collusion in all of Europe. Everywhere the human spirit, arrested in the impulse that it received thirty years ago, vacillates, hesitates and painfully seeks to advance.

This is what the history of the art of painting has been in Italy and France from the Medicis down to our time. If one glances at this great stretch of time, one sees it divided itself into two distinct eras: the Italian school with its numerous variations and the old French school that it formed are to be found in the first era; the new school occupies the second era by itself. Those who are not able to resign themselves to taking each thing as it comes insist on comparing them as formerly one compared Corneille and Racine, Racine and Voltaire, the ancients

[3] [Censorship prevented the use of Napoleon's name.]
[4] [See 1795: ROME and Kleist on Friedrich's seascape, fn. 3.]

and the moderns. I will refrain from comparing objects whose too great differences do not lend themselves to any comparison and should only be explained. I regret equally the exclusive spirit of those who call themselves classicists and the delirium of the new romantics; yet I cannot refrain from certain reflections on the vicissitudes of things human. In literature, the great geniuses of Louis XIV's century who imitated and refined the ancients are called classicists. The romantics are those who, without being subservient to the Greeks or Latins, disdaining the reserve of modern taste, have, like Milton and Shakespeare, written freely and according to the inspiration of an independent and uncultivated genius. If the same classifications were followed in painting, our new school, imitating the Greeks and regular in its compositions, would be called the classic school and here I speak only of its masterpieces; while the Italian school—inspired like Milton, Dante and Shakespeare, free, great, but uncouth like them —should be called the romantic school. Why, therefore, is that the one that is called classical? Doubtless it sparkles with sublime traits, but there are as many in the poets I have just named. . . .

I. FIRST IMPRESSIONS

The first impression produced by the Salon was not favorable because it had been promised and impatiently awaited for so long, and impatience long drawn out is difficult to satisfy. The masters let their students go first, and these alone bore the brunt of the public's severity, always so numerous and so unjust. Gérard was not able to exhibit his *Corinne at Misenum* as soon as the Salon opened; Hersent had not finished *Ruth and Boaz;* Pierre N. Guérin was still working on his *Anchises and Venus;* Gros did not make us wait for him, but, doubtless distracted by his large frescoes, he was not as lucky as in his preceding works; Girodet is taking a rest for which all the friends of his great talent will reproach him; Horace Vernet is out of the Salon; David is out of France, and his

head is turning white beneath a sky without warmth or
brightness. It is therefore in the absence of the masters
that the Salon opened. The public arrived full of indul-
gence, and after walking through vast halls without being
greatly moved by anything, they went home discontented
and complaining about mediocrity. One masterpiece at
the opening of a Salon establishes a favorable climate; ev-
erything is raised to its level, whereas if mediocrity is
offered first we reduce everything to mediocrity. A hard-
working generation was not given credit for its meritorious
execution any more than we appreciate today a young
Frenchman who is able to write a page correctly. There
have been bitter complaints about the abundance of qual-
ity and the rarity of genius. Yet, since all exaggerated
opinions encourage their contradiction, people have re-
treated bit by bit from their early severity and have begun
to give the present productions the justice they deserve.
The masters arrive a little later: Granet arrived in Paris;
Corinne has exhibited herself on Cape Misene, *Ruth and
Boaz* beneath the patriarch's tent, *Anchises and Venus* on
Mount Ida. Some charming genre pictures have been no-
ticed. Horace Vernet has opened his gallery, hopes have
risen again, and if they have not risen to the point at
which they were when David's great students were exhibit-
ing their masterpieces, yet they are still high, and for my-
self, I do not think that any exhibition has offered two
pictures more touching and more original than *Corinne at
Misenum* and *Ruth and Boaz.* . . .

II. BARK OF DANTE AND VIRGIL BY DELACROIX

. . . I have spoken of Drolling as of a consummate art-
ist, of Destouches as of a young artist who presages a very
handsome style; to these hopes it is pleasant to add an-
other, and to announce a great talent in the coming gener-
ation.

No painting in my opinion better reveals the future of a
great painter than that of Delacroix depicting the *Bark of
Dante and Virgil.* It is there above all that one can notice

the welling up of talent, that spring of talent being born which raises the hopes that have been somewhat dampened by the overly modest merit of everyone else.

Dante and Virgil, led by Charon, are crossing the infernal river and fend off with difficulty the crowd which presses around the skiff, attempting to board it; Dante, supposed to be alive, has the horrible complexion of the place; Virgil, crowned with dark laurels, has the complexion of death. The hapless unfortunates, eternally condemned to desire to cross the river, hang onto the skiff. One seizes it in vain and, overthrown by his too rapid movement, is plunged again into the water; another grasps it and repels with his feet those who, like himself, seek to clasp it; two others clench with their teeth at wood which escapes their hold. Here is the egotism and the despair of hell. In this subject, so close to being exaggerated, we yet find a severity of taste, a sort of local convention, which so heightens the drawing that strict judges might, but in this case with little justification, accuse it of lacking nobility. The brush stroke is large and firm, the color is simple and vigorous although a bit raw.

The artist has, in addition to this poetic imagination, which is common to both the painter and the writer, that artistic imagination that one might call imaginative draftsmanship and that is quite distinct from the foregoing. He disperses his figures, groups them, gathers them at will with the boldness of Michelangelo and the richness of Rubens. I do not know what memory of the great artists this picture brought to my mind. I find in it savage strength, ardent but natural, which gives way without effort to its own momentum.

Thus, Drolling, Dubufe, Cogniet, Destouches, Delacroix form a new generation which maintains the honor of our school and advances with the century toward the goal which the future presents.

IV. NAÏVETÉ IN THE ARTS

It is common to regret childhood and maturity. We, an old and civilized people, love to take ourselves back to

that time when men cultivated their own fields with their own hands, nourished themselves with the milk of their herds, when young girls went together to fetch water from the spring and wash their veils. For us there is an infinite charm attached to everything that nature leads us to do immediately. . . .

The "naïveté" of the Italian painters was mixed with improprieties, because we cannot have everything at once, reflection and freedom. Art has aged since then and has become wiser, but less ingenuous. We have seen in the great masters of the new school the ideal and the true united; but all that they have been able to do has been to unite the natural with the thoughtfulness of maturity. It is not necessary to sigh over what can no longer exist; we cannot be at once children and grownups. Yet there are fortunate genius who keep some aspects of those early days. We have seen La Fontaine write as in the first days of the world. Today we see a painter, Hersent, unite a naïve simplicity with well-thought-out taste. He has taken his latest subjects from the Bible, and nowhere could he have found one better suited to his talents. The Bible gives us the annals of a pastoral and agricultural people, who have the simplest and noblest beliefs, particular customs, and a grand and melancholy imagination. There are found the most charming pastoral poems that any people have left us. No poetry in effect is comparable to the simple account of Ruth and Boaz. This fragment has had the fortune of all beautiful things, of inspiring all talents, of supporting the weak and raising the greatest above themselves. I do not believe that Hersent has produced anything comparable to his last picture showing Ruth and Boaz. . . .

This talent is one of the most characteristic that can appear in art: thoughtful, moderate, skillful, he has all the qualities of a virile century, with all the charm of happy childhood, "naïveté" and simplicity of expression. Let him, therefore, continue along the same road, let him carry us back to the tents of Israel. Before having seen this picture, I had never breathed so deeply of the perfumed

air of those regions where frankincense is born, where the palm tree rises, where the patriarchs lived several centuries, and saw their children's beards whiten, in the midst of a numerous posterity.

V. CORINNE AT MISENUM BY GÉRARD

The novel *Corinne* is supposed to be the most fascinating composition of a famous woman [Mme. de Staël], which has surprised her century by the force and liveliness of its organization, and above all by a boldness of thought foreign to her sex. . . .[5]

Given up to that mystical taste of the Germans which is today called *le genre impressif*, and which consists, not in calling forth feelings, but in constantly recounting what the author felt, Mme. de Staël has succeeded no better than many others in describing Italy; she has described her impressions instead of creating for us the land that produced them. The ancients painted; Bernardin de St. Pierre[6] also painted, and they did not count one by one the movements of their hearts; this is what gives so much reality and liveliness to their pictures.

A great artist who unites a powerful imagination to a superior intellect, and I mean by intellect not the fecundity of his insights but the true and profound science [system] of things, has conceived the happy idea of taking the felicitous subject of *Corinne* from the mysticism of the new poetry and placing it on canvas. He has made palpable the melancholy, the passion and the enthusiasm of the arts, under the Neapolitan sky on the shores of Baia, in pres-

[5] [*Corinne, ou l'Italie* (1807), the story of an Italian poetess who achieved fame but was deprived of the happiness of love, and then died of despair, enjoyed the greatest popularity as a protest against the social restraints on women; it contributed to their gradual emancipation.]

[6] [Bernardin de St. Pierre (1737–1814), author of the popular novel *Paul et Virginie* (1788), written to prove our happiness consists of living according to nature and virtue. The scene of the novel is an imaginary tropical paradise.]

ence of Vesuvius, and he has given to all this the reality and sublimity of form.

If this was his idea in the poetic aspect, he had still another that was more personal to his art. Human nature has always been clothed in ancient form, and no matter how handsome David's Greeks and Romans are, I see in them foreigners, abstract drawings depicting moral abstractions, and even though overcome by admiration, I am not convinced. What! Through the misfortune of our clothing and our habits, can we possess neither grandeur nor exterior nobility? The generous feelings that sometimes animate our hearts, the deep thoughts that occupy us, cannot be depicted with our faces and our clothing! Are there no more noble features today, no more beautiful shapes, and no way of throwing about us graceful veils which will decorate our bodies without disfiguring them?

Such is the question raised by a painter who, after having given us so many masterpieces, famous for a picture which has been called an epic,[7] did not seem able to go beyond this. Yet he has wished to give us a modern ideal and, without traversing the centuries, to transport us into the world of art. In effect, approach that French sky that bronzes the skin and kindles the glance; go farther still, cross the Alps, travel to Florence or to Rome; the lines of the face take shape; to a dark skin and a lively eye, large features are joined; erase the imperfections, but leave the traces of passion that Raphael erased in his Virgins, and you will have the modern ideal, you will have Corinne: this Corinne is your contemporary; by traveling a few leagues, by crossing a few mountains, you might see her and hear her divine singing. . . .

Let us speak of the technical beauties. Corinne is one of the most perfect bodies that has been caught within the lines of a drawing; the costume is the literal translation of the costume of our women into picturesque drapery. All the difficulties of the subject are vanquished; the brush is that of Gérard, and I hesitate to tell the author of a mas-

7 [Probably *Henry IV's Entrance into Paris.*]

terpiece that his technique is correct. Let us speak of light and colors.

Many painters here would have failed to light the extremities of the lines in such a way as to make a brilliant thread run around a mass of shadow. Gérard has taken care to avoid this: he has made the light penetrate abundantly, and sufficiently to illuminate half the figures. As for the color, it is strong and soft, the flesh tones are vigorous; that complexion tanned by Italy's sun heightens the nobility and the purity of the features, for the beauty of the lines in a face is more noticeable in a dark complexion. Gérard has not abused the reflections, and the whole painting is bathed in a unique color and an enchanting half-light.

Now may I dare to address to him a few criticisms? Corinne's floating shawl accompanies her body well; but when I think of the strength of the wind that flutters it, it seems to me that the calm of this scene is troubled; that drapery, even though distributed around Corinne with exquisite taste, is wrinkled here and there. Finally, the shadow of that superb arm is perhaps a little gray and earthy.

If now I am asked how this admirable work ranks among those of Gérard and his competitors, I would say that it is the one that touched me the most. Without leaving the ideal, art here has taken a step toward reality. I will dare to advance the idea that the sublime austerity of David, sometimes mixed with crudeness, Girodet's great drawing, so rightly admired, were not what was appropriate to treat the subject of Corinne. An artist was necessary who was endowed with a strong but collected imagination, a superior intellect who united the two qualities indispensable to our era, profound feeling and sure judgment. It needed him who composed *Belisarius, Homer, La Famille en repos, Psyche Receiving the First Kiss from Cupid*, who, at once draftsman, colorist, poet and, above all, a lofty spirit, is free in his talent and is not obliged, by a limited skill, to adhere to certain subjects, but is able to lend himself to the demands of all, and in all expands

sufficiently each quality. Finally, he who has not worn himself out on a byway, but follows them all and advances with ever growing progress, will doubtless have no other limits than his strength and his life.

If I compare the painter and the novelist here, in thanking Mme. de Staël for having furnished the marvelous subject and the great moments in which it abounds, I still find the advantage to be on the painter's side. On the canvas I see only reason, truth and perfect purity; I encounter neither disorder nor mysticism. Corinne here is noble, touching, passionate and, in spite of her genius, still tender. Here I find above all that profound melancholy that charms me in the novel and makes me reread it often in spite of its mistaken sentiments; finally here I do not deplore an aberration of taste, on the contrary, I see with a nationalistic joy a mark of progress in art that honors, at the same time, the artist, the country and the century.

VI. THETIS BY GÉRARD

. . . I do not wish to flatter Gérard and, doubtless he would not wish me to do so. I will therefore criticize him on one point: this little picture is painted as thickly as a vast canvas. The pigment is poured on, it is plain to see that the brush was used to spread floods of color over immense surfaces; and it has thus lost much of that lightness that would otherwise be assured it by such a great delicacy of tone and so free an execution. What a pity that this picture is not, according to the language of artists, painted with nothing at all! It would be accomplished without this fault. Also, reproduced by a worthy burin, it would be an admirable engraving, and one would have one of the rarest creations of draftsmanship, in which art was rich but not capricious, negligent but not incorrect, and naïve but not unsuitable. . . .

IX. GENRE PICTURES

In grouping them under this heading, I may insult a flock of pictures that have the pretension, and sometimes

all the merit, of historical paintings. But this heading of genre, the subject of lively discussion, has not yet been very well defined. Classifications are not yet fixed in science, how can they be in the arts? The palette is not by nature enlivened to reason. How would it rise to working out nomenclatures? Moreover, it is not terribly important what class a picture belongs to. The essential thing is that it be good. I prefer one of La Fontaine's fables to many epic poems. . . .

X. GENRE, CONTINUED

Today there is much complaining about the general desertion of artists who leave history to paint genre. I admit that I would not be much alarmed if from this they become better and more original, if they were [leaving] not from weakness but from free choice of talent, for next to those great historic scenes I also love those pretty pictures of everyday life depicted with accuracy and wit. I do not ask of painters more than they are capable of, but I demand them to be capable of something, no matter what; I accept quality in every genre. . . .

I hasten to arrive at a picture that has touched the public and had a popular success. It is a bereaved family, painted by Prud'hon. A father still in the prime of life is stretched out, dying, on a chair. His oldest daughter supports him from behind, his two young sons sit at his feet weeping copiously. One of those poor children presses his face against the cold hands of his father, the other looks at him with sorrow, and a young girl standing, older than they, hides her face in her hands. As for the father, he is dying, and his pale face announces his imminent demise. It is impossible to depict the impression produced at the sight of such a simple picture in which the painter has tormented himself so little to produce an effect. It proves what has so often been repeated and what is so difficult to make artists understand: that without imagining strange and fearsome subjects, without seeking to stir our emo-

tions by bizarre circumstances, nature simply depicted is profoundly touching. . . .

XXII. LANDSCAPE

Of all the imitations of nature, I find the landscape the most moving because it gives me the greatest illusions. In history or genre the ideal of customs, expressions, drawing is necessary; and it is difficult to avoid having the conventional take the place of the ideal in at least one of these things. Also, rarely moved by historical painting, I am always charmed in the presence of a landscape, if the perspective is well observed, the planes distinct, the light appropriately distributed. Then my eye plunges into the frame, forgets the dimensions and believes it wanders in a lovely countryside; the charm lies in the illusion, which cannot be as great anywhere else. And let us not judge from the landscapes of Claude Lorrain or of Poussin, so beautiful, but darkened by the years, full of a conventional nature; one must see the superb views in the Apennines depicted with surprising reality by Joseph Vernet; we are lost in immense spaces. We wander at the feet of magnificent summits, we breathe an abundant air, we contemplate a soft warm light, different in its brilliance from that of Claude Lorrain, for once again the whole of Vernet's work must not be judged from his seaports. . . .

Of all the categories there is none in which the artist needs to do less composing than in landscape. Everywhere the lines of the horizon, the effects of the clouds, the least thickets of woods furnish, at every moment of the day, sufficiently picturesque accidents of light and perspective. When it is a question of depicting human actions it is indispensable to choose the action, to group the characters; but in landscape to add to nature is to create happenstance, for landscape is but the accidental result of the terrain; and it is proved that nature is more difficult to equal in its regular compositions than in those that are irregular. In effect, who has ever been able to imitate ruins? That one doubtless prefers a rich and picturesque site in Switz-

erland to flat and barren wastes, very well, but let that
Switzerland be imitated and not composed.

Poussin, still full of the handsome lines of the Roman
horizon, composed what might be called historical land-
scape with the great and disciplined imagination for which
he is known. But the handsomest arrangements of art are
still inferior to the least scenes in the Alps; and the land-
scapes of Poussin, very handsome as theaters for historical
action, as backgrounds for a picture, have nothing of the
grandeur of nature and do not depict its proud and savage
character. This type of historical landscape has perpetu-
ated itself among us and we have several masters who cul-
tivate it especially. Bertin in a handsome landscape, which
looks composed even if it is not, has given us an example
of this type. Here we see again the lovely shoulders of the
mountains, clouds lightly arranged, ancient buildings,
well-rounded tufts of foliage of a gentle and harmonious
tone, and a facile and expressive brush. In the foreground
some Romans, drawn in the best of taste, carry garlands
to the tomb of Atticus. All this is very impressive, very
classical if you wish; but the tone is a little cold and these
extremely regular masses certainly look to me as though
they have been consciously arranged. That one is faithful
to the harmony of the lines in organized beings, very well!
since an organized being is a harmonious whole made up
of parts reaching for a goal; but in the outcroppings of
land, the beauty of nature is in the strangeness and confu-
sion. Therefore, nature does not raise gently rolling hills;
she breaks rocks, heaves at unexpected points, shatters all
symmetry, places a striped and naked branch in the midst
of the densest foliage, mixes pyramidal shapes with
spherical shapes, confounds all lines and colors, stretches
above this savage abundance a vast and luminous sky, and
thus gives to her disorder charm and magnificence. . . .

XII. SCULPTURE

Our inferiority with respect to the ancients is so patent
in sculpture that we are grateful to our sculptors for every-

thing they do, as if they were always surpassing all our
hopes; but even if they were to produce the most beautiful
works they would never be granted the position they de-
serve. We are actually so accustomed to thinking of them
as inferior to the ancients that it is impossible to believe
that they could ever rise to a masterpiece. I will not exam-
ine to what point such an inferiority is actual, I will only
affirm that the present exhibition has satisfied every hope
and has shown us works of the brightest merit. Sculpture
at this moment seems to be taking a new route and trying
to raise itself from the beauties of style and form to that
of expression, which it has too long, perhaps, neglected.
The choice of subjects, the way in which they are treated,
demonstrates a real progress in this aspect; but if move-
ment is desirable, nothing is to be feared so much as an
ill-directed movement: I will therefore present some con-
siderations on appropriate subjects for sculpture and will
be happy if I can lead our young artists to some useful
thoughts.

The means that man has received for perceiving objects
are limited; he cannot absorb at one time more than a
part of things; and it is only little by little, with the pas-
sage of time, and when he is of a retaining frame of mind,
that he finally acquires knowledge that is fairly extensive
for him but very limited in respect to the whole of the
universe. It is because he is capable only of grasping a lit-
tle at a time that man divides and subdivides all things,
unwinds the links of truths that he calls sciences and even
separates sensations to make up the different arts. Thus,
even though nature manifests itself simultaneously
through the ears and eyes, he isolates these different sensa-
tions and composes from each a different art. Therefore,
entirely devoted to one expression, he seizes it and enjoys
it more and more deeply.

Moreover, in the decorative arts, he has separated sculp-
ture and painting, and has composed an art whose aim is
to depict as solid bodies pure forms void of color. It is a
species of abstraction that limits our view to the contem-

plation of forms alone and makes us appreciate them better by limiting us to them.

This is why the statue or the statuary group is isolated. A whole subject depicted in sculpture would be of a solidity and volume that would tire the eye. One could not measure it with one's eyes as one measures a single figure; and since it is not large groups that it is the aim of sculpture to depict, but forms, since a single figure always brings them out better, isolation is a custom in sculpture that has solidified into a law. Because the aspect of shapes changes according to the point of view, a statue is improved if it offers several different points of view. Therefore a standing or seated figure is always better in its effect than a reclining figure, which changes its appearance only slightly no matter from which point of view one looks at it.

Since the muscular parts of the face determine the expression, this should be one of sculpture's outstanding qualities. To arouse this expression, action is necessary; sculpture seeks to find some, and since action is difficult in isolation, it sometimes tries to group two figures; but it rarely succeeds, because the contrasts of forms are always disagreeable, and because one must no more accumulate solids in sculpture than colors in painting.

Because forms are the principal object of sculpture, the choice of a figure is determined; therefore an athlete with very expressive muscles suits it; a woman with enchanting contours is also suitable. A weak child with chubby limbs offers it graceful volumes to reproduce; but a young boy who has neither the agreeable plumpness of childhood nor the characteristic strength of youth, a young girl whose charms are still undeveloped, are subjects little suited to sculpture, because they lack that which it knows how to depict: forms.

Finally, since sculpture almost always has but one figure to show, or at most two, it is necessary to show it well and in its entirety. To present a statue whose head is lifted so that it cannot be seen is to disobey the rules of the art. Painting can do that, because it redeems itself by a thou-

sand other advantages, and when it does not do one thing, it does another, but when one has only a face to offer, to hide it is to deprive the eyes of that which is necessary to them.

For those who have seen the works presently exhibited and who have looked at them closely, these reflections even though general should already have a direct and applicable meaning. Thus several of our sculptors, in choosing novel subjects, have disobeyed many of the rules that I have described.

Thus, instead of presenting Venus standing as is always done, one of our sculptors has shown her kneeling down to embrace Cupid. Doubtless there are merits of several different types in this marble, but these volumes face to face look heavy and discordant; there is crowding and inconvenience, the eye cannot move freely.

Others have lifted the heads of their statues so far toward the sky that their faces cannot be seen. Allier—a young sculptor of great merit, to whom we owe one of the most original plasters of this exhibition, *The Young Dying Sailor*—has committed this mistake. We will soon return to this young man's handsome work. The author of Ajax thunderstruck has sinned more seriously than any other. His furious Ajax addresses himself to Jupiter but one must be Jupiter to see him because, for us, poor mortals who do not inhabit the sky, it is impossible to discern the features of the blasphemer. . . .

PARIS: The Exhibition
in an Artist's Studio

Adolphe Thiers, "Remarks on a private exhibition by Horace Vernet"[1]

Horace Vernet has opened his studio to art lovers eager to admire his rapid progress. It was not, as has been said, a moment of pique that led him to absent himself from the Salon. Two of his most important works were refused admission,[2] those that showed best the superior direction of his talent. He did not wish to deprive himself of his best works. He preferred to hold an open house, and he was right. The extremely varied characteristics of this genius, who has more than verve and abundance, are better known. . . .

Entering Horace's studio, one is struck by the great number of works that have issued from his brush in such a short space of years, and we admire his fecundity. Truly, only this word can characterize his talent, and it is annoying because the stupid will see nothing else and his enemies pretend that they see no further. We are astonished by so many subjects, each more aptly viewed and composed than the next! . . .

But we soon leave these subjects to admire a vaster composition: we proceed to an immense landscape, the plains of Jemmapes come into view; the French carry off their first victory and answer the insults of Brunswick by prodigious heroism. . . .

[1] [First published in *Le Constitutionnel*, Paris, 1822. Translated from Adolphe Thiers, *Salon de dix-huit cent vingt-deux* (Paris: Maradan Libraire, 1822), pp. 103–11.]
[2] [See p. 214, *The Defense of the Barrier of Clichy* and *The Battle of Jemmapes* were refused.]

From the enormous variety of subjects, and above all the accuracy with which they are depicted, we cannot fail to recognize in Horace Vernet a lively and quick spirit which paints the gayest and the most touching subjects with equal ease. It is impossible to see this young painter without receiving the impression of a being full of life and sensitive to all things, who finds it necessary to reproduce everything that attracts his attention. As lively in his execution as in his conception, he takes tones of the most different colors, and it is impossible to say in looking at a picture that it has Horace Vernet's coloring, because he takes them all by turns, and remains harmonious in all of them. . . .

. . . It is the principal trait of Vernet's talent that he knows how to make the most familiar bit of reality touching by making it both noble and true. This is also the side to which he should direct himself. This is his path and his goal. Let him therefore paint our customs and our epic with six-inch figures, a dimension in which he excels. Let him depict nature in all its aspects, from grace to strength, from the comic to the tragic. Let him reproduce it with the accuracy and that taste for imitation which is the ideal of genre, and he will be a unique painter among us, he will be our national painter. . . .

Horace has been criticized for lacking in nobility, and wrongly so. He depicts the noble subject like the common when he wishes; but he does not separate them sufficiently. If nothing is more appropriate than that wagon full of wounded in the *Battle of Jemmapes*, I am not sure whether the terror of its gross drivers fits in with the rest. The vast imagination of Vernet contains all that is necessary for great or intimate subjects. Let him give himself the trouble of selection and not content himself with an eruption that brings forth pell-mell a flow of images that are always natural and original but not always sufficiently harmonized with the time and the place.

Another inconvenience that Vernet should avoid is a too great facility in painting. His brush technique is superior; it is not easily recognizable, being so varied. . . .

These are the reflections that an ardent interest and a sincere admiration lead me to make. No one seems to me more apt than Horace to feel everything and depict everything with astonishing accuracy, and, if he would only choose, with an accuracy full of nobility and charm. But he must straighten out his compositions, control his touch, think of his ensembles and depict in dimensions that suit his talent the subjects of our era. For example, he should not be so negligent of the sky in his pictures, and not leave them as they were after the first burst of inspiration. That of Jemmapes goes badly with the whole. Let him ask himself what sort of sky his admirable ancestor would have placed there. Let him observe with what pride, but also with what care, Joseph Vernet depicted all things. Let him examine in Joseph's seaports the immense care for detail and their exactitude without obviousness. Let Horace find in this criticism lessons to guide his talent and learn that work is compatible with the most ardent genius.

I dare to tell him all this because his future is bright, because he should rise above all his works and continue to advance. He is young, favored by fame and fortune, surrounded by friends who admire him, by a public which applauds him with particular readiness. But life should not be so easy. Horace Vernet should be tormented. Let his torment be the ideal of perfection, may this ideal pursue him unceasingly. He is worthy of aspiring to this. Everything calls him to it; his genius, his age and his country, which worships a free, enlightened and generous talent.

1824

PARIS: The Official Exhibition
of the State

On St. Louis's Day, August 25, the king's name day, while masses were being said for the gravely ill sixty-nine-year-old King Louis XVIII, Parisians and tourists gathered in the Place du Carrousel to await the opening of the Salon of 1824. In the crowd were nervous artists and as many as thirty impatient reporters and writers who would review the Salon for periodicals or their own brochures. Some, whose reviews had been published for several years, were already known as *salonniers*. Others were anonymous writers for short-lived journals.

When the doors of the Louvre opened, the crowd rushed past the sculpture on the ground floor and up the great staircase to see what paintings had been hung in the prestigious Salon Carré. Tourists on a short visit to Paris were deprived of the opportunity to see the Louvre's old masters, for the Salon paintings were hung over the museum's permanent collection. Washington Irving, who was traveling in Paris, was astonished to see the frames of the works in the permanent collection extending beyond those of the Salon entries in front. Over two thousand works had been accepted by the jury, and the reporter for the *Journal du Commerce* noted it required five hours to view them.

Thiers, back from his political reporting on the Spanish frontier, filed two reports of the Salon. In the review for the liberal *Globe*, which was signed "Y," he noted:

> The only paintings . . . where one finds real progress, in color, in the management of the brush and composition, are of that new generation which has been so

attacked. There one finds, doubtless with faults, grand composition, profound feeling, naturalness that does not exclude nobility, and finally, originality, that is to say, truth: for with the falseness that reigns today, to be true is to be original.[1]

The painters whom Thiers designated as the "new generation" were now also beginning to be known as "romantics," the word Mme. de Staël had used in connection with the Nordic or Gothic tendency she had observed in the German states in 1810. They had found an emotional outlet in the Greek uprising of 1821–22 against the Ottoman Empire. Lord Byron, who embodied a freedom of thought and way of life desired by many in France, Germany and England, provided them with themes for paintings. Some artists, impelled by a similar desire for a new direction, turned to nature and landscape painting. A Prix de Rome for historical landscape, offered for the first time in 1817, had stimulated an incipient interest already reflected in Salon entries entitled *paysage composé*, *vue adjutée* and *étude d'aprés nature*.

This interest awakened an appreciation for the English landscape school, which was becoming more familiar to the French as contacts between the two countries increased after the Restoration. The market for paintings, engravings and illustrated books in London and Paris developed by French and English booksellers, printers and art dealers, which had been ruined by Napoleon's continental blockade, again became active. French writers and artists were attracted to London and relished the creative freedom and fecundity they found in English literary and artistic circles. This traffic had made it possible for Géricault to arrange for the London exhibition of *The Raft of the Medusa* in 1819 and for Daguerre to mount his Diorama there in 1821. English artists, always present in Paris as students, were now represented in the Salon. An astute art dealer, born in Paris and brother-in-law of

[1] [*Globe*, September 17, p. 7, translation from Dorothea K. Beard, *The Role of the Nouvelle École in 1824*.]

Daguerre, John Arrowsmith, who exhibited and sold paintings from his café in the Boulevard St. Martin, purchased three large paintings from John Constable. The Comte de Forbin, director of the Louvre since 1816 and in charge of mounting the Salon, gave them a favorable place in the Salon of 1824. The paintings of thirteen other English artists, whose addresses were listed as that of the art dealer Schroth, a friend of Arrowsmith, were also admitted to the exhibition—so many that some referred to this as the "English Salon." English landscapes often did not correspond precisely to the categories established for the Salon, and this presented a problem for reviewers.

Among the crowd awaiting admission to the Louvre was Auguste Jal, a *salonnier* who wrote for himself. As a twenty-year-old midshipman, Jal had joined Napoleon during the Hundred Days. When he was debarred from further government service after the Bourbons came to power, Jal became a writer and supplied articles to small papers of the liberal opposition between 1818 and 1821. Capitalizing on the public's growing interest in art—as Stendhal, Emeric-David, Ferdinand Flocon, Marie Aycard, Louis Vitet and others did—Jal chose for his first book *Mes visites au Musée Royale de Luxembourg* (1818), a guide to the newly organized museum of contemporary French art. With his next work, *L'Ombre de Diderot et le Bossu du Marais, Dialogue critique sur le Salon de 1819,* he consciously entered the field that Landon's *Annales du musée* and *Salons* had been the first to fill and satisfy. He employed the dialogue form to give opposing views on art; a favorite also of Brentano and von Arnim, this form had been in use since the Renaissance.

Jal again used the dialogue form for his report on the Salon of 1824, *L'Artiste et le philosophe,* a handsome volume illustrated with eight lithographs. The two protagonists express their observations while they saunter through the galleries. Jal assumed the role of the philosopher, who expressed the opinion that art had a moral and patriotic purpose and that artists had a responsibility equal to that

of the army and industry in maintaining France as "the
most advanced nation in civilization." Jal as a friend of
the young Victor Hugo followed his approach. The artist,
on the other hand, voiced opinions characteristic of a con-
servative academician, noting changes in technique and
the grand manner known as "style" which emphasized
contour and modeled form. Unhappy to discover any
weakening in "style," the artist was suspicious of a paint-
ing's direct appeal to emotions rather than reason.
Through this dialogue, the current definition of "roman-
ticism" became more precise. The word connotated a
delight in scenes of horror; it reflected the influence of the
writings of Walter Scott and Lord Byron and a predilec-
tion for suggestive illusionism that brought crowds to
view the dioramas of Harry Barker and Daguerre. The
pleasure both the artist and the philosopher took in a ro-
mantic landscape with ruins was contrasted with their un-
certainty when faced with "nature itself" and the tech-
nique in Constable's landscapes.

Jal's popular books continued with *Esquisses, croquis,
pochades,* subtitled "all one could want on the Salon of
1827." The three words were studio jargon referring to
sketches and studies executed before the actual painting
was begun. Only the *esquisse,* a compositional study more
finished than the thumbnail sketch, or *croquis,* and the
value study, or *pochade,* could be submitted to the Salon
jury to secure admission for a painting not yet finished. A
number of *esquisses* were on view at the Salon, but
academicians tended to feel that exhibiting an unfinished
work was pointless, since it might indicate to the public
that the painter lacked the ability to finish the work prop-
erly. The lack of finish or the *esquisse* quality in the works
of the English school and of Delacroix was criticized.
While Jal's use of the words called attention to the
change in technique and he himself was unable to approve
of Delacroix's *Sardanapalus* or the imitators of the Eng-
lish school, he was unwilling to see a return to "colored
statues" and conceded, "The romantic has remained

master of the battlefield which the classicist has moreover feebly defended. I do not pity the dead."

Two years later Jal's volume on the Salon of 1829—entitled *Le Peuple au sacre* because the exhibition was dominated by the large canvas, *The Coronation of Charles X* by Baron Gérard, painter to the king—continued the defense of academic classicism voiced by the "artist" in 1824. With *Ébauches critiques: Salon de 1831* and *Les Causeries du Louvre: Salon de 1833*, however, Jal acknowledged the merit of the younger generation of romantic painters. The July Revolution of 1830 enabled Jal to enter the Marine Ministry. He ended his literary career as a distinguished naval historian and compiler of the *Dictionnaire critique de biographie et d'histoire* (1864).

To review the Salon of 1824, the *Journal de Paris*, founded in 1777 as the first French daily, secured Henri Beyle (1783–1842), a popular critic and author whose *nom de plume* was Stendhal. He had been on Napoleon's staff as a *commissaire des guerres* and had seen active duty in Italy in 1800, Vienna in 1809, and Russia in 1811. Foreseeing the collapse of the Empire, he had severed his connection with Napoleon and embarked on a career as a writer, leaving Paris for Italy in 1814. In his first book, *Les Vies de Haydn, de Mozart et de Métastase* (*The Life of Haydn, in a series of letters written at Vienna, followed by the life of Mozart, with observations on Metastasio;* 1814), he noted a change in taste from classicism to a favoring of English forms. The material for his second book, *Histoire de la peinture en Italie* (1817), had been gathered on a rapid tour of the galleries in Bologna, Florence, Rome and Naples. He examined the outstanding qualities of the Italian artists and their ability to interpret the spirit of their subject. Depending on personal taste rather than aesthetic theory, Stendhal came to question whether the spirit of the antique, defined by Winckelmann as *le beau idéal*, was compatible with what Stendhal termed *le beau moderne*, the art that reflected

the spirit of the time. Another critic, Étienne Delécluze, called the book the Koran of the romantic school.

In 1817, Stendhal had visited London and secured Henry Colburn, the director of the *Literary Gazette*, as publisher for the English edition of his third book, *Rome, Naples, et Florence* (1818), which he described as "a collection of sensations." When forced to leave Milan in 1820 on suspicion of being a spy, Stendhal continued to support himself in Paris as a free-lance journalist and, already known in London, he supplied English periodicals with uncensored accounts of art and social events in the French capital.

A brilliant raconteur and conversationalist, Stendhal was a desired guest at every salon, whether frequented by political figures or literati and artists. Such salons, which served as outlets for the liberals, established the new French literary and artistic aristocracy, the "happy few" who were to dominate French cultural life throughout the rest of the century. Stendhal attended regularly the Réunions de Dimanche of Étienne Delécluze, art and drama critic of the prestigious *Journal des débats* and former pupil of Jacques Louis David. Here English writers, especially Shakespeare, were read and the English language studied. Its habitués were bright young men of a variety of viewpoints who were embarking on careers of influence: they included Prosper Mérimée and Emmanuel Viollet-le-Duc, the father of Eugène and Adolphe, as well as Stendhal. At these discussions, Delécluze defended the two labels he had coined in 1822 to help the 22,000 readers of the *Journal des débats* understand contemporary artistic developments. The term "Homeric" he applied to the academic classical style, and "Shakespearean" he used to designate the new divergent tendencies.

Stendhal's contributions in these discussions were published in a three-part essay, *Racine et Shakespeare*, "a response to a manifesto against romanticism given by M. Auger at a meeting of the Institute," two parts of which were published in France between 1823 and 1825. He as-

serted that Shakespearean dramas suited contemporary taste because they provided an "intimate knowledge" of the characters lacking in the classical Racine. He came to the conclusion that "Romanticism is the art of giving to a people the works of art which in the present state of its habits and beliefs are capable of giving it the greatest possible pleasure."[2]

Stendhal's report of the Salon of 1824, which first appeared in the *Journal de Paris* over the initial "A"—he intended to publish it as a brochure—incorporated the points of view he formulated at Delécluze's salon and expressed in *Racine et Shakespeare*. The account was at times ironical; he refused to be guided in his judgments by the established rules and took note both of what drew the crowd and of what interested him.

Des beaux-arts et du caractère français, which was published unsigned in *La Revue trimistrielle* in July–October 1828, was written by Stendhal on the Salon of 1827 in response to Jal's book, *Esquisses, croquis, pochades*. It was not, however, so much a review of the works exhibited at the Salon as a discussion of the problems faced by artists, particularly sculptors, attempting to create an art that would speak to contemporary values and customs. Stendhal's criticism, based on a sensitivity to the art work similar to the German romanticists' approach, was followed later by French critics, but Stendhal's analytical observations of human nature, which had led him to write *De l'amour* (*On Love*), published in 1823, led him away from art criticism. After the Revolution of 1830, he was appointed French consul at Civitavecchia, Italy. Freed from financial concerns, he completed his psychological novels, *Le Rouge et le noir* (*The Red and the Black*; 1831) and *La Chartreuse de Parme* (*The Charterhouse of Parma*; 1839), which led the way to realism in French literature.

[2] ["Racine et Shakespeare," Ch. 3, quoted from George Strickland, *Selected Journals of Stendhal*, p. 5.]

Auguste Jal, The Artist and the Philosopher: Critical Conversations on the Salon of 1824[1]

LETTER FROM "THE PHILOSOPHER" TO THE AUTHOR

August 24, 1824

You love the arts and you know how I love them, my friend. I see them as a civilizing agent and a means of perfecting the social order, and it makes me very angry to see their power ignored today. The moral aim of painting is very dear to my heart. I do not believe that people are sufficiently concerned with it and this makes me very unhappy. One virtuous act well depicted can make more impression on a people's spirit than having the story of that act repeated a hundred times. I am sorry to see subjects without a moral, absurd traditions, frivolities of more than one sort adopted by some artists whose brushes would be ennobled by being consecrated to the great historical incidents of their country; at least they would serve to arouse the patriotism of its citizens, the filial heroism, the maternal devotion, the passion for work and order, the love of discovery and improvement, industrious competition—in a word, all the generous impulses which make a society great but whose neglect diminishes it. An impressive development can already be noticed in France; the glory of our arms and the enterprise of our industry have placed us in the front rank among nations; let the arts, following the direction taken by literature, complete our moral education, and we will leave to posterity a moving inheritance that will combine the memory of those virtues and values which have made us the equal of the ancients and the tradition of important achievements

[1] [Translated from Auguste Jal, L'Artiste et le philosophe, entretiens critiques sur le Salon de 1824, (Paris, 1824), pp. xx–xxviii, 1–19, 47–53, 292–95, 416–18.]

and valuable inventions which have made us the most advanced nation in civilization.

You see, my friend, what I expect from art. I would hope that the capable men who cultivate the arts would understand that and be willing to enter into a path along which there is so much honor to be gained. May this year's Salon show us that they are on this track! . . .

Your friend,
"The Philosopher"

First Visit to the Salon

Artist: It is not yet nine o'clock, and look at the crowding and pushing there is at the doors of the Louvre! Horace Vernet, Wilkie and even Boilly would have made an excellent picture of this outdoor scene.

Philosopher: The expression of the different groups would be hard to render. I don't think that painting could adequately express the different feelings that stir all these individuals. You, for example, are only curious and impatient. You keep looking reproachfully at your watch. As for myself, another idea concerns me most: what moral direction has the spirit of the century given to the arts, and in reaction what direction will our century be given by the work of our artists? That is what concerns me. Like you, I want to look, but for a motive that is very different from yours.

Artist: I confess that this consideration is less important to me than to you. But I am preoccupied with a no less important one: has style been completely lost by the school of France? Has color triumphed over drawing? Shall we continue as in the Low Countries or as in Spain? Has David been permanently forgotten? That is what I ask myself. Let us wait; in an hour I will have some answers. If we are impatient, the artists are even more so. One has painted a mediocre picture; he hopes that the full light of the Salon will perform a miracle in his favor. Another has done a good piece of work, but will it perhaps be badly hung?[2] A third has

[2] I have yet to hear a painter congratulating himself on the placement of his work at the Salon. . . .

painted a well-known person; if the public is struck by
the resemblance, his triumph will be complete, his
name will spread through the Faubourg St. Denis.
That is all he asks; all he has put in the Salon is the
trade sign of his painting shop. Another is in need of
work and has exhibited an ostentatious piece. If one
or two newspapers speak of it, if the director of the
division of art likes it, he will be satisfied. The pub-
lic's judgment does not matter to him; he does not
paint pictures for the public. There, look at that
young man, I know him, he has painted his second
picture [for the Salon]. His future depends on a
success. Will he achieve it? . . .

Philosopher (*as they enter*): Oh, good Lord, how pleased
our friend Diderot would have been if he could have
seen this year's exhibition! He wanted the director of
the Academy to obtain a royal decree requiring every
artist to send at least two works to the Salon on pain
of expulsion [from the Academy]. Certainly he
would be satisfied. The catalogue lists 2,180 pieces
and that does not include the groups of several paint-
ings listed under one number! To view two thousand
objects is intimidating!

Artist: Heavens, you are lucky! What if the jury had not
spared you the eight hundred daubs, at least, which it
rejected?

Philosopher: I am grateful to the jury, but I would be still
more grateful if they had made the rows less crowded
and spared me the trouble of viewing compositions I
do not understand and which have neither content,
detail nor useful aims.

Artist: My friend, let us not complain. The Salon as a
whole is very satisfactory. I have already noticed many
good things and I would say, quoting your Horace:

> . . . *Ubi plura nitent.* . . . *Non ego paucis*
> *Offendar maculis.*[3]

[3] "Where several beauties shine, I am not offended by a small
number of blots."

Philosopher: Then you find the Salon "strong," as you would put it, I believe?

Artist: Yes, and I am delighted. Some of my fears have been calmed. But I still have some worries. I see few works that stand out because of their "design" or draftsmanship, and I am struck by the general tendency toward color or, more accurately, toward effect. I would like to see more harmony and less noise. I am afraid that people are taking great pains to seem extraordinary when their concerns should be to appear natural.

Philosopher: And I—I have already made an observation that will astonish you. You have seen effect, while I have seen a universal sadness. Painting is ill. Look at the melancholy atmosphere of all these works. I can hardly find a cheerful idea; one would say that the malaise of literature is contagious. Here we can see the infiltration of romanticism. Will our painters weep like our poets? . . .

Romanticism is flooding through society and, since painting is also the expression of society, painting becomes romantic. I do not complain about it, by the way; I have had enough of the old Greeks. It is the modern Greeks who interest me. Hector, Achilles, Agamemnon tired me with their sublimity. Georges, Colocotroni, Odysseus, Jorjaki, those are names that echo in my heart.[4] I have wept enough over the eternal misfortune of eternal Ilium; Ipsara[5] thy recent misfortunes stir my soul. What are the soldiers of King Priam to me! It is Keftis, the Armotolis who interest me. Farewell then, ancient Greece who has seen so much bloodshed, and who has cost our poets so much ink, our artists so much pigment! Hail, Hellas, young and proud, who leaves its ruined nursery to cries

[4] [Leaders of the Greek Revolution. Theodoros Colocotroni was a leader of the Moriats, and Odysseus Androutosos an eastern Greek chieftain, actually a collaborator with the Turks.]

[5] [Ipsara is an island northwest of Chios which was ravaged by the Turks in 1824; its population was exiled to Euboea.]

Second Visit

Philosopher: . . . But let us leave that and let us stop in front of this great picture. Lord, what energy! what expression! Whose is this painting which strikes me with terror and pity?

Artist: It [is a scene of *The Massacre at Chios* and] is by a young man named Delacroix.[6]

Philosopher: A young man! Oh! Yes, there is the fire, the vigor, the audacity, the temerity, the inexperience and the ardent genius, happy appendages of youth! How this tragedy excites profound emotion in me. What! Those are the last remnants of a rich and valorous population![7] The most beautiful country of Greece is devastated, the houses are burned, the children are crushed under rock, the churches profaned, the steps of the sanctuary saturated with Christian blood, the scattered limbs of the dead are thrown to the devouring dogs. Neither unhappy courage nor imploring beauty nor Nature in tears can find grace before the wild Turk. Must everything perish! No, a torture more frightful than death on the battlefield, more horrible than assassination and massacre, hunger will decimate the few brave Chian survivors unless, by a refinement of barbarism, the infidel has marked for slavery the chiefs of the free party, and for the harem the virgins consecrated to the service of the mother of God. . . .

Artist: I listen to you and, listening, congratulate the painter who has found the secret of exciting your sensitivity to this degree. Not over your soul alone has he gained this hold. See all the crowd press around his painting. Read on the faces of these spectators the indignation with which you are moved. The dejected si-

[6] The minister of the king's house bought this painting for six thousand francs. It is destined, no doubt, for the Luxembourg Museum.

[7] [In 1822 the Chian Christians had risen in revolt against their Turkish overlords and in reprisal were ruthlessly slaughtered.]

lence with which each one observes the sight of this
scene of desolation, and the tears which flow from the
eyes of this young woman at the painful spectacle of
the frightening episode with which the composition
on the right ends; there is the most glorious success
which the artist could have wished. What does it
matter that after this approbation we say that this
conception is almost sublime, that the execution is
stamped with extraordinary force, that the color is of
an uncontestable energy, that the paintbrush ran on
the canvas with the vivacity of thought? We would
add nothing by these remarks to the eulogies which
the public gives to the work of M. Delacroix.

Philosopher: For me it is the most beautiful painting of
the exposition, for it is the most expressive.

Artist: It is, without doubt, an interesting piece; but let us
not hasten to give him the palm. If it is remarkable
for its astonishing qualities, it is marred by great
deficiencies. In general, it lacks style; M. Delacroix
did not keep in mind, in fixing the character of these
heads and of these naked bodies, that he was painting
Greeks, who continue to be the model of human
beauty; he equally forgot that the population of Chios
was prodigiously rich, and that the Chians could not
be clad in disgusting rags; still, one would pardon
him, in favor of the color, this omission of appro-
priateness, if the rules of drawing were a little more
respected. But it seems that he did not have the lei-
sure to think about them. One must urge M. Delacroix
to draw with more care. I like the abrupt and severe
manner well enough, but I also like the modeled man-
ner; I want an arm to be well articulated, and a naked
cadaver executed in beautiful proportions. Let us en-
courage the young painter not to stop. Already he has
worked for his fame, and he has the capacity to exe-
cute a masterpiece; let him rise to the height of the
ingenuity of the painting which we have before our
eyes; let him deign to make himself a little more un-
derstood; let him be neater without being elaborate;

let him never fall below the execution of the woman's torso tied to the tail of the Arabian horse; let him do as well as he has executed this Greek full of resignation and courage, whom I see seated on a rock, awaiting death; let him be as moving as he is with this young wife bursting into tears on her despairing husband's breast . . . , then we will crown him, we will award him that palm of the competition.

Philosopher: Ah! my friend, how I would like to be at the next Salon! While today I am enthusiastic, transported, I do not know this M. Delacroix; but if I meet him, I will make the most extravagant scene! I will embrace him; I will congratulate him, and I will cry; yes, I will cry from joy and from gratitude. Brave young man, may fortune help him! He has well merited the friends of the arts; he has well merited the enemies of despotism, he has shown it in all its horror. . . .

Fifth Visit

Philosopher: . . . Because chance has led us to speak of this painter [M. Bouton] who is so skilled in the secrets of producing illusions that I cannot forget his *Baths of Julian,* his *Calvary of St. Roch,* and above all his *Interior of Canterbury Cathedral,* which was formerly exhibited at the Diorama, tell me if I will find some new evidence of his talent here?

Artist: Do not doubt it. The important works of the Diorama have not absorbed all this artist's time. Here is a large painting which testifies to his dexterity, to the greatness of his manner and the boldness of his coloring [*The Interior of a Gothic Ruin at the Seashore with Snow,* No. 243].

Philosopher: One's interest is sharply arrested by the heartbreaking scene that M. Bouton has imagined. . . .

Artist: You have spoken enough of the accessory figures? Let us speak of the major elements.

Philosopher: Of the accessory figures?

Artist: Yes, because for painters of architecture, interiors and ruins, the principal element is the composition of the edifice they wish to depict—the effect they wish to produce and the aerial and linear perspective—but it is not the subject. They do not work on that until they have finished their painting. I would wager that M. Bouton—as he opened out that long gallery, as he shattered its vault, as he hung on the groins the masses of snow that you see and covered the ground with it, as well as the bases of the columns—I would wager that at that point the thought of his subject was not very clear in his head. He had dreamed of something melancholy, but he had not yet seen in his mind's eye either that woman or that child or that dog so unfortunately placed there.

Philosopher: You astonish me greatly.

Artist: I believe it, but what I tell you is the most exact truth. Therefore in the future do not confuse the genres. In a historical painting, the subject comes first; in a picture of ruins the architecture comes before everything and the drama follows, if some can be found. M. Bouton was clever enough to fit an interesting scene into the setting of his picture. It is even so well fitted that it first drew your attention, and though subordinate in fact to the rich details of this ruined building, for you the scene was the painting and the architecture only the frame, while in my eyes the scene didn't cease to be other than that which it should really be: a fitting accessory to enhance the work that surrounds it. Now that you are alerted, let me bring to your attention how artfully M. Bouton has made the light play under the prolonged arched vaults that move toward the vanishing point of the arched vaults that move toward the vanishing point of the picture. See what delicacy of tone in the parts left in half-tone, what vivacity in the illuminated portions, what fortunate contrasts without harshness, what magical effects, what a free and able touch, what a large and precocious brush; finally

what sincerity in this way of rendering everything
without harming the illusion and the general arrange-
ment of the planes.

Philosopher: Really, that is marvelous; if I knew another
word to express my astonishment I would use it. . . .

Artist: Who can speak of Pylades without speaking of
Orestes! Who can speak of M. Bouton without imme-
diately speaking of M. Daguerre? United by friend-
ship and by mutual triumphs, they are henceforth in-
separable. A common glory crowns them at the
Diorama; if in the Salon M. Bouton has the advan-
tage, M. Daguerre maintains his reputation [with his
Ruins of Holyrood Chapel, No 400]. Here, my friend,
you see the importance of the choice of a subject
even in a secondary genre. M. Bouton has done some-
thing we were not familiar with; he put his skill and
his intelligence into it and it delighted us. M. Da-
guerre copies himself; he reproduces for our gaze a fa-
miliar piece that we contemplated with delight when
he showed it to us in the vast and imposing frame-
work of the Diorama. He has brought extraordinary
care to the execution of this painting that he has
repeated. He has succeeded in creating a sky that
charms by its brightness and delicacy. He has given to
the right-hand section of his work an enchanting mys-
tery and harmony. Yet, while we admire the painting,
we are not gripped by it. Why not? Because the piece
at the Diorama defied nature; everything joined to
make it prodigious: the stars sparkled; the moon
traced a path across the sky; the light of the funerary
lamp threw uneven shadows; in the distance the bag-
pipes of the Scottish shepherd could be heard; a
religious silence reigned over the building in which
the spectator was placed. There was, on the whole, a
quality of distinction not found here [at the Salon]. A
gold frame with wide bands that catch the light and
the eye, darkening the canvas; the proximity of pink,
carmine, blue paintings; some shadows that are per-
haps a little too strong; the particular means of the

palette as opposed to the mechanical procedures of il-
lusion; finally the comparison between the first paint-
ing and its copy: these are all disadvantages that ac-
company M. Daguerre's painting to the Louvre. A
beautiful execution, skillfully rendered portions, and
equally important, the esteem we have for the painter,
all fight in vain in its favor. I think that M. Daguerre
made a mistake in not executing a new composition,
or at least in not treating by daylight the subject that
he wrapped so delightfully in the mysterious veils of
night [at the Diorama]. His fame would have grown,
and all that was needed was the quality that connois-
seurs have seen in this large—overly large—composi-
tion for his fame to have received a damaging blow
from the exhibition of a work which was not a failure
from an artistic point of view, but only as a public ex-
hibition piece. Be that as it may, this painting, whose
only fault is to be the younger brother of one that has
been universally acclaimed, I believe will certainly
take its place in an art lover's gallery.

Sixth Visit
Artist: . . . I see that M. Gassies has wished to imitate the
English painters, and has lavished heavy color in the
foreground just to imitate the wild and bizarre man-
ner of John Constable.
Philosopher: I read in the newspaper that this John Con-
stable, whose name we have just mentioned, had sent
to Paris some paintings which have troubled the
peace of mind of all our landscape painters. Are those
pieces here?
Artist: I am going to show them to you. Indeed, here they
are. (*The Hay Wain, A Canal* and *View near Lon-
don,* all belong to Mr. Arrowsmith.)
Philosopher: But, my friend, you know, this is very good.
It is nature itself; it is a landscape seen through a win-
dow; I do not know if, as painting, these pictures can
be appreciated; but for myself, I rate them highly, I
find in them a marvelous naïveté.

Artist: They are indeed extraordinary, with respect to their tone. It is just the aspect of the countryside. These waters are true to life, this cart is true to life, these boats are true to life; but the process that leads to this expression of the truth is quite close to affectation, one would say to a perpetual groping. This work in relief, these masses of brown, yellow, green, gray, red and white, thrown upon each other, worked with a trowel, cut with a palette knife and then glazed, in order to make them fit in harmony and in mystery; those things, I say, are less art than technique; and further, this technique is without grace.

Philosopher: What does it matter if it leads me to a perfect illusion?

Artist: But this illusion ceases if you approach a little; and as landscape paintings are made to be seen at close distance, the painter has missed his goal, because he calculated his effect like that of a decoration, whose lines, tones and details would only reach the eye after crossing great spaces of air. Moreover the handling of color is the same everywhere in the works of the English landscape painter. The cart is done like the ground, the farm like the boats, and the same for the rest; and then the sky is bumpy, rough and heavy because the paintbrush has not played freely with the forms of the clouds. Landscape also has its style, its poetry; M. Constable has not taken any notice of it. His compositions reduced to an outline would be ultrapoor.

Philosopher: But landscape should not be reduced to an outline. Color is indispensable to it.

Artist: It is as if you were saying that there are no lines in nature, no forms in a tree trunk or in the face of a rock, no angles in the superimpositions of mountains and in the movement of terrains.

Philosopher: Do you believe that there is a tree made like this one, a house made like that one, a pond hollowed out like the one this cart is crossing, a canal winding

like the one that furrows this plain, these meadows, distances similar to those which we see here?

Artist: Without doubt, there are; but it is not those that one must choose; art must have as its object the beautiful.

Philosopher: Yes, and one gives him the artificial for a goal. What else is your historic landscape? A genre where the grandiose is pretension, nature is convention, poetry is system? Indeed, see instead this composition of M. Turpin. [Turpin de Crisse, *Apollo Teaching the Shepherds Music*, designated for the Luxembourg, No. 1638.]

Artist: But the movement of lines is happy enough; the plants in the foreground are well done, the trees are massed and drawn with skill.

Philosopher: And the blue color, lilac and colorless as the enamel of a porcelain would be! . . .

This landscapist [M. Regnier], whom the title of romantic fits perfectly, is not among those who show us the laughing solemnities of nature, as initiates call it. His brush is melancholy, he always depicts the earth and the skies in widow's weeds. Fog, storm clouds, rain, dry rocks, or rocks covered with peeling lichens, black pines, wild-haired oaks, waters sleeping in mysterious shadows, cemeteries, Gothic castles, these are the things that attract the imagination of this Young[8] of landscape. He enjoys rousing terror and provoking gloomy meditation. He has followed the original route he chose with a constancy that has earned him more than one success. I would like to see him sacrifice once in a while to the Graces; then I would appreciate all the more his offerings to Eumenides. Byron only pleases me as much as he does because in him I see the tender Gulnare placed side by side with Conrad.[9] Let us, however, take things as

8 [Young's *Night Thoughts*, see 1808–10 BERLIN, Brentano and von Arnim.]

9 [Conrad was the hero and Gulnare the "Harem Queen" of Byron's *Corsair*.]

they are; tell me what you think of this large land-
scape in which we see William Wallace dressed as a
minstrel presenting himself at the gates of the castle
where the king of England keeps the famous robber
Bruce imprisoned. (*William Wallace*, No. 1391,
which is said to have been purchased by the minister
of the king's household for 26,000 francs and which is
destined to decorate the Luxembourg Museum.)
Artist: I like it very much. . . .

 M. Regnier's small canvases, which are exhibited in
such great quantity, recommend themselves through
their great accuracy of tone. As proof, I give you just
these studies and especially that panoramic view of
the plain of Paris in the neighborhood of Mont-
martre. (*Studies after Nature*, No. 401, belonging to
John Arrowsmith.) It would seem that in this later
painting the author wished to combat Constable; his
sky is more delicate than that of the English land-
scapist, and the landscape that he has depicted is no
less extensive. But in Constable's *Hampstead Heath*
the sunlight effects are really excellent. . . .

Eighth Visit
Artist: . . . M. Verboeckhoven, whose name I defy you to
pronounce, imitates a little coldly the genre of his
compatriots, the former Flemish marine painters. He
is luminous, but not much of a colorist. The admirers
of the English genre must appreciate the works of this
M. . . . Prompt me, Verboec . . . , I will never say
it. This artist's brother made quite pretty paintings of
animals, which are not as good as those of MM.
Demarne, Leprince or Berre, but which one can put
beside those of M. Knip.

 M. Bonington also holds his place among the sea-
scape painters. He is an Englishman transported to
Paris, where he brought the faith. For quite a long
time the art amateurs swore only by him; he made
proselytes and had imitators. His paintings have, seen
from several steps away, the accent of nature; but

they are only, to tell the truth, rough sketches. I much prefer those of M. Eugène Isabey to them. M. Bonington's figures are indicated with spirit, but they are too careless.

M. Colin seems to want to walk in the steps of M. Bonington. I would advise him, if I knew him, to follow his own instinct. He is naïve, the English genre will make him affected. His paintings, *Day After a Shipwreck*, *The Poor Man's Door* and *Young Fisherman*, show fortunate aptitudes; one could not urge the author too much to be on his guard against lack of restraint, which is not facility; against geniality, which is not always natural.

Since I am speaking to you about English painting, I must show you the water colors of Fielding.[10] Certainly, they are skillfully done; and as one says in the studios, boldly or gallantly attacked. The tone in general is superb, the light is well distributed, its effects are grand; but I see these beautiful things with distress. They will turn many heads in Paris. All our artists, who can do very well by heeding the nature of their talents and by being aware of, and obeying, the consciousness of their strengths, are going to want to do Fieldings; the merchants will not want anything except things of this genre; and we will be inundated with stupid imitations. I would like to persuade our compatriots that the Fieldings cannot be imitated when one was born in France, any more than one can imitate the genre of Desaugiers, when one was born on the banks of the Thames. . . .

[10] [Thales Fielding, who shared a studio with Delacroix in 1823–24, had three paintings in the Salon of 1824. His brother, Anthony Copley Fielding, known as Copley, was also known for his water colors.]

17. Delacroix, *Dante and Virgil*

18. Hersent, *Ruth and Boaz*

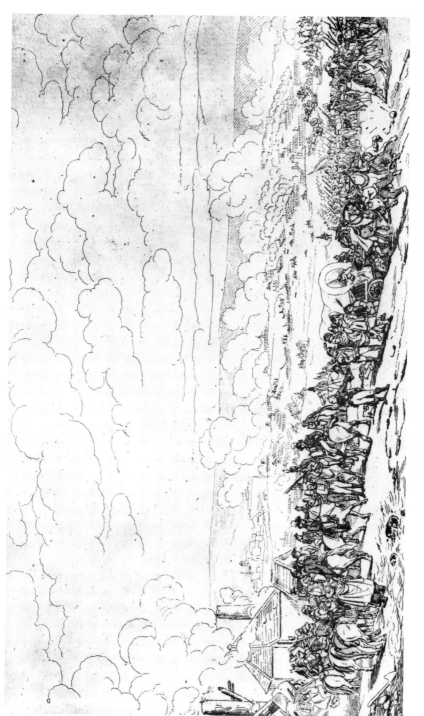

19. Vernet, *The Battle of Jemmapes*

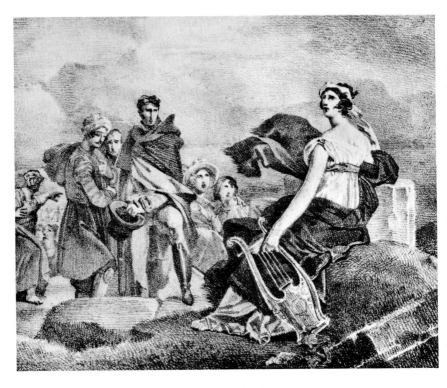

20. Gérard, *Corinne*

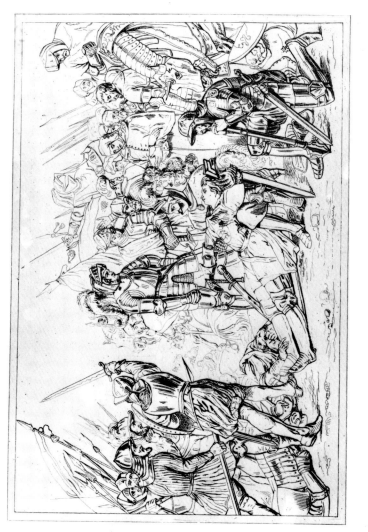

21. A. Scheffer, *Gaston de Foix Killed at Ravenna*

22 Constable Hay Wain

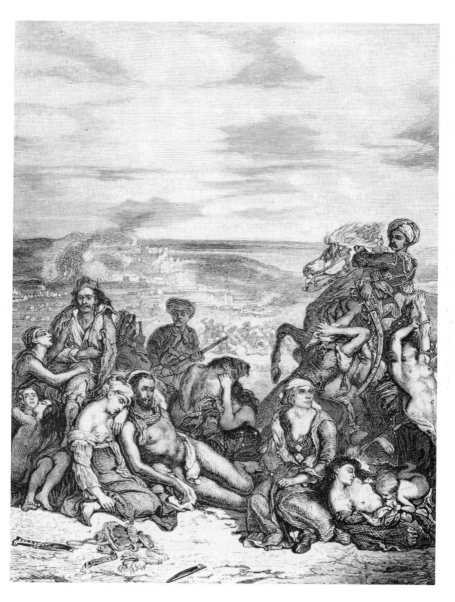

23. Delacroix, *Massacre of Chios*

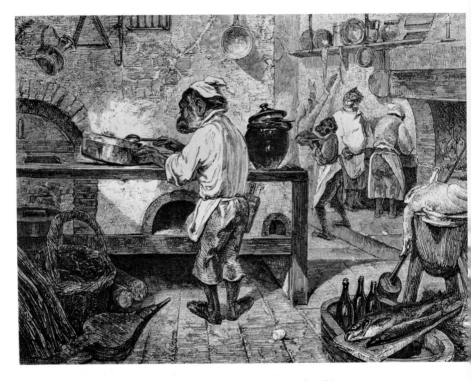

24. Decamps, *The Monkeys Cooking*

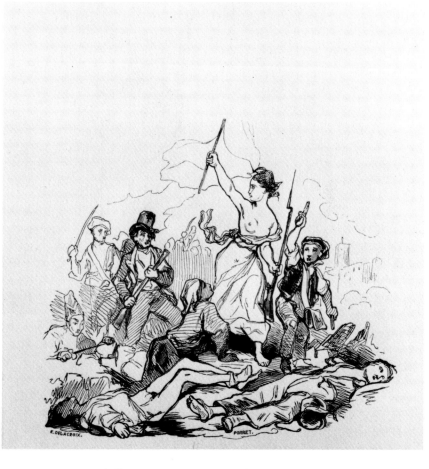

25. Delacroix, *Liberty Leading the People*

26. Robert, *The Harvesters*

27. Delaroche, *Richelieu Escorting Cinq Mars and de Thou*

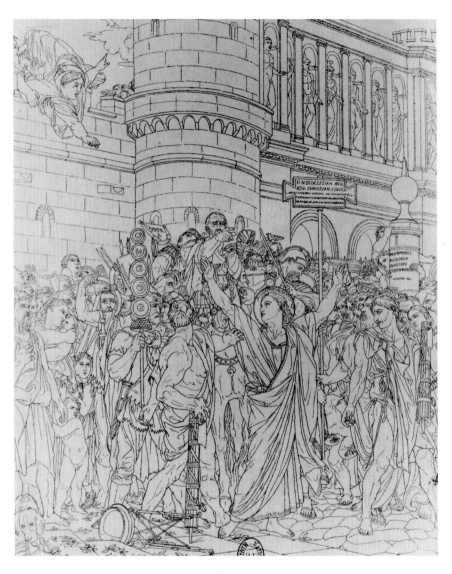

28. Ingres, *Martyrdom of St. Symphorian*

29. David d'Angers, Medallions of J. Flaxman and Rouget de Lisle

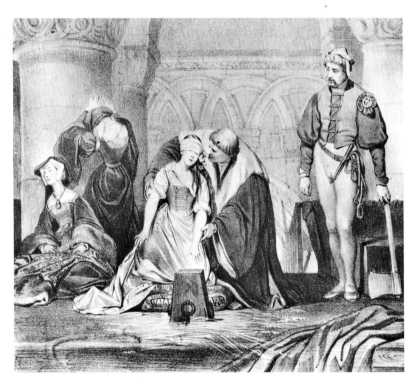

30. Delaroche, *Jane Grey*

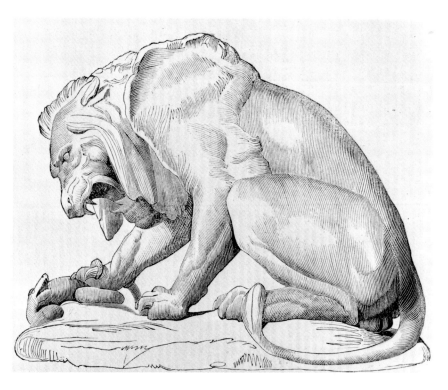

31. Barye, *Lion and Serpent*

32. Turner, *Venice of Juliet and Her Nurse*

Stendhal (Marie Henri Beyle): "Salon of 1824"[1]

Article 1, August 31, 1824.

We are at the dawn of a revolution in the fine arts. The huge pictures composed of thirty nude figures inspired by antique statues and the heavy tragedies in verse in five acts are, without a doubt, very respectable works; but in spite of all that may be said in their favor, they have begun to be a little boring. If the painting of *The Battle of the Romans and the Sabines* were to appear today, we would find that its figures were without passion and that in any country it is absurd to march off to battle with no clothes on. "But that is the way it is done in antique bas-relief!" cry the classicist painters, those men who swear by David and who cannot say three words without speaking of *style*. And what do I care about antique bas-relief! Let us try to do good modern painting. The Greeks liked the nude; we, we never see it, and I will go further and say that it disgusts us.

Without heeding the clamors of the opposite party, I am going to tell the public frankly and simply what I feel about each of the pictures it will honor with its attention. I will give the reasons for my particular point of view. My aim is to make each spectator search his soul, analyze his personal manner of feeling, and come in this manner to form his own opinion, a way of seeing based on his individual character, his taste, his dominating passions, provided that he has passions, for unfortunately they are necessary in the judgment of art. To disabuse equally the youthful painters of the school of David and of the imitation of Horace Vernet, that is my second aim; my love of art inspires me. . . .

[1] [Excerpts from a series of articles originally published in the *Journal de Paris*, Paris, 1824. Translated from Stendhal, *Mélanges d'art* (Paris: Le Divan, 1922).]

Article 4, September 12.

Throw the most ordinary man into prison, the one least familiar with every idea of art and literature, in a word, one of those ignorant lazybones who are encountered in such large numbers in a vast capital, and as soon as he has recovered from his initial fright, tell him that he will be set free if he is capable of showing at the Salon a nude figure perfectly drawn according to the system of David. You would be astonished to see the prisoner in the experiment reappear in the outside world at the end of two or three years. Correct, scholarly drawing imitated from antiquity as the school of David comprehends it is an exact science like arithmetic, geometry, trigonometry, et cetera. That is to say, with infinite patience and with the brilliant genius of Barême,[2] one can arrive in two or three years at a knowledge of the conformation and the exact position of the hundred muscles which cover the human body and be able to reproduce them with a brush. During the thirty years that David's tyrannical government has lasted, the public has been obliged to believe, under penalty of being charged with bad taste, that to have had the patience necessary to acquire the *exact science* of drawing was to be a genius. Do you still remember the handsome pictures of nude figures of Madame ——? The last excess of this system was the *Scene from the Deluge* by Girodet which may be seen at the Luxembourg.

But I return to the prisoner we have thrown into a tower of Mont St. Michel. Tell him: "You will be free when you are capable of depicting, in a manner recognizable by the public, the despair of a lover who has just lost his sweetheart, or the joy of a father who sees the son appear whom he believed to be dead"; and the unfortunate will find himself condemned by this to perpetual imprisonment. This is because, unfortunately for many artists, the passions are not an *exact science* that the igno-

2 [Barême was an eighteenth-century mathematician whose name became proverbial: "to count as Barême" meant the idea of an infallible science in practical arithmetic.]

rant may master. To be able to paint the passions, they must have been seen, their devouring flames must have been felt. Note well that I do not say that all passionate people are good painters; I say that all great artists have been passionate men. This is equally true in all the arts, from Giorgione dying of love at thirty-three because Morto de Feltre, his student, had stolen his mistress, to Mozart, who died because he imagined that an angel disguised as a venerable old man called him to heaven.

The school of David *can only paint bodies; it is decidedly inept at painting souls.*

Article 5, September 16.

. . . It is with pleasure that I come to Scheffer. I am somewhat ashamed of always criticizing. I have been told that amateurs pay highly for this artist's paintings. I feel that this is important. Apparently Scheffer has divined the public's taste. Everyone says that his painting *Gaston de Foix Killed after Ravenna* is not finished enough and I agree. Not that I would have wanted the armor of Bayard, Lautrec, La Palisse, et cetera, to be too carefully treated; that would have cast a chill. But the painter has fallen into the opposite excess. The armor in his picture is rendered with such a rapid and careless brush stroke that, instead of reflecting on the battle or Ravenna, one thinks far too much of how little time the painter spent on his picture. This is, however, an attractive work, with the exception of the theatrical figure of the future Leo X, who certainly did not go into battle in this costume and did not wear this contrite visage. Giovanni de' Medici was a great lord and not an obscure country vicar. The faces in this picture are interesting; they are accurate and lively. What a pity that the painter did not think of showing Gaston de Foix bare-chested. When the prince's friends found his body in a ditch, they would have had his cuirass removed and bared his breast to see if some heartbeat might not still be felt. Nothing would be more natural than this; and a handsome, well-painted torso would relieve the eye, tired of so much ironmongery. Such as it is, this painting is not

in the ordinary run of work, and one can hope for great things from its author. His genre seems to me close to that of Hayez of Venice, the foremost painter in Italy at the present time.

Despite the glaring faults of the *Gaston de Foix*, I would rather have painted this work than twenty paintings like *Agamemnon Disregarding the Predictions of Cassandra*. It is exaggerated truth contrasted with an excessive use of style. The *Agamemnon* is no more than a theatrical scene.

I will speak at length in a forthcoming article of Schnetz, who among the young painters seems to me to stand above his rivals. I beg the reader to seek out, in the small galleries near the staircase that leads down to the sculpture, *Young Roman Peasant Woman Assassinated by Her Lover*. This is completely in the character of Michelangelo Caravaggio at his best. The *Shepherd in the Roman Countryside* near the Appian Way and the *Brigand's Wife Fleeing with Her Child* must be seen. The deliberate vigor that distinguishes these last two paintings is what gives a leading place in my opinion to Schnetz. I am told that this young artist painted all the pictures he exhibited this year in Rome; this is probably why his flesh tones are too dark. Schnetz must have copied his models too literally. In working for French eyes he should have approximated the flesh tones that are seen at the School of Swimming. If Schnetz's paintings darken with age even slightly they will lose much of their effect.

Article 6, October 7.

. . . Two pictures have been very successful at this exhibition because of their content: *Dying Soldier* by Vigneron and *Narcissus* by Sigalon.[3] In the features of the slave whose trembling limbs are twisted in agony, we see

[3] [The title in the official catalogue is *Locuste remettant à Narcisse le poison destiné à Britannicus, en fait l'essai sur un jeune esclave*. The theme is from Racine's *Britannicus*: "*Le poison est tout prêt. La fameuse Locuste* // *a recoublé pour moi ses soins officieux;* // *Elle a fait expirer un esclave à mes yeux. . . .*" (Act IV).]

the noble Britannicus expiring; beneath Narcissus' toga we see a young emperor poisoning his brother. This admirable debut is by a young man who recently supported his family by hastily daubing signs for the tradesmen of the Rue St. Honoré; this very original picture [Narcissus] has not left its place: it hangs above the door to the Apollo Gallery.

It is said that in Nero's reign the emperor's poisoner would not have been reduced to living in a cave. This reasoning is not valid for painting. This is one of the falsifications that are necessary to this art. A hideous half-naked body is necessary to depict the soul of Locusta; so is the bold brush of Salvator Rosa. This indicates another reproach that I have heard addressed to Sigalon.

People have expressed the desire that this young man, who, thank God, as yet copies no one, used a smooth brush stroke and rivaled, so to speak, porcelain—for which reason I criticize Mauzaisse's *St. Stephen.* They have gone so far as to criticize Locusta's convulsive gesture. They base their argument on one of those philosophical truths which the painter, who must rely on the movements of the body to depict those of the soul, should have the right to disregard. It is incontestable that a person long hardened in crime does not make convulsive gestures at the sight of something as simple as a slave being put to death. In Rome, under the emperors and before the triumph of Christianity, putting a slave to death was comparable to having killed a mongrel dog whose yelps are bothersome in the Paris of today. If you agree with this excellent reasoning very worthy of men of letters who, we know not why, give themselves the mission of judging the arts, you will have a work as estimable as a hundred other pictures which unfeeling men have hung in the Salon. These artists, undoubtedly, have much spirit, but one is hard put to find ten spectators who stop before one of their works, while Sigalon will perhaps be a great painter, precisely because he has had the courage to reject all that half-baked philosophy that poisons the arts. His heart imperiously dictated to him the picturesque truth that first his Locusta

must be a woman with hideous features and that subsequently she must be half crazed by the effect of the crime. Locusta commits the crime but, if I dare speak in this fashion, her soul is stricken by it because she once had a heart capable of feeling noble and tender emotions. Painting needs such characters, and this accuracy of *feeling* is almost entirely lacking in the famous painters of today.

Another criticism of Sigalon's picture seems excellent to me: the dying slave should not have been made into an "ignominious son of misfortune." Saddened by Locusta's figure, our eyes demand of Sigalon an adolescent of striking beauty. There is a drowned woman in Girodet's *Deluge* which has always given me the greatest pleasure because she is very beautiful and her beauty removes the "horror" from my feelings, leaving me "somewhat consoled" with only noble sadness, the only feeling that "fine arts" should attempt to produce. I beg the pardon of prosaic souls for using this language for a moment. In disdaining "beauty," Sigalon has shared one of the mistakes of the painters of 1824.

Whenever a painter can do so without doing violence to his subject, he should present us with the highest degree of beauty he is capable of attaining. This is one of the reproaches I intend to address to Horace Vernet: not that the painter of *The Defense of the Barrier of Clichy* should make Belvedere Apollos of the little figures in his battles, but occasionally in his foregrounds he could give us the portrait of one of those handsome young men who are so often noticed among the non-commissioned officers of our regiments. Looking at several of Horace Vernet's works, *The Battle of Jemmapes,* for example, one would say that this painter loves ugliness. I do not ask for ideal beauty; I ask for the face of General Hoche, General Develle, General Colbert, who in their day elicited the admiration of the army.

I have been told that Sigalon was dismissed from a studio several years ago because he insisted on seeing nature in his own way and on not *copying* his master, who ad-

vised him to go and demand a place in the *droits réunis*.[4] It would be nice if this story were true. It would be very useful to connoisseurs, and I would be assured that Sigalon would be a great painter. It would be good if this young man were rich enough to go and spend a year in Venice; there he would acquire a feeling for *color*. He would live among a people who, since they are not obliged to preoccupy themselves with politics, constantly discuss the arts and value color above all. This is the advantage of a trip to Italy. I will dare to make one more recommendation to Sigalon: once out of France, he should never speak to any Frenchmen under any pretext.

The students of the School of Fine Arts in Rome in my day (many years ago) never mingled with Italians and, it was said, gathered together to speak ill of Italian artists with all the intensity of an unfortunate rivalry. One of those gentlemen spoke to me of Canova with a sour laugh, saying, "He does not know how to create a man." The French Academy is like an oasis in Rome; the students live together; nothing is as fatal to a young artist arriving in Rome as the society of his comrades and, at times, as the advice of the director. The young Frenchman who arrives in Rome knowing no one needs to have courage not to give way to the agreeable company of the young artists who get together in the café on the Via Condotti. It would be difficult to find anywhere more amiability, more wit, more true kindness toward the poor arrivals, who are always a bit lost at first. What I abominate are their theories on painting. I feel that their maxims are deadly to the arts. I would propose to the first connoisseur with some influence at the Ministry of Fine Arts that the school at Rome be suppressed, that 5,000 francs a year be granted to the students who are sent to Italy, and that, as their only obligation, the students be required to spend a year in Venice, a year in Rome, six months in Florence and six months in Naples. The students would continue to send pictures to Paris.

[4] [Reference is to *l'Administration des droits réunis*, the office for indirect contributions under the First Empire.]

I wanted to state a useful idea that will draw criticism today but that will perhaps be considered twenty years from now. Someone favored by fortune, it is said, spent 6,000 francs on Sigalon's picture. I wish this millionaire had thought of paying the same price for the first two paintings that Sigalon would paint in Rome, and asking the young artist to go and start them immediately. Sigalon can take another course; he can stay in Paris and grow rich in doing portraits. In ten years he will have, perhaps, an income of twenty thousand pounds, and in thirty years he will be spoken of as today we speak of Lagrenée, Carl Van Loo, Fragonard, Pierre and the other heroes of Diderot's salons. If he wishes to stay poor and become glorious, let him leave for Rome. There he will see the models of the heads which we admire in Lethière's *Brutus* and Schnetz's *St. Genevieve.*

Article 7, October 9.

. . . With the best will in the world, I cannot admire Delacroix and his *Massacre at Chios.* It always seems to me the picture was originally intended to depict a plague, and that the author, after having read the newspapers, turned it into a *Massacre at Chios.* I can only see in the large animated corpse which occupies the middle of the composition an unfortunate victim of the plague who has attempted to lance his own boils. This is what the blood appearing on the left side of this figure indicates. Another fragment that no young painters ever omit from their pictures of the plague is an infant who tries to suckle at the breast of his dead mother; this can be found in the right-hand corner of M. Delacroix's painting. A "massacre" demands that there be an executioner and a victim. There should have been a fanatical Turk, as handsome as Girodet's Turk, slaughtering Greek women of angelic beauty and menacing their father, an old man who will in turn succumb to the Turk's blows.

Delacroix, like Schnetz, has a feeling for color; this is important in this century of *draftsmen.* I seem to see in him a student of Tintoretto; his figures have movement.

The *Journal des débats* of the day before yesterday says that *The Massacre at Chios* is like Shakespearean poetry. It seems to me that this painting is mediocre because of its insignificance, as are so many classical pictures that I could name, and which I will carefully not attribute to the school of Homer, who must be turning over in his grave at what is being said and done in his name. Delacroix has, in any case, an immense superiority over all the painters of the large pictures that paper the great Salons, in that at least the public has greatly concerned itself with his work. This is better than being praised in three or four newspapers that hold onto old ideas and disguise new ones because they cannot disprove them. . . .

Article 8, October 16.

. . . However bad the portrait of Monsieur [le Duc de] Richelieu by Sir Thomas Lawrence may be, it has a little more character than that by M. Hersent. M. Lawrence's manner is a caricature of the carelessness of genius. I admit I do not understand the reputation of this painter. He is good for us in that he seeks to depict the appearance of nature by means that are absolutely opposed to those of French painters. His figures do not have a *wooden appearance* (if I may be excused that studio term); but truthfully, they possess very little merit. The mouth of his portrait of a woman [Mrs. Hartford] looks like a small piece of red ribbon glued to the canvas. And it is with a talent of this kind that one places oneself at the head of the arts in England! M. Lawrence must be very clever, or else our London neighbors must be very poor connoisseurs. Certainly M. Horace Vernet does not excel in his feminine portraits; he does not know how to give the shading of the complexion; he paints women with the same brush stroke he uses for men; and yet his portrait of a woman with her head in the shadow, placed beside that of M. Lawrence, to the left of the door of the Grand Gallery, is a hundred times superior to the work of the English painter.

If the foremost portraitist of London is quite mediocre and completely in the type of Carl Van Loo, in contrast,

the English have sent us magnificent landscapes this year; I do not think we have anything to equal those of M. Constable. Their truthfulness catches the eye and draws one to these charming works. M. Constable's brushwork is extremely casual and the composition of his pictures is not thought through, and he does not idealize at all; but his delightful landscape with a dog on the left [*View on the Stour*] is the mirror of nature, and it completely eclipses a large landscape by M. Watelet placed near it in the Grand Salon. . . .

Article 10, October 27.

This year an epidemic has spread among the landscape painters at the Salon. Many of these gentlemen have undertaken to paint the sites of Italy, but all of them have given to their pretended landscapes the *sky* of the Montmorency Valley, choosing the moment when it is "going to pour," as one says in Paris. In Rome, the superb promenade of the Pincio, constructed by the French at the expense of two or three monastery gardens, was very stylish in my time; it is the Bois de Boulogne of that country. One of the landscapes that I found most striking at the Salon is the *View of Rome, from Monte Pincio.* The catalogue informs me that the painter's name is M. Chauvin. No painting could have more exact drawing than this landscape, and at the same time a color more strangely false. Again the sky of the Montmorency Valley is spread out over the monuments of Rome. This degradation of such a beautiful thing puts one out of temper. It is as if the painter has overlaid a good likeness of a beloved woman with smallpox scars. . . .

I have warmly praised M. Constable's landscape; *truth* has for me a charm that grips one and immediately carries one away. The followers of the school of David greatly prefer the landscapes of M. Turpin de Crissé, especially the one that shows us Apollo driven from the sky. I will say nothing about the overworked idea of showing us again Apollo and the Muses, which shows a poor ac-

quaintance with the nineteenth century. What struck me was that the followers of the old French taste should praise the landscapes of M. Turpin de Crisse as having some *truth*. I shall begin by saying that perfection in landscape painting, in my opinion, would be reached by *drawing* the views of Italy as M. Chauvin has done, and by painting them with M. Constable's naïveté of color. Returning to the big question of *truth*, as it is still understood by certain critics, who are behind the times, I will mention two widely known novels. In *The Prison of Edinburgh*,[5] Walter Scott depicts a young girl, the touching Jeanny Deans, who obtains a pardon for her condemned younger sister Effie from the sovereign. Would you like to know what the partisans of antiquated taste would have done with this subject? The famous Mme. Cottin takes it upon herself to answer: they would have turned it into an *Elizabeth, or the Siberian Exile*. In this last painting, everything is noble, everything is consistent; nothing deviates from those tedious conventions that you know by heart, but the real pleasure *The Prison of Edinburgh* once gave me has perhaps made me mention this novel out of context. This example explains everything to those who can understand it.

The foliage in M. de Crisse's landscapes obviously lacks truth and energy—for the foliage of a group of trees can have *energy, grace, magnificence*. When one enters the Tuileries by the Pont Tournant, one can see, beyond the great basin and to the left of the large avenue, a group of chestnut trees that obviously has *magnificence*. Well! Those people whose souls are fitted to enjoy painting will never find this kind of sensation in the landscapes of M. de Crisse. In the paintings of the old school the trees have *style*; they are elegant, but they lack truth. M. Constable, on the other hand, is as true as a mirror; but I would rather have that mirror placed in front of a magnificent site, such as the entrance to the valley of the Grande

[5] [The popular novel *The Heart of Mid-Lothian* appeared in France with this title.]

Chartreuse near Grenoble, than in front of a cart of hay
that is fording a canal of still water. . . .

Article 13, November 23.

. . . I do not think very much of water color, it is a
poor genre; but the fable, too, is a small thing compared
to an epic poem, and La Fontaine is as immortal as
Homer. In the fine arts, where mediocrity is nothingness,
one must excel no matter by what means. I do not claim
that the water color of [Thales] Fielding showing *Mac-
beth and Banquo Stopped on the Heath by the Three
Witches* is a small work as perfect as a fable by La Fon-
taine; but I have decided to speak of it because, since I
discovered this picture two weeks ago at the end of the
Halls of Industry, near the Prussian candelabra, I have
never been able to leave the exposition without going to
see it again.

This little work of no consequence perfectly depicts the
scene with the witches with which the protectors of out-
of-date ideas so frequently reproach Shakespeare. I see in
this water color a fine lesson in poetry; this is how super-
natural things must be presented to the imagination. Dur-
ing the tempest, the witches are seen in a black cloud dis-
tinctly enough to say they exist, but not clearly enough for
the eye to distinguish the members of those bodies which,
formed of air, will dissolve in air as soon as Macbeth's
restless ambition plies them with questions. A year from
now, I shall still remember this poor little water color of
two square feet, and I shall have forgotten, as will the
public, those immense oil paintings that paper the Grand
Salon. In a similar way, a little fable by La Fontaine wins
out over a tragedy by La Harpe. In the arts, one must
touch deeply, and leave a memory; it is not the time, it is
the *manner* that has nothing to do with the business.

I went to the Louvre to ascertain the impression Satur-
day's visitors received from the paintings; I also wished to
see a new work that is well spoken of: the picture by In-

gres which has just been hung in the Grand Salon.[6] It shows *The Vows of Louis XIII*.[7] It is, in my opinion at least, a very dry work, and what is more, a patchwork of borrowing from the Italian masters. The Madonna is doubtless beautiful, but it is with a sort of *material beauty* that excludes the impression of divinity. This fault, which is one of feeling *and not of science*, shows even more in the figure of the Infant Jesus. This Infant, which is, by the way, very well drawn, is anything but divine! The celestial physiognomy, the *unction* that is indispensable to such a subject, is entirely missing from the figures of this painting.

The catalogue says that Ingres lives in Florence. In studying the old masters, how has Ingres not seen the painting of Fra Bartolomeo, he who taught Raphael chiaroscuro? The works of this monk, which are common in Florence, are models of unction. Do you wish to know why? Fra Bartolomeo, touched by the preaching of Savonarola, stopped painting, in fear for his soul. Since he was one of the foremost painters of his century—and of all centuries, I feel—after four years the superior of his convent ordered him to resume painting; and Fra Bartolomeo, in the *spirit of obedience*, returned to painting masterpieces. This appears to me to be the whole secret of the superiority of the fifteenth century over ours. Two months ago a steam cannon was invented that will fire twenty shells a minute the distance of a league. We triumph in the mechanical arts, in lithography, in the Diorama; but our hearts are cold, all forms of passion are missing, and particularly so in painting. No painting in the exposition has as much spirit as is found in an opera by Rossini.

I hasten to drop this digression, which will have scandalized scholarly painters, in order to return to Ingres, who is

[6] [Delacroix's *Massacre at Chios* was also hung in the Grand Salon.]

[7] [The painting commemorates the king's gratitude for intercession obtained when the French army forced passage through La Brunette, a pass into Italy, and defeated the Duke of Savoy, March 1629.]

himself one of the great draftsmen of our school. How
could Ingres, a perceptive man, not see that the less
touching the action in a religious picture, the more neces-
sary *unction* is for the painter to put us under the spell?
The angels holding back the drapery on either side of In-
gres's painting are painted in a very dry manner, as are
their draperies; the little cloud in which the Virgin stands
is like marble; there is a general crudity in the colors.

Louis XIII's movement is very animated; but nothing
shows us the leader of a great empire imploring the divine
blessing for his innumerable subjects. The little Spanish
mustache of the principal figure, which is almost all one
sees of the face, produces a rather meager effect. Here is
an accumulation of criticism of Ingres's work, and yet I
consider the *Vow of Louis XIII* one of the better religious
paintings in the exposition. It benefits from being seen
again; it would benefit still more from being placed in a
church where one would be forced to look at it for an en-
tire hour. I find in this work a depth of learning and con-
centration that proves that Ingres is devoted to painting
and exercises his art conscientiously.

This painting is valuable above all at this time when so
many young painters seem to work only to give subjects to
the lithographers. If the painter had been endowed with
the necessary celestial fire to put a little soul and expres-
sion into the Madonna, he could have easily attracted the
public's attention. As soon as we begin to meditate upon
the works of the painters who shone twenty years ago, we
always come to that disagreeable truth that I do not enjoy
repeating; David's school, while very skillful in depicting
the muscles that cover the human body, is not capable of
doing faces that express accurately a given emotion.

Let us urge Ingres and his contemporary painters to
treat historical subjects which do not demand a great
depth of expression. Without departing from the story of
Louis XIII, Ingres could have shown that brave king at
the attack of La Brunette, at the moment when Bassom-
pierre said: "Sire, the violins are ready; when Your Maj-
esty wishes, the ball will begin!" . . .

Article 15, December 11.

At this time, as my duty calls me to give an account of the impressions received by the public from the statues admitted this year to the exposition . . . I think it useful to glance rapidly at the state of sculpture in Europe. Rome has just lost Canova, who invented a new type of *ideal beauty*, closer to our taste than that of the Greeks. The Greeks esteemed *physical strength* most highly, while we esteem spirit and feeling. Over a long period of time the ferocious Hellenes forced themselves into the regions where their descendants are found today; it seems to me that *physical* strength was more necessary than the wit of Voltaire to *Ulysses* or to the brave captain Canaris.

Whether this theory is valid or not, Canova began with exact imitation of nature as is proved by the group of *Icarus and Daedalus*. This great man is perhaps most badly spoken of in Rome. Need I add that this illustrious man is detested by the French school; his works are *expressive* as the *Madeleine Sommariva* proves, and he has *grace*, for the *Hebe* exhibited four years ago is still remembered.[8] All this is somewhat lacking in the school of David. That illustrious painter, the most skillful of the eighteenth century, has had perhaps more influence on sculpture than on painting. We have seen, when discussing the pictures, that a new school has arisen this year to the great dissatisfaction of the pupils of David. Schnetz, Delacroix, Scheffer, Delaroche, Sigalon have had the insolence to make themselves admired. According to me at least, two or three of Schnetz's pictures will still be admired a hundred years from now. No similar movement can be noticed in sculpture. "So much the better!" cries the school of David. "So much the worse!" says the amateur who leaves the Hall of Sculpture with no deeply felt emotion.

In Rome, a German school of painting exists that is not without merit. Cornelius, Weiss, Begas imitate Ghirlandaio, Perugino and other painters preceding Raphael; they claim that this great man spoiled painting. But what good

[8] [Stendhal's discussion of Canova was continued in *Des beaux-arts et du caractère français in 1828.*]

is it to stop with an artist's theories? Schiller, when he wrote *William Tell* and *Don Carlos*, was irrational on the subject of the *sublime*. The works of the German school in Rome are very remarkable; these young artists give a very clear image of what they undertake to show the spectator. An idea of good style may be gained from the engravings exhibited at the Salon in the Halls of Industry.

The young German artists are even more critical of Canova than are the French. But at least they can justify their hard words with the works of two sculptors famous throughout Europe: Thorvaldsen, a Dane who lives in Rome, and Dannecker of Munich. Some people do not think that Thorvaldsen's statues rise above a very scholarly mediocrity, but his bas-reliefs are excellent. *The Entry of Alexander into Babylon*—a bas-relief of great finish, with figures about two feet high—is a magnificent work if the figure of Alexander, whose pose is theatrical, is excepted. Nothing shows the exaggeration necessary to the theater in a more ridiculous light than the *eternal immobility* of sculpture.

Several of Thorvaldsen's busts are excellent, and what proves that this artist is of the first rank is that the merit of these busts is entirely different from that of Canova's busts. You will find too much idealized grace in the bust of the painter Bossi at Milan, one of Canova's masterpieces, and his own bust—both of colossal size. This grace is very ill conceived in the bust of Pope Pius VII, which served as an ornament in the magnificent hall of the Museo Pio-Clementino, built by that pontiff, a patron of the arts. There is a famous bas-relief by Thorvaldsen depicting *Sleep* of which copies or casts are found in all the northern cities. This charming work has not been allowed to enter France, for we feel that honor requires us to reject all foreign products. This is perhaps very well for cotton, broadcloth or nankeen; but if I had the honor to be a French artist, far from seeking to encourage this where the arts are concerned, nothing would seem more humiliating to me.

In Thorvaldsen's studio in Rome, I have seen thirteen

colossal statues representing *Jesus and His Apostles*. These statues are to be placed in the open air, to ornament the façade of a church in Copenhagen. I fear that there is *heaviness* in these large figures, and that fault particular to German sculpture, *rounded forms*, is noticeable in them. The statue of Christ is very handsome; it has no longer the fearsome expression that Michelangelo would have given the Redeemer. Our ideas have changed since the year 1510. Openness and goodness dominate in the type of ideal beauty adopted by the Danish sculptor.

I have heard Canova exalt the merit of Dannecker of Munich, but I have only been able to see one statue by this artist whom all Germany proclaims, with a certain affectation, to be the foremost sculptor of the century. I think that I perceived in this statue several aspects of ideal beauty, but also a bit of German heaviness, above all in the articulations. . . .

Many statues are made in England. Fortunately for the fine arts, aristocratic vanity maintains the custom of constructing marble tombs for illustrious men in the churches. If the dean and the chapter of Westminster had not refused the author of *Don Juan* and of *Cain* entry into their cathedral, English sculptors would have had a handsome sculptural subject, a young poet with a charming face, agitated by the most somber passions, whose genius was to paint the transports of a soul torn by the conflict of pride with the tender passions.

I would try in vain to describe the ridiculousness of most of the English statues decorating the tombs in Westminster and St. Paul. The English sculptor, far from neglecting detail like Sir Thomas Lawrence, undertakes to depict with a hopeless exactitude buckles, shoes, stockings, pants, even the peruke of the noble lord he is depicting on his tomb. His way of translating into stone the great blue sash of the country is sidesplittingly funny. Recently that sort of hypocrisy applied to everyday action, called *cant* in England, relaxing somewhat from the severity established by the Puritans, has permitted the placing of naked angels on the tombs of great men. The tomb of the

two naval captains killed before Copenhagen, placed near the north portal of St. Paul's Cathedral, has an angel whose profile is worthy of the century of Canova. General Moore's tomb, placed across from it, is really not bad.

But Chantrey's busts are very good. This artist was herding cattle a few years ago. He went from there to being a sculptor, and I am sure he is earning as many millions as Sir Walter Scott. Like that genius, Chantrey has all the skill, all the cleverness, all the flexibility necessary to be a success in London, and never to shock the fashionable *cant*. It would be difficult to express the pleasure that the bust of Walter Scott gave me. I would like a cast of this bust in the Louvre next to the bust of Lord Byron by Flatters. The bust of Lord Byron by Thorvaldsen looks like a schoolboy's attempt compared to the work of Chantrey. . . .

Article 16, December 22.

. . . M. Horace Vernet has bravura in his genius. In this timid and mincing century he dares and he dares happily; he paints well, he paints quickly, but he paints appropriately. The great fault of the French school of painting is the total lack of chiaroscuro that also ranges among mediocre works and is in this large portrait so impatiently awaited. In representing the sacred person of the king [Charles X] and that prince who merely appeared in Spain yet who managed to acquire so much fame there, you will never guess where Vernet has placed the principal light of this picture, and thus fixed the attention and the first glance of the spectator. This principal light is thrown on the ground of the Champ de Mars where the scene takes place. From this light, so strangely placed, the spectator's eye rises to the lower part of the figure's boots. It is only by a mental effort and against the natural inclination of his eye, which should above all be satisfied in painting, that the spectator, remembering that he has come to the Louvre to see the king, is able at last to make out the head of the principal figure. . . .

A critic, a great enemy of romanticism, has applied the strange epithet of *Shakespearean* to Vernet's painting,[9] while calling the pictures of Raphael and David *Homeric*. It would be simpler to say: *I will call romantic everything that is not excellent*. Through this simple trick, bit by bit the word "romantic" would become a synonym of *bad* to the public. That which is *romantic* in painting is *The Battle of Montmirail*, that masterwork by Vernet, in which everything can be found, even chiaroscuro. That which is *classic* is a battle by Salvator Rosa, of about the same size, which can be seen at the end of the great gallery on the side toward the Seine. The romantic in all the arts is that which shows the men of today and not those who probably never existed in those heroic times so distant from us. If you will take the trouble to compare the two battles that I have mentioned, and above all the *amount of pleasure* they give to the spectator, you can form a clear idea of what romanticism is in painting. The classic is, on the contrary, those entirely naked men who fill up the picture, *The Battle of the Romans and the Sabines*. With equal talent, Vernet's battle would be better than David's battle. What sympathy can a Frenchman feel, who has given some saber cuts in his life, with those men who fight *naked?* The simplest good sense says that the legs of such soldiers would soon be flowing with blood, and in every age it has been absurd to go into battle naked. That which may console *romanticism* for the attacks of the *Journal des débats* is that good sense applied to the arts has made immense progress in the last four years and particularly among the leaders of society. . . .

[9] [Delécluze regarded Horace Vernet as the founder of the modern school, "*trône à tête des shakespeariens*." See *Journal des débats*, January 19, 1825.]

PARIS: The Official Exhibition
of the State

In the three-year interval between 1824 and 1827, Charles
X had demonstrated his conviction that he reigned by
"divine right" rather than by the charter offered by the
people to his predecessor. The prosperity nurtured by
Louis XVIII had declined, aggravated by crop failures and
severe winters. Art dealers were the first to suffer. John
Arrowsmith went bankrupt. Schroth, another Parisian
dealer, withdrew the purchase agreement he had made with
Constable before the economy fell.

In spite of the economic depression and government
censorship, discussion and creativity flourished. An English
theater company played a season of Shakespeare to packed
audiences. The Société des Amis des Arts, formed during
the Revolution only to disappear after a few years, had
been revived in 1816 and thrived through the decade of
the twenties. Its exhibitions, financed by raffles of the
paintings it bought and exhibited, were held regularly on
years when there was no Salon. Both older artists, such as
Bertin, Lethière and Granet, and younger artists, including
Bracassat, Eugène Isabey, Horace Vernet, Alexandre De-
camps and Achille Devéria, were represented. Delacroix
sent two works for consideration in 1826, but they were
apparently not accepted by the society's jury. In May 1826
an independent exhibition for the benefit of the Greeks
fighting for their independence was held in the Galerie
Lebrun; Delacroix sent two works, *Marino Faliero*, based
on Byron's drama, and *Death of Hassan*.

In 1826 writers and artists began to assemble on Sunday

evenings in the attic of Victor Hugo, whose defense of
freedom of genius and style in the preface to his play
Cromwell (1827) made him the leader of the new writers
as Delacroix was of the painters of the romantic move-
ment. At the regular gatherings of his famous Cénacle,
artists and writers continued to debate the questions that
had been discussed at the Réunions de Dimanche of
Delécluze, though Delécluze was probably never present
to defend the ideas he had first developed as a student of
David.

Étienne Delécluze, the son of a successful Parisian
architect, had entered Jacques Louis David's studio in
1796 and was advanced to the master's class the next year.
He was a member of the small group who assisted David
with the completion of *The Battle of the Romans and the
Sabines* and remained an intimate of the David family
until their exile in 1816. Delécluze's paintings, one of
which won a gold medal first class in the Salon of 1808,
were treatments of classical themes in the manner of *les
Barbus* or *Primitifs*, a group in David's studio led by
Maurice Quai and Charles Nodier who returned to the
pre-Phidian period of Greek art for its models. Its theories,
set down by Nodier in 1832, Delécluze included in his
book, *Louis David: son école et son temps* (1855) and in
Souvenirs de soixante années (1862).

Unable to compromise his art principles with the fashion
of painting represented by David's other pupils, Gros and
Girodet, or his liberal politics with those of the Napole-
onic Empire, after 1810 Delécluze declined state com-
missions and exhibited for the last time in the Salon
of 1814. Abandoning painting for letters, he became asso-
ciated with the *Lycée français* and reviewed the Salon of
1819. When the paper failed, he joined in 1822 the *Jour-
nal des débats*, a leading Parisian daily owned by the Ber-
tin brothers, and his reports on the Salons, art events and
the theater appeared on its front page for the next forty
years. During the winter of 1823–24 he reported from
Italy in "*Letters*" that were later published as *Le Vatican*

(1833). No account appeared of his five-month visit to England in 1826.

The Salon of 1827 opened as was customary on the king's name day, now November 4, St. Charles's Day. The next day the conservative bourgeois readers who unfolded their large thirty- by twenty-centimeter *Journal des débats* found at the bottom of the front page the first installment of the review by Étienne Delécluze. The subsequent reports were forced to compete for space with news of the defeat of the Turkish and Egyptian navies by the English, French and Russian fleets at the Battle of Navarino and reports on the governmental changes proposed by the king. Delécluze's published report repeated some of the critical remarks on Delacroix's works he made in a summary of the Salon in his own journal.

With the Salon, the renovated portions of the Louvre designated the Musée Charles X were opened to the public. Artists favored by the Academy had been commissioned to decorate rooms used by the king on state occasions, including the Salon award ceremonies. In the ninth room *The Apotheosis of Homer* painted by Ingres contained the elements of a style that Delécluze regarded as the most promising for the future of French painting. Delécluze remained loyal to principles acquired from David. He valued academic discipline for artists and insisted that sound composition should not be sacrificed to technical virtuosity or emotional appeal and that knowledge acquired from the study of nature should be poured into the mold of classicism. Ingres's substitution of the Raphael school for classicism, based as it was on a linear conception of form with color in a subordinate role, made it acceptable both to the powerful permanent secretary of the Academy, Quatremère de Quincy, and to Delécluze, art editor of the influential *Journal des débats*.

Étienne Delécluze, "The Salon was opened to the public yesterday"[1]

6 November 1827, Paris

The Salon was opened to the public yesterday. It was the king's feast day. There was a stream of curiosity seekers. The Musée Charles X and the State Council chambers, forming altogether a suite of thirteen rooms, must have been decorated (walls and ceilings) by all the reputable painters of today: Gros, H. Vernet, Abel de Pujol, Picot, Fragonard, Meynier, Heim, Ingres, Bouillon, Guillemot, Hesse, Dubufe, Gassies, Blondel, Delaroche, Lethière, Rouget, Schnetz, Thomas, Drolling, Mauzaisse, Alaux, Franque, Coutan, Colson, Dejuinne, Lancrenon, Steuben, Delacroix, et cetera. Since all the persons named above form the elite of the present school, it follows that when the works that they have completed for the Musée Charles X and for the State Council have been seen, one can then get an accurate idea of what good work our school has done in this year of 1827.

The exhibition rooms, given over yesterday to public curiosity, show only works done by some of the painters we have named, and especially by those young artists who have been students in Rome or who are beginning in Paris, who have bowed to the jury.

It is said that this year's jury was very severe. A large number of paintings were refused, and yesterday at the Salon I heard artists complaining loudly. This severity, it must be said, did not keep the majority of historical paintings from being mediocre or a considerable number of bad paintings from among the small compositions and the portraits.

However that may be, this exposition is odd because of

[1] [Translated from *Journal de Delécluze, 1824–1828*, ed. Robert Baschet, (Paris, 1942), pp. 477–83.]

the diversity of the works admitted to it. Never has the
diffusion of the tastes under which the artists have worked
been so great as it is at present. There is not one painting
whose composition, draftmanship and coloring is not at-
tached to a system peculiar to each originator. This disper-
sion of tendencies, which, without contradiction, would
favor the truly original man of strong genius, becomes the
reef on which mediocre talents founder. Those pretended
originalities of color and composition are only eccen-
tricities constructed over more or less concealed imita-
tions. To give an idea of the first part of the exposition I
will point out certain pictures that are by way of being
focuses of different tastes toward which other, less striking
paintings tend, but less strongly. . . .

Nothing recalls exactly the era in which David's *Oath of
the Horatii* and Drouais's *Marius*, a successful but servile
imitation, were made. The painting by Charles Moreau
[is] an imitation of Poussin. Finally, we see at the
Salon a painting by Mme. Mongez, *The Seven Chiefs be-
fore Thebes*, a very imperfect imitation of David's *Battle
of the Romans and the Sabines* but which reminds us of
the direction the school in France was moving from 1799
to 1812. One dreamed only of Greece, wanted to paint
only nudes; expression, coloring and even composition
were totally sacrificed to form and visible beauty.

Four portraits by Gros, that of the king and three others
representing private men and women, show by themselves
the singular modification of art in 1803 or 1804 by the ap-
pearance of *Napoleon Visiting the Plague-stricken at Jaffa*,
of Bonaparte delivering the swords of honor, and of sev-
eral portraits by that painter who revolutionized the
school and carried minds back to the study of color and
expression. At this time a part of the school who followed
David's principles exclusively made themselves more or
less successful imitators of Gros.

During this same period Revoil and (Fleury) Richard
thought of using the anecdotal genre. They depicted
small, familiar subjects extracted from memoirs of French
history, and this genre was very successful. It was so suc-

cessful that from 1806 on it turned public taste and attention away from large, important works. There are paintings by Revoil and Laurent at the exposition.

M. Granet's reputation dates from about the same time and the painter of those shadowy cloisters fathered in historical painters the thought of adding more complicated backgrounds, of searching for more piquant effects. M. de Forbin, through several attractive works, contributed to this modification of art.

The imitators of Revoil, of Fleury Richard, of Granet and Forbin swarmed, of course. Among them it is well to point out one whose name is unknown today but who can be thought of as the one who contributed most strongly by his example to bringing in that expeditious, facile and, it must be said, careless manner in which almost everyone works today. It is Vermay, a student of David. This young man was gifted with great facility in painting and composing. These double natural gifts always kept him from serious study. In 1808 he painted a picture of Mary Stuart listening to her death sentence which was noticeable at the exposition for the simplicity of the expressions, the picturesqueness of the characters' dress, and the general effect. In addition to this, the work was executed with an ease, I would even say with a carelessness, that put the manner of Revoil, Richard and Laurent in the wrong. It seemed possible to treat this genre in a superior manner and M. Gros did so in his *Charles V visiting the Abbey of St. Denis.*

From then on, historical painting based on the imitation of the forms and customs of antiquity received a serious blow. Nothing less than David's *Leonidas* and the individual authority which this man exercised over the entire school was necessary at that point to keep this genre from losing all the importance it then possessed.

David himself, carried away by both public events and the defection of taste, found it necessary to paint *The Coronation of Napoleon and Josephine, The Distribution of the Eagles,* et cetera. M. Delaroche's picture of the Trocadéro brings to mind sufficiently the spirit in which David did the last compositions I have mentioned.

The era of the Restoration and David's exile was a great
mishap for art. The use of the artists' talents to paint
church pictures was tried. This attempt was successful nei-
ther for the government nor for the artists. The traditions
of the figure types and dress of the sacred characters were
lost. The Christian religion was no longer understood ex-
cept through the writings of M. de Chateaubriand. The
paintings were done with affected, characterless holiness.
They fell back on contemporary history in miniature com-
positions.

This taste for small pictures, joined to the appearance of
several talented men treating genre painting, reduced all
painters to throwing themselves into the latter manner.

Finally, in 1824, the school that I have entitled Shake-
spearean arose whose sole support today is Delacroix, for
he is the only one who has persisted in his bizarre ideas.
He painted a *Christ on the Mount of Olives* in which, as
far as composition is concerned, one finds a Jesus à la
Rubens mixed with angels as gracious as little English
girls, the whole colored according to the procedures of the
school of Rembrandt.

After this come all the artists of the modern school
drafted on that of England. Overly brilliant portraits, pre-
tentious effects, compositions in which modern Greeks,
with their shoddy clothes and their scratchy looks, figure
in the midst of horses, peculiar weapons and a darkened
sky as though Greece were at the latitude of Edinburgh,
all these paintings are insupportably monotonous and cer-
tainly even duller or at least in a more disagreeable way
than the production of David's school, which imitated an-
tiquity. For this latter style at least was not limiting in
that it shaped good genre painters while the other pre-
vents the development of historical painters.

Just one work of the many that are exhibited at the
Salon has gained universal approbation: it is the portrait
of the Abbé of Lamennais by P. Guérin. It is an excellent
work that is reminiscent of no manner, of no school, and
in which nature is imitated with as much truth as taste.
Everyone agrees on this painting. So far as the others are

concerned, they give rise to as many different discussions as there are works, so varied and exclusive are the tastes of those who produced and those who look at them.

Étienne Delécluze, "Salon of 1827; Fifth Article"[1]

In art, accurate imitation is not the goal, it is only a means. This outstanding truth, on which the arts are based and from which they take their very soul, cannot be repeated and defended too often. The most common error today is to try to superimpose reality on poetry and to believe that a statue [or] a picture should produce a complete illusion for our senses. This error degenerates into a mania; and if this mania lasts it will be the reason that poets, sculptors and painters in the future will develop themselves only with difficulty.

Among [the painters] I will cite one who has not ceased to make noble efforts to conserve intact the nature and the dignity of the art he serves. It is M. Ingres. Perhaps no one has tried to *imitate* more conscientiously than he. But in his works the imitation has always been subordinated to a precise, strong idea, either gracious or majestic according to the subject to which it has been applied. Even in his portraits this need to concentrate his thought by giving homogeneity to the forms and the instinct, which forces him to bring the details that tend to stray into unity with the principal features of a face or a whole person, is very marked. There are few works of which one can say: *Tantum series juncturaque pollet!* more appropriately than those of M. Ingres.

This rare ability of idealizing has naturally found a worthy application in the composition of *The Apotheosis of Homer* which M. Ingres has painted to decorate the ceiling of the ninth gallery of the Musée Charles X. Here is the idea and a summary description of the painting:

[1] [Translated from *Journal des débats*, Paris, January 2, 1828, pp. 1ff.]

outlined against a blue sky are the pediment and the top of the columns of a marble temple dedicated to Homer. In front of the portico, Homer himself, seated on a golden throne, holding a lance in one hand and a scroll of his works in the other, occupies the center of the picture. . . . If one imagines that Homer is surrounded by a double line of figures leaving the temple, describing a curve around the throne, and then drawing themselves in more tightly toward the center as they approach the bottom edge of the picture, then one has an idea of the physical placement of the figures. . . .

This work is executed with a finesse and sureness of touch that distinguish M. Ingres's talent. It is worth observing that this painter, in showing on the same canvas both ancient characters and modern ones, has shown an uncommon flexibility of talent. . . .

In giving more relief to the modern figures and gradually weakening his colors as he reaches the semi-fantasy figures of Orpheus and Linus, who are on the farthest plane of the picture, M. Ingres has pretended to submit less to the laws of linear perspective than to laws of a perspective that one could call *chronological.* Therefore I return to what I said of this painting in describing the Musée Charles X. It is of the genre of poetic dreams that the artists and writers of the fourteenth, fifteenth and sixteenth centuries made for us in Italy, embroidering as on a canvas their beautiful works. A host of passages from Dante, especially the fourth chapter on the Triumph of Love and the third on the Triumph of Fame, and from Petrarch evidently gave birth to compositions with which Beccafumi decorated the pavement in the Siena Cathedral and to the paintings of Raphael in the Stanza della Segnatura: *The [Disputation over the] Holy Sacrament, The Schools of Athens,* and *Parnassus and Jurisprudence.* Ingres has started from this systematic corpus of poetry, philosophy, ethics and criticism to create a picture the elements and the goal of which were like those of the works mentioned; however, all the details imagined by the French painter are characterized by great originality.

Originality? How this word gives birth to false ideas and exaggerated pretensions! Some are still so mistaken as to believe in the possible appearance of a Homer, a Dante, a Shakespeare, a Phidias or a Michelangelo. The individual originality of these men is incontestable, but what placed them beyond all comparisons were the era and circumstances under which they lived. Homer found himself at the right point for giving life to mythological traditions; Dante for fixing the poetic theology born in the fifth century; Shakespeare for transfusing the ideas of the south into northern brains; Phidias for clothing symbolic idols with man's image; and Michelangelo for *incarnating* the Middle Ages. But once all these great combinations have been fashioned and determined, all that can be done is to modify the archetypes indefinitely. This happened in antiquity as well as in modern times. Sophocles and Praxiteles, Petrarch and Raphael, Racine and Poussin, Milton and Reynolds illustrate this. All these men, though very original, came too late to *find*, to *discover*, to *invent*. The archetype was known; they adopted it. The impulse was given; they followed it. For me that is a new proof of the vigor of their genius and their talents, because it is an attribute of weak spirits to insist on novelty at all costs, even at the risk of falling into the bizarre. . . .

The colorists are sometimes like musicians when they abuse the science of harmony: sometimes they weary us with a succession of sensations without giving rise to an idea. Paul Veronese sometimes does this. Although I admire his painting of *The Marriage at Cana*,[2] I notice that Sultan Suleiman II is there, drinking from a footed glass not far from the Virgin and Jesus Christ. However, vision for vision, I prefer those of Petrarch and Raphael, or even the latest one of this genre, *The Apotheosis of Homer* by M. Ingres.

[2] [Because of its delicate condition, Paul Veronese's *Marriage at Cana* remained in France when works in the Musée Napoléon were returned to their countries of origin.]

1831

PARIS: The Official Exhibition
of the State

In 1831 spring was welcome in France. Parisians hurried forward, hoping for better times and eager to leave behind the memory of recent political turbulence. The year 1829 had ended in cold and starvation, and in January 1830 a new journal had appeared, the *National*, edited by Adolphe Thiers, his close friend Françoise Mignet, and Armand Carrel. It had steadily attacked Charles X, his reactionary ministers, and their disregard for the charter. When the king's policies were officially repudiated by a vote of no confidence in the Chambre des Députés in March, Charles X called for new elections. The opposition, led by well-known liberals, including General Lafayette, and supported by the *National*, *Globe*, *Constitutionnel* and the *Journal des débats*, began a carefully planned election campaign. Fearing a revolutionary republic, both Bonapartists and the liberal bourgeoisie joined in opposition to the king. As a substitute for Charles X, the opposition press advocated the Duc d'Orléans, whose father had taken the name Philippe Egalité—equality was the most cherished heritage of the Revolution—and who had prudently kept officers of the Empire on his staff at the Palais Royal. The election reaffirmed the rejection of the king's policies. On July 26, Charles X replied with the July Ordinances, dissolving the newly elected chamber and calling for a new election, which the king hoped to control by suppressing the press and reducing the voting power of the bourgeoisie.

In the days that followed, barricades were set up to hinder the advance of the royal troops. They were manned

by determined republican artisans of the old, established crafts who were led by veterans of the imperial wars. The journalists of eleven papers gathered at the *National* offices to sign the protest drafted by Thiers against the illegal suppression of the press. By July 30, Paris was in the hands of the people, its defense secured by the National Guard, disbanded by Charles X in 1827 and now recalled by General Lafayette. The people longed for a restoration of the "liberty, equality, fraternity" associated with the Revolution and a regeneration of the national prestige of the Empire. Many hoped the government would become a republic which General Lafayette would lead, but the general was apprehensive of an extended period of disorder and publicly embraced the Duc d'Orléans before the Hôtel de Ville, after having received the verbal assurance that as Louis Philippe he would reign as a constitutional monarch.

The news that the French monarch's attempt to set aside the charter had been thwarted triggered revolts in Rome, Poland, Prussia and Belgium by people eager for more participation in government. In London, demands for parliamentary reforms increased. Belgians demanding self-government independent of Holland formed a National Assembly and drafted a Constitution. Some, supported by the French republicans, favored a reunification with France, and in 1831 the Assembly elected the son of Louis Philippe to be king of Belgium. The French monarch, fearing for French relations with England, forbade his son to accept and sent Talleyrand to Britain; as a result of the negotiations, Belgium was constituted a perpetually neutral state, thus preventing the country's annexation by France. Parliamentary reforms began in Britain, but elsewhere on the Continent the immediate repressive measures of bureaucratic monarchies prevented the pockets of rebellion from spreading or uniting.

In the German states, where radical literary groups who expressed their politics in everything they wrote were prevalent, Heinrich Heine was a prominent figure. He had studied drawing with Peter Cornelius, once a Nazarene in

Rome, and aesthetics with the classicist Friedrich von Thiersch in his native Düsseldorf. In the manner of nineteenth-century German students, Heine went from university to university, writing superb poetry and identifying himself with the young Germans in their demands for the liberalization of political institutions. In Bonn he studied medieval and modern literature with August W. von Schlegel; in Berlin, Hegel was his teacher and the circle of romantic writers including Ludwig Tieck, La Motte Fouqué and the theologist and philosopher Friedrich Schleiermacher accepted him. At Göttingen he received a law degree in 1825 and was baptized a Lutheran Protestant to qualify for state employment in Prussia. The next six years he spent traveling to England, Holland, Italy, and in Germany writing and searching for a permanent position. The charm and political audacity of the first two volumes of his Reisebilder (Travel Pictures; 1824, 1826) made him well known in Germany. The second volume was banned in Prussia and Austria. When a hoped-for professorship in Munich was not awarded him, Heine gave up the co-editorship of the Neue allgemeine politische Annalen, a Cotta publication, and left Munich to return to Berlin. The ever increasing political conservatism of Prussia, a wave of anti-Semitism and the news of the French revolt led Heine to Paris in May 1831. Baron Cotta made him a Paris correspondent of the Augsburger allgemeine Zeitung, Cotta's largest newspaper, and its literary supplement, the Morgenblatt. Heine's poetry and translated parts of the "Harz Journey," a central portion of the Reisebilder, appeared in the Revue des deux mondes and made him well known to Parisians.

A socialist by inclination and a frequenter of the Saint-Simon group in Berlin, Heine was warmly received by the Saint-Simon Society in Paris, which had just acquired the Globe. The Comte de Saint-Simon (1760–1825) had envisioned a state directed toward the "amelioration of the moral and physical existence of the poorest class," the productive workers. In his Opinions littéraires, philosophiques et industrielles (1825), Saint-Simon had suggested that

the administrative elite of the new society should be an "avant garde" made up of scientists, industrialist-artisans, and artists. He defined the artist as a "man of imagination," a broad characterization that included poets and literary artists as well as painters and sculptors. In his *Nouveau Christianisme* (1825) he further advocated that artists, rather than the clergy, should promote religious feelings. After Saint-Simon's death his disciples were led by Prosper Enfantin. In August 1830, in the midst of the Revolution, Enfantin had issued a proclamation demanding "community of goods, the abolition of the right of inheritance and the enfranchisement of women," but the working classes were no more politically powerful under Louis Philippe than they had been under the Bourbons.

The political uncertainty of the winter had not postponed the Salon. Louis Philippe, to win favor with the artists, had decreed that the Salon would be held annually. He left its organization unchanged, despite artists' requests that it be reconsidered: the Academy still controlled the jury and the classicists the Academy. In fact the Academy's control of the jury was strengthened, since Louis Philippe did not continue Louis XVIII's practice of appointing non-Institute members to the jury. The grip of the classicists on drama and music had been loosened by the performances of *Hernani* by Victor Hugo and the *Symphonie Fantastique* by Berlioz, who had won the Prix de Rome for music in 1830 with his cantata on the assigned subject of "the death of Sardanapalus." When the Salon opened on May 1, 1831, the sensation of the exhibition was Delacroix's *Liberty Leading the People, July 28, 1830.*

Heine's first assignment for *Morgenblatt* was a review of the Salon, published in September and October. He used the review to propagandize blatantly for a social concept, the first critic to do so. He concentrated on the historical and genre paintings to convey the excitement aroused by such works amid the current political scene and used French reviews published prior to his own to give the reactions of the Parisians. While expounding

Saint-Simonist concepts, Heine also voiced the romantics' demand for complete creative liberty and freedom from judgments based on aesthetic rules. Affirming the appropriateness of art's appeal to the senses, he examined in a refreshing manner the contemporary suitability of the traditional Salon categories.

Since Heine reported French political news and scandals with the same sarcastic frankness that had resulted in his exile from Prussia, the French government took action against a Parisian editor who reprinted one of Heine's reports, and Baron Cotta, perhaps at the suggestion of Thiers, did not retain Heine as his Paris correspondent after 1832. At this time Heine, in keeping with his natural independence, freed himself from the Saint-Simonists and continued as a free-lance writer whose works were published in five languages. Aware that liberal literary circles in Germany and Paris shared common interests and a curiosity about each other, he sought to bring up to date Mme. de Staël's De l'Allemagne with his L'état actuel de la littérature en Allemagne (The Romantic School; 1833) and De l'Allemagne depuis Luther (Germany; 1834). His account of the Salon of 1831 and a shorter review of the Salon of 1833 were incorporated into the first volume of his Der Salon (1834). He continued to use the title for other later volumes of his miscellaneous literary sketches.

When Adolphe Thiers became president of the Council of Ministers after 1848, he urged Heine to accept French citizenship. Heine refused, but did accept a pension provided to distinguished exiles resident in France and was at once mercilessly attacked by his German critics. Half blind, painfully paralyzed, and bedridden for the last eight years of his life, Heine continued his literary work. He himself attached little value to his fame as a poet and asked that a sword be laid on his coffin, "for I was a brave soldier in the war for liberation of humanity." Certainly the revolutionary cause was Heine's foremost concern when he reported on the Salon of 1831.

Heinrich Heine, "The Salon: The Exhibition of Pictures of 1831"[1]

The Exhibition is at length closed, its pictures have been shown since the beginning of May. They were generally looked at with only fleeting glances, for people's minds were busy with other things, and anxiously occupied with perplexing politics. As for me, who had but recently come for the first time to the capital of France, and who was bewildered with innumerable new impressions, I was much less able than others to wander through the halls of the Louvre in a befitting tranquil state of mind. There they stood, close by the other, three thousand beautiful pictures, the poor children of Art, to whom the multitude threw only the alms of an indifferent look. How they begged in silent sorrow for a little bit of sympathy, or to be sheltered in some tiny corner of the heart! It was all in vain, for all hearts were full of families of their own feelings, and had neither board nor lodging to bestow upon strangers. Aye, there it was! the Exhibition was like an orphan asylum—a crowd of infants gathered here and there, left to themselves, and none of them related one to the other in any way. They moved our souls, as they are wont to be moved on seeing childlike helplessness and youthful despair.

With what a different feeling are we seized on entering a gallery of those Italian paintings which are not exposed like foundlings to the cold world, but which, on the contrary, have drawn their nourishment from the breast of one great common mother, and which, like members of one large family, live together in peace and unity, speaking

[1] [Verbatim from *The Works of Heinrich Heine*, trans. Charles Godfrey Leland (New York, 1906), Vol. IV, pp. 1–5, 8–13, 16–19, 24–29, 31–50, 52–63, 66–69, 82–90, 95, 99–104, 118–22, 129–30.]

the same language, though they may not utter the same words!

The Catholic Church, which was once such a mother for this and all other arts, is now herself poor and helpless. Every painter now works according to his own taste and on his own account. The caprices of the day, the whims of the wealthy, or of his own idle heart, suggest subjects; the palette offers the most glowing colours, and the canvas is patient to endure. Add to this, that now a badly understood Romanticism flourishes among French painters, and according to its chief rule, every artist strives to paint as differently as possible from all others, or, as the current phrase has it, to develop his own individuality.

As the French have in any case much sound common sense, they have always decided accurately as to failures, readily recognized what was truly characteristic, and easily fished out the true pearls from this pictured ocean of many colours. The artists whose works were most discussed and most highly praised were Ary Scheffer, Horace Vernet, Delacroix, Decamps, Lessore, Schnetz, Delaroche, and Robert. I will therefore limit myself to repeating public opinion, which differs little on the whole from mine, and also avoid as much as possible criticism of technical merits or defects. It would be of little use as regards pictures which will not remain in public galleries exposed to general view, and of still less advantage to the German reader, who has not seen them at all. It is only fleeting comments or hints as to the subject and significance of these pictures which can interest the latter; and, as a conscientious reporter I begin with the works of—

ARY SCHEFFER

The *Faust and Marguerite* of this painter attracted the most attention during the first month of the Exhibition, because the best works of Delaroche and Robert were not shown till later. Moreover, those who have never seen anything by Scheffer will be at once struck by his manner,

which expresses itself particularly in colour. His enemies say of him that he paints only with snuff and soft soap. I will not say how far they do him wrong. His brown shadows are often much affected, and fail to produce the chiaroscuro of Rembrandt which the artist aimed at. His pictures have mostly that repulsive colour which would disgust us, if we, wearied with a night's watching and in an ill-temper, should see our faces in one of those green mirrors such as are found in old inns where the diligence stops of a morning. But, when we look long and more closely into Scheffer's pictures, we learn to like his manner, we find that his treatment of the whole is very poetic, and we perceive that the glow of feeling breaks through these gloomy colours, glittering like sun rays through dark clouds or misty vapour. This painting, which seems smeared or swept ill-temperedly, those tired-to-death colours, with uncanny vague outlines, have actually a good effect in the pictures of *Faust* and *Marguerite*. . . .

We find, unfortunately, Scheffer's style in all his pictures, and though it may be appropriate to his *Faust and Marguerite*, it utterly displeases us in subjects which require a cheerful, vigorous, clear, and well-coloured treatment, as, for instance, in a little picture representing dancing school-children. With his misty, sad colour, Scheffer has given us a troop of small goblins. However remarkable his talent for portraits may be, and however much his originality of conception deserves praise, so much the more repulsive in this respect is his colour. And yet there was in this Exhibition a portrait to which his manner was perfectly adapted. It was only with such vague, deceitful, deadly faded hues, without character, that the man could be painted whose fame consists in this, that his thoughts can never be read in his face, or rather that we ever read in it their opposite. I mean the man to whom we might give a kick behind without the disappearance in front of the stereotyped smile from his countenance.[2] I mean the man who swore fourteen false oaths, and whose talent for

[2] [He refers to the French statesman and minister, Charles Maurice de Talleyrand-Perigord (1754–1838).]

lying was employed to their advantage by all governments in France in succession, whenever a deadly act of perfidy was wanted, so that he reminds me of that Locusta,[8] the old compounder of poisons, who lived like an infamous heirloom in the house of Augustus, and was silently and safely transmitted by, and served one emperor after another, and one against the other, with her diplomatic draughts. When I stand before the portrait of the evil and false man, whom Scheffer has painted to the very life, even depicting with hemlock-poison colours the fourteen false oaths in his features, then the freezing thought runs through me, "For whom will he brew the next potion in London?" . . .

Portrait painters are divisible into two classes. Some have the marvelous talent of exactly perceiving and reproducing those traits which may give any stranger an idea of the face represented, so that he at once grasps the character of the unknown originals, and would immediately recognize the latter should he chance to meet him. This manner or merit we find among the old masters, especially in Holbein, Titian, and Van Dyke; and what at once strikes us in their portraits is the directness which so infallibly guarantees them resemblance to their long-deceased originals. "One would swear that this portrait is perfect," we often say when wandering through galleries.

Another or second manner of painting portraits prevails, especially among the English and French, who aim no higher than at the ready recognition of some one whom we already know, and place upon the canvas only those traits which call back into our memories the face and character of the well-known original. Such artists work for the memory alone, and they are especially dear to well-bred parents and tender married couples, who show us their family pictures after dinner, and can never sufficiently assure us how much the portrait resembled dear little Johnny before he had the whooping-cough, and how astonishingly like the original is the portrait of "my dear husband"—if we only knew him!—a delight which is

[8] [Locusta: see Stendhal, pp. 265–66.]

reserved for us until Mein Herr shall have returned from the Brunswick Fair.

The remaining pictures by Scheffer are not worth notice. However, they attracted much admiration, while many better pictures by less known painters passed unheeded. Of so much avail is the name of a master. When a prince wears a Bohemian glass stone on the finger, it is believed to be a diamond, but if a beggar bore a diamond ring, the world would think it was but worthless glass. . . . I now come to

DELACROIX

who has contributed a picture [*Liberty Leading the People, July 28, 1830*] before which there was always a crowd, and which I therefore class among those which attracted the most attention. The sacredness of the subject forbids a severe criticism of the colouring, with which fault might otherwise be found. But despite a few artistic defects, there prevails in the picture a great thought, which strangely attracts us. It represents a group of the people during the Revolution of July, from the centre of which—almost like an allegorical figure—there rises boldly a young woman with a red Phrygian[4] cap on her head, a gun in one hand, and in the other a tricolor flag. She strides over corpses calling men to fight—naked to the hips, a beautiful impetuous body, the face a bold profile, an air of insolent suffering in the features—altogether a strange blending of Phryne,[5] *poissarde* and goddess of liberty. It is not distinctly shown that the artist meant to set forth the latter; it rather represents the savage power of the people which casts off an intolerable burden. I must admit that this figure reminds me of those peripatetic female philoso-

[4] [The red conical cap worn by Phrygians in ancient art came to be associated with liberty—although to the classical Greeks "Phrygian" meant "slave"—because the region of Phrygia was conquered by Lydia.]

[5] [Phryne: "the most beautiful courtesan," whom Apelles and —according to some—Praxiteles used as a model for Venus.]

phers, those quickly running couriers of love or quickly loving ones, who swarm of evenings on the Boulevards. And also that the little chimney-sweep Cupid, who stands with a pistol in either hand by this alley-Venus, is perhaps soiled by something else as well as soot; that the candidate for the Pantheon who lies dead on the ground was perhaps selling *contre-marques* yestereen at the door of a theatre, and that the hero who storms onward with his gun, the galleys in his features, has certainly the smell of the criminal court in his abominable garments, And there we have it! a great thought has ennobled and sainted these poor common people, this *crapule,* and again awakened the slumbering dignity in their souls.

Holy July days of Paris! ye will eternally testify in favour of the original dignity of man—a dignity which ne'er can be destroyed. He who beheld you grieves no more o'er ancient graves, but full of joy, believes in the resurrection of races. Holy days of July! how beautiful was the sun and how great the people of Paris! The gods in heaven who gazed on the great battle, shouted for joy; gladly would they have left their golden chairs and gone to earth to become citizens of Paris. But envious and peevish as they are, they feared lest men would bloom too far and too gloriously above them; so they sought, by their ever-willing priests, "to blacken the brilliant and lay the lofty in the dust," and so organized that Claude-Potter animal piece, the Belgian rebellion.[6] Therefore it has been provided that the trees of liberty do not grow quite up to heaven.

There is no picture in the Salon in which colour is so sunk in as in the July Revolution by Delacroix. But just this absence of varnish and sheen, with the powder-smoke and dust which covers the figures as with a gray cobweb, and the sun-dried hue which seems to be thirsting for a drop of water, all gives to the picture a truth, a reality, an originality in which we find the real physiognomy of the days of July.

[6] [Paul Potter was the popular animal painter. Louis de Potter (1786–1858) was the leader of the Belgian rebellion of September 1830. Heine is confused when he refers to "Claude-Potter."]

Among the spectators were many who had been actors
or lookers-on in the Revolution, and these could not
sufficiently praise the picture. *"Matin!"* exclaimed the
grocer, "these *gamins* fought like giants." A young lady
observed that the Polytechnic[7] scholar was wanting, who
is invariably found in all pictures of the Revolution of
July, of which there were more than forty exhibited. An
Alsatian corporal said in German to his comrades, "Isn't
painting now a great artificiality? How closely everything
is imitated! How naturally that dead man lying there on
the ground is painted; one would swear he was alive."

"Papa," asked a little Carlist girl, "who is the dirty
woman with the red cap?" "Well, truly," replied the
noble parent with a sweetly subdued smile, "I do not find
her so ugly—she looks like the most beautiful of the seven
deadly sins." "And she is so dirty!" observed the little one.
"Well, it is true, my dear," he answered, "that she has
nothing in common with the purity of the lilies. She is the
goddess of liberty." "But, Papa, she has not on her even a
chemise." "A true goddess of freedom, my dear, seldom
has a chemise, and is therefore very angry at all people
who wear clean linen."

Saying this, he drew his linen sleeve-cuffs still further
over his long idle hands, and said to his neighbor, "Your
Eminence, should the Republicans succeed today in hav-
ing some old woman shot by the National Guard at the
Porte Saint-Denis, then they would bear the sacred corpse
round the Boulevards; the mob would go mad, and we
should have a new Revolution" . . .

But I forget that I am only the reporter of an exhibi-
tion. As such, I must now mention a painter who, while
attracting general attention, appealed so markedly to me,
that his pictures seemed to be like a many-coloured echo
of the voices of my own heart, or far more as if the natu-

[7] [The École Polytechnique was established in 1794 to train
engineers and was made a military school by Napoleon in 1804.
It was one of the schools the Revolution had founded to form
an aristocracy of merit. The graduates of these schools provide
France with its high-ranking civil servants.]

rally allied tones of colour in my heart re-echoed wondrous
strange.

DECAMPS

is the name of the painter who so enchanted me. Unhap-
pily, I have not been able to see one of his best works,
The Dog Hospital. It had been taken away before I visited
the Exhibition. Several other excellent works by him es-
caped me because I could not find them in the vast num-
ber of other pictures before they were taken away.

I saw at once that Decamps was a great painter when I
first met with a small picture by him, the colour and sim-
plicity of which vividly impressed me. It only represented
a Turkish building, high and white, with here and there
small windows, out of which peered a Turkish face, while
below was a silent water in which the chalk-like walls,
with their rosy shadows, mirrored themselves in a marvel-
ous calm. I afterwards learned that Decamps had been in
Turkey, and that it was not only his own original colour-
ing which has so much impressed me, but also the truth-
fulness with which the accurate yet modest colouring is set
forth in his pictures of the East. This is strongly marked
in his *Turkish Patrol*, in which we see the great Hadji-Bey,
head of the police at Smyrna, who is going the rounds sur-
rounded by his myrmidons. . . . As the houses before
which the procession passes are whitewashed, while the
soil is yellowish, the whole makes an impression as of
ombres chinoises when we see the dark, droll figures hurry-
ing along the light, bright back- and foreground. It is clear
twilight, and the grotesque dark forms and the lean legs of
men and horses add to the oddly magic effect. And the
fellows run, also with such droll *caprioles*, such unheard-of
leaps; even the horse throws out his legs with such eccen-
tric rapidity, that it seems to be half-creeping on its belly,
half-flying, and certain critics here have very much abused
all that, as unnatural and caricatured.

For France has also its standing and never moving army
of art critics, who carp at and condemn, according to old

conventional rules, every new work, its subtle and refined connoisseurs who sniff round in the ateliers, smiling approbation when any one tickles their hobby, and these people have not failed to pass judgment on the picture of Decamps. A M. Jal,[8] who publishes a pamphlet on every Exhibition, has, by way of a postscript to it, attempted to injure that picture in the *Figaro*, and he thinks that he has neatly ridiculed the friends of the work when he, with affected modesty, declares that he is "a man who only judges according to reasonable conceptions, and that his poor reason could not see in the Decamps picture that great masterpiece which is beheld by those transcendentalists who do not judge by intelligence or common sense alone."

The poor, wretched rascal, with his miserable intelligence or "understanding," he knows not how accurately he condemns himself. Poor understanding or sense should never have the first word when works of art are discussed, any more than either was called to take any leading part in their creation. The idea of a work of art is born of the emotions or feeling, and this demands of free, wild fancy the aid of realization. Fancy then throws him all her flowers—indeed, almost smothers the idea, and would more probably kill it than give it life, if understanding did not come limping up to put aside or clip away the superabundant blossoms. Understanding or judgment only keeps order, and is, so to speak, the police in the realm of art. In life it is generally a cold calculator who adds up our follies; unfortunately, it is often only the bookkeeper of the bankruptcy of a broken heart.

The great error always exists in or consists of this: that the critic asks, "What should the artist do?" It would be much more correct to say, "What does the artist desire?" or even, "What must the artist execute?" The question, "What should the artist do?" originated with those art philosophers who, without any poetry of their own, abstracted characteristics from different works of art, and

[8] [See 1824: PARIS; Jal's *Ébauches critiques* appeared in July.]

from that which existed deduced a standard or rule for all future art, and so established species, definitions, and rules. They did not know that all such abstractions can be of use only to judge of imitations, and that every original artist, and even every new genius in art, should be judged according to his own law of art, which he brings with him. Rules and all such antiquated doctrines are, for such souls, much less applicable. "There are no laws or rules of fencing for young giants," says Menzel,[9] because they break through every parade [line]. Every genius should be studied, and only judged according to what he himself wills or means. Here we have only to answer the question, "Has he the ability to carry out his idea?" "Has he applied the right means?"; here we stand on firm ground. We measure or decide no longer, as to the work submitted, according to our own subjective wishes, but we come to mutual intelligence as to the God-given means at the command of the artist for realizing his idea. In the recitative arts, these means consist of intonation or sound and words. In the representative arts, they are supplied by colour and form. Sounds and words, colours and forms, that above all which appeals to sense, are, however, only symbols of the idea— symbols which rise in the soul of the artist when it is moved by the Holy Ghost of the world; for his artworks are but symbols, by which he conveys his ideas to others. He who expresses the most, and the most significant, with the fewest and simplest symbols, he is the greatest artist.

But I think it attains its highest value when the *symbol*, apart from its inner meaning, delights our senses externally, like the flowers of a *selam*,[10] which, without regard to their secret signification, are blooming and lovely, bound in a bouquet. But is such a concord always possible? Is the artist so completely free in choosing and binding his mysterious flowers? Or does he only choose and bind together what he must? I affirm this question of mys-

[9] [Reference perhaps to Baron von Menzel (1698–1744), so called "*Husaren menzel*," a popular soldier who became celebrated in verse.]

[10] [*Selam*: greeting, peace, as in *Salaam aleikum*.]

tical unfreedom or want of will. The artist is like that *somnambula* princess who plucked by night in the gardens of Bagdad, inspired by the deep wisdom of love, the strangest flowers, and bound them into a *selam*, of whose meaning she remembered nothing when she awoke. There she sat in the morning in her harem, and looked at the *bouquet de nuit*, musing on it as over a forgotten dream, and finally sent it to the beloved Caliph. The fat eunuch who brought it greatly enjoyed the beautiful flowers without suspecting their meaning. But Harun al Raschid, the commander of the faithful, the follower of the Prophet, the possessor of the ring of Solomon, he recognised the deep meaning of the beautiful bouquet; his heart bounded with delight, he kissed every blossom, and laughed till tears ran down his long beard.

I am neither a follower of the Prophet nor possessor of the ring of Solomon nor of a long beard, yet I dare assert that I have understood the beautiful *selam* which Decamps brought us from the East far better than all the eunuchs with their Kislar-Aga, the great first connoisseur, the pandering messenger in the harem of Art. The twaddling of such castrated connoisseurship is intolerable to me, especially the traditional forms of speech, and the well-meant advice to young artists, and even the pitiable referring them to Nature, and always to dear, sweet Nature.

In art I am a supernaturalist. I believe that the artist cannot find all his types in Nature, but that the most significant types are simultaneously revealed in his soul as the inborn symbolism of inborn ideas. A recent professor of aesthetics, who wrote *Italienische Forschungen* [*Italian Researches*, 1827–31],[11] has endeavoured to make the old principle of imitating (or conforming to) Nature again palatable by declaring that the creating artist should find all his types in Nature. This aestheticist, while thus set-

[11] [Karl Friedrich Rumohr (1785–1843); the book dealt with Italian art from Charlemagne to Raphael in the form of research into separate problems chosen for their critical interest.]

ting forth such a fundamental principle for the formative arts,[12] never thought of one of the earliest of them, or architecture, whose types men are now foolishly pretending, to support this doctrine, to find in forest foliage and rocky grottoes, but which most certainly were not thence derived. They did not exist in external Nature, but in the human soul.

The artist may answer the critic who misses Nature in the picture by Decamps, and who blames the manner in which the horse of Hadji-Bey throws out his feet and how his people run as unnatural, that he painted it quite accurately according to fairy-tale fancy and to the inner intuition of a vision. . . .

JEAN SCHNETZ

is a well-known name. . . . It may be that the amateurs who had seen far better works by him (than those here exhibited) assigned him a high rank, and I therefore give him in consequence a reserved seat. He paints well, but is not, in my opinion, a good painter. His great picture in the Salon of this year, representing Italian peasants imploring a miraculous cure of the Madonna, has certain admirably executed details; as, for instance, that of a boy afflicted with tetanus is admirably drawn, and great mastery of art reveals itself in technicalities everywhere; but the whole is rather edited than painted, the figures are placed *en scène* with a declamatory air, and there is a want of intuition, originality and unity. Schnetz has to make too many strokes and touches to express his idea, and then that which he sets forth is partly superfluous.

. . . Schnetz has, as regards studies and choice of subjects, much in common with a painter who is in consequence often classed or mentioned with him, but who, in the Exhibition of this year, surpassed with few exceptions not only him, but all his art contemporaries, and who, as a

[12] *Bildendren Kunste.* I think it was Hazlitt who first used the word "formative" in English as applied to art. French versions are *l'artiste plastique* and *les arts plastiques*. [Translator.]

testimonial of public recognition of his merit, received in the award of prizes the degree of an officer of the *légion d'honneur.*

LÉOPOLD ROBERT

is his name. "Is he an historical or *genre* painter?" I seem to hear from the masters of the guilds of Germany. Unfortunately, I cannot evade this question. I must once for all come to some understanding as regards this unintelligible expression, in order to avoid great misunderstandings. This distinction between history and genre is so bewildering, that one might well believe it was invented by the artists who worked on the Tower of Babel. Yet is is really of much later date. In the earlier stages of [modern] art there is only historical painting, that is to say, scenes from sacred history. After this, men distinctly designated as historical paintings those whose subjects were drawn not only from the Bible and [religious] legends, but also from profane or modern history and ethnic fables of the gods. And this was done in opposition to representations of ordinary life, which came mostly from the Netherlands, where the Protestant spirit turned away from both Catholic and mythologic material, there being, perhaps, neither models nor inclination for the latter, and where there were, notwithstanding, many admirable painters wishing for employment, and so many friends of art who gladly purchased pictures. The different developments of familiar life therefore became known as genres. . . .

When art, after a long sleep, again awoke in this our age, painters were in no small perplexity as regards material. The sympathy for subjects drawn from sacred history and mythology was completely dead, in the greater portion of Europe, even in the Catholic countries; and yet our contemporary costume seemed to be too unpicturesque even to depict history or common life itself. Our modern frock- or dress-coat is really so very prosaic to its very depths, that one can only use it as a caricature in a picture. . . .

The predilection for ancient historical subjects has
been by this greatly heightened, and we find in Germany a
whole school, which certainly does not lack talent, but
which is unweariedly occupied in clothing the most every-
day of modern men with the most everyday feelings in the
wardrobe of the Catholic and feudal Middle Age, in cowls
and coats of mail.

Other painters have had recourse to other expedients,
and choose for models populations from which progressive
civilization has not stripped their originality or national
garb. Therefore the scenes from the Tyrolean mountains,
which we so often see in the pictures of Munich artists.
This mountain country lies near, and the costume of its
inhabitants is more picturesque than that of our dandies.
Hence those gay pictures of popular Italian life, which is
also dear to most artists when in Rome, where they find
that ideal nature, and those primevally ancient human
forms and picturesque costumes, for which their artist
souls yearn.

Robert, a Frenchman by birth,[18] and an engraver in his
youth, subsequently lived many years in Rome, and the
pictures which he has this year exhibited belong to the
same genre or kind of which I speak, that is, repre-
sentations of popular Italian life. "Therefore only a genre-
painter," I hear one of the German guild-masters cry, and
I indeed know a lady historical-painter who quite turns up
her nose at Robert. Yet I cannot quite assent to the term,
because there is no longer any historical painting, in the
old sense of the word. It would be too vague should one
claim this term for all pictures which express a deep
thought, the end of which would be a quarrel over every
picture as to whether it had any thought in it, the result
of all the dispute being only a word. If it should be ap-
plied, in its most natural and obvious sense, to repre-
sentations of the world's history, the term, "historical
painting" would be approximate to a kind which is now
extremely exuberant, and whose growth is seen in the mas-
terpieces of Delaroche. . . .

18 [Robert was born a Swiss.]

But before I particularly discuss the latter, I would devote a few words to the pictures of Robert. They are, as I have said, all Italian scenes, and such as bring before us most wondrously the loveliness of this land. . . . *The Harvesters* is as it were the apotheosis of existence, at the sight of which we forget that there is a realm of shades, and doubt whether it is anywhere more glorious or brighter than on this earth. "The earth is heaven and men are holy, yea, deified." That is the great revelation which gleams with happy colours from this picture. The Parisian public has received this painted evangel far more favourably than if Saint Luke had delivered it. In fact, the Parisians have a much too unfavourable prejudice against the latter.

In the picture of Robert we see a desert place in La Romagna in the most glaring of Italian sunsets. The centre of the composition is a peasant's cart, drawn by two immense buffaloes [sic] harnessed with heavy chains, and filled with a family of peasants who are about to halt. . . .

In the method of colour in Robert's picture we recognize the study of Raphael, and the architectonic beauty of the grouping also recalls the latter. There are, too, certain forms, such as that of the mother and child, which resemble figures by Raphael, and that in his earliest springtime, when he reflected the severe type of Perugino with tolerable truth, but gently and gracefully softened.

It would never occur to me to draw comparisons between Robert and the great painter of the great Catholic era, but I cannot refrain from recognizing their relationship. And yet it is only a material affinity of form, and not a spiritual relationship. Raphael is utterly imbued with Catholic Christianity, a religion which expresses the conflict of soul with matter, which has for object the suppression of matter, which calls every protest of the latter a sin, and which would spiritualize the earth, or rather sacrifice earth to heaven. But Robert belongs to a race in which Catholicism is extinguished. . . . Robert is a Frenchman, and he, like most of his fellow countrymen, cherishes unconsciously a still disguised doctrine which

will know nothing of the battle between spirit and matter, which does not forbid to man the certain pleasures of earth, and, on the contrary, promises him all the more heavenly enjoyments in mere moonshine, but which would much rather make man happy here on earth, and regards the sensual world as holy as the spiritual; "for God is all that there is."

Robert's *Harvesters* are, therefore, not only sinless, but they know no sin; their earthly, daily work is piety; they pray continually without moving their lips; they are blessed without heaven, atoned for without sacrifice, pure without constant ablution, and altogether holy. And as we see in Catholic pictures the heads alone, as the seat of the soul, radiating the auerole or symbol of spiritualization, so, on the contrary, we behold in the work by Robert a matter sanctified, since here the entire man, body as well as head, is surrounded by heavenly light as by a glory.

But Catholicism is not only extinct in modern France; it has not here even a reactionary influence on art, as in our Protestant Germany, where it has regained a new value by the aid of poetry, which always embellishes the ruins of the past. It may be that there is in the French a sullen spite which disgusts them with Catholic tradition, while a deep interest manifests itself in them for all historical subjects. I can prove the remark by a fact which in turn is explained by the remark itself. The number of pictures representing Christian subjects drawn from the Bible or from religious legends is so insignificant in this year's Exhibition that many a subdivision of a secular motif contains many more and far better pictures. After counting accurately, I find among the three thousand numbers in the catalogue, only twenty-nine such religious pictures, while there are thirty representing scenes from Walter Scott's novels. I can, therefore, when I speak of French painting, not be misunderstood when I use the expression "historical painting" and "historical school" in their most natural meaning.

DELAROCHE

is the leader of such a school. This painter has no great
predilection for the past in itself, but for its repre-
sentation, for the illustration of its spirit, and for writing
history in colours. This inclination manifests itself among
most French artists. The Salon was full of scenes from his-
tory, and the names Devéria, Steuben, and Johannot de-
serve the most distinguished consideration. There is also
such a tendency in the sister arts, especially in the poetic
literature of the French, which Victor Hugo cultivates in
the most brilliant manner. The latest advances of the
French in the science of history, and their vast contri-
butions to the practical writing thereof, are consequently
no isolated phenomena.

Delaroche, the great historical painter, has exhibited
this year four works, the subjects of two of which are
drawn from French history, and of the other two from
that of England. The former are small, such as are called
cabinet pieces, and very rich in figures and picturesque.
One represents Cardinal Richelieu, "who, while dying, as-
cends the Rhone in a boat, to which is attached another
in which are Cinq Mars and De Thou, whom he is taking
to Lyons, to have them beheaded."[14]. . .

The two other pictures of Delaroche set forth subjects
from English history. They are of life-size, and more sim-
ply painted. One represents the two young princes in the
Tower, who were murdered by command of Richard III.
The young king and his younger brother are seated on an
antique bed, while their little dog, running to the door of
the prison, seems to announce by his barking the coming
of the murderers. The king, who is between boyhood and
youth, is a very touching figure. . . .

And yet the other picture of Delaroche awakens still
more painful feelings. It is a scene from English history

[14] [The instigators of a conspiracy to overthrow Richelieu.
They were beheaded in Lyon in 1642.]

[*Cromwell Opening the Coffin of Charles I*], and from that
terrible tragedy which has been translated into French,
and, causing many tears to flow on both sides of the Chan-
nel, has also deeply moved German spectators. We see on
the canvas the two heroes of the play, one as a corpse in a
coffin, the other abounding in strength of life, and lifting
the coffin-lid to look at the dead enemy. And after all, in-
stead of being heroes themselves, are they not merely
actors to whom the Director of the world assigned their
parts, and who, without knowing it, act in tragedy two
warring principles?[15] I will not name them here, these
two inimical principles, the two great thoughts which con-
tended perhaps in the soul of God while creating the
world, and which we here see opposed in this picture, the
one shamefully wounded and bleeding in the person of
Charles Stuart, the other bold and victorious in that of
Oliver Cromwell. . . .

The character of the talent of Delaroche, as well as of
most of his contemporaries, closely approaches that of the
Flemish school, only that the French treat subjects with a
lighter grace, and its national elegance flits over it
superficially yet beautifully. Therefore I would call De-
laroche a graceful and elegant Dutchman. . . .

I may, in another place, report the conversation which I
frequently overheard near this Cromwell. There could be
no better place for eavesdropping, and catching public
feelings and opinions. The picture is hung in the grand
salon, at the entrance of the long gallery, and near it was
placed Robert's admirable masterpiece, which is equally
consoling and conciliatory. In fact, if the rough and mili-
tary Puritan figure, that terrible harvester with the shorn
royal head, stepping from a dark background, terrified the
beholder and awoke in him wildly all political passions,
the soul again felt itself calmed at the sight of those other
more peaceful reapers, who, returning with their more
beautiful sheaves, bloomed in the purest light of heaven at

[15] [The reference is to *capacité* and *hérédité*, two principles
the Saint-Simonists saw in permanent conflict. See Mary H.
Clarke, *Heine et la monarchie de juillet* (Paris, 1927), p. 247.]

the harvest-home of love and peace. And though we may feel before one of these pictures that the great battle of the age is not yet at an end, and that the earth still trembles 'neath our feet, though we still hear the roaring of the storm, which seems to threaten that it will soon tear earth from its firm foundations, though we see a monstrous, deep abyss which thirstily absorbs the stream of blood so that dread fear of utter ruin seizes on our souls; still, in the other picture, we behold how peaceably secure the earth remains, how lovingly she yields her golden fruits, though all the mighty Roman tragedy, with gladiators and great emperors, vices and elephants, once trampled down the whole beneath their weight, then passed away. If we have contemplated in the first that history which rolls on so crazily in mud and blood, and then for centuries keeps calm and quiet to bound up again, and right and left goes wildly raging on—that which we call the history of the world; then in the picture, on the other hand, we read a history which is greater still, yet which has ample space to show itself in a farm-wagon drawn by buffaloes, a tale without a beginning or an end, which ever tells itself again like the sea-waves, and which, indeed, is simple as the sea, as the blue sky, or as the seasons' round—a holy history which the poet sings whose archives are in every human heart;—I mean the history of humanity!

It was really benevolent and beneficent that the picture of Robert was placed so near that by Delaroche. . . .

Returning to my subject, I should here have praised many a brave painter, as, for example, the two marine artists, Gudin and Isabey, as well as certain distinguished depictors of ordinary life, such as the brilliantly clever Destouches and the witty Pigal; but, despite the best will, it is all the same impossible to analyse their merits calmly, for there, out of doors, the storm rages too terribly, and no one can concentrate his thoughts when such tempests re-echo in the soul. It is even on so-called peaceful days very hard in Paris to turn one's mind away from what is in the streets and indulge in wistful private dreams. And though Art blooms more luxuriantly in Paris than elsewhere, we

are still disturbed in its enjoyment at every moment by
the rude rush and roar of life; the sweetest tones of Pasta
and of Malibran[16] are jarred by the suffering cries of bitter
poverty, and the intoxicated heart, which has just drunk
eagerly from the inspiring cup of Robert's colour, will be
immediately after sobered by the sight of public misery. It
requires almost a Goethean egoism to attain here to undis-
turbed art enjoyment, and how very difficult art criticism
thereby becomes I feel at this moment. I succeeded yester-
day evening in writing something more of this paper, de-
spite having seen a deathly pale man fall to the ground on
the Boulevards from hunger and wretchedness. But, when
all at once a whole race falls on the Boulevard of Europe,
then it is impossible to write further in peace. When the
eyes of the critic are wet with tears his opinion is not
worth much.

Artists justly complain in this time of discord and gen-
eral enmity. They say that painting needs the peaceful
olive tree in every respect. Hearts which are anxiously
awaiting the sound of the trumpet of war certainly have
not an ear for sweet music. Men listen to the opera with
deaf ears, the ballet is stared at too with little joy. "And it
was all the fault," the artists cry, "of that damned Revolu-
tion of July," and they curse freedom and the detestable
politics, which absorb everything, so that nobody so much
as mentions them. . . .

My old prophecy as to the end of the art period, which
began with Goethe's cradle and which will end with his
coffin, seems to be near its fulfillment. The present art
must perish, because its principle is rooted in the worn-out
régime, or in the vanishing past of the Holy Roman
realm. Therefore, like all the faded relics of that past, it
stands in comfortless cold contradiction with the present
age. It is this contradiction, not the tendency or taste of
the time itself which is so injurious to art; on the contrary,

16 [Giuditta Pasta, née Negri (1798–1865), popular Italian
dramatic soprano. Maria Felicita Garcia (1808–36) (Malibran
was the name of her first husband), operatic contralto, daughter
of Manuel Garcia.]

this tendency and action of the age must strongly stimulate, as was the case in Athens and Florence, where even in the wildest storms of war and factions art developed its most magnificent results. It is true that those Greek and Florentine artists did not lead an isolated, egoistic art life (or one of) idly imagining souls hermetically sealed to the great joys and sorrows of their day; on the contrary, their works were but the visioned mirror of their age, and they themselves were thorough *men*, whose individuality was as strong as their creative power. Phidias and Michael Angelo were men of one piece with *their* works, and as they were in keeping with their Greek or Catholic temples, so were those artists in holy harmony with their surroundings; they did not work with pitifully limited, private personal inspiration, which easily and falsely insinuated itself into any subject at will. Aeschylus sang of the Persians with the same truth which he manifested in fighting them at Marathon, and Dante wrote his comedy, not as a poet waiting for orders, but as a fugitive Guelf and in proscribed exile, and in the dire need of war he did not bewail the decay of his genius, but that of freedom.

However, the new age will bring forth a new art, which will be in inspired accord with itself, which will not need to take its symbolism from a faded past, and which must even develop a new style of work, which will altogether differ from that which preceded it. Until then the most self-intoxicated subjectivity, the individuality free from social, worldly influence or divine personality, may assert itself in all possible enjoyment of life, which is always worth more than the dead, sham existence of ancient art.

Or is there to be a sad and dreary end of art, as with the world itself? That overwhelming spirituality which now manifests itself in European literature is perhaps a sign of near extinction, just as men at the hour of death suddenly become clairvoyant and utter with pallid lips the most supernatural secrets. Or will grey, old Europe rejuvenate itself, and is the twilighting spiritualism or supernaturalism of its artists and authors not a marvelous foreboding of

death, but the terrible thrilling prescience of a new birth, the intellectual wafting of a new spring?

The Exhibition of this year, has by many a picture, removed that uncanny fear of death and announced a better promise. The Archbishop of Paris expects all benefit from the cholera or death; from it I hope for freedom and for life. There our faiths differ. I believe that France, from the depths of the heart of her new life, will exhale a new art. Even this difficult problem will be solved by the French, by that light, fluttering people whom we so naturally compare to a butterfly.

But the butterfly is also a symbol of the immortality of the soul and its eternal renewal in youth.

1833–34
PARIS: The Official Exhibition
of the State

Despite Louis Philippe's decree calling for an annual
Salon, none was held in 1832 because of an outbreak of
cholera which swept Europe. It took 18,450 lives in Paris
during April and May, including that of Casimir Périer,
the liberal but repressive First Minister. The epidemic was
particularly devastating among the city's poor. Although
the Industrial Revolution progressed more slowly in
France than in England, farm workers migrated to urban
centers to look for work in new factories. By 1800 the
population of Paris had grown by over a third. There had
been no increase in the city's housing, and the majority of
Parisians lived in misery. Economic distress was nation-
wide and affected industrial workers in other French cities
as well. In 1831 an insurrection of desperate silk weavers
in Lyons was suppressed by the army, as were strikes in
Grenoble.

The republican press maintained a continual attack on
the government with articles and caricatures of Louis
Philippe and his ministers, including Adolphe Thiers,
Minister of the Interior since 1832, and François Guizot,
the uncompromising doctrinaire Huguenot Minister of
Public Instruction. The first satirical journal with carica-
tures, Le Nain jaune (1814–15), had been suppressed by
the censor. It had been followed by La Caricature
(1830–34), which was joined in 1832 by Charivari
(1832–42), which published caricatures by Daumier, Ga-
varni, Granville and Travies expressing the populace's con-
tempt for the governing institutions.

When the Salon of 1833 opened in April, the visitors to

the galleries who walked with self-satisfaction and content-ment were the victors of the Revolution of 1830: the *grande bourgeoisie*, businessmen and industrialists, and the *petite bourgeoisie*, shopkeepers. The *petite bourgeoisie* had provided much of the leadership during July when they united with artisans and students to erect barricades. Now the owners of businesses opposed the extension of the benefits won to the craftsmen and the increasing num-ber of laborers. In the words of Victor Hugo, "The Revo-lution of 1830 had stopped halfway."

Young writers, political theorists, musicians and artists, determined to influence events by making their ideas known, obtained positions on the increasing number of newspapers and periodicals or secured financing to estab-lish their own journals. No *belles-lettres* and art periodical had been published in Paris until Achille Ricourt founded *L'Artiste* in February 1831. Ricourt, an architect and able caricaturist, had established a successful publishing house for fine editions in 1818 and was the first publisher of Honoré Daumier. Among Ricourt's friends were Dela-croix, Decamps, and the sculptors David d'Angers and Pradier. *L'Artiste* carried illustrations of contemporary art-ists' work in the form of engravings and, later, lithographs. The views of its staff, contemporary or younger than the innovators in the art world, mirrored the attitudes of their peers.

A witty, brilliant twenty-nine-year-old reporter for *Fi-garo*, Jules G. Janin, was hired to review the Salon of 1833. A precocious boy, born in the mining town of St. Etienne in central France, Janin had been sent to the Collège Louis le Grand in Paris. He had remained in Paris and worked as a tutor while edging his way forward as a writer and discreet art and drama critic. His wry, satir-ical parody, *L'Âne mort et la femme guillotinée*, published in 1829, had secured him a place in the circles of his class-mate Sainte-Beuve and of Victor Hugo. In 1830 the Ber-tin brothers, owners of the *Journal des débats*, named him drama editor of the paper, which was already distin-

guished by Delécluze's criticism. Janin occupied the post for forty years but continued to contribute to *L'Artiste*.

When he reviewed the Salon of 1833 in a series of articles for *L'Artiste*, Janin found no startling innovations among the 4,500 paintings hung on the screens of cloth covering the old masters. Janin felt art was the product of its epoch and commented: "When everywhere, in literature, in morality, in politics, ties slacken and no conviction has yet replaced those that have died, when for lack of an authority to collect and focus them, the sentiments of the masses wander at the whim of the day's interests and fantasies, how can the fine arts escape this huge ruin of inspiration and thought?" He reported that the painters' interest in the external world expressed itself in portraits, landscapes and marine scenes or was diverted to subjects inspired by the imagination, in dream scenes taken from biography, the history of art, or the works of poets like Dante, Goethe, Scott or Byron.

A regeneration of sculpture similar to that accomplished in painting by Delacroix and the landscape school of 1830 appeared in the work of Auguste Préault, Jean Bernard du Seigneur and Antoine Barye exhibited in 1833. The gradual acceptance and recognition of the value of "originality"—Hugo called attention to it—and of a naturalism that rejected the ideal enabled Janin to respond to Barye's work when he reviewed the sculpture in his fifth article. Still respectful of the rules of classicism for sculpture and the traditional function of sculpture in society, Janin could not approve of a distortion of form to achieve expressiveness, especially in themes borrowed from contemporary literature. Later he would also oppose Balzac's realism.

The attention now accorded the individual art object by the journalists led to an awareness of the effect of its installation on the viewer. Janin, a drama critic conscious of the importance of staging in a show, complained that the installation of the sculpture at the Salon was prejudicial to the entries.

Janin was an indefatigable and prolific writer; his re-

sponsibilities as drama critic for the *Journal des débats* did not prevent him from supplying reports of art exhibitions to various publications or writing his volumes on the history of the French theater and on social life in the eighteenth century. He received the highest literary distinction, election to the Académie Française, in 1870. The title "prince of critics who never made an enemy" was given him for his judicious and intelligent reports of events in the art world.

The doors of the Louvre had scarcely closed on the Salon of 1833, the old masters been cleared of their covering, and the crowds of the curious in the galleries replaced by a few students, connoisseurs and tourists, when preparations had to be begun to receive, classify and jury the three thousand or more entries expected for the Salon of 1834. Artists who had obtained neither a purchaser nor a state award in 1833 were obliged to weigh the financial cost involved in preparing for the next Salon during the nine months before it opened.

The uneasy outward political stability continued. Thiers, still Minister of the Interior, was determined to crush opposition and banned political organizations in April 1834. Parisians took to the streets in protest, only to be driven back to the workers' district by the National Guard, now formed of taxpayers who could afford to buy their equipment. Fourteen demonstrators were killed in the Rue Transnonian; Daumier recorded the tragedy in a lithograph.

Thiers, ignoring the squalor in the eastern districts of Paris, pushed forward public works for the beautification of the city. He completed the Madeleine, the Place de la Concorde and the Arc de Triomphe and commissioned Delacroix in 1833 to decorate the Chambre des Députés in the former Palais Bourbon and Barye to execute a lion, the astrological symbol of the July Days, to ornament the Victory Column erected on the site of the Bastille.

Young intellectuals and artists, bourgeois, but deeply concerned with the theoretical and philosophical questions

implied in the sociopolitical ferment, had used their pens and brushes as weapons. Since 1824 their attempt to revolutionize the art world had brought about two mutually incompitable artistic spheres: their innovations were opposed by the older generation of classicists who continued to dominate the Institute. The aesthetic difference between the two groups reflected somewhat their political leanings; and the staffs of the periodicals and newspapers, striving to keep their readers abreast of events in the art world, tempered their articles to the social and political interests of the subscribers. A bridge of communication between these two groups in the field of the arts was possible, for all were basically middle class; a third, moderate, middle way, *le juste milieu*, was developed, advocated by the cautious *Journal des débats*. Artists like Delacroix, who had shared in the three glorious days, on viewing the developments, had withdrawn into cynical aloofness, aware of their powerlessness.

Neither the innovators nor the classicists had contact with the third element of the French population that had been forming as a result of the Industrial Revolution and the population growth. Only a few artists and caricaturists and theoretical activists, like Auguste Blanqui, who was prepared to realize his theories by force, bridged the gap between the bourgeoisie and the new working class. A follower of Saint-Simon, Émile Barrault, issued a pamphlet, *Aux artistes: du passé et l'avenir des beaux-arts, doctrine de Saint-Simon*, in 1830 to rally writers and artists to support actively social reforms.

The social philosophy the young intellectuals had learned from reformers like Benjamin Constant and Saint-Simon influenced the reports of art events in a periodical founded by the group's elite. *La Revue des deux mondes* had been established in 1829 by François Buloz. A young man of twenty-seven, Buloz had recruited talent of his own age—Sainte-Beuve, Victor Hugo, George Sand and Alfred de Musset—as collaborators.

Among the contributors to the *Revue des deux mondes* was Gustave Planche (1808–57), a onetime medical stu-

dent and pupil of Victor Cousin, the advocate of an empirical, eclectic philosophy. Planche had determined to become a man of letters and had prepared himself by omnivorous reading and a proficiency in English. Through his friendship with Sainte-Beuve he did an English translation for Victor Hugo which gave him an entrée into the literary world. He frequented the studios of Gérard, Eugène and Achille Devéria, Delacroix, the landscapist Paul Huet and the sculptor David d'Angers. Planche's first art criticism, *"Concours pour le grand prix de sculpture,"* was published by the *Globe* in 1830.

Eager to have French art acquire a new and vigorous direction, Planche assumed the responsibility for correcting the artists' choice of subject and technique and for informing the public what should be required of artists. He justified this by his assumption that a man possessing his familiarity with the arts and artists could do so. With the detachment of a surgeon (a contemporary had said that "criticism also is a science"), Planche criticized first the subject, then the execution and refused to admire art for sentimental or aesthetic reasons. He was empirical and, like his teacher Victor Cousin, he chose the best where it was to be found.

Planche published at his own expense his review of the Salon of 1831, illustrated with eight wood engravings. It won him a place on the *Revue des deux mondes* and Buloz assigned him the review of the Salon of 1833. In it Planche noted three directions to which he assigned the terms "renovation," "conciliation" and "innovation," and stated that the future belonged to the third. The following year in *"De la critique française,"* in the *Revue des deux mondes,* Planche, painfully aware of his lack of genius and deeply wounded by his break with George Sand, described the role of the critic as a creative and co-operative one, collaborating with the artist in the interpretation of the artist's thought. Planche remained with the *Revue* until 1846, but was not hindered from contributing articles to *L'Artiste* and the *Journal des débats,* or from being briefly on the staff of Balzac's *Chronique de Paris.*

Planche was a humanitarian influenced by the socialist ideas of Saint-Simon and Fourier (the word "socialist," as first used in 1831, meant a criticism of the existing order as unjust and a demand for social equality). He believed that the arts were the means by which man could be improved and society advanced toward perfection. He did not, however, envisage artists actively participating in politics. He refused the directorship of the École des Beaux-Arts to be "free" to theorize. Though he was obliged to support himself by writing reviews, Planche was aware of the deficiency of his talents. His criticism, colored by the view that art has a mission to perfect society and the critic the duty to instruct and draw the less knowledgeable spectator to the work of art, and his rejection of realism's lack of ideal content, gradually aligned him with the reactionary, conservative academicians of the Second Empire. He became alienated from both his innovative friends among the realists and the advocates of pure "art for art's sake." Planche's independence and his sincerity (often mistaken for animosity since he regarded those who objected to the dictates of *"bon sens et du bon goût"* as traitors to the mission of art) made him respected but unpopular even among those he admired. It could be said more truly of Planche than was said of Janin that, "like most critics, he is a sort of literary eunuch; deprived of generative power, sometimes he rocks the cradles of infants, but more often he devours them."

Jules G. Janin, *"Salon of 1833: Sculpture"*[1]

In our reviews of the painting galleries we have remarked on "facile" paintings, on paintings remarkable for a rare skill of execution, on works that made us say "No! we must not despair over the state of art in France!" But from that multitude of canvases spread before us we did

[1] [Translated from "Salon de 1833, Article VIII" and "Salon de 1833, Article IX," *L'Artiste*, Paris, 1833, Vol. 5, pp. 141–43, 153–55.]

not draw attention to any with a great and strong originality, to any from which, in Diderot's words, "it was possible to receive a violent shock, a deep sensation that remains with one and haunts one like a ghost." The sculpture exhibit has made a completely different impression on us. This year the genius of sculpture is amply demonstrated in significant works that are irresistibly attractive. They reveal on the part of their creators that patient study and passion for art which we relish in the great artists of antiquity and the Middle Ages.

Extraordinary circumstance! Sculpture is the last of all the arts to develop and perfect itself, and is influenced by almost all other media, yet in this exhibit it has outdistanced them all.

In our examination of the works in this small, cold hall of sculpture, we will trace the development of the art itself during the last fifteen years: first we will stop before works which still belong to the old, academic school; then we will come to those of the so-called romantic school, inspired by the writings of M. Victor Hugo especially; finally we will contemplate works of independent and individual fantasy, works of an inventive and novel inspiration.

With *Cyparissus and His Stag*, M. Pradier, its creator, has proved that he knows how to carve marble and how to give a human body proper proportions and quite elegant forms; but tell me, do you feel any vitality, any soul, in this young man busy bending a tree branch? The whole surface of the body is pure and well polished, but the flesh is not alive. You answer: "But how could you animate such a subject or make its flesh alive?" Then why choose such a subject? This is the failing of the school to which M. Pradier belongs: it disdains inspiration and subordinates the interest of the subject to an exclusive preoccupation with form and technical perfection. M. Foyatier, on the contrary, depicted a dramatic action: the athlete Astydama saving Lucilia and her infant child from the destruction of Herculaneum. Unfortunately the execution is weak: it is not a feminine body that the athlete holds in

his arms but an anonymous lump; Astydama's figure is expressionless and, additionally, since he is walking through the debris of shattered buildings, he ought to watch his step, instead of gazing at the heavens in a theatrical manner. His pose is wrong. We expected better from the creator of Spartacus.

M. Jacquot's *Odalisque* is a large woman whose soft, rounded forms look very like those lithographic nudities of the streets and boulevards. I pass over the heroes of mythology, the virgins, the saints, Peter and Paul, the personifications of French cities, to come to the romantic school—I continue to use that hackneyed word because it does express a mental attitude and characterizes the inspiration of the works I am going to deal with. Here we see sculpture continue the reaction begun in other media—in painting against the school of David and in literature against the classical school—but the reaction of sculpture in this Salon is false and exaggerated. As much as the former school loved the nude, purity and finished forms, MM. Préault and du Seigneur adore bodies with sketchy forms, fleshless features and thin hideous limbs. *The Two Poor Women of the Earth, Mendacity* and *The Death of Gilbert* by M. Préault all resemble exhumed cadavers. It is fine to show us the destructive effects of sorrow, misery and despair, but it is still necessary to show us human beings; we like to see hands and feet. One would be tempted not to be too severe with such works if they were not the unfortunate symptom of the spread of certain artistic aberrations which have seized some ardent and undisciplined imaginations. Préault's and du Seigneur's formless efforts are only the offshoots of some monstrous novels, just as those novels are only the pale shadows of *Han d'Islande* and *Notre Dame de Paris* [of Victor Hugo]. We deplore such excesses all the more strongly because we discern in those sketches by M. Préault mentioned earlier a passion and depth of feeling with the potential, if well directed, for creating complete and original works. But to achieve this, art must be taken seriously; one must consecrate oneself to some grand thought; one

must possess that patience for study without which the best talents are stillborn. . . .

We have seen a group of three children's heads by M. Valois, rather mannered but with animated and lively expression; we especially like the left head for the accuracy of the features and the naïveté of the expression. Who has not praised the *Young Neapolitan Fisherman* by M. Rude? This piece was finished with the care and patience we always demand of an artist: the flesh masses are accurate; all the gestures are natural; the young fisherman's smile of pleasure is treated with delicacy and finesse. The *Fisherman Dancing the Tarantelle* by M. Duret is another work the public enjoys stopping in front of; we might wish for less slimness in the body and legs, less of that affected delicacy which is often merely meager and weak. But there are grace and precision in the pose and gestures of this statue. It is a pity M. Duret made this *Molière*; cold and uninspired; although some parts are treated with talent, on the whole it is very mediocre.

All the works mentioned stand out because of their facile and finished execution and their graceful and pure detailing. But now we come to works which are more complete and more original, of a loftier inspiration. Today it is rare to encounter artists who are, as Bonaparte put it, "squarely individual," that is to say complete, vast and profound, who carry into the smallest details of their works the vital imprint of their originality because they have a genius for the totality and a feeling for the infinite. Barye seems to us to be one of these artists within the specialty that he has so ardently embraced. His talent has brilliantly developed and perfected itself in this exhibit and has made him our leading sculptor in everyone's eyes. It would be impossible to capture more powerfully or accurately the movements, the gestures, the attitudes, the habits, the entire range of animal life. I say the entire range because he shows us faithfully and lyrically not only a particular incident but also widely varied episodes of different species. Just look: here is a huge lion defending itself against a serpent. What strength and naturalness in

the pose! How graceful and facile is the carving of the curve extending from the animal's head to its tail. The expression of the head is simultaneously frightened and angry. Baring his claws, he presses his paw on the serpent and you can almost feel the weight of that paw; you expect to see it move with the slightest twitch of the reptile. It is alive and one could spend whole hours analyzing such masterpieces, because the details in a work which duplicates life so perfectly are infinite and give birth to feelings just as infinite. But, as I said, M. Barye's talent is so complete that he is able to carry the same genius of execution into subjects very different in their dimensions and habits. You have seen that huge lion, full of life, now look at this little gazelle stretched out on its flank, dead. The admirable mastery with which this subject is treated proves that the artist is endowed with deep and authentic feeling and can lend it to all his subjects. In front of this charming gazelle, you are as moved as though you had known it, had fed and cared for it; Barye has made you love it. If you analyze this shrunken form, this sightless eye, these slender legs, you will acknowledge that Barye has carved death as perfectly as he carved life in the colossal lion. The sight of this dead gazelle moves me like the touching elegies of the Arabs on the death of their beloved horses. This is not all. Barye is great and sublime with his lion, tender and touching with his gazelle, see him now naïve and witty with his bears: a crouching bear feeding, a bear standing erect, two bears fighting. In the smallest details there is always the same accuracy of execution. With their endearing gestures and similarity to cunning peasants, those bears make you laugh in spite of yourself, just as at the Jardin des Plantes. Remember the *Asian Elephant,* the *Stag Pulled Down by Two Blooded Hounds,* the *Horse Overthrown by a Lion.* Admire the way the lion flattens itself on the horse! Do not forget *Charles VI in the Forest of Mans;* the king is outstanding for his frightened pose. Can you believe that this young man—who appears before us with this strength and originality, with this intelligent comprehension of his art—was for a long time obscure and neglected, unable to

rise and show himself as we see him now, too poor to pay
for the tools of his art or hire models! Would you believe
that this young man competed for the first prize in sculp-
ture and was only able to win a second prize? But neither
obscurity and misery nor the ignorance of the academies
discouraged him; he heard the magic voice of art calling
him and he followed persistently. Because he could not
afford to hire models, he managed to find magnificent
ones free. He moved into the Jardin des Plantes; he lived
with the lions, tigers and bears; he spent his life studying
their physiognomy, their color, their movement, their
habits, and he became, willy-nilly, a sculptor of originality
and an artist who has reproduced a whole segment of crea-
tion. I only acknowledge as worthy of the name of artist—
a name so prostituted today—such men whose dignity,
perseverance and devotion attest to their lofty and ener-
getic abilities.

After Barye comes another young man whose work pre-
dicts a successful future; I am speaking of M. Étex and his
Cain. This group carries the stamp of its generous concep-
tion; its imposing unity attracts one immediately. Cain
has been cursed by God and is bowed by the weight of
that terrible sentence. Seated on a rock, he drops his head;
deadly sadness is strongly marked on all his features. His
wife is kneeling on his left, resting her head on his thigh,
holding an infant at her breast; she is desolate, but patient
and faithful. Cain's whole family has cursed and aban-
doned him, except this woman. His son, leaning against
his right shoulder, looks at him questioningly. Cain
stretches his hands apart so as not to touch his family and
infect them with the divine curse; he hides the right hand
that committed the murder.

One can see that the underlying conception is grand
and dramatic, and the emotion is equally praiseworthy.
The figure of Cain has large prominent masses and sturdy
limbs; he is just as one would imagine the imperfect man
of those early human races to be. M. Étex's treatment of
the facial expression is profound and energetic. Neither re-
pentance nor anger animates the features of Abel's mur-

derer, but the sense of an overwhelming fate; he has been brought low, he has just said to the Lord: "My iniquity is too great to be pardoned." The woman is posed naturally; her body is modeled with feeling and authenticity. Look at this group from every side—from the front, from the back, from the sides: from any angle you are struck by its handsomely unified character, by the large and simple forms. As far as I am concerned, this work seems to be one of the most remarkable pieces exhibited in the last twenty years. It is certainly to be hoped that M. Étex will be able to translate this magnificent group into marble to perfect all its details.

Next to Étex's *Cain* are found two statues by Bra: *Ulysses* and *The Virgin*. Ulysses is seated on the shore of the island of Calypso. Motionless, he seems to meditate and look into the distance; he dreams of Ithaca and sorrows for his homeland. His head is of a handsome type, of sad and lofty expression. The Christ with the Virgin is shown receiving divine revelations; the inspiration ruffles his hair, swells and agitates his brow; his gaze is absorbed in his internal meditation. Its religious expression makes this head beautiful. There is another statue by Bra, that of *Benjamin Constant*, in which brilliant qualities are to be noted. The head particularly keeps that mark of intelligence, of the fermentation of ideas, which characterized Benjamin Constant's last moments. All Bra's works stand out because they deal with great concepts and are handled with lofty inspiration; but he is generally criticized because his execution lacks vitality and accuracy. Let us hope that he will not delay in producing a work that will prove the power of his chisel, of his feeling for flesh and form.

. . . Sculpture is a monumental art, an art whose particular and firmly defined characteristics do not lend it to the treatment of vulgar or shabby ideas, of formless or hideously sketched subjects. A disorganized and willfully contorted execution is more obviously offensive in sculpture than in poetry, painting or music. In antiquity, sculpture was called the art of the gods and heroes, that is to

say, the art of solemn actions and serious beliefs. It was
charged with depicting for everyone the highest human
ideals, with exalting a people's imagination by sublime cre-
ations inspired by their history, religion and customs! If
the sculpture of the Middle Ages happened to show us
ugly and misshapen creatures, like the bizarre and horrible
monsters that you see in the voussoir of the portal of
Notre Dame de Paris, still it obeyed, despite itself, a belief
in a necessity to depict religious and popular ideas. The
use of the ugly and the deformed in the arts has no other
rationale or excuse. But the theories developed recently
and dogmatically formulated by Victor Hugo have tended
to make the treatment of the ugly and the grotesque a ne-
cessity and a principle that should be found in every art-
ist's work. However, I believe that such theories will col-
lapse when they are applied to sculpture. I cannot
conceive of a great work of sculpture depicting only moral
or physical deformities like Han d'Islande, Quasimodo or
Triboulet, et cetera.

We feel compelled to warn against the dangerous
influence of this literature on sculpture, not only for love
of the medium itself, but also in the interest of those
young people whose talents, feelings and vitality of execu-
tion we have seen dissipated in the wrong direction. This
is why we have been severely critical of MM. Préault and
du Seigneur. Energy and animation are found in their
medallions, but there are also exaggerated features and a
singular predilection for the grotesque. This love of the
grotesque spoiled for us M. Préault's splendid notion of
depicting *Gilbert's Death in the Hospital*. What subject
could be more touching or more dramatic, more worthy of
all the feeling and patience of an artist! What a head to
carve! That poor young poet abandoned, disdained, suc-
cumbing to the weight of his unrecognized genius, whose
face, shrunken by misery and sorrow, should express both
bitterness and despair! O Monsieur Préault! Please take a
little inspiration from the beautiful pages of Alfred de
Vigny's *Stello* and re-do your Gilbert for the next exhibi-
tion; spend a year if necessary and give us a masterpiece.

Quasimodo and Esmeralda by du Seigneur is another proof of the falseness of the direction along which sculpture is led by M. Victor Hugo's works. What can art gain by presenting us with a monster—bandy-legged, hunchbacked and one-eyed? What strong influence can such a creation have on the public? Artists are not the only ones at fault here: [We must also look to] those in society for whom the artists are obliged to carve or paint for a living. More than any other art, sculpture needs to encounter an energetic and widespread social impetus, to be a part of the vast movements of a powerful and active civilization. It needs to confront independent and unique individuals with noble and altruistic mien, who carry the mark of a great soul, the evidence of strength and intelligence: in a word, it needs heroes. But I beg of you, look around and show me heroes among all these honest and peaceful bourgeois who are the only ones today possessing the means of inspiring and enriching artists. Only one man has been able to make a unique and original portrait of a contemporary bourgeois. It was possible because he envisaged his subject as the most eminent representative of his class, because he endowed him with the most outstanding and the least vulgar characteristics personified in that class. Thus we have the portrait of *Monsieur Bertin* by M. Ingres, but I would defy M. Ingres to create a second of equal strength with any other model taken from the same circle. . . .

Gustave Planche, "The French School at the Salon of 1834"[1]

This year's Salon is more important than last year's and except for Léopold Robert—who missed the roll call and has not yet completed his Italian epic of which the last canto, *The Harvesters*, was so magnificent and rich—all

[1] [Translated from *Revue des deux mondes*, Vol. 2, Paris, 1834, pp. 47–54, 56–60, 62, 70, 76–81, 85–86.]

the original or renewed diversities of French thought are now present in the Louvre. The work of Robert we were expecting was to have been a Venetian scene. Is the work unfinished? Or, as is said, did the author regret the imperfections of his canvas just as he was sending it, and does he want to go over his first work to make it more complete and pure? Whatever the explanation for this noticeable absence, we can very well understand M. Robert's delay or scruples: after *The Harvesters* he must go forward, not backward.

M. Ingres, so long awaited, appeared this time. M. Delaroche, whom we hadn't seen since his *Cromwell Opening the Coffin of Charles I*, has given us his *Execution of Lady Jane Grey*. M. Eugène Delacroix is finally showing us a fragment of his trip in Africa.[2] An unfortunate accident has deprived us of the landscape which M. Charles de Laberge intended for this year's Salon; but last year, in his second work, he indicated his style clearly enough to mark his place in the ranks of competitors.

There are no debutantes. Several advanced talents have revealed a new aspect of their power, but we have no glorious baptism of a previously unknown name to note. We have several downfalls to mention, and no occasion to proclaim any new kings.

To several serious minds M. Ingres's painting appears to be the subject of inexhaustible controversy, but no one I know foresees in this work, so diversely judged, the immediate future of French painting. Whatever popular success *The Martyrdom of St. Symphorian*[3] may have, the event is only of slight importance to the personal glory of the painter and does not promise to engage public sympathy. Is the controversy as obscure as it is claimed to be? I don't think so. The question raised by M. Ingres is posed today in the same terms as last year, and last year it was the same as in 1827.

[2] [Delacroix was part of a diplomatic mission sent by Louis Philippe to Morocco from January to July 1832.]

[3] [Commissioned in 1824 for the altarpiece of the cathedral of Autun, the *Martyrdom* took Ingres ten years to complete.]

If *The Martyrdom of St. Symphorian* differs in several respects from *The Apotheosis of Homer*, it must at least be recognized that the general will which has presided over these two works has not contradicted itself in a seven-year span. The diversity of the two subjects alone does not account for the apparent variations in the author's style. What has happened in painting for the last seven years inevitably had to awaken new ambitions and a more ardent thirst for popularity, which M. Ingres lacked until now. Without abandoning either the project of Raphaelesque renovation which he has pursued for twenty years or the habitual round of his studies, he has naturally been led to look for qualities little developed in his technique up to now which could surprise and hold attention; it is in this way that I account for the singular accent which he has given to his drawing.

The general color of the painting is dull, lusterless, and not terribly engaging; the blue and red portions are at first glance harsh and loud. We think that there are colorists far superior to Raphael among the Spanish and Flemish masters—that is why we do not advise anyone to study Raphael with the intention of reproducing his color—and we also believe that this time M. Ingres is far from having achieved the general harmony that was never lacking in the painter of the Loggias.[4]

What should be studied in this famous master—and what will provide even the most distant generations to come with eternal admiration and will continually stir up competition and verve in young artists—is the linear beauty, the divinity of the contours. Now, are these noble merits found in *The Martyrdom of St. Symphorian?* If one excludes the principal actor and a child placed to the left, who resemble too closely several of the master's figures, is there not an exaggeration, an emphatic vigor in the design of most of the personages which resembles Michelangelo and Domenichino to a slight extent? The lictor's muscular physique, viewed from the back, is much too detailed; the anatomy of the legs, in particular, is so

4 [Raphael painted the Loggias in the Vatican.]

extremely precise that statuary would scarcely dare to ven-
ture into similar revelations. As for the lictor on the right,
his muscular energy seems to defy even the most singular
boldness of Rubens; that which is acceptable when
painted with vivid and true color astonishes without
charming in the range of alternating gray or yellow tone
scales that M. Ingres has chosen. Abstract form, form
without color, needs to be harmonious and pure; the lictor
on the right does not satisfy these conditions.

Does this mean, however, that there are not several
figures of remarkable merit in this composition? Of course
not. The martyr himself is a very noble piece of
work. . . .

Paul Delaroche's *Execution of Lady Jane Grey*, without
representing real progress in his technique, as some hold,
nonetheless literally sums up all the undeniable qualities
and all the equally evident faults that he has revealed up
to now. The painting of the masses is less heavy than in
The Death of President Duranti; the gestures are more
distinct than in *Cromwell Opening the Coffin of Charles
I*; the color is less violent than in *The Children of Edward
IV*; the limbs of the principal figure are articulated better
than in *The Death of Queen Elizabeth*; nothing in *The
Execution of Lady Jane Grey* is so precocious or awkward
as in *Cardinal Mazarin on his Deathbed* or *Cardinal
Richelieu on the Rhone*. Is this to say, however, that *Jane
Grey* marks a brilliant advance in the art of the painter? It
is true that several mechanical details of execution have
been improved: one cannot, without doing injustice, fail
to recognize a greater application of the brush. But viewed
from the consideration of the rapport of poetic composi-
tion, pictorial interpretation and absolute originality in
lines and figures, I do not think that M. Delaroche has
progressed much this year.

The public readily admires Jane Grey's pose. It admires
the cautiousness of the hands, the sickly whiteness of the
shoulders; there is nothing that is not approved of by in-
terested viewers, even down to the left knee, resting alone
on the pillow. I note with care this singularity of popular

opinion because it is related to similar singularities in public taste with regard to music and poetry. It is clear that the painter, in order to interest us in Mary Tudor's victim, has purposely exaggerated her pallor and frailty. Undoubtedly this is the reason he showed only one knee instead of two and obliterated the relief of the arms to the point of making the contours almost entirely disappear; he used the same technique in the neck, chest and shoulders. Was he right in doing so? The Jane Grey we know through history would read texts of Plato while the court was out hunting and was one of the most knowledgeable and pious persons of her century; did she indeed die in this way, stumbling in her last hours like an ordinary woman? Are not her resignation and courage at the moment of her agony proverbially known? In M. Paul Delaroche's canvas the movement of her hands and the position of her head not only fail to express the courage that I would like to see, but also do not even betray the fear that the painter wanted to attribute to the principal figure. . . .

Does his composition, which does not seem good to me, at least have the merit of originality? Either one is terribly mistaken or one must decide it does not. In the illustrations of David Hume there is a sketch by Opie, engraved by Skelton and published in 1795 by Bowyr, Pall Mall, which represents the death of Mary Stuart. . . . Now I ask, is there not a striking analogy between Opie's work and that of M. Paul Delaroche? I would be reluctant to imply imitation after a thirty-nine-year interval if French painting did not already have unfavorable precedents for it. M. Delaroche's *Death of Queen Elizabeth,* which in 1827 enjoyed such a brilliant success, was only the literal reproduction of a drawing by R. Smirke, engraved in London by Neagle and published by the same Bowyr. M. Paul Delaroche only took the trouble to turn the figures around, as one ordinarily does when one engraves a picture. I do not pretend to generalize about the two examples but leave it to the scholars to discover the calligraphic origins of the master's other compositions,

if these origins exist somewhere. I stick to what I know and will not take the trouble to complete my information.

Despite all these criticisms, M. Paul Delaroche's *Execution of Lady Jane Grey* threatens to be the greatest success of this year's Salon. His entirely new figures are pleasing to most eyes. The quiet daintiness of the accessories and the shimmering colors—which, without being true and pure, at least have refinement and abundance to their credit—win an approval whose sense and cause are not difficult to recognize. As for the absent poetry, the public is not the least bit concerned; it isn't bothered at all that M. Paul Delaroche's *Jane Grey* is more theatrical than dramatic. The crowd which fills the galleries of France rarely judges by itself; it relies voluntarily on several skillful commentators. The latter eagerly seize the occasion to interpret vague physiognomies or uncertain gestures of any canvas they have before their eyes; they treat incomplete paintings as Italian singers treat second-rate music, with a marked partiality. . . .

The Battle of Nancy of M. Eugène Delacroix did not fulfill all our hopes. Despite several beautiful parts that here and there reveal the touch of an eminent artist, I cannot be pleased with this composition. . . .

But the major fault of this painting is that the terrain, the snow, the sky and the figures have been excessively worked over without being brought to a definitive and satisfying end. Evidently this canvas has often been left, taken up again, forgotten, and finally continued when the artist no longer enjoyed his work. It is not only that linear and poetic unity are lacking to the spectator's glance and thought, but even after an attentive examination, one still finds that even unity of tone and unity of paint are missing. It is obvious that in the course of this work, begun five years ago, the painter's technique changed several times, and that these frequent contradictions could not be reconciled in the final product. . . .

[The criticisms of the *Interior of a Dominican Convent*, *A Street of Mequinez* and the *Portrait of Rabelais* are omitted.]

It has been necessary for me to speak of all these works with a disinterested severity in order conscientiously to praise *Women of Algiers* with greater pleasure and more complete security. This important piece of work, which is of interest only by merit of its painting and is in no way connected with the literary nonsense of sometime art-gapers or the sentimentality of frivolous women, marks a grave moment in the intellectual life of M. Delacroix. It will soon be ten years that, year in and year out, he has sought the revival and regeneration of painting such as he conceives it. *The Bark of Dante and Virgil, The Massacre at Chios, Death of Sardanapalus, Liberty Leading the People* have signaled, with diverse chances of glory and success, his laborious mental efforts. If I except the first and the last of the works I have just cited, it does not seem to me that any of them have realized Delacroix's intentions and desires so closely as has the *Women of Algiers*.

The figures and the background of this painting have magnificent richness and harmony. Everywhere the color is vivid and pure; nowhere is it crude or abrupt. The postures are full of softness and nonchalance; the heads are fine and delicate. I especially admire the figure of the woman on the left in a mysterious shadow; her clothing is well arranged. I am grateful to the painter for having spared us the black fingernails of the peasant women; this is a detail that painting can very well do without. I regret that in the second figure on the left the right arm is too short and the left arm too long; it is an error that can easily be remedied, but one that stands out as a flaw in the general success of this composition.

This painting, in my opinion, is the most brilliant triumph that M. Delacroix has ever achieved. To interest by the art of painting itself reduced to its own resources, without the aid of a subject that can be interpreted in a thousand ways and too often distracts the eye of superficial viewers who, occupied only with their own thoughts, value a painting according to their dreams and conjectures, this is a difficult undertaking, and M. Delacroix has succeeded in it. In 1831, when he skillfully

framed historic reality into allegory, his artistic power did
not affect merely curious souls. His street urchin, gaunt
and bold, crossing the bloody barricades joyously to place
himself before the musket fire, and following with spar-
kling eyes his young rigid-breasted Liberty, the furious
Misery, stumbling over the cadaver of a soldier, these were
elements of interest and sympathy almost independent of
the painting itself. Here imagination conspicuously aided
the skill of the brush. In *Women of Algiers*, there is noth-
ing of this sort; it is painting and nothing more, fresh,
vigorous painting, energetically defined, with a Venetian
boldness which, however, has nothing to teach the masters
it resembles. I don't hesitate to say it, I think that this
time the painter has discovered a broad and fertile style,
which he can continue for a long time, and which, I hope,
will be able to give us numerous works. With the help of
encouragement he has the right to claim a chapel to dec-
orate, or a palace to reclothe with lively figures and
animated scenes. I am sure that the industrious artist to
whom we owe so many diverse and patiently invented
pages will, before looking for a new style, await the glori-
ous exhaustion of this one that he has just found.

Three years ago the paintings of M. Decamps stimu-
lated a general enthusiasm. One thought that the best pe-
riod of the Flemish school had returned; nothing in
Rembrandt's work could be found that was richer or more
accentuated than the scenes of the Orient with which the
author had filled his portfolios, from which he would de-
tach a leaf each day for our pleasure and admiration. Al-
though everyone acknowledged his prestige as a colorist,
his striking accuracy in details, few people suspected his
gift of imagination or greatness of thought. His *Battle of
Marius Against the Cimbri* victoriously refutes negation
and doubt. I hardly think it necessary to talk about *The
Interior of a Guardhouse* on the road from Smyrna to
Magnesia, whose figures are so real, whose costumes are so
brilliant, and in which all the actors are individual and
precise, created and rendered with a supreme skill. I
hardly think it useful to insist on the warm, translucent

tone, in which the eye discerns camels and camel drivers on the left of the canvas. Need I speak of an exquisite water color in which some young bathers reveal forms to the astonished eye that one did not expect from the brush of Decamps, or of [a painting of] the reading of a firman in which all heads are so attentive and so meditative?

No, this year Decamps is entirely in his glory. It is in his *Marius* that we must study all the richness of his palette, all the resources of his imagination. The landscape is immense, the crowd is numberless, the combat desperate and bloody, the disorder furious and hopeless. One understands that it is not a question of the fortune of one day but of the ruin of a nation. . . .

From this year forward, Decamps has won a new place in the French school; he has taken his place among first-rate inventors, without losing anything in this glorious metamorphosis of the candor and naïveté of his painting. One month ago he was a talent of exquisite delicacy; today he is a serious master. . . .

Among the three landscapes by M. Paul Huet, the one I prefer is *View of the Vicinity of Honfleur*. The *View of the Castle of Eu* and the *General View of Avignon* do not please me as much. In the foreground of *View of Avignon* there are several masses that are very skillfully treated; the earth and the walls are of an excellent substance, but the silhouette of these foreground scenes is not successful. In spite of the skillful combination of colors distributed in the foreground of the canvas, the eye is far from being satisfied and searches endlessly for something it cannot find: I refer to linear harmony, without which there is no pictorial composition. . . .

What is laudable in M. Pradier's group [*The Satyr and Bacchante*] is his marvelous interpretation of antiquity. Evidently the artist sees only one type of elegance and beauty in the masterpieces of our museums, which he sets about reviving more through the study of nature than by literal reproduction. I do not think that this is the truest or most successful course. I do not think that the most beautiful works should stimulate in the artist's soul any-

thing other than emulation and enthusiasm. I do not think that it is necessary, in the creation of a group of paintings, ever to be preoccupied with lines and drawings that one has seen elsewhere. One must learn from the ancients the grace and harmony that they possessed to a high degree, but one must not lose sight of the goal that they so gloriously touched upon, following a personal and original path in the attempt to attain it.

What is lacking in M. Pradier's works, and in particular in his group this year, is imagination. He depicts quite admirably a torso, a limb; he rivals the most accomplished ancients in certain parts of his works. But his work lacks continuity and logic. Next to a fragment depicted in the restrained method of the ancients, next to a shoulder learnedly interpreted in the tradition of Greek art, one finds an arm that is good by its own merit, that he took pleasure in copying in detail directly from nature. This adulterous confusion of systematic beauty and real nature takes away from his works the harmony and unity that burst forth so powerfully in the products of the ancient art.

This is why M. Pradier, who, by his learned execution, takes his place in the highest ranks, is well below the models that he has sent up and wants to resemble.

It is to be greatly regretted that M. David d'Angers has sent only two busts [of *Cuvier* and *Paganini*] to the Louvre this year, a medallion and a statue of St. Cecilia. I would like to have seen exhibited publicly the model of the *Philopoemen* that will take its place in the Tuileries, the model of the bas-relief destined for the arch of Marseille, and also the portraits of Béranger, Sieyès, Merlin de Douai and Grégoire. Greece will soon have a statue of a young girl trying to read the names of Marcos Botzaris on a tombstone. Why didn't all this come to the Louvre? It is not enough merely to let a few élite friends or several privileged curious people see his work. M. David owes it to himself to exhibit, whenever the occasion presents itself, the works with which he decorates France, and which will go across the seas never to return. His *Jefferson* is now in Philadelphia. In several days his *Young Greek Girl* will

leave in the care of Prince Soutzo. Fortunately, the works
that we have this year in the Louvre can provide the means
to imagine the works we lack. *Béranger, Sieyès* and *Merlin*
seem to me to be far superior to *Cuvier* and *Paganini*. But
the medallion of Casimir Périer can be compared to
David's best portraits. In this figure I can easily sense a
will overriding intelligence and pent-up anger, which
comprised the essence of the model's character. The
enshrining of the eye, which seems to regard the enemy
and calculate the danger, the wrinkles on the lips, tight
and compressed, a manifest sign of an obstinate will that
fumes at an obstacle but does not allow itself to be beaten
by it, the unhealthy tension in the nostrils: everything in
this pensive and suffering physiognomy reveals the interior
turmoil that in several months devoured the man whom
the tribune had spared for fifteen years. . . .

The *St. Cecilia* is gracious, young and meditative, but
she is too timid to be inspired. The shape of the head is
good, but it is not the head of St. Cecilia. As for the dra-
pery, it is a wise compromise, but unacceptable, in my
opinion, for ancient, Renaissance or Gothic sculpture.
Thus, in certain parts, the nude can be seen under the
drapery, as in ancient sculpture; elsewhere, the drapery, in
love with itself, undulates and frolics around without
bothering to convey anything, as in Renaissance art; else-
where, the drapery twines around the nude without in-
terpreting it and without exposing the harmonious lines,
as one sees in the statues that adorn cathedrals; it is a ca-
pable piece of work, but not one of David's best. . . .

The bronzes sent by M. Barye show us in a more exqui-
site form the groups of animals of last year's Salon. Bronze
is decidedly the medium best suited to this artist's style.
His handsome lion of last year should have been cast and
not sculpted. It must be said, to the shame of the public
(and I myself am no longer able to doubt it, though I
blush to admit it), that there is among the spectators such
a profound carelessness that I have heard them confuse
the admirable works of Barye with the formless, lineless
masses, lacking in any apparent individuality, signed by

the name of M. Fratin. A lot of good it does to be a first-rate artist and to see oneself swallowed up in the same category with the most unskilled practitioners! To be Corneille, yet called a Mairet![5] To be a Landseer or Barye, but called Fratin! . . .

I hesitated a long time before believing the testimony of my eyes in reading at the base of a bust of Rossini the name of the singularly famous Florentine sculptor, Bartolini. . . . Is it indeed there that one finds all that is behind the name of Bartolini, this name so praised by the tourists, so glorious in Byron's journal? Byron, it is true, judged statuary a bit as Napoleon did music, that is to say, very poorly. But he willingly repeated the opinion of others in matters about which he was ignorant. There was a crowd in Italy who admired Bartolini, and look what he has sent us. The Florentine bust could be teamed with M. Brulow's canvas.

The newspapers of Milan made a success of *The Destruction of Pompeii* [by Brulow], which gained acceptance in all the capitals of Europe. Today we have the masterpiece, and we lack the courage to scoff at it; for impotence and mediocrity deserve something other than derision. . . .

If, from this rapid account of the principal works sent to the Louvre this year, we try to proceed to the general ideas which dominate French art, or rather which share and divide it, here is what we will find at the end of our studies. Three distinct principles are present in the French school: Renovation, Conciliation and Imagination; that is to say that minds break up into three separate camps: one, which stays up night and day trying to recapture the ideal purity of the sixteenth-century Italian masters; another, which hesitates between the present and the past, and would like to reconcile all European schools in one restrained and innocuous style; and finally the third, which takes the past for what it is worth, for an education, and

[5] [Jean Mairet (1604–86), dramatist, author of the pastoral comedies *Sylvie* (1626) and *La Sylvanire* (1630), was generally credited with having introduced the classical unities to French drama.]

which wants to continue by laying it as a foundation for a new future. The leader of the first camp is M. Ingres; the leader of the second is M. Delaroche, the command of the third is gloriously shared by MM. Delacroix, Decamps and Paul Huet.

In sculpture, the same principles are formulated in almost the same terms by MM. Cortot, Pradier, David [d'Angers] and Barye. M. Cortot wants renovation of Roman statuary in the way M. Ingres wants the revival of Raphael; M. Pradier wants the conciliation of Greek art with the modern world, as M. Paul Delaroche hopes for the alliance and union of the illustrious masters, whoever they are, with nature, which he tries to copy; finally, MM. David [d'Angers] and Barye, each taking a personal route, contrast innovation with renovation, as do MM. Delacroix and Decamps. The pictorial and sculptural question thus posed, the equation of the historical problem being formulated in these terms, it does not seem to me to be difficult to determine the *unknown*. There is no need to put the terms of the equation through numerous transformations to be able to show that the future does, and can only, belong to innovation, i.e., to persevering and fertile thought that sees in past centuries only food for thought.

In Art, no more than in Religion, Law or Society, can history repeat. What has been, had its reasons for being, and no longer has them.

In Art, as in Law, Religion or Society, it is madness to want to reconcile and confuse in one intimate union the budding ideas of different ages and diverse countries.

In Art, as in Law, Religion and Society, it is necessary to consult the needs of one's times in order to satisfy them; one must create monuments, statues, symphonies, paintings and poems according to the public wish, just as one must found institutions and dogmas according to the inner state of mind of their intellects and society.

This is why, without wishing to contest the influence and perseverance revealed by the first two principles, we do not think they have a claim on the future. The future

will be the exclusive domain of Imagination. If it were different, then the future would not *be*, for it would absorb itself entirely in the past and continue it without expanding it.

LONDON: The Exhibition
of a Semi-Official Society

Art events were prominent in London's social life in the late 1830s. The last Royal Academy exhibition in Somerset House, between the Thames and the Strand, was held in 1836. In 1837, William IV, who had followed George IV to the throne in 1830, inaugurated the Royal Academy rooms in the east wing of the new National Gallery. The following year his successor, lovely eighteen-year-old Victoria, opened the new National Gallery itself.

Drawn by the exhibitions as much as by the visits of royalty, Londoners flocked to the building, located on "the finest site in London," the recently completed Trafalgar Square designed by John Nash. Visitors crowded into the National Gallery on Mondays especially, when admission was free. On May 1, the traditional opening date of the Royal Academy exhibition, they hurried to the East Gallery, where the Hanging Committee placed the paintings it considered exceptional, and noted eagerly which artists had been further honored by having work placed "on the line" marked by a ledge about eight feet from the floor.

The Royal Academy's new location, built at government expense, indicated Parliament's continued support for the institution despite attacks on the Academy. Though it was not directly supported by the British government, the Royal Academy enjoyed a pre-eminent position in Britain. The choices of the Academy's committee, a rotating body of twelve on which all academicians eventually served, determined the "accepted" style of art and provided an artist's initial entrée into the Academy: Royal Academy associates were chosen from exhibitors and academicians

elected from associates. The annual exhibition was also important for sales: after the queen's visit, a private view was held for people of taste and wealth.

Between 1816 and 1820 the Academy and its exhibitions had been criticized, chiefly by Benjamin Haydon, in the reviews of the *Annals of the Fine Arts*. Support had been mounted by the *Somerset House Gazette*, edited by William Henry Pyne. In 1823 the Society of British Artists had been founded in order to exhibit more realistic paintings than those admitted to the Royal Academy's exhibitions. More recently, in the wake of the Reform Act of 1832, which had reorganized Parliament and given seats to industrialists in the new northern cities, radicals in the reformed Parliament had, through the Select Committee on Arts and Manufactures of 1835, questioned the Royal Academy's "monopoly" of patronage and the government's financing of a building at public expense for a financially independent institution. The committee's inquiry into the "state of the higher branches of Art and the best mode of advancing them" did not affect the Royal Academy's status, largely because more pressing matters occupied the government. There was continuing agitation for social and economic reforms; the invention of the steam railway engine in 1830 had introduced the railroad age; the Houses of Parliament had burned in 1834.

The increasingly affluent middle classes who flocked to the National Gallery's east wing in the late thirties were not interested in large-scale paintings of heroic themes from obscure classical sources. They decorated their town houses or suburban villas with small landscape and genre paintings. They bought "Keepsakes" or "Books of Beauty" (albums of prints depicting feminine charms) and appreciated paintings and prints illustrating familiar episodes from literature and history.

Newspapers and magazines with general or literary interest added an art editor or recruited an established writer to cover Royal Academy exhibitions and other exhibits by the Water Colour Society, the Society of British Artists and the British Institution. Because of their large circula-

tions—a successful periodical needed six thousand readers to survive—the newspapers' reviews determined the success of an artist and contributed to the creation of opinion or the continuation of certain preferences in all the arts. No art journals, though increasing in number, had an influence on the general public comparable to that exercised by a newspaper like the *Times*, with its three million subscribers, or such general magazines as the *New Monthly Magazine* (for which Stendhal wrote), the *London Magazine*, the *Athenaeum*, the *Literary Gazette*, the *Examiner*, a weekly, the *Quarterly Review*, *Blackwood's Edinburgh Monthly Magazine* or *Fraser's Magazine*. Their reviewers, sometimes trained in painting but unschooled in principles of formal aesthetics, couched their evaluations and descriptions of what they saw in literary terms. The words "composition," "color," "design" and "expression" lacked precise conceptual connotations for them but served in descriptions. Supported by Hogarth, Burke and even Reynolds, reviewers gave emotion an important place in their critical judgments. They were most at ease when reporting on genre, landscape and portraits, for their interest, and that of the reader, was in the subject of a painting or statue and its truth to nature and its literary or historical source. The aesthetic basis for their criticism was the principle of *ut pictoria poesis*, persistent in England (see 1808: LONDON, Landseer on Turner), and Archibald Alison's Associationism theory, which required the work of art to kindle the imagination to "a play of fancy." "Taste," which became a synonym for critical judgment, consisted of the ability to discern and appreciate beauty; theorizing interrupted the train of agreeable ideas aroused by objects associated with emotions.

The *Edinburgh Monthly Magazine*, founded by William Blackwood in 1817 and known by his name, attracted excellent writers of serial novels by its high rates of pay and soon was an influential magazine. Its review of the Royal Academy exhibition of 1836, unsigned, in keeping with the policy of the "Maga," as Blackwood's came to be called, was by the Rev. John Eagles, a principal con-

tributor on art and nature after 1831. Eagles, a Scotsman, had been trained as an artist, taking a special interest in landscape, but after he failed to win membership in the Water Colour Society he took orders and was appointed a curate.

Constable would not have seen Eagles' severe criticism, for he saw no newspaper, "not allowing one to come into my house." Of the picture he exhibited, *Cenotaph to the Memory of Sir Joshua Reynolds,* he wrote on May 12 to George Constable (not a relative), "I got up a tolerably good picture for the Academy, not the 'Mill', . . . I found I could not do both; and so I preferred to see Sir Joshua Reynolds' name and Sir George Beaumont's once more in the catalogue, for the last time at the old house."[1] Constable was preparing his last lecture on landscape painting for the Literary and Scientific Institution at Hampstead during that summer. He had been admitted to the Academy only nine years before when he was fifty-two. He died suddenly ten months after the exhibition of 1836, on March 31, 1837, and under the rules of the Royal Academy the last time a picture by him could be exhibited was in 1837.

Eagles' criticism of Turner roused one of Blackwood's readers, seventeen-year-old John Ruskin, to draft a defense of the artist. It was never published—Turner, to whom it was sent, answered, "I never move in these matters"—but it contained the germ of the aesthetic ideas Ruskin developed in his influential *Modern Painters* (1843).

The review of the Royal Academy exhibition of 1838 which appeared in the provocative and illustrated *Fraser's Magazine* was signed Michael Angelo Titmarsh, one of the many pen names used by William Makepeace Thackeray after he took up the socially "unacceptable" profession of free-lance journalism. Thackeray, born in Calcutta, had been sent to England at the age of five. He received the usual education of a young gentleman and disliked most of it. By nature a keen observer, he was drawn to journalism and contributed to the *Snob* while at Cam-

[1] [C. R. Leslie, *Memoirs of the Life of John Constable* (London: Phaidon Press, 1951), p. 254.]

bridge. He left before graduating. After spending six months of 1830 studying German at the Weimar court, still dominated by Goethe, Thackeray returned to England to study law but gave up his studies to purchase the *National Standard*, a weekly paper. The paper failed after six months. Thackeray, who possessed a natural facility for drawing, then studied art in Paris until the loss of his inherited income brought him back to London. There he resumed his studies with Henry Sass, who prepared artists for admission to the Royal Academy schools. Common interests brought Thackeray the friendship of Daniel Maclise, George Cattermole, John F. Lewis, Frank Stone and George Cruikshank, who had once been Thackeray's teacher. As the correspondent of his stepfather's paper, the *Constitutional*, Thackeray returned to Paris, married, and continued his art studies, copying in the Louvre and drawing at the Life Academy. When the *Constitutional* failed in the general depression of 1837 and 1838, Thackeray, once more in London, was obliged to seek assignments. William Magnin, editor of *Fraser's Magazine*, gave him the review of an etiquette book in October 1837, and Thackeray assumed the pseudonym Charles James Yellowplush. *The Yellowplush Papers* became a popular fictional serial in 1837 and 1838, and in 1838 Yellowplush was joined by Michael Angelo Titmarsh, art reviewer and travel reporter. Titmarsh's jocular familiarity made his readers allies in the ridicule of the pompous humbug of High Art. While the style annoyed some of the "Ministerial and Lordly patrons of the Academicians and the Associates expectant," it corresponded to that of *Fraser's Magazine*, noted since its founding in 1830 for its "bold slapdash" yet serious comment on current events. The personal preferences of Titmarsh/Thackeray indicate the current drift of taste and the direction English art was to take under the reign of Victoria.

Titmarsh continued to serve *Fraser's* as an art reviewer and travel reporter until 1845, but Thackeray's art criticism was not limited to these articles. In 1841 he published *The Paris Sketch Book*, a group of articles written

during his years in Paris including "The French School of Painting" and "Caricatures and Lithography in Paris." He wrote for the *Westminster Review* in June 1840 a review of the work of George Cruikshank and for the *Quarterly Review* in December 1854 an appraisal of another friend and associate, "John Leech's Pictures of Life and Character."

Thackeray disapproved of most London critics, who "in daily, weekly, monthly prints protrude their nonsense upon the town. What are these men? Are they educated to be painters? —No! Have they a taste for painting?—No! I know of newspapers in this town, gentlemen, which send their reporters indifferently to a police office or a picture gallery, and expect them to describe a Correggio or a fire in Fleet Street with equal fidelity."[2]

Thackeray's first paid appearance under his own name was in *Bentley's Miscellany* in 1837 at the same time the magazine was publishing Charles Dickens' anecdotal novel, *Oliver Twist*. Dickens believed this description of the wretchedness of "the laboring class in all the squalid poverty of their lives would be a service to society." Thackeray found Dickens' work absurd and unreal, for Thackery was not, as Dickens was, a moralist examining social conditions; he was a journalist observing society's manners.

After *Punch, the London Charivari*, was established in 1841, Thackeray made occasional contributions to it until he became a regular contributor in 1844. His ridicule of the absurdities of contemporary society's foibles, particularly *The Book of Snobs*, contributed to the magazine's popularity. His parodies in the series "Punch's Prize Novelists," *A Legend of the Rhine* (1845), and *Rebecca and Rowena* (1850), burlesques of the literary themes made popular by Scott and Dumas, did much to shatter the romance of knighthood.

By 1851 the success of *Vanity Fair, A Novel without a*

[2] ["Introductory Letter to Mr. Yorke," *Fraser's Magazine*, June 1840, *The Works of William Makepeace Thackeray* (Boston: Houghton Mifflin, 1889), Vol. XXII, p. 140.]

Hero, begun in 1845, enabled Thackeray to give up free-lance journalism. It was followed by other novels, *Pendennis* (1848–50), *Henry Esmond* (1852), and *The Newcomes* (1853–55). The latter, depicting the position of the artist in English society, was based on his experiences in the studio of Henry Sass.

Throughout his career, in both his early criticism and the later novels, Thackeray's trained artist's eye saw reality accurately. His vision was refracted neither by aesthetic nor social theories; as Thackeray himself said, "I have no head above my eyes."

Rev. John Eagles: "The catalogue of the Somerset House Exhibition is now lying on our table . . ."[1]

The catalogue of the Somerset House [Royal Academy] Exhibition is now lying on our table, and we make no apology for offering a few of the notes we made while the pictures were before us. The first on the list is No. 8, *Gathering Sea-weed,* F. R. Lee, A. It is too white, of that faulty school which aims at uninterrupted light, which is always disagreeable to the eyes; yet we have seen pictures by this artist that persuade us to believe he sometimes paints against his own taste.

No. 9, *Cenotaph to the memory of Sir Joshua Reynolds, erected in the grounds of Coleroton Hall, Leicestershire, by the late Sir George Beaumont, Bart.,* J. Constable, R.A. If ever a subject required chaste and sober colouring it is this; yet is flickering throughout with impertinent lights, and dots of all colours, utterly ruinous to the sentiment; but lest we should mistake the sentiment intended, the

[1] [Excerpts verbatim from "The British Institution for Promoting the Fine Arts in the United Kingdom, &c.," *Blackwood's Edinburgh Magazine,* October 1836, No. 252, pp. 543, 549, 556. The "&c." refers to the Royal Academy and the Society of British Artists. The appraisal of the role of the British Institution has been omitted.]

painter has added to the description the following lines
from the pen of Wordsworth:

> Ye lime-trees, ranged before this hallow'd urn,
> Shoot forth with lively power at spring's return,
> And be not slow a stately growth to rear,
> Of pillars branching off from year to year;
> Till they have framed a darksome aisle,
> Like a recess within that sacred pile,
> Where Reynolds, midst our country's noblest dead,
> In the last sanctity of fame is laid:
> And worthily within these sacred bounds,
> Th' excelling Painter sleeps—yet here may I
> Unblamed amid my patrimonial grounds,
> Raise the frail tribute to his memory—
> An humble follower of the soothing art
> That he professed—attached to him in heart,
> Admiring, loving—and with grief and pride,
> Feeling what England lost when Reynolds died.
> *Inscribed by Wordsworth, at the request, and in the
> name, of Sir George Beaumont.*

The intention of the poetry is solemn, sepulchral; the
lime-trees planted by friendship are to grow, and overarch
as some sacred aisle, fit repository for the dead. If there be
light, it should be the "dim and religious," and that green
and melancholy monumental tree of perpetual repose. But
this is not the picture. We do not say that it is all light—
it may be considered in the Academy a dark picture, but
its darks are interrupted by spots of white, and other
colours, and are not cool and sombre, but brown, and con-
sequently too violent for repose. The picture has not a
melancholy sentiment. It is scratchy, and uncomfortable
in execution, painted, it should seem, on a principle of
contrast and interception, ill suited to the subject. We
were recently in some beautiful grounds where the land-
scape-gardener had with great taste formed such an aisle as
the great poet describes; the level path was narrow, and
the stems of two large trees were magnificent pillars, so
near the eye, that they were, as in a cathedral, only seen in

part; not a dot of blue sky was visible through the thick foliage, but the light was all green, and that faintly touching the large trunks was most lovely—it seemed radiating around the mystery of some sacred aisle. Pursuing our walk, we were struck with the variety in the continuation of the one character. Now some such hue should have pervaded this sepulchral subject. We remember last year a picture by Mr. Constable,[2] which we heard generally animadverted upon severely, and we thought justly, for the powdering the artist had bestowed upon it. This picture has the same fault, though in a much less degree. We remark it now, as we verily believe there is no virtue in the dredging box; and as these are the days when imitators out-Herod Herod, we would caution younger artists, in this respect at least, not to outrun the Constable.

No. 339, Landseer's *Mustard, the son of Pepper, given by the late Sir Walter Scott to Sir Francis Chantrey, R.A., &c.* Now, is this an immortal picture, whatever some may think of the subject; it has all the poetry of which it is capable—you see into the character of Mustard as if it had been drawn by Sir Walter himself. It is a life, a perfect reality. Mustard is sitting guard over some woodcocks, to which, under the table, a cat is creeping up. Mustard does not see the thief, but has a knowledge of her presence by an instinct peculiar to his race. There is not a muscle that does not bespeak fidelity. The brilliancy, colour, and execution—all so true to the subject, are quite charming.

No. 22, *Macbeth, and the Weird Sisters. Macready as Macbeth.* J. Maclise, A. We know not how to congratulate the three Macs—Macready, Macbeth, or Maclise. . . .

It is quite painful to come to the next object of our criticism.

No. 73, *Juliet and her Nurse.* J. M. W. Turner, R.A. This is indeed a strange jumble—"confusion worse confounded." It is neither sunlight, moonlight, nor starlight,

2 [*The Valley Farm* was exhibited at the Royal Academy in 1835.]

nor fire-light, though there is an attempt at a display of fireworks in one corner, and we conjecture that these are meant to be stars in the heavens—if so, it is a verification of Hamlet's extravagant madness—

> Doubt that the stars are fire;
> Doubt that the sun doth move;
> Doubt Truth to be a liar;

but with such a Juliet you would certainly doubt "I love." Amidst so many absurdities, we scarcely stop to ask why Juliet and her nurse should be at Venice, thrown higgledy-piggledy together, streaked blue and pink, and thrown into a flour tub. Poor Juliet has been steeped in treacle to make her look sweet, and we feel apprehensive lest the mealy architecture should stick to her petticoat, and flour it. And what is this great modern's view of *Rome from Mount Aventine?* A most unpleasant mixture, wherein white gamboge and raw sienna are, with childish execution, daubed together. But we think the "Hanging Committee" should be *suspended* from their office for admitting his *Mercury and Argus*, No. 102. It is perfectly childish. All blood and chalk. There was not the least occasion for a Mercury to put out Argus's eyes; the horrid glare would have made him shut the whole hundred, and have made Mercury stone blind. Turner reminds us of the story of the man that sold his shadow, and that he might not appear singular, will not let any thing in the world have a shadow to show for love or money. But the worst of it is, there is so great a submission to Turner's admitted genius, that his practice amounts to a persuasion to hosts of imitators to reject shadows, find them where they will. They would let in light to Erebus, and make "darkness" much beyond the "visible" point. Turner has been great, and now when in his vagaries he chooses to be great no longer, he is like the cunning creature, that having lost his tail, persuaded every animal that had one, that it was a useless appendage. He has robbed the sun of his birthright to cast shadows. Whenever Nature shall dispense with them too, and shall make trees like brooms, and this green

earth to alternate between brimstone and white, set off
with brightest blues that no longer shall keep their dis-
tance; when cows shall be made of white paper, and milk-
white figures represent pastoral, and when human eyes
shall be happily gifted with a kaleidoscope power to pat-
ternize all confusion, and shall become ophthalmia proof,
then will Turner be a greater painter than ever the world
yet saw, or that ever the world, constituted as it is at pres-
ent, wishes to see. It is grievous to see genius, that it
might outstrip all others, fly off into mere eccentricities,
where it ought to stand alone, because none to follow it.[3]

No. 96, *Psyche having, after great peril procured the
casket of cosmetics from Proserpine in Hades, lays it at
the feet of Venus, while Cupid pleads in her behalf.* W.
Etty, R.A. There is always something to please in Etty's
works. His Psyche is very beautiful, and we are sure [that]
for her Cupid would not plead in vain; but we fear that
box of cosmetics; it must contain some very potent poison,
for laid at Venus' feet, see how the mischief worked up-
wards, and poor Venus' limbs are immensely swollen. We
thought it had only been among the Hottentots and some
savage Indian tribes that magnitude of limb made beauty
a divinity. His *Venus*, No. 187, is a little too blowzy for
her doves.

No. 195, *Portrait of a Lady in an Italian costume.* C. L.
Eastlake, R.A. This is very happily coloured. Though gay,
it is not glaring in light, as in inferior hands attempts at
gaiety are. There is much natural air, pleasing expression,
and the colouring is in harmony.

No. 225, *Sowing corn.* F. R. Lee, A. In this picture the
artist is inferior to himself. We like not such subjects, but
they should have more pleasing colour for repose to the
eye. We congratulate him on his *Salmon trap*, No. 344,
which has much of the repose of Nature. It is clearly

[3][Constable observed to George Beaumont concerning
Turner: ". . . Turner has outdone himself; he seems to paint
with tinted steam, so evanescent and so airy. The public think
he is laughing at them, and so they laugh at him in return."
Leslie, op. cit., pp. 254–55.]

painted and well coloured, and is perhaps the nearest approach to landscape that we have seen in the Exhibition. . . .

Let us now imagine ourselves in the Suffolk Street Gallery, Pall Mall East [of the Society of British Artists]. Here we have pretty much a repetition of Somerset House. Here perhaps the race of imitators more conspicuously *shine.*

No. 11, *Ancient Jerusalem during the approach of the miraculous darkness which attended the crucifixion.* W. Linton. We see no reason why the darkness should be supposed to proceed out of a furnace. The long quotations in the catalogue to impress an idea of the grandeur and beauty should not be needed—the picture should perform the office—and it is brazen enough to be its own trumpeter. . . .

No. 149, *Christ Raising the Widow's Son.* B. R. Haydon. We are quite at a loss to understand Mr. Haydon. He is either much above or below our taste and comprehension; he must have some unexplained theories of art, for nothing can be more unlike nature, under any form, shape, or colour, than his practice. Here are strange mixtures of red, blue, lamp black, and treacle. The figure raised from the dead should surely appear free from pain, or there is a sad deterioration of a miracle. Here, however, is the expression of fever; the rolling eyeballs and stricken forehead are all indicative of intense pain. The background is strangely coloured, raw blue stained over with dirty colour, as in imitation of old pictures uncleaned, by putting on all one would wish to see cleaned off; and how weak is the principal figure, the Christ—the only miracle appears [to be] that such a hand and arm should support such a heavy leaden cloak. But let us see Mr. Haydon on a classical subject.

No. 221, *Discovery of Achilles, &c.* He must have very strange notions of an Achilles, such as are not to be found in Homer certainly; but the colouring is the most extraordinary on record—never was anything like it; there is nothing like blue and red in his estimation—every shadow

is as red as vermilion-cake can make it—it is all so bloody,
it would shame a butcher. . . .

Is it true that, after Sixty-eight Royal Exhibitions, the
arts have retrograded? We fear it is. It is with vexation we
admit it. Our best painters were before the Royal Acad-
emy. Among the first exhibitors (and certainly there were
many bad enough, but they have easily dropped down into
oblivion) were the giants of English art. These are our
"old masters," and have not only not been excelled in
whatever upholds the dignity of art; but their names stand
upon an eminence that, in our annual retrogression, ap-
pears ascending out of our reach. . . . Oh, why this insen-
sibility to God's most rich, most beautiful, most peaceful,
and most awful works over which he has given us unlim-
ited control and power, if we will but cultivate the genius
bestowed on us, to combine in endless variety, to imitate
his creation, and build up worlds of our own from the
profusion of the materials his great wonders have thrown
around us. There was once a promise in this walk of art,
but it is gone. We recollect, when the first great change in
water colours began with landscape, many very beautiful
and original specimens of English genius. When Turner
was really great; when Havell and Varley felt a love and
passion among the mountains and waters. We have seen
no such beautiful drawings since those days; perhaps there
may be, but that we doubt, some more power over the ma-
terials, but it has left landscape. . . . But from landscape-
painting, as founded by those great Masters, has arisen a
new art, to which the painter has scarcely yet deigned to
hold out the hand of fellowship—landscape-gardening.
The followers of that art are greatly improving, and if we
may speak of their works as pictures, we do not hesitate to
say, that they know more of light and shade, their propor-
tions, relative values, depths and tones, than any of our
modern painters, and often afford us a pleasure that in
vain we look for at Exhibitions.

We are forced to admit that the progress of our painters
has been in the lower departments of art. The great en-
couragement given to portraiture prevents higher efforts,

where they might have been expected. And we are persuaded the faulty practice of some Royal Academicians, whose favour is to be obtained, and whose works are therefore imitated, inflicts the greatest injury on British taste. They have neglected nature, and run into bad systems which they call art. They are at total variance with all that has obtained the admiration of the world in the old masters; and we will determinedly, to the best of our power, expose the errors into which the rising artists may too readily fall. . . .

William Makepeace Thackeray, Excerpts from "A Second Lecture on the Fine Arts, by Michael Angelo Titmarsh, Esquire: The Exhibitions"[1]

Jack Straw's Castle, Hampstead

My dear Bricabrac,

. . . From "Jack Straw's Castle," an hotel on Hampstead's breezy heath, which Keats, Wordsworth, Leigh Hunt, F. W. N. Bayley, and others of our choicest spirits, have often patronized and a heath of which every pool, bramble, furze-bush-with-clothes-hanging-on-it-to-dry, steep, stock, stone, tree, lodging-house, and distant gloomy background of London City, or bright green stretch of sunshiny Hertfordshire meadows, has been depicted by our noble English landscape-painter, Constable, in his own Constabulary way—at "Jack Straw's Castle," I say, where I at this present moment am located (not that it matters in the least, but the world is always interested to know where men of genius are accustomed to disport themselves), I cannot do better than look over the heap of picture-gallery catalogues which I brought with me from Lon-

1 [Written for *Fraser's Magazine*, June 1839. Excerpted from *The Works of William Makepeace Thackeray* (Boston: Houghton Mifflin, 1889), Vol. XXII, pp. 124-33, 138-64, 189-209.]

don, and communicate to you, my friend in Paris, my remarks thereon.

A man with five shillings to spare may at this present moment half kill himself with pleasure in London town, and in the neighborhood of Pall Mall, by going from one picture gallery to another, and examining the beauties and absurdities which are to be found in each. There is first the National Gallery (entrance nothing), in one wing of the little gin-shop of a building so styled near Saint Martin's Church; in another wing is the exhibition of the Royal Academy (entrance, one shilling; catalogue, ditto). After having seen this, you come to the Water-Color Exhibition in Pall Mall East; then to the Gallery in Suffolk Street; and, finally, to the New Water-Color Society in Pall Mall,—a pretty room, which formerly used to be a gambling-house, where many a bout of seven's-the-main, and iced champagne, has been had by the dissipated in former days. All these collections (all the modern ones, that is) deserve to be noticed, and contain a deal of good, bad, and indifferent wares, as is the way with all other institutions in this wicked world.

Commençons donc avec le commencement—with the exhibition of the Royal Academy, which consists, as everybody knows, of thirty-eight knight and esquire Academicians, and nineteen simple and ungenteel Associates, who have not so much as a shabby Mister before their names. I recollect last year facetiously ranging these gentlemen in rank according to what I conceived to be their merits,— King Mulready, Prince Maclise, Lord Landseer, Archbishop Eastlake (according to the best of my memory, for "Jack Straw," strange to say, does not take in *Fraser's Magazine*), and so on. At present, a great number of newcomers, not Associates even, ought to be elevated to these aristocratic dignities; and, perhaps, the order ought to be somewhat changed. There are many more good pictures (here and elsewhere) than there were last year. A great stride has been taken in matters of art, my dear friend. The young painters are stepping forward. Let the old fogies look to it; let the old Academic Olympians beware,

for there are fellows among the rising race who bid fair to oust them from sovereignty. They have not yet arrived at the throne, to be sure, but they are near it. The lads are not so good as the best of the Academicians; but many of the Academicians are infinitely worse than the lads, and are old, stupid, and cannot improve, as the younger and more active painters will.

If you are particularly anxious to know what is the best picture in the room, not the biggest (Sir David Wilkie's is the biggest, and exactly contrary to the best), I must request you to turn your attention to a noble river-piece by J. M. W. Turner, Esquire, R.A., *The Fighting Téméraire*—as grand a painting as ever figured on the walls of any Academy, or came from the easel of any painter. The old *Téméraire* is dragged to her last home by a little, spiteful, diabolical steamer.[2] A mighty red sun, amidst a host of flaring clouds, sinks to rest on one side of the picture, and illumines a river that seems interminable, and a countless navy that fades away into such a wonderful distance as never was painted before. The little demon of a steamer is belching out a volume (why do I say a volume? not a hundred volumes could express it) of foul, lurid, red-hot, malignant smoke, paddling furiously, and lashing up the water round it; while behind it (a cold gray moon looking down on it), slow, sad, and majestic, follows the brave old ship, with death, as it were, written on her. I think, my dear Bricabrac, (although, to be sure, your nation would be somewhat offended by such a collection of trophies), that we ought not, in common gratitude, to sacrifice entirely these noble old champions of ours, but that we should have somewhere a museum of their skeletons, which our children might visit, and think of the brave deeds which were done in them. The bones of the *Agamemnon* and the *Captain*, the *Vanguard*, the *Culloden*, and the *Victory* ought to be sacred relics, for Englishmen to worship almost. Think of them when alive, and braving the battle and the breeze, they carried Nelson

[2] [One of the first paintings to show a product of the industrial age, the steamer.]

and his heroes victorious by the Cape of Saint Vincent, in the dark waters of Aboukir, and through the fatal conflict of Trafalgar. All these things, my dear Bricabrac, are, you will say, absurd, and not to the purpose. Be it so; but Bowbellites[3] as we are, we Cockneys feel our hearts leap up when we recall them to memory; and every clerk in Threadneedle Street feels the strength of a Nelson, when he thinks of the mighty actions performed by him.

It is absurd, you will say (and with a great deal of reason), for Titmarsh, or any other Briton, to grow so poetically enthusiastic about a four-foot canvas, representing a ship, a steamer, a river, and a sunset. But herein surely lies the power of the great artist. He makes you see and think of a great deal more than the objects before you; he knows how to soothe or intoxicate, to fire or to depress by a few notes, or forms, or colors, of which we cannot trace the effect to the source, but only acknowledge the power. I recollect some years ago, at the theatre in Weimar, hearing Beethoven's *Battle of Vittoria* [Opus 91], in which, amidst a storm of glorious music, the air of *God save the King* was introduced. The very instant it began every Englishman in the house was bolt upright, and so stood reverently until the air was played out. Why so? From some such thrill of excitement as makes us glow and rejoice over Mr. Turner and his *Fighting Téméraire;* which, I am sure, when the art of translating colors into music or poetry shall be discovered, will be found to be a magnificent national ode or piece of music.

I must tell you, however, that Mr. Turner's performances are for the most part quite incomprehensible to me; and that his other pictures, which he is pleased to call *Cicero at his Villa, Agrippina with the Ashes of Germanicus, Pluto carrying off Proserpina,* or what you will, are not a whit more natural, or less mad, than they used to be in former years, since he has forsaken nature, or attempted (like your French barbers) to embellish it. *On*

[3] [Bowbellites are Cockneys, those born within the sound of the "Bow bells," the bells of the London church of St. Mary le Bow.]

n'embellit pas la nature, my dear Bricabrac; one may make
pert caricatures of it, or mad exaggerations like Mr.
Turner in his fancy pieces. O ye gods! why will he not
stick to copying her majestical countenance, instead of
daubing it with some absurd antics and fard of his own?
Fancy pea-green skies, crimson lake trees, and orange and
purple grass—fancy cataracts, rainbows, suns, moons, and
thunderbolts—shake them well up, with a quantity of
gamboge, and you will have an idea of a fancy picture by
Turner. It is worth a shilling alone to go and see *Pluto
and Proserpina*. Such a landscape! such figures! such a lit-
tle red-hot coal-scuttle of a chariot! As Nat Lee sings—

> "Methought I saw a hieroglyphic bat
> Skim o'er the surface of a slipshod hat;
> While, to increase the tumult of the skies,
> A damned potato o'er the whirlwind flies."

If you can understand these lines, you can understand one
of Turner's landscapes; and I recommend them to him, as
a pretty subject for a piece for next year.

Etty has a picture on the same subject as Turner's *Pluto
carrying off Proserpina*; and if one may complain that in
the latter the figures are not indicated, one cannot at least
lay this fault to Mr. Etty's door. His figures *are* drawn,
and a deuced deal *too much* drawn. A great large curtain
of fig-leaves should be hung over every one of this artist's
pictures, and the world should pass on, content to know
that there are some glorious colors painted beneath. His
color, indeed, is sublime; I doubt if Titian ever knew how
to paint flesh better—but his taste! Not David nor
Girodet ever offended propriety so—scarcely ever Peter
Paul [Rubens] himself, by whose side as a colorist and a
magnificent heroic painter, Mr. Etty is sometimes worthy
to stand. I wish he would take Ariosto in hand, and give
us a series of designs from him. His hand would be the
very one for those deep luscious landscapes, and fiery
scenes of love and battle. . . .

The artists say there is very fine painting, too, in Sir
David Wilkie's great *Sir David Baird*; for my part, I think

very little. You see a great quantity of brown paint; in this is a great flashing of torches, feathers, and bayonets. You see in the foreground, huddled up in a rich heap of corpses and drapery, Tippo Sahib; and swaggering over him on a step, waving a sword for no earthly purpose, and wearing a red jacket and buckskins, the figure of Sir David Baird. The picture is poor, feeble, theatrical; and I would just as soon have Mr. Hart's great canvas of *Lady Jane Grey* (which is worth exactly twopence-half-penny) as Sir David's poor picture of *Seringapatam*. Some of Sir David's portraits are worse even than his historical compositions— they seem to be painted with snuff and tallow-grease: the faces are merely indicated, and without individuality; the forms only half-drawn, and almost always wrong. What has come to the hand that painted *The Blind Fiddler* and *The Chelsea Pensioners*? Who would have thought that such a portrait as that of *Master Robert Donne*, or the composition entitled *The Grandfather*, could ever have come from the author of *The Rent Day* and *The Reading of the Will*? If it be but a contrast to this feeble, flimsy, transparent figure of Master Donne, the spectator cannot do better than cast his eyes upwards, and look at Mr. Linnell's excellent portrait of *Mr. Robert Peel*.[4] It is real substantial nature, carefully and honestly painted, and without any flashy tricks of art. It may seem ungracious in "us youth" thus to fall foul of our betters; but if Sir David has taught us to like good pictures, by painting them formerly, we cannot help criticising if he paints bad ones now: and bad they most surely are.

From the censure, however, must be excepted the picture of *Grace before Meat*, which, a little misty and feeble, perhaps, in drawing and substance, in color, feeling, composition, and expression is exquisite. The eye loves to repose upon this picture, and the heart to brood over it afterwards. When, as I said before, lines and colors come to be translated into sounds, this picture, I have no doubt, will turn out to be a sweet and touching hymn-tune, with rude notes of cheerful voices, and a peal of soft melodious

4 [Sir Robert Peel was the leader of the Conservative Party.]

organ, such as one hears stealing over the meadows on sunshiny Sabbath-days, while waves under cloudless blue the peaceful golden corn. Some such feeling of exquisite pleasure and content is to be had, too, from Mr. Eastlake's picture of *Our Lord and the Little Children*. You never saw such tender white faces, and solemn eyes, and sweet forms of mothers round their little ones bending gracefully. These pictures come straight to the heart, and then all criticism and calculation vanish at once—for the artist attained his great end, which is, to strike far deeper than the sight; and we have no business to quarrel about defects in form and color, which are but little parts of the great painter's skill. . . .

Passing from Mr. Eastlake's pictures to those of a greater genius, though in a different line,—look at Mr. Leslie's little pieces. Can anything be more simple— almost rude—than their manner, and more complete in their effect upon the spectator? The very soul of comedy is in them; there is no coarseness, no exaggeration; but they gladden the eye, and the merriment which they excite cannot possibly be more pure, gentlemanlike, or delightful. Mr. Maclise has humor, too, and vast powers of expressing it; but whiskey is not more different from rich burgundy than his fun from Mr. Leslie's. To our thinking, Leslie's little head of *Sancho* is worth the whole picture from *Gil Blas*, which hangs by it. In point of workmanship, this is perhaps, the best picture that Mr. Maclise ever painted; the color is far better than that usually employed by him, and the representation of objects carried to such an extent as we do believe was never reached before. There is a poached egg, which one could swallow; a trout, that beats all the trout that was ever seen; a copper pan, scoured so clean that you might see your face in it; a green blind, through which the sun comes; and a wall, with the sun shining on it, that de Hooche could not surpass. This young man has the greatest power of hand that was ever had, perhaps, by any painter in any time or country. What does he want? Polish, I think; thought, and cultivation. His great picture of *King Richard and Robin Hood*

is a wonder of dexterity of hand; but coarse, I think, and inefficient in humor. His models repeat themselves too continually. Allen-a-Dale, the harper, is the very counterpart of Gil Blas; and Robin Hood is only Apollo with whiskers: the same grin, the same display of grinders,— the same coarse luscious mouth, belongs to both. In the large picture, everybody grins, and shows his whole râtelier; and you look at them and say, "These people seem all very jolly." Leslie's characters do not laugh themselves, but they make you laugh; and this is where the experienced American artist beats the dashing young Irish one. . . .

The great advance of the year is in the small historical compositions, of which there are many that deserve honorable mention. Redgrave's *Return of Olivia to the Vicar* has some very pretty painting and feeling in it; *Quentin Matsys*, by the same artist, is tolerably good. D. Cowper's *Othello relating his Adventures*, really beautiful, as is Cope's *Belgian Family*. All these are painted with grace, feeling and delicacy; as is E. M. Ward's *Cimabue and Giotto* (there is in Tiepolo's etchings the self-same composition, by the way); and Herbert's elegant picture of the *Brides of Venice*. Mr. Severn's composition from the *Ancient Mariner* is a noble performance; and the figure of the angel with raised arm awful and beautiful too. It does good to see such figures in pictures as those and the above, invented and drawn,—for they belong, as we take it, to the best school of art, of which one is glad to see the daily spread among our younger painters. . . .

I feel, I confess, a kind of delight in finding out Mr. Edwin Landseer in a bad picture; for the man paints so wonderfully well, that one is angry that he does not paint better, which he might with half his talent, and without half his facility. *Van Amburgh and the Lions* is a bad picture, and no mistake; dextrous, of course, but flat and washy: the drawing even of the animals is careless; that of the man bad, though the head is very like, and very smartly painted. Then there are other dog-and-man portraits; *Miss Peel with Fido*, for instance. Fido is wonder-

ful, and so the sponges, and hair-brushes, and looking-glass, prepared for the dog's bath; and the drawing of the child's face, as far as the lines and expression go, is very good; but the face is covered with flesh-colored paint, and not flesh, and the child looks like a wonderful doll, or imitation child, and not a real young lady, daughter of a gentleman who was prime minister last week (by-the-by, my dear Bricabrac, did you ever read such a pretty Whig game as that, and such a nice *coup d'état?*).[5] There, again, is the beautiful little Princess of Cambridge, with a dog, and a piece of biscuit: the dog and the biscuit are just perfection; but the princess is no such thing,—only a beautiful apology for a princess, like that which Princess Penelope *didn't* send the other day to the Lord Mayor of London.

We have to thank you (and not our Academy, which has hung the picture in a most scurvy way) for Mr. Scheffer's *Prêche Protestant*. This fine composition has been thrust down on the ground, and trampled under foot, as it were, by a great number of worthless Academics; but it merits one of the very best places in the gallery; and I mention it to hint an idea to your worship, which only could come from a great mind like that of Titmarsh,—to have, namely, some day a great European congress of paintings, which might be exhibited at one place,—Paris, say, as the most central; or, better still, travel about, under the care of trusty superintendents, as they might, without fear of injury. I think such a circuit would do much to make the brethren known to one another, and we should hear quickly of much manly emulation, and stout training for the contest. If you will mention this to Louis Philippe the next time you see that *roi citoyen* (mention it soon,—for, egad! the next *émeute* may be successful; and who knows when it will happen?) —if you will mention this at the Tuileries, we will take care of St. James's; for I suppose that you know, in spite

[5] [Peel had resigned after Queen Victoria refused his request that she replace some of her Whig ladies-in-waiting with women sympathetic to the Conservative Party.]

of the Whigs, her most sacred Majesty reads every word of *Fraser's Magazine*, and will be as sure to see this on the first of next month, as Lord Melbourne will be to dine with her on that day. But let us return to our muttons. I think there are few more of the oil pictures about which it is necessary to speak; and besides them, there are a host of miniatures, difficult to expatiate upon, but pleasing to behold. . . .
These things seen, take your stick from the porter at the hall door, cut it, and go to fresh picture galleries; but ere you go, just by way of contrast, and to soothe your mind, after the glare and bustle of the modern collection, take half an hour's repose in the National Gallery; where, before the *Bacchus and Ariadne*, you may see what the magic of color is; before *Christ and Lazarus* what is majestic, solemn grace and awful beauty; and before the new *Saint Catherine* what is the real divinity of art.[6] Oh, Eastlake and Turner! —Oh, Maclise and Mulready! you are all very nice men; but what are you to the men of old! . . .[7]
. . . Wishing many remembrances to Mrs. Bricabrac, and better luck to you in the next *émeute*, I beg here to bid you farewell and entreat you to accept the assurances of my distinguished consideration.

<div style="text-align: right;">M.A.T.</div>

Au CITOYEN BRUTUS NAPOLÉON BRICABRAC, *Réfugié d'Avril, Blessé de Mai, Condamné de Juin, Décoré de Juillet, etc. etc. Hôtel Dieu, à Paris.*

[6] [Thackeray refers to Titian's *Bacchus and Ariadne*, purchased in 1826, Sebastiano del Piombo's *Raising of Lazarus*, acquired in 1824, and Raphael's *St. Catherine of Alexandria*, bought in 1839.]
[7] [The report on the Water Colour Society's Exhibition is omitted.]

1841
PARIS: The Official Exhibition
of the State

The popular promenade in fair weather was the Jardin des Tuileries. From its broad central walk a fine view extended to the west through the garden laid out by Le Nôtre for Louis XIV to the Tuileries Palace. It blocked the view of the Obelisk in the Place de la Concorde and beyond to the Arc de Triomphe de l'Étoile, finally completed in 1836. At the opposite end was the Louvre, where the Salon opened in March. A walk in the sunshine and a visit to the Salon were pleasures enjoyed by all Parisians in the years of severe depression after 1838. Thackeray, in Paris in July 1841 to report for the *Times* and *Fraser's Magazine*, wrote of his visit to the Salon:

> Genteel people, who can amuse themselves every day throughout the year, do not frequent the Louvre on a Sunday. You can't see the pictures well, and are pushed and elbowed by all sorts of low-bred creatures. Yesterday there were at the very least two hundred common soldiers in the place—little vulgar ruffians, with red breeches and three halfpence a day, examining the pictures in company with fifteen hundred *grisettes*, two thousand liberated shop-boys, eighteen hundred and forty-one artist-apprentices, half a dozen of livery servants, and many scores of fellows with caps and jackets, and copper-colored countenances and gold earrings, and large ugly hands, that are hammering or weaving or filing all the week.

Reporters and *feuilletonists* were admitted to the Salon before the formal opening. Théophile Gautier (1811–72),

long-haired and handsome, crowded others aside to come closer to the paintings. Forced to give up his studies in Rioult's studio because of his nearsightedness, Gautier devoted his appreciation of the visual world and his gift for description to poetry. In 1841 journalists reviewing the Salon recognized him both as the respected art and drama critic for *La Presse* and as a controversial literary figure, who in 1830 had worn a rose-colored vest in the claque for Victor Hugo's *Hernani* when the younger generation of romanticists had routed the classicists in the Théâtre Français and in 1835 had written the sensational novel *Mlle. de Maupin.*

Gautier and his intimates, the poets Gérard de Nerval and Pétrus Borel, had resorted to *la vie de Bohème:* fantastically dressed, smoking hashish, staging bizarre parties, they espoused decadence as their form of protest against the injustices and conventions of bourgeois society. Ignoring the political and social conditions that repelled them, they pursued pleasure and art for their own sake while eking out an existence writing for avant-garde magazines and the half-political, half-theatrical press that bought their talent for minimal fees. They argued that art should have no rationale beyond beauty, and though they admired Hugo, they now questioned the cult of medievalism that had become identified with romanticism.

Gautier's first novel, *Mlle. de Maupin,* and its important introduction were statements of his belief in the essential non-usefulness of art and the primacy of sensual pleasure and beauty, a credo that came to be known as "art for art's sake." In the introduction, he castigated "utilitarian critics" and Saint-Simonists who demanded that art serve the moral needs of society and the progress of man. Gautier concluded: "There is nothing truly beautiful but that which can never be of any use whatsoever, everything useful is ugly, for it is the expression of some need, and man's needs are ignoble and disgusting like his own poor and infirm nature." The novel itself was an example of art for art's sake: the plot was slight; the book

consisted largely of descriptions exploring forbidden sensual pleasures.

Gautier's first Salon review had appeared in *La France littéraire* in 1833, the same year as his *Les Jeunes-France*, a collection of pieces satirizing the excesses of the romantics. In 1836 he signed a contract with Émile Girardin, owner of *La Presse*, and was that daily's drama critic for nineteen years while he continued to sell articles to other papers.

In his account of the 1839 Salon for *La Presse*, Gautier, stimulated by Goethe's assertion that every artist should carry within himself "a small complete world" from which he pulls the conception and form of his works, first expounded his theory of the "microcosm." According to the theory, which Gautier expanded in his 1841 review for *La Revue de Paris*, one of the best-written of the Parisian papers, the works of great artists are not imitations of nature made according to rules, but transformations of the sensual experience of nature into art, unified and made harmonious through the faculties of the microcosm. This exposition contained the small sum of his conceptual thought.

Gautier proceeded from no theory or canon of judgment; he disapproved only when a work of art was not wholly beautiful. This devotion to beauty enabled him to appreciate Ingres as well as Delacroix and to become an early "discoverer" of the amoral and themeless art of Watteau and the rococo.

Gautier's reviews were written with the literary craftsmanship of a poet—his first volume of poetry had appeared in 1830 and his finest, *Émaux et camées* (*Enamels and Cameos*), would be published in 1852. His descriptions of what was to be seen at the Salon titillated his readers, permitting them to relish the tactile and visual excitement of a painting while being intrigued by its literary content. Much of the power of his critical writing came from his skillful use of poetic correspondences. Such phrases as "the dancing women sparkle like a bouquet of

flowers" achieved a synopsis of the senses and suggested to his readers how to "see" with sensuous pleasure.

Seemingly tireless, Gautier, in addition to poetry and criticism, wrote novels, vaudeville skits, ballets and travelogues. At the same time that it published Gautier's review of the Salon of 1841, *La Revue de Paris* also ran the first of his brilliant travelogues, an account of his trip through Spain the year before. In the spring of 1841, inspired by Heine's *L'Allemagne*, Gautier wrote the successful ballet *Giselle or the Willis* for the beautiful dancer Carlotta Grisi, a sister of his mistress. *Giselle* was followed in 1843 by *La Péri*; its oriental subject reflected a preoccupation that Gautier, who was often seen wearing Turkish slippers or a burnoose, shared with much of Paris since the Eastern Question, aroused by French involvement in a conflict with the crumbling Eastern empire of the Ottomans, increasingly filled the newspapers.

Gradually Gautier came to acknowledge the validity of the taste of the public, though professing that his own differed. At the end of his life he was probably France's most influential and popular art critic. For a younger generation of poets, including Charles Baudelaire, who dedicated his *Fleurs du mal* to Gautier in 1857, he indicated a direction for the romantic movement's creativity after it sought to shed its literary and historical content.

Théophile Gautier, "Salon of 1841"[1]

It is customary to preface articles of criticism of the Salon with a more or less elegiac discourse on the decadence of art. It would be perhaps more apropos to write on the decadence of the public, for, as we see it, art has never been in a better state than it is today. The French school, which derives from the Italian, Flemish and Spanish schools, but only from a great distance, *longo in-*

[1] [Translated from *La Revue de Paris*, 3e série, April 28, 1841, pp. 153–71.]

tervallo, now occupies first place and thus stands alone. The school of Munich, too preoccupied with the archaic, with pedantic imitations, with symbolism and aesthetics, can be considered merely a class in metaphysics and philosophy whose disciples draw instead of writing. The fate of art today is being decided in France, and Paris has become the Rome of modern times. There is not a single talented painter in Italy now, and taste there is so perverted that the painting by M. Brulow, *The Destruction of Pompeii,* was showered with laurel wreaths and sonnets [when it was shown there]. A recent sojourn in Spain convinced us that any connection between the old masters and the artists of today has been broken. Good old Goya was the last painter who carried on the tradition of Velazquez and understood the old masterpieces. Agaricio, Tejeo, Maella, Madrazo and the rest are merely pale imitations of David. Belgium, in spite of the efforts of a few talented men, has no place in the tournament and England has produced but one portraitist, Lawrence, and his reputation is more fashionable than real. Düsseldorf has produced two artists, Bendemann and Lessing, men of undisputed talent, but too few to constitute a school. It is France that, unchallenged, holds the scepter of painting today. The Salons of these last few years have, in general, been remarkable, and it would be impossible in any country to bring together periodically such a large collection of painting and sculpture commendable in so many respects, for no one could ask of a country, or of a period, two thousand masterpieces every year. What is so curious is that the public in no way gives any encouragement to the efforts of artists. One would assume, in seeing the enormous number of young men who become painters or sculptors, that the French are ardent lovers of art, that they expend huge sums of money on pictures and sculptures, or at least that they appreciate them and judge them with an unusually lofty taste. Not at all! The public admires only small paintings made by small painters; the pots and pans of Drolling and the portraits of Dubufe are what they take to their hearts! And it could be said that

the public's enthusiasm is a sort of certificate of nothingness. We should be grateful to today's painters for the innovations and activity which they practice in spite of everything, while contending with the general indifference and without any outside assistance. Excepting for the government, no one commissions artists. A shameful thing! One sees thirty-sou engravings in some apartments where there are twenty or thirty thousand francs' worth of furniture and carpets. Buying a book or a picture is an idea that rarely penetrates the brain of a French millionaire; or if such a fantastic notion does occur to him, he will frame in gold a sooty, questionable canvas that some Jew sold him as a Raphael. Official commissions, meanly paid for, are nearly always mistakenly given; a battle scene is given to a painter of interiors, a religious painting for a church to a landscapist, and so on: it's merely a question of covering a certain stretch of wall space within the limits of a set sum of money. That's all! In spite of so many obstacles, the French school has nonetheless succeeded in attaining first place, and has presented the phenomenon of an art developing on its own, with no other public than the artists themselves.

This is particularly true of sculpture, which is the art of the gods and of kings. The gods have gone and kings will soon depart, at least kings in the old meaning of the word. And truly, we are afraid that, in spite of the sacrifices made by its practitioners, sculpture will disappear within a few years. In our industrial and civilized world who will care about the whiteness and the purity of marble? In this age of hydrogen gas and steam engines, who still thinks of the day when Venus arose naked from the depths of the sea?

We never go into the galleries to which the works of sculpture have been relegated without experiencing a feeling of profound sadness. One realizes that this is a dead art. This must be true since these works are shown in a vault. Nothing is sadder to contemplate than this sort of sculptural morgue where, illumined by a damp and pallid ray of daylight, the marble corpses of ancient gods which

their celestial relatives have not yet claimed are displayed. In this chilly cellar the last blooms of antique beauty sadly wither away, like fading lilies; there the great poem of the human body, sung in strophes of bronze and alabaster by the divine choir of Greek artists, comes to a dishonorable end; there the divine nudity of the [human] form still dares to show itself. Brave and determined champions, aware of the futility of their dedication, the sculptors have fought to the end; in their vast, solitary studios, they have religiously sought the purity of contour, the cold chastity of marble from Carrara or Paros, while the common herd is pleased only by obscene, coarse color prints, by violent and brutal dramas. The last worshipers of forsaken gods (for paganism will always be the religion of sculptors), they have held to that tradition of primitive beauty that will soon disappear in this black chaos of civilized barbarity which is becoming a Low Empire.[2] Indeed it is a very courageous thing for a handful of men to support, at their own risk and peril, a sublime form of human thought, a great art that is disappearing, perhaps never to return, and it seems to us, in view of the absence of the public [support], the critics should treat them more kindly. Meanwhile, in times when interest can no longer be resuscitated even by a masterpiece, sculpture generally receives but a few disdainful lines tossed in at the end of articles on the exhibitions.

In the above-mentioned narrow little vault are gathered together all the works that deserve attention and analysis: the *Odalisque* of M. Pradier; the *Monument to Géricault* of M. Étex; *The Disillusion* of M. Jouffroy; *The Nymph Armini* of Bartolini of Florence, and *Eudorus and Cymodoce*, a bas-relief by Tenerani.

You know what a happy feeling for sculpture M. Pradier possesses: marble is truly pliable in his hands; he kneads it and shapes it as others model in wax or clay; never was there a chisel so delicate, so supple, so free or so skillful; he expresses the delicacy of flesh, the moisture and texture of skin effortlessly and without too much de-

[2] [*Bas-Empire*: Byzantine Empire, hence decadent period.]

tail. But sometimes he replaces form by sensuality and the visionary ideal by desire. He forgets that marble should only be loved platonically, and that perhaps one will be obliged someday to protect his statues from the adoration of the English, as in the case of the Venus *Callipygus* [*Crouching Venus*] in the Museo Nazionale at Naples. This year's *Odalisque* gives the impression of an enlarged statuette, and the pose reminds one a little of a terra-cotta work by Clodion; the head, though delicate and pretty, does not have enough austerity; the Orient, if not Greece, could provide the artist with a purer and more poetic model; the torso, very well worked and well portrayed, is perhaps too artless and lacks nobility; it would have been better to eliminate some of the detail and to simplify the divisions. The *Crouching Venus*, whose pose is similar, could have served as an example for M. Pradier, who sacrifices too much to reality. His love of flesh sometimes diverts him from the purity of the Greeks, those sovereign masters of sculpture. We approve of neither the roses in the coiffure nor that turban arranged with such fashionable elegance. With these reservations, the *Odalisque* is a statue of much grace and of superior achievement. The back, the arms, the loins are charming; it has the suppleness and casual unconstraint of life.

The *Tomb of Géricault*, by M. Étex, is distinguished by its simple composition, its tranquillity, and by its grandeur, which is appropriate to the subject. Géricault, wrapped in a long robe arranged in the manner of the draperies of Paul Veronese, is half reclining on the stone of his tomb; in one hand he holds his palette and in the other a paintbrush. The hand holding the paintbrush falls languidly, as if weakened by illness and great mental activity. The head, whose structure reminds one, though it does not have their leanness, of the anatomical lines of the plaster masks so well known in the studios, wears a sort of toque or cap that lends character and does not detract from the verisimilitude. The expression is full of nobility and melancholy. One feels the sorrow of dying [is there].

On the pedestal is a bas-relief in bronze, copied from

The Raft of the Medusa, done with infinite skill and an admirable understanding of the model; it leaves no doubt in one's mind of the name of the personage in whose honor the monument is raised. On the two other surfaces are engraved in intaglio two other celebrated compositions of Géricault, *The Mounted Officer of the Imperial Guard* and *The Wounded Cuirassier*. These representations do not please us; their lines etched in cinnabar are scanty and disagreeable. Since M. Étex knows the art of translating canvas into bas-relief so well, he should have copied these two magnificent figures in bronze, as he has done with *The Raft of the Medusa*: they would have completed the appearance of the monument and would have been much more worthy of the painter and the sculptor.

M. Jouffroy, it is not to be forgotten, is the creator of *Ingenuousness or A Young Girl Confiding Her First Secret to Venus*, a very Greek and charming idea interpreted with perfect naïveté. This year he is exhibiting *The Disillusion*, a subject more literary than sculptural. Certainly Phidias never thought of it, nor Praxiteles. Byron touched upon it, and so did George Sand. The restlessness of these [two] great geniuses has nothing in common with the pale and snowy art of the sculptor. The sole subjects of the sculptor are form and beauty, and whenever he attempts something else he goes beyond their limits and inevitably goes astray. Marble, which is calm, impassive, everlasting, and confines religiously within its dazzling whiteness the features entrusted to it, lends itself less than any other medium to the expression of the stress of thought, the weariness of the heart and the ravages of passion. Although we disapprove of his choice of subject, M. Jouffroy's work is wrought with much taste and feeling. . . .

Eudorus and Cymodoce, a bas-relief by M. Tenerani of Rome, is of a simplicity too much like [that of the sculpture at] Aegina. The tiger for which the animal tamer lifts the grating looks like a rat that is being pushed out of a mousetrap; the martyrs look like dolls, and the pose of the animal tamer resembles the contortions of the clowns of

Franconi. MM. Bartolini and Tenerani are, however, the most famous sculptors of modern Italy. Their work is not much, compared with that of MM. David [d'Angers], Pradier, Étex, Simart, Rude, Duret, Jouffroy, L'Escorné, Antonin Moine, Klagman, and many others, who lack only a pope or a patron prince to create a Renaissance as brilliant as the first one.

Let us not overlook, before leaving this sepulchral cavern, the bust of Mme. Schikler, by Dantan the Younger; the *Nymph Educating a Satyr* by M. Garraud; a statue of a young girl scattering flowers by Geefs; and a bust of a man by M. Ottin, perfectly modeled and beautifully executed. Then let us lay a well-deserved curse upon the jury as regards M. Auguste Préault, systematically rejected for nearly ten years. Is it not strange that the jury should deny a place in a damp corridor to a man of whom the entire press has taken notice and whose rejected name has resounded in every newspaper? M. A. Préault has had the great courage to persist and to present a new work each year, only to incur this insult, which dishonors only those who inflict it. No one questions M. Préault's talent and his *Flavia* is equal to any of the works most favorably noticed in the Salon. What we say about M. Préault applies equally to M. [Théodore] Rousseau, a landscapist of the highest order, another martyr whose smallest sketch is worth all of the landscapes of his judges. M. Couvelet also had a canvas refused, *Camel Camp near Smyrna*, which may be seen in the gallery of M. Aguado, who has just bought it. We are forced here to censure gravely such men as MM. H. Vernet, Delaroche and other influential members of the jury who, under the pretext of being revolted by the injustices committed by the jury, refuse to take part in its deliberations and wash their hands of such unjust and ridiculous rejections. It is often the way of honest men to abstain and to let things take their course; they are wrong to do so, for Pontius Pilate was the cause of the suffering of Jesus Christ. The wicked are active and the good are lazy; that is the cause of most of the misfortunes of this world. Only three painters attended the de-

liberations: MM. Garnier, Bidault and Bertin. It is truly disgraceful to be obliged every year to resume the same quarrel and to toss to the winds the same complaints.

Now let us leave this limbo, peopled with pale phantoms, and climb toward the warmer regions of life and light, that is, to the great Salon Carré.

By now we have written about many Salons, and always the name of M. Delacroix is to be found first at the tip of our pen. That is because, actually, M. Delacroix is the adventurous painter *par excellence*. One turns immediately to him before any other because he dares more often than anyone else to paint masterpieces. He can be displeasing at first glance, but one ends up by acknowledging that the future of painting is being realized on his canvases; he is the true child of this century and one feels that every piece of contemporary poetry has cast its shadow on his palette. There are perhaps better paintings in the Salon, but certainly not a better painter. How is it possible, cry his detractors, that you can proclaim the greatness of an artist whose drawing is inaccurate or trivial or non-existent, who seems to be enamored of ugliness, whose technique is tortuous, incoherent and bizarre? Is a *beautiful color* enough to compensate for so many defects? For our part, we don't know whether M. Delacroix draws well or badly, whether or not his figures deviate from the classical model, or whether his execution is good or bad; for us he has a quality that is worth all else. He exists, he lives within himself; in a word, he carries within himself the *microcosm*. Excuse this unusual and mysterious term, but it interprets perfectly our concept—that is to say, a small but complete world. This precious faculty of interior creation belongs only to elite intelligences, and it is the secret of the power that M. Delacroix possesses in spite of all his faults. Let me explain what is mysterious about this [power]: an artist is moved by his natural surroundings in accordance with his sensibilities; the sky leaves favorite and special colors within his eye. Certain physiognomies impress him more strongly than others. He grasps relationships invisible to others. But not everyone has enough

genius or memory to co-ordinate his impressions and give them coherence. These others lack unity, because they do not have intuition and they are misled by some unexpected detail, by a form not prescribed by the academies and their models. M. Delacroix is endowed to the highest degree with this gift of assimilating objects, of coloring them [according to] his own prism, and of taking from them precisely what suits his own conception. If he does a bit of landscape, the plants he sows there are exactly the ones nature would place in the scene he wishes to paint; similarly, the figures who appear in it are perfectly adapted to the scene and above their heads appears a sky created expressly for them. When M. Delacroix composes a picture, he looks within himself instead of putting his nose to the window; he has taken from creation what he needed for his art, and that is what gives this force of intimate attraction to his paintings, so often shocking. His color, in traveling from his eye to the tip of his brush, has come by way of his brain and has taken on there the nuances that may seem at first glance to be bizarre, exaggerated or false, but each stroke of the brush contributes to the harmony of the whole and depicts, if not the prosaic aspect of an object, at least the painter's own perception or idea.

M. Eugène Delacroix is showing three pictures this year, for he is essentially a hard-working man, always ready to stand in the breach: *The Entrance of the Crusaders into Constantinople, The Shipwreck of Don Juan,* and *Jewish Wedding in Morocco.*

The *Crusaders* is the one that provokes the liveliest criticism and whose success is the most hotly contested. It is principally reproached for having a certain resemblance to a Gobelin tapestry. This criticism, though justified, is not alarming; the Gobelin tapestries are themselves very beautiful, and this coloring is a proof of the painter's delicacy of feeling, which, in realizing a bit of pomp, gives it a touch of ornament and color that is entirely suitable since, after all, the picture is destined to adorn a gallery. This muted and tranquil coloring astonishes and confuses one at first glance; from the title one expects a flood of splen-

dors, streams of light, all the enchantment of the Orient, because one imagines Constantinople as a dazzling white between two immutable blues. M. Eugène Delacroix, for whom it would have been easy to realize this ideal, has chosen cloudy and almost northern weather. A large black cloud casts the shadow of its long vulture-like wings over the city (which one perceives in the distance); only the sea has kept its shade of greenish turquoise. . . .

The [Shipwreck or] Bark, which the catalogue does not identify more completely, was inspired by the admirable account of the shipwreck in the Don Juan of Byron. M. Delacroix has wisely omitted this circumstance and given his composition a wider significance. This is simply any shipwreck, whichever one you prefer; it doesn't matter. The sea is choppy, opaque and turbulent as after a great storm. The sky is covered with low-hanging clouds heavy with rain and lightning that cast a leaden reflection on the sad scene over which they hover. In the midst of this double immensity a small, overloaded boat floats aimlessly. In this frail craft are huddled together thirty or so miserable characters, emaciated, gaunt and livid, who are drawing lots from the hat of one of them to decide which will be the first to be eaten. This group consists of the strongest and most animated of this band of specters; the others, lying at one end of the ship in attitudes of dumb despair, do not even realize what is going on. The dazzling red fires of famine shine in their eyes. Nearer to the fatal group from which will come the death sentence, a half-naked sailor, seen from behind, amuses himself like an imbecile child by leaning over the boat's gunwale at the risk of submerging the passengers. On the poop deck, next to a dying woman, is seated a group of men, wrapped in their cloaks—men with braid on their hats, officers probably— who by their silence protest against this abominable lottery. Their attitudes are sad and desperate but not brutalized; moral force still struggles within them; they have not yet fallen into the bestial dejection or brutish indifference of their coarse companions. This contrast is

beautifully and perfectly expressed. The *Shipwreck* to us seems one of the best works of M. Delacroix; in it all his best qualities can be seen, and his defects are overshadowed by the subject itself. We would have liked to see a little more finesse in the execution of the hands and several other details that are scarcely noticeable when one looks at the picture close to. It is in our estimation the best marine painting that we have ever seen, and as drama we do not know of anything more striking. In *The Raft of the Medusa* one sees a sail on the horizon; one is certain of the rescue and one already pictures the excellent soups and the generous portions of fortifying cordials that are being prepared for the survivors. Here there is nothing of the sort, not a glimmer of hope in the passengers' despair; nothing but a cold gray horror and dismal suffering.

The *Jewish Wedding* is a picture in which all the mysterious sweetness of the Orient breathes; the effect is calm, silent, full of smiling repose and tranquil joy. The musicians and the men seated with crossed legs are natural and perfectly in character. The dancing women sparkle like bouquets of flowers, and others who are watching them, bathed in fresh and transparent shadow, are true masterpieces of chiaroscuro; the half-tones are marvelous. Art disappears, it is nature itself. The honors of the Salon return to M. Eugène Delacroix, for no one else has shown a more supple and varied talent. As an interior one can find nothing to challenge the *Jewish Wedding*, as drama nothing to challenge the *Shipwreck*, and the *Crusaders*, though more controversial, holds first place among the commissioned works of pomp.

A Scene from the Inquisition by M. Robert-Fleury is truly a major work, and it is difficult to see how there could be anything better in the genre of demi-character and storytelling. The execution is good, candid and solid, altogether without pretentious finish, without tinsel and affectation; the composition happily avoids the drawbacks of this sort of scene, which can be melodramatic and theatrical. Such scenes certainly occurred. In a dungeon,

which is purposely not represented as horrible, several in-
quisitors, the indispensable accused, an executioner with
his apparatus for extracting confessions, and the clerk who
will record it are grouped in the simplest manner. The
painter has not committed the error of giving to his in-
quisitors monstrous and ferocious faces; their expressions
are simple-minded, good-natured, ordinary and self-impor-
tant—[they are] agents of the king going about their
business. The legs of the accused are in a sort of pillory,
the soles of his feet turned toward a brazier whose red
light illumines the executioner, who is leaning over it to
stir up the coals. With the executioner at his feet and the
clerk at his ear, the victim makes a prodigious moral effort
to withhold his secret, while nearly bursting with pain.
The inquisitors wait patiently, not too curiously, sure of
the efficacy of their methods of extracting confidences
from the most uncommunicative people.[8] The head of the
large man who leans forward to watch could have been
stolen from Velasquez, so sure is the painter's touch, so
very Spanish the character. . . .
Within the limits he has established for himself one can
hardly criticize M. Robert-Fleury. He has arrived at that
culmination in the career of an artist where the hand does
everything that the head commands. Certainly one could
wish for more fantasy and more of the ideal, a greater con-

[8] [In his review for *Fraser's Magazine* July, 1841, Thackeray
wrote: "The only one of the acknowledged great who has ex-
[8] [In his review for *Fraser's Magazine*, July, 1841, Thackeray
hibited this year is Monsieur Delacroix, who has a very large
picture relative to the siege of Constantinople that looks very
like a piece of crumpled tapestry, but that has nevertheless its
admirers and its merits, as what work of his has not?" Of
Robert-Fleury Thackeray wrote: "His mind, judging from his
works, is rather of a gloomy turn; and he deals somewhat too
much, to my taste, in the horrible. He has this year A *Scene
from the Inquisition*. A man is howling and writhing with his
feet over a fire; grim inquisitors are watching over him; and a
dreadful executioner, with fierce eyes peering from under a mys-
terious capuchin, is doggedly sitting over the coals. The picture is
down-right horror, but admirable and honestly drawn; and in
effect rich, somber and simple."]

cern for lofty inspiration, but within this ring of warm and candid reality that the painter himself has imposed on his talent, it would be unfair to demand more. We prefer, after all, small pictures painted grandly to grand pictures painted meagerly; and finally, artists must accept the loss of exaggerated dimensions, for the whole arrangement of modern life contradicts them, and furthermore, not so much room is necessary for painting a masterpiece; four or five feet will suffice. Look at Poussin!

The *Andromeda Chained to the Rocks by the Nereids*, by M. Chassériau, however narrow its frame, is surely as great as *The Surrender of Ptolemy* of M. Blondel or any other of the historically insignificant canvases that adorn the top rows of the Salon Carré. Andromeda on the rocks is ordinarily for painters merely an excuse for a school study figure which they arrange with more attention to the gracefulness of the pose than to the truthfulness of the expression. M. Théodore Chassériau has treated the scene entirely differently. The Nereids tighten the bonds of the pale, nude victim, who is struggling in fright and in an agony of mortal terror, for she has already seen the monster stirring up the sea foam and has not yet seen Perseus, the liberator, who appears in the blue sky. One of the Nereids recoils with the fear of being engulfed by the monster wreaking vengeance [on behalf] of Amphitrite. The sad and mysterious heads, borrowed from primitive Greek types, the draperies in the Etruscan style, the coiffures, bizarre in style and with an air of barbaric coquetry, the coloring at the same time pale and warm, all give to this picture an originality that attracts and surprises. The eccentric character and unknown aspects of antiquity are understood and placed beneath a sky altogether different from that envisaged by the pseudo classicists. Treated thus, mythology is a source of refreshing and new inspirations. . . .

The Martyrdom of St. Polycarpus by M. Chenavard is another of those pictures that are only successful in the eyes of other artists. Never fear that the bourgeois will lift

his nose from the varnished *grisettes*[4] or the wounded École Polytechnique students of M. Destouches to look at it. This painting of M. Chenavard reveals immediately that he has been nurtured for a long time on hard study and has lived in intimacy with the great old masters, [M. Chenavard is] very different from many other artists who cast off tradition and think they are modern because their paintings have no resemblance to the sacrosanct masterpieces; without any show of servile imitation he follows in the footsteps of the masters and does not find it necessary to stray from that path. He accepts art as made by the old masters and his pictures could be placed with impunity in a gallery of the Florentine school. Very few painters today could draw the man upside down and foreshortened from the top of his head. The upper grouping where one sees the haloed Virgin and the Child Jesus receiving the souls of the martyrs has much nobility and character. The young woman with long blond hair whom an angel is presenting to the Virgin is of a rare and perfect beauty; the proconsul and the judges have truly Roman heads worthy of antiquity. A few harsh colors, which time will deaden quickly enough, monopolize the eye, which is not drawn by any well-determined source of light, a fault that is excused by the needs of a double composition. We regret that this remarkable canvas should have been placed so high, for its execution is delicate, carefully done, and deserves to be examined at a closer distance. . . .

It is only M. Schnetz's long-standing reputation that gives any merit to the pictures he has sent to the Salon. It is hard to find his former talent in the *Procession of Crusaders* or in his *Young Greek*. M. Schnetz had in the highest degree a sort of untamed energy, a careful treatment, a crudeness of color that went well with the vigorous Roman character that seems to have been exclusively adopted by him. One misses these qualities in his most recent works in which only a certain spontaneity and robustness remain by which one might recognize the

4[*Grisettes*, also known as *lorettes*, were young women from the working classes who earned their living as prostitutes.]

Schnetz of the *Vow of the Madonna* and of *Sixtus Quintus*.

The portrait of an old lady by M. Hippolyte Flandrin, placed near the door that leads to the exhibition of prints, deserves praise in all its aspects. It is well drawn, finely modeled in a felicitous, tranquil fashion; and although the person portrayed is not young, one's glance is willingly arrested. Completely absorbed by the murals he is painting at St. Severin, Flandrin has been able to send only this portrait to the Salon. We note with pleasure the increase in church decoration of paintings done directly on the walls; their effect is always more satisfying than that of pictures composed in the studio under different lighting. We hope very much that young artists will in the future continue this trend toward fresco painting, or at least painting on the wall, for, as Michelangelo, that veteran molder of marble, said, easel painting is only good for women or lazy people. . . .

As for M. Dubufe, we have nothing to say to him; he paints duchesses as Joncherie paints herrings and fried eggs; he is a veritable factory. The ladies particularly admire the portrait of the Duchess of Dino, who wears a blue-pointed tiara in her hair, a lacy bodice and sleeves of silk. However, M. Dubufe's popularity is unquestioned, which does not say much for the public's taste.

Let us terminate this review of portraits with *The Octogenarian* by M. Hornung, which is the true and faithful portrait of the roots of the boxwood tree. It is impossible to push trifling minutiae and extravagant detail any further; it is no longer painting, it is dermatology; a study of cellular tissue, carried to extremes of microscopic investigation. M. Hornung seems to see nature through a magnifying glass, so careful is he to indicate the defects—the pores, the creases, the wrinkles, the folds, the warts and other minute details of the human skin. Balthazar Denner, the painter of old ladies, is a "loose" painter beside M. Hornung, and Quentin Metzys and Holbein have left us only rough sketches. Certainly one can accept this excessive representation in detail in art, but the true

masters of the harsh and minute have also marvelous qualities of drawing, of finesse and truthfulness that are completely lacking in the work of M. Hornung. *The Savoyards,* listed in the catalogue under the peculiar title of *Happier Than a King!* oversteps the limits of the base and the ugly without having the vitality of life and color that excuses this kind of painter among the Flemish and Spanish artists. Our criticism will not prevent the public from crowding before those two sweating monsters who are drinking purple wine out of filthy glasses and who gnaw, from the bottom of a broken plate, a bone that a mastiff from Montfaucon would scorn. So it is this, after the painting of M. Dubufe, that most delights the public. Now tell us that *vox populi, vox dei.* Triviality, polished and varnished, never fails to excite the admiration of the crowd, and these words of Horace are still valid when applied to art.

PARIS: The Official Exhibition
of the State

In 1844 interest was distracted from the Salon, opened on March 15, by the Exposition of Industry, which Louis Philippe opened on May 1. A handsome building had been erected for the exposition on the Champs Élysées; five thousand more meters of space than had been used for the last exposition, held in 1839, were needed to accommodate the exhibitions. The visitors, some of whom had courageously come to Paris by the two railroads opened the year before, crowded into the building to examine the engines, motors and ingenious machines for weaving, printing and other processes that were exhibited along with the articles they produced. Porcelain, crystals and luxury items produced by skilled artisans attracted the bourgeoisie. Also on display was a large collection of the little silver pictures called daguerreotypes after Daguerre who, with J. Nicéphore Niepce, had invented the process. Daguerreotypes, which reproduced the world in astonishing detail, had been first introduced to Paris in 1839 at a joint session of the Académie des Sciences and the Académie des Beaux-Arts. The Exposition of Industry offered Frenchmen their first opportunity to see a large exhibition of the images made by the increasing number of those who employed the process.

France's industrial progress, though celebrated by the exposition, still lagged behind that of Britain and failed to quiet undercurrents of discontent with the capitalist oligarchy which controlled the government and ran the country for its own benefit. Longings for national glory, unassuaged by the progress of the conquest of Algeria, had

been aggravated by the cult of Napoleon. Louis Napoleon's *Des idées napoliennes* (*Napoleonic Ideas*) had appeared in 1839; Thiers was writing a history of the Consulate and Empire; and in 1840 the remains of Napoleon himself had been transferred to Les Invalides while the crowd shouted "Vive l'Empereur!" Louis Napoleon's attempted coup of 1840 had been unsuccessful, however, and from prison he was unable to nurture the cult to his advantage.

Some Frenchmen looked not to past glories but to new social theories for the solutions of their frustrations. Since 1820, Paris had become the intellectual center of the socialist movement and had attracted from all Europe determined reformers. Friedrich Engels, Karl Marx, Louis Blanc, Pierre Joseph Prudhon, the followers of Fourier and Saint-Simon discussed the problems so evident in the distress of the increasing populations of Paris and other industrial cities. Louis Blanc's *Organisation du travail* (*The Organization of Work*; 1839) had suggested that employment was a right and that "social workshops" should be created. Prudhon asked, *Qu'est-ce que la propriété?* (*What Is Property?*; 1840) and answered "*C'est le vol* (It is theft)." Karl Marx, who came to Paris in 1843, complained that the government was a "Joint Stock Company for the exploitation of France's national wealth." August Comte, formerly a Saint-Simonist, published his *Cours de philosophie positive* (*Positive Philosophy*; 1842) in which he suggested that if the principles of science (which had produced the results celebrated by the Exposition of Industry) were to be put to answering moral questions it would result in a new age of universal harmony.

Another follower of Saint-Simon was the art critic and historian Théophile Thoré (1807–69). Determined to realize the aspirations his parents had held for France in 1790, Thoré studied law at Poitiers and then went to Paris, where he became active in socialist circles. His participation in the July Revolution of 1830 earned him a state appointment in the provinces, but he was too innovative in this office and was relieved of his duties. Well

33. Turner, *The Fighting Téméraire*

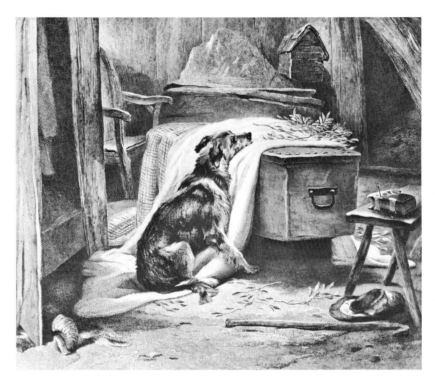

34. Landseer, *The Old Shepherd's Chief Mourner*

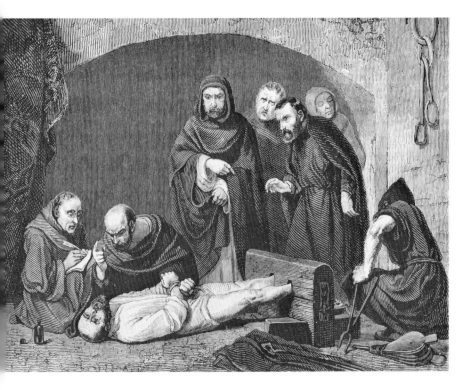

35. Fleury, *A Scene of the Inquisition*

36. Delacroix, *Shipwreck of Don Juan*

37. Rousseau, *Soleil Levant*

ROYAL ACADEMY.

"DEAR PUNCH, "*Newman Street, Tuesday.*

"ME and another chap who was at the Academy yesterday, agreed that there was *nothink in the whole Exhibition* that was worthy of the least notice—as our pictures wasn't admitted.

"So we followed about some of the gents., and thought we'd *Exhibit the Exhibitors;* among whom we remarked as follows. We remarked

MR. SNEAKER, R.A., particularly kind to MR. SMITH, a prize-holder of the Art-Union. N.B. SNEAKER always puts on a white Choaker on Opening day ; and has his boots *French pollish.*

"Presently we examined MR. HOKEY, a-watching the effect of his picture upon a party who *looks* like a prize holder of the Art-Union. Remark the agitation in HOKEY'S eye, and the tremulous nervousness of his highlows. The old gent looks like a flat : but not such a flat as to buy HOKEY'S picture at no price. O no !

"Our eyes then turned upon that *seedy gent.*, ORLANDO FIGGS, who drew in our Academy for ten years.

Fancy FIGGS's delight at finding his picture on the line ! Shall I tell you how it got there ? *His aunt washes for an Academician.*

"The next chap we came to was

SEBASTIAN WINKLES, whose *profound disgust* at finding his portrait on the floor, you may *imadgin.* I don't think that queer fellow

PEOMBO RODGERS was much happier ; for his picture was hung on the ceiling.

"But the most *riled* of all was

HANNIBAL FITCH, who found his picture wasn't received at all. Show 'em all u dear *Mr. Punch*, and oblige your consta reader, "MODEST MERIT."

38. Thackeray, *Modest Merit*

39. Ingres, *Antiochus and Stratonice*

40. Diaz, *View of a Forest*

41. Daumier, *Robert Macaire—The Connoisseur*

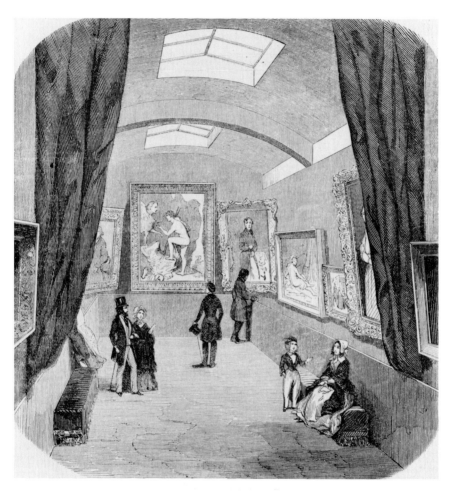

42. *Exposition in Beaux-Arts Gallery*

43. Gérôme, *The Cock Fight*

44. Couture, *Romans of the Decadence*

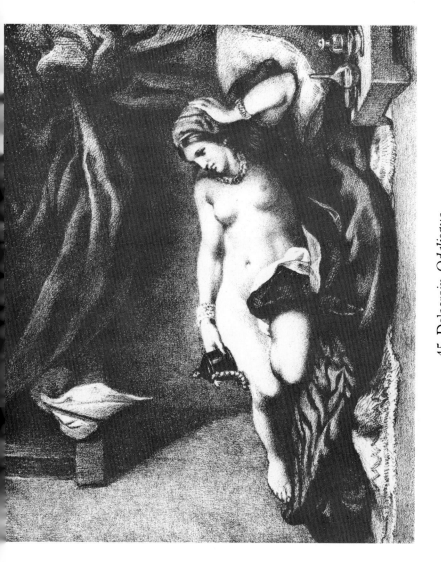

45. Delacroix, *Odalisque*

46. Clésinger, *Bacchante*

47. *Bertall Looking for the Best of the Republics at the Exposition of l'Ecole des Beaux-Arts.*

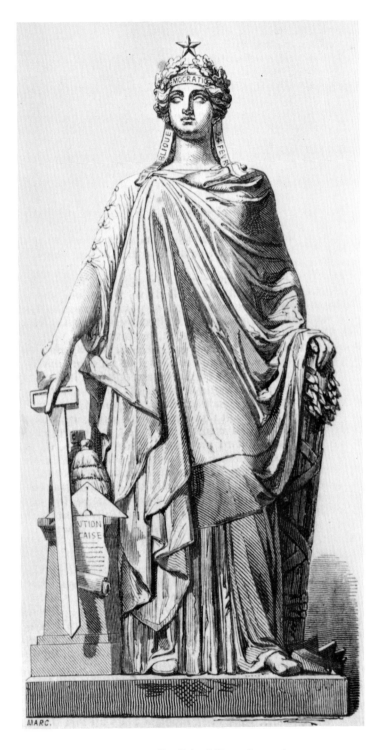

48. Soitoux, *La République française*

aware of the importance of the press for the realization of his political ideals, Thoré founded *La Revue républicaine* with Louis Blanc and the Arago brothers in 1834. The paper failed after a year, but Thoré continued to write for a variety of other papers.

As a follower of Saint-Simon, Thoré initially felt that art should be directed into a social, political and "philosophical" course. In an article, *"L'art social et progressif,"* that appeared in *L'Artiste* in 1834, he appealed to artists: "I repeat it, to depict current events, to penetrate to the core of the age, to give the fine arts their social character, that is the evolution that is to be accomplished."

Thoré supplemented his income with a *Dictionnaire de phrénolgie et de physiognomie* (1836), a subject made popular by the republishing of Lebrun's and Lavater's work. His contributions to *Le Siècle*, the outspoken opposition newspaper begun in 1836, increased through 1836 and 1837, while he continued to write articles for *L'Artiste* and *La Revue de Paris*. At this time he also, with Victor Schoelcher and H. Celliez, founded *La Démocratie* (1838) to defend his belief that a balance was possible between liberty and authority, collectivity and the individual.

In 1840, Thoré also used his position as a journalist to publicize a petition asking for reforms in the Salon jury. Since the mid-1830s the jury had been criticized by reviewers and artists because it regularly rejected from the Salon the works of artists whose talent was generally recognized. The petition of 1840, directed to the Chambre des Députés by a painter and engraver, Audry, was signed by four members of the Academy—David d'Angers, Horace Vernet, Paul Delaroche and Martin Drolling—who had in the past made a practice of abstaining from jury duty because of their disgust with the conduct of their colleagues. The petition resolved nothing: the Salon was actually held at the invitation of Louis Philippe, who owned the Louvre by virtue of an act passed in 1832, and the Chambres des Députés could do little to reform it. But Thoré's support

for the petition helped bring the issue to the attention of the public.

Revolutionary ideas were tolerated in art and literature, but when Thoré published a pamphlet, *La vérité sur le parti démocratique en 1840*, he was imprisoned for a year as an anarchist. Upon his release, he joined with a book dealer, Paul Lacroix, to establish Les Alliances des Arts, an agency for the sale and exchange of books and pictures. The organization also published a bimonthly *Bulletin des Alliances des Arts* (1842–48), which reissued as pamphlets the Salon criticism that Thoré wrote for the *Constitutionnel*, the daily paper resuscitated by Louis Désiré Veron in 1839.

In 1842 and 1843 the jury ignored the criticisms directed at it. In 1843 it was stricter than ever, partially or wholly excluding the works of Ary Scheffer, Hippolyte Flandrin, Louis Boulanger, Théodore Chassériau, Eugène Isabey, Léon Cogniet, Robert-Fleury, Charles Gabriel Gleyre, Jules Dupré, François Louis Français, Constant Troyon and Théodore Rousseau. In reaction a *Salon libre* was organized. Held at the Bazar Bonne Nouvelle, a covered arcade that had opened in 1838, it was not very successful: Boulanger did send a work, Barye showed elsewhere, and the landscapists Dupré and Rousseau did not show at all. As criticism of the jury mounted, it tried a new tactic in 1844 and admitted almost everything. Eight hundred more items than had been included in the catalogue of 1843 were listed; Corot's *Burning of Sodom*, rejected in 1843, was resubmitted and accepted under the title *Destruction of Sodom*.

Thoré's "Salon of 1844," published in *Le Constitutionnel*, was introduced by an open letter to the landscapist Théodore Rousseau. Rousseau, Thoré's neighbor since 1835, was one of a group of landscapists who, prepared by the writings of Chateaubriand and Jean Jacques Rousseau and the paintings of the English landscapists, began to see nature freed from the classical rules and to paint its moods and aspects as they saw them. The work of the group, which included Jules Dupré and Diaz

de la Pena and later Constant Troyon, had first been seen in the Salon of 1831. Opposed by the classical landscapists of the Salon jury, notably Joseph Xavier Bidault, in the following years their work was among that regularly denied admission to the Salon. In 1836, Ary Scheffer had opened his studio to the public to exhibit the work by Rousseau which had been refused that year. Under the leadership of Jules Dupré, the group publicly refused to send their work to the Salon of 1840. Only a few of their paintings were to be seen in 1844. Thoré had learned much from Rousseau as he developed his own approach to art and art history, and his open letter was an acknowledgment of this debt and his admiration, and an explanation of his own views. Thoré pointed out the difference between his and Rousseau's attitudes toward nature:

> Your love, O painter, is much more real. Painting is an actual conversation with the exterior world, it is a positive and material communication. It is a domination that you exercise over nature, and from this affectionate household a new being results, a creation that reproduces the elements of the father and the mother, of nature and the artist.

In his Salon reviews Thoré, who had begun as a reporter eager to find political philosophy and social import in contemporary works, used the exhibited paintings to elucidate an aesthetic theory. His conscious recognition that criticism was a creative activity spared Thoré any sense of frustration in explaining the art of his contemporaries. He gave himself firm footing in his criticism by constant reference to examples of art in the past as confirmation of excellence in contemporary work. Artistic sensibility and a knowledge of the history of art were the required tools of such a critic.

Théophile Thoré, "Salon of 1844"[1]

I. Confusion of the Exposition[2]
How are we to dive into this ocean of paintings and bring up some small and perfect pearls? . . . Where is art? Instead of art we find only industry. Ask these uninspired workers what the principle of painting is. They know nothing about it. Most of them will tell you that it is the imitation of reality. They could, therefore, be sent back to the daguerreotype and the darkroom. A figure of pink wax could be substituted for the *Venus de Milo.* Is music the imitation of reality?

Poetry, which is the principle of all arts, rhythm, sound, form or color, is exactly the opposite of imitation. It is invention, originality, the manifest sign of a personal impression. Poetry is not nature but the feeling with which nature inspires the artist. It is nature reflected in the human spirit.

Ask further of those painters what are the special means of their art. Are they not color, or harmony? They do not know. What key are they playing in? What is the dominant note in the harmony of their picture? Velazquez could have answered: "I am in the silvery-gray tones." Decamps would answer: "Grenadine or faded brown." Delacroix would say as did Beethoven: "My symphony begins in purple major and continues in green minor." Titian, Rembrandt, Rubens and Murillo had no trouble with this divine music, whose secret is not even guessed by the majority of the exhibitors.

In truth, the French school has never been strong in coloring but has almost always replaced that special talent of expression in painting that is color with an intellectual quality. The quality of the composition is the distin-

1 [Translated from *Salons de T. Thoré,* with a preface by W. Burger, Paris, 1868.]
2 ["Lettre à Theodore Rousseau" is omitted.]

guishing mark of our national artists and their main prin-
ciple of life. The principle of the Florentine school was
drawing, the curve of a line, the style of a form. The prin-
ciple of the Venetian school was color and light. The prin-
ciple of the Roman school was the general composition,
the arrangement and the staging of the subject. Our great
artists belong to Raphael's school with no less an amount
of logic and reason, even if without so much poetry. Pous-
sin and Le Sueur, and more recently Léopold Robert, be-
long to this system. Also the tendency of our school has
always been toward history, while Italian painting in gen-
eral aspires to poetry, and the Flemish and Dutch schools
reflect domestic life.

In every age there is a certain determining reason at the
basis of a native art, a logic that does not contradict it-
self. . . .

Today the French school, as it is presented by the
Salon, in the absence of glorious individuals who have not
exhibited their works, has no longer any rule, principle or
love. Composition, design, color show themselves seldom,
and only by accident. These artists, whose essential facul-
ties should be a shrewd eye, clear thinking and heartfelt
convictions, all follow in confusion after blind hazard.

Let us wander along the walls tapestried with paintings,
even as each painter's brush wandered over his canvas. We
will be forgiven if, in imitation, this review lacks system
and perhaps also style and color.

How many large canvases! How many large and heavy
figures for so little thought! How much time, how many
materials wasted! What will the future do with these im-
mense empty paintings? This sky three meters square
could be contained in a little corner several inches square.
Ruisdael did not need as much as that to express the
tempest of the air and the depth of infinity. . . .

There are in the Salon several hundred canvases more
than ten feet square. It is ten times, a hundred times too
much. The majority have been commissioned for the mu-
seum at Versailles or for provincial churches. Neither art
nor religion will gain anything from them. The religious

paintings have lost their significance; the historical paint-
ings are interesting only because of their subjects. How-
ever, here is a picture that attracts the eye. It is *The Fed-
eration* at the Champ de Mars in 1790[3] painted by M.
Auguste Couder. It is said that Louis Philippe often went
to watch M. Couder at work in the studios of the Louvre.
He was able to provide memories of the Duc de Chartres.
Nevertheless, it would appear that the painting has not
caught the feeling of this great national celebration. The
composition lacks any sense of unity. One looks in vain
for the center of the action. Is it the group of Louis XVI
and his family? Is it the altar at which Talleyrand con-
ducts divine service? Is it the Constituent Assembly? Is it
the municipality of Paris? The eye loses its way in the de-
tail, without being able to grasp the whole. One notices
only the small, brilliant figures in the foreground who are
ascending the stairs; the individual episodes eclipse the
main point. . . .

M. Couder's picture is like a play whose five great acts
are filled with anecdotes, more or less *piquants*, which go
far beyond any dramatic conception. A few facile verses, a
few witty and glittering words are not enough to save the
play. Compose a madrigal or a couplet if drama and com-
edy are beyond your capabilities. Historical painting, like
serious theater, demands unity, clear-cut action and out-
standing thought. Be a Gavarni, a Charlet or a Daumier if
you cannot attain the stature of a Paul Veronese, a
Raphael or a Poussin. It is better to be a good lithog-
rapher than a mediocre painter. Sancho preferred his joy-
ful donkey to Don Quixote's sad charger. . . .

M. Eugène Isabey is also one of these improvisors who
do not have time to work on a picture. To paint at the first
attempt a work worthy of praise, more than talent is
needed; there must be genius. The great masters, in fact,
are admirable in their studies and in the least of their
sketches. Often a rough outline has more style and vigor

[3] [Celebrated on the Champ de Mars, July 14, 1790, the Fed-
eration marked King Louis XVI's acceptance of the Constitution
drafted by the National Assembly.]

than the finished work. However, these preliminary studies should be [considered] only as motifs destined to become part of a more conscientious and severe elaboration. *The Meeting of King Louis Philippe and Queen Victoria*[4] in the anchorage of Treport has brilliance and spontaneity; the color is rich but false. M. Isabey is happier with his little marine paintings. . . .

II. Memories and Regrets

Where is the time of those great arguments that impassioned the artists and the critics? An effect of light, the expression of a face, the turn of a limb caused great excitement then. At that time it was necessary that those figures who allowed themselves to appear in the public theater have the good taste to cut a certain figure and play their roles bravely. The drama depicted on canvas was taken seriously, like the dramas that were played on the stage. Sigalon's *Athalie*, Eugène Delacroix's *Dante* were compared to the spirit of Racine's play and to the spirit of the immortal Italian poet. *The Massacre at Chios* caused swords to be drawn as did *Hernani* by Victor Hugo. . . .

Where is the time of the *Locusta* of Sigalon, of *The Raft of the Medusa* by Géricault; of the *Death of Sardanapalus* by Eugène Delacroix, of the *Turkish Patrol* by Decamps and even the *Fishermen* by Léopold Robert or *The Martyrdom of St. Symphorian* by Ingres? Mediocrity has replaced inspiration in artists; indifference has replaced interest in the public. One could have expected better things of that feverish crisis that promised a complete reestablishment. In literature, at least, the romantic insurrection conquered a clever instrument, a showier and freer practice. The literary movement has continued with notable progress. The writings of George Sand, for example, join to the eloquence and the conviction of J. J. Rousseau the elaborate and fantastic allures of the nineteenth century. In painting, French tradition is lost as far as a mode of thought is concerned. It was in vain that Louis David,

[4] [Queen Victoria and Prince Albert visited Louis Philippe, for five days, September 2–7, 1843.]

indirectly taking up again Poussin's work, resurrected the
heroes of history. The contemporary school renounces
French genius that is the preoccupation with great civil
and social movements. In the same way, as far as form is
concerned, present-day painters are not taking any better
advantage of the conquests of the romantic revolution.
Even so, the two schools that have succeeded each other
since the end of the eighteenth century could have pro-
duced a national art full of life and originality by combin-
ing their elements. Yes, [Louis] David was right in evok-
ing Socrates, Leonidas and the Horatii; for these are the
characters that the memory of men should eternally
preserve; and the reproduction of high points of history is
a fruitful allegory for the current generation. Yes, Géri-
cault and Delacroix were right, for the same reason, when
they painted the dramas of contemporary history; for the
domain of art is infinite: all of humanity, all of nature, be-
long to it. Art is everywhere, it is only necessary to see it.
Artists are those whose glance seizes an image and a feel-
ing and whose skilled craft knows how to reproduce this
impression in a particular way. When nature or meditation
give you an abstract idea, you are a philosopher; when
they create within you living forms, you are a poet; if you
have the divine power to draw these animated beings out
of your head, with distinctive color and normal propor-
tions, you are a painter.

The exhibitors in the Salon of 1844 are not in the least
tormented by this interior spirit, this poetic flame, as it
was called in the seventeenth century. Painting is no
longer anything more than a vulgar trade, as are all the
other professions. Art for art's sake was worth more than
this. Each one, at least, tried to distinguish himself
through a certain interpretation of nature, through an orig-
inal feeling. Today you may walk the length of the galler-
ies of the Salon without having any characteristic work
catch your attention. All the paintings are alike. One
would think them the products of the same factory. . . .

Some artists, however, do recommend themselves
through individual qualities. The paintings of Corot,

Leleux, Diaz, Couture, Marilhat, Muller, Glaize, Charpentier, Français, Aligny; the portraits by Lehmann, Louis Boulanger, Gallait, Perignon, Alfred Dedreux, and others merit a special examination.

Corot is a landscapist much appreciated outside the Institute, who refused him, again this year, a painting. The three landscapes by Corot are incontestably among the best in the exhibit: *View of the Roman Countryside*, *The Destruction of Sodom*, *Landscape with Figures*.[5] The latter is in the Salon Carré. It represents a sort of open-air concert in the midst of a harmonious and melancholy landscape. Some imaginatively draped figures are playing musical instruments in the shade of great mysterious trees. Corot's compositions involuntarily recall antique idylls. His modest and solitary talent inclines him to a touching reverie that is reflected in his painting. He has never sinned through ambition for a pompous show. His figures do not make much of a stir in his tranquil landscapes. The aspect of the whole is always very accurate. A soft light, well-managed half-tones, envelop his whole composition.

We must not ask of him the heat of the western sun and those shadows that cut the earth; but the evening wind sways the elegant branches of his trees and caresses the hair of his little figures. In his open-air concerts it seems that the sound of the instruments mingles with the movements of the air. While a half-naked young woman touches the strings of a violoncello, a young girl stretched out on the grass listens contemplatively. Some other figures are scattered in the background of the landscape; *Fortunatus nimium agricolas.* Luckily, there is no danger that the bucolic poetry of Corot will remove us from the agitation of a political society; but it is a contrast to our contemporary customs, like poetry in the time of

5 [Neither of the two pictures last mentioned exists now as exhibited in 1844. Corot painted over them. He retained the title of the first but changed the second to *The Concert* and exhibited it in the Salon of 1857. See A. Robaut, *L'oeuvre de Corot* (Paris, 1965), pp. 168, 344.]

Augustus, the Epicureanism of Horace and the *Aeneid* of
Virgil.

The Destruction of Sodom managed to pull Corot out
of his usual placidity. It is a scene of a great disaster, in
which earth and sky are confounded. The tempest blows
on a city the color of ashes; great trees are stripped of
their branches; desolation covers nature, and Lot's family
flees in the foreground, pursued by livid reflections. Don't
look too closely at Corot's figures; they are slapped to-
gether with large abrupt strokes, which sacrifice micro-
scopic detail to general effect. This incomplete style has,
at least, the merit of producing a harmonious whole and
an arresting impression. Instead of analyzing one part, you
experience an emotion. . . .

Here we have Diaz. This man does not fear the most
brilliant light. His pictures are like a pile of precious
stones. The reds, blues, greens and yellows, all [are] pure
tones and all combined in a thousand different ways, their
brilliance gleaming from every point in his pictures; it is
like a bed of poppies, tulips, bouquets scattered under the
sun; it is like the fantastic palette of a great colorist. It is
impossible to risk more and to succeed better. Diaz has
carefully observed the most virgin corners of the forest of
Fontainebleau. He has caught the effects of autumn that a
more cultivated nature could not offer. The trees, the ter-
rain, the shadows of his landscapes have strange and po-
etic aspects. The *View of Bas-Breau* is an excellent study,
altogether removed from any vulgar feeling. One must be
a great artist to see the landscape in such a way and to
paint it with a courage worthy of the Spanish masters.

The Descent of the Gypsies is somewhat inspired by
The Descent of Cows in a Swiss Ravine by M. Théodore
Rousseau. All friends of beautiful painting know this curi-
ous work by Rousseau, which was for a long time exhib-
ited at Ary Scheffer's studio after having had the honor of
being refused at the Salon. Along the length of a steep
road, shaded by somber vegetation, several herdsmen with
their herds are going down into a plain with huge grasses,
into which the cows are plunging up to their chests. Diaz,

borrowing the general design of this poetic composition, has changed its character to accommodate his subject. Instead of its mystery and solitude, he has animated his picture with an exuberant joyfulness and a sort of extravagance. His Bohemians, mottled with a thousand colors, with costumes of every country, with the most varied shapes in the world, lurch along to the bottom of the path. Some are lost in the bushes; but the Bohemians always get back together again, and they are too spirited to miss the festival. . . .

Couture has, like Diaz, good qualities as a colorist and a craftsman. His large painting titled *Love of Gold* is given much attention by artists and even by the crowd. The light that shines on the chairs is admired, with reason, as is the strange physiognomy of the characters. A man with uncombed hair, with hollow cheeks, with a wild and restless look, defends his treasures against the passions that assail him from all sides. His hands grasp despairingly the piled-up coins. Will he resist that beautiful half-naked woman who provokes him with her round shoulders and her dimpled thighs? Poetry who attracts him and wishes to dictate to him the language of the gods! Will Plutus[6] triumph over all the gods of ancient Olympus? Our man seems to belong to the nineteenth century, and one can wager that Apollo will be vanquished.

This painting is organized like works of Valentin and Caravaggio. The figures, life size, are cut at the mid-point. Couture's talent lends itself well to large compositions. He has a certain largeness and liveliness. He distributes light and shadow freely. Perhaps he is still lacking the positive science that binds all the members of a figure of heroic proportions solidly together.

Couture is young, according to what they say. Study and experience may give him, in time, that certainty acquired in former times in the great Italian schools through the daily teachings of the masters, through strong traditions and infallible methods. Unfortunately, the painters of today are abandoned to their own efforts and often they

[6] [The god of wealth.]

repeat to their own cost and for a complete loss experiments whose result is already known. This, above all, was the excellence of the sixteenth-century schools: they gave young artists the secrets of a craft verified by genius. After a novitiate in the studio of Raphael or Michelangelo it was only necessary to be a poet. The craftsman was formed. . . .

III. [Landscape]

. . . The quality of composition is so essential that it is the principal one, even in landscapes; and it is through it that the masters have ensured the viability of their works. This quality can be felt in the great lines of Poussin and his school. For nature has its unity, its ensemble, its physiognomy, as does human society. When you look at an immense horizon, or the smallest landscape, you do not have a circumscribed picture before your eyes, but the elements of a picture. Talent consists of framing a main effect by the accessories. The old classical school of landscape painting had a saying, which, in truth, did not make it produce masterpieces, but which reunited it with the tradition of the great schools. It said: A *composed* landscape. The simplest motif takes its importance from the good qualities of the composition.

The Dutch and the Flemish, those naïve and modest artists, themselves owe a part of their merit to it. Ruisdael was perhaps not a very subtle philosopher, and the little *Thicket* that is in the Louvre does not exhibit profound thought. It is a poor little bunch of ill-combed thorns and scrub on a small rise; to the left the countryside stretches out to meet a gray sky; on the right a luminous path leads to a little house. But this little thicket, is it by accident that it finds itself here on a throne of rocky ground covered with some moss disguised as velvet and gilded nails? In my opinion, the *Thicket* by Ruisdael resembles the melancholy statue of Lorenzo de' Medici by Michelangelo that ornamented the tomb of Julius II and is called in Italy *The Thinker*. The warrior, tired of life, has withdrawn into himself, his back is bent in an arch; his elbow rests on his thigh and his hand supports a bent head. The

little thicket, worried by the tempest that whips it members and bends its head, also rests from the tumults of nature. Its leaves fall back on its desolate branches and it seems to groan in its solitude.

If there is so much composition and feeling in a little corner of wild countryside, then what is a painting by Raphael or Poussin? Poussin, so sober in his paintings, so sure of himself, you must see with what perseverance he studied his compositions. There are perhaps a hundred sketches by Poussin on the subject of *Moses Saved from the Waters* for three or four paintings that he did. And what singular drawings, in ink or crayon; they are as rapid, as temporary, as vague as the painting is calm and correct! They are the transports of a spirit tormented by the search for perfection. The most spontaneous painters have often had, like all the others, this inquietude. The organization of *The Raft of the Medusa* is not brilliant and has justly been criticized in a thousand ways. And yet, how many studies Géricault did for it! Ary Scheffer possessed more than a dozen of them, not to count those of M. Étienne Arago, of M. Marcille, and of several other amateurs. You noticed one above all, very characteristic and very interesting in explaining Géricault's passion. On the margin of a large study for a different subject is found a little sketch of the raft that the painter threw out as a new image jumped into his mind.

And Robert, how many preliminary sketches for his favorite paintings! Did he not change ten times the organization of his *Fishers of the Adriatic?* M. Marcotte has the principal studies, both in ink and in oil. The transitions of the artist's genius can be seen there in its ultimate arrival at a masterpiece.

There is a man who enjoys a reputation everywhere in Europe, with a talent that is without true poetry, without inspiration and without style, the painter of *The Execution of Lady Jane Grey* and of all those well-conceived, if not well-executed, dramas, over which the crowd waxes enthusiastic at the exhibition. To what does Paul Delaroche owe this partly legitimate success? To the general organi-

zation of his subject, to the skillful arrangement of the picture. . . .[7]

V. Woman and Child

Nothing looks better on the branches of an apple tree than apples. The most beautiful oranges would not look as well there. Nothing looks better with a woman than a child. Her natural fruit ornaments her more richly than stones torn from the breast of the earth. The handsomest collar a man can have is the two arms of a woman who loves and is loved. The most precious jewel for a woman is the infant she carries at her breast.

Woman and child, mother and son, the Virgin and Jesus, Charity, Fecundity, Motherhood—what masterpieces have been made with this symbol and this image. The entire Middle Ages were inspired by these. From the eighth to the sixteenth century, Christian art can almost be summed up by the Virgin and Child. In the Renaissance it was again the pure and motherly woman who animated the genius of Raphael. The most magnificent Andrea del Sarto is the *Charity* of the museum, that powerful nurse, with the flocks of children hanging around her neck, at her breast, around her legs, on her arms. Each of the noble artists of the Middle Ages and the Renaissance painted his Madonna and Child, and this was always, up through the eighteenth century, the favorite subject of the masters in all the schools, around Titian, the Carracci brothers, Rubens, or Murillo, and all the others.

It has never been pointed out that never does Greek art depict a mother with a child. Search through your memory, what statue, what group, what bas-relief in all the Greek or Roman works depicts woman and her fruit, indicates that attachment and that unity of the two beings? In ancient paganism, each individual was separated from his species, as each people was limited in the midst of other foreign tribes. When children were carved, they were carved alone, as were adults, and occupied with an independent action. It is *The Child with a Goose*; it is

7 ["Section IV, The Portrait" is omitted.]

Cupid sharpening his arrows. In Greek art it would seem that children arrived by accident and without a link with others of their kind. If perhaps a child is found in a group, it is a little Bacchus between the nymphs, like the Jewish Moses in the midst of Pharaoh's daughters: a passing child who has arrived there by unknown means. The quest for motherhood is forbidden. Odd thing: pagan gods often have several mothers. Motherhood had so little importance in the ancient world that it was left in doubt. Who is Bacchus' mother?

And in the case of the Romans, there is also one birth, one nursing and one education carved on monuments, in marble, in stone, on medals: it is the birth of Romulus and Remus. The Mother, the nurse, is a wolf!

The observation is unusual and new, and is worthy of the trouble of making it. Woman is nothing in the art of these beautiful civilizations. She is nothing as mother and as wife, as a creature endowed with intelligence and feeling. She only exists in the role of Venus, or in other words, Voluptuousness. If one takes as example the Cupids who sometimes accompany the pagan Venus, one would probably not think of Cupid as the son of Venus. Cupid is her attribute and not her fruit. She is supposedly created by and for love, rather than giving birth to love. . . .

Many things are lacking in Greek art in relation to our modern ideas. It lacks nothing, assuredly, in form or in execution. Given a certain conception of life, Greek art expresses it with overwhelming superiority, and the art of no other time has achieved such perfection. However, mankind grows and gives art new inspirations and concepts. . . .

Christianity, without doubt, owes its historical power and its archaeological interest to this new conception of life [this conception of mother and child], the germ of the family and of human fellowship. Besides this type of Virgin mother, Christianity has also introduced into art the subject that is treated again and again in every different fashion. This is the Holy Family. It is not enough to link

the child to the woman. The woman and child must be linked to the man. This insoluble trinity is all of humanity. Christian art, then, has had an affection for the Holy Family more than for any other subject. But its family is still false and incomplete: where is the father and husband? We see him as the devoted and obliging protector; but St. Joseph is not the patron saint of married men. . . . There is a more poetic family than that of Christianity, it is the Holy Family of Mankind, equal and independent.

There is something lacking in Christian thought from the point of view of art and poetry. We can hope in the future for an art more and more complete, expressive and religious, as the consciousness of life and the inspiration of truth develop in modern societies. Thus, form is not everything in art. The principle of art is the ideal, feeling, and invention. . . .

VI. The Devil and the Landscapist

One day the Devil, traveling around, saw in the corner of a wood a young artist painting a picture. The Devil, who likes to look into everything, ran to look over the painter's shoulder at the painting; and since he likes to say everything, he whispered into the artist's ear, "You are in love." "That is true," answered the artist, "but what shows that I am in love?"

Without being the Devil of Hoffmann's[8] stories, one can tell, by looking at a picture, even a landscape, what ideas preoccupied the painter, what his emotions were. Four or five years ago Théodore Rousseau had the misfortune to lose his beloved mother. For a long time his landscapes were unbelievably sad. He saw only the most savage and desolate corners of the forest of Fontainebleau, or the blackest aspects of the Auvergne countryside. I have before my eyes a landscape from this period, a picture of evening and of a storm at the edge of a forest. The wild earth

[8] [Theodor Hoffmann (1776–1822), German critic of music and author of romantic fantasy, was a major figure of the German romantic school.]

is burned and studded with ruins of trees, with shattered trunks, with dead limbs, and dry leaves drifted by the wind, with rusty stones in brown, gray and bluish tones, like the reflections of an old rusty suit of armor. The trees are blasted and leafless, rotting; they have barely preserved some rusty leaves similar to the remains of a fire. There is no sky above these trees. A heavy, somber, impenetrable atmosphere broods over this composition, which is analogous to the *Erlkönig* by Schubert,[9] without Rousseau having thought of it. One suffocates in this painting. There is no air, no life. Only, on the horizon, the length of the line that unites earth and sky, there is a lurid light, a tumult of phosphorescent clouds, agitated like the waves of the sea, and a tiny rider can be seen losing himself between the trees. Wrapped in a cloak the color of dead leaves and bending over his black horse, he fights the tempest. He is doubtless hurrying to arrive at a hut the roof of which is revealed in the distance by the lightning flashes. The only things lacking to illustrate Schubert's ballad to perfection are the son in the rider's arms and the phantom in the clouds.

It is true that Rousseau is, beyond comparison, our leading landscapist. The supreme quality of his paintings is the rarest quality in all the arts: poetic feeling. Among the old masters, and among the leaders of every school, there is no one who loves nature better or who understands it better. There is none more spiritual, in the sense that he penetrates the inner life of nature, that he reacts to all its agitations and to the least movements of its face. A lover does not follow more carefully the secret feelings of his mistress. Rousseau shares, to a certain extent, all of nature's passions. He reads, in a manner of speaking, with nature's eyes; he worries about the light's paleness, the wind's fever, the tree's health. He shivers with the tempest, or he shines with the sun. No one expresses so well the character of a landscape; for he has the gift of color in the same degree as that of poetry. Thanks to this double strength, he has painted the most difficult aspects

9 [Goethe's *Erlkönig* set to music by Franz Schubert.]

of nature, storm and rain, spring and fall, evening and
even night, the rising and the setting of the sun. Only one
artist has done a better sunrise than Rousseau's picture; it
is George Sand in her novel *Lélia*.

One must be mad to imagine that it is possible to copy
a landscape. The lovely theory of the imitation of nature
is even weaker here than anywhere else. Have you ever
seen the same effect in the sky or in the country for two
consecutive hours? The face of nature is even more
changeable than the face of man. Earth, spinning eter-
nally on its way, takes on all colors and all forms, under
the rapid caress of light. Fortune and the seas are less
changeable than the sun. In landscape there are only fleet-
ing expressions and capricious effects that can be repro-
duced by means of visual memory and poetic invention.

You know the history of that unfortunate de Laberge,
dead so young in the pursuit of an unattainable goal. This
was a man who spoke marvelously of his art, and who in
the beginning painted profusely and vigorously. Unfortu-
nately, he got it into his head that the landscapist should
study and conscientiously depict the smallest detail of na-
ture. His first trial of this system produced a sheep and an
old woman, scrupulously, patiently and painfully rendered
in miniature on a tiny canvas. Even though the system
was absurd, the talent and the persistence of the artist
drew attention. But de Laberge was not content with his
work. He resolved with new tenacity to undertake the
exact copy of a bit of landscape. He chose a small elegant
bush growing against a piece of wall. Then, saying good-by
to Paris and his friends, he rented a small house near his
dear bush and began his work, similar to the work of the
Danaë, as you will see. As he was trying to sketch the
bush's general lines, the wind moving the light branches
annoyed the stubborn Utopian. Alas! Morning, noon and
night, our bush passed ceaselessly from shadow into light,
from sadness into joy, from one half-tone to another. The
painter had barely placed a tone on his canvas when the
subject's tone would change. Alas! Each day brought terri-
ble cataclysms to the little world that de Laberge contem-

plated endlessly with anxiety. The cruel wind tore a leaf
from a branch; the mortar of the wall fell away bit by bit,
opening holes and shadows between the stones; an almost
invisible insect gnawed a shoot with an obtinacy equal to
that of the painter; a branch grew and lengthened, with-
out worrying about the proportions already laid down.
Sometimes, while the sun was rising, he found on his bush
a silver curtain; the web of an industrious spider. All na-
ture conspired to change. The dew, the wind, the sun, ev-
erything distorted his microcosm. What ceaseless activity!
What mobility! What life!

And when fall came, how could he continue the paint-
ing begun in the summer? De Laberge wrapped himself in
his cloak through the winter, stoically awaiting the rebirth.
But the following year the little bush no longer resembled
the bush of last spring. This courageous artist kept on,
however, for three years, it is said. No wonder he died!

Many landscape painters are set on the theory of the
imitation of nature. But they do not have, happily for
their health, the perseverance and the restlessness of M.
de Laberge. The search for art in these false conditions
will not kill M. L. Cogniet and the so-called realists, who
have, at least, the moderation of mediocrity. It is only
given to a man of a certain character to persist in these
ambitious tournaments. . . .

This is the difficult part of landscape: to harmonize sky
and earth. We believe that the majority of landscape
painters are wrong in always beginning their paintings
with the actual structure of the site they wish to repro-
duce and trying subsequently to make their sky fit in with
the terrain and the trees. Skillful restorers of old paintings
know how difficult it is to retouch a sky, while it is quite
easy to retouch the other parts of a painting if the sky is
intact. Similarly, in a landscape composed by an artist,
when the sky is done the rest of the painting is safe. Then
it suffices to have a feeling for harmony and enough pa-
tience for the work, for the effect produced on a country-
side is always the result of the light from the sky. But how
difficult is this passage from the infinite and vague atmos-

phere to the real and finite form of daylight image! We
have seen Rousseau, whose talent is one of the most curi-
ous lessons for artists, labor on a dozen consecutive paint-
ings to express the true harmony of this mingling of sky
and earth, of sun and nature, on the distant line of the
horizon. A precise and positive separation is never there,
no mathematical and inflexible line; for all light eats away
slightly the borders of the image it illuminates.

Some painters have found a very simple but very radical
way of avoiding the difficulties of light and color. They
have quite frankly eliminated the sun from their land-
scapes. The procedure is a little unceremonious. Also, vari-
ety, movements, charm and life have left their pictures
with the sun. Almost the entire school of Ingres, in land-
scape as in other types of painting, has made this unhappy
sacrifice. Paul Flandrin has enjoyed himself at length in
this obscurity. He has a feeling for style and sometimes a
certain elegance; but no light. His landscape audaciously
entitled *Green Oaks* shows only flat gray oaks. For it is
light that models figures in addition to giving them their
color. All M. Flandrin's pictures look alike, trees being
like cats: at night all trees are gray.[10]

The quality of color is so necessary in painting that it is
impossible to be a painter without being, first and
foremost a colorist. No other quality can replace this one.
When you have started by giving up light there is no way
of becoming a skillful craftsman. . . .

VII. Sculpture

The majority of sculptors are very wrong in seeking
their model almost exclusively in the past. The golden
age is before us, as Saint-Simon said. However, while
painters have been mainly studying reality, sculptors have
been mainly studying tradition—an incomplete and sterile
method. It is within themselves, in the feeling of immor-
tal life, that artists should find inspiration after, however,
contemplating history and nature—for to study is to un-

10 [Thoré paraphrases the proverb, "*Dans la nuit, touts les
chats sont gris.*"]

derstand and to interpret. The three essential elements of art, like those of philosophy, science and any intellectual creation, are the external world, humanity and man himself. Nature and tradition should unite themselves within the heart of the artist in a mystic marriage that will produce offspring. This is the law of all spiritual generation, as well as of all natural generation.

This principal element in poetry, the living element of individual genius, which expresses itself in the creative interpretation of nature and of history, is, however, the most neglected in our contemporary school of art. Above all spontaneity and creativity are lacking in our artists. Manual dexterity, skill and a certain practical talent are noticeable in our sculptors, more so than in our painters. But lacking any inner poetry, they hardly ever produce anything but trite and ordinary works, without character and without beauty.

Where are character and beauty in antique sculpture? In the expression of the ideal that the artists felt in their own hearts. Ancient thinking was so clear, so well defined, that it was incarnate in form with a rare perfection. But again, feeling in the modern world is the antithesis of that in antiquity. Since our ideas and our methods and our civilization have changed, the poetic faculty, that second sight, which is the most discerning and the most lucid, cannot visualize life as the Greeks visualized it; form must change along with ideas. . . .

The physical world itself protests against the plastic imitation of Greek or Roman art. The human form has changed perceptibly since the pagan era and in a manner similar to the revolution of the spirit. It is above all phrenology that, in studying the conformation of the head, has shown these singular differences. When, at the end of the eighteenth century, Winckelmann—that grand resurrectionist of marble fossils, that Cuvier[11] of art—

[11] [George Cuvier (1769–1832), noted for his system of zoological classification, wrote Mémoires sur les espèces d'éléphants vivants et fossiles (1800) and the more celebrated Recherches sur les ossements fossiles des quadrupèdes (1812).]

gave, with his ingenious fanaticism, the formulas of an-
tique statuary and the rule of proportions used in Greek
figures, he stated that the forehead, to be beautiful, should
be short. Later, he spoke ill of Bernini and other sculptors,
those "corruptors of art" who have lengthened foreheads
in modern statues. It is certain that in the case of the
Greeks the average length of the head above the line of
the eyes was only one and a half times the length of the
nose. Today a well-shaped head has twice this length, that
is to say, the horizontal line of the eyes cuts the head in
half. All other proportions of Greek statues were in har-
mony with the head. Therefore, the Belvedere Apollo is at
least twelve heads high. . . .

There is, then, only one fruitful method of borrowing
from tradition: it is to see that which our predecessors
have done within the structure of their time, to penetrate
their methods of interpretation and to express oneself
each in his turn, with a lively, spirited and completely
original inspiration.

Since Coustou's school, great sculptors have been rare in
France, but not skillful craftsmen. Caffieri, the creator of
the busts of Routrou and Corneille at the Comédie Fran-
çaise,[12] and Houdon, the creator of the statue of Voltaire,
must be mentioned. The sculptors of the Empire were not
capable of leaving even a bust of Napoleon; it was [Jacques
Louis] David, the painter of the Revolution, who at their
default executed the equestrian statue of the Emperor on
the Alps in the famous portrait painted in relief.

David [d'Angers], the sculptor, has successfully at-
tempted to regenerate our school; it is he who has been
the most productive for the past twenty years. He has sent
his works everywhere to the cities of France and to the
cities of other nations. He has the merit of seeking to ex-
press thought simultaneously with the grand style, and his
execution is absolutely masterful. Barye has restored to
sculpture an element that had been completely forgotten

[12] [Thoré published "*Étude sur la statuaire française du dix-
huitième siècle*," based on the busts in the foyer of the Com-
édie Française, as an introduction to his *Salon of 1847*.]

by several generations of artists, the element of fantasy and of finesse and of vivacity. Barye is a man from Benvenuto [Cellini's] century. Several other artists, such as Antonin Moine, Pradier, Préault, Foyatier, du Seigneur, Maindron, et cetera, by different qualities have contributed to reanimating French sculpture. Today the school is very skillful and the Salon has popularized some young talents. . . .

1845

PARIS and MUNICH: The Official
Exhibition of the State
and
LONDON: The Exhibition
of a Semi-Official Society

In 1845, in addition to the annual academy exhibitions in
Paris and London, there was, for the first time in seven
years, a major exhibition in Munich. In each capital re-
ports on the academy exhibitions at home and abroad ap-
peared in a local periodical devoted to the fine arts, whose
success in reporting the general news of the art world and
reviewing exhibitions of art dealers and auction houses
attested to the increasing desire of the new patrons—
merchants and manufacturers—to know more about con-
temporary painting and sculpture.

Reporters sent abroad to review exhibitions saw their
compatriots' entries side by side with the work of the for-
eign school. Eager for recognition, German and British
artists sent their work to Paris, for it continued to be the
center of European art as it had been in the eighteenth
century when London and Munich modeled their acade-
mies and exhibitions on the French example. French
paintings and sculpture attracted attention in exhibitions
in other capitals. Everywhere foreigners' work was meas-
ured against local work and the comparisons fostered an ir-
resistible spirit of competition. Loyal support for native

artists was encouraged and methods to improve the quality of their performances explored.

In Paris the 1845 Salon jury accepted a relatively large number of works, but they were not indiscriminate in their choices: four paintings by Delacroix were accepted, a fifth, *The Education of the Virgin*, painted for and at the home of George Sand, was rejected. Complaints voiced by artists and critics at the unfavorable placement of some works were met as formerly by closing the Salon for a week to shift canvases from poor locations to better ones. Some artists' frustration with their continuing exclusion from the Salon was slightly allayed by exhibitions arranged by art dealers and furniture rental establishments from which paintings could be rented for a week, a month or longer.

The dean of Parisian critics, Étienne Delécluze (see 1827: PARIS), wrote for the leading daily, the *Journal des débats*. His opinions, expressed with unquestionable sincerity in simple, direct language, had appeared on the front page of the paper since 1822 and were popular with its readers. Delécluze had formulated the principles by which he judged art in the introduction to his *Précis d'un traité de peinture* (1828) and in his *Notice sur la vie et les ouvrages de Léopold Robert* (1838), an artist who Delécluze felt judiciously combined the classical tradition with contemporary tendencies. Between 1838 and 1850 he published his translations of Dante, the first in French, studies of Italian history, a novel, and some short stories, as well as criticism. Only two of his Salons for the *Journal des débats* were to be published separately, *Exposition des artistes vivants 1850* (1851) and *Les Beaux-Arts dans les deux mondes en 1855* (1856). Reporting on the Salon of 1845, Delécluze voiced the doubts about the new school of landscapists that were shared by classical landscape painters.

Among the first of the European art magazines able to maintain publication was *L'Artiste* of Paris (see 1833–34: PARIS). Founded in 1831 by Achille Ricourt, the magazine had become as indispensable to the liberal circle of art patrons as Landon's *Salons* had been to an earlier pub-

lic. In 1842, Arsène Houssaye, a versatile writer and friend
to Jules Janin, Théophile Gautier and others, was named
its editor. Several novels by Houssaye had been published—
the first two when he was only twenty-one—and these
were followed by *Galerie de portraits du XVIII*ᵉ *siècle*
(1844) and *Histoire de la peinture flammande et hollan-
daise* (1847). After taking part in the Revolution of 1848,
Houssaye would be made director of the Comédie Fran-
çaise in 1849. In 1855 he would leave *L'Artiste* and the
following year would be appointed inspector general of
France's provincial museums. His final works would in-
clude *L'Histoire de l'art français* (1860), *Von Ostade, sa
vie et son oeuvre* (1874), and *Jacques Callot, sa vie et son
oeuvre* (1875). Houssaye's approach to painting was ro-
mantic and literary and his youthful review of Delacroix
in *L'Artiste* in 1845 was an "artistic" commentary tinged
with the condescension of a man *des belles-lettres* for
those who work with their hands.

L'Artiste's complete report on the Salon was assigned to
twenty-four-year-old Paul Mantz, an aspiring poet from
Bordeaux. Supported by a post in the Ministry of the Inte-
rior, acceptance at *L'Artiste* launched Mantz on his life-
long career as influential critic and historian. He would
write for *La Revue de Paris, La Revue française* and *Le
Temps* as well as *L'Artiste*, would be a collaborator of
Charles Blanc, founder and editor of the *Gazette des
beaux-arts*, on Blanc's *Histoire des peintres* (1845), and
would write his own volumes on Holbein, Boucher and
the Salon of 1889. Mantz's rather sarcastic treatment of
the battle paintings in the Salon of 1845 reflected the
opinion of innovative artists and critics, not that of the
public, hungry for national victories, who were attracted
to Vernet's sixty-seven-foot-long painting of *The Taking
of the Smalah of Abdel-Kader.*

The Royal Academy exhibition of 1845, affected by
other events in the English art world, demonstrated
the difference between British and French patronage. The
battle and history paintings which fascinated the French
public were commissioned by the French government. In

England, where private patronage predominated, portraiture and genre dominated the Royal Academy exhibitions. A certain respect for the "higher" forms was maintained. Britons came to admire the work done by artists in Germany, where history painting was sponsored by the courts in the small principalities. English artists and connoisseurs had become acquainted with the work of German artists when Charles Eastlake and others associated with the Nazarenes in Rome (see 1819: ROME). The Nazarenes' later work executed in fresco in Germany and that of the German genre painters were viewed with enthusiasm by the English. Interest in the "higher" forms and in the German example was a major factor in the British government's decision to sponsor the decoration of the Houses of Parliament, being rebuilt after the fire of 1834.

Parliament's patronage venture was, however, to be cited by the *Art Union Journal*'s anonymous critic in 1845 as a reason for the mediocrity of the Royal Academy exhibition. In 1841 a Select Committee on the Fine Arts headed by Prince Albert had proposed the decoration of the buildings with historical scenes executed in fresco—the medium revived by Peter Cornelius for his state commissions—as a means of encouraging all branches of the arts in Britain. Since 1843, when the exhibition of competitors' designs was held, the painters whose designs were chosen—William Dyce, an associate of the German circle in Rome, C. W. Cope, E. M. Ward, J. C. Horsley, Daniel Maclise, John Tenniel, and G. F. Watts—had received no funds, yet were fully occupied, so little of their work was seen at the Royal Academy exhibition.

The *Art Union Journal*, established in 1839 with the avowed purpose "to seek out and place contemporary artists in advantageous light," was happily associated with the Art Union, an organization, established in 1837, similar to the German Kunstverein. Illustrated by engravings, the magazine published the fine art in royal and private collections and exposed the "manufacture" of "old masters" in Britain. It often joined the Royal Academy's

critics, whose opposition to the selection and hanging arrangements was expressed in pamphlets and articles and in lawsuits alleging mismanagement of funds. Edited by Samuel Carter Hall until 1880, the Art Union Journal (known as the Art Journal after 1848) provided well-informed reports on art events throughout Europe.

The academy exhibition in Munich in 1845 celebrated the opening of the Kunstausstellung (Art Exhibition) building, designed for special temporary exhibitions, which was part of the embellishment of Munich planned by King Ludwig I of Bavaria with the assistance of his architect Leo von Klenze. Designed by George Friedrich Ziebland and located in the König Platz opposite Von Klenze's Glyptothek, it affected the king's own predilection for neoclassic architecture. During the seven years required to complete the new structure, no exhibition of substantial size had been held in Munich.

The inaugural exhibition was organized by the Academy's director, Friedrich von Gärtner, who had replaced Peter Cornelius in 1841. The exhibition of 352 works included—in addition to paintings, statues, busts, medals and architectural designs—paintings on glass, a technique native to Bavaria, drawings in chalk, and lithographs. The last categories were not found in the academy exhibitions in London and Paris, where they were designated "mechanical" or "industrial" arts and were exhibited in the periodic expositions of manufactured items; one Art Union Journal report of the Munich exhibit had the heading "Industrial Arts."

The exhibition attracted attention within the German states, for the new building seemed to realize the German artists' long-held desire for a national exhibition facility to free them from the limitations of local patronage. The academies of Germany's small principalities controlled the courts' patronage, and deviations from classical and traditional styles were not supported (see 1800: WEIMAR). A slightly wider if not more liberal patronage was provided by the art unions or Kunstvereine. The first such art association, established in Zurich in 1788, was modeled

on the Society for the Encouragement of Arts and Manu-
factures, founded in England in 1754. Similar organizations
appeared in Karlsruhe (1818), Munich (1824)—where it
became the Badischer Kunstverein—and Berlin (1825),
and in 1829 the Kunstverein für die Rheinlande und
Westfalen was founded. In Italian art centers, the societá
promotrici di Belle Anti was formed in Milan (1829),
Florence (1844) and Turin (1857); in England the Art
Union was created in 1839.

Members of the art unions were required to subscribe to
an annual sum that was used to purchase works of art for
which the members then drew lots. The system encouraged
the production of work to meet the taste of the purchasers
for the Art Union. Conventional, less talented artists with
little or no chance for admission to academy exhibitions
produced much of the work for the *Kunstvereine*. Even
though *Kunstverein* exhibitions circulated from city to city
within the small states, and art unions exchanged exhibi-
tions among themselves, their members led more localized
and isolated lives than did the more talented artists.
Unorthodox artists were obliged to organize their own ex-
hibitions or find an art dealer with sufficient perception to
recognize their genius or to hope their work would be ac-
cepted for the Salon in Paris.

Founded in Stuttgart by Ludwig von Schorn in 1832,
the *Kunstblatt* was early associated with the *Kunstverein*
movement. After Schorn's death in 1842, the magazine
was directed by two influential art historians, Ernest
Förster (1800–85) and Franz Kugler (1808–58). In-
formed visitors to the 1845 Munich exhibition had un-
doubtedly been schooled by Kugler's popular *Handbuch
der Geschichte der Malerei (Handbook of Painting; 1837)*
and the often reprinted and translated *Handbuch der
Kunstgeschichte* (1841–42), a first attempt to relate a sur-
vey of art to world history. Both books exerted a lasting
influence. Kugler's *Geschichte Friedrichs der Grosse (His-
tory of Frederick the Great; 1840)*, brilliantly illustrated
by Adolf von Menzel, enhanced his reputation. Ernest
Förster had been a theology student until Cornelius per-

suaded him to assist in the painting of the fresco decoration of the Glyptothek and the Hofgarten arcades. Sent on a study trip to Italy, he joined art history and criticism to his work as a painter. After he had completed Schorn's translation of Vasari's *Lives*, he supplied reports of art events in southern Germany to the *Kunstblatt*.

The *Kunstblatt*'s report of the 1845 exhibition mirrored the Germans' eagerness for international recognition. Immediate hopes for a permanent exhibition building where German art could be viewed as a national entity ended with this exhibition. In 1846, King Ludwig converted the building into the Neue Pinakothek, a museum housing his acquisitions of contemporary art.

Neither the Royal Academy exhibition nor the Salon, each the art event of the year in their respective countries, was other than mediocre in 1845, and dissatisfaction with the system and procedures of the juries and the arbitrariness of hanging committees was extended beyond the artists to journalists and patrons.

Étienne Delécluze, "Salon of 1845: Fifth Article, Painting"[1]

. . . The objective that was proposed fifteen or twenty years ago has been attained. There is no longer a school in the sense that there is no longer one taste that rules all the others, and art, like so many other things, has passed from the monarchical state to a state of democracy. In this particular case, the general law has not failed to exercise its necessary influence, and where there were palaces, immense parks and magnificent mansions reserved for the small number of privileged people, now we see the rise of innumerable little gilded dwellings that are comfortable, elegantly bourgeois and inhabited by merchants, salesmen, manufacturers and people of independent means who vie

[1] [Excerpts translated from *Journal des débats*, May 13, 1845.]

with each other for a certain banal elegance that the perfection and inexpensiveness of furniture and materials of all kinds make accessible to everyone. It is the same for the statuettes, the small gay, amusing paintings, the portraits done with art and coquetry, the anecdotal and genre pictures, not to mention the vaporous pastels, the brilliant water colors, and a mass of drawings in pencil, pen or wash; brilliant and light but ill-assorted, this whole parade of small, agreeable, facile works forms, in the end, the mass of objects that constitute the exposition today. That is what the bulk of the public likes, looks at and sometimes buys, and if the state, in its wisdom, did not tend the sacred fire that at least encourages efforts to undertake grand things, art would promptly fall lower than democracy. What is more, the natural tendency is this direction, now that there is no longer a school, now that all tastes are indifferently permitted, and now that talent alone justifies the choice of ideas. . . .

In spite of this very marked tendency of the general taste for pleasant little things, the Salon, as one could perceive, includes a rather large quantity of works by which several artists protest against this inclination; and, in this case, it is necessary to take even good will into account, as I have not failed to do on several occasions. . . .

In anecdotal painting, the Exposition is rich, as usual. . . . An anecdotal painting particularly worthy of observation is that of M. Martesteig. The artist has portrayed in it *The Protest of the Evangelical States before the Diet of Augsburg* in 1530 before the Emperor Charles V. In this work of small size, each historical character is painted with as much intelligence as truth; and one has the impression of being present at the great event, for the varied expressions of each character give so much reality to this important scene. The dignified reserve of the emperor, contrasted with the diverse sentiments that the Catholics and the dissidents feel when Melancthon reads the protest, gives life and a powerful interest to this anecdotal painting, the most remarkable in this style of the Exposition, in my opinion. The number of artists who fol-

low the fashion is rather numerous, as is known, and we
will indicate a lovely scene entitled *Sadness* painted very
delicately by M. Bérard. . . .

The elimination of the schools has been most favorable
to this kind of painting. The best proof that can be given
is the number of skillful artists who distinguish themselves
in this style, for besides those I have already named it is
necessary to place again in the first rank M. E. Isabey, cre-
ator of *The Alchemist*; M. Lepoittevin, whose composi-
tions are so witty and amusing; among others, the *Lunch
in the Forest of Eu*; M. Meissonier, who, every year, in-
creases and improves the race of miniature chess and
piquet players. *The Fruit Market* of M. Brias is still a re-
markable work in its imitation of nature and the finish of
the work, and *The Effect of Winter* by M. Wickenberg is
marked with the seal of truth. As for *The Effects of Light*,
rendered with so much felicity and vividness by M. La
Faye, it is only right that they have been noticed in the
Salon, and I do not believe that, in this genre, paintings as
brilliant and at the same time as true as the *Room of the
Crusades* at Versailles and *St. Joseph's House* in Paris
have yet been seen.

I shall not leave painting of this type without speaking
of a familiar scene entitled *The Falling Leaves* painted by
M. A. L. Patry, the originator of an almost microscopic
odalisque shown two years ago. The new work by M. Patry
is much larger in its proportions, for the figures are five or
six inches tall. The imitation of contours and relief in this
painting is of such material exactitude that everyone with
a well-trained eye will be impressed. One might think that
it is the result of a daguerreotype operation and, in that,
this painting would offer nothing extraordinary today.
But what makes this work worthy of observation is the
way in which it is painted and colored. For all my ex-
perience in different methods of painting, I was unable to
discover M. Patry's method. Might it be that we are
threatened with an invention that would trace and repro-
duce coloring? Physicists might look forward to it; but

what an embarrassment for those who want to do painting
that is real! . . .

Let us now turn our attention to the landscape. In addi-
tion to the natural taste I have for this kind of painting, I
still have a weakness for those who cultivate it, although I
do not know them very well personally. But of all artists,
they are the ones who do not overly commend themselves
and who write me the fewest letters. What is more, they
have kept a lively taste for meandering and independence.
They run about the fields and forest looking for beautiful
sites, admiring the trees and the flowers. They enjoy work-
ing. They do their studies and their pictures with pleasure
during the summer months and then, as the winter
months approach, they finish the works they intend to ex-
hibit in the Louvre. The landscape painters are certainly
the most constantly busy at their art, for which I praise
them, and the ones who wait for the critiques with the
most *sang-froid* and resignation—two qualities that have
become very rare in the last eight or ten years.

In the grand manner called the historical style, M.
Rémond has done a landscape that deserves the attention
of the experts. The artist has depicted Hippolytus in his
chariot, carried away by his sea horses at the apparition of
the monster whose back rises above the sea like a damp
mountain. Racine's narrative, followed by M. Rémond,
happily inspired the painter, who has shown himself dou-
bly skillful in making a very beautiful group of figures and
horses and in placing this scene in a seascape treated with
verve and truth.

In addition to several sites of the Roman countryside,
M. Desgoffe has shown, under the title *St. Marguerite*, a
mystical landscape with an arrangement of grandeur and a
charming aspect. At the top of the composition is a halo
from which light descends and then penetrates into a deep
valley. This is a happy idea and I would praise its execu-
tion if M. Desgoffe had abstained from applying gold leaf
to the luminous part of his painting. It is time for people
of taste to give up artifices that have not only been out of

use for four centuries but, moreover, produce shocking in-
congruities in works done in all their other parts with the
help of modern methods and experience.

In the choice of lines, in the disposition of masses of
light and shadow, the pure, severe taste of M. P[aul]
Flandrin is still recognized. His *Roman Campagna* and
Rocks furnish proof of this, if proof is actually needed;
but it would be desirable if this artist varied his coloring
and especially his technique, which is too uniform in all
the planes of his painting. The art of accentuating forms
because of the distance that separates them from the eye
is one of the greatest difficulties in landscape painting and,
for this reason, it is necessary to make constant efforts to
surmount it. These efforts are indispensable. . . .

M. Corot showed three landscapes, of which the most
important portrays *Homer and the Shepherds*. I admit
that there was often turgidity and stiffness in the manner
in which painters of the imperial era depicted Homeric
subjects; but I point out, with the same frankness, that
the careless and prosaic manner introduced today in heroic
scenes is completely shocking. The most serious criticism
that can be made of M. Corot's painting is to ask, Where
is Homer? Take away the lyre and substitute any other or-
dinary instrument you please and the singer of Achilles
will disappear, for there is no characterization either in his
attitude or in his form. Was the artist more fortunate in
his choice of setting and in the development of lines that
come from all the fields and the vegetation that covers
them? In this countryside where Homer begs is there any
aspect particular to Greece? Assuredly not; thus, only
what M. Corot wanted to paint must be sought in the
landscape: a very rustic place where simplicity and calm
invite the soul to rest. In the end, here is the composition
that the artist can make his spectators accept and his
work, of which I have just spoken, that produces this
effect would have still more power if the details were stud-
ied with a more scrupulous care. . . .

In spite of the antipathy shown by several people of our
time for *le juste milieu*, there is one in art that cannot be

sought with too much ardor. One certainly has the right to reproach M. Corot for the negligence with which he reproduces details; but the opposite observation is strictly applicable to the works of M. Hostein. In the principal landscape of this artist, *The Banks of the Moyne at Clisson*, the uniform care with which all the details of the vegetation and the factories are painted, from the border of the painting to the planes farthest away from the eye, certainly harms the work as a whole; all the parts, taken one by one, do excite one's interest—perhaps even too much. In every sort of composition, the gradual sacrifice of the different subordinate parts to the important feature, to the main subject that one wishes to make prominent, is the great secret of the art. Whether it be a question of dramatic interest or the disposition of the lines, of the arrangement of the light, or even of the material execution, a principal personage is necessary, a more luminous and cared-for point, to which all the others are subordinated. M. Hostein should seek to yield to this important condition of unity in order to give his works, already rich in true and pleasant details, the tranquillity and majesty of nature.

M. Diday has painted *After a Storm in the Alps*, a picture in which this artist has put all the qualities that distinguish his remarkable talent. . . .

But in the agrarian, rustic genre of painting, the palm goes to M. Bracassat. Among several of his landscapes, all marked by the seal of talent, the public has picked out *The Cow Attacked* by wolves and defended by bulls. This very dramatic scene is rendered with as much simplicity as energy and the execution of this painting, in my opinion, has the rare and priceless merit of letting itself not be forgotten, for it contributes so directly to the development of the subject.

The exchange and consummation of ideas are so rapid nowadays that former tastes are not long in becoming new again. For several years the French landscape painters have explored the world so well that one begins to grow tired of settings in the Orient, Greece, Italy and Switzer-

land. The return to views of the native country, and even to views of the environs of Paris, is a fact remarkable enough for me to point out, because the nature of the places where one studies is not without influence on the manner in which one portrays them on the canvas. Among the painters who seek their inspiration in France is M. Jules André, who has portrayed with verve and talent *A Small Farm and a Forge* near Gironde. Then M. Thuillier who, in his original manner, has enjoyed portraying settings of Puy-de-Dôme and the upper Loire. One of the principal merits of our landscape painters today is that each one obeys his instincts and has developed a style that corresponds to them. The result is that in their works one finds truth and variety, the two real elements of success. M. Fiers has again shown himself to be very skillful in the graceful, piquant pictures that the areas around Dôle and Beauvais inspired. M. Français has found a way to interest and to please without going beyond Bougival and Courbevoie.

Of those landscape painters who adopt a purely rural and agrarian style, M. Léon Fleury is, without contradiction, one of the most skillful. After having studied nature in Italy, where he strengthened his talent through conscientious work, he now applies himself to depicting settings in our country. His *View of Cagnes*, near Antibes, and of Rouen, of a windmill on the banks of the Seine, are paintings full of charm and truth and, although they are simple in aspect, they provide food for the imagination and stand up under examination.

A young artist whose debut I reported last year, M. Adolphe Viollet-le-Duc, also seems to have a liking for the style of simple, tempered landscapes. In this type of painting, his *Souvenirs of Piedmont* and *Normandy* certify to the progress he has already made and leave no doubt as to the love and respect with which he studies nature.

I am far from finding fault with those who treat the landscape that I call *champêtre* or rustic, for lack of a more precise expression; but admitting this restrained, simple style, it must not be forgotten that it is indis-

pensable to set it off, to give it energy through a firm and scrupulous imitation of nature by means of a choice of appropriate and striking details that are always rendered with verve. When a landscape does not act upon the vision and imagination of the spectator, through the majesty of the lines of the horizon, as usually happens in countries such as Greece and Italy, it is through the details that attention must be captivated. So it is essential to choose them well and to execute them in a superior manner in order not to fall into the style known as "of the little house," in which Lantara was the Claude Lorrain. . . .

If the whole of our observations on the Salon of this year is fair, the result is that, in general, the method of imitation of nature, in whatever style it may be, is good and is obliged to be true, which is an essential point for art; but what is less reassuring is the multiplicity and divergence of tastes—accidents that almost always cause a relaxation in the care with which nature is simply and attentively imitated. Already some examples of fantasy put in the place of study have shown up: care should be taken in this! The most important fact that could be observed in the Louvre is the slight desire to bring the present school back to the principles and tastes professed by artists in 1772. This accident should keep awake all the men sincerely interested in the maintenance and progress of the arts.

Arsène Houssaye, "Salon of 1845; M. Eugène Delacroix"[1]

With M. Eugène Delacroix, criticism must maintain a respectful attitude. He is a great painter who looks for the poetry of human sorrows, for the sentiment that seizes the heart, the idea that elevates the soul, and who searches above all for one of the most beautiful attributes of painting: color.

1 [Translated from L'Artiste, April 6, 1845, pp. 209–11.]

We know that M. Eugène Delacroix is, moreover, a scholar who loves old books and old traditions, who, even while he wants to introduce a new era to painting, spends his time admiring the masters of all eras, studying the antique art of Etruscan vases as much as the modern art of Veronese and Rubens. No one knows better than he the history of the arts in Greece, Italy, Antwerp and Paris. If M. Eugène Delacroix wanted to take the time—he has proved this several times—he would be a knowledgeable critic, well worthy of continuing the tradition of Wincklemann and others. . . .

. . . Criticism must have its days of doubt, even after its days of enthusiasm. It must have the courage to voice all its thoughts concerning the faults of a genius, because the mistakes of genius are copied more often than its master strokes.

He who comes in good faith to learn from the genius of M. Eugène Delacroix at the Salon of 1845, will he go away profoundly edified? M. Eugène Delacroix wanted to demonstrate his power in four very different paintings: *The Magdalen in the Desert, The Last Words of the Emperor Marcus Aurelius, The Sibyl, Muley-Abd-Err-Rhamann, Sultan of Morocco, Leaving His Palace at Mequinez, Surrounded by His Guard*. One sees that the painter has poetically chosen his subjects: the Sibyl and the Magdalen, both pagan and Christian antiquity; the Emperor Marcus Aurelius and the King of Morocco: Rome about to die and the poetry of the desert about to be devoured by European civilization, a culture a thousand times more barbaric than barbarism itself.

Let us see how M. Eugène Delacroix has understood these four pages, so remarkable in the epic of humanity.

I cannot myself explain the Magdalen. Pausing before this bold sketch, I recognized immediately the work of a powerful hand, but I did not recognize Mary Magdalene in the desert: the Magdalen whose heart still beats among us, Magdalen, the poetic symbol of Christian love, Magdalen, the most beloved woman during her life, the most beloved saint after her death. (I do not include here

Mary, who is more than a saint, since she is the mother of Jesus Christ.) M. Eugène Delacroix is among those, moreover, who should love the Magdalen profoundly. No doubt, to him she appeared beautiful, with the beauty of divinity and of humanity, beautiful with hope in God and with memories of worldly joys. The Magdalen of M. Delacroix is beautiful neither in line nor in sentiment. The suffering expressed by the painter is human, but altogether physical; in vain does one seek a ray of divine love. One asks, seeing this head leaning back on the stone of the cave, is this the figure of a woman who dreams, of a woman who sleeps, or of a woman who has just died? M. Eugène Delacroix wanted to paint a figure that suffering has beaten into a stupor. Unquestionably he has succeeded, but why baptize this work with the sacred name of the Magdalen?

The Sibyl of M. Eugène Delacroix "points out in the heart of the shadowy forest the golden bough, the acquisition of the great hearts and the favorites of the gods." This Sibyl is no more of her time than is the Magdalen of hers. By desiring to express too much, by wanting to push the worship of the palette too far, the painter has lost the feeling of the tradition and the love of severe lines. Character was ever more necessary in the drawing than in the coloring. It is often a proof of strength to show oneself sparing in this regard. M. Eugène Delacroix tries to take too great advantage of his powers. He should choose subjects that are in harmony with his palette. He could find subjects of a more passionate nature in pagan antiquity. M. Eugène Delacroix is much more a painter than a sculptor. He is incapable of depicting either Night or Silence; his genius is too clamorous and too brilliant. His Sibyl thus has neither antique serenity nor a grave and thoughtful beauty. The draperies lack majesty; the landscape lacks elegance. Nevertheless, as always, the whole is harmonious, distinguished in feeling and fine in tone.

"The perverse inclinations of Commodus had already exhibited themselves; the emperor, in a dying voice, commends his son's youthfulness to several friends, philoso-

phers and stoics like himelf, but their despondent atti-
tudes show only too well the futility of these
commendations and their fatal premonitions for the fu-
ture of the Roman Empire." This page from history
struck M. Eugène Delacroix, and he wanted to paint a
picture whose heart and soul would be the last words of
Marcus Aurelius. Why this unfortunate trip into the
Roman Empire? Did M. Eugène Delacroix want to prove
to himself that M. David was definitely mistaken? Strange
turn in the history of art! After the reign of LeBrun,
Lemoine wants to bring back life and color; after David's
Romans, here we have Delacroix's Romans. But—why not
say it here?—M. Eugène Delacroix is no luckier with his
Romans than Lemoine was among the semi-divine Greeks.
To paint the Romans, a respect for line, a more severe
style, is necessary. It is necessary to accept the tradition,
still alive in our minds, that shows us the Romans naïvely
dignified, draped with a little solemnity. . . .

I come to the Sultan of Morocco, the best of the four
paintings exhibited by M. Eugène Delacroix. Here is the
artist's note on the painting: "This painting reproduces
exactly the ceremony of an audience that the artist
witnessed in March 1832 when he accompanied the Royal
Mission Extraordinary to Morocco. . . ." One says: the
Orient shines in this painting. The painter has endowed a
memory already old with real power. The truth is here and
grips you and shows you the happy falsehoods that blos-
som on the opposite wall in *The Taking of the Smalah of
Abdel-Kader*. One cannot, however, accept this as a
finished work. The draperies are rumpled; several figures
disappear in the half-shadows. Certain people blame poor
workmanship and negligence. But that this painting has
character, truth and grandeur cannot be denied.

The critic, I know, is always wrong concerning an artist
like M. Eugène Delacroix. He has reached that stage in
his career where advice, even the most humbly given, only
makes his genius rebel. But to this proud genius, one of
the most vital and beloved of our glories, we would dare to
recommend a little less disdain for precision, a little more

firmness in his contours. A day will come, a day still far distant, when M. Eugène Delacroix will not find on his palette all these shining colors, all these burning and vital rays that still astonish our eyes. When this sad day comes, the light will have faded. The feeling that the painter now finds so alive in a heart that youth excites with all its mad, sad or charming visions will be replaced by a more austere feeling. He who dreamed yesterday will think tomorrow. Inspiration that springs from the heart like a fiery fountain will pass henceforth into wrinkles in the forehead. . . .

Paul Mantz, "Salon of 1845; Battle Paintings"[1]

If we begin with the battle paintings, it is not because we have at heart a strong love for the sound of arms, the flash of swords and the cries of soldiers. Let others sing in joyous rhythms the emotions of war; the fraternal group of poets and women will never smile at these celebrations of death that cause so much blood and so many tears to flow over the peaceful earth! Why must human ideas transform themselves sometimes into a form so terrible, and the angel of progress appear so often in history armed with a flaming sword? . . . But let us leave the rhapsody. Withdrawing into the question of art, one must recognize, no matter how one feels, that a battle is an admirable thing. A thousand accidents of color and drawing appeal to the artist and inspire him; under the hand of a strict artist, disemboweled horses and warriors' cadavers piled up on the earth are so many occasions for multiplying foreshortenings and making unexpected lines supple. A daring brush knows how to streak all the richnesses of the palette into the pale faces of the dying, into the luxury of costumes and weapons. Ask Rubens what a painter can throw of color, light and life into a battle; ask Salvator Rosa what movement and savage verve one can put there.

1 [Translated from L'Artiste, March 25, 1845, pp. 177–79.]

But these are very great names, and perhaps it is not generous to pronounce them in front of contemporary artists' official works destined for the museum of Versailles. This year at the Louvre there are twenty-odd battles, some commissioned by the government, others undertaken by young artists at their own risk and peril. But all fade away, all disappear before the immense canvas of Horace Vernet, *The Taking of the Smalah of Abdel-Kader*. When you enter the Salon Carré you are seized as you walk by a group of horsemen who stop you. Impossible to escape them! M. Vernet throws them at you at full gallop, and there you are, taken. So you estimate by eye the space you have to proceed through, you consult your watch, and if your business leaves you several hours of leisure, you take off! What a long trip! In order to see everything, one must return several times, like those open-air book lovers who, under the impatient eyes of the secondhand bookseller, leaf through a volume indiscreetly left open and each day take up their reading at the page they marked the day before. For me, the *Smalah* still holds many surprises. What an amusing sequence of episodes! It is a whole novel, and in this apparently inoffensive word lies a serious reproach. Yes, it is a novel, but, it goes without saying, it is a novel in the manner of Alexandre Dumas: a serial of episodes. The scenes follow one another and are linked one to the other by small means (I would say *threads*, if I dared) that resemble those dramatic events whose secret is known today by every minor novelist. It is on this point that M. Horace Vernet provides a foothold for criticism. The law of grouping has inflexible requirements; he does not seem to have taken them into account. Undoubtedly, on a canvas this large it is difficult to submit the arrangement of the figures to the tyranny of the laws that rule all composition, but it is important, and perhaps not impossible, to maintain around a central point an equilibrium of the elements in the whole work. It is necessary that the action have a soul; it is necessary, by whatever means, to draw the eye of the spectator to the very heart of the battle. An affect of light, an accident of

the landscape, could have contributed toward this result; a splendid piling of figures knowledgeably entangled among themselves would perhaps have been enough. Veronese obeyed this rigorous law of concentration when, in the *Marriage at Cana*, he placed in the middle of his brilliant canvas, in the foreground, the slaves filling and emptying golden vases, the musicians proudly turned out, and all the people whom we would greet like old friends; the *Smalah* hides these figures, which should be permitted to show themselves in the sun.

M. Horace Vernet has never been a colorist and makes no great effort to become one. He is always satisfied with an approximation that the public has obligingly seen as sufficient; sometimes he has managed to be completely mistaken (in his *Judith*, for example) and to pile up haphazard touches of discordant shades. M. Vernet has not committed a fault this serious in the *Smalah*, but he seems to have forbidden himself strong colors. The whole is cold; the sky is of a pale, faded blue to which the burning climate of that region would never admit. The ground and the soldiers and the tents are painted in essentially the same color range. If M. Vernet imagines it is necessary to paint in a monotone in order to paint harmoniously, it would suffice to stop for a moment before a Rubens or a Titian to correct this misapprehension.

But, someone will say, the artist had to follow faithfully the account in the *Moniteur* and was not completely free. One may regret, even while acknowledging it, that even if left to himself M. Horace Vernet, an essentially methodical and orderly spirit, perhaps could not have understood the drama otherwise. With respect to exactitude it seems the painting's triumph is complete. "One is assured," says M. Delécluze with a mild note of enthusiasm, "that military men are fully satisfied." That is very well, but reality contains poetry: blows of sword and gun do not occur without a gripping emotion. M. Horace Vernet paints history the way certain writers recount it: with much spirit and adroitness. This is not enough. In a battle, whatever battle it be, there is a feeling, an idea, perhaps a dream.

The war in Africa is never just a vaudeville act. Whether they are conscious of it or not, our soldiers accomplish a hard mission in the sands of Algeria, and the desert race valiantly defends its God. The clash of these two civilizations, so different, should set off sparks. . . .

Opposite *Smalah* has been hung *An Episode from the Sack of Aquila* by M. Schnetz. The city is in flames; the barbarians have invaded the ancient city, and the streets are full of raging soldiers. In the middle of the scene, a wild horseman tries to carry off a young girl in tears, while a mother bursts into prayer over the body of her son who, according to the *livret*, succumbed in defense of his home. M. Schnetz, in the habit of making mediocre paintings, has on this occasion renounced his custom in order to be frankly and sincerely awful. That is true loyalty; we will not take advantage of it. . . .

There are, nevertheless, two great works in the Salon Carré: the Battle of Rivoli, by M. Philippoteaux, and that of Hastings, by M. Debon. . . .

M. Debon is of a completely different school than M. Philippoteaux. Too ardent to contain his seething courage, he could well kill himself in an engagement before he earns an officer's commission. He bravely runs the risks of inspiration and throws himself into the melée with such a vigorous leap that one hardly knows whether he will return alive. One has reason to think that those poor devils, the Saxons, could not have been more roughly treated by William the Conqueror than they have been at the Louvre by this fierce M. Debon. Clearly, this is how one should understand battles. M. Debon has remembered an incident of *The Bridge of Taillebourg,* and we do not reproach him; he has looked for color and happily has often found it. We do not know whether he will go further, but he is on the right path. Of all the battles at the Salon, his is perhaps the only one in which the soldiers do not fight as at the games at Olympia.

. . . Our trip through the Salon has not been rich in serious discoveries. . . . War has gone the way of the gods of the past. But in what fashion could I repeat this? Be-

sides, one tires quickly of big words; when one belongs to the race of shepherds one tires quickly by moving a cuirasse, waving unfurled flags in the air and marching full tilt at the head of rapid ranks of soldiers. Let us stop here; this is more than enough blood for one day.

Anonymous: "Royal Academy, Seventy-seventh Exhibition, 1845"[1]

The Seventh-seventh Exhibition of the Royal Academy consists of 1470 works—of which 146 are in sculpture.[2] On the whole, it has not been—and cannot be—regarded as satisfactory; the *Seniors* in Art have done little; nor can the *Juniors* (with a few cheering exceptions) be said to have done much. We trust the former will make amends by "reporting progress" in Westminster Hall; it is known, indeed, that the absence of two or three from the walls in Trafalgar-square is the consequence of labor for the approaching Exhibition, under the auspices of the Royal Commission. Still, we think, care should have been taken to have avoided so comparatively weak a gathering as this —which our great National Demonstration of the year presents. *Maclise* is altogether absent; *Mulready* sends but one small picture—"painted in 1830"; *E. Landseer,* usually a contributor of five or six, furnishes only one, *Uwins* has no more—and his one is, we regret to say, "a repetition!" while of the Associates we have nothing from *Cope* and *Dyce,* and barely one each from the other men of mark among the subalterns in the rank of the Academy. The consequence has been that aspirants for honors hereafter have had good chances; the members, not having had

1 [Verbatim from *Art Union Monthly Journal,* June 1, 1845, pp. 179–93.]
2 Last year there were exhibited 1410; in 1843, there were 1530; in 1842, there were 1409; in 1841, there were 1343; in 1840, there were 1240; in 1839, there were 1390; in 1838, there were 1382. The number, therefore, has not materially increased; nor can it increase, until the space has been augmented.

pictures of their own to place "upon the line," have been compelled to make selections from the Profession at large; many, therefore, are fortunate enough to have had their pictures seen and appreciated—in some instances to the serious damage of "distinguished neighbours.". . .

The evils to which we have thus made reference do not lie upon the surface; it is otherwise with those which regard *the multiplicity of portraits*. This year the "blots" seem, and we believe are, more numerous than ever— human forms and faces, of all conceivable expressions, literally covering the walls of "the great room." North, south, east and west, above the line of living and moving heads (and on the opening day it was impossible to see anything below them), are quadrupled rows of copies of patrons of portrait-painters; here and there you notice some "touch of history"—in one sense elevated—but carry your eye around the huge apartment, and you see a crowded assemblage of inanities, of whom the world knows, and for whom it cares, nothing.

In order to exhibit this evil in the strongest light, we made a drawing of one of the four sides of the Great Room (above *the line*)—the other sides are still more objectionable; so that, in printing this cut, we, at least, give the case fairly. The side here pictured contains just forty pictures, of which twenty-eight are portraits—several of them full length; of the pictures not portraits seven of the twelve are placed at the top of the room, close to the ceiling; and the other five are pushed into the two corners. The portraits we have left black; the pictures not portraits, white; but we ought, perhaps, to have made some of them piebald, for four out of the twelve are "fancy portraits."

We have said that the other sides are "more objectionable"; the left wall contains 27 pictures, 22 of which are portraits; on the right wall are hung 26 pictures, 25 of which are portraits. Matters are much the same in the "middle room"; not quite so bad in the "west room"; in the "octagon room" there is but one portrait! . . .

On the first day, when the crowd and the dust effectually kept us from the sight of all works on or under "the line," we were, as we have intimated, compelled to look only round the walls above; and a pleasant sight it was! Our visits subsequently have been more successful—having paid some six or seven shillings for liberty to enter before reasonable people breakfast, we have as often found the rooms empty; and, therefore, trust we shall be enabled to introduce our readers to the pictures, and the pictures to our readers. For the ability to do so, however, we give no thanks to the Royal Academy; that most generous and liberal body still asserts its claim to be the only public Society or Institution in Great Britain which resolutely keeps out critics as long as it can; and, as we are not fortunate enough to inherit a title—or to possess any, except that which our brain has "sweated" to obtain—we pushed our way into the room on Monday, May the 5th; after Friday had been given to the Queen and her suite; Saturday to the buyers and the dinner; and Sunday to such persons as it would have been impolitic—perhaps—to have refused. . . .

. . . The numbers—as usual—commence over the door of the

The East Room.

No. 50. *Whalers*, J. M. W. Turner, R.A. We have long been accustomed to this artist's manner of painting the Mediterranean and Adriatic, and have now seen him paint the North Sea in a like manner. The title is accompanied by a reference to "Beale's Voyage"; we have never read the book, but conclude that the whale-catching is going on somewhere near the Arctic circle; yet the whole scene is painted with not an iota less of vibrative whitelead than Mr. Turner employs in his southern waters. Hence arises the question, if these pictures be not painted from mere force of manner, by what philosophy are the northern and southern aspects of nature thus reconciled? The very selection of such a subject—a subject he could not have seen—argues an unworthy affectation. This and its "companion"

were painted for a wealthy gentleman who made his for-
tune by whale-killing.

No. 51. *Portrait of the Rev. Dr. Brunton, D.D., one of
the Ministers of the Tron Church, and Professor of Orien-
tal Languages in the University of Edinburgh,* J. Watson
Gordon, A. This is one of the most striking portraits we
have for some time seen. The figure is full length and
seated, and the treatment of the whole becomingly grave.
The great power of the artist is especially shown in the
roundness and momentum with which he has invested the
figure, and the light and pose is so perfectly managed as to
render the head something more than the mere mask com-
monly miscalled portraiture. There can be no question
that it is the best picture of its class in the Exhibition; in-
deed it is scarcely too much to say that we should find it
difficult to meet a production of our time anything like so
good. It is a veritable work of genius—a work that does
honor to the Exhibition, and goes far to redeem its char-
acter. It would have been, we think, well to have deprived
the room of some of its close and prison-like aspect. . . .

No. 77. *Whalers,* J. M. W. Turner, R.A. A companion
to the other picture by the same artist (No. 50), and exe-
cuted in a corresponding feeling. . . .

No. 109. *Cupid interceding with his Mother for Psyche,*
W. Etty, R.A. The Venus of this composition is pre-
sented seated in profile; Cupid is at her knee, and Psyche
is weeping at a short distance. The two latter figures are
inaccurate in drawing, and the limbs of Venus are by no
means those of Phryne, but unmodified from such natural
fleshy roundness as would have delighted Rubens;—but
the mythology out of the question, there is a potent
charm in the execution of this study. . . .

No. 117. *Venice—Evening: Going to the Ball,*
J. M. W. Turner. The subject, we learn from the cata-
logue, is from some MS. pet poem, entitled "The Fallacies
of Hope,"—with some lines of which, we believe, the
world has been favored in former catalogues. The artist
has worked up to the vivid coloring of· the poetry. A
company of gondolas are borne on the lustrous waters,

either approaching the spectator or plying the other way (*n'importe*), and these, together with the distant buildings, are lighted by rays of the setting sun;—thus it is not night, while yet the "the moon is up," in the picture. Two words on the absurdity of a title of this kind; the view has been painted by this artist twenty times before; and it had been really sensible, notwithstanding, to have entitled the work merely 'Venice—Evening,' than to have yielded to the affectation of referring to a MS., of which nobody ever heard save through the catalogues of the Academy; and which no one will desire to see; for the few specimens, printed from time to time, show it to be a most poor and paltry production; we fear its "inspiration" may have contributed to weaken the powers of the great artist—the greatest artist of the age and country—whose modern follies are to be deplored as so many injuries to mankind.

No. 126. *Underclift, near Ventnor, Isle of Wight*, W. Collins, R.A. The cliff rises in the middle of the canvas, and, the point of view being on an opposite eminence, we see on the right a portion of the country; and on the left the sea, specked with flitting lights, which fall on it through the openings in the clouds. This picture is an admirable example of truth as regards local color: it is rare, indeed, to see so strictly literal a translation of the hues of nature; and, as regards composition, the principal lines are supported by a variety of others, all contributing to the harmony of the whole. This is a work of the kind that has established the high reputation of the artist, and which we rejoice to see resumed; while it is admirable as a painting, it is eloquent as a story; how capitally characteristic is the group of boys climbing up the cliff; one can absolutely hear the joyous huzza of the urchin who has reached the top, nor will it be very difficult to catch the murmurs of alarm which come from the venerable couple approaching from the background—full of terrors lest the adventurous rogues should fall.

No. 131. *The Heiress*, C. R. Leslie. This picture, in point of argument, is far below the average of the artist, who is usually a most eloquent *raconteur*. There is no

story. Three female figures appear in a well-furnished sa-
loon, one of whom is writing—the other, we presume, the
heiress, is seated, and in discourse with a lady in a white
shawl, who is standing. The artist has not dropped a single
oracular straw *apropos* of "the heiress" for us to catch at.
The objective of the picture is most elaborate: it is, in
short, a picture of rich upholstery and hardware. Unless
the sitting figure be a portrait, there is no solution to this
problematical subject.

No. 141. *** E. Landseer, R.A. This is the only contri-
bution of the artist—it appears in the catalogue without a
title. The canvas is somewhat large, and the composition
remarkable as constituted of small objects. It represents—
in a few words—a shepherd, kneeling in prayer before a
stone *calvaire* or figure of the Saviour crucified, around
whom, and straggling into distance, is a very numerous
flock of sheep. The sentiment of the work is of the charac-
ter more elevated than any thing the artist has ever before
attempted: it is a hallowed tranquillity which at once
reaches the sense, and maintains there an increasing
influence as long as the eye dwells upon the picture, for
there is nothing to disturb the spiritual repose. Even the
trees are mannered into reverential eloquence consonant
with the main purpose. The stone figure is unusually large,
and this very much reduces the importance of the living
figure, who is habited in a blue blouse in the manner of
the French peasantry, and of whom it is to be observed,
that, having his eyes closed, were he in another attitude,
he might be supposed to be asleep. The shepherd then is
French, but for the sake of the picturesque, the artist has
given him a flock of Scotch sheep duly proportioned with
those wild black-faced tups that will dispute with a
stranger a narrow path in their mountain pastures. Not-
withstanding the great excellence of the picture, the com-
position has an artificial appearance, but the eye is se-
duced by the golden fleeces which lie around in profusion,
and the admirable trick by which they assume the perfect
semblance of wool. The picture is, we believe, the prop-
erty of Sir Robert Peel; and we understand it has been al-

ready secured for engraving—at a cost which seems to us absurd; for the work is not of a nature to become attractive and popular as a print. . . .

No 145. A *Sketch*, W. Mulready, R.A. This sketch is a small picture of high finish, painted according to the catalogue in 1830. A boy is holding a child, which he amuses by showing the prints in the family bible, while the mother is seen at the door. The little picture is full of material, every item of which has its use in contributing to composition and color. Setting aside the simplicity of the subject, it is in the best style of the artist, who is among the most accomplished of the living masters of color. We can scarcely pardon him, however, for having contributed only this example of his genius. . . .

No. 396. *Venice—Noon*, J. M. W. Turner, R.A. Again supplied we are to understand, from "The Fallacies of Hope"; and we have again, in the nearer parts of the picture, water and gondolas, and in the distance the quays, buildings, and shipping of Venice. The picture is a repetition of what we have seen already twenty times—of late years—from the easel of Mr. Turner. . . .[3]

West Room.

No. 460. *The Judgment of Adam and Eve*, J. Martin. In composition and execution the work is precisely similar to all the works the artist has recently painted from "Paradise Lost." The lines supplying the matter are—

> The voice of God they heard,
> Now walking in the garden, by soft winds
> Brought to their ears, while day declined; they heard,
> And from His presence hid themselves among
> The Thickest trees, both man and wife, till God,
> Approaching, thus to Adam called aloud—
> * * * * * *
> * * * * come forth!

The figures form a bright spot in the composition, cut out, as it were, and placed on the canvas; although they

[3] [The criticism of Turner's *Venice-Sunset-a Fisher*, No. 422, has been omitted.]

are at some little distance, yet we are in their presence, so forward are they brought by being left so high in tone and tangible in substance. The effect is, as usual, a strongly glazed brown shadow opposed to a mélange of the most brilliant colors the palette affords. One or two passages of distance are painted with truly fine feeling, but from these the eye rises to a pink sky, unlike even the rarest aspects of nature. Everything is lost in manner, so often the great infirmity of genius in painting: the leading point of the subject—"the voice of God"—is unheard by all in the picture; there is nothing to indicate that Adam has been called forth, and he himself does not convey to us that he is conscious of the presence of his Maker. Everything is forgotten for the inglorious spread of color in the sky and distance. . . .

No. 536. *A View on the Hudson River—the Highlands at West Point. On this point is located the Military Academy of the United States*, T. Doughty. We know this gentleman to be one of the most distinguished of the American landscape-painters; but we are deprived of the power to inspect this picture from its being hung so high. All we can say is, that the view seems to have been selected with judgment, and made the most of as to general effect; and if it be as good as, or better than productions of his pencil with which we are acquainted, it is a picture which ought, in common justice, to have been placed more on a level with the eye. . . .

No. 605. *Uriel and Satan*, B. R. Haydon. This is from the third book of "Paradise Lost," illustrative of the interview between Uriel and Satan, who appeared to him as a cherub, soliciting information as to the region in which might be found the world, with its new inhabitant, man. Uriel stands in a calm and self-possessed attitude; while Satan, having obtained the information he desired, and taken leave, now—

> Throws his steep flight in many an aery wheel,
> Nor staid till on Niphate's top he stands.

Uriel is a figure standing perhaps ten feet high, and refers very strongly to Greek Art; but the reference is not consistent, inasmuch as the Greeks did not display the veins and superficial detail of their deities. Uriel, therefore, as a spirit, should have been spared a comparison with humanity by an omission of anatomical display. Be that as it may, there is majesty, nay grandeur, in the presence. The work seems intended for ultimate execution in fresco. It is marked by the peculiarities of the painter's later style; but has also some of the marks and tokens of his better and more vigorous time. It shows what he could do—and might have done;[4] and makes us once more grieve over the evils that follow self-will—unguided by judgment—in a man of genius. . . .[5]

Ernst Förster, "The Munich Art Exhibition of 1845"[1]

An exhibition of works by contemporary artists, the first in Munich after an interruption of seven years, opened this year on August 25, the birth and name day of King Ludwig. It calls for a review and an orderly report on the varied impressions that remain with the spectator. The reason for the interruption of the exhibitions, which formerly were held every three years, is familiar to most people and is a pleasing one. As in other European cities, where exhibitions even larger than those held in Munich are customary, Munich had lacked a proper building devoted to exhibitions. As elsewhere, the practice of using galleries' and art academies' rooms for temporary exhibi-

[4] [Benjamin Haydon was not to commit suicide until June 1846; the tone of this criticism might suggest why he was driven to do so.]

[5] [The Octagon Room and Drawings and Miniatures have been omitted.]

[1] [Excerpts translated from Kunstblatt, October 23, 28, November 1, 1845, pp. 353–55, 357–59, 362–67.]

tions brought many inconveniences and even damage to
the institutions. In Munich, the rooms of the Akademie
der bildende Kunst, which organized this exhibition, were
used. Our monarch, a patron of the arts who has done so
much for the permanent revival of a serious and refined
aesthetic sense, could not ignore this deficiency. Thus it
was in accordance with his administration, which dealt
evenhandedly with the needs of art in all fields, to have
erected a building that was designed expressly for works of
art and industry. It deserves praise as the first and only
building of its kind. After the cornerstone was laid in
1838 the exhibitions were canceled until the completion
of the building. Therefore it can be rightly said that with
the opening of the newly acquired space a new era has
begun for this exhibition and for all subsequent ones. The
building is situated opposite the Ziebland Glypothek. Its
exterior, built in the style of a Greek temple with a portal
of eight Corinthian columns and a gable decorated with
sculpture by Schwanthaler, expresses its function in a
most dignified manner. The entering visitor feels com-
pletely satisfied with the serviceable arrangement and the
effectiveness of the overhead light. Approximately four
hundred works of art are exhibited; this figure is small com-
pared to the size of exhibitions in other cities and even to
some of the earlier exhibitions in Munich. While the
smallness of the exhibition must be admitted, it is com-
pensated by the fact that most of the works are of excel-
lent quality and that only a few are mediocre or poor. It is
remarkable that paintings by many well-known artists are
missing, but one has to take into consideration the fact
that works of larger dimensions are accessible to the resi-
dents and visitors in the studios and that smaller easel
paintings are permanently on view at the art association.
Furthermore, most of our artists are not forced, as in sev-
eral places (certainly to the detriment of the development
of art), to rely principally on the great exhibitions for the
sale of their works. Finally, this must be said: only the
most outstanding work of those students of the Academy
whose sketches and studies had earlier comprised a sub-

stantial portion of the exhibited works are publicly exhib-
ited this time. Genre and landscape painting, as well as
portraits, are the most completely represented. History
painting in the proper sense, along with glass painting,
represents less than a quarter of the total number of paint-
ings and drawings exhibited. The work of artists from out-
side Munich in this exhibition must be considered as sub-
stantial, since they are represented in the painting section
by two hundred works and make up more than a third of
the exhibit. Among these are striking works from Ger-
many, with Düsseldorf, Berlin, Dresden and Weimar
sending the most valuable contributions. (Vienna and
Frankfurt sent nothing.) France, Holland and Belgium
are represented with many paintings, and artists resident
in Rome have also given many competent works. Most im-
portant are the numerical proportions of the cast and
pressed works of sculpture which fill two rooms and num-
ber only about one hundred; one fifth of these works have
been sent by artists living outside Munich, so the exhibi-
tion no longer maintains its former local character but has
taken on a wider importance. Consequently, the trans-
portation costs for the works add considerably to exhibi-
tion expenditures. For this reason a moderate admission
fee was introduced as has been usual for some time in
other places. The educated public should only be grateful
for this, because formerly the perpetual crowd of unin-
formed curious people was a distraction to the true enjoy-
ment of art. The catalogue, which appeared also in a
French edition, was better arranged: works were listed sep-
arately according to the different categories and those
works that were sent to the Academy for sale were in-
dicated as well.

* * *

The history paintings in the exhibition do not provide a
corresponding indication of the development of those high
ideas which, since the time of Cornelius, have struck such
deep roots in monumental works here. But they clearly
demonstrate that the tradition persists and that religious

expression is still preferred in this area. While the artist may find the acclaim won by an ingenious and technically perfect treatment of famous incidents, following the example of the well-known pictures of Gallait and Biefve, to be very enticing, Christian religious history still remains the vital center for art just as it forms the core of the world's history. There alone art finds an unchanging ideal world and art must ever return to it. Without the penetrating light of these ideals, the secular history that is the basis of the artist's creation would become a sad, confused and incomprehensible mass of incoherent activities and events.

A *Judith* by Professor Wach of Berlin presents another treatment of theme that has recently been handled so successfully by Riedel. The frequent return to this task is understandable, when one considers how much it must excite a painter to represent a splendidly dressed feminine being whose spirit and beauty are highly praised in the Holy Scripture at the moment when she overcomes the inherent modesty of her sex and by an audacious act heroically frees her people from a powerful, feared enemy. The Wach painting cannot be denied great recognition. The heroic woman has emerged from the tent in which the murder has occurred; her right hand carries the bloody sword and her left Holofernes' head, which the maidservant is about to conceal in a sack. Proud courage and the exaltation of victory are painted on her face. The entire composition does not attract by novelty but reveals a reflective artist. The execution is thorough, careful and of a significant technical perfection. An unfortunate effect results from Wach's placement of the pure, ideal features of Judith in contrast to those of the servant girl, whose figure is too coarse and fleshy. It would have been more appropriate if the companion had been left unseen or had been presented on a higher spiritual level by accentuating the natural womanly horror at the deed which Judith repressed by the strength of her exaltation and conviction. Although the treatment of the material of Judith's splendid garment is true to nature, it cannot be said to be free from overloading and monotonous symmetry.

The Düsseldorf school is represented by Director Schadow, Steinbruck and Deger. . . .

During its closing days the exhibition acquired a very valuable contribution: twelve pencil drawings by Overbeck of subjects taken from the life of Christ. . . . Overbeck's handling of these well-known biblical subjects, which are usually treated very conventionally, has such fresh immediacy of feeling, such noble simplicity and surprising originality, that they arouse spontaneous pleasure. This pleasure is partly due to one's encountering, in a period when people are interested in origins, such wonderfully fragrant blossoms on the traditional stem of Christian art and due partly to the genius of Overbeck, which history has recognized and which is now linked to new works of undiminished, yet frequently maturer, creative strength. This strength is German, in the strongest sense of the word. The profundity of the German character speaks in the comforting features of the Savior-teacher, in the sublime, pure form of Mary and in the angelic countenances removed from everything earthly. The moral dignity of the German spirit under Christian inspiration demonstrates its dominant strength even when in the grasp of hostile elements, of the Pharisaical and the Sadducean, and with the torch of art it casts a light into the deepest recess of evil and darkness of the divine image in order to give it expression. Moreover, true and unfalsified sensitivity emerges everywhere in these drawings by Overbeck. Art serves the master not as a goal in itself but only as a means for the development of his inner self. He develops his spiritual life before he takes up his slate pencil and therefore his implement rarely fails him. But, as has already often been observed, Overbeck is endowed with grace in its original meaning, and his treatment of strong, savage or overpowering characteristics is less successful. This is confirmed also, in our opinion, by the drawings under discussion. *The Flagellation* is the least satisfactory for this reason. Among the best are without dispute the groups of angels, full of wonder, devotion and love, hurrying to the Christ child lying in a manger. (Still one must note that the im-

pression of the whole has certainly benefited by the omission of the shepherds in the background.) The principal emphasis in *The Slaughter of the Innocents* has, with noble restraint, been placed on the suffering of the mother and not on the horrible slaughter of the little ones. . . .

. . . From Paris Julius Ziegler has sent a picture whose composition we must characterize as a remarkable artistic mistake. It represents Jacob's dream of the ladder to heaven. The biblical narrative quite possibly appeared too trite and too common to the artist. The subject should receive a touch of modern ideas and received them wonderfully well: angels passing above must symbolize agriculture, art and industry, by which the future is revealed to Jacob. According to the words of the catalogue, the veiled angels in the background are supposed to indicate those arts "that were revealed to Jacob but are still hidden from us." Poor Jacob, railroads, steam engines and factories also have harassed you in your patriarchal dream! Not only does the invention rest on a misconception of the idea, but the execution is also unsatisfactory. The cold blue color of the apparition of angels does not harmonize with the warm flesh tones of Jacob. The entire treatment is materialistic and inadequately thought out. . . .

* * *

Battle and genre painting, which are most easily understood by the crowd and have thus become the most popular categories in our time, contain (next to landscape and portraiture) the largest number of pictures that can qualify as first-class art works in the exhibition. During the present period of a long peace, the tumultuous times of the recent European wars are gladly looked back to as a period that offers inexhaustible material for painting. Princes and army leaders especially want a pictorial souvenir of the great, famous events of war in which they personally participated.

The numbers of spectators for paintings of landscape and the life of people are constantly expanding because of the easier means of transportation and the constantly in-

creasing interest in travel; an interest, previously unknown, in paintings of distant regions and peoples has developed. However, preferences soon turn from one thing to another according to fashion and the mood of the day, and the change is often determined by political events. Now it is the Netherlands, so eminently depicted by the new school of Belgium and Holland, as well as Italian, Spanish and oriental folk scenes that are predominant. Mountain scenes of Bavarian and Austrian highlands with poachers and Alpine dairy maids, which were formerly so beloved and numerous, are now entirely absent. . . .

For some time Peter Hess of Munich has been busy with a commission for the Russian Tsar for a series of large battle scenes. The most recently completed of these is one of the best paintings by this indefatigably active artist and also the principal ornament of the exhibition. It shows Napoleon's army retreating in November 1812 across the Berezina, pursued by Russian troops, and it was executed according to eyewitness reports of the most horrible drama that recent military history can provide. With shattering truth the frightful scenes of those days pass before our vision, and the eye, after having devoted itself to the total impression of the fearful catastrophe, is only gradually able to see the multitude of details. These details demonstrate the master's artistic judgment, his astonishing objectivity and his perfect mastery of the profuse material.

The better genre paintings belong to the Dutch and Parisian schools, and a painting by Claudius Jacquand of Paris is indisputably the best among them. It depicts gypsies who, accused of robbing a traveling bishop, appear before the local noble to hear their sentence from his district judge.

. . . While we must concede the superiority of the Netherlands and France in genre painting at this exhibition, the Germans show themselves equal and occasionally superior to foreigners in the ideal landscape. Munich and Düsseldorf have been rivals for the palm in this area. A large landscape by Heinrich Heinlein of Munich, *The*

West Face of the Ortler in South Tyrol, is based on a strongly poetic view of nature and developed in a free and bold style of sharply emphasized individuality. On the right, gloomy dark woods and rocks are depicted with fresh green meadows, while to the left a powerful ascending view of the Ortler opens above a valley ravine. The glaciers are arranged in a magical, vibrant light and wild water rushes from their crevasses to dash foaming to the depths of the bare cliffs in the foreground. While Heinlein has been absorbed in the grand external appearance of the world of mountains, Shrimer in Düsseldorf has delved into the interior of a primeval German forest. In one painting, he allows a deer to graze in secret loneliness on turf gleaming with the rays of the morning sun at the foot of moss-vine-covered oaks. Plant life with innermost sensitivity, untouched by human hand, which thrives around the dark mirror of the shadow-shrouded spring, unfolds with strength and freedom in every twig, leaf, reed and fern, and a wonderful freshness and energy of color is spread throughout the scene like a direct breath of nature. . . .

We believe a landscape by Turner of London cannot be left unmentioned as it is an incomprehensible curiosity of the exhibition. This master is well known as one of the foremost living landscape painters of England. The subject of the painting is supposed to be *The Inauguration of Walhalla* in allegorical form, according to the catalogue. The allegory unfortunately lacks all firm drawing and is so deeply immersed in the unrecognizable, in the *phantomistisch,* in a dissolving mishmash of color, that nothing remains for the critic but to express regret that British landscape painting is represented in such an odd, almost comic manner. . . .

1846

PARIS: The Exhibition
of a Society

Late in 1845 the Société des Artistes,[1] founded in 1844 by the writer, illustrator and inspector of fine arts, Baron Isidore Taylor, planned an exhibition the proceeds of which would go to the society's relief and pension fund. A committee asked collectors and artists to lend paintings of eminent artists who had influenced French art since the Revolution. Greuze, whom Diderot had admired in the Salon criticism he wrote for Grimm's *Correspondance littéraire*, was the earliest artist to be included. Ten paintings by Jacques Louis David were once more on view. Contemporary artists whose genius was not acknowledged by the conservative committee were not included. Delacroix's works were not chosen, though canvases by Géricault, Girodet, Guérin, Horace Vernet, Paul Delaroche, Ary Scheffer and Léon Cogniet were included. For many Parisians the eleven paintings by Ingres were the most in-

[1] [La Société des Artistes is known by a variety of names. A. Tabarant referred to it as l'Association des Artistes (*La vie artistique au temps de Baudelaire*, Paris, 1942, pp. 95–97); Léon Rosenthal called it both l'Association des Artistes and l'Association Taylor (*Du romantisme au réalisme*, Paris, 1914, pp. 31, 51); Théophile Thoré reviewed it as la Société des Peintres (W. Burger (T. Thoré), *Salons de T. Thoré, 1844, 1845, 1846, 1847, 1848*, Paris, 1868, p. 207). La Société des Artistes has been used here because, according to Jonathan Mayne, this was the name used on the catalogue for the exhibition (*Art in Paris 1845–1862, Salons and other exhibitions reviewed by Charles Baudelaire*, London, 1965, p. 33, fn.). The English translations of the various names for the organization create further confusion about its identity, suggesting that translating such names should be undertaken with caution.]

teresting works. When his *Martyrdom of St. Symphorian*
received harsh criticism at the Salon of 1834, Ingres,
deeply offended, had left for Rome to assume the direc-
torship of the École Française. He had sent no canvases to
France and even after his return to Paris in 1841 had
declined to participate in the Salon. The Société des
Artistes exhibition offered many Parisians their first oppor-
tunity to see Ingres's work.

The committee secured exhibition space in the com-
mercial Galerie des Beaux-Arts owned by a bookseller,
Techener, who charged admission fees for the exhibitions
he held. Ten thousand visitors had viewed the paintings
by Raphael he exhibited in 1842. The gallery was located
in the Bazar Bonne Nouvelle, which was—like the Ville
de Paris, the first department store, built in 1842–43 on
the Boulevard Montmartre—a smart shopping center for
the bourgeoisie and the successful artists like Delacroix
who lived on the south slope of Montmartre. This district,
improved and embellished by the building of Notre Dame
de Lorette in 1823, became increasingly chic. Here was
the center of newspaper and publishing houses. Theaters
and music halls lined its boulevards. Here resided the
"Lorettes," the companions of artists and journalists fea-
tured in Gavarni's lithographs. Here was the Basilica St.
Vincent de Paul, completed in 1846 and awaiting its deco-
rations by Hippolyte Flandrin. The recently completed
railways from the north terminated in the district and
plans for the stations were under way.

When the exhibition at the Bazar Bonne Nouvelle
opened in January 1846, it was soon crowded with gentle-
men in long tight trousers, redingotes and top hats, and la-
dies whose hooped dresses were just beginning their out-
ward expansion. Fashionable Parisiennes could show their
prosperity by draping themselves with increasing yards of
material as power looms lowered the cost of cloth. Pa-
tronesses of the Société des Artistes threaded through the
crowd selling tickets to the Benefit Ball, to be held at the
Odéon on January 31.

The unique historical character of the exhibition chal-

lenged the art critics. In the *Journal des débats* of January 28, 1846, Étienne Delécluze, who had been a student in David's studio in 1796 and had known of many of the artists represented in the exhibition, praised the lenders' generosity. He pointed out that David's contribution to the development of the French school lay in the artist's having adapted the "grand manner" to paintings of contemporary history and that Ingres, whom the critic had championed for twenty years, demonstrated his genius in the variety of his subjects and techniques.

Théophile Thoré, writing for *Le Constitutionnel* and the *Bulletin des Alliances des Arts*, found the exhibition an interesting prelude to the Salon of 1846, which would open March 6. He used his report as an introduction to his review of the Salon of 1846, which he dedicated to George Sand, when he published his collected Salons as *Salons de T. Thoré avec une preface de W. Burger* (Paris, 1868). Concerning Ingres, Thoré noted:

> Ingres is the most romantic artist of the nineteenth century, if romanticism is the exclusive love of form, the absolute indifference to all mysteries of human life, skepticism in philosophy as in politics, and egotistical detachment from all ordinary, fraternal feelings. The doctrine of art for art's sake is, in effect, a sort of materialistic Brahminism that absorbs its disciples, not in the contemplation of eternal things, but in the monomania of external and perishable form. It is remarkable that romanticism, whose good influence on style cannot be denied, has not produced one man with social convictions. . . . Ingres can therefore be reproached with his indifference in religious matters, in philosophy, in politics, in morals, in history, and in all that deeply interests man and society. The position of Ingres is so eminent in our school that he is responsible for the direction taken by a whole set of artists. Once a bad principle is accepted, it can compromise a whole generation.

In the crowd of well-dressed visitors to the exhibition
was bareheaded Charles Baudelaire (1821–67), strangely
costumed in patent leather shoes and a white linen smock
that ballooned around his thin frame. He was accompa-
nied by Émile Deroy, a young artist friend who had
painted Baudelaire's portrait in 1844. While still a stu-
dent, Baudelaire had desired to become a man of letters.
To discourage him, his stepfather, General Jacques Au-
pick, a career military officer, had arranged for Baudelaire
to spend eighteen months voyaging to India. The young
poet cut the journey short, returned to Paris and his inher-
itance, and established himself on the Île St. Louis. His
mother and stepfather, alarmed by Baudelaire's dissolute
life, placed his inheritance in trust, which limited him to a
meager allowance.

Eager to be recognized as a writer and hoping to supple-
ment his income, shortly after his twenty-fourth birthday
Baudelaire had published in 1845 at his own expense
(using the name Baudelaire-Dufays to identify himself
with his mother and her family) sixty-four pages of com-
ment on the Salon of that year. Baudelaire's friends in the
press had commented favorably on the brochure; an
anonymous notice, probably written by Baudelaire's friend
Champfleury, comparing the young author to Stendhal
and Diderot, had appeared in Le Corsaire-Satan, a literary
paper in which many brilliant young writers published
their work.

On the strength of the promise shown in Baudelaire's
brochure, the director of Le Corsaire-Satan, Leopoitevin
Saint-Alme, accepted his review of the benefit exhibition.
In his visit to the Bazar Bonne Nouvelle, Baudelaire may
well have profited from his friend Thoré's comments on
the paintings on view. Written in beautiful prose, the re-
view enabled him to practice the dominant note of his
later art criticism, "the glorification of the cult of the
image," which he called "my great, my unique, my primi-
tive passion."

Having thus been confronted three times in the course
of a year with the problem of reviewing an exhibition,
when he wrote on the Salon of 1846, Baudelaire asked
himself, "What is the good of criticism?" and answered:

> I sincerely believe that the best criticism is that
> which is amusing and poetic; not cold and mathe-
> matical criticism which, on the pretext of explaining
> everything, has neither hate nor love and willingly
> strips itself of every sort of emotion; but—a hand-
> some picture being nature reflected by an artist—the
> best criticism would be that picture reflected by an in-
> telligent and sensitive mind. Therefore, the best ac-
> count of a painting might be a sonnet or an elegy.
>
> But that type of criticism is destined for antholo-
> gies of poetry and poetic readers. As for what is prop-
> erly termed criticism, I hope that philosophers will
> understand what I am going to say: to be accurate,
> that is to say, to have a reason for being, criticism
> should be partial, impassioned, political—that is to
> say, made from only one point of view, but from the
> point of view that opens the widest horizons. . . .
>
> Each century, each people having possessed the ex-
> pression of its beauty and its ethos—if by roman-
> ticism you are willing to understand the most recent
> and most modern expression of beauty—the great art-
> ist will then be—for the reasonable and impassioned
> critic—he who unites to the condition demanded
> above naïveté, the most of romanticism possible. . . .

By enabling the critics to compare the works of contem-
porary French painters with those of their predecessors,
the retrospective exhibition at the Bazar Bonne Nouvelle
led them to a self-critical and analytical attitude and
obliged them to consider where current art was in point of
time and history.

Charles Baudelaire: "The Museum of Classics
at the Bazar Bonne Nouvelle, in the Galerie des
Beaux-Arts, Boulevard Bonne Nouvelle, 22"[1]

Every thousand years or so a brilliant idea arises. Let us
count ourselves fortunate therefore to have numbered the
year 1846 in the tale of our existence, for this year has en-
abled all sincere enthusiasts of the fine arts to feast their
eyes on ten pictures by [Jacques Louis] David and eleven
by Ingres. Our annual exhibitions, those turbulent, noisy,
riotous bedlams, can give no idea of this one, which is as
calm, gentle and serious as a scholar's study. Without
counting the two eminent artists whom we have just
named, you will be able once more to enjoy noble works
by Guérin and Girodet, those remote and delicate masters,
those proud continuers of David, himself the proud
Cimabue of the genre called Classical; and ravishing
pieces by Prud'hon, that brother in Romanticism to André
Chénier.[2] . . .

The classical exhibition achieved at first no more than a
loud guffaw from our young artists. The majority of these
presumptuous gentlemen—we would prefer not to name
them—who in art correspond well enough to the adepts of
the false Romantic school in poetry—whom we would
prefer not to name either—can learn nothing from these
austere lessons of Revolutionary painting, that painting
which voluntarily denies itself all unhealthy sugar and
spice, and whose life is primarily one of thought and
soul—as bitter and despotic as the Revolution from which
it sprang. But our young daubers are far too clever and
know much too much about painting to rise to these

[1] [Verbatim from *Art in Paris 1845–1862, Salons and other
exhibitions reviewed by Charles Baudelaire*, trans. and ed.
Jonathan Mayne (London, 1965), pp. 33–40.]

[2] [André Chénier (1762–94), friend to LeBrun and various
artists, was a poet.]

heights. Color has blinded them; and they can no longer see and trace their way backwards to the austere roots of Romanticism, that expression of modern society. Laugh on, then, and fritter away your time at your ease, you juvenile greybeards; and let us concern ourselves with our masters.

Among the ten works by David, the most important are *Marat, The Death of Socrates, Bonaparte on Mont St. Bernard,* and *Telemachus and Eucharis.*

The *divine* Marat, with one hand hanging over the edge of the bath, limply holding its last pen, and his breast transfixed with the *sacrilegious* wound, has just breathed his last. On a green desk placed in front of him his other hand is still holding the treacherous letter: "Citizen, my extreme misery suffices to give me a right to your benevolence." The water in the bathtub is red with blood, the paper is blood-soaked; on the ground lies a great kitchen knife reeking with blood; on a wretched packing-case which comprised the working-furniture of the tireless journalist we read: "A Marat, David." All these details are as historical and real as a novel by Balzac; the drama is there, alive in all its pitiful horror, and by an uncanny stroke of brilliance, which makes this David's masterpiece and one of the great treasures of modern art, there is nothing trivial or ignoble about it. The most astonishing thing about this extraordinary poem is the fact that it is extremely rapidly painted, and when you think of the beauty of the design, this becomes quite staggering. It is the bread of the strong and the triumph of the spiritual; as cruel as nature, this picture has all the perfume of the ideal. Where now is that famous ugliness which holy Death has so swiftly wiped away with the tip of his wing? Henceforth Marat can challenge Apollo; Death has kissed him with his loving lips and he is at rest in the peace of his transfiguration. There is something at once both tender and poignant about this work; in the icy air of that room, on those chilly walls, about that cold and funereal bath, hovers a soul. May we have your leave, you politicians of all parties, and you too, wild liberals of 1845, to give way

to emotion before David's masterpiece? This painting was a gift to a weeping country, and there is nothing dangerous about our tears. . . .

Guérin is represented by two sketches, of which one, *The Death of Priam*, is a superb thing. In it are to be found all the dramatic and almost fantasmagoric qualities of the author of *Theseus and Hippolytus.*

It is certain that Guérin was always much taken up with melodrama.

This sketch is based on Virgil's lines. There is Cassandra, with her hands bound, snatched from the Temple of Minerva, and the cruel Pyrrhus dragging the trembling old Priam by the hair and cutting his throat at the foot of the altar. —But why has it been so carefully hidden? Can it be that M. Cogniet, one of the organizers of this festival, bears a grudge against his venerable master?

Girodet's *Hippocrates refusing the Gifts of Artaxerxes* has returned to us from the École de Médecine to display for our admiration its superb structure, its excellent finish and its spirited details. It is a curious thing, but this picture contains particular qualities and a multiplicity of intentions which remind one, in another system of execution, of the admirable canvases of M. Robert-Fleury. We should have liked, however, to have seen at this exhibition a few compositions which would have properly expressed the essentially poetic side of Girodet's talent (something like the *Endymion* or the *Atala*). Girodet translated Anacreon, and his brush was always dipped in the most literary springs.

Baron Gérard was in the arts exactly what he was in his drawing-room, the Amphitryon eager to please everyone; and it is this courtier-like eclecticism that was his undoing. David, Guérin and Girodet have stood firm, unshakeable and invulnerable relics of that great school, but Gérard has left behind him no more than the reputation of a delightful and highly witty man. Nevertheless it was he that proclaimed the arrival of Eugène Delacroix, saying "A painter has been born to us! He is a man who runs along the rooftops."

Gros and Géricault, without possessing the finesse, the delicacy, the sovereign reason or the harsh austerity of their predecessors, were nevertheless generous temperaments. There is a sketch by Gros at the exhibition, *King Lear and his Daughters*, which is very arresting and strange; it reveals a fine imagination.

Next comes the delightful Prud'hon, whom some people go so far as to prefer to Correggio; Prud'hon, that amazing mixture, Prud'hon, that poet and painter who, in front of David, dreamt of colour! That soft, artful and almost invisible line which winds beneath his paint is a legitimate subject for surprise, especially when you consider his date. —For a long time to come our artists will have insufficiently well-tempered souls, so to speak, to attack the bitter joys of David and Girodet. The delicious caresses of Prud'hon will thus act as a preparation. We were particularly struck by a little picture, *Venus and Adonis*, which will doubtless give M. Diaz something to think about.

In his special gallery M. Ingres proudly displays eleven pictures; in other words, his entire life-work, or at least specimens from each period—in short, the whole Genesis of his genius. For a long time M. Ingres has refused to show at the Salon, and in our opinion he is right. His admirable talent is always more or less shouted down in the midst of those crushes in which the stunned and exhausted public wearily submits to the law of the loudest. M. Delacroix must have superhuman courage annually to brave so much paint-splashing. M. Ingres, however, gifted with a patience no less great, if not with so generous a boldness, sat waiting his chance in his tent. Well, the chance has come, and he has made superb use of it. We have not the space, nor perhaps the command of language, to praise worthily his *Stratonice*, which would have astonished Poussin, his *Great Odalisque*, by which Raphael would have been tormented, his *Little Odalisque*, that delicious, odd fantasy which has not a single precedent among the old masters, and the portraits of M. Bertin, M. Molé and Mme. d'Haussonville—real portraits, in

other words, ideal reconstructions of individuals. We think it well, however, to put right certain prejudices which are current on the score of M. Ingres among a certain section of the community whose ears are better endowed with memory than their eyes. It is agreed, or recognized, that M. Ingres' painting is *grey*. —Open your eyes, you nation of boobies, and tell us if you ever saw such dazzling, eye-catching painting, or even a greater elaboration of color? In the second *Odalisque* this elaboration is excessive, but in spite of their multiplicity, the colours are all endowed with a particular distinction. —It is also generally agreed that M. Ingres is a great but clumsy draughtsman, quite ignorant of aerial perspective, and that his painting is as flat as a Chinese mosaic; to which we have nothing to say, except to compare his *Stratonice*, in which an enormous intricacy of tone and lighting-effects does nothing to upset the harmony, with the *Thamar*, in which M. Horace Vernet has resolved an incredible problem—how to produce painting which is at once infinitely gaudy and infinitely indistinct and confused! We have never seen anything so chaotic. One of the things in our opinion that particularly distinguishes M. Ingres' talent is his love of women. His libertinism is serious and convinced. M. Ingres is never so happy nor so powerful as when his genius finds itself at grips with the charms of a young beauty. The muscles, the folds of the flesh, the shadowed dimples, the hilly undulations of the skin—nothing is overlooked. If the Island of Cythera were to commission a picture from M. Ingres, you can be very sure that it would not be laughing and frolicsome like Watteau's, but robust and nourishing like antique love.[3]

It gave us great pleasure to see again the three little pictures by M. Delaroche, *Richelieu*, *Mazarin*, and *The Murder of the Duc de Guise*. These are charming works

[3] M. Ingres' draughtmanship reveals elaborations of a quite personal kind—extreme refinements, due perhaps to unusual working methods. We should not be surprised, for example, to find that in the *Odalisque* he had used a Negress as a model to emphasize more markedly certain bodily developments and attenuations.

in the middle reaches of talent and good taste. Why then
has M. Delaroche succumbed to the disease of painting
large pictures? Alas, they are always no more than just lit-
tle ones—a drop of the pure essence in a barrel.

M. Cogniet has taken the best place in the gallery in
which to hang his *Tintoretto*. M. Ary Scheffer is a man of
outstanding talent, or rather a happy imagination, but he
has changed his manner too often to possess a good one;
he is a sentimental poet who soils canvases.

We saw nothing by M. Delacroix, which seems to us to
be only one reason the more for speaking of him here.
—On our honor, we naïvely believed that if the Commis-
sioners had not asked the leader of the present day school
to take part in this artistic occasion, it was because, not
understanding the mysterious kinship which binds him to
the revolutionary school from which he emerged, they
were chiefly concerned with unity and uniformity of as-
pect in their final result; and this we judged if not praise-
worthy, at least pardonable. But not a bit of it. If there
are no Delacroixs, it is because M. Delacroix is not a
painter but a journalist; at least that was the answer given
to one of our friends when he made it his business to ask
for a little explanation on this matter. We have no desire
to name the author of this witticism, sustained and sup-
ported as he was by a swarm of vulgar jibes which these
gentlemen have permitted themselves at the expense of
our great painter. —There is more in it for tears than for
laughter. —Can it be that M. Cogniet, who has made such
a good job of concealing his illustrious master, feared also
to support his illustrious co-pupil? M. Dubufe would have
behaved better. Doubtless these gentlemen would deserve
some respect because of their weakness, if they were not at
the same time spiteful and envious.

Many a time we have heard young artists complaining
of the Bourgeois, and depicting him as the enemy of ev-
erything great and beautiful. —This is a very false idea
which it is time to pin down. If there is one thing a thou-
sand times more dangerous than the Bourgeois, it is the
Bourgeois-artist who was spiritually created to come be-

tween the public and the genius; he blocks one from the
other. The Bourgeois, with few scientific notions, goes
wherever he is pushed by the oracular voice of the Bour-
geois-artist. —If he could be abolished, the grocer would
carry M. Delacroix shoulder-high in triumph. The grocer
is a great thing, a heavenly man whom we should respect,
homo bonae voluntatis! Be very careful not to mock him
for wanting to get out of his sphere and to aspire, excel-
lent creature that he is, to the loftier regions. He wants to
be moved, he wants to feel, to know, to dream, as he
loves; he wants to be complete; each day he asks you for
his ration of art and poetry, and you snatch it from him.
He lives on a diet of Cogniets, and this proves that his
goodwill is infinite. Put a masterpiece before him, and he
will digest it and feel only the better as a result!

1847

PARIS: The Official Exhibition
of the State

In 1846 and 1847—years marked by poor harvests—a
restless, disturbed, expectant atmosphere pervaded and
spread throughout Europe. Liberal political leaders,
writers, artists and workers had become impatient. Storm
centers were forming in the Austrian imperial states of
Venetia, Modena, Parma and Hungary, in the Papal
States, and in the principalities of Germany. In 1847 the
Prime Minister of Piedmont, Count Cavour, brought out
the first issue of his newspaper, *Il Risorgimento*, to rally
the scattered advocates of a federated state in Italy.

In France no party—liberal, socialist, republican, Bona-
partist—could any longer ignore the electoral and parlia-
mentary corruption. By July 1847 all factions of the oppo-
sition instituted "reform banquets" to evade police
regulation of political assemblies. Radicals campaigned for
universal suffrage; liberals for an extension of the right to
vote. The populace listened to the platforms for reforms
and signed petitions that demanded their rights be recog-
nized.

Artists joined students and radicals to demand reforms,
and hoped for changes in the Institute de France as well
as in the government. The Salon jury of 1846 had again re-
jected a large proportion of the works submitted for con-
sideration. Corot, Diaz and even Decamps had works re-
fused. Baudelaire declined to comment on the situation
in his review of the Salon, but Thoré, Gautier and other
critics made their resentment towards the jury known. In
January 1847, Clément de Ris published a pamphlet, *Ap-
pel aux artistes: de l'oppression dans les arts et de la*

*composition d'un nouveau jury pour les ouvrages présentés
en 1847*, which suggested reforms in the jury procedure.
The king gave an indirect promise that changes would be
provided for in the Salon of 1847, but there was no tangi-
ble evidence of it. Of the 4,900 works submitted to the
jury, over half were rejected. In response, many artists
signed a petition directed to Louis Philippe by Arsène
Houssaye that began:

> The complaints that the jury's judgments produce
> each year at the time of the exhibition of living artists
> must have reached as far as Your Majesty. Today,
> Sire, these refusals strike the works of artists whose
> merit is so incontestable that one can believe in sys-
> tematic ideas on the part of the members of the jury.
> These decisions without appeal legitimize the com-
> plaints of the artists from whom is thus taken the
> only kind of publicity open to them and over whose
> future such decisions can exercise the most distressing
> influence. The artists have protested these exclusions
> for several years, but their entreaties have remained
> unanswered.

While the quarrel between the jury and other French
artists might point out differences in styles and tech-
niques, the actual debate was not over this but over the
artists' rights as secured by precedent and law. Even well-
established artists like Delacroix, who had received nu-
merous government commissions, were forced to submit to
the jury and could be—and were—refused as easily and
completely as the youngest unknown. This was recognized
not only by liberal critics, like Thoré, but also by more
conservative writers. Delécluze, a defender of classical tra-
ditions, proposed an alternative jury system in his opening
article on March 20 in the *Journal des débats*. The ques-
tion advanced in news interest from the art periodicals to
the columns of the daily newspapers. Émile de Girardin,
owner of *La Presse*, Paris' largest daily, published on
March 24 an open letter to Gautier containing a plan for
the revision of the jury.

Thoré's review of the Salon appeared under the title "*Revue des arts*," his column in *Le Constitutionnel*. In his review, dedicated to Firmin Barrion, a country doctor in the Vendée, Thoré opposed the "art for art's sake" of Gautier with "art for humanity's sake." Barrion, who worked for humanity and lived surrounded by nature, resembled Thoré's ideal painter, the landscapist, who remained untouched by the destructive materialistic spirit of the age and translated an almost mystical sense of the beauties of nature into his paintings.

Artists had been emboldened by the appearance of exhibition facilities apart from the Salon: La Société des Artistes continued to hold exhibitions at the Bazar Bonne Nouvelle and several artists had exhibited their works in the foyer of the Odéon. They began to gather to plan other independent exhibitions. On April 15 the sculptor Barye was joined in his studio by Ary Scheffer, Daumier, Decamps, Théodore Rousseau and a notary to formulate the rules of an independent Salon. Préault, Jeanron, Chenavard and Étex met Daumier at his studio for a similar purpose.

As 1847 drew to a close it was rumored that the Salon would not be held in 1848, but in December appeared the announcement that the Salon would take place, juried as usual, and in preparation the Louvre would close on February 1.

Étienne Delécluze, "Salon of 1847: Recommendations Concerning the Jury"[1]

. . . Of 4,800 art objects presented to the jury this year 2,321, which makes a little less than half, have been admitted to the exposition. The jury was severe; but if it is assumed, not without reason, that the pieces rejected, taken all together, are inferior to a third of the very weak

1 [Translated from *Journal des débats*, March 20, 1847.]

compositions that are included among the ones seen in the exposition today, the necessary conclusion is that, if everything that was sent into the Louvre had been admitted (aside from the impossibility of finding a place for all of it), the small number of works of merit would have been overwhelmed, drowned in an ocean of mediocrity—a circumstance very unfavorable for art and very unentertaining for the public.

The ever increasing number of people who throw themselves into a career in the arts seem to have given rise to a small revolution the symptoms of which I have already pointed out. The private expositions, the exhibitions held under various pretexts, actually have as their purpose to respond to a very natural double desire: on the one hand, our distinguished artists do not wish to be confused with the mediocre students and amateurs, and on the other hand, the public is tired of looking, as in a bazaar open to all kinds of merchandise, for some prize gems. These exhibitions, as I said, are fatally threatening the Louvre exposition, which is already very ill. No one is unaware that, among the artists of the Institute who are members of the jury, there are quite a few—some of the most skillful and famous—who excuse themselves from assuming this heavy task; and if we are to believe the rumors that have been circulating for a year, the elite of our painters might have resolved to establish private associations in order to show their works on the side.

Apart from the competition in the Louvre, which has an effect on the men whose talent is recognized (much less in quality than in number), certain arbitrary decisions of the jury concerning them have made them dread entering this annual competition which, from time to time, causes them to fall back into the category of students who are showing their works for the first time. Thus I shall cite the names of several artists who, from 1829 until today, have captivated public attention by their various talents and have attained fame; several of them have obtained commissions from the government and have received honorable compensations, and yet they have seen their works

refused. These are MM. Delacroix, Tony Johannot, De-
camps, Amaury-Duval, Barye, Maindron, Corot, Dupré,
Cabat, Marilhat, Étex, H. Flandrin, T. Rousseau, Odier
and Chassériau.

At present this is not a question of taste but of rights,
and it may be asked why the artist's profession is not sub-
ject to the same conditions as other professions. A patent
is required of the merchant, and those who want to be
doctors of medicine and lawyers must obtain their degrees;
but once these guarantees are secured, neither a new type
of guarantee nor taking the baccalaureate examination five
or six times is required of the admitted candidate. Why
do not artists, whose already large number still tends to in-
crease, benefit from the common law? Every wise govern-
ment always strives to strengthen existing conditions in
order to spare men the anxiety of having their existence al-
ways in question and is eager to acknowledge the rights at-
tained.

All has changed in the republic of the arts in the last
twenty years. In going back to 1827, it is seen, for exam-
ple, that the debut of a young artist at the Salon was, for
his master, his fellow students, and even for a certain sec-
tion of the public, an affair of sufficient seriousness to be
talked about all during the exposition and the young art-
ist's success or failure was pointed out in the newspapers.

But now that most artists train themselves or have freed
themselves from the type of responsibility that heads of
schools believed necessary for the first attempts of their
students, no dike stands in the way of the overflowing tor-
rent of mediocre beginners; this torrent has even swollen
so much that the artists, the public, and critics have
ceased to pay any attention to it. I do not know whether
the administration of the museum has kept a record of the
new exhibitors in the last twenty years, but there must be
very many; and it would be useful to know this, because in
clarifying the problem that is bothering us, it might help
to solve it.

The rejection and the scorn of the master and the
school began to show itself under the Directory. In the

catalogues of this period we already see the independence affected by young artists who called themselves "Students of nature and meditation." Soon there were others who openly renounced the teaching they had received; and finally, when the phalanx of painters was growing larger by the day, it was decided, in order to decrease the size of the catalogue, to omit the indication of the schools from which each painter came.

Perhaps the members of the jury might be able to make up for this preliminary, paternal criticism from which young artists have freed themselves, if, as it occurs to us, the academicians made legitimate use of their knowledge and authority to delay the debut of beginners in order to allow each one's talent to take a direction consistent with its nature, except when artists had obtained the right of exhibition.

As for conditions that would be imposed in order to receive the right to exhibit, perhaps three consecutive admissions might be required of the artists, but once these tests were successfully passed, the artist would no longer depend on the jury and would be exclusively subject to the public's jurisdiction, except in cases where works presented might be of a kind to disturb public order.

I offer this method although it undoubtedly needs to be thought out and improved; but as for the necessity of using a method that would determine the manner of reception and would put an end to the precarious situation wherein artists constantly find themselves at each exposition, that is urgent. Whether the interest of people is taken particularly into consideration or whether the problem is looked at from the point of view of the artistic celebrations of the Louvre, I believe it is indispensable to remedy the disadvantages and even the injustices that are involuntarily committed because of a faulty set of regulations with which some of the jury members do not wish to comply. . . .

Théophile Thoré, "Salon of 1847"[1]

I. General Review[2]

We are at the twenty-fifth of July in the kingdom of the arts. In the memory of criticism, one has never seen a similar insurrection against the jury sponsored by the Civil List. But will we have the three glorious days that will assure the victory and promise artists the best of republics? Will the Polignacs of the Institute and the *camarilla* be dispatched to Cherbourg?[3] Despite the general exasperation, we doubt that this revolt will become a serious revolution.

Well, they have refused everyone—every school and every party, the swamp and the plain as well as the mountain.[4] They have even refused very bad painters. . . .

How many indignant cries, how many modest complaints, how many very legitimate lamentations did we hear today in the galleries of the Louvre. But however much the dignity and the interests of these artists suffer, it is nevertheless the artists' own fault. Why do they submit to this slavery? Why do they accept this *ancien régime?* If there is a jury ordered by the Civil List, it is because there are painters who present their works to the arbitari-

1 [First published in *Le Constitutionnel*. Translated from *Salons de T. Thoré*, with a preface by W. Burger (Paris, 1868).]

2 [Omitted here are the Preface, to Firmin Barion, and the Introduction, "Le Foyer de la Comédie Française."]

3 [Jules de Polignac was a favorite minister of Charles X; he came to office in August 1829 and helped write the July Ordinances of 1830. *Camarilla*, from the Spanish, refers to a group of persons who have access to a king or leader and exercise great influence over him; cf. English "cabinet" and French *cabinet particulier du roi*.]

4 [The swamp (*le marais*), the plain (*la plaine*) and the mountain (*la montagne*) were factions in the National Assembly during the French Revolution.]

ness of this absolute, irresponsible jury that exercises its power like a Turk or a Venetian. If the artists had a sense of their solidarity and some independence, they would leave MM. Garner, Hersent, Pujol, Heim, Bracassat, Blondel, Petitot, Ramey, Nanteuil, Huve, Fontaine and the others waiting in the solitude of their council to destroy their rivals, and the artists would all together organize a beautiful, permanent, free exhibition. . . .

II. [Thomas] Couture

. . . All the great masters in the arts and particularly in painting have always snatched glory by some untamable and rare passion, by a dominating and exceptional quality. Raphael himself owes his immortality to a stubborn love that caused his death: the love of feminine beauty. Every famous artist is a maniac, carried by an irresistible instinct into a special circle of the sky. Michelangelo is mad about grandeur and movement; Titian about color, Rubens about flesh, Claude about sunlight, Watteau about voluptuousness. Sublime delirium teaches common man the fantaticism of nature and the religious enthusiasm of universal life.

All that is lacking to make Couture's picture [The Romans of the Decadence][5] a masterpiece is that indescribable stamp of violent originality; yet his painting has not been directly influenced by anyone. He is lacking I do not know what whisper of poetic unity to give him a most distinctive character; and yet his thought is written from one end of the canvas to the other with a most masterful liberty and frankness. A central focus is lacking that would bring together the pieces of this large picture and assemble it into a living being; yet life is scattered throughout, light, form and sensuality are everywhere. . . .

It must be said that Couture painted this magnificent palace and this innumerable crowd in an ordinary studio without sufficient space to be able to retreat and see at a glance the whole of the canvas, which is thirty feet long.

[5] [Couture derived his theme from Juvenal's VI Satire in the J. Lacroix translation. It is cited by Thoré.]

Every large picture should be seen from a distance and cal-
culated like a decorative painting. What often seems an
exaggeration when seen close up takes on another aspect
when intervening space neutralizes the half-tones and
swallows the contours. . . .

We see that Couture's picture is as remarkable for its
organization and its thought as for the splendor of its exe-
cution. It may well be that Couture never thought of
these refinements of contrast, of the effect of the intrusion
of philosophy in the middle of the corruption of antiquity
and of the lesson that results for the sense of his poem.
Artists are sometimes astonished by all that critics believe
they discover in their works. Art being original, it sponta-
neously creates a more or less complete image, which the
critics then analyze by means of reflective processes. . . .

This is not to say categorically that art is easy and criti-
cism is difficult, the opposite of that famous verse the ac-
curacy of which can, however, be questioned. Criticism
and art are not easy, in the sense that they demand a pre-
liminary education and the habitude of proceedings that
are particular to their nature. If art creates, criticism ex-
plains; it is the handmaiden of art, subordinate to it, as
analysis follows feeling; but it is, up to a certain point,
identical with the genius that invents and achieves, the
way a good metaphysician cannot completely separate feel-
ing and intelligence. If there is intelligence in all artistic
work, there is also a true poetic feeling in all famous crit-
ics, without which, on both sides, one would only end in
insignificance and sterility. . . .

These reflections have no other end than to present the
unity of art and of letters. Nothing is more fruitful for
writers than the study of painting. Beautiful images teach
beautiful style. But aesthetics opens to artists, who have
not concerned themselves with it, new, immense horizons.
It is a country whose explorations have been too much
neglected by our modern school. How many gifted
painters have therefore fallen powerless at the beginning
of their careers, after a glorious debut! For our part, we
have never been fooled by these transient reputations

which, due to the charm of brilliant painting, or to the interest of the subject, often attract the public's admiration. Couture's future seems to us assured by more solid reasons. The author[6] of *Romans of the Decadence* is a painter who knows his business like a seasoned practitioner and who joins the liveliness of his impressions to a feeling for grandeur and style. The marvel of this picture, besides the science of the drawing and the beauty of the color, is a deliberate, free brush stroke without any trace of fatigue, light and yet very vigorous. In several places the canvas, barely stroked, serves as a background and link in the general harmony. Couture chose a moment of verve and good fortune to carry off each portion. Perhaps the only thing he needs to fear are the seductions of success. Yet one can say without fear that this "decadence" will decide his ascension, to imitate the bad pun that was made by one of the friends of the *Medusa*'s author at the Salon of 1819: "My dear Géricault, you have painted a shipwreck that will not be one for you."

III. [J. Léon Gérôme]

We have enthusiastically applauded Couture's painting, citing the qualities of this light, free painting, instead of seeking minor imperfections in it with the solicitude that certain bilious artists display. Admiration is healthy for the mind; and as far as we are concerned, we are very happy when the rare occasion presents itself to approve a fine piece of work. . . . But I ask you, in the modern school, from Géricault's *Raft of the Medusa* onward among the large pictures, which compositions are preferable to that of *The Romans of the Decadence?* The decorations by Eugène Delacroix? Homer's ceiling by Ingres? Some poems by Ary Scheffer or others? If you add Rousseau, Decamps, Diaz, Meissonier, Dupré, Marilhat and some others, how many really good painters have you among our contemporaries? It is said that the French

6 [Thoré, like Planche and Delécluze, often used the word "*auteur*" in the sense of creator or inventor. Ary Scheffer's paintings are referred to as "poems" and George Sand is called a "painter."]

school today is without a rival in the world. Let us hasten to encourage it, when it is fighting valiantly for a good cause. . . .

We have also discovered another young painter who promises to develop a certain, quite distinguished style, even though he comes from Paul Delaroche's studio. Léon Gérôme is not over twenty,[7] according to what I hear, lucky artist! His *Cockfight* somehow brings Theocritus and the light poetry of the ancients to mind.

Lazily stretched out, the little Greek watches, with a finely captured expression, two cocks being goaded by her half-naked brother, who leans over the brilliantly lit sand. The drawing of these figures is correct without being cold, the color sober, accurate and harmonious. How did the jury ever let this first work of an unknown student pass?

IV. Eugène Delacroix

. . . Eugène Delacroix's pictures are well scattered among all these discordant paintings. So what a happy find, when one encounters a clear harmonious pearl amid these vulgar stones! Here is a man of quality by right of his talents, as was said in the seventeenth century when the accident of birth was acknowledged. Even if Delacroix had done only one of his little easel paintings, or the least of his sketches, he would still be the most refined painter of the modern school. But he has painted with an abundance worthy of Rubens and Murillo, whose paintings are innumerable. The works of Eugène Delacroix are everywhere, and for twenty-five years his superiority has never faltered. . . .

Eugène Delacroix has always had the gift of those strange perceptions of modeling and color that make his images stand apart from common forms. This lucky artist has never seen any subject through the glasses of an imitator. He slants his idea using an unexpected lighting in a way that no one could have predicted. He does not resemble any of the masters of the past, even though he has basically the same inspiration. The painter to whom he is per-

7 [Gérôme was twenty-three.]

haps closest is Velazquez. He has his slightly savage style, his silvery tone; his abrupt brush stroke, his superb effects; but he is no more Spanish than he is Venetian or Flemish.

He is not very French either. An eccentric genius whose genealogy cannot be guessed: *Prolem sine matre creatam.* He most certainly does not belong to Poussin's or Louis David's family any more than he does to Watteau's or Boucher's, the two distinct races whose dynasties have reigned in turn over our school. And yet he is not a foreigner, the man who painted *Liberty on the Barricades,*[8] the one beautiful painting in which the people will relive their July Revolution. . . .

In the Salon of 1847, Delacroix has six very different paintings. His *Christ on the Cross,* belonging to Barroilhet,[9] brings to mind Rubens' magnificent crucifixions; a resemblance of poetry and of color, like that of Giorgione to Titian. Even if Rubens had never existed, Eugène Delacroix would still have painted this Christ with the same feeling and in the same way. The body is seen in three-quarter profile, turned to the left, the head falling on the chest, the two feet separated and fixed to the cross, each by a nail. Delacroix does not perhaps realize that this separation of Christ's feet, united since the thirteenth century one on top of the other and nailed with but one nail, is today an iconographic heresy; he does not care about it one way or the other and neither do you. . . .

This Calvary, of admirable feeling and color, shows up on a background of fantasy and most poetically blue sky. Eugène Delacroix is incomparable in the painting of skies. Infinity is always open before him. This is why he is accused of never having finished; but look at the nature of his grandiose effects, always strange and varied; details never stand out from the whole; space envelops all the forms and wraps them in a meaningful harmony. It is exactly like music, where all the notes blend into the domi-

[8] [Exhibited in 1831 with the title *Liberty Leading the People.* See 1831: PARIS and illustration.

[9] [Paul Barroilhet (1810–71), the opera singer and art collector.]

nant harmony and dance in chorus. If Barroilhet was not a famous singer, since he has acquired Eugène Delacroix's Christ, I would take him for a great musician. Rossini and Lablanche[10] also passionately love the painting of the great colorists that sings a thousand delightful motifs in their ears. Eugène Delacroix is very close to Beethoven, and Cimarosa has always made me think of Watteau. . . .

The *Military Exercises of the Moroccans* shows a dozen riders emerging from the space and dust. Near me someone was saying in a critical tone, "None of those horses is touching the ground." I believe it, they are flying. In Raphael's *Expulsion of Heliodorus* there is the figure of a young man thrown forward with such a light, sudden movement that one finds oneself looking for his wings. These mad Arab horses have wings on their backs and on their feet. . . .

Almost across from the Moroccan riders is the *Odalisque with Parrot* lying voluptuously in the half-light, under a red curtain, which reddens her velvet hand. Her head is framed in the crook of the left arm, and the right arm stretches along her voluptuous thighs. The right leg stretches to the limit of the bed of silk and down; the left thigh is bent a little too sharply. On a cushion, near the beautiful dreamer, are little jars of perfume executed with Teniers's light touch and Paolo Veronese's splendid color. A tepid perfume like the exhalation of a flower or of a woman dominates this tranquil interior. What god or sultan will raise the mysterious curtain?

The odalisque figure is drawn with irreproachable perfection. Ingres could not criticize its contours, and the interior modeling is as full and firm as that of Correggio and the other masters of the school of Parma or of Venice. This particular quality of softly lit flesh with its peachlike skin and its silken reflections is marvelously expressed.

[10] [Gioacchino Antonio Rossini (1792–1868), Italian composer of opera whose works include *The Barber of Seville* (1816) and *William Tell* (1829). Luigi Lablanche (1794–1858), the greatest—and largest—operatic basso of his day.]

Flesh does not take light the same way cardboard, draperies or inanimate objects do; living flesh seems to suck up the rays of the sun and never lets them slide off with indifference. The sun likes skin better than any of the other materials it absent-mindedly caresses. Apollo always halts his shimmering chariot when he passes over a beautiful naked woman.

In addition to the modeling and the qualities of the color, Delacroix shows in this *Odalisque* a peculiarity of execution that is very rare today, even in the most skillful of craftsmen. The touch, or the way of laying on the color and stroking with the brush, is always in the direction of the form and contributes to the relief. When the surface turns, the artist's brush turns in the same direction, and the paint, which follows the direction of the light, never interferes with the beams that spread over the painting. Imagine a statue carved against the grain with a chisel! No matter how mathematically correct the form, it will never look right. In painting we are not preoccupied enough with this compelling necessity of method. The majority of painters stroke their canvas contrariwise, at random, without thinking of the necessary structure of all objects and the natural geometry. It is possible to build a well with a stroke of a trowel here and there, but this is not the way one caresses the face of his mistress, to begin with the chin.

Jewish Musicians of Mogador is in the Salon Carré to the right of Watelet's landscape. Three figures stand out on a pearly panel without any accessories; there is nothing around them but space. This space, however, is filled by imponderable atmosphere that makes itself felt like that in the sober Dutch interiors by Pieter de Hooch. . . .[11]

The sixth painting by Eugène Delacroix, *The Shipwrecked Abandoned in a Lifeboat*, is to be found between the *Christ* and the *Odalisque* on the left, in the first alcove of the gallery. It is a very poetic painting with an arresting effect. It makes one think of the *Shipwreck*

[11] [The discussion of the fifth painting, *The Interior of the Guardhouse at Meknes*, is omitted.]

shown in 1841,[12] which today belongs to M. Moreau, the stockbroker. This shipwreck does not fear comparison with the best paintings of the Venetian masters; a masterpiece whose color improves with age, contrary to all inferior paintings. . . .

Eugène Delacroix, in our opinion, has better understood the drama of a shipwreck than Géricault did in his *Medusa*. The scene on the raft [of the *Medusa*] takes place very close to you and is, in a way, within reach of help. . . .

But if, instead of bringing the spectator close to the sailors abandoned on the sea, far from all land, you surround that nutshell with storms, buffeted with its group of men, how much keener and sharper an impression it makes! There is no way to save them. In this way nature's poetry reinforces the poetry of the human soul. That is what results from the composition of the two shipwrecks painted by Eugène Delacroix.

In the Salon of 1847, Eugène Delacroix is, as always, a great poet and a great painter of a marvelous profundity, who puts as much true art in a little canvas as in his handsome decoration of the Chambre des Députés or the Chambre des Pairs.[13]

VI. The Landscapes[14]

Corot has never done better painting than in his picture of *Evening* in the Grand Salon; a river, toward the middle of it a small boat silhouetted in black, clumps of large trees on the left, and on the right a background of lead-colored sky, almost everything in the same dusty tone except for two notes that combine or answer each other, dark brown and dull silver, a simple and plain execution, a very melancholy feeling, silence and reverie; that is all.

[12] [The *Shipwreck* of 1841 is better known as *The Shipwreck of Don Juan*. See 1841: PARIS.]

[13] [The Minister of the Interior, Adolphe Thiers (see 1822: PARIS), awarded Delacroix the commission to paint the Salon du Roi in 1834 and that of the library of the Chambre des Députés, the former Palais Bourbon, in 1838.]

[14] ["Section V, Diaz" is omitted.]

Pause in front of this little picture that has, at first, the look of a confused sketch; you will feel a soft and almost motionless atmosphere, you will plunge into the filmy mist that floats on the river and blends itself in the far distance with the greenish hues of the sky at the horizon. You will hear imperceptible noises in this calm nature, a bare rustling of leaves or the jumping of a fish, you will recall all the emotion of some evening in which you sat alone at the edge of a lake, after a dull day, waiting for the first stars to come out.

If the aim of painting is to communicate to others the impressions felt by the artist confronting nature, Corot's landscape fulfills the conditions of the art. How does this landscape, quite oddly painted, produce this result? It seems to me that the slightly mystical painting of Corot acts upon the spectator a little like music on a music lover, through indirect and inexplicable means. How does a musical phrase by Beethoven, a vague and fugitive sound, inevitably provoke one certain idea and not another? Recently we have tried to express music through direct and material means, in the analogy of the sound with the thing that we wish to represent; but the bass drum and the cymbals have never succeeded as well as a simple and pure melody that addresses itself to the soul. Imitative music will never equal poetic music.

It is certainly a weakness, in a plastic art such as painting, to show the image perfectly, even when feeling is behind it. This is Corot's native weakness. His originality presents itself behind triple veils that he has never been able in any picture to cast aside. This awkward execution, this painful drawing, even though it is sometimes elegant, this sad, badly applied color—everything betrays a difficult perseverance that has never been able to master the practice of his art. Corot is like a sensitive but eloquent man whose speech remains well below the impression he makes. We have, however, seen sketches of his that were quite frankly painted in a hurry, and so accurate with their soft lighting effects that they could hold their place beside more vigorous and brighter paintings.

Corot's other landscape is, as usual, a sort of pale idyll, in which a young naked shepherd is playing with his goat. I have always thought that Corot would translate Celtic better than Greek. It is an experiment that he could try and his reputation would benefit without a doubt. . . .

We are far from preaching to artists the imitation of nature in landscape painting any more than in the other subjects in which humans find themselves interested. In addition, what, if you please, is reality? Is there the same reality for everyone? Not at all. For twenty of the world's most naïve painters, all proposing to copy an object placed before their eyes, would see and depict it in twenty different and often contradictory ways. Everything that exists takes on a form and color that is related to our personal organization. Green tends more toward blue or more toward yellow according to our visual faculties, and people impress us through certain more or less exaggerated characteristics according to our different temperaments. Moreover, the same man never sees the same object twice in the same way. Wonderful mystery of variety and infinity!

How, then, can we copy reality in the arts? Schools have been known whose pretension this was; but the inevitable happened to these narrow sectarians. In spite of themselves they were never able to eliminate their personality and they ended, as always, in a mixture and an approximation.

Let us leave this pretended naturalism to one side then. It is against nature and does not even truly exist, this absurd theory of *material* imitation, which supposes for a beginning the suicide of the artist and the annihilation of all things; for it would be necessary to remove at the same time the painter's soul and the incessantly mobile life of the being he wishes to paint. Let us assume what is true, that art results from the impression produced by nature on man, from the reflection of the exterior world in the microcosm, in this little world that we carry within ourselves. But nature is indispensable in this combination, as are the feelings of the artist. If the spirit works alone, outside the influence of nature and in a vacuum, so to speak,

the images produced by this "onanism" will not have the characteristics of life and stability. They will fade like mist before the wind.

On the contrary, if the artist is not his own object, as a German philosopher would say, if he takes his object outside himself, and finds his point of departure in nature, the double condition for the normality of the images' development is met. The artist has a much more sympathetic contact with other men who are also pursuing, each in his own manner, the interpretation of the same natural objects.

Flandrin belongs to a system that sacrifices nature to the solitary pride of men. He has returned to the school of Bidault, J. V. Bertin, and the landscapists of the Empire. His theory is exactly the same: compose a stylized landscape without leaving your studio. The recipe is easy and simple: take a grandiose site, elegant trees, a little architecture, a background of mountains and clear skies; in the foreground some antique tomb, an oleander, a fragment of a column, a nude figure or one draped in Roman style. . . .

VIII. Promenade

An excellent painter who will soon be a famous painter is Jean François Millet, already known for his vigorous pastels. Millet has abandoned pastels for oil painting, and he was right to do so. Do not judge him yet on his young *Oedipus Taken from the Tree*, a singular and almost incomprehensible picture. Oedipus poses a riddle to the public instead of answering that of the Sphinx. It is difficult to pick out, in this mixture of every color, the figure of the child held with a foot in the air and its head downward, the figures hidden in the landscape, and the black dog that forms a spot on the ground. But there is in this fantasy an audacious brush stroke and an original colorist.

We have seen paintings by Millet that remind us of Decamps and Diaz at the same time, a little of the

Spaniards and very much of the Le Nain, those great and naïve artists of the seventeenth century to whom posterity has not yet given their legitimate place among the best painters of the French school. . . .

IX. Little Genre Paintings

. . . To sum up, the Salon of 1847 was not brilliant. For the most part, the famous names were lacking—Ingres and Delaroche, Ary Scheffer, Decamps, Rousseau, Dupré, Cabat, Meissonier; but it disclosed two new talents, Couture and Clésinger who, according to what I hear, have just been decorated. Delacroix and Diaz were there. It showed Camille Roqueplan in a new light. It introduced a young painter, the creator of the *Cockfight*, and an able sculptor, M. Wichte.

In our opinion, a sad thing happened; the critics were almost in agreement and the crowd agreed with the critics! I do not speak of some of the banal phrases poured in a leaden mold or icily framed that attempted to belittle the two successes of the Salon as in former days they struck at Lamartine and Victor Hugo. There was also vague mention of a resurrection of the French mannerists of the eighteenth century; however, the majority of public opinion agreed with the newspapers. We are unfortunate enough to feel that this was a symptom of weakness on the part of the press and the public. Is the artistic revolution finished? Are we at one of those periods of blindness and weakness in which poetry has forgotten its inquietude; the spirit its virility; and journalism its initiative?

In fact, criticism is following a narrow, beaten path. It is watching its own feet and is content to describe the bushes it passes, or the people it meets, without asking them where they are going and what they want, without lifting its gaze to the infinite horizons. We cannot hide from the fact that art for art's sake, that is to say, art without deep feeling or social convictions, is triumphant in painting during decadent eras. Except for the landscapists, who have revived the poetry of nature with an enthusiasm and a coloring worthy of the great masters, and except for

the hearts of two or three artists that vibrate in harmony
with the human heart, our painters now are no more than
more-or-less-skilled craftsmen. The eloquence of art is for-
gotten in favor of grammar. Art for the living man, and
not for the dead form, no longer makes its voice heard.

For a moment, after 1830—already it seems so long ago
—the young press, moved by the flood of a political revo-
lution, had dimly perceived higher destinies for the fine
arts. Then we dared to say that art is a priest who
preaches the holy doctrines that correct the customs of
mankind through the influence of ideal beauty. Plato's
words were remembered: Beauty is the splendor of truth.
There was then a half-poetic, half-philosophical school, of
which we are proud to have been an obscure participant,
that concerned itself with the soul as much as with the
eye or the hand, that asked for the significance of the im-
ages under the magnificence of modeling and style. The
renovation of language and the plastic arts was assured.
What would be done with this newly reforged instru-
ment? Alas! The beautifully decorated instrument, or-
namented with precious stones, has remained a sword of
luxury similar to a useless jewel. For this good Toledo
blade, no valorous and devoted soldiers have been found
to engrave immortal legends on the rock, like the heroes
of Leonidas at Thermopylae. The parade sword is rusting
in its scabbard or foolishly battling the breeze. The danc-
ing of the sunlight on the steel is enough to amuse our
poets, and our country no longer has priests or warriors,
only jugglers.

We have all been affected by this civic degradation.
Some, discouraged, have retired to a desert Thebaid, con-
templating the future in their private, mute thoughts; it
would be braver to prepare it through action. Others, lost
in the crowd, have vainly fought against unforeseen disas-
ters. After fifteen years of palliative treatments by homeop-
athy and ether, and sometimes by violence, France has
had her heart extracted, which has never been seen before
in any sociological operating room. Painting now has noth-

ing in its breast, even though it is still moving its eyes and hands by agile reflexes. The act is over.

XI. The Artists Refused by the Jury

We certainly owe them one day's notice on the part of our hundred thousand readers, since they were deprived of the attention of a million spectators who visited the Louvre during the two months of this exposition. The jury also refused several important works of great interest, among them, *The Jews of Constantine* by Chassériau, *Charlemagne* by Gigoux, *Attila and St. Genevieve* by Maindron. You can see that we are concerned here with men who are quite well known in the world of art and who have already proved themselves. Maindron has executed statues in the Luxembourg Gardens and monuments; Gigoux can be seen in our churches, in our museums, and his *Charlemagne* is justly destined for the halls of the Council of State. Chassériau has painted chapels and has been occupied for the past four years in painting the murals of the Hôtel de Quai d'Orsay.

What is the meaning of this persecution by the Academy of artists whom the ministers, the directors of the Beaux-Arts, and the press judge to be worthy of great public works? Is this not the jealousy of their competitors? What are the titles of the geniuses and the official celebrities who have the right to judge and to condemn the great contemporary artists and the youth who belong to the future! . . .

XII. Sculpture

. . . [*Woman Bitten by a Snake.*] This naked woman by Clésinger is one of the most charming statues of the modern school, and I do not believe that marble has been made more alive since the Coustous. At the risk of annoying the Capuchins who have pretended to take Mme. Keller's well-developed muscles for wads of cotton under a jersey, one may enjoy the Greek Venuses rising from the waves, the Danaë of Titian and Correggio, Jean Goujon's Dianas, Rubens' Bacchantes, Puget's Andromedas, Coyse-

vox's nymphs, Watteau's courtesans, Boucher's shep-
herdesses. The feminine form is the supreme divine crea-
tion and the highest expression of beauty. . . .

Marble adapts best to woman's pure and luminous
forms. White marble for goddesses; bronze for great men
and heroes accentuates fierce male beauty. Marble is suita-
ble for flesh, for its transparency and imperceptible wrin-
kles. . . .

Clésinger's statue is in white marble, lying on a bed of
flowers lightly tinted red and blue by means of an acid.
The little bronze serpent was only added to rivet the jury's
attention on the pretext that it was Cleopatra, classical
nudes being absolved in advance by the Academy. The
truth is that Cleopatra and the tradition of antiquity have
nothing to do with it. Let us say that this living marble
symbolizes Voluptuousness or a Dream of Love. The title
is of little importance in art, and it would be difficult to
find titles for most of the masterpieces of Greece or of the
modern Renaissance. This is why undetermined statues
are always classed with the Venuses or Apollos. . . .

Cleopatra or Voluptuousness, Clésinger's statue is abso-
lutely modern in its feeling and its shape. Its ancestor is
not to be found in all the statues derived from tradition.
This originality is due to the exclusive love of nature that
is predominant in Clésinger's talent. It is a rare quality
and perhaps at the same time a fault. Absolute *naturalism*,
as the philosophers say, is at times the origin of very dan-
gerous errors; but it is also the starting point of all the
plastic arts. The contemplation of nature, querying the
inner emotion it causes and comparing this completely in-
dividual impression with the feelings and images this same
nature has inspired in great poets and great artists—such
is the secret preparation that should precede every work of
art. Clésinger is a sculptor of a free race, spontaneous, ar-
duous, like all slightly savage beings, bold like all passion-
ate temperaments. He carves a statue the way one goes to
war, with a vehemence that knows no barrier, with a
bravura that takes advantage of the unexpected. He is the
Murat of statuary. There is more chance luck than deep

scheming behind his successes. He would never read Caesar to determine a clever strategy. He will not be found in the night, like Napoleon in his tent, meditating on his campaign plans. He is a man of a leap and a glance who hurls himself toward victory. . . .

Clésinger's talent is therefore very new and very individual in our present school. While David d'Angers continues the noble tradition of French thought, while Barye resuscitates the delicate and capricious artists of the Renaissance, while Pradier is a pagan of the decadence with some memories of ancient Greece, while several other sculptors undergo diverse influences, Clésinger has taken up his art at its beginning, not concerning himself with any system or the broad roads beaten out by his predecessors. He opens his eyes and goes directly to the images that infinite nature offers to his enthusiasm.

1848

PARIS: The Official Exhibition
of the State

On February 18, 1848, a reform banquet was announced for the twenty-second. *Le National* and *La Réforme*, opposition papers, urged participants to gather near the Madeleine, march by way of the Place de la Concorde and the Champs Élysées to the banquet hall. On February 21 the prefect of police banned the banquet and destroyed the preparations. Nevertheless, crowds assembled at the Madeleine on the evening of the twenty-second. Shouting *"Vive la Réforme! À bas Guizot!"* they proceeded through the streets. When Louis Philippe called in the National Guard to disperse the marchers, the guardsmen, sympathetic to demands for reform, stood aloof.

By the evening of the twenty-fourth, his dismissal from office of Prime Minister Guizot having failed to satisfy the rebellious populace, Louis Philippe had abdicated and fled with his family to England. The people seized the royal palaces, the Tuileries and the Louvre. Neither was sacked. The Louvre was symbolic to Frenchmen: they had seized it in 1793 and placed in it the pictures, statues and trophies they had won by conquest. Parisians now assumed responsibility for their national treasures.

A provisional government of ten men was formed in the Hôtel de Ville to govern until elections for the Constituent Assembly could be held. The majority of the ten were republicans, led by Lamartine, the poet and pamphleteer, and Ledru-Rollin; a minority were socialists, including Louis Blanc. Universal suffrage was declared immediately and national workshops, based on the "social

workshops" Blanc had called for in *L'Organisation du travail*, were instituted shortly thereafter.

Ledru-Rollin became Minister of the Interior and thus responsible for all artistic matters. When Thoré refused the directorship of the Beaux-Arts, the painter Philippe Auguste Jeanron, friend of Louis and Charles Blanc and founder of the Société Libre de Peinture et de Sculpture, was appointed director of the Louvre and national museums.

At six o'clock on the twenty-fifth, a notice was posted: "The jury charged with the responsibility of receiving the pictures for the annual exhibition will be named by an election. The next notice will convoke the artists for this purpose. The Salon of 1848 will open on March 15." On the twenty-ninth, the same day the second notice was posted, a petition signed by Diaz, Barye and Couture demanded that the artists be empowered to elect all officials who would be responsible for artistic matters. On March 3, at a general meeting of artists, their future organization was discussed, but little was settled.

Two days later, 801 artists assembled at the École Nationale des Beaux-Arts to elect a commission of forty—fifteen painters, eleven sculptors, five engravers, five architects and four lithographers—to be responsible for the arrangement of the works received for the Salon. The jury that had been at work was pushed aside. Artists hurried to bring in their canvases and the commission extended the exhibition area, finding space for 5,362 entries. The sculpture was installed for the first time in the well-lit Egyptian Galleries.

On March 15 crowds singing the "Marseillaise" hurried up the stairs of the Louvre to the galleries. Some held the thick catalogue, sold for the benefit of poor workers and abandoned children, though many artists felt it would have been more appropriate had the proceeds gone to artists. During the following days—while in the streets the alliance between the radicals and the liberals began to break down and the National Guard and workers met in counterdemonstrations—Parisians visited the Salon and

laughed as they tried to choose the most ridiculous works from the crowd of mediocre paintings that smothered the work of the talented and the famous.

Thoré, who was giving his full attention to launching, with George Sand, Pierre Leroux and Armand Barbès, the daily paper *La Vraie République* and to campaigning for election to the Constituent Assembly, wrote his report of the Salon for *Le Constitutionnel*. He was forced to admit the open Salon had not been entirely successful; other liberal art commentators, Gautier and Houssaye, reported their dismay and called for a fair system of jurying that would sift the mediocre from the talented. The Paris correspondents of the English *Athenaeum* sent back accounts of February's events. More complete coverage was given in the *Art Journal*, interspersed with accounts of uprisings that had been triggered by news of the Paris events in Frankfurt and Munich, where a desire for reform was strong.

On March 17, Joseph Garraud, acting director of the Bureau des Beaux-Arts, called on painters and sculptors to enter a contest for a symbolic figure of the Republic that would replace the image of the sovereign in public buildings and monuments and on engravers to compete for a design for coins of the Republic and the seal of the National Assembly. The artists were to send their sketches in time for a public exhibition to be held April 25–30; in each medium, three finalists who would develop their sketches into finished works for another judging were chosen by a jury of artists, politicians and writers that included Ledru-Rollin, Lamartine, Arago, Thoré, Charles Blanc, Jeanron, Ingres, Delacroix, Delaroche, Meissonier, Robert-Fleury, Decamps and Cogniet. All entries were to be exhibited anonymously—a measure designed to encourage unknown talents to compete. When the exhibition opened there were 696 entries—451 paintings, 173 statues and 72 medals; the response of the painters had been so overwhelming that the number of finalists to be chosen was raised to twenty.

Two days before the exhibition was opened, Frenchmen

had gone to the polls to elect the Constituent Assembly and returned a conservative majority. The provisional government was immediately replaced by an executive board that included no socialists. Before the competition exhibition and the Salon closed, Charles Blanc, Louis's brother, was named director of the Bureau des Beaux-Arts and a permanent Commission des Beaux-Arts was established. Debates on a new jury system for the Salon began.

The political events dissipated optimism for the contest. It had had the support of the entire art community and of a regulatory bureaucracy that had assumed an egalitarian position. The winners in the preliminary judging were announced by Charles Blanc on June 7 and their sketches were re-exhibited at the École des Beaux-Arts. The exhibition of the finished works would begin on October 1. The twenty painting finalists' sketches were reviewed in L'Artiste by Charles Isnard, and Théophile Gautier summarized the problem the competitors had to solve as they prepared their final works.

On June 24, to protest to the Constituent Assembly's order to dismantle the national workshops, Parisian workers took to the streets. Only after three bloody days was order restored. For his participation in the uprising, Thoré received a death sentence and escaped to Belgium. The Assembly began drafting a constitution that would place a president elected by the people at the head of the government. By November the Constitution had been written and the campaign for the presidency began; the candidates for the office included Ledru-Rollin, Lamartine and Louis Napoleon Bonaparte, an elected member of the Assembly.

On October 23, following the exhibition of the finished paintings in competition for the symbolic figure of the Republic, the jury decided unanimously that none of the entries would be acceptable and that no new contest would be held. The sculpture competition was closed by an exhibition held January 2–7. Its jury announced the winner to be Soitoux. Born at Besançon, a pupil of David d'Angers, he was a young, unknown sculptor whose previ-

ous work had been limited to finishing the statues of established sculptors. The only winner to have his interpretation gain general acceptance was the engraver of medals, Jean Jacques Barré, whose winning design was used for the coins of the Republic.

In December 1848 the French people chose Louis Napoleon Bonaparte to be their president—his names were synonymous in their minds with "Liberty, Equality and Fraternity," stable government, and national glory. The artists also voted to elect the members of the jury entrusted with the selection of the works to be admitted to the Salon of 1849.

Théophile Thoré: "Salon of 1848"[1]

The revolution in February surprised the academic jury in the midst of its business. The separation of the elected and the damned had already been begun; the slender sketches by Lessore had been refused and the famous female torso that has so amused the crowd in its corner had been accepted. However, hearing of the insurrection against the royal family, the civil servants had only time to take off their spectacles and their wigs and flee. To keep from being recognized M.A. painted his face with tar, and M.B., like Louis Philippe, his master, shaved off his sideburns.

The jury, the directors of the Institut des Beaux-Arts, the former administrators of the museum, all disappeared with the civil servants. Nothing has yet been reconstituted, except for the fact that Jeanron is conservator of paintings in the Louvre. The arts have been abandoned to their fate since the beginning of this tempest. The republican minister even employs, in I do not know what sort of mission, a former censor, a former count, a former conser-

1 [First published in Le Constitutionnel, 1848. Translated from Salons de T. Thoré, with a preface by W. Burger (Paris, 1868).]

vative deputy who voted for Guizot's address. These figures still seem to be in the administration; but we hope that the Republic will soon cast out the former censors of thought, and all the servants of the monarchy. One is never betrayed except by one's enemies.

The first measure to be taken in favor of the arts after the revolution should have been to gather together all the artists, inviting them to elect a permanent committee that would represent them with the Republic and that could announce their wishes. All that was done was to name a commission charged only with hanging the works in the Salon. The assembly took place at the École des Beaux-Arts, and the old professors had invited all their students. Do you know who was elected? Léon Cogniet. Except for two members of the former jury, Bracassat and Abel de Pujol, the composition of this temporary committee is quite an accurate expression of all talents and all the different schools, and proves that the system of universal suffrage comes closer to the truth than any other. By some quirk of chance, Couture's name was drawn from the urn next to that of Abel de Pujol and Théodore Rousseau's name next to that of Bracassat. Among the sculptors, the assembly allowed two of the former jurors to remain, but it elected Barye, Rude, David [d'Angers] and other independent artists.

Let peace be with us from now on, because the artistic tribe has placed at its head those whom the Academy banished, in the same way that we have at the head of the state a poet, a worker and the historian of the ex-king Louis Philippe. Really a century has passed since February 24!

Jeanron and his aides showed prodigious activity in hanging so many frames on the museum's walls, in placing on the ground floor so many blocks of marble, stone and plaster. But it was better that the National Exhibition was not put off; in addition, it would have been impossible to solve for this year the question of a new jury and a new exhibition hall. We can be certain, however, that in the future the galleries of the museum will no longer be used

for periodic Salons. The flight of the royal family has left us room in the Louvre, in the Tuileries and in all the national monuments.

The 5,180 works presented before the revolution were therefore admitted without being examined and the artists' commission had only to oversee their classification so as not to allow works worthy of the daylight to go astray into the catacombs. In any case, this too hasty sorting is very imperfect. We have seen one of Meissonier's portraits and a forest by Diaz and some distinguished landscapes lost in the middle of some most peculiar paintings.

In fact, the Salon of 1848 offers a very curious spectacle. There are paintings there whose like have never been seen in the windows of a country glassmaker; some like them, however, appeared in every Salon, admitted by the civil service jury, for the former jury was more interested in keeping its enemies out than in examining the worth of the paintings. The only thing that is different today is the prodigious number of these eccentric paintings. But the lesson of publicity will be beneficial, and we can hope that the welcome the crowd gave to several hundred of these smudged paintings will convince their painters to take up another profession. Yesterday, I mean a century ago, under the reign of the last of the Bourbons, the unfortunate workers erring among the arts could cry persecution and repression, and imagine that they lacked only a little recognition and publicity. After having been laughed at, why would worthy citizens persist in trying to force entry into the world of poetry when republican society offers them a trowel instead of a brush?

In my opinion, in spite of the clownishness of the present Salon, I am not absolutely convinced of the necessity of any jury at all except for classification. I would approve another trial of unlimited liberty at the next national exposition, on condition that an intelligent committee separate the works of art from all this unqualifiable rubbish. Any idiot has the right to speak in public, running the risk of being booed by the crowd and reduced to silence by

real orators. Liberty is still the best way to order and justice.

What is singular and sad is that there is not one new talent among this confusion of bizarre works. But how could artists have developed under a regime dedicated to the glorification of material interests and evil passions? Among those whom God had predestined as poets, the weakest, like Hector Martin, have died in misery and disenchantment; those who were strong in character and in patience have taken their rightful place in spite of oppression. The present generation is more or less classified. The hope of the Republic is in the new and lively generations whose vocation will be encouraged by a national education system, by the exaltation of noble thoughts, by the shining influence of a human and universal art. We are sure that we will already see in next year's Salon, and above all in the public monuments, brave efforts by this new art, fertile and durable. . . .

We will not take much of our readers' time for the Salon of 1848. Politics has more interesting things to show us. Today we are making more than art and poetry: we are making living history.

Anonymous, "Art in Continental States"[1]

GERMANY, Munich, March. —The great political emotion, the stage of which is not only Italy or France, but the whole of Europe, leaves no time to the Fine Arts at this moment. The news from all the German countries, till a few weeks ago filled with notices of works finished or undertaken, has scarcely a share in this relation. Our artists have changed the pencil for the *fusil*, and stand now

[1] [Verbatim from *Art Union Monthly Journal*, April 1, 1848. The identities of "F.," who reports here from Munich, and "O.M.," reporting from Paris, are unknown. "F." might be Ernst Förster (see 1845: MUNICH).]

exercising under arms. There is no other thought than "Germany and Liberty." . . . F.

FRANCE, Paris. —Vive la République! (in Art). Revolution has been the order of the day, not in the *grande politique* alone; it has deigned to extend its overpowering arm into artistic affairs also. Everything from the old system of Art-Jury to the very name of the Louvre, has had to submit to the hand of revolution. In fact, our letter this time must consist of little else than a detail of summary changes effected in Art-matters here.

First, however, we would say a word on the transactions of the ever-memorable 24th February; that we may give our testimony, as an eye-witness, to the respect shown to works of Art, in the midst of the turmoil of popular victory. We were among the first to enter into the Palace, after having seen his late Majesty depart. When we got to the private apartments of the Duchess of Orleans,[2] a full-length portrait of her and her two children stood in the ante-room, half-finished, with a fauteuil arranged for posing; for all the world as if the universally-respected mother had but just risen from a sitting. Already a citizen-soldier had planted himself and bayonet before it as guard; and, as we stood looking at it, the people who passed, cried, lifting their caps, "Vive la Duchesse d'Orléans!" As we passed through the rest of the apartments, through those of Montpensier and Aumale,[3] we were greatly pleased at the remarkable respect paid to the works of Art suspended or laid about, many of great value in small bulk. On passing, afterwards, through the State-rooms, though now the uproar was at its height,—the crowd being suffocating in the *Salle du Trône*, mounting, like a pyramid on the throne itself and its steps, and roaring out the "Marseillaise," as if with the voice of an ocean lashed by a mighty storm,— still works of Art were spared; except those of too obnox-

[2] [The Duchesse d'Orléans was the mother of Louis Philippe's grandson, who was still a child in 1848 when the king abdicated in his favor.]

[3] [The Duc de Montpensier and the Duc d'Aumale were two of Louis Philippe's sons.]

ious a political signification. Thus, the portrait of Bugeaud,[4] for example, was torn down from its place in the *Salle des Maréchaux*, and a bust of Guizot launched out at the window. We went into the private rooms of the king; we passed a merry group of the triumphant populace finishing a breakfast, which the king had been obliged to leave on the table, and emptying unsparingly his private larder. We came to a smiling portrait of his late Majesty himself, which, in the excitement of the moment, we laid hands on, to turn to the wall at least. But a sword-point started before our nose, and—"Stop!" cried a blouse, "let him hang—he's national property now; we'll keep him in order henceforth." . . .

On the commencement of some reorganisation after this thorough overturn, the artists have not been behind-hand in making their desires known to the Provisional Government. On the 29th of February, a deputation of three waited on the Government, with a petition praying "that the Functionaries, who exercise an immediate influence on the Fine Arts, be elected by the Corporation of Artists, in a general assembly; and the Government name a day for the general meeting." This, we believe, was a somewhat hurried step, taken by a few artists desirous of notoriety. However, the said general meeting took place a few days after, in the *Salle Valentin*. If ever you have been in a bird-shop, where a score of parrots keep up a continual ear-deafening din, you have an idea of the confusion, noise, self-shouting indescribable, of this first re-union of what you would expect to be men of elevation, intelligence, and cultivated manners. It seemed to be the idea, that he who cried loudest should be considered the greatest artist; in short, nothing actually could be done. Nevertheless, some one had made out of this Babel, and published, that an Artists' Association has been formed, with Ingres as president, Delacroix vice; and others,

[4] [Bugeaud de la Piconnerie (1748–1849), who had been active in the French campaign in Algeria, had been put in charge of the army by Louis Philippe at the same time that the king discharged Guizot.]

painters, sculptors, engravers, authors, dramatists, as the Committee; an arrangement already re-arranged, and upon which we will report when finally established.

An Artists' Club has also appeared; but in general, as in this case, with new ideas of order and dignity; the title *Society* has been substituted for the old one *Club*.

On the 5th of March, the old Jury-system having gone down with the Monarchy, the artists met in the École des Beaux-Arts, to exercise for the first time the right of universal suffrage, in the choice of hangers for the exhibition. It having been decided by Government that all pictures sent in should be exhibited, the office of *selection* is done away with; and the only duty remaining is that of *hanging five thousand three hundred* pictures! What description will you expect of such an Exhibition? What a task for the hangers! The following artists were elected for this onerous duty—fifty-one in all.

Painters:—Cogniet, Ingres, Delacroix, Vernet, Decamps, Robert-Fleury, Ary Scheffer, Meissonier, Corot, Delaroche, Dupré, Isabey, Drolling, H. Flandrin, Roqueplan: Isabey, Bracassat, Rousseau, Couture, Pujol.

Sculptors:—Rude, Jouffroy, Barye, David [d'Angers], Dantin, Pradier, Toussaint, Debay, Maindron, Petitot, Daumas, Dumont, Fouchère, Nanteuil, Briant; with some architects, and nine engravers and lithographers.

The name of the Louvre is restored to what it was in the great revolution, *Musée National*. The wooden gallery, which only served for Exhibitions, is demolished. The sums annually allotted to Louis-Philippe for the continuation of the Louvre, will be devoted to their purpose. The Exhibition is to open immediately. . . .

The Louvre Exhibition is opened. Words cannot give an idea of the motley assemblage of pictures on the walls, of visitors on the floor. It is most amusing, and yet saddening at the same time. There are pictures crowned already by the crowd with funeral wreaths and sarcastic condemnations,—as "To great artists, the grateful country!" "This is a woman!" "What's this!" stuck up in the frames of several pictures that defy all description for hideous

worthlessness. There never was held, in all the history of Art, such a *reunion* of all that could be fished up from broken stores or atelier garrets, jostling works of merit and of value. The Exposition of 1848 would alone tell a stranger that Paris was revolutionized. We doubt not it will lead to a new discussion on the propriety of a jury. Meantime, the public are bitter and unsparing judges. Before the worst, there are continual crowds, whose satiric laughs are heard from one end of the long gallery to the other. The *scene* is worth a visit, even from the other side of the straits. For a notice of the works, we must refer to next month's number.

Théophile Gautier, *"École Nationale des Beaux-Arts: The Symbolism of the Republic"*[1]

At Rome, Liberty had a temple on the Aventine Hill where the people withdrew to protest the oppression of the patricians. Built by Tiberius Gracchus, the temple was supported by bronze columns and preceded by a court called the *Atrium Libertatis*.

In the sanctuary rose up a statue of Liberty represented as a Roman matron, dressed in severe white drapery and holding a scepter in one hand and a cap in the other. At her feet rolled a cat.

At her side were placed statues called Adeone and Abeone.

The stola of the Roman matron signified that Liberty should be chaste and serious; the white color of her draperies symbolized the spotless purity she exacted; the scepter, the empire she won over virtuous hearts; the bonnet, the deliverance of slaves—for the ancients put such hats on those of their slaves whom they freed; and the cat, independence—because this animal is never perfectly tamed and supports any constraint impatiently and it was

[1] [Translated from *L'Artiste*, June 15, 1848, 5e série, tome 1, pp. 160–61.]

for that reason that the Alans, the Vandals, the Suevians and the ancient Burgundians carried it with them on their coats of arms.

The goddesses Adeone and Abeone who accompanied Liberty, and whose names signified, respectively, the Power to Come and the Power to Leave, indicated that the cult of the goddess was completely voluntary, that she neither enticed nor rejected anyone; [it is] a completely intellectual manner of conceiving Liberty, which does not seem to have been that of the republicans of the *ancien régime,* since to the proud legend "Liberty, Equality, Fraternity" they added "or Death." . . .

That is roughly the manner in which the ancients undertook to render Liberty.

The moderns, who have more of a propensity for rebus and more ingenious intellects, symbolized it by an open cage from which a bird escaped or simply by a bird taking flight with a thread on its claw. This is very pastoral, and virile antiquity would not have dared such overrefinements.

César Ripa, the iconologist, gives three emblems of Liberty in which the Roman types can, so to speak, be traced. A woman dressed in white who holds a scepter in her right hand and a hat (*pileus*) in her left; a woman who holds a hat and a club; a woman who holds a hat and tramples a broken jug underfoot: it is not varied much. Gravelot believed it necessary to paint her walking, because one of Liberty's characteristics is action. Different attributes often collected around her indicate that she is the mother of the knowledge and the arts that have taken from her the name *liberal.*

In addition to these there are the boats setting off and the birds that migrate with seasons; today one could add the locomotive. But at that time steam had not been invented. Cochin, who is closer to the modern style, substituted for the hat the Phrygian bonnet, elevated on the point of a spike.

As for the figure of the Republic, properly so called, one finds few or no examples in antiquity. For the Romans,

the Republic was Rome, for the Athenians, Athens; and they did not distinguish it with special emblems. The abstract idea, difficult to render, was not natural to the ancients' simple genius. One must return to the moderns to find representations of the Republic in the democratic sense attributed to it today. The iconographies of the last century depict it as a modestly dressed woman, crowned with vine and elm and holding wreaths and a pomegranate —the pomegranate contains a multitude of seeds within a single rind, signifying individuals melded in unity. Occasionally one sees her seated on an open sack of wheat, indicating the solicitude with which she concerns herself with the people's subsistence.

During the French Revolution she coifed herself in the bonnet of the freedwoman, in one hand holding a level and with the other leaning on a fasces of rods from which emerged an ax whose significance was only too clear.

It is in this rather wild and menacing guise that the Republic has manifested itself in France. An object of adoration for some and of terror for others, the type is indelibly engraved in memories. This is not the least of the difficulties our artists have to conquer: if they call it to mind, they are frightening; if they deviate from it, they are no longer comprehensible; nevertheless, the Republic of '93 is not the Republic of 1848.

Charles Isnard, "The Contest for the Symbolic Figure of the Republic"[1]

The contest for the symbolic figure of the Republic has been judged and the twenty sketches declared the best have just been re-exhibited at the École des Beaux-Arts; their authors are going to execute full-scale paintings after these same sketches and this last competition will produce a definitive judgment designating the figure of the Repub-

1 [Translated from *L'Artiste*, June 15, 1848, 5e série, tome 1, pp. 161–63.]

lic that will serve as our model and from which copies
[will be made] to be sent to the various departments.

The jury was composed of painters and of literary and
political men; I do not see how the opinion and influence
of the literati and politicians could have affected the ac-
tual judgment. It is sufficient to glance at the first two
sketches—numbers 441 and 76—to see that these gentle-
men's ideas about the manner in which our Republic
should be represented are no more fixed than those of our
painters. One of these sketches represents for us the ele-
gant form of a young girl, dressed in white, with out-
stretched wings and feet seeming barely to touch the altar
of Fraternity on which she is placed; she descends from
the sky; she hardly touches the ground. The other, on the
contrary, is a strong, powerful woman seated squarely in a
niche of Tuscan architecture; her arms and her hands,
reaching toward her head and heart, emphasize the gen-
eral idea of stability that dominates the entire composi-
tion. Well! these two sketches, with such opposite ideas,
are placed side by side in the front rank.

Nevertheless, this judgment appears to us as fair as one
could possibly want, considering the physical difficulty of
agreeing on the particular merits of such a large number
of compositions and of ideas so absolutely different from
each other; and, as imperfect as it is, this competition
proves to us that we must not despair of art, no matter
what some pessimists say: almost all the sketches chosen
by the jury belong to young talents full of promise.

Men of recognized and proven talent, however, sent
sketches; several members of the Academy have even been
mentioned to us, but the Academy is so far from being in-
fallible!

I. No. 441. This item, placed first, must belong to a
man who has studied simple and large monumental paint-
ing;[2] we find an analogy between this sketch and a paint-
ing of Napoleon as legislator seen at the Salon of 1847.
The painter of this Republic explains it himself; let us
take the time to read what is written on the lower part of

[2][Hippolyte Flandrin.]

the frame: "The Republic takes as its base and throne the altar of Fraternity on which she sacrifices all hate, represented by a serpent. She brings peace to the world and with her right hand presents the symbol of it; in her left she holds the French flag, whose staff is strengthened by the fasces, the emblem of union. The Republic is white and pure, a virgin without blemish! Her throne sits on the globe and she has spread wings to indicate the grandeur of her future!" This figure has a distinguished appearance; she holds an olive branch in her right hand and at her left side hangs a shield seen in profile. This same artist has sent a second sketch, No. 428, with almost the same appearance, only the right arm is raised and the shield is seen in full face.

II. No. 76. This item reminds us of the supple execution and of the tendency to an elevated style of the painting of Cleopatra and Anthony on Cydnus exhibited at the last Salon.[3] This is an original sketch with profound ideas; it is worthy of a German thinker. The Republic, with its Michelangelesque forms, seems colossal because of its proportions; seated in a niche on an antique chair, she leans two fingers of her right hand on her forehead and with her left hand she presses her heart; she seems to want to appeal both to her intelligence and to her love to endow her children's future. . . . [Numbers III to X are omitted.]

XI. No. 364. It is said that a witty draftsman[4] made this powerful woman suckling two powerful infants. . . . [Numbers XII to XIX are omitted.]

XX. No. 234. This sketch must have come from the school of Robert-Fleury.[5] The figure of the Republic carries a flag on which one reads: "Those who want to be first must be the servants of all." A sash of a beautiful yellow, a color this school knows well how to make, surrounds the svelte body of the Republic. . . .

And now we ask ourselves this: this classification from

3 [Henri Pierre Picou.]
4 [Honoré Victorin Daumier.]
5 [Louis Charles Auguste Steinheil.]

one to twenty, is it real or fictitious—is there a first and a twentieth sketch or are there twenty first sketches? If one wanted to place them all in the same rank, one should, I think, have followed the natural sequence of the presentation numbers. But no, the order of these numbers is transposed and a classification does in fact exist. In this case, what chance of success is there for those accepted last? Don't forget that the jury includes literati and politicians. Since we see perfectly executed sketches placed after those that are inferior to them in terms of execution, we can conclude that the artist's political idea was very important in the order of classification and, consequently, that an artist whose idea met with little approval could never be included in the first rank, even if he executed it better than Raphael himself. . . .

Since the contest has not completely lived up to the judges' expectations—according to the original plan, they were to have chosen only three sketches—I believe it would have been more rational to consider this as a preliminary contest and to choose a hundred, two hundred, all of those sketches that offered some guarantee of capacity and to make their authors recompete on the same subject. From contact with all these different ideas, simpler and larger ideas would necessarily have been born—the artists would have instructed each other and I believe a second contest would have produced complete works for us; it would have been sufficient to have the three or five best sketches executed in full scale without changes and, as this last contest would concern only execution, one could be sure, in choosing the best-executed painting, to have a composition whose idea had been judged worthy in a previous contest. . . .

I end then by wishing the contestants good courage and happy success, as much for them as for us who are interested in having a beautiful and noble Republic before our eyes.

André Thomas, "Fortnightly Review: Theaters and Fine Arts"[1]

The jury charged with pronouncing judgment on the competition opened for the symbolic figure of the Republic has not long delayed its decision. There, where all were called, not one has been chosen. No figure exhibited has been judged worthy of a prize and, it must be said, this is just. Without doubt a great amount of talent has been expended in this contest: MM. Diaz and Picou, Steinheil and Gérôme are certainly no longer students, and all, however unequal their chances, have racked their brains to unite the beauty of a model and the eloquence of a symbol in their compositions. But no one has succeeded. We will not blame the basic principle of the competition, as many have done already. No, if we have not known how to paint a worthy Republic, it is rather our fault and that of our times. We have forgotten the austere language spoken by the masters of Rome and Florence. We are, we moderns, sometimes admirable in our feelings, but we lack style; we are ignorant of the secrets of beautiful form. One final word: however powerless we may be, there is no need to overlook the fact that the greatest painters would have hesitated before the specified subject. The Republic! . . . there is nothing more complex, more abstract, more infinite, and what brush could say everything about it! One can paint Charity, Justice, the Homeland, but to summarize in a single figure all the best feelings and all the poetry of the human soul is certainly not easy, and Andrea del Sarto himself would perhaps have hesitated.

[1] [Translated from L'Artiste, November 15, 1848, 5e série, tome 2, p. 84.]

BIBLIOGRAPHY

1785 Rome

Pelles, G., *Art, Artists and Society, Painting in England and France, 1750–1850* (1963).

Rosenblum, R., *Transformations in late 18th Century Art* (New York, 1970).

1787 Rome

Licht, F., *Sculpture: 19th and 20th Centuries* (Greenwich, Conn., 1967).

Butler, R., *Western Sculpture, Definitions of Man* (Boston, 1975).

Butler-Mirolli, R., *Nineteenth-Century French Sculpture, Monuments for the Middle Class*, Exhibition Catalogue, J. B. Speed Museum (Louisville, Ky., 1971).

1793–96 Paris

Dowd, D. L., *Pageant Master of the Republic: Jacques Louis David and the French Revolution* (Lincoln, Neb., 1948).

Leith, J., *Art as Propaganda in France 1750–1799* (Ontario, 1965).

Brown, M., *The Painting of the French Revolution* (New York, 1938).

1795 Rome

Pevsner, N., *Academies of Art, Past and Present* (London, 1940).

1800 Weimar

Goethe's *Theory of Colours*, trans. C. Eastlake (London, 1840).

1803 Paris

Gould, C., *Trophy of Conquest, the Musee Napoleon and the Creation of the Louvre* (London, 1965).

1808 London

Haydon, B. R., *Autobiography and Memoirs, 1786–1846*, 2 vols. (London, 1926).

Honour, Hugh, *Neo-Classicism* (London, 1968).

Gowing, L., *Turner: Imagination and Poetry* (New York, 1966).

Gage, J., *Color in Turner, Poetry and Truth* (New York 1969).

Raine, K. J., *William Blake* (London, 1970).

1808 Dresden

Börsch-Sapan, H., *Caspar David Friedrich* (München, 1973).

Ernst, M., *Seelandschaft mit Kapuziner* (Zürich, 1972).

Champa, K., *German Painting of the 19th Century*, Yale Exhibition catalogue (1970).

1819 Rome

Andrews, K. *The Nazarenes* (Oxford, 1864).

1819 London

Todd, R., *Tracks in the Snow, Studies in English Science and Art* (London, 1946).

Eitner, L., *Gericault's Raft of the Medusa* (London, 1972).

1822 Paris

Clark, K., *The Romantic Rebellion* (London, 1973).

1824 Paris

Boime, A., *The Academy and French Painting of the 19th Century* (London, 1971).

Brookner, A., *The Genius of the Future* (London, 1971).

1827 Paris

French Painting 1774–1830: The Age of Revolution, exhibition catalogue (Detroit, 1975).

1831 Paris

White, C., *Canvases and Careers: Institutional Change in the French Painting World* (Cambridge, 1965).

1833 Paris

Trollope, Frances, *Paris and the Parisians in 1835* (New York, 1836).

1836 London

Peacock, C., *John Constable, the Man and His Work* (Greenwich, Conn., 1965).

1841 Paris

Richardson, J., *Theophile Gautier, His Life and Times* (London, 1958).

1844 Paris

Herbert, R., *Barbizon Revisited*, exhibition catalogue, Boston Museum of Fine Arts (1962).

1846 Paris

Journal of Delacroix, trans. W. Pach (New York, 1948).

Tabarant, A., *La Vie artistique au temps de Baudelaire* (Paris, 1942).

1847 Paris

Letheve, Jacques, *The Daily Life of French Artists*, trans. by H. E. Paddon (London, 1972).

1848 Paris

Clark, T., *The Absolute Bourgeois* (London, 1973).
　　　Image of the People (London, 1973).

Sloane, J., *French Painting Between the Past and the Present* (Princeton, 1951).

Romantic Art in Britain: Paintings and Drawings 1760–1860, exhibition catalogue (Detroit, 1961).

INDEX